Film and Video Editing Theory

Film and Video Editing Theory offers an accessible, introductory guide to the practices used to create meaning through editing. In this book, Michael Frierson synthesizes the theories of the most prominent film editors and scholars, from Herbert Zettl, Sergei Eisenstein, and Noël Burch to the work of landmark Hollywood editors like Walter Murch and Edward Dmytryk. In so doing, he maps out a set of craft principles for readers, whether one is debating if a flashback reveals too much, if a certain cut clarifies or obscures the space of a scene, or if a shot needs to be trimmed. The book is grounded in the unity of theory and practice, looking beyond technical proficiency in a specific software to explain to readers how and why certain cuts work or don't work.

Michael Frierson is a Professor in Media Studies at the University of North Carolina at Greensboro. He is the author of *Clay Animation: American Highlights 1908 to the Present* (1994), which won the McLaren-Lambart Award from the National Film Board of Canada for the Best Scholarly Book on Animation for 1995. He teaches film theory, film/video production and editing, and has produced, shot and edited feature documentaries, as well as short films for Nickelodeon, Children's Television Workshop, MSN Video, and AT&T Blue Room.

Film and Video Editing Theory

How Editing Creates Meaning

Michael Frierson

Routledge
Taylor & Francis Group

NEW YORK AND LONDON

First published 2018
by Routledge
711 Third Avenue, New York, NY 10017

and by Routledge
2 Park Square, Milton Park, Abingdon, Oxon OX14 4RN

Routledge is an imprint of the Taylor & Francis Group, an informa business

Library of Congress Cataloging in Publication Data
A catalog record for this book has been requested

ISBN: 978-1-138-20206-1 (hbk)
ISBN: 978-1-138-20207-8 (pbk)
ISBN: 978-1-315-47501-1 (ebk)

Typeset in Times New Roman
by Apex CoVantage, LLC

Visit the companion website: https://www.michaelfrierson.com/.

For Martha who has taught me so much

Contents

Figures

Preface

Why did cinema become the twentieth century's dominant art form? One reason is its unmatched ability to narrate using a system for representing space-time that mimics our experience, the ordinary, human experience of four-dimensional space-time as length, width, height and past-future. Stephen Heath has summarized this idea brilliantly.

> From the very first, as though of right, human figures enter film, spilling out of the train, leaving the factory for the photographic congress, *moving* – this is the movies, these are moving pictures. The figures move in the frame, they come and go, and there is then need to change the frame, reframing with a camera movement or moving to another shot. The transitions thus effected pose acutely the problem of the filmic construction of space, of achieving a coherence of place and positioning the spectator as the unified and unifying subject of its vision. It is this process of constructions, indeed, which is often regarded as the power of cinema.[1]

In Heath's account, it is movement of the figures that necessitates editing, movement of the figures that forces the filmmaker to consider how to construct filmic space, so that the spectator is the focal point where that screen representation "comes together." Or as he puts it, "positioning the spectator as the unifying subject of the camera's vision." This complex process of constructing filmic space – a result of shooting and editing – is one of the primary gifts of cinema, creating a rich stimulus set that draws audiences to the experience.

This book is not about some of the important work that editors do: developing a character or shaping the emotional tone of a scene, since that kind of theorizing would require more of a case study comparing the available footage and the final cuts that were made. Rather, this book tries to distill and illustrate the thinking of a diverse group of filmmakers and theorists who have written about how editing constructs filmic time/space, and how editing signifies in other ways. Their writings chart the struggle to come to grips with the topic we might broadly label "how editing creates meaning." My purpose is to collect and critically examine these foundational ideas on film editing, the conceptual grids developed by significant thinkers like Herbert Zettl, Noël Burch, David Bordwell and Andre Bazin, as well as groundbreaking filmmaker/theorists like Sergei Eisenstein, Walter Murch, Edward Dmytryk, Andrei Tarkovsky and Maya Deren. Their writings deal almost exclusively with how editing works in *narrative* film, and include some general rules of thumb formulated by working editors about what makes classical Hollywood editing work well. I call all of this material "film theory," following David Bordwell's and Noël Carroll's call for "mid-level theorizing:" "We should countenance as film theory any line of inquiry dedicated to producing generalizations pertaining to, or general explanations of, filmic phenomena, or devoted to isolating, tracking, and/or accounting for any mechanisms, devices, patterns, and regularities in the field of cinema."[2]

There is broad agreement with Heath among filmmakers and film scholars that editing is the true power of cinema. Consequently, for film students, for film scholars and even general readers – anyone learning to "read" and/or "write" with moving images – understanding how editing creates meaning lies at the center of the undertaking. Since the late 1980s, the emerging field of digital video and nonlinear editing has created a world where our ability to capture and manipulate vast amounts of image data far outstrips our artistic ability to create meaning. Filmmakers benefit from the potential and precision of digital methods, but struggle to overcome software bugs, workflow issues and constant technical change in the field. Often, technical issues seem to overwhelm the thinking of beginning filmmakers. And for beginning editors, the belief that acquiring basic fluency in a particular editing software is crucial to their success creates a false equivalence: a person who is good with Final Cut Pro or Adobe or Avid is a good editor. This fallacy often overshadows a sustained discussion of the real, and very daunting question they face: why does a particular cut work or not work?

Understanding some of the foundational ways that editing creates meaning can help editors make better films, and the hope here is that the reader will gain some useful, enduring conceptual tools from both the analysis of writings *and* the analysis of films. So in this book, we will 1) examine key written texts about editing, trying to unpack what claims the writer makes and 2) explicate specific sequences or scenes from narrative feature films that demonstrate the claims made. Much of this work involves applying different schemata to edited sequences to understand how editing works at the local level: we examine and classify edits. Jacques Aumont, the great French film theorist, writes,

> The idea of describing the various kinds of montage and grouping them into typologies is itself an old practice; it has been translated for a long time by the construction of montage tables or grids. These tables, often based more or less directly on the practice of their authors, are always of interest; yet their goal for the most part is somewhat confused since they generally become more of a collection of recipes designed to nourish the techniques of film production than a theoretical classification of editing effects.[3]

I agree and I disagree. Yes, these "taxonomies of montage" are often based on the practice of the authors, they are always of interest, and they nourish the filmmaker/editor. (On another level, the same could be said of this entire book: it is colored by my own concerns and pursuits as a filmmaker, film teacher and film scholar, and it contains ideas – alas, only those available in English – that have nourished me for decades.) And yes, many of these authors discover a particular cinematic technique that they privilege as the "essence of cinema:" montage vs. the long take, to name the most obvious instance at hand. The medium specificity argument says that cinema, like other art forms, has certain unique expressive qualities, and that the source of films' artistic quality is the exploitation of these unique qualities. Nevertheless, if these taxonomies are not "a theoretical classification of editing effects," then what is? These authors give an account for editing "mechanisms, devices, patterns, and regularities in the field of cinema." As theories of editing they are intellectual grids that can be held up against specific scenes, specific films and specific situations in the edit room to gain insight into how editing works. In short, they are ways to think about "how editing creates meaning." My hope is that the reader will not evaluate them in simple terms – correct or incorrect, helpful or unhelpful – but on a much broader range of criteria. As Robert Stamm puts it, "Rather than being simply right or wrong – although on occasion they are one or the other – these diverse [theoretical] grids are relatively rich or impoverished, methodologically open or closed, culturally dense or shallow, fastidiously anal or cannibalistically oral, historically informed or ahistorical, one-dimensional or multidimensional, monocultural or multicultural."[4] Reading these critical texts, studying the relevant clips (most of which are available on

www.CriticalCommons.org) and thinking about where these ideas fall along the criteria Stamm suggests will surely deepen the reader's understanding of how editing creates meaning.

A Note Regarding Editing Credits

The process of collaboration (or lack of collaboration) between directors and editors is a critical component to the creation of motion pictures, and those relationships vary widely. Studio contracts and union rules dictate that even directors who are deeply involved in the cutting of their films work with a hands-on editor, who is rightfully given screen credit as "Editor." In the era of the Hollywood "Dream Factory," editors like Margaret Booth were extremely influential but largely unknown outside the industry. Booth went to work for D.W. Griffith right out of high school, and by the 1930s was one of the top editors in the business. From 1939–1968 she was Supervising Editor at MGM, with enormous influence: "All filmmakers from the late 1930s through the late 1960s who worked at MGM had, in the end, to go through Booth to have the final editing of sound and image approved."[5] Trained in the film industry as editors, some, such as Robert Wise, David Lean and Edward Dmytryk, moved on to become directors, and presumably held strong ideas on how their films should be cut. Akira Kurosawa's production chief once said, "Among ourselves, we think that [Kurosawa] is Toho's Best director, that he is Japan's best scenarist, and that he is the best editor in the world."[6] In the New Hollywood era, James Cameron, Steven Soderbergh and the Coen Brothers have edited many of their own films, and the enduring collaborations between Martin Scorsese and Thelma Schoonmaker, Francis Ford Coppola and Walter Murch, and Steven Spielberg and Michael Kahn have been lauded.

Consequently, untangling the creative contribution of director versus editor for the films discussed here – were it even possible – is beyond the scope of this book, and I will follow the common practice of crediting the director as the creator of the film: e.g., *Inception* (Christopher Nolan, 2010). Full credits for all the films discussed are widely available on the worldwide web.

Notes

1 Stephen Heath, "Narrative Space," in Philip Rosen, *Narrative, apparatus, ideology: a film theory reader* (New York, NY: Columbia Univ. Press, 2008), 393.
2 David Bordwell and Noël Carroll, *Post-theory: reconstructing film studies* (Madison: University of Wisconsin Press, 1996), 41.
3 Jacques Aumont, Alain Bergala and Michel Marie, *Aesthetics of film* (Austin, TX: University of Texas Press, 1999), 52.
4 Robert Stamm, Film theory: an introduction (Malden, MA: Blackwell, 2000), 8.
5 Douglas Gomery, "Booth, Margaret," in International dictionary of films and filmmakers, edited by Sara Pendergast and Tom Pendergast, 4th edn, vol. 4: Writers and Production Artists, St. James Press, 2000, pp. 100–101. Gale Virtual Reference Library.
6 Hiroshi Nezu quoted in Donald Richie and Joan Mellen, *The films of Akira Kurosawa* (Berkeley, CA: University of California Press, 1998), 238.

Acknowledgments

Many people deserve thanks for their help with this book. David Cook was kind enough to read the manuscript closely, and his careful eye gave me the benefit of his broad and detailed knowledge of film history. Kevin Welles read and clarified my thinking about key passages. Ken Terres is a long-time colleague and film collector who helps me troubleshoot all things technical and manages our extensive DVD library, which was generously donated to our department by Jim Almoney. Issac Smith and Martha Garrett did wonderful work creating illustrations, and Catilin Cook helped me tweak many of them. My son Evan and my brother Dargan brought their knowledge of music to bear where mine was sorely lacking. The librarians at Jackson Library epitomize the value of public institutions: they are consummate professionals who help people find information. I am particularly thankful for the help of Mark Schumaker in Reference, Gaylor Callahan and Pat Kelly in Interlibrary Loan, Amy Houk-Harris in Research, Outreach and Instruction and Cathy Rothermel in Instructional Media. The members of my MST 485 class – Shawndale Arnold, Walker Kenion, Hoon Lee, Taylor Rodgers, Aaron Seyerle and Aron Shindledecker – as well as my colleague David Row were most helpful shooting video for this book. This book would not have been possible without the support of Provost Dana Dunn, Dean John Kiss and my department head Kimberlianne Podlas who helped tremendously obtaining grants and a research leave. Finally, I'd like to thank colleagues in other departments who lent their expertise: for help with specific content areas, Joeseph Starobin shared his knowledge of Russian culture, Chiaki Takagi her knowledge of Japanese culture, and Charlie Headington his knowledge of religious icons. My website was expertly designed by my daughter Georgia. And of course Simon Jacobs and William Burch from Taylor and Francis offered much encouragement and advice, and Ruth Bourne did a marvelous job of copy-editing the manuscript.

1 Herbert Zettl, Approaches to Building Screen Space and Vectors

Approaches to Building Screen Space

Our first approach to understanding how editing creates meaning is to set aside the usual narrative functions of editing – the story the film is trying to tell, the notion of coverage, the need to shape dialogue scenes – and simply consider the film image as a two-dimensional *screen space*, a combination of interacting visual elements enclosed by a frame. With his background in gestalt psychology and art theory, Rudolf Arnheim (1904–2007) laid the groundwork for this approach in the early period of classic film theory with his seminal text *Film as art* first published in 1933. There are few theorists more central to our understanding of how motion pictures work – indeed how the visual arts work – than Arnheim. He was a profound thinker and gifted writer who could explicate difficult concepts with brilliant clarity. After studying gestalt psychology with Max Wertheimer in Berlin in the 1920s, Arnheim spent most of his life applying its concepts to explain how visual perception works in art.

Gestalt psychology, Arnheim writes,

> came about as an amendment to the traditional method of scientific analysis. The accepted way of analyzing complex phenomenon scientifically had been that of describing the parts and arriving at the whole by adding up the descriptions thus obtained. Recent developments in biology, psychology, and sociology had begun to suggest, however, that such a procedure could not do justice to phenomena that are field processes – entities made up of interacting forces.[1]

Gestalt psychology noticed that the laws governing the physical world are reflected in human visual perception, making it possible to coordinate and map mental functions with the physical world, and ultimately to see art as the expressive, intelligent translation of visual thinking into the creative potentials of a given media. As Arnheim puts it,

> even the most elementary processes of vision do not produce mechanical recordings of the outer world but organize the sensory raw material according to principles of simplicity, regularity, and balance, which govern the receptor mechanism [the eyes and the brain structures that control the eyes]. This discovery of the gestalt school fitted the notion that the work of art, too, is not simply an imitation or selective duplication of reality but a *translation* of observed characteristics into the forms of a given medium.[2]

Writing in the early 1930s, Arheim agreed with a few early film theorists that the medium of film was not a mechanical recording of the world but rather reshaped reality using its unique potentials. As he put it, "Art begins where mechanical reproduction leaves off, where the conditions of reproduction serve in some way to mold the object."[3] In a brilliant turn of thinking,

Arnheim argued that it is *precisely* the limitations of film – projection of solids onto a plane surface, reduction of depth, framing/limitation of the field of view, etc. – that supply film with its artistic means.

Arnheim lectured on the psychology of art at a number of American universities after World War II, including Sarah Lawrence College, Harvard University and the University of Michigan. Fellowships from the Guggenheim and Rockefeller foundations gave him time to research the application of gestalt theories to the visual arts. His major opus *Art and visual perception: a psychology of the creative eye* (1954) was followed by *Visual thinking* (1969), and his scholarly writing continued for decades. With a deep love of art in all its forms, a deep respect for artists, and a deep understanding of the psychology of visual perception and cognition, Rudolf Arnheim – who died in 2007 at the age of 103 – is a towering figure in advancing our understanding of how mind and art interact.

Arnheim's work was influential in turning public opinion about value of motion pictures. Photography – regarded as a dry, mechanical method for realistically reproducing images – and motion pictures – with their reliance on melodramatic narratives that appealed to the masses – struggled during the early period of their history to be recognized as art forms with unique properties of expression. Against the claim that film is a mechanical medium that merely reproduces reality, Arnheim argued that what makes film an art is its unique formal qualities that make it *un*real, or *different from reality* – its projection of three-dimensional solids on to a two-dimensional screen, its reduction of a sense of depth, the framing of the image, the absence of continuous time because of editing, etc. An often-quoted section of Arnheim's *Film as art* argues that:

> The effect of film is neither absolutely two-dimensional nor absolutely three-dimensional, but something between. Film pictures are at once plane and solid . . . film gives simultaneously the effect of an actual happening and of a picture. A result of the "pictureness" of film is, then, that a sequence of scenes that are diverse in time and space is not felt as arbitrary. One looks at them as calmly as one would at a collection of picture post cards. Just as it does not disturb us in the least to find different places and different moments in time registered in such pictures, so it does not seem awkward in a film. If at one moment we see a long shot of a woman at the back of a room, and the next we see a close up of her face, we simply feel that we have "turned over a page" and are looking at a fresh picture. If film photographs gave a very strong spatial impression, montage [editing] probably would be impossible. It is the partial unreality of the film picture that makes it possible.[4]

Thus, the world captured in film is translated by the lens from a three-dimensional space to a two-dimensional screen space, a flat, mediated representation of the world that simultaneously feels like "an actual happening." According to Arnheim, it is this very trait of film – a mediated space that exhibits both "pictureness" and "actuality" – that makes editing possible.

This screen space presents the audience with a variety of changing visual forces, a rich two-dimensional stimulus set, a visual field that our brains habitually decode using the fundamental gestalt principles our perceptual systems have evolved like laws of grouping which include proximity, symmetry, similarity and closure.[5] These characteristics that Arnheim first identified suggest a scheme that we can use to look at how cutting works. Think of a single edit not as a change of shot that might, for example, simply go from a long shot to a close up to cover a character's reaction, but as one two-dimensional frame full of screen elements and screen forces that changes to another two-dimensional frame full of screen elements and screen forces. As the shot changes, the screen elements may or may not match, the screen forces at work may or may not continue. Thinking this way, in terms of *screen space* – using the framed, two-dimensional, visual elements that underlie the outgoing shot and comparing them to the same parameters of the incoming shot – turns out to

be a valuable tool for evaluating many aspects of the basic question all editors face: does the cut work (or not), and if so why (or why not)? In other words, for the editor, the focus of the analysis becomes a comparison of abstract, visual forces that occur across the cut.

Debates about screen space in classical film theory continued through the 1960s and often revolved around the nature of the film image and of the film frame. Just as Arnheim felt that screen space was "something between," the *frame* of the moving image itself was thought to have dual function. Specifically, classical film theorists raised this question: does the frame in motion pictures function primarily to formalize the elements within it or does it function more like a window, selecting what the viewer sees while simultaneously recognizing that action spills out beyond its edges?[6]

In the first case – the formalizing function of the frame – the director uses the rectangular shape of the frame to clarify and intensify the actions within in it. Here, the director uses the frame to create meaningful, arranged compositions within the two-dimensional screen space, allowing us to more easily experience things like triangular compositions where character positions form triangular shapes, often to reinforce underlying thematic concerns. In the famous scene from *Citizen Kane* (Welles, 1941) the young Charles Foster Kane, powerless to determine his future and soon to be sent away from his mother, is centered at the bottom of a triangular composition that features – as an inside joke perhaps – an actual triangle dinner bell placed deep in the center of the space (Figure 1.1). In such moments, the audience feels the formalizing approach of the director's hand, carefully composing the scene to create meaning in purely visual terms.

Figure 1.1 The formalizing function of the frame in Citizen Kane. In this shot from *Citizen Kane* (Welles, 1941) the film frame functions more like the frame of a classical painting, creating clear diagonal and triangular patterns that reinforce underlying thematic concerns: here, the young Charlie Kane is at the center of a custody squabble over whether he will remain with his mother on the right and his father center, or be taken to the city to be raised by Mr. Thatcher on the left.

In the second case – frame as window – the director selects an area of the world without tightly controlling what happens within the screen space, so that the action spills off screen, a style of direction that remains true to the realistic décor before the camera, minimizing the difference between the audience's perception of the screen and normal perception, and forcing the audience to seek out areas of visual interest without the guiding hand of the director. Ridley Scott exploits this notion of "frame as window" in many shots within the opening battle scene of *Gladiator* (Scott, 2000), coupling it with underexposure, to force the audience to explore the frame (Figure 1.2).

This early theorizing about screen space and the dual nature of the frame was broadened, and carried into the contemporary arena of practical theorizing by Dr. Herbert Zettl. Zettl is a Professor Emeritus of Broadcasting and Electronic Communication Arts in the College of Creative Arts at San Francisco State University. He studied at Stanford University in the 1950s where he received bachelors and masters degrees. Early influences included the philosophy of Bauhaus design and gestalt psychology. The seminal work by Rudolf Arnheim, *Art and visual perception: a psychology of the creative eye* (1954), greatly influenced Zettl, who published a dissertation on the use of television in adult education in 1966, earning his doctorate from University of California, Berkeley.

A teacher-scholar for 50 years, Zettl was a very early advocate for the notion that television could be an art form, a visionary idea when his book *Sight, sound, motion* was first published in 1973. This text, revised and developed in the eight editions that followed, theorizes how moving images can not only be "read" to understand their underlying creative structures – a process long known to traditional aesthetics – but how new moving images can be conceived and "written" to communicate with maximum effectiveness. Fundamental concepts Zettl articulated like *vectors*, *principal*, *secondary and tertiary motions*, *event intensity*, etc. gave producers and scholars alike a new descriptive vocabulary for unpacking the underlying aesthetic forces that shape moving images. An advocate for the notion that the museum is not the sole province of art, Zettl argues that life and art are dependent, that aesthetic experiences are part of everyday life, and that all experience has the potential to be the raw material for art if it is structured effectively.

Sight, sound, motion also offers an insightful, creative guide to applied media aesthetics, which in the case of television, film and other audiovisual media, is the examination of the formal

Figure 1.2 Frame as window in Gladiator. In this shot from *Gladiator* (Scott, 2000), the film frame functions more like a window, creating the sense of a real battle as the clashing armies chaotically spill outside the frame. Here, the rectangular frame structures the visual field less formally, forcing the audience to scan the frame to discover areas of significance.

Source: Copyright 2000 Dreamworks Pictures.

elements of media (like sound, lighting, camera angle, etc.) to understand how they interact, and how the viewer reacts to them.[7] Zettl argues that, like writing where we learn parts of speech and vocabulary as essential prerequisites for creative writing, we need to study the fundamental image elements that function within the "aesthetic field" that the filmmaker manipulates in creating a film.[8] While traditional aesthetics can be used for critical analysis of a completed work, Zettl advocates *applied media aesthetics* because it can be practiced when we analyze existing media *and* when we synthesize or create media at the production stage. For the editor, the most important elements Zettl identifies that we need to learn to structure are the forces within the two-dimensional field (Figure 1.3), and the four-dimensional field of time/motion.

According to Zettl, the film frame gives us a field with three axes, following the Cartesian coordinate system of x-axis for the horizontal dimension, y-axis for the vertical dimension and z-axis for the line extending from the camera to the horizon. With this three-dimensional spatial framework established, Zettl can specify any number of dynamic forces within the frame space using the concept of a *vector.* Borrowing from the term in physics, Zettl says that "In media aesthetics [a vector is] a perceivable force with a direction and a magnitude."[9] He goes further to delineate three main types of vectors in film:

1) A *graphic vector* is one created by a line or screen elements arranged to suggest a line. Graphic vectors do not indicate a clear-cut direction, but they do have a prevailing tendency: they may be predominantly horizontal, vertical, rounded, elliptical, etc. So we recognize, for

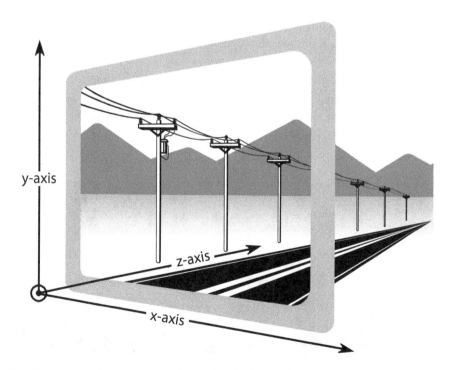

Figure 1.3 The x,y,z coordinate system applied to the film frame. The spatial coordinate system first developed by Rene Descartes in the seventeenth century has been usefully adapted by Herbert Zettl to describe the screen forces and primary motions that occur within a film frame.

Source: Illustration adapted from Zettl.

example, a horizontal graphic vector in the shot of a building (Figure 1.4) as positioned along the x-axis without knowing if it suggests a *direction* left or right. Here, the horizontal vector can be scanned by the audience either left to right – an easier process for cultures who read left to right – or right to left, with a bit more effort.

2) An *index vector* is one created by something that clearly points in a specific direction. The human face, a loud speaker, a pistol, a lens, an automobile – anything that points in a single direction – carries that directionality into the frame and creates an *index vector* (Figures 1.5 and 1.6).

3) A *motion vector* is one created by something moving across the frame in a particular direction.[10] A film of a train in motion (shown here as a still photograph) is an example of a motion vector. Using Zettl's x, y, z coordinate system, we could describe the image more precisely as exhibiting a predominantly z-axis motion vector that moves principally right to left, along the shallow z-axis angle created by camera placement that allows the track to recede to the horizon mid-height at the right side of the frame (Figure 1.7).

Zettl develops the notion of vector further, pointing out that *within each category* of vector, there exist low magnitude and high magnitude instances. For example, one shot of the bridge can create a low magnitude and another a high magnitude graphic vector (Figures 1.8 and 1.9).

Similarly, motion vectors created by objects moving quickly across the frame are higher in magnitude than those created by slower moving objects.

We can also compare relative magnitude *across* categories: other things being equal, motion vectors are inherently higher in magnitude than index vectors, which are higher in magnitude than graphic vectors. In other words, elements that simply create line within the screen space will always be relatively less impactful, less dynamic than an index vector that has an unambiguous front/back orientation, or motion vectors that transit the screen space, entering, exiting, crossing horizontally or moving dynamically towards the camera. To summarize, while each category may exhibit low and high magnitude instances, when we compare vector magnitude:

motion vectors > index vectors > graphic vectors.

As editors, when we apply this scheme of screen vectors to existing films or to source footage, we begin to understand that the *vector field* – the mix of vectors exhibited by a moving image – can be enormously complex, and may vary based on the unit of analysis chosen. Are we analyzing

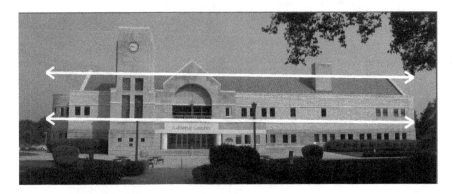

Figure 1.4 Horizontal graphic vector. This shot of the library at Immaculata University exhibits a predominantly horizontal *graphic* vector, that is stable and balanced, punctuated by a few vertical elements.

Source: Ruhrfisch / Wikimedia Commons / CC BY-SA.

Figure 1.5 Index vector of a fire hydrant. A shot of a fire hydrant contains an index vector, a perceivable screen force in a particular direction.

Source: Dori / Wikimedia Commons / Public Domain.

Figure 1.6 Index vectors: skull. This composite shot of a 2.1 million-year-old specimen Australopithecus africanus discovered in South Africa exhibits a range of index vectors.

Source: José Braga; Didier Descouens / Wikimedia Commons / CC BY-SA 4.0. Arrows added.

Figure 1.7 Oblique z-axis "motion" vector. If this were a moving shot, the train pictured above would cre-
ate a motion vector on an oblique z-axis moving left to right.

Source: Franz Jansen (†), Erkrath / Wikimedia Commons / CC BY-SA 3.0.

a screen vector field within a single frame? Are we analyzing a screen vector field as it changes
frame to frame? Are we analyzing a vector field within a single shot? Are we analyzing a vector
field within a sequence?

Along with questions about the unit of analysis, discussions of screen space require us to
verbalize impressions of very complex visual phenomena. The spatial and temporal complex-
ities created within the film frame by a series of shot changes is easy for us to read visually,
but often overwhelming when we try to reduce it to simple, descriptive terms. In the case of
screen vectors, we tend to simplify descriptions of the vector *field* – the myriad vectors that
may manifest in a shot – into a single, short hand description of the *dominant* vector within
a shot.

For example, there are many vertical and horizontal graphic elements in the shot of Old
Library at Trinity College (Figure 1.10): the horizontal rows of books, the vertical pillars, the
vertical stanchions holding the ropes and the vertical pedestals for the busts. But given the
placement of the camera, the prominent central arch and upper railing, the *dominant vector* is
the z-axis towards the center of the frame. We often simplify our description to "This image
is a z-axis vector," What we mean is that the *dominant* elements of the graphic vector field
within a scene create a z-axis. So, at the level of a single frame, the vector field may contain a
complex combination of one type of vector. Or, more likely, it will move beyond a single *type*
of vector: the frame may simultaneously exhibit vertical graphic vectors *and* index vectors
pointing in multiple z-axis directions. Moreover, if the unit of analysis moves from a single
frame to a *multiframe* comparison, another type of vector is introduced: the motion vector of
the main character may move left to right in the frame along the x-axis.

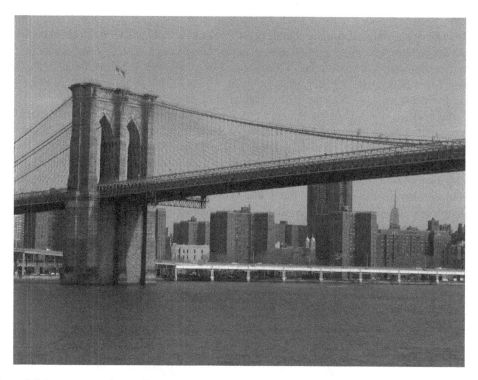

Figure 1.8 Low magnitude graphic vector: Brooklyn Bridge. Within each category of vector, there can be low magnitude . . .

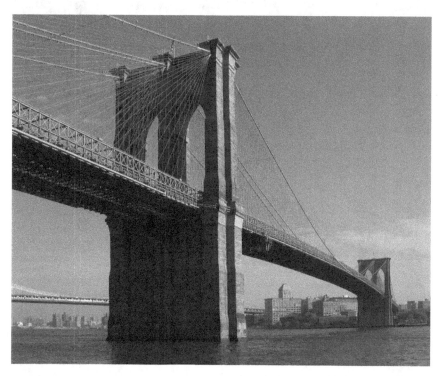

Figure 1.9 High magnitude graphic vector: Brooklyn Bridge. . . .and high magnitude instances.

Here we begin to run into issues of complexity that can make analyzing vector fields across types of vectors and across a series of shots seem useless. Perhaps the most useful unit of analysis for the editor to return to ultimately is the last frame of the outgoing shot compared to the first frame of the incoming shot:[11] specifically, what happens when the vector field of the outgoing shot changes to the vector field of the incoming shot? Does the general pattern of vectors *continue* in the incoming shot or is it *discontinuous?* When we edit for continuity, we try to maintain vectors that continue from shot to shot. In narrative filmmaking and in any film where we intend to keep the audience oriented spatially, Zettl argues that we need to follow a prescribed syntax of continuity editing, a classical pattern of selecting and sequencing images that maintains the spectator's spatial orientation, allowing them to easily maintain a cognitive mental map that structures and unifies their reading of the on and off screen space given by the shots in a sequence.[12] In the discussion that follows, the underlying assumption is that an editor would follow this syntax of continuity editing almost by default, as it is the general practice when we distill narrative events to tell stories, or more generally in any moving image text when we want to create a consistent, orderly spatial progression. Discontinuous approaches are more likely used for other purposes, including purely abstract visual sequences, and for instances of complexity editing, the use of shots – independent of whether or not they follow the conventions of continuity editing – to reveal the story and amplify the underlying emotion of a scene.[13]

Graphic Vectors and Index Vectors: Continuity and Discontinuity

Consider the case of shots that do not contain motion, but do contain screen elements arranged in a line, like a shot of the open desert road extending to the horizon (Figure 1.11). This is a

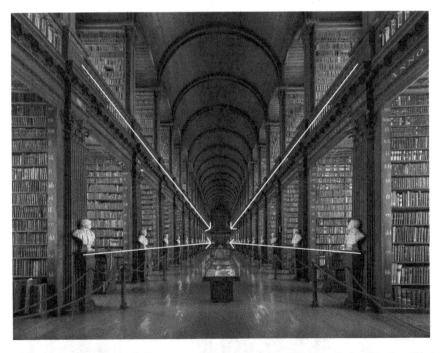

Figure 1.10 Dominant z-axis vector. The vector field in this shot contains vertical and horizontal elements, but given the placement of the camera, the prominent central arch and upper railing, the dominant vector is the z-axis towards the center of the frame. A shorthand description of the image would be, "This image is a z-axis vector," meaning the *dominant* elements of the graphic vector field within a scene create a z-axis.

graphic vector with a prevailing z-axis orientation, but one that does not indicate a clear-cut direction, since it can be seen either as extending away from the camera or towards the camera. If the editor cuts from that image to another image of an open desert road extending to the horizon (Figure 1.12), the dominant z-axis graphic vector *continues* from outgoing to incoming shot.

As these images demonstrate, the more closely that vectors align from image to image, the smoother the cut.[14] However, if we cut from the same outgoing shot (Figure 1.13) to a roadside sign in the desert landscape, the dominant z-axis graphic vector in the outgoing shot is replaced by the dominant *horizontal*, x-axis vector of the incoming shot (Figure 1.14), made prominent by the sign, the road and the mountains in the distance. Since the graphic vector field changes, a cut from Figure 1.13 to 1.14 exhibits what we can call *discontinuous graphic vectors*, even though the subject matter – the desert landscape – continues.

This designation is not to value continuous vectors above discontinuous vectors, as if "discontinuous" was somehow less useful: determining how the vector field changes from shot to shot may be only one of many considerations the editor faces when considering a shot change. Beyond graphic vector continuity/discontinuity, Zettl articulates three other cases in the image track where editing is concerned with vector fields: index vector continuity/discontinuity, motion vector continuity/discontinuity and the special case of continuity using z-axis vectors.

Since an *index vector* usually points unambiguously in a specific direction, a cut from a shot containing one index vector to another index vector either continues the general directionality of the outgoing shot or does not continue it. If the dominant index vector continues, the change in screen space feels "softer," the cut smoother, while large changes in the dominant index vector are considered "harder" cuts. For example, if the editor cuts from an outgoing shot of a ship with a specific index vector (Figure 1.15) to an incoming shot of another ship that roughly continues that same index vector (Figure 1.16), that is considered a relatively smooth cut.

Conversely, a cut with the incoming image of the ship's prow flopped left to right would generally be regarded as a harder cut (Figure 1.18). Again, this is not a value judgment: a harder cut may be just what the editor is seeking.

Because the human face at rest looks in a specific direction, it has an inherent index vector. The face is the most prominent image in narrative films, and so the face is central to creating meaning in film through dialogue and facial expression. In the film world, this facial index vector is commonly called *eye-line*, the direction of a character's look in the frame. Index vectors or eye-lines guide the viewer to see what the character sees *within* the frame – on screen space – as well as what the character sees *outside* the frame – off screen space. As the shots within a scene oscillate between objective and subjective camera, taking the character's position in point-of-view placements, or simply cutting to what the character is looking at, index vectors of the principal actors' faces are the primary cues to the spectator for spatial orientation. To paraphrase Stephen Heath, the spectator reads a film on the basis of the camera's view and the editor's construction of those views into a flow of images. In Heath's view, a film character becomes a "figure of the look . . . a kind of perspective within the [film's] perspective system, regulating the world, orientating space, providing directions . . . for the spectator."[15] In short, the eye-lines of the characters orient the audience spatially.

Like Heath, Zettl believes that index vectors of the human face are key to building and stabilizing the viewer's mental map, the viewer's spatial orientation.[16] The index vector field of a shot can encompass index vectors that *continue* – a vector points in a direction and another vector points in the same direction; *converge* – a vector points towards another vector; or *diverge* – a vector points away from another vector. See Critical Commons, "*Maltese Falcon*: opening scene."[17] For example, in the opening of *Maltese Falcon* (John Huston, 1941) Ruth Wonderly (Mary Astor) comes to the office of Sam Spade (Humphrey Bogart) ostensibly to seek his help finding her missing sister.[18] Huston establishes the two sitting opposite each other at Spade's desk (Figure 1.19), then cuts in closer to an over-the-shoulder

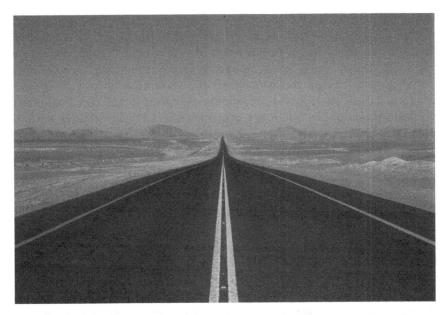

Figure 1.11 Continuing graphic vector outgoing shot . . . If we cut from 1.11 to 1.12, the dominant graphic vector of the road leading to the horizon in the outgoing shot . . .

Source: Copyright (c) Nepenthes. via GNU Free Documentation License.

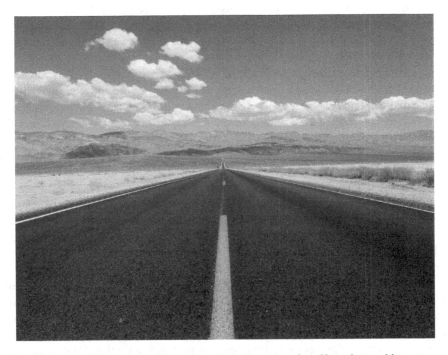

Figure 1.12 Incoming shot. . . . generally continues in the incoming shot. Since the graphic vector matches, a cut from a to b is continuous and smooth.

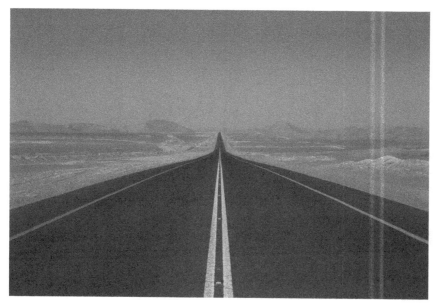

Figure 1.13 Discontinuous graphic vector outgoing shot . . . If we cut from 1.13 to 1.14, the dominant z-axis *graphic* vector of the road leading to the horizon in the outgoing shot . . .

Figure 1.14 Incoming shot. ...collides with the horizontal x-axis graphic vector of the incoming shot.

Figure 1.15 Continuing index vector outgoing shot . . . If we cut from 1.15 to 1.16, the dominant index vector – the direction of the ship's prow of the outgoing shot . . .

Source: Christian Ferrer / Wikimedia Commons / CC BY-SA 4.0.

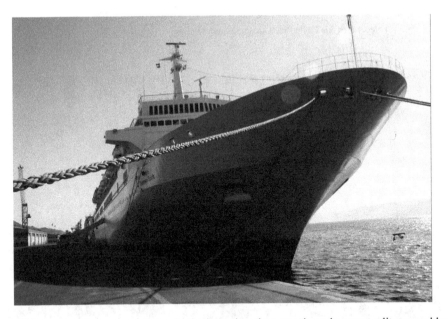

Figure 1.16 Incoming shot. . . . continues in the incoming shot, creating what most editors would regard as a "softer" cut. The incoming shot maintains the overall "gestalt" of the outgoing shot: the shot change does not ask the viewer to reorient the overall visual structure in processing the incoming image.

Source: IDS photos / Wikimedia Commons / CC BY-SA 2.0.

shot of Wonderly (Figure 1.20), so that her index vector (eye-line) in the outgoing two-shot *continues* in the incoming close up.

 As with any continuity cut from a wider shot to a closer one, this is traditionally called a *cut in.* Its spatial clarity derives in part from the fact that it carries information that is redundant from the

Figure 1.17 Discontinuous index vector outgoing shot . . . If we cut from 1.17 to 1.18, the dominant index vector – the direction of the ship's prow of the outgoing shot . . .

Source: IDS photos / Wikimedia Commons / CC BY-SA 2.0.

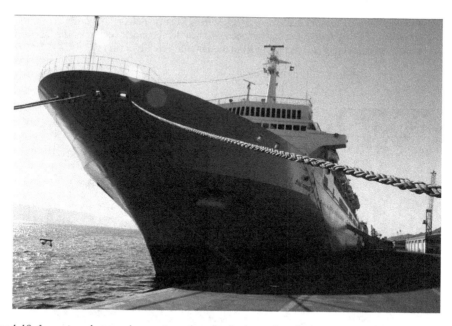

Figure 1.18 Incoming shot. . . .does not continue in the incoming shot, creating what most editors would regard as a "harder" cut, in that the incoming shot changes the overall directionality of the outgoing shot.

Source: IDS photos / Wikimedia Commons / CC BY-SA 2.0.

establishing shot. Its dramatic value in this opening scene is to concentrate the narrative exposition, since Wonderly recounts what brought her to Spade's office: she is searching for her sister who has disappeared.

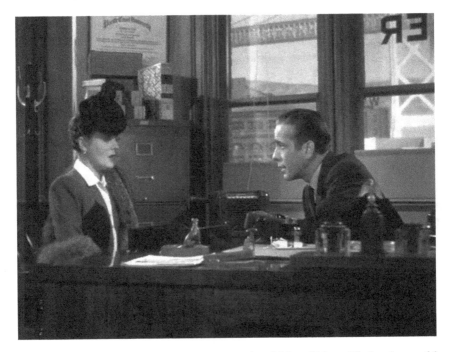

Figure 1.19 Continuing index vectors in a dialogue scene from Maltese Falcon. *The last frame of the outgoing shot 1* . . . In a dialogue scene between two people, the index vectors of the faces orient the viewer by continuing across the cut from the outgoing shot two shot . . .

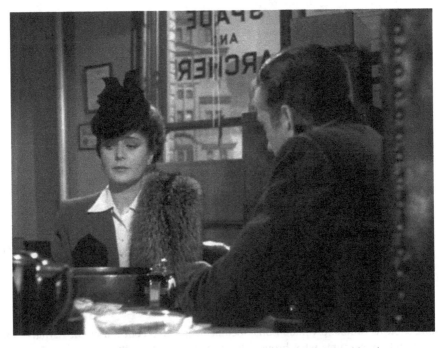

Figure 1.20 First frame of the incoming shot 2. . . to the incoming over-the-shoulder shot.

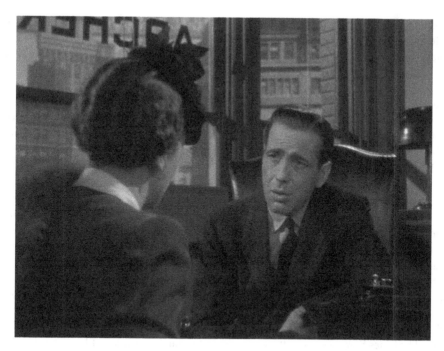

Figure 1.21 The shot 3 reverses the angle. Huston's next cut is to an over-the-shoulder shot where the converging index vectors of their faces, and particularly, their converging eye-lines, make the edits as spatially coherent as possible.

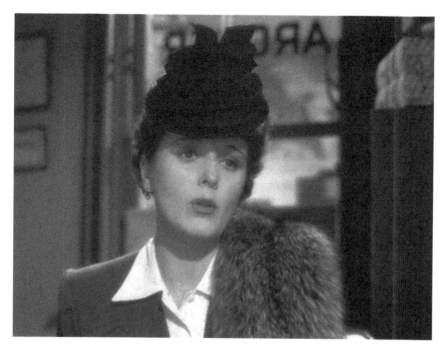

Figure 1.22 Shot-reverse shot: outgoing. Huston cuts shots from either end of the axis created by their converging eye-lines (and body positions) in an alternating pattern between the speaker . . .

Huston's next cut is to an over-the-shoulder shot of Spade (Figure 1.21) that roughly matches the scale and graphic balance of the previous shot. In both over-the-shoulder shots, the converging index vectors of their faces, and particularly, their converging eye-lines, make the edits as spatially coherent as possible. This pattern – cutting from Figure 1.20 to Figure 1.21 – can be classified as a *shot-reverse shot*: shots from either end of the axis created by their converging eye-lines and body positions are cut in an alternating pattern between the speaker and the person spoken to. More typically, the shot-reverse shot pattern moves into close ups, and the two adjacent spaces shown are "knit together" by the converging eye-lines. Here, as the story Wonderly tells of searching for her sister gets more convoluted (Figure 1.22), Huston's reverse close up of Spade shows his skepticism as he lights a cigarette (Figure 1.23).

This cutting pattern, a cinematic figure of style using alternating, converging close ups is ubiquitous in dialogue scenes, and began to appear around 1910. Bordwell notes this mechanism was unique to cinema: "The shot/reverse-shot device deserves to be called a stylistic invention [of cinema]. It wasn't determined by the technology of the cinema, and I can find no plausible parallels in other nineteenth-century media, such as comics strips, paintings, or lantern slides."[19] But at the same time, the parallels to human communication are obvious. Since personal communication where the speakers are directly facing each other is a universal human behavior, "shot/reverse shot is instantly recognizable across cultures and time periods."[20] By contrast, staging characters facing away from each other produces *diverging index vectors*, an atypical arrangement for conversation that suggests an unusual interpersonal dynamic. In a richly comedic scene from *The Shop Around the Corner* (Ernst Lubitsch, 1940) Alfred Kralik (James Stewart) is relentless in his quest to gain the attention of Klara Novak (Margaret Sullavan). While Lubitsch stages much of the dialogue in the usual converging index vectors, as Karlik returns to sit behind Klara at a restaurant (Figure 1.24), their index vectors initially diverge – but only briefly – as Stewart playfully tries to keep their conversation from ending. See Critical Commons, "*The Shop Around the Corner:* Converging and Diverging Index Vectors."[21]

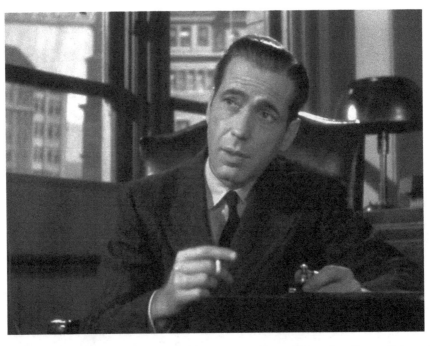

*Figure 1.23 Shot-reverse shot: incoming. . . and the person spoken to. This unique figure of cinematic style is called *shot-reverse shot,* and began to appear around 1910.*

Source: Copyright 1941 Warner Brothers.

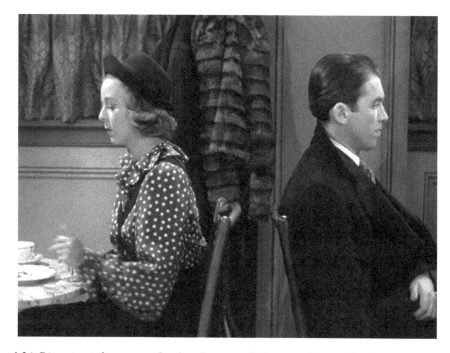

Figure 1.24 Diverging index vectors. Staging characters facing away from each other produces *diverging index vectors.* In *The Shop Around the Corner* (Lubitsch, 1940) the index vectors of Alfred Kralik (James Stewart) and Klara Novak (Margaret Sullavan) initially diverge – but only briefly – as he playfully tries to keep their conversation going.

Source: Copyright 1940 Metro-Goldwyn-Mayer.

Clearly, staging dialogue with diverging index vectors can also suggest hostility or alienation between characters.

180° Rule: Continuity at the Production Stage

Once early films moved beyond full figure framing and tableaux staging, *analytical editing* became the dominant mode of the classical continuity style, and was firmly established around the world before 1920. Analytical editing is a style of cutting that first shows the scenic space in a wide, establishing shot to illustrate the relative positions of significant elements, and subsequently breaks down the action into closer shots, ensuring that the viewer is spatially oriented. Often, if a character changes position or crosses the space, a wide shot re-establishes the relative positions of the characters. (Herbert Zettl calls this the *deductive approach*; see p. 35 below.) At the production stage, the analytical style of editing was facilitated greatly by establishing an *axis of action*, an imaginary line between two characters facing each other, and always positioning the camera on one side of this line so that their eye-lines would converge in every shot. As Kristin Thompson has pointed out, the shooting environment in early studios often dictated this approach:

> The introduction of the cut-in as a standard device and the resulting breakdown of a single scene into multiple shots brings up the question of screen direction (later to be called the "axis of action" or "180° rule") . . . There was seldom any question of moving to the other side of the action. The standard painted sets had only a backdrop and perhaps two small segments of other walls at the sides. In order to keep the setting in the background of the closer

The 180° Rule

Figure 1.25 The 180° rule. Early in film history, directors realized that spatial coherence was easier to maintain at the editing stage if a primary axis of action was established and all of the shots for that scene are taken on the same side of that line. Using the master scene technique for a dialogue scene, five shots could typically provide safe coverage of a scene.

shot, the camera *had to stay on the same side* of the characters. Since filmmakers usually did close-ups directly after the long shots, by simply carrying their cameras forward, problems seldom arose, even in exteriors done without sets.[22]

At the production stage, the mode of shooting to ensure that footage could be successfully cut in the analytical style became known as the *180° rule*: in every scene where multiple shots of varying scope would be taken, a primary axis of action was established – an imaginary line created by converging index vectors of two people talking, or the motion vector of a ship moving across the water – and all of the shots for that scene are taken on the same side of that line (i.e., within the semicircle that inscribes 180° on one side of that axis.)

Directors quickly learned that the safest way to ensure that a scene would cut together was to establish an axis of action in a scene, and then shoot it using the *master scene (or master shot)* technique, which captures a piece of dramatic action in long shot then repeats all or part of the action in closer shots. The 180° rule coupled with the master scene approach virtually guarantees that the takes will match in screen directionality, an idea echoed by Hollywood director Ron Howard, who tells beginning directors, "If all else fails, shoot a master and shoot overs [over-the shoulder shots] and singles."[23] For example, if two actors have a dialogue scene (Figure 1.25), five "standard" shots of the action could be taken in which all (or part of) the scene was photographed:

1 a two-shot (master shot) in a wide shot showing the two characters (often the entire scene)
2 over-the-shoulder shot of character A (repeat all or part of the action)
3 close up of character A (repeat all or part of the action)

4 over-the-shoulder shot of character B (repeat all or part of the action)
5 close up of character B (repeat all or part of the action).

If all of these shots are taken from the same side of the axis of action, the index vectors of the character's faces will match from shot to shot. The worldwide acceptance of this approach is noted by David Bordwell,

> Commercial storytelling cinema has long followed the conventions of analytical editing: master shot, followed by a two-shot or over-the-shoulder shots, followed by singles high-lighting each participant in shot/reverse–shot fashion. In fact, seldom do we find in any art a style with such pervasive presence and 100-year longevity. These norms have provided easy, comprehensible ways for narrative action to be understood.[24]

Bordwell points out that increasing the pace of dialogue scenes in more recent films

> has reinforced certain premises of the 180-degree staging system. When every shot is short, when establishing shots are brief or postponed or nonexistent, the eyelines and angles in a dialogue need to be even more unambiguous, and the axis of action is likely to be respected quite strictly . . . Still, the 1990s saw a slight tendency for the camera's viewpoint to hop back and forth across the 180-degree line during dialogue scenes.[25]

Of course, crossing the 180° line makes the index vectors of the characters' bodies and faces flip back and forth from shot to shot, and while establishing an axis was one of the few hard and fast rules of the studio system, many violations – intentional or otherwise – are scattered throughout film history. A few examples will suffice.

In *The Getaway* (Sam Peckinpah, 1972) an ex-con Carter "Doc" McCoy (Steve McQueen) and Carol McCoy (Ali MacGraw) launch a tenuous romantic relationship as they run from the law after a botched robbery. When they reunite at a train station, Carol asserts the power of her sexuality, acknowledging what Doc is angry about: that she did sleep with a man to obtain his release from prison, and that she can get him out of prison at any time because she can "screw every prison official in Texas if I want to." The tension between love and sexuality is underlined when Peckinpah crosses the 180° line, reversing their position in the frame, as Carol asks "You'd do the same for me, Doc, wouldn't you? I mean, if I got caught, wouldn't you?" Here, the visual swapping of their positions highlights the sacrifice Carol has made and punctuates her demand for equality in their budding relationship. See Critical Commons, "A violation of the 180-degree rule."[26] A more prominent use of this "visual swapping" happens in the famous bathroom scene from *The Shining* (Stanley Kubrick, 1980). Jack Torrance (Jack Nicholson) the newly-hired, mentally unstable caretaker of the Overlook Hotel confronts the ghost of Delbert Grady (Philip Stone) in the bathroom of the hotel bar, where Jack goes to clean up after he has spilled a drink on himself. See Critical Commons, "*The Shining*: Crossing the 180° Line."[27] Jack says he recognizes Mr. Grady from the newspapers as the former caretaker who chopped his wife and daughters to bits, and then blew his brains out. The film cuts very slowly back and forth across the axis of action as Grady first answers that he has no recollection of that (Figure 1.26), and then that Jack is the caretaker, and has always been the caretaker (Figure 1.27). Part of the impact that Kubrick derives from cutting across the 180° line in this scene comes from the highly symmetrical composition of every shot, using single point perspective where the orthogonal of both ceiling and floor converge on the two centered characters, framed in either a *plan américain* or wide shot taken with a short lens, before the scene ever cuts to a single.

The symmetrical, "visual swaps" collide as Kubrick cuts across the line, creating a visual metaphor linking Jack and Mr. Grady as unstable, socially isolated characters who are mysteriously drawn to the caretaker position at the Overlook Hotel.

Figure 1.26 Crossing the 180° line, outgoing shot . . . In The Shining, *Kubrick cuts across the 180° line to create a visual metaphor linking Jack (Jack Nicholson) and Mr. Grady (Philip Stone) as socially isolated characters by flipping their position from shot . . .*

Figure 1.27 Incoming shot . . . to shot.

Source: Copyright 1980 Warner Brothers.

In the more recent *Argo* (Ben Affleck, 2012) a dialogue scene early in the film demonstrates a contemporary approach to shooting dialogue, a style that reflects a much looser adherence to the pervasive Hollywood norms attached to the 180° rule. The scene shows two men driving to get lunch, and sitting down to eat it: Tony Mendez (Ben Affleck), a CIA expert in exfiltration, and Lester Siegel (Alan Arkin), a Hollywood producer he hopes to work with to free the six American embassy officials who were captured when Iranian students stormed the U.S. Embassy in Teheran and took 60 people hostage in 1979. The establishing shot of their meal is a long shot of the granite steps as they

open the bags of food (Figure 1.28), a shot the film does not return to. The traditional axis of action would be the line between them, and the 180° of space in front of them would inscribe the traditional arc where single shots of the actors are taken as three-quarter frontal close ups. Instead, the second shot is a "reverse" over-the-shoulder shot taken from "across the axis," from behind them that shows a profile of Affleck (Figure 1.29) and the back of Arkin's head. As they talk about their families, the shots continue in this fashion: shot-reverse shot using over-the-shoulder shots from behind them, where one subject's shoulder is in the shot and the other character is in profile (Figure 1.30). The fourth shot of the sequence is a tight two-shot that re-establishes the space of their conversation *from behind* (Figure 1.31), and in a sense confirms that the 180° space behind them will remain the axis of action for the scene. See Critical Commons, "*Argo*: Continuing Motion Vector and Crossing the 180° Line."[28] Some of these staging choices may have been driven by the fact that camera placement would be easier behind them, and also that by shooting from behind them, the sequence creates a feeling for the space of the studio lot that they look out on to. This staging of the seated dialogue scene, shot from behind in over-the-shoulder shots or singles, has become a common and effective re-imagination of the more rigid approach dictated by strict adherence to 180° staging.

Figure 1.28 Establishing shot from Argo. In *Argo*, the establishing shot of Tony Mendez (Ben Affleck) and Lester Siegel (Alan Arkin) having lunch on a studio lot suggests a traditional line of action . . .

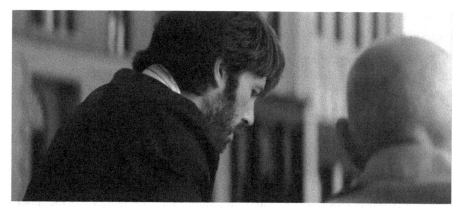

Figure 1.29 Over-the-shoulder shot from "across the axis". . . . that is immediately crossed by a "reverse" over-the-shoulder shot.

Figure 1.30 Over-the-shoulder shot from "across the axis". The pattern of over-the-shoulder shots taken from "across the axis" continues . . .

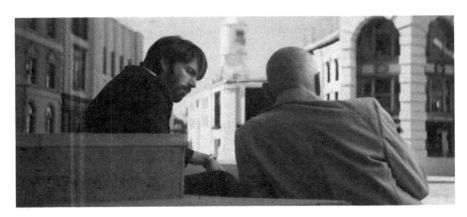

Figure 1.31 Two-shot "re-establishes". . . . when a cut to a tight two-shot "re-establishes" the axis of action behind them, an effective re-imagination of the more rigid approach dictated by strict adherence to 180° staging.

Source: Copyright 2012 Warner Brothers.

Motion Vectors: Continuing, Converging

Like index vectors, objects in motion within the frame create a dominant vector of movement. And as with index vectors, an editor can look at a shot change to see how the motion vector of the outgoing shot relates to the motion vector of the incoming shot. As a shot changes, the dominant motion vector of the incoming shot can *continue* the motion vector of the outgoing shot, *converge* with the motion vector of the outgoing shot or *diverge* from the motion vector of the outgoing shot.

In *Argo*, a typical, "garden variety" motion vector that continues over the cut is found in the scene we just examined. As Tony Mendez drives off the studio lot seated in Lester Siegel's golden Rolls Royce, Affleck cuts in closer, maintaining the motion vector across the cut, showing the two proceeding with their plan for developing the fake movie that will be their cover story. While the outgoing shot establishes the Burbank studio, the gate and the car (Figure 1.32), the closer incoming shot confirms the characters within (Figure 1.33). And given the high magnitude of the motion vector the first shot establishes, continuing that in the second – matching direction *and speed* – is crucial for maintaining the viewer's orientation across the edit.

Figure 1.32 Continuing motion vector outgoing shot . . . The high magnitude of the motion vector from the outgoing shot . . .

Figure 1.33 Incoming shot. . . continues in the incoming – matching direction and speed – and confirming the characters within.

Source: Copyright 2012 Warner Brothers.

Like the shot-reverse shot that utilizes converging index vectors, *converging motion* vectors is a powerful method for knitting together cinematic space. A typical trope that uses converging motion vectors is the "romantic run" that intercuts shots of lovers running towards each other. In *Gone with the Wind* (Victor Fleming, 1939), Melanie Hamilton (Olivia de Havilland) sees a returning soldier in the distance coming towards Tara plantation, and assuming he is hungry like the others who have happened by, starts to go inside to prepare some food for him. She slowly realizes it is her husband Ashley Wilkes (Leslie Howard), and begins to run towards him. After two wide shots – one that establishes Melanie coming off the porch of Tara and a second that establishes them both accelerating on the same path towards each other – dynamic, converging motion vectors are created with studio tracking shots set against rear screen projections, first of Melanie moving right to left (Figure 1.34), then Ashley left to right (Figure 1.35). See Critical Commons, "*Gone with the Wind*: Converging Motion Vectors."[29]

Unlike a "last minutes rescue" where the converging shots would accelerate to build excitement, here the tracking shots alternate but do not accelerate: Melanie (:01 second, 14 frames), Ashley (:02 seconds, 6 frames), Melanie (:02 seconds, 6 frames). The sequence resolves with Ashley stepping

Figure 1.34 Converging motion vector outgoing shot . . . Converging motion vectors are created with studio tracking shots set against rear screen projections, first of Melanie Hamilton (Olivia de Havilland) running to meet . . .

Figure 1.35 Incoming shot. . . her husband Ashley Wilkes (Leslie Howard) returning from the war.

Source: Copyright 1939 Metro-Goldwyn-Mayer.

into a wide shot, staged in a 3/4 profile, that Melanie enters to embrace him (:07 seconds, 10 frames). As she does, the camera dollies in closer signaling the resolution of their reunion.

Another quirky version of this figure of style, the "romantic convergence," is found in *Moonrise Kingdom* (Wes Anderson, 2012) where Sam (Jared Gilman) and Suzy (Kara Hayward) decide to elope, and meet in a field to plot their escape. See Critical Commons, "*Moonrise Kingdom*: Converging Motion Vectors."[30] There's no running here, just two twelve-year-olds hauling maps, canteens, binoculars, beef jerky and a trout fishing creel with a cat inside. Using a widescreen format, Anderson also frames wider shots with strict, self-conscious, rectilinear staging: balanced waist shots with converging index vectors and extensive "look space" give way to formal, full shots with slower tracking that only advance once the character moves (Figures 1.36 and 1.37). The pattern is

Figure 1.36 Converging motion vector outgoing shot . . . Using a widescreen format, Wes Anderson frames wide shots with strict rectilinear staging that tracks and slowly converges right to left motion . . .

Figure 1.37 Incoming shot. . . with left to right motion.

Source: Copyright 2012 Focus Features.

the same as *Gone with the Wind,* but slower: Sam (:04 seconds, 3 frames), Suzy (:03 seconds, 18 frames), Sam (:04 seconds, 17 frames), resolving in Suzy's final tracking shot where they converse at length, and then exit (:21 seconds, 15 frames). As Bordwell notes, formal, planimetric staging and deliberate, rectilinear camera moves "opens up the comic possibilities that Keaton recognized in such films as *Neighbors* and *The General.* A rigid perpendicular angle can endow action with an absurd geometry and a deadpan humor, qualities that Anderson has exploited freely."[31]

A Special Case: Continuity with Z-axis Index Vectors and Z-axis Motion Vectors

Converging vectors move dynamically across the x-axis primarily, but images with strong z-axis orientation – potentially the most neutral orientation – offer the editor a special opportunity to cut with limited juxtaposition to the vector field of the shot that comes before or after it. Zettl argues that a typical image showing a dominant z-axis vector has *zero directionality* because it does not point to a screen edge and the off screen space beyond that edge, but rather straight ahead at the space "behind the camera."[32] So in a sequence with strong z-axis staging, spatial orientation for the viewer is not as pressing an issue. Typical examples would be a head-on close up of a human subject (a neutral, z-axis index vector), or a head-on shot of a vehicle moving towards or away from the camera (a neutral, z-axis motion vector).

In the opening of *Ferris Bueller's Day Off* (John Hughes, 1986), Ferris (Matthew Broderick) breaks the fourth wall by telling the audience how he plans to skip school. In a variety of shots, Ferris delivers his lines directly to camera – a neutral, z-axis index vector that dominates the composition. See Critical Commons, "*Ferris Bueller's Day Off*: Z-axis staging for 'zero directionality.'"[33] Each cut that follows these neutral shots moves the story forward spatially and temporally, and the cuts are smoothed by the zero directionality of staging his lines into the camera. Notice that each shot following a z-axis shot begins with an "empty frame": Ferris is not present in the *incoming* frame (or he is just entering the incoming frame), so matching the action of his body from shot-to-shot is not the issue (see further uses of the word "match" in Chapter 3, p.87).

The sequence opens with a few cuts that are on the z-axis, but not directly into the camera. Standing at a window, Ferris addresses the viewer directly and asks, "How could I possibly be expected to handle school on a day like this?" Then he looks up, into the distant sky above the camera, and a series of five quick cuts of the sky follow, shots from his point of view. This figure of style is often called a *referential cut*: a character looks towards a space outside the space of the frame, the shot holds for a few frames, then cuts to what the character is looking at. Later, Ferris is in the shower, complaining about a test he has that day on European socialism, staged in a medium close-up addressing the camera, creating a zero directionality vector field (Figure 1.38). Herbert Zettl argues that the neutrality of the outgoing shot "softens" the incoming shot, a close-up of a shower head pointing right to left that carries a high magnitude, x-axis index vector (Figure 1.39). Zero directionality throughout the monologue scene simplifies many of the issues of cutting to shots carrying vectors of higher magnitude.

Consider a romantic scene between two lovers. A classically edited scene might include the typical moment where the lovers gaze into each other's eyes, directly addressing the camera and locating the viewer as the subject of the lovers' gazes. Typically, z-axis close-ups read as continuing the converging index vectors of the two-shot. An awkward romantic kiss that plays on these classical conventions is found in *Moonrise Kingdom*. See Critical Commons, "*Moonrise Kingdom*: Converging Vectors, Crossing the 180° Line, Z-axis Vectors."[34] Sam and Suzy celebrate their freedom on the beach by playing records and dancing. The line of action established by shooting from the shoreline towards the lake creates converging index and motion vectors as they dance wildly, then move to embrace and dance closer, leading to a first kiss, and a first French

Figure 1.38 Cutting from a "zero-directionality" z-axis outgoing shot . . . Ferris Bueller is in the shower, addressing the camera, creating a z-axis, "zero directionality" vector field. Herbert Zettl argues that the neutrality of the outgoing shot . . .

Figure 1.39 to a x-axis incoming shot. . . ."softens" the cut to the incoming shot, a close up of a shower head with a strong x-axis index vector.

Source: Copyright 1986 Paramount.

kiss. Anderson crosses the line of action for a tight over-the-shoulder shot as Suzy pulls Sam close, the camera moves back and forth across the line as they trade lines about Sam's awkward erection. The line crossing is temporarily "neutralized" by two tight, z-axis close ups.

In a play on the romantic gaze directly into camera, Sam asks Suzy to tilt her head before he kisses her (Figure 1.40), and in the next shot she complies (Figure 1.41). These z-axis shots easily read as *continuing* the converging index vectors of the outgoing over-the-shoulder shot of Suzy that came before (not pictured). Moreover, with zero directionality these two close ups cut smoothly with the next shot from "across the line" (i.e., from the lake towards shore) of their feet stepping closer together (Figure 1.42). Here again, Zettl's claim that the neutrality of the outgoing screen vectors eases the cut to the higher magnitude x-axis shot of the feet seems correct. The scene closes with a two-shot of Sam touching Suzy's breast – Suzy: "I think they're going to grow more" – and a neutral cutaway to the portable record player that plays out the scene.

Figure 1.40 Cutting from a "zero-directionality" z-axis outgoing shot . . . Moonrise Kingdom: two tight
z-axis close ups of Sam . . .

Figure 1.41 to a second z-axis shot . . . and Suzy signal their upcoming kiss. With "zero directionality" these
two close ups cut smoothly . . .

*Figure 1.42 to a shot with converging x-axis vectors. . . .*with the next x-axis shot of their feet stepping
closer together.

Again, z-axis shots – because of their neutrality, their zero directionality – are useful in other settings including, for example, chase sequences. See Critical Commons, "*Lucy*: Neutral Z-axis Vectors Cut Easily as Continuing."[35] In *Lucy* (Luc Besson, 2014), the protagonist Lucy (Scarlett Johansson) is a woman endowed with psychokinetic abilities after she unwillingly absorbs a powerful drug. Lucy, who has never driven a car before, commandeers the police car of Pierre Del Rio (Amr Waked) and races through the streets of Paris trying to rescue a person at the hospital. The police car leaves the street and drives onto the covered sidewalk. At the beginning of this sequence, a series of three travelling shots races along with the car from behind (Figure 1.43). Two of these travelling shots are from "eye-level" and one is from a higher angle. Intercut with these z-axis travelling shots is a series of shots – two-shots and singles of Lucy and the policeman from inside the car (high magnitude x-axis vector field shot), and tracking shots of the car taken from the street towards the covered walk (high magnitude x-axis tracking shots). Because the z-axis travelling shots are *zero magnitude*, when intercut with Lucy driving (Figure 1.44) – a high magnitude "right to left vector field" – or with the tracking shot – a high magnitude "left to right vector field" – the cuts easily read as *continuing motion vectors*, facilitating smooth cutting within the chase.

Figure 1.43 Cutting from a "zero-directionality" z-axis outgoing shot . . . A shot that follows the police car in *Lucy* is zero magnitude allowing it to be easily cut with . . .

Figure 1.44 to an incoming shot with a high magnitude x-axis vector field. Lucy (Scarlett Johansson) driving – a high magnitude "right to left vector field."

Source: Copyright 2014 Universal Pictures.

This method is typical for the chase sequence, where a neutral direction z-axis motion shot is used to ease the transition to a series of x-axis shots where the movements are right to left or left to right. Moreover, inserting a shot that initially has zero directionality but ends with a *specific vector directionality* can facilitate shifts in direction when cutting to shots that would otherwise reverse direction. In other words, if there are two shots – one left to right and one right to left – *inserting* a z-axis shot between them that transitions to a "right to left" motion solves the problem of reversing screen direction: it allows the editor to follow the directionality of the inserted cut. Theoretically, when shooting coverage for a chase scene, for example, it would be useful to gather z-axis shots towards the camera that cover *all the potential screen directional changes* (Figure 1.45), by having the character exit every off screen vector – essentially every frame edge – that the camera offers:

Shot A: the character runs towards the camera and exits frame right.
Shot B: the character runs towards the camera and exits frame left.
Shot C: the character runs towards the camera leaping over a low camera placement.
Shot D: the character runs towards the camera underneath a high camera placement.[36]

Armed with this series of shots, an editor can use the z-axis neutrality to cover changes in the screen direction of subsequent shots, though in practice, A and B would be the most likely shots. Notice that the first two Shots A and B, while neutral at the beginning, offer the editor an opportunity to shift or pivot the directionality of the continuing motion vectors of a sequence: as the character exits, a non-neutral motion vector is created. A scene being assembled with a series of shots containing x-axis movements from right to left, and ending with a series of shots containing x-axis movements from left to right, can use Shot A above to soften the directionality shift and keep the audience oriented in space. In essence, using Shot A allows us cut to a neutral z-axis shot to "pause" the right to left series and then continue the directionality that Shot A *ends with* – a slight x-axis exit towards frame right – in the left to right shots that end the sequence. Shots C and D are even more neutral because they don't end with an x-axis motion, but a *y-axis exit either out of the top or bottom of the frame*. These shots can also ease the transition to a different screen direction because they read as an even more neutral vector than Shots A (exit right) and B (exit left). In practice, they

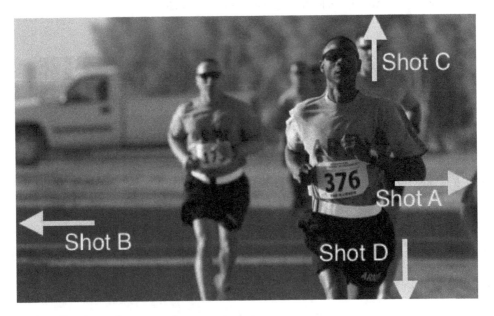

Figure 1.45 Four lines of movement from a z-axis shot.

would more likely be cut with shots of the character moving away from camera on the z-axis, as in the editorial figure of speech called *head-on, tail-away*, where a character moves towards the camera until they fill the frame and the image goes soft then cuts to the same character moving away from the camera, to reveal what is "behind the camera" or to change to a new scene. For example, in *Scarface* (Brian De Palma, 1983) a musical montage depicts Tony Montana's (Al Pacino) rise to incredible wealth. One cut shows Tony and his gang walking straight into the camera so that the frame is almost filled with his double-breasted coat and the lens begins to go dark. A soft-edged wipe to black crosses the frame from right to left, mimicking the shadow density of the outgoing shot, which is darkening from right to left as Tony almost touches the lens. The transition hangs in black for four frames, and then Tony moves away from the lens, in to the next scene (Tony is wearing a different coat) where the gang enters a newer, larger office for their expanding drug operations. Here the neutral z-axis motion directly into the camera provides a natural moment of soft focus, and a natural fade as the character approaches the camera and as he departs, allowing the creative match between the shots, and in this instance, creatively changing the scene to a different time and place. See Critical Commons, "*Scarface*: Z-axis Motion for a Head-on, Tail-away Edit."[37]

In *Occurrence at Owl Creek Bridge* (Robert Enrico, 1962), a slightly different *head-on, tail-away* transition is used to advance the character "magically" forward as he approaches opening gates, a symbol of his return home and impending death. See Critical Commons, "*Occurrence at Owl Creek Bridge*: Z-axis Staging for Head-on, Tail-away Edit."[38] Peyton Farquhar (Roger Jacquet) appears to escape his hanging on Owl Creek Bridge, and makes his way back through the woods to his homestead. As the the camera reverse dollies with Farquhar staggering down a road, he stops and lifts his gaze upwards (Figure 1.46). Pausing for a moment, a smile comes over his face and he proceeds forward until his shoulder almost covers the lens (Figure 1.47). This is a "head-on" movement that comes very close to the camera that is answered by a "tail-away" wide shot that marks a "magical" ellipsis (Figure 1.48): the man has advanced a few yards forward in the incoming, and is already stepping through gates that appear to have opened autonomously, magically granting his entrance. The use of neutral, z-axis staging in both shots facilitates spatial

Figure 1.46 Occurence at Owl Creek: *Reverse dolly comes to a halt.* As the camera reverse dollies with the condemned man staggering down a road, he stops and lifts his gaze upward, and then . . .

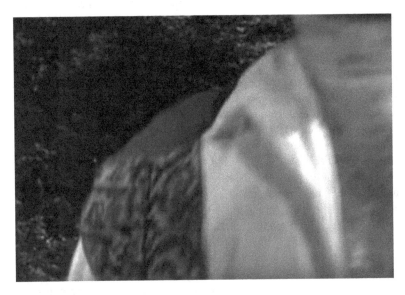

Figure 1.47 A "head on" move to the camera in the outgoing shot . . . he proceeds forward until his shoulder almost covers the lens. This is a "head on" movement that comes very close to camera that is answered by . . .

Figure 1.48 cuts to the incoming shot. . . a "tail away" wide shot that marks a "magical" ellipsis: the man has advanced a few yards forward in the incoming shot.

Source: Copyright 1962 Film du Centaure.

clarity and a smooth, elliptical cut through the gates that magically welcome him. This style of creative editing was part of the reason the French film won an award at Cannes and "Best Live Action Short Film" in the 1963 Academy Awards, before appearing on Rod Serling's *The Twilight Zone* in 1964.

Broader Views for Building Screen Space

Considering vectors that continue, converge and diverge is one of the fundamental approaches to thinking about how screen space is built. Considering how screen forces found in the outgoing shot relate to those found in the incoming shot can be a useful tool for evaluating what is happening across a specific cut. Taking a broader view, Zettl offers two more comprehensive schemas to understand the construction of a film or video: how it will be visualized – *ways of looking* – and how it will be structured – *inductive versus deductive approaches.* Zettl presents these ideas as questions for the director at the preproduction stage, and uses them to stimulate considerations about where the work will ultimately be presented, on anything from a small low definition display like a cell phone to a large movie screen. While these considerations are crucial for preproduction planning, they also offer the editor a practical tool to use when building screen space in postproduction. Clearly, an editor must take as a starting point the footage available. Yet, both of these approaches can be helpful as the editor assembles his or her drafts of the story, and works through the development of "what follows what" in building a sequence.

Ways of Looking: Looking at, Looking into, Creating an Event

Zettl argues that representing reality with moving images requires a basic decision in our visual approach when creating media. While noting that these approaches may overlap with one another, Zettl identifies the three approaches as follows:

Looking at an Event

If the event is to be presented on screen in order to clarify the viewer's understanding of what is occurring, the camera's view of the event follows closely the point of view of someone actually present and merely reports the main elements of the event as it unfolds. For a director at the production stage, and for the editor in postproduction, this approach would dictate the use of straightforward angles and naturally exposed images that are composed to allow the audience to clearly see the action at hand. In a staged dialogue scene between two people, shots that clearly establish the relative position of each speaker and straightforward images showing the speakers as alternates their dialogue back and forth would fit this style. In other words, *event clarification* guides the construction from shot to shot.[39]

Most television coverage of live sporting events – at least in their play by play presentation of the game – tend to merely look at the event, assuming an objective and neutral construction of the actions unfolding. In the realm of motion pictures, the *observational documentary* is considered a form that tries to objectively look at events unfolding before the camera. Known also as direct cinema or cinema vérité, in an observational documentary,

> the focus of the film is usually on the details of everyday life, often in intimate settings. It can be thought of as the 'fly on the wall' type of approach. The final version of the film is not dominated by voice-over, and point of view is that of the characters in the film; there is no script. The viewer is looking in on and overhearing the people's lived experiences.[40]

Utilizing the latest portable camera and sound equipment, *Salesman* (Albert Maysles, David Maysles, Charlotte Zwerin, 1968) looks at four salesmen as they travel in New England and Florida selling expensive Bibles door-to-door. The film's opening scene shows Paul Brennan seated in a living room with a woman, making small talk and touting the features of the edition, as her child climbs all over and fiddles around on a nearby piano. The camera's point of view places the viewer

in the room, remains relatively objective throughout, showing the main events of their interaction. The event is delineated, not interpreted, with no significant attempt to highlight the psychological implications of the character's interaction. See Critical Commons, "*Salesman* opening."[41]

Looking into an Event

If an event is to be presented on screen in order to probe its psychological connotations, its underlying emotional tensions and unspoken implications, then its screen presentation must move beyond clarification and work to intensify the event. One of the primary tools used to intensify an event on screen is the use of closer shots of event details. Event "intensification" employs more overt stylistic elements that go beyond those found in classically edited Hollywood narratives to reveal unfolding character psychology.[42] Here, in a staged dialogue scene like the one described above, a director might intensify the scene by including close shots of hand gestures, oblique angles of speakers and extreme close ups of eyes. If these moments are included in such a way that makes covering the dialogue almost a secondary concern, the audience begins to probe the subtext of the scene. Here, *event intensification* not *event clarification* guides the scene's construction.

In *The Passion of Joan of Arc* (Carl Theodor Dreyer, 1928), Joan of Arc (Renée Jeanne Falconetti) has fought the English, been captured and taken to Normandy to be tried for heresy by clerics loyal to the English. See Critical Commons, "*The Passion of Joan of Arc*: Looking into an Event."[43] Dreyer uses the iris as a framing device to enclose the tight close ups that are used almost exclusively throughout the scene. Alternating subjective, z-axis close ups from low and high angles, Dreyer skips the long shots that would clarify the spatial arrangement of the scene. When Joan says that "The English will be pushed out of France . . ." Dreyer cuts energetically between pan shots and close ups of the interrogators, punctuating their troubled reactions. When she continues " . . . except those who die here!" Dreyer goes so far as to stage a close up of an angry soldier on a swing, cutting so that his face pushes forward in a rage angrily towards the camera, not once, but twice (Figure 1.49).

Figure 1.49 The Passion of Joan of Arc: *looking into an event.* Dreyer stages a close up of an angry soldier on a swing, cutting so that his face pushes forward in a rage towards the camera twice.

Source: Copyright 1928 Société Générale des Films.

Next, a tracking shot increases the rhythm of the scene as the other clerics stir with agitation. Only towards the end of this sequence does a cleric dressed in dark robes rise and step into the same filmic space where Joan kneels, bringing accused and accuser together in the same space. By using close ups almost exclusively, Dreyer is able to show us to the burning eyes of a female zealot and the myriad facial types of powerful old men whose sneering looks and skeptical glances carry the emotional tension simmering within the scene. Examining this underlying tension is the thrust of Dreyer's approach, a goal that moves beyond the simple clarification of plot events.

Creating an Event

If an event is captured with the aim of completely transforming it using the potentials of the medium, we create an event that is unique and exists only on the screen. When we create an event, postproduction processes are emphasized with the primary aim to form and shape the event using digital effects. The editor takes source footage and "turns up the art" to construct media-dependent images, visualizations that bear little resemblance to the real world. In narrative films, such visual effects might be used to represent anxiety, delirium or a psychotic state. In an abstract art film, these visual effects might be used to interrogate the formal potentials of the medium itself. In either case, *event complexity*, transforming the lens-captured event into one that is medium dependent and formally expressive guides the scene's construction. (See also the discussion of creating a Lezginka event in Chapter 5, p. 173)

In *Persona* (Ingmar Bergman, 1966), the film opens with a montage that is a reflexive meditation on how film as a medium can address personal anguish and death, and how the spectator connects to the mediated world the film creates. See Critical Commons, "*Persona:* Creating an event."[44] Bergman opens with a shot of two carbon rods igniting in an arc lamp film projector (Figure 1.50), and proceeds to intercut other imagery showing the physicality of cinema:

Figure 1.50 Persona: *creating an event. Persona* opens with a montage that is a reflexive meditation which is complex, signifying and a medium-dependent experience.

Source: Copyright 1966 AB Svensk Filmindustri.

a whirring projector shutter, a piece of film spooling off a projector sprocket, the lens and the film plane of the projector showing a countdown leader moving through the gate. (As a joke Bergman even inserts a very brief shot of an erect penis in the montage that syncs with the *two pop*, a 1kHz tone that is one frame long and placed two seconds before the start of the program as part of the Academy leader system to ensure synchronization between sound and picture in film.) More film transport sprockets, the projector loop, as well as images from an early animated film follow. After a section of solid white, over-exposed film, the montage shows a trick film in miniature on the white field, before moving to more visceral images printed into the white frame: a close up of a tarantula then a series of shots of a sheep being slaughtered and eviscerated. The montage ends with close ups of a crucifixion: a hand twitches and bleeds as the hammer strikes the nail. Here, the aim is using the medium of film itself to completely transform the meaning of the captured images from their simple referents into a complex, signifying, medium-dependent experience, one that takes for its subject matter the nature of the medium itself. As Susan Sontag writes, "*Persona* is not just a representation of transactions between the two characters, Alma and Elizabeth, but *a meditation on the film which is 'about' them.* The most explicit vehicle for this meditation is the opening and closing sequence, in which Bergman tries to *create that film as an object*: a finite object, a made object, a fragile perishable object, and therefore existing in space as well as time."[45] With the growing accessibility of digital video effects, the arena for experimentation in image transformation has been greatly extended. Creating a compelling, mediated screen event – an event that exists solely through the exploration of the formal potentials of digital imagery – is becoming a practical editorial approach for expressing a character's inner events or for transforming ordinary footage for purely experimental ends. Moreover, the three broad approaches Zettl identifies here for building screen space can guide the filmmaker in envisioning a sequence, providing a general direction for the creation, selection and manipulation of shots depending on what the aim of the scene is: presenting the event clearly, intensifying the event, or transforming the event into a complex mediated experience.

Inductive Versus Deductive Approaches to Building Screen Space

At the micro level, at the level of the shot, Zettl proposes that the vector field can be a useful analytical scheme for understanding the visual forces at play when building a sequence shot by shot by shot. At the macro level, Zettl also catalogs two more broad approaches to building screen space that sequences images based on *scope of the shot*, based on how framing structures the on screen and off screen space. Zettl notes that the question of building screen space comes into acute focus when we construct "openings," when the filmmaker considers how to open a sequence, or how to open a film, and he identifies two approaches to the problem: *deductive sequencing versus inductive sequencing.* When an editor opens a scene with a long shot that establishes the locale, time of day, and relative positions of event details that closer shots will subsequently reveal, this approach is sequencing images *deductively* (also known as *analytical* editing). A typical opening sequence might proceed with a long shot of a forest, a medium shot of a tree branch swaying in the wind, a medium shot of a bird on the ground searching for food, followed by a close up of a bee buzzing around a flower. Deductive sequencing of images – where the spectator is given the establishing shot first – is the dominant Hollywood approach. This style of opening asks little of the viewer, since the sequence clearly communicates the broad space of the scene first, and reinforces that orientation shot by shot by shot. Scope of the shot is a central feature of this approach: the wide shot, held for enough screen time for the

audience to scan the frame, allows a complete "mental map" of the space to register. As closer shots follow – shots that will almost always use continuing graphic, index or motion vector – spatial orientation is almost guaranteed.

In contrast, when an editor starts with the particulars of the scene using a series of close ups to show event details *before* showing a wider shot, this approach is sequencing images *inductively* (also know as *constructive* editing).[46] A typical opening sequence might begin with a close up of a rusted shovel against a wall, followed by a close up of galvanized bucket lying on its side, followed by a close up of the flywheel on an aging pump before showing a wider shot of the interior of a dilapidated barn. The editor carefully selects event details that give the essence of the scene, impressions that the viewer will – consciously or unconsciously – begin to actively interrogate and, as the images unfold, construct into a larger meaning. Inductive sequencing is thought to more actively engage the viewer than deductive sequencing since, in the absence of the opening wide shot, the viewer will try to synthesize the wider space and the broader meaning that the close shots seem to point to.

Note that these two approaches can stand alone or be interwoven. The opening title sequence of Lawrence Kasdan's *The Big Chill* (1983) uses an interesting mix of deductive and inductive approaches to image sequencing, in essence cutting back and forth between the two types of images as Marvin Gaye sings *I Heard It Through the Grapevine* in the film's opening track and the film's main titles are presented. See Critical Commons, "Deductive and Inductive Approaches to Image Sequencing in *The Big Chill*."[47]

In a series of wider shots, Kasdan introduces the main characters of the film, former college buddies who will reunite 15 years later to spend a weekend together at a vacation house in South Carolina, the setting for the bulk of the film. Sarah Cooper (Glenn Close) is introduced as a mother who receives a phone call while her husband bathes their son (Figure 1.51). Kasdan then cuts to the first close up we will see of an unknown man, a shot of his leg and sock and hands pulling up the sock (Figure 1.52). Next we are introduced to Karen Bowens (JoBeth Williams) as a suburban wife in a tennis outfit, suggesting a comfortable lifestyle (Figure 1.53). Another close up follows, showing hands buttoning the shirt of the unknown man we saw previously (Figure 1.54). Michael Gold (Jeff Goldblum) is introduced next, and from the looks of his study, he is a writer (Figure 1.55). A third close up of the unknown man follows, his belt being buckled by a woman's hands with conspicuous red fingernail polish (Figure 1.56). Here the audience's inference follows the sexual suggestion of the image: this unknown man is being dressed after a sexual encounter.

The sequence continues in this mode, alternating between deductive wider shots that introduce the group of friends – an executive in a corner office, an actor flying first class on a plane, an athletic dancer stretching on the floor – and inductive close ups of the unknown man – hands tying his shoes, his necktie carefully arranged by the woman with the red fingernails, his hair brushed. The inductive sequence indicates a man dressing with a woman present, an inference driven by mere juxtaposition (see the "Kuleshov effect" in Chapter 5, p. 149). It's not until the end of the sequence that the last close up of the man reveals his sutured wrist and the hands of the woman with the red fingernails covering his injury with his shirtsleeve (Figure 1.57). Our assumptions are now overturned, and we must redeploy this sequence of close ups to construct a new idea: this unknown man is actually the corpse of a man who committed suicide, and we resolve retroactively that the parade of characters we have been introduced to are reacting in shock to news of his death. This redeployment of the sequence's meaning will be confirmed in the remainder of the film as they gather to remember him and struggle with the meaning of their own lives in middle age.

Figure 1.51 In *The Big Chill*, wider deductive shots introducing the characters are intercut with . . .

Figure 1.52 closer inductive shots suggesting, "a man being dressed by a woman."

Figure 1.53

Figure 1.54

Figure 1.55

Figure 1.56

Figure 1.57 The last shot indicates the man being dressed committed suicide.

Deductive Versus Inductive Sequencing and Screen Resolution

Along with this useful differentiation between deductive and inductive sequencing, Zettl argues that deductive sequencing is best suited for large screen displays. Grand establishing shots on such displays carry great picture detail and move beyond mere spatial orientation to generate greater aesthetic energy.[48] Inductive sequences, Zettl maintains are more suited to the small screen, since picture detail is lost on the small screen, while the close up reads more easily and delivers more aesthetic energy regardless of the shot's content.[49] Here, Zettl urges creators to consider the size of the display that the finished work will be presented on, and he correctly argues that *aesthetic impact increases with screen size.* Watching an IMAX movie moves audiences in a way that an iPhone cannot.

Yet, in the age of iPads and smartphones, many questions remain that center on screen resolution. If editors are creating moving images for web display or smartphones, should the shots be sequenced differently from work to be presented in theatres or on large HDTV displays? Is screen resolution a significant factor for driving decisions about the use of close ups or long shots, and specifically their use in *openings* – the beginning of a film or the beginning of a scene? How well do wide shots with a large amount of small picture details work on small screens? The answers to these questions are not as simple as they once might have been when shooting film and exhibiting 35mm prints in a theater defined high resolution moving images, while shooting video and exhibiting those images on a cathode ray tube television in the family living room defined low resolution.

Historically, until the introduction of television into the home in the 1950s, there was only one dominant form of display for moving images: a large screen in a public space that often allowed viewing distances of hundreds of feet. In tandem with this large screen mode of presentation, very early continuity editing discovered the narrative clarity that could be gained from using the long shot to establish a scene, followed by "cut ins" to closer shots to reveal details.[50]

The syntax of Hollywood continuity editing quickly understood the use of the establishing shot to *both* illustrate broadly the location of the action, as well as to communicate the aesthetic energy of a space (e.g., Monument Valley in the films of John Ford). That wider shots also mark the relative position of characters in a space and indicate time of day (e.g., an exterior of a home at dawn, followed by interior shots of characters drinking coffee) added to their narrative efficiency.

In contrast, early directors of live television quickly came to the realization that television is a "close-up medium." Given the low resolution of early displays, the close up – a shot of a single character that included anything from head and shoulders to the "slash" close up that cut off the tops of heads and the bottoms of chins – became a staple of live television drama and soap operas. But given the changes in live television production style in the digital age – the emergence of digital overlays, split screens and computer graphics that tend to "graphicate" and flatten the televised space in news and sports particularly – "televisual space privileges the two-dimensional space of the screen's *x* and *y* axes."[51] In the televisual world of CNN, Fox News, MSNBC, ESPN, Bloomberg News, etc., – where digital graphics, on set LCD displays, replays and screens within screens are commonplace – does it still make sense to call television a "close-up medium"?

The emergence of HDTV broadcasting in the United States in 1996 with a resolution of 1920 x 1080 pixels stimulated the invention of LCD displays with dimensions increasing to 42" diagonally by a mere decade later. A large screen television for the home – now with 4k resolutions of 3840 x 2160 pixels and diagonal screen sizes up to 88 inches – diminishes the issue of relative resolution between the cinema screens and broadcast television that is viewed at distances limited by living room spaces. And on the small end of moving image displays, does it still make sense to refer to an iPhone 10 with a 5.8 inch diagonal, 2436 x 1125 pixel display at 458 ppi and a viewing distance measured in inches as "low resolution"? For the editor, there is value in considering the primary display the piece will be viewed on, and thinking about how scope of the shots chosen

may or may not work effectively at that resolution. But given that many pieces the editor constructs will be scaled for a range of playback resolutions, the best practice may be simply to view cuts nearing completion on a series of representative screens to see if key information will be lost or may be better communicated with shots of varying scope.

Conclusion

Herbert Zettl has made a significant contribution to our understanding of how screen spaces work as we conceive shots in preproduction, as we gather them in production and as we combine them in postproduction. Building on early work by classical theorists like Rudolf Arnheim, his account of how any dynamic force within the frame space can be conceptualized, described and manipulated using the concept of a vector is a practical tool for editors to use when analyzing their own work for its effectiveness in maintaining the viewer's spatial orientation, and for "reading" in more abstract terms the interplay of dynamic forces that occurs as shots change. Zettl goes further, giving editors a tool for considering how event details within the screen space can be objectively presented or emotionally charged by approaching the moving image sequence with an overall style that "looks at," "looks into" or "creates" that event. Finally, Zettl's understanding that scope of the shot plays an important role in how a sequence cues a spectator to deductively or inductively construct space and narrative continues to be a foundational tool for editors to plan how a particular sequence might unfold. As we will see in Chapter 2, Noël Burch's account of the history of continuity editing offers a wholly different take on how classical cutting creates meaning.

Notes

1 Rudolf Arnheim, "Gestalt Psychology," in W. Edward. Craighead and Charles B. Nemeroff, *The Corsini encyclopedia of psychology and behavioral science* (New York: Wiley, 2001), 401.
2 Rudolf Arnheim, *Film as art* (Berkeley: University of California Press, 2009), 3.
3 Ibid., 57.
4 Ibid., 27.
5 Dejan Todorovic, "Gestalt principles." Scholarpedia. Accessed August 22, 2017. http://www.scholarpedia.org/article/Gestalt_principles.
6 This second position is associated with realist film theorists, including Andre Bazin, and will be dealt with more fully in Chapter 6.
7 Herbert Zettl, *Sight sound motion: applied media aesthetics* (Boston, MA: Wadsworth Cengage Learning, 2017), 4.
8 The five aesthetic fields that Zettl identifies are light and color, 2-dimensional space, 3-dimensional space, time/motion and sound.
9 Herbert Zettl, *Sight sound motion: applied media aesthetics* (Boston, MA: Wadsworth Cengage Learning, 2017), 421.
10 Here we are setting aside movement that might be created by the camera alone. Zettl calls this *secondary motion* – movement that is medium dependent, created movement of the camera and movement generated by zooming. Since this type of movement is separate from event motion, it tends to draw attention to itself and away from the event the filmmaker is trying to clarify or intensify.
11 This approach, asking "What happens at the cut? What happens spatially, or temporally, or graphically, or rhythmically when Shot A changes to Shot B?" will be a useful one that answers a number of the practical theoretical issues addressed in this book.
12 Herbert Zettl, *Sight sound motion: applied media aesthetics* (Boston, MA: Wadsworth, 2014), 369.
13 Ibid., 395.
14 These examples set aside consideration of the audio track in the editing of these shots: while dialogue, music and sound effects would offer other creative potentials for the editor, editorial practices for the visual track are the focus in discussions of vector fields.
15 Stephen Heath, "Narrative Space," *Screen* 17(3): 91.
16 Herbert Zettl, *Sight sound motion: applied media aesthetics* (Boston, MA: Wadsworth, 2014), 370.

17 The clip, "*Maltese Falcon*: opening scene," is on Critical Commons at http://www.criticalcommons.org/Members/m_friers/clips/maltese-falcon-opening-scene.

18 A very useful explication of the editing of this opening scene is found in David Bordwell, Kristin Thompson and Jeff Smith, *Film art: an introduction* (New York, NY: McGraw-Hill, 2017), 233–236.

19 David Bordwell, *Poetics of cinema* (New York: Routledge, 2008), 58.

20 Ibid., 94.

21 The clip, "*The Shop Around the Corner*: Converging and Diverging Index Vectors," is on Critical Commons at http://www.criticalcommons.org/Members/m_friers/clips/the-shop-around-the-corner-converging-and.

22 Kristin Thompson, "The Formulation of the Classical Style, 1909–28," in David Bordwell, Janet Staiger and Kristin Thompson, *The classical Hollywood cinema: film style and mode of production to 1960* (New York: Columbia University Press), 202, my emphasis.

23 Ron Howard, quoted in David Bordwell, *Figures traced in light: on cinematic staging* (Berkeley, CA: Univ. of California Press, 2008), 22.

24 Ibid., 48.

25 Ibid., 124 and 178.

26 The clip, "A Violation of the 180-degree Rule," is available on Critical Commons at http://www.criticalcommons.org/Members/ogaycken/clips/getaway-axis.mp4.

27 The clip, "*The Shining*: Crossing the 180° Line," is on Critical Commons at http://www.criticalcommons.org/Members/m_friers/clips/the-shining-crossing-the-180deg-line.

28 The clip, "*Argo*: Continuing Motion Vector and Crossing the 180° Line," is on Critical Commons at http://www.criticalcommons.org/Members/m_friers/clips/argo-continuing-motion-vector-and-crossing-the.

29 The clip, "*Gone with the Wind*: Converging Motion Vectors," is on Critical Commons at http://www.criticalcommons.org/Members/m_friers/clips/gone-with-the-wind-converging-motion-vectors.

30 The clip "*Moonrise Kingdom*: Converging motion vectors" is on Critical Commons at http://www.criticalcommons.org/Members/m_friers/clips/moonrise-kingdom-converging-motion-vectors.

31 David Bordwell, "Wes Anderson Takes the 4:3 Challenge," in Matt Zoller, *The Grand Budapest Hotel* (New York, NY: Abrams, 2015), 240.

32 See the discussion of z-axis motion vectors and continuity in Herbert Zettl, *Sight sound motion: applied media aesthetics* (Boston, MA: Wadsworth Cengage Learning, 2017), 384.

33 The clip, "*Ferris Bueller's Day Off*: Z-axis staging for 'zero directionality,'" is on Critical Commons at http://www.criticalcommons.org/Members/m_friers/clips/ferris-buellers-day-off.

34 The clip, "*Moonrise Kingdom*: Converging Vectors, Crossing the 180° line, Z-axis Vectors," is on Critical Commons at http://www.criticalcommons.org/Members/m_friers/clips/moonrise-kingdom-converging-vectors-crossing-the.

35 The clip, "*Lucy*: Neutral Z-axis Vectors Cut Easily as Continuing," is on Critical Commons at http://www.criticalcommons.org/Members/m_friers/clips/lucy-neutral-z-axis-vectors-cut-easily-as.

36 If the series A–D above is also be taken with the character running *away* from the camera, then continuing the neutral vector from a variety of camera positions is possible.

37 The clip, "Z-axis Motion for a Head-on, Tail-away Edit in *Scarface*" is on Critical Commons at http://www.criticalcommons.org/Members/m_friers/clips/z-axis-motion-for-a-head-on-tails-away-edit-in.

38 The clip, "*Occurrence at Owl Creek Bridge*: Z-axis Staging for Head-on, Tail-away Edit," is on Critical Commons at http://www.criticalcommons.org/Members/m_friers/clips/occurence-at-owls-creek-bridge-z-axis-staging-for.

39 Zettl's account of "looking at" an event is brief, but in some ways comes close to V. I. Pudovkin's 1926 formulation that a shot change "must correspond to the natural transference of attention of an imaginary observer," Pudovkin, *Film technique and film acting* (New York: Grove Press, 1976), 71. David Bordwell traces Pudovikin's account of the imaginary observer and summarizes the logical difficulties it presents as it was stretched to fit stylized cinematic devices such as high angle and low angle shots, split screen, and negative imagery in *Narration in the Fiction Film* (Madison: University of Wisconsin Press, 1985) 10.

40 H. James Birx, ed., *21st century anthropology: a reference handbook, Volume II*, (Thousand Oaks, CA: SAGE Publications, 2007), 910.

41 The clip "*Salesman* opening" is on Critical Commons at http://www.criticalcommons.org/Members/ccManager/clips/mayslesSalesmanOpen.mp4.

42 To clarify, since the classical Hollywood narrative shows psychologically delineated characters struggling towards specific goals, revealing character states of mind also underlies much of this body of work. For example, in the opening of the *Maltese Falcon*, it is important to establish – if not "intensify" – the character psychology underlying the events that launch the narrative. From the moment Ruth

Wonderly enters the opening scene, Huston underscores her presence with reeds and strings in a minor key that suggest an air of mystery about her persona. Later, Huston holds shots of Bogart "sizing her up," looking skeptical as Wonderly becomes increasingly agitated telling the story of her search for her sister (Figure 1.23, p. 18). Even though it is described as "invisible," this type of editing to underline character psychology is the norm in the classical Hollywood cinema, without doing much towards "intensification."

43 The clip, "*The Passion of Joan of Arc*: Looking into an Event," is on Critical Commons at http://www.criticalcommons.org/Members/m_friers/clips/joan-of-arc-looking-into-an-event.

44 The clip, "*Persona*: Creating an Event," is on Critical Commons at http://www.criticalcommons.org/Members/m_friers/clips/pesona-creating-an-event.

45 Susan Sontag in Lloyd Michaels, ed., *Ingmar Bergman's Persona*, (Cambridge, England: Cambridge University Press, 2000), 74, my emphasis.

46 Notice that these designations – deductive and inductive – are also the names of approaches to reasoning, and that they approximate in a very rough fashion those modes of argument. One typical mode of deductive reasoning is syllogism such as in the following statement: all men are mortal; Socrates is a man; therefore, Socrates is mortal. Here the first premise is broad and categorical – a kind of "establishing" premise that parallels a long shot – followed by a more specific second premise. Inductive reasoning is often described as drawing a general conclusion from specific observation like the following: I observe a small sparrow; I observe another small sparrow; and another; and another; therefore, all sparrows are small. Here, the accumulation of particular instances – a kind of "single" premise that parallels a close up – leads to a broader conclusion. Induction leads to conclusions that are probable, but not certain.

47 The clip, "Deductive and Inductive Approaches to Image Sequencing in *The Big Chill*" is on Critical Commons at http://www.criticalcommons.org/Members/m_friers/clips/a-mix-of-deductive-and-inductive-approaches-to.

48 Herbert Zettl, *Sight sound motion: applied media aesthetics* (Boston, MA: Wadsworth Cengage Learning, 2017), 226.

49 Ibid., 227.

50 Though close ups are found in the earliest films, D. W. Griffith's *The Lonedale Operator* (1911), which shows a close up of a wrench that Lillian Gish fakes for a gun, is often cited as an early, effective use of a close up for narrative purposes that signals the emerging codification of the continuity editing style.

51 Caren Demming, "Locating the Televisual in the Golden Age of Television," in *A companion to television*, edited by Janet Wasco, West Sussex: John Wiley and Sons, 130.

2 Noël Burch, PMR Versus IMR and Continuity Editing in a 5 x 3 Matrix

Editing is a significant component of a film's *style*, a term that broadly includes how the individual filmmaker chooses to represent his or her material. Style is defined as

> a recognizable group of conventions used by filmmakers to add visual appeal, meaning, or depth to their work.[1]

Style includes choices that affect *mise-en-scène* – the physical arrangement of actors, props, costumes and space – as well as choices made regarding lighting, lens, camera movement and how the film will be edited. Looking at film style from its earliest history to the present, film scholars have identified a few major trends that have become part of the central story of cinema's history.[2]

In the earliest period of film history through the 1910s and 1920s, most trade papers, film journals and newspaper critics worldwide solidified what Bordwell terms the "Basic Story," a standardized account of how film became an art form. The Basic Story maintains that, early on, film struggled to establish itself as a distinct art form by casting off its ability to simply record an event and developing the specific, inherent creative potentials that make it an art form distinct from painting, the novel, the magic lantern show, the nineteenth-century melodrama, etc. In this early period, according to the Basic Story, early directors like D. W. Griffith and Sergei Eisenstein, as well as national cinemas that developed in places like Sweden, Germany, France and Russia made significant contributions to cinema's struggle to become a unique, expressive art form. The advent of sound, according to the Basic Story, marked an end to this period of development and a return to the more "theatrical" style of filmmaking that had dominated before cinema had uncovered its expressive, visual potentials.[3] But more importantly, world cinema during this period became exceptionally homogenous – the feature film, a fiction narrative told in a style that was extraordinarily consistent became a worldwide norm, completely dominating other forms of motion pictures in sheer number of films made, so much so that it narrowly systematized what filmmakers and audiences alike had come to think of as " a film." Writing for *Cahiers du Cinema* in the 1960s, Noël Burch was an influential film theorist who first labeled this style of filmmaking the *Institutional Mode of Representation* (*IMR*), a term that suggests the hegemony and rigidity of the system that dominated film style around the world.

Burch identified the main characteristics of the IMR and went on to demonstrate that this style of filmmaking grew from the bourgeois desire to create a mode of representation that would complete and make total the illusionistic practices that had come before it, like perspective painting. Why did Burch undertake this project at this particular moment? New forms of filmmaking emerged in the 1960s that showed the Institutional Mode of Representation in a new light. The sixties were marked by a number of trends that tried to stake out a "modernist" response to the IMR, including startling new work by Jean Luc Goddard, Alain

Resnais, Frederico Fellini, Michaelangelo Antonioni and Ingmar Bergman. Experimental films – shot in formats like 16mm or 8mm, rather than the standard 35mm format almost universally used professionally – made the personal expressions of film artists like Maya Deren, Kenneth Anger, Stan Brakhage, Andy Warhol and Barbara Hammer a new kind of "underground cinema." Recognizing this cultural sea change in filmmaking, Noël Burch developed theories that critiqued the dominant form, opposed its hegemony, and endorsed contemporary films that he felt were truly modernist. Burch saw new works by the likes of Antonioni as confirming his belief that the IMR was more a chance development than a style organic to the medium. If this is true, the Basic Story – the notion that film in the silent period became a distinct art form by abandoning its ability to record and developing into a creative but limited system of narrative – would need revision.

IMR Versus PMR

If there is one thing that sets cinema apart as a unique art form – the well-worn question of "cinema's specificity" – Burch argues that it is cinema's ability to create a "story space:"

> [W]ithin the broad spectrum of classical narrative in general, it is the *singular strength of its diegetic production* that sets cinema apart, that has made it a uniquely powerful tool, not merely of social control but of social and even revolutionary mobilization.[4]

Though the Institutional Mode of Representation includes techniques like acting methods that encourage the psychological identification with characters, our focus here is on editing. Central to the IMR is the development of a standardized "language" of editing in film, a system aimed at maintaining comprehensible time and space relationships using smooth cuts between shots of differing scope and placement. This development did not happen overnight, but came out of a range of experiments in storytelling taking place all over the world from roughly 1894 to 1914. In America, these experiments took place in an art form that was immersed in an emerging industry, driven by a developing technology, competing with a culture of vaudeville, and coded using a range of previous stage and screen practices. While a full account of the cultural underbrush[5] from which cinema emerged is not possible here, for the editor it is worth understanding the basic developments in the history of editing styles, because it clarifies, by comparison to present practices, the *wholly different language that most silent films speak*. It also makes plain the struggles early filmmakers faced in developing modes of representing stories in motion pictures. When we look at silent films with an informed eye, we can appreciate their accomplishments more fully. More importantly, we can understand that *editing* should never be thought of as equivalent to *continuity editing*. Rather, we need to remember that the "mother tongue" of all editing – continuity editing – is nothing more than a stylistic choice that emerged in a particular period. The IMR and continuity cutting are now universal screen practices for communicating stories, but it could have been otherwise. Other modes of communication could have developed, but the unique ability of the IMR to efficiently and seamlessly tell a story made it a dominant force in creating motion pictures within the industry that emerged. Today, the dominance of the IMR still stands: "If you want to become a director, a cinematographer, a performer, or an editor, you will need an intimate understanding of continuity editing,"[6] as David Bordwell rightly affirms.

What is the IMR? How does it differ from what Burch calls the *Primitive Mode of Representation* (*PMR*), a style of filmic construction that Burch identifies with silent films made before 1914? The IMR encompasses what editors would call "standard continuity editing," where the goal is to produce spectator identification with psychologically delineated

characters by way of cuts to camera placements that mimic character points of view. According to Burch, the IMR

1 uses a sequence of shots, including close shots that reveal special moments of narrative information
2 creates the illusion of a continuous three-dimensional space *within* a shot by using techniques such as the three-quarter profile shot of human faces and volumetric lighting, and *across shots* by using the eye-line match, and the cut on action, and fluctuating on screen and off screen space
3 uses the close up, in conjunction with acting styles appropriate for motion pictures, to reinforce unique character psychology and ensure audience involvement as they query character motivation.

Unlike the IMR, Burch argues that much of silent film before 1914 used a wholly different mode of representation – the *Primitive Mode of Representation* (*PMR*). This explains why today's audiences, immersed in the IMR, find silent films odd and confusing. The PMR was an evolving mode of representation that developed as the motion picture industry progressed from a novelty in 1896, through the Nickleodeon era 1905–1907, to the emergence of the feature film by 1914.[7] Burch argues that the PMR, while never as systematically developed as the IMR, did have established characteristics that grew over time including

1 use of the tableaux[8]
2 arranged action staged frontally along the x-axis and played out in a single shot, or a succession of shots that each represents a unique scene
3 dominance of the long shot, with horizontal/frontal camera placement at what is sometimes called "stage distance" showing an area in front of the actors' feet and space above their head
4 acting styles that rely on the grand gestures of bourgeois theatre, mixing with "narrative or gestural material deriving from melodrama, vaudeville, pantomime (in England), conjuring, music hall and circus"[9]
5 the narrative often lies outside the film itself: specifically, the early films of this period often used presenters or lecturers, much like illustrated slide lectures that existed before cinema, to explain the story unfolding on the screen to the audience.

Key here is the long shot, a scope that requires a survey or "topographic reading by the spectator, a reading that could gather signs from all corners of the screen in their quasi-simultaneity, often without very clear or distinctive indices immediately appearing to hierarchise them, to bring to the fore 'what counts,' to relegate to the background 'what doesn't count'."[10] On the production side, the almost universal use of the long shot produced a concomitant need to guide audience attention to significant actions, reinforcing the need for styles of acting based in grand gestures. Of all the characteristics that distinguish the PMR from the IMR, the PMR's demand that the spectator locate areas of narrative significance that are occurring simultaneously in the long shot versus the IMR's offer of unfettered mobile camera placements that mimic character points of view and harness the viewer's eye is crucial; in fact, it is the *essence* of narrative continuity editing.

Burch also emphasizes the importance of the lecturer to the PMR as the first attempt at *linearizing* the audience's reading of the motion-picture screen, guiding the audience to see key moments unfolding in a wide shot before them that might otherwise be missed. "In the long term [lecturers] surely taught filmgoers how to read the vast, flat and acentric pictures [of the PMR]. The regular spectator before 1910 surely learnt to be more alert to the screen than the modern spectator,

more on the look-out for the surprises of a *booby-trapped surface*."[11] Burch further argues that the development between 1904 and 1912 of the *cut–in* from the long shot to the medium close up, paralleled the role of the lecturer. "Like the lecturer's unfolding narration that took the simultaneous signs of the primitive tableau and linearized them into a story, the cut from long shot to medium close up was a critical first step in the development of film editing, one that visually isolated, excerpted and linearized."[12]

Edwin S. Porter and the PMR

Edwin Stanton Porter was a true pioneer in the American film industry, directing over 250 early films, many of which are regarded as innovative, canonical works of the silent period. A survey of key works in his oeuvre will reveal critical features that marked the early development of the PMR. The PMR in the earliest period (before 1907) developed from existing screen practices like travel lectures using slides that were often sold to exhibitors as individual "views" rather than in sets. The earliest films were likewise sold as single shots, roughly 1:00 minute in length, the runtime of a single roll of 35mm film. Before he became a cameraman/director at Edison Studios, Edwin S. Porter was a projectionist at the Eden Musee, an entertainment center that featured wax figures, lantern shows and music in New York City. There, Porter, like all early film exhibitors, served as a kind of proto-editor.

> Projecting the Musee's films, Porter . . . selected and acquired short films and frequently edited these subjects into programs with complex narrative structures. They were also responsible for the sound accompaniment: a lecture, music, sound effects, and even voices from behind the screen.[13]

In this period, 1897–1900, the producer of motion pictures and the exhibitor of motion pictures were co-creators, with the exhibitor as "editor," selecting, splicing and building single subject films into complex "stories" and outfitting them with sound. While motion pictures were still a novelty in their first year or so (1897–1898),

> . . . exhibitions were initially organized along variety principles that emphasized diversity and contrast even while the selections often built to a climax and ended with a flourish . . . Surviving programs from the period suggest the extent to which exhibitors favored variety over possible spatial, temporal, narrative, or thematic continuities. At Proctor's Twenty-third Street Theater in March 1897, the Lumière cinématographe was listed as showing the following twelve subjects:

1 Lumière Factory
2 Columbus Statue, Entrance Central Park
3 A Battle with Snowballs
4 Niagara Falls
5 Children Playing
6 Dragoons of Austrian Army
7 Brooklyn Bridge
8 French Cuirassiers
9 Union Square
10 The Frolics of Negroes While Bathing
11 Card Players
12 Shooting the Chutes[14]

Here, the exhibitor/editor has "spread out" some of the films, so that the four scenes representing New York – 2, 4, 7 and 9 – are placed throughout the bill, rather than grouped them thematically, presumably to increase the sense of diversity.

In November 1900, Porter, experienced in exhibition as a projectionist and electrician, came in to the Edison Studios, the production arm of Thomas Edison's motion picture enterprise. The operation had recently moved into a rooftop studio enclosed in glass and located on East 21st Street in Manhattan, and Porter was employed to improve the technical operations of cameras, projectors and the machine that perforated the film. He was soon working with George Fleming, an actor and scenic designer hired a few weeks later, at what was clearly the most influential studio in the United States. Charles Musser notes that over the course of many motion pictures,

> filmmaking personnel assumed unprecedented (by American standards) control over motion-picture storytelling, and as a result, the production company, rather than the exhibitor, began to create the program. Edison filmmakers, along with those of other countries, began to elaborate a system of representation, of spatial and temporal relations between shots, that typified the cinema [until 1907].[15]

An early film that clearly exhibits Burch's Primitive Mode of Representation is a longer work Fleming and Porter made together entitled *Jack and the Beanstalk* (1902). See Library of Commons, *Jack and the Beanstalk.*[16] *Jack* is a ten-minute, ten-shot film that took six weeks to complete, cost one thousand dollars to make, and was twice the length of any previous Edison film. It is now held in the Library of Congress, preserved from paper prints that early producers were required to place on file in order to copyright a film. Solidly in the style of the early PMR, *Jack* displays a few advances in editing that seem trivial today, but were significant in their day. Unlike previous single shot films, the narrative of *Jack and the Beanstalk*

> was distributed among the various shots, a marked innovation over previous Edison fiction films . . . While temporality remains nonspecific, if generally linear, the spatial world is meticulously constructed, often by effective use of entrances and exits. In shot 5, for example, Jack exits by climbing the beanstalk, and moving out of frame. In shot 6 he is still climbing the beanstalk, then looks downward and waves as if to his mother and playmates beneath him. Such glances reinforce the spatial relationships between shots.[17]

Setting aside the spatial relations *between* shots, a look at two shots of the film – the opening and closing shots – illustrates the primary characteristics of the early PMR that lie *within a shot.* It will also demonstrate how much of the narrative is extra diegetic, that is, lying outside the film's world and dependent on the exhibitor to narrate as the film is projected.

Jack opens with a man walking over a bridge in a set made of painted backdrops that suggests a mill. A fairy pops into frame, and the man bows to her, and extends his hat. The fairy waves her magic wand over his hat, and it fills magically with something we cannot really see in the long shot – beans perhaps. Next the fairy gestures, indicating something to the man. She disappears, and Jack enters with a cow (two men in a full-sized paper mache cow costume). The man exchanges the beans with Jack, pouring them into Jack's feathered cap (Figure 2.1) Jack hands over the cow's lead, and skips happily out of frame, leaving the man struggling to lead the cow over the bridge. The man finally kisses the cow to placate it, and the scene ends with man and the cow heading over the bridge.

This opening shot mystifies contemporary audiences. Who is the man? What does the fairy tell the man through her gestures? What does the fairy magically give the man? For audiences in 1902, however, the narrative would be clarified by extra-filmic means. In many settings, the

Figure 2.1 The Primitive Mode of Representation (PMR) in Jack and the Beanstalk *(Porter, 1902).* The use
of painted theatrical backgrounds, presentational staging and grand, theatrical gestures in the
opening shot of *Jack and the Beanstalk.*

Source: Higgins, Steven, Charles Musser, Patrick Loughney, Michele Wallace, Eileen Bowser, William Heise, W. K.-L.
Dickson, et al. 2005. *Jack and the Beanstalk* in *Edison: the invention of the movies.* New York, NY: Kino on Video.

audience would hear a presenter describing the scenes in the film as they were projected. The
presenter often used catalog copy prepared by the production company as the basis for the pres-
entation. The Edison catalog copy for *Jack's* opening scene reads as follows:

> Scene 1 – Trading the Cow. Jack's mother, being very poor, has dispatched him to the mar-
> ket to sell her only cow that they may not starve. The good fairy meets the village butcher at
> the bridge and informs him that Jack will pass that way with a cow which he can doubtless
> purchase for a hatful of beans, Jack being a very careless and foolish lad. The fairy vanishes,
> and Jack appears upon the scene leading the cow. The bargain is struck, and Jack runs away
> to show his mother what he considers a very gratifying price for their beautiful animal.[18]

Comparing this Edison film catalog description and the shot itself, we understand how much
of this story's opening is not communicated *within* the shot: namely, that the mother has sent Jack
to town, that the man is a butcher, and that the good fairy tells the butcher that Jack is approach-
ing. Beyond extra diegetic narration, the opening of *Jack* illustrates many of the staging and
photographic conventions at this early stage of the PMR's development. Specifically, the action
is shown in a single long take of approximately 1:00 minute, the runtime of a single roll of the
35mm negative used at the time. (Every shot in the 10:00 minute film is roughly 1:00.) Moreover,
the shot illustrates nineteenth-century bourgeois theatre conventions in its use of painted back-
grounds, particularly the mechanical effect of the moving waterfall. The shot also includes the
linear, frontal, presentational staging of the characters and the grand gestures of the butcher and
Jack, working to draw our eye to key action in the absence of the medium close up.

In the final shot of *Jack,* Jack and his mom float in a fantastic flowing river surrounded by trees
and a spinning sun, again done as painted backdrops with mechanical motion effects (Figure 2.2).
In many prints of the film, this scene was hand painted to add spectacular color effects. The fairy

Figure 2.2 Closing Tableau: Jack and the Beanstalk *(Porter, 1902).* The closing shot of the film harkens
back to pre-cinematic forms like the *tableau vivant.*

Source: Higgins, Steven, Charles Musser, Patrick Loughney, Michele Wallace, Eileen Bowser, William Heise, W. K.-L.
Dickson, et al. 2005. *Jack and the Beanstalk* in *Edison the invention of the movies.* New York, NY: Kino on Video.

gestures as if to lead them forward, frozen in a tableau typical of the PMR that harkens back to
other pre-cinematic forms like the *tableau vivant*, a representation of a famous scene from thea-
tre, literature, painting or sculpture by a person or group posed silent and motionless. The Edison
catalog again adds extra diegetic story elements to this shot, and promotes the smooth editing of
the scenes into a coherent whole:

> Closing Tableau. A most beautiful scene, showing Jack and his mother seated in the fairy's
> boat, which is drawn by three beautiful swans, proceeding on their way to the castle which
> is to be their future home. The good fairy is seen to be flying through the air, guiding Jack
> and his mother on their way. In introducing this novel tableau, giving as it were an entirely
> new version to the ending of the story, we believe we are adding a feature which will be most
> pleasing to every child who witnesses the performance. . . . Note – In this beautiful produc-
> tion, in changing from one scene to the other, transformations are made by beautiful dissolv-
> ing and fading effects. There are no sudden jumps whatever, and the entire effect is at once
> pleasing, gratifying and comprehensive, and the audience finds itself following with ease the
> thread of this most wonderful of all fairy tales.[19]

Jack and the Beanstalk was Porter's first long-form film, an ambitious production that is strug-
gling to find new modes of cinematic representation. While *Jack* marked an advance for Porter in
terms of the complexity of its production and the elaboration of the narrative across shots, audi-
ences today regard it – like most early silent films – as an oddly incomprehensible, flawed film
that communicates its story incompletely. But its "flaws" are apparent only if we look at it from
our present day perspective. In reality, *Jack*

> only lacks an adequate cinematic language if the film is expected to act as a self-sufficient
> narrative – a misreading of its institutional context . . . If the exhibitor so wished, he could

let his patrons rely on their own familiarity with the story . . . A lecture, however, enabled the exhibitor to make his own creative contribution to the cinematic story.[20]

Life of an American Fireman (1903) is another Porter film that has been extensively analyzed by film scholars, including an exceptional, comprehensive examination of the film by Charles Musser, who debunks the claim that the film was the "first story film" and concludes that it is, nevertheless "a landmark film as much because of its role in film historiography as because of its remarkable manifestation of early cinema's representational practices."[21]

Shot 1 of *Fireman* opens with a fireman asleep in a chair dreaming of a woman and a child, a tableau shown as a composite image, the dream occupying a round vignette in the upper right frame.[22] The dream vignette fades out, the fireman paces, takes his hat, exits frame right. Without a lecturer, it is unclear what the spatial or temporal relationship of this shot has to the rest of the film, but the Edison catalog says,

> Scene 1 – The Fireman's Vision of an Imperiled Woman and Child. The fire chief is seated at his office desk. He has just finished reading his evening paper and has fallen asleep. The rays of an incandescent light rest upon his features with a subdued light, yet leaving his figure strongly silhouetted against the wall of his office. The fire chief is dreaming, and the vision of his dream appears in a circular portrait upon the wall. It is a mother putting her baby to bed, and the inference is that he dreams of his own wife and child. He suddenly awakes and paces the floor in a nervous state of mind, doubtless thinking of the various people who may be in danger from fire at the moment. Here we dissolve the picture to the second scene.[23]

In a close up rare for the day, the second shot shows a hand open a fire call box and (fakes the motion as if he) activates the alarm, leading to the next shot which shows firemen jumping from their beds and sliding down the fireman's pole to the engine room – eight men grab the top of the fire pole, and slide down through a hole in the floor. Shot 3 ends as the fire captain descends last (Figure 2.3). Shot 4 shows the bottom of the fire pole with the engines ready. The stable doors open, the horses emerge and are harnessed to the engine (Figure 2.4) – that is, we see the pole for a significant temporal overlap of roughly five seconds *before* the firemen slide down the bottom of the pole to complete their move.[24]

Shot 4 ends as the fire engines are pulled away by the accelerating horses and clear the frame. Shot 5 again presents overlapped or "mismatched" action as the doors of the firehouse open on the street and the horses, at a near stop, emerge from the doors. For a film of this era, these opening shots represent a remarkable launch to the story – the dream vignette that lays out a narrative premise that could only be fully understood as described by a lecturer, followed by an exterior (and rare for its scope) close up shot that immediately motivates action in a successive interior long shot, followed by a temporally delayed but spatially consistent move as the firemen exit from the bottom of the frame in shot 3, and enter from the top of the frame in shot 4, followed by a temporally delayed shot 5 that does not match the energy of the horses' exit in shot 4. As Musser notes,

> In shots 3, 4, and 5, Porter shows everything of dramatic interest occurring within the frame. This results in a redundancy of dynamic action – the slide down the pole, the start [of the horses] to the fire – effectively heightening the impact of the narrative. At the same time, the repeated actions clearly establish spatial, temporal, and narrative relationships between shots. It is, as Porter realized, *a kind of continuity, but one radically different from the continuity associated with classical cinema.*[25]

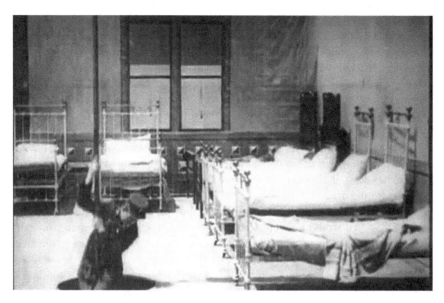

Figure 2.3 Temporal overlap in Life of an American Fireman *(Porter, 1903).* The outgoing shot 3 ends with the fire captain sliding down the pole.

Source: Higgins, Steven, Charles Musser, Patrick Loughney, Michele Wallace, Eileen Bowser, William Heise, W. K.-L. Dickson, et al. 2005. *Life of an American Fireman* in *Edison the invention of the movies.* New York, NY: Kino on Video.

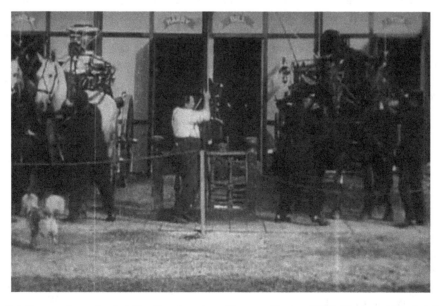

Figure 2.4 Temporal overlap in Life of an American Fireman *(Porter, 1903).* The incoming shot 4 shows the exterior with horse drawn engines for roughly 5 seconds before the first fireman slides down into frame.

Source: Higgins, Steven, Charles Musser, Patrick Loughney, Michele Wallace, Eileen Bowser, William Heise, W. K.-L. Dickson, et al. 2005. *Life of an American Fireman* in *Edison the invention of the movies.* New York, NY: Kino on Video.

This alternate continuity – a key element of Burch's PMR – is most striking in the last two shots of the film, which show the rescue of the woman. Film scholars have previously analyzed these two shots, in part because of their centrality to film historiography: when compared to the paper print, the print from the Museum of Modern Art that circulated widely and was the basis for claims about Porter's innovations in film editing was found to have been *re-edited* sometime in the 1940s to fit the style of Hollywood continuity, the IMR.[26] See Critical Commons, *"Life of an American Fireman* (1903) – The rescue."[27]

Life of an American Fireman concludes with the rescue of a woman who awakes in shot 8 to find her room on fire and filled with smoke, tries the window and swoons on the bed. A fireman smashes down the door with his fire ax, knocks out the exterior window, picks up the woman and takes her out the window and down the ladder (Figure 2.5). He returns, removes a child from the bed and carries her down the stairs to safety. Two firemen climb into the room with a fire hose and begin to extinguish the fire.

Shot 9 *roughly repeats the entire action* of shot 8, showing it from an exterior position, including all of the action that would be seen from that placement, e.g., the fireman who just smashed down the door in shot 8 enters through the main building entrance and moves up the interior stairs to the woman's bedroom. From outside, shot 9 shows the woman opening the window and crying for help – an action that does not precisely match the interior shot – and continues with the firemen's rescue of the woman (Figure 2.6), whose actions indicate that her child is still trapped, and their subsequent rescue of the child. As Burch notes, this non-linear repetition of the action in the final film is completely foreign to modern filmgoers because "It is so self-evident today that a film must tell its own story that we are often unable to read such narratives."[28]

Moreover, presenting the action in interior and exterior shots indicates Porter recognized an alternative viewing strategy in audiences of the day:

> Once these two shots were filmed, it was decided to connect them in a manner implying an *obvious non-linearity rather than disturb the unity of the spatial viewpoint*, [which] seems to me to say a good deal about the *alterity* of the relationship these early films entertained with the spectators who watched them. Does it not suggest that the feeling of being seated in a theatre in front of a screen had, for spectators then, a sort of priority over the feeling of being carried away by an imaginary time-flow, modeled on the semblance of linearity which ordinary time has for us [and represented using the IMR]?[29]

In 1903, as the film production companies were taking control of editing from the exhibitors, Porter's struggle with representing time and space through editing in *Fireman* with its repeated actions and its flexible temporality, its use of vignettes and a single close up is squarely in the evolving mode of the PMR. As Musser notes, *"Life of an American Fireman* remained indebted to the magic lantern show, with its well-developed spatial constructions and an underdeveloped temporality. By showing everything within the frame, Porter was, in effect, making moving magic lantern slides with theatrical pro-filmic elements. Shots are self-contained units tied to each other by overlapping action."[30] And although it was a style ultimately discarded, it shows how ingrained the idea is in the modern filmgoer that a film should be both free standing in its narration and able to easily cue the audience to its *linear* reconstruction – "what follows what." We will return to this idea when we look at the editing theories of David Bordwell.

One final film by Edwin Porter deserves our consideration, *College Chums* (Porter, 1907). The film comes at a time when producers were grappling with the decline of film as spectacle within a variety program, with the demand for story films spawned by the rise of the Nickelodeon, and with the emergence of the "movie fan,"

Figure 2.5 Temporal overlap in Life of an American Fireman *(Porter, 1903).* Shot 8 shows the entire rescue from the interior angle, and the spatial unity of the shot is preserved. Here, the fireman carries the woman out from the interior angle.

Source: Higgins, Steven, Charles Musser, Patrick Loughney, Michele Wallace, Eileen Bowser, William Heise, W. K.-L. Dickson, et al. 2005. *Life of an American Fireman* in *Edison the invention of the movies.* New York, NY: Kino on Video.

Figure 2.6 Temporal overlap in Life of an American Fireman *(Porter, 1903).* Shot 9 repeats the entire rescue from the exterior angle, again preserving the spatial unity of the shot. Here, the fireman carries the woman out from the exterior angle.

Source: Higgins, Steven, Charles Musser, Patrick Loughney, Michele Wallace, Eileen Bowser, William Heise, W. K.-L. Dickson, et al. 2005. *Life of an American Fireman* in *Edison the invention of the movies.* New York, NY: Kino on Video.

the one who attended every day or went from show to show, [and] existed before there was a star system or a fully integrated narrative system. It was this fan that presented at the same time a demand for stars, a more complex narrative, and for more clarity in narrative techniques . . . Films that could be understood without the lecturer to explain them could be shown everywhere.[31]

Circa 1907, this need for clear narratives that could stand on their own created a "crisis in the film narrative," in the words of film historian Eileen Bowser, which would ultimately push directors to new methods of representing time and space. We can compare the editing of a simple scene – a telephone conversation – in two different films from this period to see how the Institutional Mode of Representation (IMR) would ultimately define the future of this representation in the story film.

In *College Chums*, Porter stages a telephone conversation graphically, with a man and a woman on opposite sides of the screen in circular vignettes, the distance between them depicted as illustration of a city scape seen from above, and their conversation animated with text that moves between them (Figure 2.7). With this moving image, Porter, the projectionist/engineer is looking backward to lantern slides and strip cartoons for visual codes to delineate the scene and make it visibly concrete, a single image compositing the speakers, their spatial relationship, and their dialogue shown in animated text.[32]

The same year that *College Chums* was released, D. W. Griffith, a struggling playwright, came to the Edison studio to try to sell a script to Porter, who instead gave him his first motion picture job, acting in *Rescued from an Eagle's Nest* (1908). Griffith, who was not a film exhibitor like Porter but a product of the theatre, is typical of a number of new American directors coming into the motion picture business at the time. Working in film, these newcomers began to standardize film production, working in genres that were cross cultural and not tied to classical European tales, creating films that did not need a lecturer, that ran a standard length, that could be identified as a brand, and that would make it possible for the studios to further regularize their production

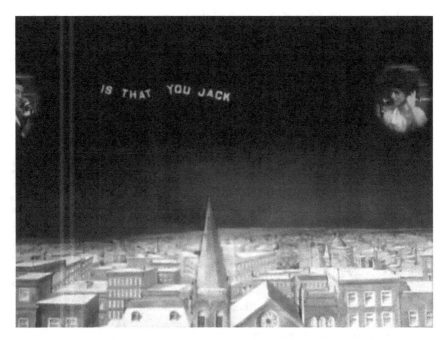

Figure 2.7 Creating space graphically in College Chums *(Porter, 1907).* Porter creates a cross town telephone conversation graphically, with circular vignettes, a city scape and animated text, a design that looks backwards to magic lantern shows.

Source: Higgins, Steven, Charles Musser, Patrick Loughney, Michele Wallace, Eileen Bowser, William Heise, W. K.-L. Dickson, et al. 2005. *College Chums* in *Edison the invention of the movies.* New York, NY: Kino on Video..

process. The result: "The development of new ways to connect shots, or editing, was probably the most important change in film form to take place during the 1907–1909 period."[33]

A mere two years after Porter's "graphic telephone call" in *College Chums,* D. W. Griffith's film *The Lonely Villa* (Biograph, 1909) took a different approach that is uses "alternate scenes" –what we would today call *crosscutting* – to show a frantic telephone conversation between a husband and his wife. See Critical Commons, *The Lonely Villa* (1909).[34] The melodramatic telephone scene begins when the husband, a doctor, is lured away from home by vagrants, experiences car trouble, and calls his wife to let her know he will be late coming home. As she picks up the phone, the doctor learns she is under attack from the same vagrants, and has barricaded herself and her three daughters in a room for safety. From this point forward, crosscutting is used to develop the actions of father/rescuer and mother/prey as the phone call builds to a conclusion.

The doctor, still on the phone, tells his wife to get the pistol he left for her protection and shoot the invaders. The mother tries, but the gun is empty – only the audience saw the vagrants surreptitiously empty the gun earlier. The father frantically indicates he will return to rescue her, and at this point, Griffith crosscuts to show the vagrant cutting the phone line. We see both father and mother react to this new threat as the line goes dead: the father leaving to race home in the auto, the mother now left helplessly distraught. The entire telephone episode takes roughly two minutes, and shows *16 shots* of the father or mother on the phone, and four shots that advance the narrative without showing the phone – the father runs outside to see if the car is repaired, the vagrants continue to try to jimmy the door, the vagrant cuts the phone line, the father runs out into the street to seek help from a policeman. Here, then is a telephone conversation, advancing the plot like *College Chums,* but using crosscutting to show distance and simultaneity, rather than covering a phone conversation in a single graphically animated shot of 44 seconds. *Lonely Villa* also builds considerable narrative tension as the father's sense of helplessness builds. In two short years, Porters' "PMR approach" to narrating a phone call is replaced by Griffith's "IMR approach," a sophisticated manipulation of the audience's emotion that presumes succeeding shots from distant locations will be read as we read them today, spatially distant and temporally simultaneous. Musser notes that the matching action of *Lonely Villa* drove a rigorous, linear temporal edit where "the shot ceased to be a discrete unit and became completely subservient to the narrative and linear flow of events. *Action now moved across shots, not within them.* Linear temporality, parallel editing, and matching action encouraged a more efficient narrative structure."[35]

Griffith soon made a name for himself using this technique, the "last minute rescue," in numerous films, crosscutting between threat and rescue, varying the pace of the cutting to make the threat more menacing and the rescue maddeningly delayed, while the relentless forward motion of time in the film became the focus of these scenes. This editing style is a new mode of representing time and space that superseded previous practices. It is editing within the Institutional Mode of Representation, the standardized global language of editing we know today.

Découpage and Burch's Matrix

Nöel Burch's study of film grew from his study of modernist music, and his belief that film should not seek inspiration from narrative forms like theatre and literature, but from more abstract arts like modern painting and music. Burch moved from the U.S. to France in 1951, and earned a degree in filmmaking at the Institut des Hauts Etudes Cinématographiques. Burch also made experimental films, and translated the work of the musicologist André Hodeir. He began using formalism – the notion that a piece of music's meaning was derived solely from its form – to analyze motion pictures, and published his book *Theory of Film Practice* in 1969, collecting essays he had written for *Cahiers du cinema* in 1967–1968. Burch says,

> when I was nineteen and I went to school, I was already developing the idea that basically cinema is a kind of music, and this idea is formulated in my first book, which is called, *Theory of Film Practice* in English. It is basically about this idea that what counts in film is

the *mise-en-scène*, and that narrative is a kind of convenient support that has no importance whatsoever.[36]

Not surprisingly, editing and the structures it creates are of special interest to Burch, as Bordwell notes,

> In surveying the possibilities open to formal exploration, Burch treats the techniques of the medium as "parameters." Each parameter exists as a binary alternative. Thus one parameter is soft-focus/sharp-focus imagery; another is "direct" sound versus postsynchronized sound. In *Praxis du cinema*, an exhaustive survey of cinema's parameters, Burch pays particular attention to editing.[37]

In his exploration of editing, Burch employs the notion of *découpage,* a French term that he says has at least two meanings that it shares with English:

1 the final form of a script, incorporating whatever technical information the director feels it is necessary to set down on paper to enable a production crew to understand his intention and find the technical means with which to fill it
2 the more or less precise breakdown of a narrative action into separate shots or sequences *before filming . . .* called a "shooting script" in English.

[Burch continues,]

> A third French meaning of *découpage,* however, has no English equivalent. Although obviously derived from the second meaning of a shot breakdown, it is quite distinct from it, no longer referring to a process taking place before filmmaking or to a particular technical operation, but, rather, to the *underlying structure of the finished film.* Formally, a film consists of a series of succession of fragments excerpted from a spatial and temporal continuum. *Découpage* in its third French meaning refers to what results when the spatial fragments, or, more accurately, the succession of spatial fragments excerpted in the shooting process, converge with the temporal fragments whose duration may be roughly determined during the shooting, but whose final duration is established only on the editing table. The dialectical notion inherent in the term *découpage* enables us to determine, and therefore to analyze, the specific form of a film, its essential unfolding in time and space.[38]

This third notion of *découpage* describes the overall phenomenon – the underlying structure of the film, the spine of the film made up of shots – and posits the shot as the basic unit. In Burch's view, the shot is a spatial fragment with a temporal duration that is roughly established at the shooting phase and refined during editing stage. That Burch describes *découpage* as a dialectical notion recognizes that our distinction between space and time is somewhat artificial, as the term *space-time continuum* makes explicit. Moreover, his dialectical term recognizes that editing motion pictures at once temporalizes space and spatializes time: if a character walks through a wide shot, *découpage* contains both notions: 1) the articulation of space moved through and 2) the time it takes to move through it.

Armed with this notion of the shot, Burch constructs a 3 x 5 matrix that lays out all of the possible iterations of how space and time can change when we cut from one shot to the next. This is a formalist approach: Burch believes that if we want to understand the overall structure of a film, we can break the complex structure into parts (shots) and analyze these individual structures for their articulation of time and space and thereby begin to understand the larger structure. Burch's formal analysis of an edit – comparing the outgoing shot to the incoming shot on two parameters – *the space shown and the time shown* – offers a narrow, but fairly precise understanding of how these two variables change

over time. "Narrow" because the time and space considerations may or may not relate to the general narrative or thematic goals of the scene, but precise in that we can consider questions as simple as "Is there any space in the outgoing shot that also appears in the incoming shot?" Looked at from this level of abstraction, a shot change offers a moment to consider spatial and temporal relations between shots at the micro level. To understand Burch's approach, it is best to first fully describe the temporal and spatial concepts, then examine some of the possible spatial temporal relationships (or as he calls them, "articulations"), and finally consider some of the limitations of Burch's approach. As we enumerate the possibilities of spatial and temporal articulations, we will make reference to table in Figure 2.8 below to clarify how a particular edit visualizes space and time.

First, in the broadest terms, looking at a single edit to compare *time* across the cut, the horizontal temporal axis of the chart below shows five temporal possibilities between the outgoing shot A to the incoming shot B: Temporally Continuous, Temporal Reversal Measurable, Temporal Reversal Indefinite, Temporal Ellipsis Measurable and Temporal Ellipsis Indefinite. Notice that Temporally Continuous is a single case, while larger categories of Reversal and Ellipsis can be subdivided into Measurable or Indefinite cases.

Second, looking at a single edit to compare *space* across the cut, the vertical Spatial Axis of the chart shows three possibilities between the outgoing shot A to the incoming shot B: Spatially Continuous, Spatially Discontinuous Proximate, Spatially Discontinuous Radical. Here again, notice that Spatial Continuity is a single case, while the larger category Spatial Discontinuity can be subdivided into Proximate and Radical. Let's examine the temporal axis first.

	TEMPORAL CONTINUITY	TEMPORAL REVERSAL MEASUREABLE	TEMPORAL REVERSAL INDEFINITE	TEMPORAL ELLIPSIS MEASUREABLE	TEMPORAL ELLIPSIS INDEFINTE
SPATIAL CONTINUITY	**Case 1** Spatially Continuous Temporally Continuous	**Case 2** Spatially Continuous Temporal Reversal Measureable	**Case 3** Spatially Continuous Temporal Reversal Indefinite	**Case 4** Spatially Continuous Temporal Ellipsis Measureable	**Case 5** Spatially Continuous Temporal Ellipsis Indefinite
SPATIAL DISCONTINUITY PROXIMATE	**Case 6** Spatially Discontinuous Proximate Temporally Continuous	**Case 7** Spatially Discontinuous Proximate Temporal Reversal Measureable	**Case 8** Spatially Discontinuous Proximate Temporal Reversal Indefinite	**Case 9** Spatially Discontinuous Proximate Temporal Ellipsis Measureable	**Case 10** Spatially Discontinuous Proximate Temporal Ellipsis Indefinite
SPATIAL DISCONTINUITY RADICAL	**Case 11** Spatially Discontinuous Radical Temporally Continuous	**Case 12** Spatially Discontinuous Radical Temporal Reversal Measureable	**Case 13** Spatially Discontinuous Radical Temporal Reversal Indefinite	**Case 14** Spatially Discontinuous Radical Temporal Ellipsis Measureable	**Case 15** Spatially Discontinuous Radical Temporal Ellipsis Indefinite

Figure 2.8 Nöel Burch "Spatial Temporal Articulations, a 3 x 5 Matrix"

The Temporal Axis: Temporal Relations between Outgoing Shot A and Incoming Shot B

Burch first considers the relationship of time across a shot change. He argues that the time articulated in outgoing shot A can have five possible relationships to the time articulated in incoming shot B. Look at the top row of the chart above. Setting aside for a moment considerations of *space* – in other words, for this discussion, we will use row two "Spatial Continuity," but we could just as easily have chosen row three or row four – we can look only at the possible *temporal* relations between an outgoing shot A and incoming shot B. In the broadest terms, Burch says shot B can show time that is absolutely *temporally continuous* to shot A (case 1), or shot B can show time that is *temporally reversed* from shot A (cases 2 and 3), or shot B can show time that is a *temporally elided* from shot A (cases 4 and 5). To reiterate, Burch subdivides reversal and ellipsis in two smaller categories – *measurable* and *indefinite* for a total of five temporal possibilities. So, once again, setting aside considerations of *space*, let's examine *only* the temporal relations that are possible in the second row.

Temporal Continuity

Case 1 – *temporal continuity* – seems straight forward: the quarterback in shot A takes a snap from the center and drops back to throw a pass and shot B shows a closer shot as he continues to drop back, sets his feet, and throws. The two shots are absolutely *temporally continuous*. We would expect this temporal continuity in live, televised football, and of course, we could shoot such a scene easily for a narrative film using two cameras and cutting between the two shots. Or we can duplicate the representation of temporal continuity by cutting together two different takes of the same material if we were shooting a narrative film with one camera that showed a quarterback taking snap and throwing a pass.

Temporal Reversal

In Cases 2 and 3 – *temporal reversal* – indicates that the time shown in the incoming shot B "flashes back" in time. Flashbacks are common in literature and drama, and are found in films in the United States as early as 1907.[39] Burch wants to differentiate between editing using short time reversals – overlapped action that is repeated by showing short jumps backwards to replay a moment in time as when a character's moment of death is quickly replayed for emotional or kinetic impact – from traditional *flashbacks* – say, a cut from a character reminiscing to a previous time in his life. Three examples can clarify these distinctions. See Critical Commons, "*Mission Impossible 2*: Temporal Reversal Measureable, Overlapping Edit."[40] In *Mission Impossible 2* (John Woo, 2000), Ethan Hunt (Tom Cruise) uses the mirror on his motorcycle to fire his pistol at the bad guy pursuing him (Figure 2.9). Woo shows the bullet strike that hits the bad guy's windshield twice, repeating the moment of impact in two shots (Figure 2.10 and 2.11) that are framed slightly differently. The first shot shown (Figure 2.10) is roughly 16 frames long, before we repeat the action in slight slow motion (Figure 2.11) for roughly 20 frames. Burch points out that none of this discussion is referring to the common practice of editors repeating a few frames of the incoming shot to create a smoother cut when matching action (a notion we will deal later with in Chapter 3.) Here, Burch is describing overlapped cutting for impact, a simple visceral, kinetic effect (or even a meaningful inference) that editors create by repeating action that viewers register at least at the threshold of consciousness.

A traditional, more common kind of flashback occurs after the opening scene of *Iron Man* (Jon Favreau, 2008). See Critical Commons, "*Iron Man*: Flashback, Measureable Temporal Reversal."[41] Tony Stark (Robert Downey, Jr.) is in Afghanistan riding in a Humvee caravan that is attacked by insurgents using an IED, small arms fire, and even a rocket-propelled grenade made

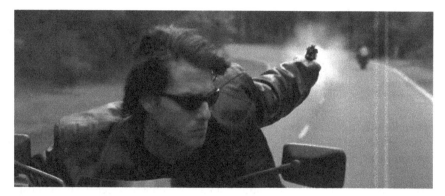

Figure 2.9 Flashback/overlapped action for impact in Mission Impossible 2 *(Woo, 2000).* Ethan Hunt (Tom Cruise) uses his mirror to fire on his pursuer.

Source: Copyright 1999 Paramount Pictures Corporation.

Figure 2.10 Flashback/overlapped action for impact in Mission Impossible 2 *(Woo, 2000).* The film cuts to the pursuer, showing his windshield shattered by the bullet.

Source: Copyright 1999 Paramount Pictures Corporation.

Figure 2.11 Flashback/overlapped action for impact in Mission Impossible 2 *(Woo, 2000).* The film quickly cuts to another shot of the pursuer, and repeats the action of the windshield shattered by the bullet. This cut is an example of Burch's Case 2 — a cut that is spatially continuous, Temporal Reversal Measureable — used here for kinetic impact.

Source: Copyright 2000 Paramount Pictures Corporation.

by Stark Industries. Stark awakens from the grenade explosion bloodied and surrounded by insurgents holding him captive (Figure 2.12). A cut to the main title card – an element from outside the diegesis or story space – "Iron Man," then to a wide shot of the Apogee awards ceremony with stage surrounded by large images of Stark and the title keyed below "Las Vegas, 36 Hours Earlier" (Figure 2.13). Here, the incoming shot is a *temporal reversal measurable*, namely a reversal of 36 hours, a narrative choice that cues the viewer to infer that much of what we will see in the remainder of the film will take us from this flashback of the awards ceremony through to Stark's capture, and in the process show us how he got from here to there.

One final example is a more traditional narrative flashback in which a character in the film recounts something in his or her past, and we see that event enacted on screen. See Critical Commons, "Flash back in *Forrest Gump*."[42] In *Forrest Gump* (Robert Zemeckis, 1994) Forrest (Tom Hanks) strikes up a philosophical conversation with a nurse on a park bench about her shoes. As the camera pushes in, Forrest recalls truisms his mother told him about shoes, leading him to say "I bet if I think about it real hard I could remember my first pair of shoes." He closes his eyes, thinking hard, and continues, "Moma said they would take me anywhere . . . " (Figure 2.14).

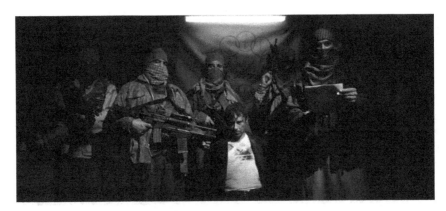

Figure 2.12 Flashback/Temporal Reversal Measureable in the opening of Iron Man *(Favreau, 2008).* The film's opening scene ends with Tony Stark (Robert Downey, Jr.) surrounded by terrorists holding him captive.

Source: Copyright 2008 Paramount Pictures Corporation.

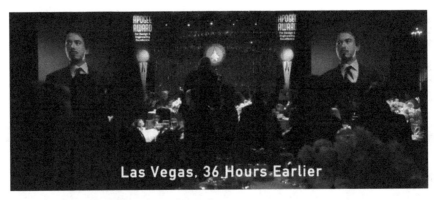

Las Vegas, 36 Hours Earlier

Figure 2.13 Flashback/Temporal Reversal Measureable in the opening of Iron Man *(Favreau, 2008).* After a title card is shown, the film cuts to the Apogee awards ceremony with the title keyed below "Las Vegas, 36 Hours Earlier," suggesting that the film will cover that time period and show how Stark became a captive.

Source: Copyright 2008 Paramount Pictures Corporation.

Cut to Forrest as a young boy (Michael Humphreys), striking the same facial expression (Figure 2.15) as the camera pulls back and the adult Forrest's voice continues, "She said they were my magic shoes." The camera reveals Forrest in a doctor's office, where a cigarette smoking country doctor says, "All right, you can open your eyes now." As Forrest opens his eyes in astonishment, the camera continues back to reveal his first pair of leg braces.

So here in *Forrest Gump,* we have a temporal reversal.[43] But is it *measureable* or *indefinite?* Burch is evasive on this issue, but we can think of the qualifier *measureable* or *indefinite* as a continuum: certainly, where the filmmaker specifies the length of time that the incoming shot reverses — "Las Vegas, 36 Hours Earlier" that we mentioned above – that is a *measureable* temporal reversal. Compared to *Iron Man,* quantifying the reversal in *Gump* is certainly *less definite:* we know it's roughly the time of Gump's early adulthood to the time he was a 8 or 9 year old boy. That time is *indefinite,* but it is probably not 40 years earlier, and certainly not 100 years earlier. And to reiterate, measureable or indefinite lie on a continuum: films such as *Last Year at Marienbad* (Resnais, 1961) have plots that intentionally obscure the temporal relationships between shots, making moments of temporal reversal *much more indefinite* than this example from *Gump.* One solution is to adopt the convention that, except in cases where the film *explicitly* states the length of time reversed, every other reversal is

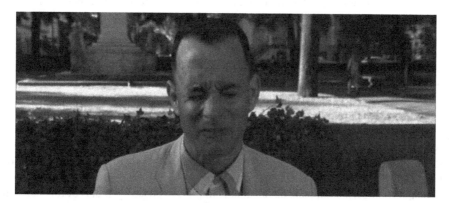

Figure 2.14 Flashback/Temporal Reversal Indefinite in Forrest Gump *(Zemeckis, 1994).* Forrest Gump (Tom Hanks) closes his eyes trying to remember his first pair of shoes.

Source: Copyright 1994 Paramount Pictures Corporation.

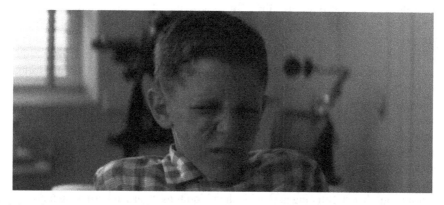

Figure 2.15 Flashback/Temporal Reversal Indefinite in Forrest Gump *(Zemeckis, 1994).* The film cuts to Forrest as a young boy (Michael Humphreys), striking the same facial expression as the camera pulls back to reveal his first pair of leg braces.

Source: Copyright 1994 Paramount Pictures Corporation.

indefinite.[44] Before we leave the flashback, it is worth noting that the term itself is purely cinematic, not one drawn from literature, though it is now used in literary contexts. The *Oxford English Dictionary* identifies the first use of the term *flashback* in an October, 1916 issue of *Variety*: "In other words the whole thing is a flash-back of the episodes leading up to her marriage." The terminology at that time was still in flux. Books like *The Techniques of the Photoplay* (3rd edition), published three years earlier, were using a different term, the cut-back: "*Cut-back*, one or more returns to a previous action, either to avoid the showing of prohibited action, to raise the effect through contrast or to quicken the action."[45] Eventually, the term *flashback* won out.

Temporal Ellipsis

In Cases 4 and 5 – *temporal ellipsis* – Burch indicates that the time in shot B does not *continue* the time in shot A, but is *advanced* from the time shown in shot A. If you consider how the word itself, *ellipsis*, is used to refer to punctuation that shows missing material, the notion of temporal ellipsis should be clear. Consider how we shorten the following quote, and use the punctuation mark for ellipsis to indicate that material has been removed. If we were reading a book that quotes the famous Gettysburg address, we could show the full opening line: "Four score and seven years ago our fathers brought forth on this continent, a new nation, conceived in Liberty, and dedicated to the proposition that all men are created equal," or we could shorten it and use ellipsis marks to indicate that material is missing: "Four score and seven years ago our fathers brought forth . . . a new nation . . . dedicated to the proposition that all men are created equal." Similarly, in editing we can think of temporal ellipsis broadly as the " . . . " – the "dot dot dot" – of a shot change.

Ellipsis is ubiquitous in cinema. A sequence shows a man talking on his cell phone. He says, "I'll see you at the airport," hangs up, and walks out his house. Cut to same man standing in an airline ticket line talking to his wife. This is ellipsis. When we edit, we almost always elide material. We remove the "boring parts" to advance the narrative: here, do we need to see the man get into his car, drive down the highway, park in the parking lot, get his luggage from the car, jump on the shuttle, enter the terminal and walk up to the ticket counter? Only rarely, and ellipsis allows us to emphasize the narrative logic of the outgoing shot: shot B of the man in the airline ticket line answers the question "What happens next?" that is implicitly posed by shot A of the man walking out of his house. An editing style that leaves elided action without including establishing shots or transitions such as dissolves is called *elliptical editing*.

Burch breaks down the category of temporal ellipsis further into *measurable* or *indefinite*, and here again struggles to definitively differentiate them. While the two concepts represent a continuum from one extremity to the other, Burch says that if we can determine what time has been elided – that is, if we look at the shots closely, and some factor *within* the shots tells us how much time has elapsed – we have a *measurable temporal ellipsis*. Example: if the outgoing shot A shows a car pull up in front of a house, and a woman exits the car and steps towards the house, then we cut to an interior shot B of a door and the door opens and she enters, we can estimate that "the time it took her to walk from the street to her porch" has been elided, and the temporal difference between the shots is *measureable*. This kind of ellipsis – tightening action in a way that is largely unseen by the viewer – is ubiquitous. And here, *visual information within the shots themselves* shows us how much time has been dropped out: if we pay attention to the cutting (which we ordinarily do not) we can actually note the "ball park duration" of material that has been elided. If we can make that kind of judgment from *visual information within the shots themselves*, we can classify those cuts as *measureable* temporal ellipsis.

Burch points out that "tightening action" is the ubiquitous, "garden variety" temporal ellipsis, a widely accepted technique to advance the story and an ordinary part of the "invisible" style of narrative continuity editing. It is frequently read by the audience as Case 1, absolute spatial and temporal continuity. But "tightening action" does not specifically address another use of the

measured temporal ellipsis that we commonly call the "jump cut:" a shot in which some of the frames have been excised, creating an undisguised, measured temporal ellipsis that shows time has been elided. In the common form, these measurable temporal ellipses come within a single take with the camera locked down or moving only slightly, so that the spatial framing is preserved and the actor performs a familiar, linear action so that the time elided is clearly understood – making the elisions measureable rather than indefinite because the total duration of the linear action is roughly known. It is also worth noting here that the term "jump cut" is used loosely, and has been broadly applied to any hard cut: "a cut between the two shots that seems abrupt and called attention to itself because of some obvious jump in time or space."[46] And further, that "jump cut" need not apply exclusively to temporal ellipsis: it is often used to describe the cutting together of *any* "two noncontinuous shots within a scene so that the action seems to jump ahead *or back in time*."[47]

Barry Salt argues that jump cuts appeared in films before 1908, since

> For the most efficient use of the 1000 feet of film per reel that was all that was available for standard films, it was very frequently necessary to start the next scene [with] some of the actors from the previous scene already in shot, even though the new scene was taking place later and in some other place.[48]

Narrative titles soon became the solution to cut in to cover these jump cuts, which is why, by 1908, American films routinely contain titles that are redundant. However, Salt notes, that the jump cut as we know it today "in which the same actor is shown in different positions in the *same* location on either side of the cut, probably first appeared in Godard's *À bout de Souffle*."[49] Known in English as *Breathless* (Jean-Luc Godard, 1960), it was an enormously influential film that startled audiences with its abrasive use of jump cuts, and became the archetypical *French New Wave* film. Action driven, with improvised characters drawn from American crime movies, the handheld, "shot-in-the-streets" quality to the film established it as something entirely new in filmmaking. "The principle of novelty, in *Breathless,* lies in its acceptance of an exhausted genre – the Hollywood grade-B crime film – as a simulacrum of reality . . . *Breathless* is a mannerist fantasy, cinematic jazz."[50] The audacity of its inventive style is seen in the film's second scene where Michel (Jean-Paul Belmondo) drives into the country after stealing a car. See Critical Commons, "*Breathless (À boute de souffle)*: Jump cuts, Measurable Temporal Ellipsis."[51] As Michel begins to pass a slower car, Godard combines four shots taken from the point of view of Michel's car showing different vehicles being overtaken, each on a completely different section of the roadway. Since the viewer assumes that time is moving forward in the film, these cuts are seen as temporal ellipsis, and *measureable* in the sense that they are part of the same drive in the country, and set against a piece of continuous audio in which Michel sings to himself in the car about his girlfriend Patricia (Jean Seberg). Given that the audio is diegetic and short, certainly the effect created *feels* as if the cars are passed one immediately after the other, so the time elided *feels* short, as if the shots are fusing into the *essence* of passing a car. The short duration of the four shots – three are roughly :01 second long and one is roughly :02 seconds long – contributes to this feeling that the time elided is short. Godard returns to the interior of the car for a medium shot of Michel driving, smoking his cigarette and thinking out loud to himself, "So I'll get the money. I'll ask Patricia yes or no, and then . . . [he sings again] *Tonight my love . . . Milan, Genoa, Rome.*" This audio plays out over a shot of nearly :13 seconds of three more vehicles being overtaken, a kind of "resolution" of the passing sequence that is punctuated (in a one-cut) of a loud car horn passing (i.e., "Doppler shifting") as the large American sedan that Michel is driving passes a fixed camera beside the road.

Later, in a shot that is almost a minute long, Godard surprises us with Michel's "direct address to the camera – he invites us to go to hell if we disagree with him – Godard impolitely reveals the

presence of screen and audience."[52] Taking a pistol from the glove box, Michel begins to point is playfully at his rearview mirror and passing cars. Godard plays out this action in a series of four jump cuts of widely varying length (the shortest is roughly :03 seconds, and the longest :12). The *graphic mismatches* in exposure between two of the shots of Michel driving emphasize the jump cut more than the slight changes in position that result from *spatial mismatch,* and the gun play ends with a "Hollywood" gun shot on the soundtrack that is cut to a moving shot from the driver's side of the car of the sun filtering through the trees, a complete "visual collision" with what has come before.

After Michel is spotted by the cops passing illegally, a dizzying series of pan shots follow moving back and forth from the front of the car to the rear of the car, and other long shots from the road that show reverse screen direction shots of his car going one way, the police the other. Within this sequence is one of the most notable jump cuts in Godard's oeuvre: the camera pans to the rear of the car to reveal a truck following Michel (Figure 2.16), with the cops struggling to pass – cut to the same shot with the truck now out of the shot and the two cops following (Figure 2.17). This jump cut, in the tradition of Georges Méliès, creates a stop motion substitution effect that "pops" the truck out of frame as if by magic.

Here, the power of editing to simply remove whatever gets in the way of the story is flaunted, and Godard's directorial hand is clearly expressed. His instinct to pare down a sequence to the minimal, indispensible action needed continues through the end of the scene. As a policeman approaches Michel's broken down car, Goddard combines four shots to show Michel shooting him. The shots are very tightly framed, using simple, unidirectional camera moves that virtually trace the process from thought to action: a tilt down from his head to his arm, a pan to his hand cocking the revolver, and an extreme close up pan from the cylinder to the tip of the barrel, ending in a "Hollywood" gunshot on the soundtrack that cuts to the policeman falling backwards, shot in the chest. It was Eisenstein who purportedly said, "Editing is the ruthless suppression of the inessential," and these four shots are strong evidence of Godard's commitment to that principle. In four visceral, stripped down shots, Godard creates the film version of "thought—point—cock—fire—impact" with absolutely nothing superfluous left in the :07 seconds of screen time the entire action takes. As Richard Brody points out,

> Godard (and the editor, Cécile Decugis, who essentially executed Godard's instructions) did not, for the most part, cut at random; on the contrary, he responded to his enthusiasms, and removed all moments – within scenes, even within shots – that seemed to him to lack vigor. He kept in the film only what he thought was the strongest, regardless of dramatic important or conventional continuity, thus producing many jump cuts . . . Such cuts were generally considered to be a cardinal error of an amateurish film technique and loosely avoided in the professional cinema.[53]

Beyond that, in just a few minutes of the film's opening, Godard has exploded the gangster film, "abstracted and broken down the signs of the genre and questioned the preeminence of our gaze into the fiction. He has brought the fiction and its method to the foreground by first scattering before us the basic things to look at – the gangster, his girlfriend, car and gun – and at the same time not cutting those images into the patterns we expect to see."[54]

The changes wrought by Godard's use of the ruthless jump cut were significant, as the French New Wave style of personal filmmaking developed into a broader international style for the sound film that revitalized the role of the camera and montage, which had been subordinated by the studio films of the 1930s. The jump cut became an accepted technique of narrative ellipsis, and retains some of its power as a marker of "auteur innovation." A typical example is a scene from *The Royal Tenenbaums* (Wes Anderson, 2001) in which Richie Tenenbaum (Luke Wilson) cuts his hair and shaves his beard, before ultimately slashing his wrists in a suicidal moment.

Figure 2.16 Jump cut in Breathless *(Godard, 1960).* One of the most notable jump cuts in Godard's oeuvre shows a truck following Michel with the cops struggling to pass . . .

Source: Copyright 1960 Les Films Impéria.

Figure 2.17 Jump cut in Breathless *(Godard, 1960).* . . then cut to the same shot with the truck now out of the shot and the two cops following, creating a stop motion substitution effect that "pops" the truck out of frame as if by magic.

Source: Copyright 1960 Les Films Impéria.

See Critical Commons, "*The Royal Tenenbaums*: Temporal Ellipsis Measurable."[55] With the Elliott Smith song "Needle in the Hay" as a bed, Anderson presents 18 jump cuts of Richie looking into the bathroom mirror/camera as he removes his hair and beard. Anderson mixes shorter and longer shots to give the scene an odd, off balanced visual quality as Richie sheds his professional tennis player persona. One of the longer moments of elided action is between outgoing frame of shot A (Figure 2.18), Richie removing his armband, and the incoming frame of shot B (Figure 2.19), Richie reaching for his headband. Later, the scene moves very freely in time and includes short flashbacks to earlier scenes to creatively recapitulate the drama of the situation.

Notice that this type of jump cut does not exhaust the possibilities of the technique: a jump cut could use material from a single take and simply rearrange *time* so that some of the moments constitute measurable temporal *reversals* (Case 2). Or in rare cases the actor in the foreground can

Figure 2.18 Jump cut/Temporal Ellipsis Measureable in The Royal Tenenbaums *(Anderson, 2001).* In a disturbing scene from *The Royal Tenenbaums*, Anderson jump cuts a scene in which Richie Tenenbaum (Luke Wilson) shaves, cuts his hair and slashes his wrists. In the last frame of the outgoing shot A, Richie removes his armband.

Source: Copyright 2001 Buena Vista Pictures.

Figure 2.19 Jump cut/Temporal Ellipsis Measureable in The Royal Tenenbaums *(Anderson, 2001).* In the first frame of the incoming shot B, Richie reaches to remove his headband. The elided material is shown by the shots themselves, so the cut is a measurable temporal ellipsis.

Source: Copyright 2001 Buena Vista Pictures.

move continuously or appear static and continuous while the background changes time (and perhaps place). Even before CGI, Buster Keaton used this transition creatively as a sight gag in *Seven Chances* (Keaton, 1925). Here, Buster gets in his car, and the background scene changes from his house (Figure 2.20) to the house of his girlfriend (Figure 2.21): the background is Spatially Discontinuous Radical, Temporal Ellipsis Indefinite (Case 15). But in the foreground, Buster

Figure 2.20 A carry over dissolve in Seven Chances *(Keaton, 1925).* Even before CGI, Buster Keaton created dissolves where the background changes location and jumps forward in time – what Burch would call "Spatially Discontinuous Radical, Temporal Ellipsis Indefinite" – but the foreground appears continuous. The outgoing shot from *Seven Chances* takes us from Buster's house to . . .

Figure 2.21 A carry over dissolve in Seven Chances *(Keaton, 1925).* . . .his girlfriend's house, though in the foreground, Buster appears to remain seated in his car uninterrupted – he is Spatially and Temporally Continuous. This kind of transition where the background and the foreground are separated is called a "carry over dissolve."

Source: Copyright 1925 Metro-Goldwyn.

seated in his car appears to remain spatially and temporally continuous (Case 1). This transition is sometimes referred to as a "carry over dissolve," because the foreground "carries over" as the background changes scene.[56]

Returning now to Burch's matrix, in Case 5 the temporal ellipsis between shot A and shot B might be *indefinite*, as when the length of the abridgment "may cover an hour or a year."[57] Without trying to unpack all of the ambiguities in Burch's categories, suffice to say here that if we have only the vaguest sense of how much time has elapsed between the end of shot A and the beginning of shot B, we can classify that as an *indefinite temporal ellipsis*. Burch points out that the distinction between *measurable* and *indefinite* lie on a continuum, and that these distinctions are sometimes clear and sometimes muddy:

> The reader may object that the boundary between the "measurable" ellipsis and the "indefinite" ellipsis is not clear. Admittedly a segment of time abridged in the process of splicing together two shots showing someone walking through a door can be measured rather accurately – namely, as that part of the action that we know must be gone through but do not see, whereas we are less capable of measuring "the time it takes to climb five flights of stairs." However, "the time it takes to climb five flights of stairs" still constitutes a unit of measurement, much as "one candle power" is the amount of light furnished by one candle; this is not at all the case, on the other hand, when we realize that something is occurring "a few days later," as in an indefinite ellipsis.[58]

The Flashforward: A Relatively Rare Occurrence

Previously we identified a common use of the flashback in films like *Forrest Gump*: a character remembers an event and the film cuts back in time – temporal reversal — to show us past events. (That cut can be either a measurable or indefinite temporal reversal.) But how often do filmmakers use the *flashforward* – temporal ellipsis – to show us *future* events in cinema? This is rare because time as human beings experience it only moves forward. We do not ordinarily know the future, whereas we know the past easily, so motivating a *flashforward* within a narrative is difficult: the character must have special visionary powers or be in an altered state to see the future, or the filmmaker may want to show the character's imagination of the future. Two examples can clarify these distinctions.

In *Easy Rider* (Dennis Hopper, 1969) Wyatt (Peter Fonda) and Billy (Dennis Hopper) are two wandering motorcyclists who visit a brothel in New Orleans. While waiting for the women to arrive, Billy proceeds to get drunk. See Critical Commons, "Flash forward scene in Easy Rider."[59] As Wyatt looks around the antiquated room decorated with classic bronzes and marble (Figure 2.22), the camera tilts up to a faux plaque painted on a wall above him: "Death only closes a man's reputation and determines it as good or bad" (Figure 2.23). Hopper cuts to a very short aerial shot pulling away from of a fire beside a deserted road (Figure 2.24), then cuts back to Wyatt (Figure 2.25), who sighs pointedly and looks down, as if he has had a momentary thought. The aerial fire shot flashing quickly "into this space" is puzzling and inexplicable. But notice that the editing concentrates the motivation of the fire shot on Wyatt: he looks, the camera tilts to death plaque he reads, the fire shot is inserted, and *most importantly,* the editor *returns* to a close shot of Wyatt, whose sigh and downward reaction seals off the moment as Wyatt's thought. The return to Wyatt is classical editing, a visual "figure of speech" that simply would not have implied "this is Wyatt's thought" if the editor had returned from the fire shot with, say, a cut to Billy getting drunk nearby.

We only learn at the end of the film that this shot of the fire was actually Wyatt's premonition of his own death. Billy and Wyatt are both shot at the end of the film, and the closing scene repeats the aerial fire shot. Now we know that the aerial pull back is from Wyatt's wrecked motorcycle, engulfed in flames. The film's ending retroactively answers the puzzlement created earlier in the brothel. The search for freedom, the wanderlust that is driving this film, has led Wyatt to a premonition: perhaps death is the only escape from the constraints of this earth. Here, the flashforward is an irrational moment, a mental aberration that foreshadows his death at the end of the film. It's worth noting too that his "flash cut" style of editing – cutting short flashes into a scene – is common throughout the film as Hopper frequently uses short, back and forth, intercut shots of the outgoing and the incoming scene cued to the opening chords of a rock soundtrack for transitions.

One final use of the flashforward is worth noting. In *Sherlock Holmes* (Guy Ritchie, 2009) Holmes (Robert Downey, Jr.) is battling a large fighter named McMurdo in a bare-knuckle fight. After McMurdo spits on him, Holmes sets aside his emotions to plot how he will defeat his opponent, using his famous powers of deduction. Here the film uses the flashforward to illustrate a character planning for the future and imagining how that future might proceed. See Critical Commons, "Sherlock Holmes timeslice."[60]

Holmes is shown in close up, having just been spat upon, with McMurdo behind him in soft focus continuing to taunt him. Holmes thinks in voice over, "This mustn't register on an emotional level," a line followed by a speed shift to slow motion, and a whoosh in the soundtrack that suggests "time is slowing down" (Figure 2.26).

Holmes continues "thinking out loud" as the combat moves he plots are shown, their impact heightened by speed shifts that show fast and slow motion of key moments in the Holmes' plan of action. "First, distract target," Holmes "thinks" in a voice over as we see him – in slow motion – toss a white handkerchief into McMurdo's face. "Then block his blind jab," Holmes continues, as we cut on the action of him slapping the counterpunch downward. Holmes next imagines, "Counter with cross to left cheek," and we see a crushing blow to McMurdo's face, the flesh of his cheeks rippling in slow motion. "Discombobulate," Holmes thinks, and we see him clap his opponent's ears with both hands, like a percussionist crashing two cymbals together. Holmes' plotting continues in voice over, illustrated mostly in slow motion shots that occupy: 48 seconds of screen time.

Using deductive logic, Holmes plots out how to use the handkerchief and some well-calculated moves to take out his opponent. Ritchie presents the fight sequence twice: once as a flashforward while Holmes is mentally thinking through his attack, and then in real time as he executes it. The execution follows the plan precisely, and starts when he flicks the handkerchief in front of McMurdo to distract him. Now as the moves plotted earlier are replayed, Holmes moves in real time with exacting precision, his maneuvers executed with blinding speed: now it takes only :09 seconds of screen time for the execution of the moves versus the :48 seconds of screen time used earlier to show Holmes thinking through the plan. With McMurdo lying crushed on the ground, the onlookers are stunned, and one of them muses, "Where did that come from?" as Holmes stoops to pick up the handkerchief.

Using editing to advance the narrative is common, as we have seen: tightening the action, eliminating the superfluous through ellipsis is common practice for editors. But a flashforward where plot events that will take place in the future are shown is rarely called upon, except in extraordinary circumstances: as we have seen here, where a character foresees the future or a character wants to plot his future actions as an illustration of the methodical nature of his mental powers.

Figure 2.22 Flashforward/premonition in Easy Rider *(Hopper, 1969).* In Easy Rider, Wyatt (Peter Fonda) visits a brothel in New Orleans with Billy (Dennis Hopper). While waiting for the women to arrive, Wyatt looks around the room.

Source: Copyright 1969 Columbia Pictures.

Figure 2.23 Flashforward/premonition in Easy Rider *(Hopper, 1969).* As he looks up, the camera tilts up to a faux plaque painted on a wall above him: "Death only closes a man's reputation and determines it as good or bad."

Source: Copyright 1969 Columbia Pictures.

Figure 2.24 Flashforward/premonition in Easy Rider *(Hopper, 1969).* The film cuts to a very short aerial shot pulling away from a fire beside a deserted road.

Figure 2.25 Flashforward/premonition in Easy Rider *(Hopper, 1969).* The film then cuts back to Wyatt, who sighs pointedly and looks down. We only learn at the end of the film that this shot of the fire was actually Wyatt's premonition of his own death. Billy and Wyatt are both shot at the end of the film, and the closing scene repeats the aerial fire shot. The film's ending retroactively answers the puzzlement created earlier in the brothel by cutting to the aerial fire shot.

Figure 2.26 Flashforward/thinking ahead in Sherlock Holmes *(Ritchie, 2009).* During a fight, Holmes
begins to think logically about how he can defeat his opponent. In a voice over, he thinks aloud,
"This mustn't register on an emotional level," the line followed by a speed shift to slow motion,
and a whooshing soundtrack that suggests "time is slowing down." Holmes continues "thinking
out loud" as we see the combat moves he plots.

Source: Copyright 2009 Warner Bros. Pictures.

The Spatial Axis: Spatial Relations between Outgoing Shot A and Incoming Shot B

When we cut from one shot to the next, Burch describes three possibilities for the way the space
in shot A relates to the space in shot B: the space is continuous (Spatial Continuity), or the space
is discontinuous, a broader case that he further subdivides into Spatially Discontinuous Measur-
able or Spatially Discontinuous Indefinite. Spatial Continuity (Cases 1–5) is commonplace in
continuity editing. In so-called *analytical editing*, space is shown first in a wider shot and then
broken down into smaller parts or "analyzed." The phrase "long shot, medium shot, close up, re-
establish" describes a process of moving into a scene with closer shots, and re-establishing with a
long shot when the need arises, say when a character crosses to another area in the scene. In this
traditional approach, the filmmaker provides an establishing shot that shows the spatial position
of all the relevant elements of a scene and then cuts into portions of the space – i.e., closer shots
of the action, allowing the viewer to remain spatially oriented as the scene progresses. For Cases
1–5, Burch identifies spatial continuity as a case wherein "the same fragment of space fully or
partially seen in shot A is also visible in shot B."[61] In short, the sole requirement for these cases is
that some of the space in the outgoing shot A overlaps in shot B.

Shot/reverse shot is a common editing technique that provides an opportunity to compare
Burch's notion of spatial continuity and spatial discontinuity. David Bordwell and Kristin Thomp-
son define *shot/reverse shot* as "Two or more shots edited together that alternate characters, typi-
cally in a conversation. In *continuity editing*, characters in one framing usually look left; in the
other framing, right. Over-the-shoulder framings are common in shot/reverse shot editing."[62]
Notice that this is the same editing convention that we described in the previous chapter using the
term *converging index vectors* (see Chapter 1, p. 24). Notice further that their definition of shot/
reverse shot includes over-the-shoulder shots as the paradigmatic case. Here, the camera is placed
close to the axis of action: two characters face each other and the camera moves close to the 180°
line. Since over-the-shoulder shots contain the speaker *and* the listener in each shot, alternating

these shots produces Case 1 of Burch's matrix: the outgoing shot A overlaps the space of shot B by its very nature, producing a series of shots that are spatially continuous, temporally continuous.

But what would it take for these shot/reverse shots to be not *spatially continuous* but *spatially discontinuous proximate* but under Burch's matrix? That is, the space shown in outgoing shot A is *discrete but near the space of incoming shot B*? The typical case using shot/reverse shot would be to alternate *singles or close ups* of the characters speaking. Spatial discontinuity broadly covers cases where shot A and shot B show none of the same space. In some instances where there is no overlap in space, we know from the establishing shot, from similar visual material included in each shot's background, and from the eye-lines of the characters that these spaces are close to each other or *spatially proximate.*

Just as he divided ellipsis and reversal into subtypes, Burch subdivides spatial *discontinuity* between two shots into *proximite* and *radical* spatial discontinuity.[63] In other words, while cutting between two shots that contain no matching space, we may still recognize the two spaces as close or proximate to each other: i.e., the shots show different ends of the same train car. Conversely, while cutting between two shots that contain no matching space, we may recognize the two spaces as radically discontinuous spaces: i.e., one shots shows the beach and the next shows the mountains. *Crosscutting or parallel editing* – defined as "Editing that alternates shots of two or more lines of action occurring in different places, usually simultaneously"[64] – is the paradigmatic case of shots that are radically discontinuous spatially. See Critical Commons, "Parallel editing in *The Godfather*."[65] In the baptism scene from *The Godfather* (Francis Ford Coppola, 1972) Michael Corleone (Al Pacino) is serving as the godfather in the baptism of his sister's newborn son. Coppola cuts from the church to spatially discontinuous radical locations around the city – a barber shop, a hotel, a flower show, the steps of a large building – as assassins execute five Mafia bosses. This scene is rightfully among the most famous scenes in the history of film editing because it is a scene that is "hitting on all cylinders:" it conveys the suspense of the murders, along with the religious overtones, the ceremonial irony, and the interior conflict of Michael Corleone's conversion to a Mafia don using rich cinematography, precisely paced editing and rising organ flourishes that underscore the unfolding drama. Here, if we consider the scene's *spatial parameters alone*, crosscutting is an opportunity for the editor to narrate omnisciently, to see the impact of Michael's decision to take power in the family across five locations: the editors establish a "home base" for the scene by opening in the church, then move to shots with "complete and radical spatial discontinuity," showing how Michael Corleone can serenely exercise his new power "remotely" across different, distant spaces. A single cut from the church to one of the assassinations or the reverse, a cut from one of the assassinations (Figure 2.27) back to the church (Figure 2.28) is thus, in Burch's classification scheme, Case 11 Spatially Discontinuous Radical, Temporally Continuous.

Because of its potential to advance multiple plot lines and create suspense, crosscutting was one of the editing techniques quickly adopted in early motion picture history. Eileen Bowser has given a thorough account of how the technique and the terminology to describe it evolved in the early years of cinema, under such terms as "alternate scenes" and "the cut back."[66] D. W. Griffith's use of crosscutting to create "the last minute rescue" – often used in melodramas to show the hero arriving to rescue a female character – is of particular interest in this period. It became his signature technique to resolve the ending of many of his films, allowing Griffith to accelerate the narrative by using shorter and shorter shots as the rescue converges to both increase the visual rhythm of the scene and add to the scene's suspense. This particular use of crosscutting helped clarify editing conventions in the early period, for as André Gaudreault has pointed out, the last minute rescue offered precise spatial and temporal parameters that needed articulation:

> For parallel editing (one of the most important narrative devices of cinema) to become systematic, emphasis had to be placed on the physical separation of two conflicting groups converging towards a single place at a single moment.[67]

Figure 2.27 Crosscutting in The Godfather *(Coppola, 1972).* Crosscutting is common in narrative
films, beginning in the early 1900s. In the baptism scene from *The Godfather*, Michael
Corleone (Al Pacino) is serving as the godfather in the baptism of his sister's newborn
son while assassins execute five Mafia bosses on his orders. Crosscuttting conveys the
suspense of the murders, along with the religious overtones, the ceremonial irony, and the
interior conflict of Michael Corleone's conversion to a Mafia don. A single cut from one
of the assassinations . . .

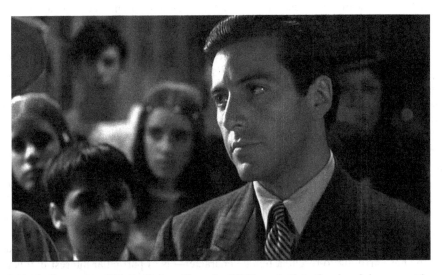

Figure 2.28 Crosscutting in The Godfather *(Coppola, 1972).* . . .back to the church is crosscutting, which
in Burch's classification scheme is Case 11 Spatially Discontinuous Radical, Temporally
Continuous.

Source: Copyright 1972 Paramount Pictures.

Filmmakers like Griffith would use the potential of film editing inherent in techniques like
crosscutting to eradicate early cinema's Primitive Mode of Representation. The "presentational-
ism" of early cinema – a style of filmmaking that directly addressed the audience, and used theat-
rical conventions with little attempt at realism – would soon be replaced by a system of temporal

and spatial articulation that would come to dominate film language around the world, the classical continuity editing of the Institutional Mode of Representation.

Applying Burch's Matrix to Welles and Scorsese

Burch's matrix is a classification scheme, and for editors, it provides one "lens" we can use to examine particular edits and think carefully about how they articulate the space and time of a particular film. The method has limitations. As Burch himself noted, difficulties sometimes arise in trying to differentiate a *measureable* versus an *indefinite* temporal reversal or temporal ellipsis, a *proximate* or *indefinite* spatial discontinuity. Other times, the classification of a cut is easy. It is often apparent how to classify a particular cut because the filmmaker is applying classic Hollywood transitions like dissolves to mark specific time/space relationships. At the same time, film editing has continued to push traditional boundaries for articulating time/space relationships, creating new cinematic methods for telling stories. If we look briefly at a few examples from Orson Welles' *Citizen Kane* (1941) and Martin Scorsese's *Goodfellas* (1990) – the former a Hollywood classic and the latter growing out of Scorsese's "New Hollywood" sensibility – we can see some of the potentials and limitations in Burch's classification scheme. As we shall see, each film uses the editing conventions of its era creatively. We would expect as much from directors of the caliber of Welles and Scorsese.

The breakfast table scene in *Citizen Kane* opens with Jedediah Leland (Joseph Cotten) recounting some of the details of Charles Foster Kane's (Orson Welles) first marriage to the reporter Thompson (William Alland). See Critical Commons, "*Citizen Kane* (Welles, 1941) – The Breakfast Table."[68] As Leland is summarizing for the reporter, "Well, after the first couple of months, she and Charlie didn't see much of each other except at breakfast. It was a marriage, just like any other marriage," the scene dissolves to Kane's breakfast room. This transition can be classified as spatially discontinuous radical, temporal reversal indefinite or Case 13 in Burch's matrix. In a dissolve, the outgoing image is faded out as the incoming is faded in. According to Frank Beaver,

> In traditional filmmaking, the dissolve came to be the accepted technique for indicating substantial geographic leaps from one place to another, passage of time from one scene to the next, or passage of time within the scene itself . . . The dissolve separates units of action by adding a note of finality to what has gone before and by offering a momentary pause in the action flow.[69]

Here, Welles takes advantage of the creative contribution of Linwood Dunn, RKO's optical printing artist, to use a more creative dissolve where the foreground character Leland is separated or matted out of the background so that he "hangs" longer in the dissolve (Figure 2.29) than the background.[70]

The incoming wide shot pushes into a tighter two-shot of Kane and Emily Norton (Ruth Warrick) seated at the table, a camera move that will be repeated to give the scene a symmetrical, formal structure when the camera pulls back at the end of the scene. This is an example of Burch's Case 13 Spatially Discontinous Radical, Temporal Reversal Indefinite. Once within the breakfast scene, the marriage is shown in a series of vignettes that mark its progression from "young lovers" to "estranged elderly couple." A pattern quickly emerges. A short dialogue vignette that encapsulates the current state of their marriage is shown in single shots (as opposed to over-the-shoulder shots). Medium close-up singles of Charles and Emily seated at either end of the table create a series of shot/reverse shots that can be classified as Burch's Case 6: *Spatially Discontinuous Proximate*, and *Temporally Continuous* since the dialogue within the vignette is unbroken. Each vignette is carefully underscored with music that changes from whimsical to darker and darker as their marriage deteriorates.

Figure 2.29 Flashback to the breakfast scene in Citizen Kane *(Welles, 1941).* As Jedediah Leland (Joseph
Cotten), recounts some of the details of Charles Foster Kane's first marriage to the reporter
Thompson, the scene dissolves to Kane's breakfast room. This transition can be classified as
spatially discontinuous radical, temporal reversal indefinite or Case 13 in Burch's matrix.

Source: Copyright 1941 RKO Radio Pictures.

Between these vignettes, Welles "dissolves" to mark the temporal ellipsis, but once again,
chooses a special optical effect to mark the transition. Here, the outgoing shot A fades to black
and the incoming shot B fades in – what is commonly called "kissing black" in live television
directing – and over this fade out/fade in transition, Welles superimposes a swish pan that appears
to be shot in the breakfast room, a series of windows passing by in blurred frames (Figures 2.30
and 2.31).

The super imposition here means that the swish pan is printed at half its value so it appears
in a translucent layer on top of the other two shots, making the transition more visible and more
expressive of the notion "ellipsis." Welles uses these "punctuated dissolves" between dialogue
vignettes to clearly mark the incoming scene spatially as *discontinuous proximate*. Since each
outgoing vignette ends with a single of Charles speaking and each incoming vignette begins with
a single of Emily speaking, there is no spatial overlap, only *proximity*, since we know from the
initial wide shot that they sit at opposite ends of the table. The time relationship between these
dialogue vignettes is punctuated by the swish pan as *Temporal Ellipsis Indefinite*, even though
we have a general sense of their age and the stage of their marriage in each vignette. Since Burch
wants to reserve the term *Temporal Ellipsis Measureable* for instances where the visual images
themselves reveal the amount of time elided, if a shot change is not absolutely *measureable*, it
should be called *indefinite*.

Martin Scorsese is a director known for innovative storytelling techniques, many of which
grow out of his creative use of editing. *Goodfellas* (Scorsese, 1990) tells the tale of Henry Hill
(Ray Liotta) who grows up in New York City, advancing from petty crimes to major thefts, as
he becomes a "wiseguy" in the inner circle of the Mafia. As the protagonist, Hill tells much of
his story in voice over, and Scorsese uses a freeze frame in one scene to stop the film's forward

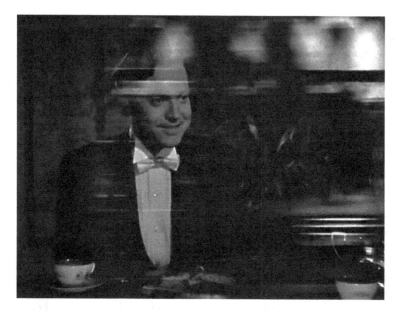

Figure 2.30 Temporal ellipsis within the breakfast scene in Citizen Kane *(Welles, 1941).* Within the break-
fast scene, short dialogue vignettes that encapsulate the stages of Kane's marriage are joined by
special "punctuated dissolves" that take us to the next scene. Here, one scene ends with a fade
out on Kane with a swish pan supered over it . . .

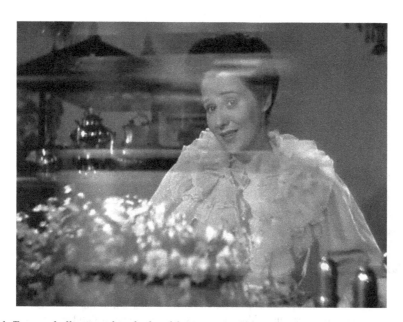

Figure 2.31 Temporal ellipsis within the breakfast scene in Citizen Kane *(Welles, 1941).* . . .and fades in
on Emily as the swish pan fades out. These "punctuated dissolves" between dialogue vignettes
clearly mark the incoming scene as temporal ellipsis indefinite. Spatially, each outgoing
vignette ends with a single of Charles speaking and each incoming vignette begins with a single
of Emily speaking, so there is no spatial overlap, only proximity.

motion while Henry offers insight into the Mafia's inner workings. See Critical Commons, "Freeze Frame in *Goodfellas* like 'thought tracking' in theatre."[71] The scene comes shortly after a group led by Jimmy Conway (Robert De Niro) executes a successful $6 million heist of the Lufthansa. Jimmy begins to worry that some of the members of the group are flaunting their new found wealth, particularly Morrie (Chuck Low). Walking down the street with Henry, Jimmy asks a simple question: "Do you think Morrie tells his wife everything?" Henry answers "Morrie, him?" Then the film cuts to a freeze frame of the pair midstride, and Henry comments in voice over, "That's when I knew Jimmy was going to whack Morrie. That's how it happens. That's how fast it takes for a guy to get whacked." (Figure 2.32) When the freeze frame is released, Henry continues his conversation with Jimmy, "You know him. He's a nut job. He talks to everybody."

The freeze frame has been used expressively at least since *Hollywood* (James Cruze, 1923)[72], and in the 1960s became something of a clichéd way to end a film, asking the audience to contemplate the film's theme or the final moment of the character's existence. Freeze frame endings are found in *400 Blows* (François Truffaut, 1959), *Butch Cassidy and the Sundance Kid* (George Roy Hill, 1969), and *The Color of Money* (Scorsese, 1986) and in the *Seinfeld* television series. Here, however, the freeze frame mirrors a theatre convention called "thought tracking," where characters in theatre freeze and one or more characters reveal their inner thoughts, allowing the audience insight into hidden meanings that underlie the moment. How would this edit be classified under Burch's scheme? Clearly, the freeze frame is *Spatially Continuous*. But once held, does the time of that moment represent "the present, a paused moment of recognition that Morrie will be whacked" or does it become a "past moment" as time moves forward? Because it is not a typical continuity edit, it is difficult to classify: if the former, it is Case 1 Spatially Continuous, Temporally Continuous and if the later, Case 2 Spatially Continuous, Temporal Reversal Measureable. The roughly :07 seconds that the freeze frame is held becomes a past moment with the measure of the reversal indicated by the cut itself.

Figure 2.32 Freeze frame in Goodfellas *(Scorsese, 1990) is like "thought tracking" in theatre.* Walking down the street with Henry Hill, Jimmy Conway asks a simple question: "Do you think Morrie tells his wife everything?" Scorsese uses a freeze frame to stop the film's forward motion while Henry Hill offers insight into the Mafia's inner workings: "That's when I knew Jimmy was going to whack Morrie. That's how it happens. That's how fast it takes for a guy to get whacked." Here, the freeze frame mirrors a theatre convention called "thought tracking," where characters in theatre freeze and one or more characters reveal their inner thoughts, allowing the audience insight into hidden meanings that underlie the moment.

Later in the film, Scorsese shows a complete "day in the life" of Henry Hill, identifying the scene as it opens with a title, "Sunday, May 11th, 1980." Henry is struggling with lack of sleep and paranoia from his cocaine addiction while trafficking the drug and trying to keep his family life together. Henry sees a helicopter in the sky throughout the day, and thinks it's following him. In the evening, he visits his girlfriend and tricks her into giving him some cocaine. See Critical Commons, "*Goodfellas*: Jump Cut and Temporal Ellipsis Measurable."[73] The scene opens with Henry snorting cocaine, and the camera crash zooms into a close up as the drug rushes into his system and he blinks, trying to maintain his composure. In the next shot, the camera is pushing in towards Henry and his mistress as she wraps and tapes up packages of cocaine. She asks him, "What do you think, you can just come over here and fuck me and leave? Huh? You got somewhere else better to be?" As Henry tries to placate her, the film jump cuts closer, as the camera moves still tighter. This cut is a traditional jump cut, Case 4 Spatially Continuous, Temporal Ellipsis Measurable: across the cut, the space is matched, and we can see the amount of time elided. The scene ends with two quick pans, one to cover Henry as he grabs the drugs she has packed and runs out the door, and then quickly back to her as she curses him and throws a bag of cocaine at the door. A quick cut back to the door shows the drugs hit the door and explode: Case 6 Spatially Discontinuous Proximate, Temporally Continuous, as the camera shows opposite ends of the line of action in separate shots.

From the explosion of drugs, we cut to a half eaten bowl of pasta, as the camera pulls back to reveal Henry's family dinner ending, the table covered in wine glasses and dirty dishes from the feast. Here, the editors return to a motif that carries throughout the "day in the life" of Henry Hill: they super a title "10:45pm" to mark exactly the temporality of the incoming shot (Figure 2.33). This cut is an example of Burch's Case 14 Spatially Discontinuous Radical, Temporal Ellipsis Measurable as we move from late evening at Henry's girlfriend's place to a specific time at the birthday party Henry is throwing for his son. Scorsese wants the audience to know the precise time of the incoming scene to emphasize the long, frantic day Henry has had, and to keep the drama of the "ticking clock" advancing, as the deadline for his drug courier/babysitter approaches to deliver a shipment. Identifying the measurable temporal ellipses throughout the scene "Sunday, May 11th, 1980" with titles specifying the time of day temporalizes the pressure Henry is under from the demands of his drug fueled life, enhancing the edgy feeling driving Henry's addiction.

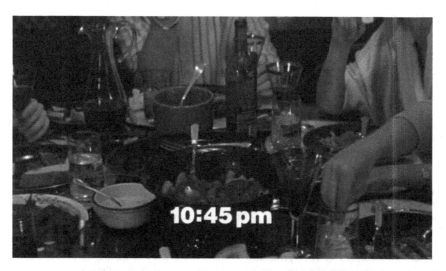

Figure 2.33 Temporal ellipsis in Goodfellas: *10:45 pm*. Scorsese specifies the time of day for this cut to precisely temporalize the pressure Henry is under from the demands of his drug fueled life.

Conclusion

Noël Burch's scholarship in film history and theory has contributed significantly to our understanding of how space and time are articulated in motion pictures. His writings on the Primitive Mode of Representation shifted our understanding of how early films signified, and how their filmic language would evolve into the Institutional Mode of Representation. Burch's work was part of a significant rethinking of how silent filmmakers addressed their audiences, and how they created meaning using a wholly different mode of spatial/temporal organization.

Moreover, Burch's formalism – his interest in setting aside narrative to exploring the formal qualities of motion pictures – provided some fundamental insights into how time and space are communicated through editing. Burch later disavowed his formalist approach in the 1980 edition of *Theory of film practice.* He came to see formalism as "narrow and incomplete," and a "flight from meaning." Burch goes so far as to say, "Although I regard the first chapter of this book as in many ways the most seminal of all, the rather solemn pronouncement that there are 15 types of spatio-temporal shot-association is assuredly one of the most useless pieces of information about film-making that has ever been set forth in print."[74] And yet Burch acknowledged that his book still had a positive effect. It "pulled focus" from what the average film viewer of Hollywood style narratives ordinarily keeps in focus – namely, the illusory narrative world we immerse ourselves in – to what is ordinarily *invisible* – the contribution of stylistic element like camera, lighting, editing, sound design. Despite his denial, Noël Burch's "spatial and temporal articulations" remain a useful tool for editors to classify cuts, and in the process, clarify their understanding of how space and time can be organized across a cut. Even if there are many edits that cannot be easily classified using Burch's scheme, the matrix he proposes forces us to recognize different ways in which editors manipulate time and space across a cut, and to carefully consider how those fluctuations of time and space impact the viewer. It remains a simple but insightful way to interrogate how an edit works spatially and temporally.

Notes

1 "Film Styles and Conventions Used by Filmmakers." Accessed January 14, 2017. http://www.cinemateca.org/film/film_styles.htm.

2 For a complete, engaging and nuanced account of the development of film style see David Bordwell, *On the history of film style* (Cambridge, MA: Harvard University Press, 2015).

3 Ibid., 13–20.

4 Noël Burch and Ben Brewster, *Life to those shadows* (Berkeley: University of California Press, 1990), 245, my emphasis.

5 Noël Burch enumerates some of this "cultural underbrush" as follows: "[T]he aggregate of folk art kept alive by the urban working classes in Europe and the United States at the turn of the century. These comprise both modes of representation and narrative or gestural material deriving from melodrama, vaudeville, pantomime (in England), conjuring, music hall and circus; from caricatures, the 'penny plain, tuppence coloured' sheets, strip cartoons; from magic lantern shows in the home, the street and the theatre; from street entertainers, fairground acts, waxwork shows." Noël Burch, "Porter, or Ambivalence," *Screen* 19(4): (1978–1979) 93.

6 David Bordwell and Kristin Thompson, *Film art: an introduction* (New York: The McGraw-Hill Companies, 2017), 230.

7 Eileen Bowser, in her authoritative survey *The transformation of cinema, 1907–1915,* points out that the term "feature" was an imprecise term in its early usage. "When the 'feature film' was first marketed, it meant a special film, a film with something that could be featured in advertising as something out of the ordinary run. It was not just another sausage." Eileen Bowser, *The transformation of cinema, 1907–1915* (New York: Scribner, 1990), 192.

8 Tableaux can describe either "a picturesque grouping of persons or objects," dictionary.com or "a group of models or motionless figures representing a scene from a story or from history," oxforddictionaries.com which is more specifically a *tableau vivant.* Filmmakers use both in the silent period.

9 Noël Burch, "Porter, or Ambivalence," *Screen* 19(4) (1978–1979): 93.

10 Noël Burch and Ben Brewster, *Life to those shadows* (Berkeley: University of California Press, 1990), 154.

11 Ibid., 155.

12 Ibid., 154.

13 Charles Musser, *Before the Nickelodeon: Edwin S. Porter and the Edison Manufacturing Company* (Berkeley: University of California Press, 1991), 103.

14 Charles Musser, *Emergence of cinema: the American screen to 1907* (New York: Scribner, 1990), 179.

15 Ibid., 315.

16 The film *Jack and the Beanstalk* is available at https://www.loc.gov/item/00694228/. "Because the copyright law did not cover motion pictures until 1912, early film producers who desired protection for their work sent paper contact prints of their motion pictures to the U.S. Copyright Office at the Library of Congress. These paper prints were made using light-sensitive paper the same width and length as the film itself, and developed as though a still photograph. Some motion picture companies, such as the Edison Company and the Biograph Company, submitted entire motion pictures – frame by frame – as paper prints. Other producers submitted only illustrative sequences." Library of Congress, "The Paper Print Film Collection at the Library of Congress." Accessed February 29, 2016. https://www.loc.gov/collections/spanish-american-war-in-motion-pictures/articles-and-essays/the-paper-print-film-collection-at-the-library-of-congress/.

17 Charles Musser, *Emergence of cinema: the American screen to 1907* (New York: Scribner, 1990), 325.

18 *Jack and the Beanstalk*. Library of Congress. Accessed February 23, 2016. https://www.loc.gov/item/00694228.

19 *Jack and the Beanstalk*. Library of Congress. Accessed February 23, 2016. https://www.loc.gov/item/00694228.

20 Charles Musser, *Before the Nickelodeon: Edwin S. Porter and the Edison Manufacturing Company* (Berkeley: University of California Press, 1991), 205.

21 Ibid., 212.

22 In the PMR, the placement and shape of the iris suggests he is dreaming, a kind of graphic depiction of his dream that shows simultaneity and distance. In the IMR, a number of tropes evolved to show a character's dreaming, one central element almost universally included would be a close up or a push into the character with his or her eyes closed in the outgoing shot.

23 The Edison catalog describes the shot change here as a dissolve, but it is actually the kind of rapid fade to black, fade in, that is common in live television when directors "kiss black."

24 *Life of an American Fireman*. Accessed September 8, 2017. http://www.afi.com/members/Catalog/AbbrView.aspx?s=&Movie=31950. Eight firemen exit using the top of the pole, but in the next shot only six are shown descending to the bottom. Musser points out that shot 4 is staged outside on grass.

25 Charles Musser, *Before the Nickelodeon: Edwin S. Porter and the Edison Manufacturing Company* (Berkeley: University of California Press, 1991), 224–225, my emphasis.

26 See "Life of an American Fireman in Film History," Charles Musser, *Before the Nickelodeon: Edwin S. Porter and the Edison Manufacturing Company* (Berkeley: University of California Press, 1991) 230–235. All of the shots of *Fireman* herein are analyzed using the original paper print that was deposited for copyright purposes at the Library of Congress.

27 The clip, "*Life of an American Fireman* (1903) – The rescue," is on Critical Commons at http://www.criticalcommons.org/Members/kfortmueller/clips/life-of-an-american-fireman-1903-the-rescue.

28 Noël Burch and Ben Brewster, *Life to those shadows* (Berkeley: University of California Press, 1990), 189.

29 Noël Burch, "Porter, or Ambivalence," *Screen* 19(4) (1978–1979): 104, my emphasis.

30 Charles Musser, *Before the Nickelodeon: Edwin S. Porter and the Edison Manufacturing Company* (Berkeley: University of California Press, 1991), 226.

31 Eileen Bowser, *The transformation of cinema, 1907–1915* (New York: Scribner, 1990), 53–54.

32 Charles Musser has documented that, while a number of narrative strategies persisted from early motion pictures, by 1907 new forms of narrative editing were emerging: the lecturer continued to explain many films' stories, as intertitles became more common, and innovative Porter films like *College Chums* toured with live actors voicing the parts from behind the screen.

33 Eileen Bowser, *The transformation of cinema, 1907–1915* (New York: Scribner, 1990), 57.

34 The film *The Lonely Villa* (1909) is on Critical Commons at http://www.criticalcommons.org/Members/kfortmueller/clips/the-lonely-villa-1909.

35 Charles Musser, *Before the Nickelodeon: Edwin S. Porter and the Edison Manufacturing Company* (Berkeley: University of California Press, 1991), 139, my emphasis.

36 "Haus.0, Interview with Noël Burch, Mai 2002." Accessed March 7, 2016. http://www.haussite.net/set.php?page=http://www.haussite.net/haus.0/PROGRAM/02/redirect/D/burch_inter_D.html.

37 David Bordwell, *On the history of film style*, (Cambridge, MA: Harvard University Press, 2015), 90.

38 Noël Burch, *Theory of film practice* (New York: Praeger, 1973), 3–4, my emphasis.

39 Charles Musser identifies a flashback in a Selig Polyscope picture *When We Were Boys* from 1907 in *Emergence of cinema: the American screen to 1907* (New York: Scribner, 1990), 478.

40 The clip, "*Mission Impossible 2*: Temporal Reversal Measurable, Overlapping Edit," is on Critical Commons at http://www.criticalcommons.org/Members/m_friers/clips/mission-impossible-2-temporal-reversal-measurable.

41 The clip, "*Iron Man*: Flashback, Measurable Temporal Reversal," is on Critical Commons at http://www.criticalcommons.org/Members/m_friers/clips/iron-man-flashback-measurable-temporal-reversal.

42 The clip, "Flash back in *Forrest Gump*," is on Critical Commons at http://www.criticalcommons.org/Members/m_friers/clips/flash-back-in-forrest-gump.

43 If we wanted to apply a term from literature, we could further qualify it as an *external analepsis* or *external flashback*: that is, external to the plot of the film as it has unfolded to this point.

44 This is analogous to adopting the convention that we will call shots "subjective," only when a character explicitly addresses the camera and looks into the lens, and camera placements that duplicate the point of view of a character but do not show other characters looking directly into the lens "subjective placement."

45 "'flashback, n." OED Online. Oxford University Press. http://www.oed.com/view/Entry/71139?rskey=krbAx9&result=3 (accessed May 23, 2016).

46 Ira Konigsberg, *The complete film dictionary* (London: Penguin, 1999), 176.

47 Frank Beaver, *Dictionary of film terms: the aesthetic companion to film art*, 4th edn (New York: Peter Lang New York, 2015), 152.

48 Barry Salt, *Film style and technology: history and analysis* (London: Starword, 2009), 107.

49 Ibid., 267.

50 Arlene Croce, "Breathless," *Film Quarterly* 14(3)(1961): 54–56. doi:10.2307/1210076.

51 The clip, "*Breathless* (*À boute de souffle*): Jump cuts, Measurable Temporal Ellipsis" is on Critical Commons at http://www.criticalcommons.org/Members/m_friers/clips/breathless-a-boute-de-souffle-jump-cuts-measurable.

52 Robert Phillip Kolker, *The altering eye: contemporary international cinema* (Cambridge, UK: Open Book Publishers, 2009), 129.

53 Richard Brody, *Everything is cinema: the working life of Jean-Luc Godard* (New York: Holt Paperback, 2009), 68.

54 Robert Phillip Kolker, *The altering eye: contemporary international cinema* (Cambridge, UK: Open Book Publishers, 2009), 129.

55 The clip, "*The Royal Tenenbaums*: Temporal Ellipsis Measurable," is on Critical Commons at http://www.criticalcommons.org/Members/m_friers/clips/the-royal-tenenbaums-temporal-ellipsis-measurable.

56 See Michael Frierson, "The Carry Over Dissolve in UPA Animation," *Animation Journal* 10 (2002): 50–66 and N. Roy Clifton, *The figure in film* (Newark: University of Delaware Press, 1983).

57 Ibid., 6.

58 Ibid., 7.

59 The clip, "Flash forward scene in Easy Rider," is on Critical Commons at http://www.criticalcommons.org/Members/m_friers/clips/flash-forward-in-easy-rider.

60 The clip, "*Sherlock Holmes* timeslice" is on Critical Commons at http://www.criticalcommons.org/Members/ccManager/clips/SHERLOCK_HOLMES_timeSlice.mov.

61 Noël Burch, *Theory of film practice* (New York: Praeger, 1973), 9.

62 David Bordwell and Kristin Thompson, *Film art: an introduction* (New York: The McGraw-Hill Companies, 2017), G-5

63 Noël Burch, *Theory of film practice* (New York: Praeger, 1973), 9.

64 David Bordwell and Kristin Thompson, *Film art: an introduction* (New York: The McGraw-Hill Companies, 2017), G-1.

65 The clip, "Parallel editing in *The Godfather*," is on Critical Commons at http://www.criticalcommons.org/Members/ogaycken/clips/godfather.mp4.

66 Eileen Bowser, *The transformation of cinema, 1907–1915* (New York: Scribner, 1990), 58–61.

67 André Gaudreault, "Temporality and Narrativity in Early Cinema, 1895–1908," in John L. Fell, *Film before Griffith* (Berkeley: University of California Press, 1983), 327.

68 The clip, "*Citizen Kane* (Welles, 1941) – The Breakfast Table," is on Critical Commons at http://www.criticalcommons.org/Members/dsbaldwin32/clips/citizen-kane-welles-1941-2014-the-breakfast-table.

69 Frank Beaver, *Dictionary of film terms: the aesthetic companion to film art*, 5th edn (New York: Peter Lang, 2015), 87.

70 See Robert L. Carringer's *The Making of Citizen Kane* (Berkeley, California: University of California Press, 1985) for a discussion of the creative contributions that Linwood Dunn made to the film using the

optical printer, a projector/camera device that allowed film images to be composited in postproduction. Dunn was the head of special effects at RKO Radio Pictures and the developer of the first commercially available optical printer.

71 The clip, "Freeze Frame in *Goodfellas* like 'thought tracking' in theatre," is on Critical Commons at http:// www.criticalcommons.org/Members/m_friers/clips/freeze-frame-that-mirrors-thought-tracking-in/ video_view.

72 Barry Salt, *Film style and technology: history and analysis* (London: Starword, 2009), 169.

73 The clip, "*Goodfellas*: Jump Cut and Temporal Ellipsis Measurable," is on Critical Commons at http://www.criticalcommons.org/Members/m_friers/clips/goodfellas-jump-cut-and-temporal-ellipsis.

74 Noël Burch, *Theory of film practice* (New York: Praeger, 1973), ix.

3 Hollywood Theorists: Edward Dmytryk and Walter Murch

Editing theories have been advanced not just by academics, but also by Hollywood editors, working professionals whose immersion in the art and craft of editing led them to write significant tracts offering their insights on how editing "works." Edward Dmytryk and Walter Murch are two such theorists. Between them, they have edited 46 feature length films, television films or shorts. Dmytryk went on to direct 55 features, including *Crossfire* (Dmytryk, 1954), which was nominated for an Academy Award. Murch has won three Academy Awards, one for Best Editing *The English Patient* (Minghella, 1996) and two for Best Sound, *The English Patient* and *Apocalypse Now* (Coppola, 1979). Their immersion in the practice of editing gives their writings credence, and they focus on specific practices gleaned from their years in the profession.

Edward Dmytryk

Born in Canada, the son of immigrants from Ukraine, Edward moved with his father to Los Angeles after his mother died. His father beat him, and Edward frequently ran away from home, so the local juvenile authorities found him a job working as a messenger at Famous Players-Lasky and allowed him to live on his own by age 15. He later worked as a projectionist and moved to the editorial department in 1929. He edited a number of unremarkable features, but by the late forties had moved to directing significant features like *The Caine Mutiny* (Dmytryk, 1949). He was a leftist and joined the Communist Party U.S.A. during World War II, and was later called before the House Un-American Activities Committee (HUAC). First refusing to cooperate, Dmytryk was jailed as one of the "Hollywood 10," but after spending a few months in jail, reversed his decision, went before HUAC and identified people he said were communists. Dmytryk's action changed the course of his career, as many in Hollywood never forgave him for "naming names." He moved to an academic position at University of Texas Austin from 1976–1981, teaching film theory and filmmaking, and later was the chair of the filmmaking program at USC from 1981–1997. He authored several books on film, including *On film editing: an introduction to the art of film construction* (Boston: Focal Press, 1984).

Given his career track, it is not surprising that *On film editing* is a very practical work, and offers insight on industry practices of his era, like the differences of cutting film on Moviolas versus flatbed editors. Dmytryk talks about the special relationship that develops between director and editor, and how the editor should negotiate the editorial demands of talented directors and incompetent hacks alike. He writes about the need for smooth, invisible continuity cutting, and how directors work on set to provide the material to make this possible, often by using master takes, i.e., filming a single long take of an entire section of a script before moving in to film closer views. On the other hand, Dmytryk rails against "perhaps the greatest sinner of all . . . the 'clever' director who 'cuts in camera.' This phrase . . . usually signifies that the director, in any particular 'take,' shoots only a portion of the scene which he expects to use as one complete cut."[1] Dmytryk

views this approach as self-defeating, since it limits the range of solutions in the edit room and forces actors to work superficially, since they do not have sufficient time to get into the particular scene at hand.

Dmytryk argues that, "The usual theatrical films, excluding art films, *film vérité,* and so forth, are meant to appeal to the largest possible audience, and sound theories of filmmaking, including cutting, are based on this fact."[2] Grounded in the film industry, his practical theorizing comes in the form of "editing rules" that will support the film's audience appeal, and he offers his insight in the form of six general rules for editing.

Six Rules for The Ideal Cut

Rule 1: Never Make a Cut Without a Positive Reason

Before addressing Rule 1 directly, Dmytryk begins by asserting, as many editors have, that "the proper cut can only be made at a single point."[3] He goes further, stating that the issue is not one of *duration* of the shot on either side of that proper point. Dmytryk says that making a cut 3 or 4 or 5 frames on either side of that "single point" would be off (short or long) by 1/6, 1/8 and roughly 1/5 of a second respectively. He grants that since the normal blink of a human eye is 1/5 of a second,[4] that duration is insignificant, and not one human beings would normally be bothered by. But to frame the problem differently, if someone asks "How can 5 frames, roughly 1/5th of a second make a difference in a cut, since that's literally the blink of an eye?" Dmytryk's answer looking at *duration* misses the point. He admits the durations involved are short, but that the issue is those frames will "spoil the match," to use his precise term.

"Match" is an editing term that applies to many situations and, taken out of context, is virtually meaningless. In its *broad* sense, the term refers to a cut where there is duplication in the pro-filmic material of the outgoing shot A and the incoming shot B. Here, Dmytryk's use of the term "match" refers to continuing an orderly sense of space and time over the cut, so that the flow of a story is not disrupted by the removal of slices of time or character positions that change abruptly. Although "match" can refer to other things like the graphic qualities of two shots, Dmytryk is using it here as it normally applies in narrative Hollywood films: that is, "match" is short for "match on action," a term that means that the incoming shot B continues an action begun in shot A. And though he doesn't specify further what "spoils the match," the continuity system he embraces assumes that when we cut on a character's action, the position, velocity and screen direction, etc. will continue from one shot to the next. So his point here is that, given an outgoing shot A and an incoming shot B, there *is* a proper cut point for the smoothest match. Therefore to focus on the fact that shifting the cut point 3, 4 or 5 frames is an insignificant change in *duration* misses the point that *one proper point carries the action across the cut better* – it creates the illusion of matching action better than other edit points do. The problem for the beginning editor is trying to uncover what the proper edit point is. Some of the rules below will help in suggesting where that point is, but often the process involves simply working with a range of frame choices and using trial and error to find the proper point. That search can be time consuming as the editor shifts out points and in points on both sides of the edit and previews the edit, looking for the right cut point. And yet to paraphrase Justice Potter Stewart's famous saying about pornography – "I know it when I see it" – most accomplished editors know the smoothest match when they find it, it simply feels right visually.

For Dmytryk, the thrust of Rule 1 is simple: don't cut just to cut, don't change the shot because the current shot is running long. The editor should change the shot only if the change improves the scene – there must be a positive reason for the shot change. He summarizes, "As long as the scene is playing at its best in the selected angle, leave it alone!"[5] In the contemporary media landscape,

this advice is widely ignored, but the editor who seeks to clarify their craft practice would do well to consider this dictum, if for no other reason that it forces one to identify *what is the specific reason behind a particular cut?*

Rule 2: When Undecided About the Exact Frame to Cut On, Cut Longer Rather than Shorter

Dmytryk argues that the editor should always follow their instinct. "The rule that applies to school examinations also applies, logically enough, in cutting: the first immediate and instinctive cut is more likely than not to be the right one."[6] However, he argues that, other things being equal, if an editor is fretting or unsure about a particular edit point, it is better to leave the shot long than to cut it too short.

Here, Dmytryk's advice is particularly apropos for the era in which he worked. When working in film, editors cut and spliced work print – an inexpensive print from the original camera negatives – so that the originals were protected and preserved to be the basis for fabricating a significant number of release prints that would be needed for projection in theaters. When the editing of the work print was complete, the work print was used as a precise map for the same edits made to conform the camera negative to the work print version, much like an offline video edit generates an edit decision list that is used to conform an online version of the video. Consequently, when working with work print using the slow process of physically cutting and tape splicing each edit, it was more efficient to be cautious, and leave a shot long rather than to cut it short, when later changes might require the editor to laboriously re-insert and splice three or four frames back into a work print.

Nevertheless, the advice is still relevant in the digital age, particularly for novice editors. If a cut is bothersome, rather than revising it endlessly trying to find the right solution, leave the edit long. By letting the edit "breathe" and be more "open" in the early stages, the editor can move forward, knowing that refinement and revision will polish the cut. This situation parallels writing. Working through a rough draft of a written document, it is often more important at the early stages to get the material out on the page from beginning to end, rather than to focus too much on specific issues like tense, word choice or sentence structure. Just as in writing, taking an edit through a number of "drafts" that ultimately leads to "picture lock," the editor should move forward to assemble the scene leaving shots long, and assuming that subsequent cuts will clarify, simplify and resolve those passages that are difficult in the first pass.[7]

Rule 3: Whenever Possible, Cut "In Movement"

Rule 3 contains some of the most valuable practical guidance that Dmytryk offers beginning editors, and most of that advice relates to the "cut on action," or as he calls it the cut "in movement." Dmytryk points out that cutting on action is the norm, but that there are some cuts in a film that do *not* involve looking for a movement to cut on: the beginning or ends of sequences, self-contained shots and dialogue or action that do not require an insert edit. Beyond those, the editor is generally looking for some character movement to motivate a cut, and "A broad action will offer the easier cut, but even a slight movement of some part of the player's body can serve to initiate a cut which will be 'smooth' or invisible."[8] He gives as an example a wide shot and a close shot of a character sitting down in a chair, noting that the editor's preferred choice would be to find a point in action of "sitting down" to make the edit, rather than allowing the action to take place fully in either the wide or the close shot.

For the action of sitting down – really for any action – the question for the editor remains, "Where in the action to cut?" For Dmytryk, the answer hinges on a hypothesis: he asserts that those moments where we can *motivate* the viewer's eyes to move or blink will provide the smoothest cut. Dmytryk gives as an example a typical case of where screen direction is maintained across a cut: the action of a character exiting frame left and entering frame right (Figure 3.1).

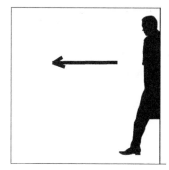

Figure 3.1 An exit/entrance cut According to Edward Dmytryk, the exit/entrance cut is an example of where the editor can motivate the viewer's eyes to move to provide the smoothest cut. Once the eyes of the actor exit frame left, the eyes of the viewer habitually move to the center of the screen. Then the entrance of the actor in the incoming cut continues to carry the viewer's eyes all the way to the right side of the screen.

He argues that once the eyes of the actor exit frame left, the eyes of the viewer begin to

> swing back to the center of the screen, then continue to its right edge, *drawn there* by the entrance of the actor in the new cut. All this has happened, quite unconsciously, in a fraction of a second, not nearly long enough for the viewer to be aware of the passage of time or to notice the cut which has slipped by in the interim. For – *and this is the most important factor in the process* – the viewer's eyes have been unfocused during their forced move, and he has seen nothing with clarity.[9]

Dmytryk is correct that when the eyes move they are "unfocused" as they move, but not literally correct. Research on reading has established that when we read, our eyes move intermittently, stopping to fixate on a word or words to bring new information to the brain, and then moving in short, rapid movements called saccades, during which vision is *suppressed*, so that no new information is taken in.[10]

Dmytryk's theory seems intuitively correct. Presumably, having the actor re-enter frame right does assist the viewer's eye reverting towards the middle of the screen, since one central function of our visual system is to detect change in the visual field. Dmytryk goes further to suggest that *anytime* we can cut within a period that the viewer's eyes are distracted, that distraction tends to smooth the cut. One such trick that is commonly used is the editorial ploy to cut on a sharp sound in the track, such as an explosion or door slam, on the assumption that the viewer will instinctively blink, distracting the eye and smoothing the cut. (As we will see in the next section, Walter Murch is another editor who is greatly interested in the correlation of "the blink" and the cut.)

In the two cases under consideration here – the character sitting down and the character exiting and re-entering – Dmytryk adds one final consideration for smoothly cutting on action: the action overlap. Here we are *not* referring to the short jumps backwards in time to replay, say, the moment of impact of bullets on a windshield as in *Mission Impossible 2* (See Chapter 2, p. 60). Rather, Dmytryk (like many editors) is convinced that whenever a shot changes, it takes three to five frames for the viewer's eyesight to register the change. Or to put it differently, every time a shot changes, the first frame that actually registers in the viewer's eyesight is frame 3 or 4 or 5 of the incoming shot. So if the goal is to match a person sitting in their chair, the editor should not search for the *exact* spatial/position match between the last frame of the outgoing shot and the first frame of the incoming shot. Instead, the edit point for the incoming shot should commence, say, five frames *before* the exact spatial match: that is, the last five frames of the outgoing is

overlapped by five frames of the incoming shot. Dmytryk theorizes that those five frames will not visually register with the viewer, but frame 6 of the incoming shot will, and frame 6 is the exact spatial match of the last outgoing frame (Figure 3.2).

It is difficult to determine with any precision how widely this practice has been adopted. However, a study published in 2014 by Shimamura et al., "Perceiving Movement Across Film Edits: A Psycho Cinematic Analysis" asked viewers (n = 48) to judge smooth movement across such edits, and found

> When edits occurred in the middle of an action, the perception of smooth movement required a brief repetition or overlap of the action across edits. Participants appeared to have missed the action across the edit and thus needed repetition of the action in order to perceive smooth movement.[11]

These findings held even when a pattern mask was placed between the shots. Dmytryk's notion that film edits disturb the viewer's cognitive processing such that they must be given a short repetition of the action on the incoming shot in order to perceive smooth movement is supported by this research.

According to Dmytryk, what is equally important to produce a smooth cut from one shot of a character walking to another shot of that character walking is maintaining the rhythmic cadence of the movement. Dmytryk says

> Therefore, when cutting from one shot of a person walking to another in which the walking continues (as in [Figure 3.1] the exit-entrance cut), care must be taken to make sure that the walker's foot hits the ground (or floor) in perfect cadence. If possible, the cut should be of the same foot, but failure to match feet is not nearly as disruptive as breaking the cadence of the walking.[12]

An Exact Spatial Match
is Perceived as a Hard Cut

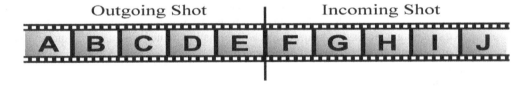

Add Overlapping Frames
to the Incoming shot

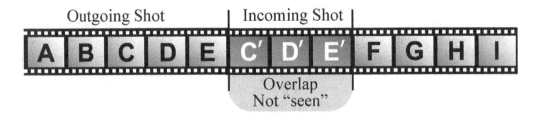

Figure 3.2 Overlapping cut for smooth continuity. An exact spatial match from the outgoing shot to the incoming shot often produces a hard cut. That's because when the shot changes, the viewer does not really "see" the first 3–5 frames of the incoming shot. Adding "overlap frames" to the head of the incoming shot – C', D', E' frames that repeat some of the action in the outgoing shot – creates the perception in the viewer that the cut was a spatial match from F to G.

Presumably, this cadence is maintained even as the editor factors in the "overlap" frames that are visually suppressed while the eyes travel back across the screen: what is important is that the hit on the ground *appears* to be smooth rather than be a technically correct spatial match.

Perhaps Dmytryk's "3 to 5 frame overlap" is too long for some cuts, suggesting a certain level of imprecision or "wiggle room" in his guidelines about smooth matching. By contrast, the Shimamura findings were quite specific: "When asked to select the clip with the smoothest movement, participants chose clips that contained a brief overlap in action (125ms)."[13] Less than the blink of an eye, 125ms is .125 seconds, or 2 frames in a 24-frame time base. Perhaps Dmytryk's '3 to 5' frames is too long for some cuts, but as noted above, trial and error in shifting outgoing and incoming edit points will often uncover the smoothest match point.

Rule 4: The "Fresh" is Preferable to the "Stale"

Dmytryk says that many professional and almost all beginning editors handle the "exit-entrance" cut by letting the character exit the frame in the outgoing shot, holding the empty frame for a beat, then cutting to the next shot. This is not the best solution, according to Dmytryk, for three reasons: it misses the opportunity to use the natural eye movement to the center of the frame, it makes the scene (and ultimately the film) unnecessarily long, and most important, "it extends a scene which no longer has any meaning or interest for the viewer."[14] In short, the thrust of Rule 4 is don't let the ends of outgoing shots run long, since, compared to incoming shots, which represent "fresh" information, outgoing shots are "stale," their interest for the viewer is in decline. Consequently a better place to let a shot run long is the incoming shot.

Dmytryk asks us to consider a stagecoach moving through a gorgeous John Ford-like painted desert. If on an outgoing shot, the stagecoach clears the frame and the editor leaves the desert on screen, the beauty of the scenery begins to take the viewer's interest, and they begin to think, "What an incredible landscape," thereby *taking them out of the film narrative.* By contrast,

> If we *start* the [next incoming] shot with the same beautiful landscape, the viewer will appreciate it as least as much, but will be accepting it in the context of the story. Most probably, of course, the stagecoach will already be seen in the distance. But even if it cannot be seen, even if, as yet, no action takes place on the screen, the viewer, while reacting to the scene's beauty, will also be anticipating some action pertaining to the film, looking for the stagecoach perhaps, thus again placing the scene into the context of the film.[15]

Dmytryk says the principle of placing extra footage in the "fresh" or incoming shot holds whether we are talking about footage that runs a few seconds or a few frames. Holding a scene after a character has exited is leaving the viewer with "cold coffee," but even a few extra frames at the beginning of the incoming shot present the viewer with a new location to assimilate into the narrative.

Rule 5: All Scenes Should Begin and End with Continuing Action

Dmytryk argues that while the principle invoked in Rule 5 is well known, directors often overlook it. He is using the term "continuing action" here to mean footage with the actor already in character and acting, whether the script calls for the character to be sleeping in bed or dancing across the room. When opening a scene showing a character, the editor needs the character to be acting, not "preparing to act" and as the scene is ending, the editor needs the actor not to immediately "let down" or come out of character. The problem for the editor is being able to find a natural cut point at the beginning or end of the take where the actor is "alive," and in character. When there is no extra footage at the beginning or end of a take that allows the actor to be in character, the

editor's job is made more difficult, because it can be hard to find a natural cut point, particularly if the scene requires "handles" to dissolve to or from the scene. Dmytryk suggests that there are few fixes when working with footage that does not support continuing action to begin or end a scene. When beginning a scene, one option is just to cut into the body of the scene, even if it means making a "*j-cut*:" a cut in which the sound of the incoming shot precedes the picture; an edit that "pre-laps" the audio of the incoming shot into the outgoing scene. When ending a scene where an actor "lets down" too soon, Dmytryk proposes cutting away to another character's reaction, or to an object within the scene, or making an "*l-cut*:" a cut in which the sound of the outgoing shot continues after the picture ends; an edit that "post-laps" the audio of the outgoing shot into the incoming shot. The l-cut is not an ideal solution, but Dmytryk suggests it is better than ending the scene (picture and audio) before the "let down," which often leaves the scene feeling short and chopped.

Rule 6: Cut for Proper Values Rather Than for Proper "Matches"

When cutting a dramatic film, Dmytryk argues that the first consideration is to go to the shot that carries the dramatic thrust of the scene, rather than one that is technically a better match cut. Why should the editor follow this rule? First, finding a technically better match point may move the edit point earlier or later to a point where it is illogical, and therefore feels like a "jump" or a hard cut in spite of the technical match. Second, such a match will damage the *dramatic* substance of the scene for the same reason: it feels illogical and forced.

Dmytryk says that in a situation where the dramatic needs of a scene *force* the editor to cut from a wide shot A to a closer shot B that contains a mismatch, the editor should first try the cut leaving the mismatch, and try to identify where within the frame the average viewer is looking from A to B. More than likely, if the viewer is looking at the actor's face and eyes, then mismatches in other areas – the position of the hands or arms that seem so prominent to the editor – will probably not be seen by the audience. The editor might next consider cutting in to another *closer shot* where only the face will carry over from shot to shot, essentially "framing out" the mismatch in the incoming shot. If there is no such closer shot, the editor can consider enlarging the incoming shot so that the mismatch material is out of frame or partially out of frame. Dmytryk did these kinds of frame enlargements in the age of film, when blowing up the frame by reshooting the footage in an optical printer always added grain to the shot that in many cases was quite visible. When enlarging digitally, the process is much easier technically as it does not require another generation of the footage. Yet, the editor faces similar problems with "digital grain" or pixilation, where pixels are displayed at such a large size that individual pixels become visible. When the image is less than 110%, such issues are mitigated. And when we shoot in a larger resolution, like 4k video, and distribute in 1080 HD, we can often just choose what part of the 4k frame we want to work with, because the larger frame size allows us to reframe in postproduction without "loss of resolution." One final work-around would be to cut to a closer shot of the person shown in shot A, before we go to shot B, thereby hiding the mismatch because the new outgoing shot is tight enough to handle the problem.

Dmytryk ends his practical theorizing with a forceful piece of advice that sums up how editors need to approach their work:

> To sum up, there is only one optimum way to cut a film, and the editor must overturn every stone in his effort to find it. Basically, it means showing, at any particular moment, that scene, move, or reaction which most effectively delivers its dramatic message. Compromises may be unavoidable, but they should never be accepted without a battle. It is good to remember that the obvious is not always the best, and if one keeps trying the ultimate solution can be superior to the original intent.[16]

Walter Murch: Six Criteria for the Ideal Cut

Director Francis Ford Coppola calls Walter Murch "a study unto himself: a philosopher and a theoretician of film – a gifted director in his own right."[17] Close collaborators for over 40 years, Murch worked with Coppola on a number of films including *The Conversation* (1974) (sound montage), *Apocalypse Now* (1979) (co-editor/sound designer), *The Godfather* (1972) (post production consultant), *The Godfather: Part II* (sound montage), and *The Godfather: Part III* (1990) (editor). Murch won his first Oscars for sound montage in *The Conversation* (1974) and he won two Oscars for the same film: *The English Patient* (Anthony Minghella, 1996) for both sound mixing and editing.

Murch's book on editing, *In the blink of an eye: a perspective on film editing* (1995) grew out of a lecture Murch gave in October 1988 in Sydney, Australia that was sponsored by the Australian Film Commission. As the title suggests, it is Murch's singular perspective on the craft he has worked in for most of his life, and like Dmytryk's work it is practical and centered on editing issues arising in narrative features. Working in the industry, Murch, like Dmytryk, experienced firsthand the dominance of Hollywood continuity as a controlling principle. Murch calls this principle "three-dimensional continuity," and describes the magnitude of its reach:

> In shot A, a man opens a door, walks halfway across the room, and then the film cuts to the next shot, B, picking him up at that same halfway point and continuing with him the rest of the way across the room, where he sits down at his desk, or something. For many years, particularly in the early years of sound film, that was the rule. You struggled to preserve continuity of three-dimensional space, and it was seen as a failure of rigor or skill to violate it.[18]

Murch argues that while "three-dimensional continuity" – matching the spatial arrangement of the actors in the filmic space from shot to shot – is taught in film schools, it is actually the *least* important consideration in editing. Rather, the primary consideration for the editor to consider is "*How do you want the audience to feel?*" and this principle is seldom taught because it is the hardest to identify and to deal with.[19] Murch argues that audiences will remember how a film makes them feel, rather than the style of the film or even the story. Consequently, if the editor has made the audience *feel* what they should feel throughout the film, the goal of the edit has been achieved. Notice that this dictum matches Dmytryk's Rule 6: Cut for Proper *Values* Rather Than for Proper "Matches."

If the editor is confronted with making a cut, what criteria does Murch suggest for evaluating the best possible choice for that cut? Murch, drawing on his decades of professional editing experience, offers "6 Criteria for an Ideal Cut" as his decision making guide. A cut is "ideal" for Murch if it satisfies all of the following at once:

1 It is true to the emotion of the moment.
2 It advances the story.
3 It occurs at a moment that is rhythmically interesting and "right".
4 It acknowledges what you might call "eye-trace" – the concern with the location and movement of the audience's focus of interest within the frame.
5 It respects "planarity" – the grammar of three dimensions transposed by photography to two (the questions of stage-line, [i.e., the 180° line] etc.).
6 It respects the three-dimensional continuity of the actual space (where people are in the room and in relation to one another).[20]

Six criteria is a lot to ask of a single cut: editors routinely make cuts with less at stake, particularly in non-dramatic films, but Murch's point is well taken. He is addressing the primary

considerations that an editor working in fiction narrative would likely encounter, but certainly these factors will often be present in non-narrative works. And more important, these criteria are ranked: other things being equal, the first consideration for the editor should be "emotion of the moment," the second consideration should be "advancing the story," etc. Murch's criteria are designed to upend the beginning editor's attachment to cuts that "match," which he places last, lower even than "questions of stage-line," his term for the 180° line. In fact, Murch goes on to give a tongue-in-cheek "weight" to each of these criteria, a percentage they should occupy in the decision making process:

1 Emotion – 51%
2 Story – 23%
3 Rhythm – 10%
4 Eye-trace – 7%
5 Two-dimensional plane of screen [i.e., the 180° rule] – 5%
6 Three-dimensional space of action – 4%

> Emotion, at the top of the list, is the thing that you should try to preserve at all costs. If you find you have to sacrifice certain of those six things to make a cut, *sacrifice your way up, item by item, from the bottom* . . . The values I put after each item are slightly tongue-in-cheek, but not completely: Notice that the top two on the list (emotion and story) are worth far more than the bottom four (rhythm, eye-trace, planarity, spatial continuity) . . . The general principle seems to be that satisfying the criteria of items higher on the list tends to obscure problems with items lower on the list, but not vice-versa . . . What I'm suggesting is a list of priorities. If you have to give up something, don't ever give up emotion before story. Don't give up story before rhythm, don't give up rhythm before eye-trace, don't give up eye-trace before planarity, and don't give up planarity before spatial continuity.[21]

Here then is a specific and useful decision making process for the editor to consider, offering six criteria to consider simultaneously in reference to a single cut, with the aim of identifying the best alternative, based on Murch's values and years of tacit knowledge he has gained from his professional life's work. Given all of the potential factors we might consider in making a single cut, identifying *only* six factors eliminates the potential for "information overload," and to some extent, "analysis paralysis," where the editor begins to over analyze the situation to the point of inaction. Notice too that the Murch decision process aims high: the goal is the "ideal cut," not just one that is satisfactory.

Murch and Blink Theory

Perhaps Murch's best known theory revolves around the observation that when a person blinks, it is not simply a point at which they need to moisten their eyeballs, because if that were true, people would blink at a constant rate in a given environment. Rather, Murch believes that blinking is a good indicator of internal emotions and the frequency or intensity of internal thoughts. And although Murch never uses the word "gestalt," his understanding of visual thinking is grounded in that model of perception. Murch asserts that blinking is a fundamental method of making sense of the world, of reducing the chaotic world of the sensory data that reality confronts us with into useable "chunks:"

> We must render visual reality discontinuous, otherwise perceived reality would resemble an almost incomprehensible string of letters without word separation or punctuation. When we sit in the dark theater, then we find edited film a (surprisingly) familiar experience.[22]

In other words, shot changes in film mimic the human blink. Murch acknowledges the original inspiration for his blink theory the Hollywood director John Huston, subject of a 1973 interview in *The Christian Science Monitor*,

> "Look at that lamp," [Huston] says, pointing to a brass floor lamp halfway across the dark green room. "Now look at me. Look back at the lamp. Now look at me. Do you see what you did? [the second time.] You blinked. Those are cuts. After the first time you know that there's no reason to pan from me to the lamp, because you know what's in between. Your mind cuts [the scene]. You behold the lamp. And you behold me. So in cutting the scene you cut with the physiology."[23]

Murch takes this idea and expands it, by observing people blinking, an activity that he has unique access to as a film editor looking at recorded takes. He notes that there is a large amount of variation in the frequency of a person's blinking, from minutes between blinks, to seconds or fractions of a second between blinks. Given this wide variation, Murch rightfully asks, "What is it that makes people blink?" Murch says the blink either *facilitates* a moment of separation between thoughts or *marks* that moment with an involuntary reflex, and he points to psychological research from 1987 that supports that conclusion.[24] More recent research that further supports Murch's theory placed subjects (n=10) in a functional MRI while watching episodes of the British television show *Mr. Bean*. This 2013 study concluded "eyeblinks are actively involved in the process of attentional disengagement during a cognitive behavior by momentarily activating the default-mode network while deactivating the dorsal attention network."[25] That is, blinking marks the point where viewers "take a breather" during periods of focused attention. When we blink we move from a state of attention (i.e., the dorsal attention network), to a moment of "wakeful rest" (i.e., the default-mode network). Contemporary Hollywood editors seem to support this position. Edgar Burcksen, A.C.E writes,

> When I read Murch's musings about eye blinking I started to pay attention to this phenomenon and I discovered that blinks play an important role in how I edit performances of actors. Apart from the physical need for eye blinks to moisten the surface of the eye, they also are an indication of the inner rhythms that govern the speech and movement of an actor. An actor always blinks their eyes when they finish or they're about to finish a line; when you mark your point one frame before this happens you have found the perfect edit the next shot.[26]

So how can this information be useful to an editor? Murch claims that it can be used two ways. First, when observing a conversation we can look at the *listener's blinks* as the precise moment where the thought being expressed by the speaker has been completely understood, "*And that blink will occur where a cut could have happened, had the conversation been filmed.* Not a frame earlier or later."[27]

For Murch, "listener blinks" suggest potential cut points in a dialogue footage, because they mark for the editor when that listener – and presumably *the audience* as "listeners" – has completely understood the thought behind a section of dialogue. If the blink marks where we "take a breather" during periods of focused attention, then it is a good place for an editor to look when seeking a logical cut point that matches the "mental rhythm" of the filmed conversation.

Second, as we noted earlier, the cut is a medium dependent technique that *mimics* the human blink, providing a visual separation that punctuates a film text. For the editor, the cut is a way of concluding one idea and starting another. When properly placed, the cut cleaves a film text in two – bringing one idea to an end and starting another, and "the more extreme the visual discontinuity – from dark interior to bright exterior, for instance – the more thorough the effect of punctuation will be."[28]

Summarizing thus far, Murch's argument is grounded in Huston's notion that the experience of watching a film is "More like thought than anything else,"[29] and so the blink has two functions for Murch. In any take the editor considers, the blink suggests natural cut points to end one thought and begin the next. Placed well, those very cuts visually structure the film text with blink-like moments of "stimulus change." But in practical terms, how does the editor bring this blink theory to bear on editing a film? Murch gives the specific example of Gene Hackman playing the paranoid surveillance technician Harry Caul in *The Conversation* (Francis Ford Coppolla, 1974) to answer this question. Murch says that because Hackman was so immersed in the character, his on camera thought patterns mirrored Harry's, leading Hackman to blink in rhythm with Harry's thoughts. Over time, as he worked with the material, Murch says he began absorbing the rhythms Hackman provided and "my cut points were naturally aligning themselves with his 'blink points.' In a sense, I had re-routed my neural circuitry so that the semi-involuntary command to blink caused me instead to hit the stop button on the editing machine."[30] In other words, Murch is picking his out point on the fly, based on where he thinks he's about to blink. He argues that a good editor must sensitize him or herself to the rhythms that the actor provides and then find

> ways to extend these rhythms into territory not covered by the actor himself, so that the pacing of the film as a whole is an elaboration of those patterns of thinking and feeling. And one of the ways you assume those rhythms is by noticing—consciously or unconsciously—where the actor blinks.[31]

Urging the editor to get "in sync" with an actor's performance and try to imbue the entire film with the actor's thought patterns and pace is solid artistic advice. And while trying to "notice unconsciously" where an actor blinks may on the surface be self contradictory advice to follow, Murch firmly believes that observing the blink can inform cutting that accentuates and amplifies an actor's performance rhythm.

Conclusion: The Tradition of Dymtryk and Murch

Today, editors work in an environment of rapid change brought on by laptop technology and software like Final Cut Pro – first introduced at the National Association of Broadcasters in 1999. This technology has democratized the editing process. Many film schools and media programs large and small now teach the basics of editing without much reference to Hollywood industry traditions, to the hierarchy of the guild system, to the older system of mentorship and on the job training. In the current phase of internet development, most of the worldwide community of editors at all levels are learning the craft outside "the industry," using resources and the aggregate knowledge provided by software instruction sites like Lynda.com, educational sites like Moviola. com and peer to peer problem solving via the web.

Dmytryk and Murch are editors cut from a different cloth, both grounded in Hollywood feature editing. Their professional work lives are bound to the routines and practices of an industry that developed the continuity style of editing as a "collective invention,"[32] to use David Bordwell's term. Before film schools began their proliferation in the 1960s, the studio system had no formal system of instruction. Aspiring editors like Dmytryk were moved from apprenticeship to assistant editor to editor, using professional mentorship to develop skills and vision, tied to the experience of editors and directors who came before him. Murch, who came through the U.S.C. graduate film program in the late 1960s, represents a different era. In the 1960s and 70s, film school graduates were challenging what remained of the old studio system, transforming the old methods of finance, production and narrative forms into an "American New Wave" where the director drove the filmmaking process, and the studio's role was greatly diminished. While the films Murch edited may have been more unconventional in subject matter and narrative logic than Dmytryk's, both largely follow classical Hollywood norms.

As professionals within the industry, both of these editors are invested in a system of continuity editing that simultaneously is a restricted form of narration with enduring rules and conventions *and* an immensely rich and creative means of expression. Despite the fact that they worked in different eras, both are immersed in the standard style of the Hollywood feature, for which continuity editing's clear articulation of space and time is a primary but "invisible" trait. The root of the tree that Dmytryk and Murch share is

> an academic style without much of a canon. . . . [Classical film style to 1960] develops more in the manner that visual perspective, or, to take a musical analogy, Western tonality did. Certainly there were powerful filmmakers who took the received style in fresh directions, and sometimes those creators influenced others. But in its totality, the classical Hollywood style is an instance of an "art history without names." It is the result of many routine iterations, accompanied by both striking innovations and minor tweaks. It was maintained for decades by a host of creators both major and minor, famous and anonymous.[33]

The editorial wisdom imparted by Dymtryk's and Murch's simple rules grows from that lineage, editing as an incredibly effective narrative tool learned from countless iterations of cutting with a splicer, countless hours of replaying cuts on moviolas and flatbed editors within the studio walls. Their insights demonstrate why Hollywood editors remain key in a system whose goal is to unfold a coherent filmic text, constructed systematically with specific devices to creatively engage the audience in story construction while remaining more or less invisible. As we will see in the next chapter, David Bordwell's work on how this larger system of narration functions reveals how fundamental editing is to the process of filmic narration.

Notes

1 Edward Dmytryk, *On film editing: an introduction to the art of film construction* (Boston: Focal Press, 1984), 13.
2 Ibid., 19.
3 Ibid., 24.
4 Research shows that the average duration of a single blink actually ranges between 0.1–0.4 seconds. See H. R. Schiffman, *Sensation and perception. an integrated approach* (New York: John Wiley and Sons, Inc., 2001).
5 Edward Dmytryk, *On film editing: an introduction to the art of film construction* (Boston: Focal Press, 1984), 24.
6 Ibid., 26.
7 In contrast to "leaving the cut long" and coming back later to "boil down the cut," Walter Murch advises editors to specify the in points on every edit, and hit the out point "on the fly," as the edit is playing, and to repeat this process more than once, so that if the out point falls at the same place a few times, the editor knows it is the right place for that shot to end. See Walter Murch, *In the blink of an eye: a perspective on film editing*. (Los Angeles, California: Silman-James Press, 2001), 65.
8 Ibid., 27.
9 Ibid., 31, my emphasis.
10 "Eye Movement in Reading." Wikipedia. Accessed June 13, 2016. https://en.wikipedia.org/wiki/Eye_movement_in_reading.
11 A. P. Shimamura, B. I. Cohn-Sheehy and T. A. Shimamura, "Perceiving Movement Across Film Edits: A Psychocinematic Analysis," *Psychology of Aesthetics, Creativity, and the Arts* 8(1) (2014): 80.
12 Edward Dmytryk, *On film editing: an introduction to the art of film construction* (Boston: Focal Press, 1984), 33.
13 A. P. Shimamura, B. I. Cohn-Sheehy and T. A. Shimamura 2014, "Perceiving Movement Across Film Edits: A Psychocinematic Analysis," *Psychology of Aesthetics, Creativity, and the Arts* 8(1) (2014), 77.
14 Edward Dmytryk, *On film editing: an introduction to the art of film construction* (Boston: Focal Press, 1984), 35.
15 Ibid., 37.
16 Ibid., 46.

17 Walter Murch, *In the blink of an eye: a perspective on film editing* (Los Angeles, California: Silman-James Press, 2001), ix.

18 Ibid., 17.

19 Ibid., 17

20 Ibid., 18

21 Ibid., 18–19, my emphasis.

22 Ibid., 63.

23 Louise Sweeney, "John Huston; Profile." *The Christian Science Monitor*, August 11, 1973, 13.

24 Walter Murch, *In the blink of an eye: a perspective on film editing*. (Los Angeles, California: Silman-James Press, 2001), 62. The article Murch is apparently referencing is J. A. Stern, "What's Behind Blinking? The Mind's Way of Punctuating Thought," *Sciences* 28(6) (1988): 42–44.

25 Nakano T., M. Kato, Y. Morito, S. Itoi and S. Kitazawa, "Blink-related momentary activation of the default mode network while viewing videos". *Proceedings of the National Academy of Sciences of the United States of America,* 110(2) (2013): 702–6.

26 Edgar Burcksen, A.C.E, "In the Blink of an Eye," *Cinemaeditor* 67, Quarter 1(2017): 15.

27 Walter Murch, *In the blink of an eye: a perspective on film editing*. (Los Angeles, California: Silman-James Press, 2001), 62.

28 Ibid., 63.

29 Louise Sweeney, "John Huston; Profile." *The Christian Science Monitor,* August 11, 1973, 13.

30 Walter Murch, *In the blink of an eye: a perspective on film editing* (Los Angeles, California: Silman-James Press, 2001), 65.

31 Ibid., 65.

32 David Bordwell, Janet Staiger and Kristin Thompson, "The Classical Hollywood Cinema Twenty-Five Years Along," Davidbordwell.net: Essays. Accessed July 12, 2016.

33 Ibid.

4 David Bordwell, the Narrative Functions of Continuity Editing and Intensified Continuity

In Chapters 1–3, we looked at several schema for analyzing how editing works: Herbert Zettl's notion of how screen vectors construct screen space, inductive versus deductive sequencing of images, Burch's matrix describing 15 ways that a shot change can represent space and time changes, and the useful rules that Dmytryk and Murch offer about how eye movements and blinks can smooth the cutting across a shot. These are all basically "micro" conceptual approaches to understanding editing. They offer frameworks for understanding cutting at the level of the shot change.

David Bordwell takes a broader, "macro" approach that is useful for editors because it allows us to zoom in and out, from "micro" to the "macro" approach when looking at a longer narrative. It asks us to take a wider view of the story being assembled, giving special attention to how the editor controls the presentation of narrative events across the entire film as it unfolds, and how that unfolding presentation shapes the viewer's construction of the film's narrative. The "unfolding" of a film that an editor creates for the spectator is key:

> In watching a film, the spectator submits to a programmed temporal form. Under normal viewing circumstances, the film absolutely controls the order, frequency, and duration of the presentation of events. You cannot skip a dull spot or linger over a rich one, jump back to an earlier passage or start at the end of the film and work your way forward. Because of this a narrative film works quite directly on the limits of the spectator's perceptual cognitive abilities.[1]

Analyzing how a film's cues us to construct a story is the objective of Bordwell's book *Narration in the fiction film*, an early, influential work that gave a cognitive explanation of how films make meaning. His account of how films tell stories leads Bordwell to examine two broad aspects of the process, "Narration and Time" (chapter 6) and "Narration and Space" (chapter 7). As we have seen, Noël Burch views editing as the articulation of temporal and spatial relationships, and he looks to the cut to schematize those relationships. Bordwell takes this idea further by asking how these temporal/spatial cues are central to the viewer's construction of a story. Armed with a broad schematic notion of how narration works, Bordwell proceeds to classify modes of narration that have emerged historically, and to give a credible account of how they tell stories including Classical Narration: The Hollywood Example (chapter 9), Art–Cinema Narration (chapter 10), Historical-Materialist narration: The Soviet Example (chapter 11), Parametric Narration (chapter 12), Goddard and Narration (chapter 13). But for our purposes, Bordwell's account of narration's relation to time and space is the most relevant to understanding editing in broad terms.

Bordwell looks at how the film parcels out pieces of narrative information – narrative "events" – by giving them *an order, a duration and a frequency*. Fundamentally, this is what editors do with the time/space fragments (i.e., shots) gathered at the shooting stage: the editor decides the

order of the presentation of shots, the editor decides the *duration* or length of shots, and the editor decides whether or not parts of the narrative need to be repeated, and if so, how many times. With this formulation, Bordwell has distilled the essence of what editors do every day*: they decide the order, frequency and duration of the audiovisual material they have.* And though Bordwell's focus is on how the editor parcels out narrative events within a *narrative feature,* the same principles apply to documentary editing or editing a :30 spot for a car maker. Editors decide what to show the audience first, second, third, etc. They decide the duration of each of those items. They decide which, if any, of the parts of the presentation bear repeating. And just to clarify, we are not excluding here the *audio channels* of a film: it is understood that our editorial decisions include what order we present sound elements to the audience, how long these elements are, and whether or not they are repeated. First, let's lay some groundwork for understanding Bordwell's theories, and then return to questions of order, frequency and duration in a moment.

Neoformalism Versus Interpretation: Building on Russian Formalism

David Bordwell is an American film theorist and historian who has authored a number of signifi-cant books in film studies. In 1985, he authored *Narration in the fiction film* and co-authored *The classical Hollywood cinema: film style and mode of production to 1960,* written in collaboration with Janet Staiger and his wife, Kristin Thompson. The latter book was very influential in film studies because of its innovative methodology: rather than write exclusively about films from the Hollywood canon, the authors selected 100 Hollywood films using an unbiased sampling procedure that ensured the author's personal preferences were excluded from the process. Each film was then viewed shot-by-shot and logged for shot changes, shot durations, setting, lighting, camera movement, etc., producing a unique data set for the description of style, economics and technology of the classical Hollywood cinema. A professor at University of Wisconsin-Madison, Bordwell has gone on to write more than 15 books, including the introductory textbooks *Film art* (1979) and *Film history* (1994). His work has been influential and widely cited in contemporary film studies.

To explain how narration – the process of storytelling – works in fiction films, Bordwell takes a neoformalist approach, with a particular focus on the mental activities of the viewer who is "reading" the film unfolding before her. Neoformalism builds on the work of Russian formal-ists, an influential school of literary critics who used a "scientific" approach to identify the set of distinct properties that are specific to poetic construction and the properties of literature that are distinct from other forms of human activity. Bringing this approach to the analysis of *film* moves the consideration of editing from a single shot change into a larger arena, one that analyzes how films use the unique devices of the medium to tell stories. Bordwell believes this focus on how the audience mentally assembles a film narrative as the film unfolds is more useful than approaches that focus on *interpreting* a film. Interpreting a film means uncovering meanings that are implicit (i.e., "theme") or symptomatic (i.e., "repressed" or "involuntary"). Often these methods of inter-pretation use a film or films to substantiate a larger, existing theory – a Grand Theory – such as Lacanian psychoanalysis. Bordwell outlines this kind of *interpretative process* in broad strokes as follows:

> For example, the psychoanalytic critic posits a semantic field (e.g., male/female, or self/ other, or sadism/masochism) with associated concepts (e.g., the deployment of power around sexual difference); concentrates on textual cues that can bear the weight of the semantic *dif-ferentiae* (e.g., narrative roles, the act of looking); traces a drama of semantic transformation (e.g., through condensation and displacement the subject finds identity in the Symbolic); and

deploys a rhetoric that seeks to gain the reader's assent to the interpretation's conclusions (e.g., a rhetoric of demystification).[2]

In contrast, neoformalism examines how the filmic text is constructed to trigger cognitive processes in the viewer to assemble a story. Bordwell argues that this sort of "mid-level theorizing" – i.e., close readings of specific film texts to understand how they cue the audience to construct a story without referencing a larger field like psychoanalysis – is a more useful approach than interpretation. This approach is grounded in Bordwell's overarching notion of *poetics*, any

> inquiry into the fundamental principles by which a work in any representational medium is constructed . . . [that] studies the finished work as the *result of a process of construction* – a process which includes a craft component (e.g., rules of thumb), the more general principles according to which the work is composed, and its functions, effects, and uses."[3]

Story Construction

It is also grounded in Bordwell's understanding of how the viewer behaves watching a film. Bordwell believes that a film viewer is *active*, reading cues in the film text and using prior knowledge, understanding of film conventions, the structure of the canonic story (e.g., to construct a coherent narrative using cause-and-effect). He devotes an entire chapter in his book *Narration in the fiction film* to describing how the viewer interacts with the film text unfolding on the screen. He summarizes his ideas in a short paragraph near the end of that chapter that is one of the clearest accounts of the mental activity of a movie viewer written.

> To sum up: In our culture, the perceiver of a narrative film comes armed and active to the task. She or he takes as a central goal the carving out of an intelligible story. To do this, the perceiver applies narrative schemata [e.g., existing models of narrative that they bring to the viewing] which define narrative events and unify them by principles of causality, time, and space. Prototypical story components [e.g., in *Bonnie and Clyde,* "lovers," "bank robbery," "small southern town"] and the structural schema of the "canonical story" [e.g., introduction, complication, rising action, climax, denouement, coda] assist in this effort to organize the material presented. In the course of constructing the story the perceiver uses schemata and incoming cues to make assumptions, draw inferences about the current story events, and frame and test hypotheses about prior and upcoming events [e.g., did character X kill character Y, will character A marry character B?][4]

Bordwell defines narrative as "a chain of events in cause-effect relationship occurring in time and space,"[5] and a key question becomes "How does a film cue us to select relevant story information – 'narrative events' – and connect those events by cause and effect?" Notice that some, but not all, of the events in a narrative are *explicitly presented* in a film (or a novel, etc.). What we routinely call *plot* is the explicitly presented events that unfold in a film.

Films normally cue the viewer to make narrative inferences as they construct the story. These are not the moment-to-moment, non-conscious "from the bottom up" judgments that take sensory stimuli from a film and make inferences to create precepts: that is a car, it is night time, that is a burglar, etc. Rather, narrative inferences are *conscious*, "from the top down" judgments involving cognitive operations utilizing background knowledge, expectations, etc. Certainly, to create the narrative, the viewer makes inferences about the explicitly presented events (the plot). But also, when information is omitted, the viewer makes *inferences about events not shown*: a man

and woman kiss goodnight by the woman's apartment door, cut to the man and woman the next morning lying in bed, and we infer they have slept together. Films encourage "*us to indulge in inferential elaboration,*" writes Bordwell. "What is the product of that process? Basically, what we call the story."[6] *Story* then can be used to describe the larger unit that a film cues us to construct: it includes all the explicitly presented events (i.e., the plot) *plus* all the events we infer from the plot. Notice that in everyday usage, plot and story are often used interchangeably, but here we will use them distinctly: plot is what is shown, and story is all that plus the events not shown but inferred.

Bordwell finds it useful to label these different notions using the terms from Russian formalist narratology: roughly *plot* is *syuzhet*, the arrangement of events in the narrative text and *story* is "*fabula,* the story's state of affairs and events."[7] He adds two final elements to complete his definition of narration: *nondiegetic information* and *film style*. The opening of *The Maltese Falcon* (Huston, 1941) contains a long, scrolling title that follows the film's opening credits. It reads in part:

> In 1539 the Knight Templars of Malta paid tribute to Charles V of Spain, by sending him a Golden Falcon encrusted from beak to claw with rarest jewels – but pirates seized the galley carrying this priceless token and the fate of the Maltese Falcon remains a mystery to this day.

Is this plot or story? It is doing the work of the plot – explicitly telling us part of the story – but not by giving us that information from *within the story space of the film* (i.e., it is not showing us Sam Spade in his office in California, interacting with the other characters, etc.) In other words, it is narrative information that is non-diegetic, or "outside the story space." It is part of the text of the film as it unfolds but not, strictly speaking, *plot.* See Critical Commons, "*Maltese Falcon*: Opening Scene."[8]

Film style is defined as "a recognizable group of conventions used by filmmakers to add visual appeal, meaning, or depth to their work."[9] Film style encompasses every aspect of a film: the filmmaker's attitude towards the film's concept, *mise-en-scène*, cinematography, lighting, sound usage and editing. Consider these two possible film versions of the tale of *Jack and the Beanstalk*. One opens in a traditional long shot as Mother opens her cabinet to find it bare, with Jack sitting nearby at a table with an empty plate, looking forlorn. The film cuts in closer, showing analytically the hunger and despair on Jack's face. This first version goes on to tell the story chronologically: Jack takes the cow to town, is hoodwinked in to selling it for a few beans, returns home where his mother gets angry at him, etc. Another version of Jack's story opens in a series of hand held camera shots from an extremely high angle, looking down over Jack's shoulder at his house as he climbs furiously down the bean stalk shouting "Mom, Mom . . . get the ax! The giant is after me!" This second version will flashback at some point to fill us in on how Jack got into this predicament. Do these two distinct film plots tell the same story? Certainly the audience is cued to construct the same story, even though each presents its narrative events in a different order, and despite their different cinematic styles. The second version not only re-orders the syuzhet's presentation of narrative events by opening with a climatic moment, it also chooses a kinetic camera/editing *style* that aims to position Jack immediately as the story's protagonist caught in a precarious life or death struggle, hounded by a giant who is not far behind him. "Narration has to include matters of film style," says Bordwell. "As we watch, in real time, online so to speak, we take the event as the narration presents it. Visual and auditory techniques are rendering the event for us, already organizing and slanting it in a certain way."[10] Elements of a film's style – how the film deploys composition, camera placement, camera movement, lens usage, lighting, sound design and particularly *editing* – is a very significant part of communicating and organizing its narrative cues. As Bordwell notes, outside of any filmic elements that can be ascribed to *excess*,[11] style in the classic Hollywood narrative *always serves the narrative*, and Hollywood style has highly regular attributes. *In the abstract*, a cinematographer can choose from a wide range of

lighting styles, and one is as likely to choose one as another. But when shooting comedy, high key lighting – overall bright lighting that minimizes shadows and shadow density – is a much more likely choice, since that style of lighting functions within the comedy genre as a highly codified marker that the film is intended to be humorous. High key lighting is part of Hollywood's "invisible style," but only when used in a comedic film: the same choice in a murder mystery would not be nearly as "invisible."[12]

Editing is no different here, with highly codified methods of articulating space (e.g., matched over-the shoulder shots for dialogue) and marking temporality (e.g., a dissolve marks the passage of time.) Editing in the classic Hollywood film will speak openly to the audience about space and time, orienting them in space by regularly returning to long shots that show the location and the arrangement of the characters, and orienting them in time with markers like fades to indicate the beginning and ends of scenes, etc. Clearly, editing is a particularly important element of Hollywood style because, for one thing, it controls the *order* of the presentation of narrative events in the film, and understanding the *order of narrative events* is critical to understanding a story, since causes must precede effects.

Here's an example that Bordwell gives to demonstrate why cause and effect are key to understanding a narrative. Compare the two cases in Table 4.1. Case A is not a narrative, but in Case B,

> We can connect the events spatially: The man is in the office, then in his bed; the mirror is in the bathroom; the phone is somewhere else in his home. More important, we can understand that the three events are part of a series of causes and effects. The argument with the boss causes the sleeplessness and the broken mirror. A phone call from the boss resolves the conflict; the narrative ends. In this example, time is also important. The sleepless night occurs before the breaking of the mirror, which in turn occurs before the phone call; all of the action runs from one day to the following morning. The narrative develops from an initial situation of conflict between employee and boss, through a series of events caused by the conflict, to the resolution of the conflict.[13]

To sum up, Bordwell says: "I take narration to be the process by which the film prompts the viewer to construct the ongoing fabula on the basis of syuzhet organization and stylistic patterning . . . Narration is more than an armory of devices; it becomes our access, moment by moment, to the unfolding story. A narrative is like a building, which we can't grasp all at once but must experience in time."[14] Or if we wanted to construct a visual model of how filmic narration looks it might look like Figure 4.1.

Editing and Canonic Hollywood Narration

After World War II, Hollywood films came to dominate world cinema, not only in number of films produced but also size of their audience. The unique voice of national cinemas in Europe, Latin America, Africa and Asia was difficult to maintain under the postwar, worldwide marketing

Table 4.1 How cause and effect are essential to the narrative

CASE A	CASE B
A man tosses and turns, unable to sleep.	A man has a fight with his boss. That night he tosses and turns, unable to sleep.
A mirror breaks.	In the morning, he is so angry he smashes his bathroom mirror.
A telephone rings.	A telephone rings. His boss has called to apologize.

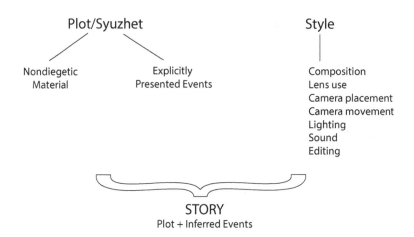

NARRATION

Plot/Syuzhet Style

Nondiegetic Explicitly Composition
Material Presented Events Lens use
 Camera placement
 Camera movement
 Lighting
 Sound
 Editing

STORY
Plot + Inferred Events

Figure 4.1 The process of film narration. Bordwell proposes two systems that interact when a film tells us a
story. First, there is plot – the unfolding narrative events presented by the film, the "programmed
temporal form" that the spectator submits to – and second, the film's style – the visual and aural
techniques the filmmaker chooses – that shape and slant that form.

of Hollywood films, so much so that "at times Hollywood appears to be . . . no longer a national
cinema but *the* cinema."[15] This dominance also extended to *style*: the cinematic devices and
mode of narration that emerged in Hollywood became the dominant mode of cinematic sto-
rytelling around the world. Embodied in Hollywood studio filmmaking from roughly 1917 to
1960, this classic Hollywood style is marked by narrative logic and clear methods of delineating
cinematic space and cinematic time, where *all* of the elements of style are used in service of the
story.

Storytelling is a ubiquitous human activity: "Our conversations, our work, and our pastimes
are steeped in stories. Go to the doctor and try to tell your symptoms without reciting a little
tale about how they emerged."[16] Consequently, we are familiar with the classic devices and the
standard structures of storytelling. "Once upon a time . . . " cues us that what follows is likely a
fairy tale. Classic narratives often follow a familiar pattern, beginning with an undisturbed stage,
followed by a disturbance, an ensuing struggle, the elimination of the disturbance and a return to
undisturbed stage. (Another way this overarching story structure is typically described is: intro-
duction, complication, rising action, climax, denouement, coda.)

Hollywood films typically enact this narrative structure, Bordwell says, by presenting psycholog-
ically delineated characters struggling to solve well-defined problems or achieve specific ends. As
the characters struggle in the narrative, they clash with others or with outer forces, and the film ends
with a clear victory or defeat, a definitive answer to whether or not the characters have achieved
their goals. So in the Hollywood film, it is the character, differentiated by evident traits, which
becomes the primary causal force in the narrative. In similar fashion, one purpose the star system
serves is to give an actor an approximate character prototype that can be adapted to a particular role.
"The most 'specified' character is usually the protagonist, who becomes the principal causal agent,
the target of any narrational restriction, and the chief object of audience identification."[17]

And how does editing figure within classical narration? First, *classic Hollywood editing* fosters identification with the protagonist through the selection of shots that display his or her characteristic traits, that give him or her visual prominence in the film (i.e., more close ups, more screen time), and that positions the audience to see what the character sees (i.e., more shots explicitly or implicitly from his or her point of view.) Second, editing is the primary tool *for structuring the narrative arc*, in both "macro" terms (over the entire film) and in "micro" terms (within scenes). On the macro level, the plot will be broken into segments, whose boundaries are marked by a standard cinematic marker like a fade, a dissolve, overlapping audio or a return to the opening shot of the segment. Segmentation creates scenes of character action or a montage. Here, editing is critical to segmentation, visually specifying the beginning and end of a scene and marking out for the audience the "correct dosage" of story information that the filmmaker deems they can handle.

On the micro level, setting aside "Hollywood montage" sequences that condense and summarize causal developments before transitioning to a new scene, the classical Hollywood scene of *character action* follows phases much like the overarching narrative, beginning with an exposition, where establishing shots orient the audience to time of day, location and relative position of the characters. In the middle of the scene, closer analytical shots cover the dialogue coherently, showing characters working towards their goals and revealing character states of mind. Foregrounding the narrative through editing ranges from basic techniques – mixing the dialogue with music and sound effects for maximum audibility – to highly creative ones – revealing subtle aspects of a character's facial expression and body language through careful selection and sequencing. For example, the choice, duration and sequencing of reaction shots is critical in dialogue editing, as it foregrounds states of mind that the dialogue may not address directly i.e., character A believes that character B is lying). And within a scene, the classically edited scene will control the release of new story information so that earlier story developments are closed off, and new lines open up, driving the narrative into the next scene. Classical editing is critical in this process as well, structuring a satisfying conclusion of a scene and simultaneously pointing where the action is headed in the next.[18]

Bordwell notes that while the "doubling" of characters or other narrative parallels may emerge, cueing the audience to uncover pertinent aspects of *cause and effect* in the story dominates in classical cinema. "Causality also motivates temporal principles of organization: the syuzhet represents the order, frequency and duration of fabula events in ways which bring out salient causal relations."[19] For an editor, this is a concise but revealing statement. Bordwell is focused here on a specific paradigm – "editing for causality" – in Hollywood cinema, but this statement reveals a broader axiomatic truth about *all* editing. If we set aside Hollywood's emphasis on causality, the same notion applies fundamentally to *all films*, including documentary or experimental films: editing is the absolute control over the order of *shots*, the frequency of *shots* and the duration of *shots.*

When we examined Burch's 15 possible spatial and temporal articulations, we looked at classically constructed temporal reversals or flashbacks, and temporal ellipses or flashforwards (see Chapter 2). Bordwell's take on these phenomena looks not so much at how time and space change *at the cut*, but more broadly on the *story constructing activities* that time and space manipulations create: to reiterate, the syuzhet (the plot unfolding as the film progresses), absolutely controls the order, frequency and duration of fabula (story) events that the filmmaker wants to use to cue the spectator to construct a story. Consequently, we will first focus on temporal organization (order) and its relation to story construction, and examine some unique uses of temporal organization that Bordwell's approach makes apparent. We will next examine how editing presents the frequency of narrative events in Hollywood cinema. Finally, we will look at how editing manipulates the duration of narrative events. Though classic Hollywood cinema dates from roughly 1917 to 1960, it will be more revealing in some instances to look at narrative films beyond these boundaries, films that are generally in the style of Hollywood films – they use continuity editing – but they also are pushing editing techniques in new directions that show how temporal and spatial organization in film can be expanded beyond the classical mode.

The Temporal Order of Narrative Events

As we noted above, the *temporal order of narrative events* is critical to understanding a story, largely because causes must precede effects. As we mentally construct the film's fabula, we infer the story order from the order the syuzhet provides us. Bordwell notes that the syuzhet can present fabula events 1) simultanesouly or successively and 2) in linear order, or in a way that juggles their order through flashback or flashforward, yielding four possible relationships between the two:

Fabula	Syuzhet
A simultaneous events	simultaneous presentation
B successive events	simultaneous presentation
C simultaneous events	successive presentation
D successive events	successive presentation.[20]

Case A: Simultaneous Events, Simultaneous Presentation

André Bazin, the French film theorist who is the subject of Chapter 6, argued that whenever the crux of a scene required the simultaneous presentation of two (or more) actions or elements, editing is ruled out.[21] Using deep space composition or off screen sound or split screen, the filmmaker can present simultaneous events simultaneously to the viewer. Obviously, deep space composition is a directorial choice, not an editorial one. The use of off screen sound can be either a directorial choice at the shooting stage, or an editorial choice created in post. A split screen edit is primarily an editorial choice in postproduction, though scenes may be photographed with that goal in mind. Two good examples of the directorial approach to presenting simultaneous events simultaneously to the viewer are found in Hollywood films of the same year: *Citizen Kane* (Welles, 1941) and *How Green Was My Valley* (Ford, 1941). Both films exploit the spatial potentials of filmmaking to enhance story construction. While the deep focus cinematography of Gregg Toland on *Citizen Kane* is widely known today, the contemporaneous work of Arthur Miller on *How Green Was My Valley*, which won the Oscar that year, is not as widely recognized. Like Toland, Miller was interested in exploring deep focus cinematography:

> I was never a soft-focus man. I like the focus very hard. I liked crisp, sharp, solid images. As deep as I could carry the focus, I'd carry it, well before "Citizen Kane."[22]

A crucial scene that launches *Kane* is the scene from Kane's rural childhood told from Thatcher's perspective. See Critical Commons, "Deep Focus Cinematography in *Citizen Kane* 2."[23] Kane plays in the snow outside the window, as Thatcher negotiates with his parents to take the young Kane to the city to raise him. Kane's energetic play outside the window is in stark contrast to the somber transaction taking place inside, and the simultaneous presentation of both events elegantly comments on the unbound potential of youth and the promise of urban life, versus the economic and cultural boundaries of his aging parents (Figure 4.2).

That same year, Miller used deep space and off screen sound in *How Green Was My Valley* for similar ends. The tension between family ties, tradition and a dying way of life versus the need for money and the economic promise of America is shown by the simultaneous presentation of two narrative events. In the film, a town of Welsh miners is split over a bitter strike called at the mine when the owner lowers wages. The Morgans, a family whose father and sons all work in the mine, mirror this split when the father sides with the owner. When the strike ends, the town and the

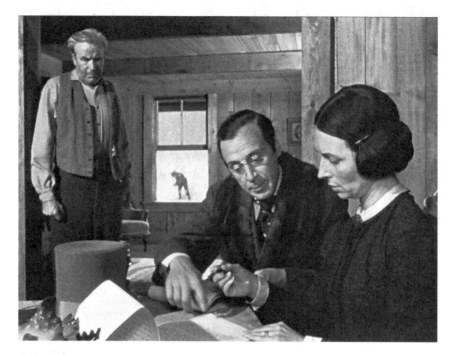

Figure 4.2 Simultaneous presentation of narrative events in Citizen Kane *(Welles, 1941).* The deep focus style employed in *Citizen Kane* allows the simultaneous presentation of simultaneous narrative events: the energetic play of the young Kane outside the window contrasted with the somber transaction taking place inside, where Kane's parents are signing the papers for him to be taken to the city by Mr. Thatcher.

Source: Copyright 1941 RKO Radio Pictures.

family are reconciled, but it is clear that the industrial economy beyond their little valley will not support the mine for much longer. The town is destined to decline and two Morgan boys decide to seek a better future in America. A letter arrives asking that the miners' choir – formed from the Welshmen who love to sing as they walk to and from work – perform before Queen Victoria at Windsor castle. See Critical Commons, "Deep Space and Off-screen Sound in *How Green Was My Valley.*"[24] As the choir rehearses that night, the father leads the men in a prayer of thanks to God as their father and Queen as their mother. The choir sings "God Save the Queen," the British national anthem, and the camera cuts to a shot of three women – the Morgan mother, her daughter and daughter-in-law – looking on with tears glistening in their eyes. The camera then tracks right to an empty street, the two Morgan boys enter frame, and the camera holds: they walk quickly up the darkened street, off to seek their fortune in America as the choir concludes the anthem with a resounding "God save our Queen" (Figures 4.3, 4.4).

Here, the tracking camera seems at first unmotivated. But the move links the two spaces and their underlying connotations: Ford simultaneously presents the older society, the choir, Welsh women dressed as if in mourning, tied to religious tradition, the monarchy and a dying economy, and the tracking shot reveals the younger generation walking briskly off on a new quest for a new life in America.

These scenes from *Kane* and *How Green Was My Valley* are both examples of Case A, simultaneous events, simultaneous presentation. Such scenes might seem trivial material for analysis: aren't there thousands of films that simultaneously show two narrative events within a single

Figure 4.3 Simultaneous presentation of narrative events in How Green Was My Valley *(Ford, 1941).* In *How Green Was My Valley* Ford uses a tracking camera to move from a view of the Morgan women . . .

Figure 4.4 to the Morgan boys who are leaving for America. According to French film theorist Jean Mitry, deep focus, movement in the frame and camera movement become points where the filmmaker's arrangement of visual material can create a "montage effect," with or without out cutting. Here the juxtaposition is between the old way of life of the miners and the promise of a new life abroad.

frame? Is every use of a sound bridge a candidate for close analysis under Bordwell's scheme? Probably not, unless we are systematically cataloging a film's temporal relations, methodically thinking through the moment-to-moment relationships of syuzhet presentation (and ultimately how these moments cue fabula construction). On the other hand, these two scenes stand out as vivid examples of simultaneity because of the juxtaposition of two opposing forces within the same frame. Jean Mitry, a French film editor turned film theorist, wrote about this phenomenon in his monumental book, *Esthétique and Psycologie du cinéma* (1963–1965). In an attempt to synthesize a middle ground between the earlier Soviet montage theorists like Eisenstein and the realist theorists like fellow Frenchman André Bazin, Mitry took a phenomenological approach to theorizing how film worked by asking what are the fundamental, unchanging elements of the subjective experience of watching a film? He argued that montage is not merely an effect that arises through editing. Rather, deep focus, movement in the frame and camera movement become points where the filmmaker's arrangement of the profilmic material can create in the viewer a *montage effect, with or without out cutting*. In fact, Mitry argued that the montage effect was one of four defining, invariant underlying structures of all filmic phenomena, regardless of cinematic style, historical period, genre, etc.[25] Here, deep focus and a camera move provide simultaneous presentation for a collision montage effect, using Mitry's term, and otherwise they might go unnoticed.

Beyond the potential of the camera to create simultaneous presentations of narrative events, "split screen" – a term that describes the composting of *two or more* images into a single film frame – is a postproduction technique that is frequently used to do the same thing. We have seen this method emerge in motion pictures as early as 1907, in Edwin S. Porter's *College Chums* (see Chapter 2, p. 54), a style chosen in that instance which references the earlier mode of production seen in lantern slides. Other early uses of split screen are found in more experimental work: *Man with a Movie Camera* (Vertov, 1929) and *Ballet Mècanique* (Léger and Murphy, 1924) are notable examples. Split screen editing in narrative films has been relatively rare, initially because of the relative difficulty of producing the effect in film in an optical printer, where the two images would have to be printed onto the same strip of film. As the technique has become technically easier in the domain of live television and the digital postproduction world, its use in television newscasts, television commercials and title sequences has become widespread. Michael Betancourt argues in *Beyond spatial montage: windowing, or the cinematic displacement of time, motion and space*, that split screen editing is actually part of a bigger phenomenon called *windowing*,

> not exclusively or only a matter of editing but of the visual organization of materials within the frame. Since the 1980s there have been several competing terms used for this same morphology: collage, mosaic-screen, spatial montage, split screen, temporal image mosaic, and, less commonly, parallelism (video art) and windowing (digital art). All identify the presentation of multiple images (shots) simultaneously on screen, all juxtaposed in a fashion that has direct parallels in both graphic design and comics.[26]

The graphic nature of split screen production was featured in a 17 screen film created by Ray and Charles Eames for IBM at the 1964 World's Fair in New York City, ushering in its use in a number of Hollywood films in the 1960s. After seeing the IBM exhibition, John Frankenheimer shot *Grand Prix* in 1966 using Super Panavision 70mm, over a five-month period on actual racing tracks in Europe, using 21 racing cars, a specially adapted camera car and a small helicopter with the newly developed Tyler camera mount. The film used multiscreen editing techniques in a number of sequences in the film. It also won three Oscars for technical achievements and was one of the ten highest grossing films of 1966, further popularizing multiscreen editing techniques, a trend that continued in films like *The Thomas Crown Affair* (Jewison, 1968), *Woodstock* (Wadleigh, 1970), *Airport* (Seaton, 1970) and *The Andromeda Strain* (Wise, 1971).

Grand Prix's opening title sequence by Saul Bass includes a range of shots where a single shot is printed multiple times – not an instance of Case A, simultaneous events, simultaneously presented (there is only one event) – but rather, the creation of a graphic grid of a single moment in time that is repeated spatially across the screen. For example, in one shot, a spare racing tire is rolled towards the camera and stops. By vertically carving the screen into a triptych, Bass takes the vertical graphic element of the tire and *spatially multiplies* it into an imposing triptych of tire and tread (Figure 4.5).

Later in the same sequence, the graphic repetition of an identical shot of a mechanic tightening a spark plug wrench (Figure 4.6) is repeated, first printed in a 2 x 2 array – a four panel shot – then a 4 x 4 array – a 16 panel shot – and ultimately in an 8 x 8 array – a 64 panel shot (Figure 4.7) that suggests all the racing teams are performing the same mundane tasks as the start of the race approaches. See Critical Commons, "Opening title sequence for John Frankenheimer's *Grand Prix*."

Betancourt calls this "single image displacement,"[27] where the editor transforms

> a singular image to create a pattern of identical elements typically composed in a grid . . . [T]he spatial repeating of the single shot creates a continuous field of imagery that acts to emphasize the graphic character of the image rather than the uniqueness of visual contents. Juxtaposed imagery is secondary to the continuous pattern formed.[28]

The graphic character of these spatial multiplications – the four panel shot, 16 panel shot and 64 panel shot – is further emphasized because all the multi-panel shots *move forward in time* using a single, long duration take of the turning wrench. So there is a perfect temporal match as each panel shot multiplies, emphasizing the graphic pattern established.

Later in the film, a race in the Netherlands is punctuated with a four panel split screen that shows the four main characters – Jean-Pierre Sarti (Yves Montand), a French racer, Pete Aron (James Garner), an American driving for an upcoming Japanese company, Scott Stoddard (Brian Bedford), a British driver who is recovering from a crash, and Nino Barlini (Antonio Sabàto), an Italian racer – racing in medium shots. The simultaneous presentation of their intense concentration, as they wrestle with the cars' steering over uneven ground, emphasizes the physical demands of the sport. Here, the four panel shot (Figure 4.8) is also a structuring device: the film returns to the four panel shot three separate times and then each quadrant is expanded to fill the screen, giving three drivers a short sequence that shows their struggle in the Dutch national race, as first Barlini spins out, then Stoddard nurses his sore knee in the cockpit, and Sarti breaks an accelerator cable. Using the four panels becomes a way to reiterate that the main characters are still in the race, simultaneously focused, and facing similar difficulties at every turn.[29] See Critical Commons, "Montage of split screen driving sequences from John Frankenheimer's *Grand Prix*".

A more recent use of split screen opens Darren Aronofsky's *Requiem for a Dream* (2000). Sara Goldfarb's son Harry is a drug addict and comes to steal his mother's television set. See Critical Commons, "Split-screen in the Opening of *Requiem for a Dream*."[30] As Sara (Ellen Burstyn) hides in the closet, Harry (Jared Leto) becomes increasingly angry with her and Aranofsky uses a split screen to *simultaneously present* both the interior of the living room closet (and occasionally Sara's subjective point of view of the living room through a hole in the closet door) and Harry's rampage in the living room as he works to steal the television set she has chained to the radiator to keep him from stealing (Figure 4.9).

Part of Aronofsky's strategy here is to replace traditional "objective" camera placements with ones that are more subjective, rendering the isolation and alienation of the main characters who suffer from addiction, particularly Sara's descent into psychosis. By *simultaneously presenting* the mother's fear – her dark, confined entrapment shown in close up and in claustrophobic subjective shots through a matte shot of the door's "keyhole" – and the son's rage – his maniacal pacing back

Figure 4.5 Tire triptych in Grand Prix. In *Grand Prix*, Saul Bass takes the vertical graphic element of the tire and multiplies it into a triptych.

Source: Copyright 1966 Metro-Goldwyn-Mayer.

Figure 4.6 Grand Prix: *Single image displacement* . . . A shot of mechanic tightening a spark plug wrench . . .

Source: Copyright 1966 Metro-Goldwyn-Mayer.

Figure 4.7 creates a pattern of identical elements composed in a grid. . . is repeated as a four panel shot, a sixteen panel shot, and ultimately this sixty-four panel shot.

Source: Copyright 1966 Metro-Goldwyn-Mayer.

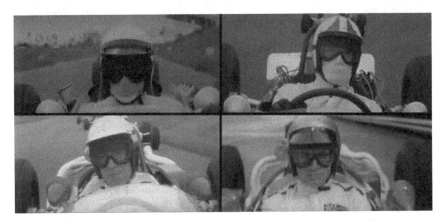

Figure 4.8 Grand Prix*: Four panel shot as a structuring device.* Returning to the four panel shot becomes a
marker of the beginning of sequences that show each driver's individual struggle to win the race.

Source: Copyright 1966 Metro-Goldwyn-Mayer.

Figure 4.9 Splitscreen in Requiem for a Dream. By simultaneously presenting the mother's fear and the
son's rage, director Daniel Aronofsky makes their estrangement and isolation visually explicit as
addiction takes over both their lives in *Requiem for a Dream.*

Source: Copyright 2000 Artisan Entertainment.

and forth, berating his mother for hiding the key to the television – the split screen in *Requiem* makes
concrete their estrangement and isolation. Addiction is taking over both their lives – only later will
we learn of Sara's developing addiction to weight loss pills. In addition, the split screen simultane-
ously presents both "cause" – the depth of Harry's addiction as he steals the television (or more accu-
rately, steals *again*, or why would she have chained it?) and "effect" – a mother's fear of her own
son, meekly enabling his addiction by turning over the key. On screen are two contrasting states of
being that are starkly opposed to our traditional image of mother and child, with the divided screen
graphically emphasizing the split between them. Later, when both are addicted we can see this split
screen opening as both a split between them and a side by side comparison of their condition.

 Like the camera track in *How Green Was My Valley*, it is this pointed aesthetic choice, the split
screen that cues the audience to the implicit meaning of the scene, a meaning beyond what an

ordinary edit of the scene might create. Betancourt recognizes this effect when he says that the combination must be seen by the audience as an *assembly*:

> Juxtaposition depends on the recognition that the collection of imagery appearing on screen is not the autonomous action of a long take "recording" actions in front of the camera but rather a consciously chosen – designed – product of human activity. Where the autonomous action of the camera is treated as a "given," producing imagery that is continuous, in contrast, juxtaposed imagery is already selected and assembled; juxtaposition is not understood as an autonomous product.[31]

Here, Aronovsky's overt aesthetic choice of the split screen manifests his intent within the opening scene, launching the narrative that he says, "is not about heroin or about drugs . . . The Harry-Tyrone-Marion story is a very traditional heroin story. But putting it side by side with the Sara story, we suddenly say, 'Oh, my God, what is a drug?'"[32]

Case B: Successive Events, Simultaneous Presentation

Presenting narrative events from different time frames *simultaneously* is rare in cinema, and usually requires motivation through a technical device such as replaying a recorded video event or character subjectivity such as an imagined memory. In David Lynch's *Lost Highway* (Lynch, 1997) the motif of video replay comes early in the film, as a series of VHS video tapes are left on the door step of Fred Madison (Bill Pullman), a Los Angeles saxophonist who gigs at clubs and suspects that his wife Renée (Patricia Arquette) might be having an affair. See Critical Commons, "*Lost Highway:* Second Video Replay."[33] The first tape that arrives shows only a black and white long shot of the exterior of the house, and a cut in to a zoom shot of their door. Renée dismisses it as something that must have come from a real estate agent. The second tape, however, arrives the morning after Fred and Renée have had sex, and Fred has recounted a disturbing dream he had in which a figure he was in bed with turned out to be an old man, not Renée. They sit down to watch the tape, and it opens with the same long shot and cut in to their door. At first they think it is the same tape, but as it continues with a grainy fisheye view of the inside of their apartment, the camera moves through the living room, down the hall, and into their bedroom showing them sleeping at a previous time. The reaction shots of Fred and Renée observing the tape get closer, ending with extreme close ups of them cut against the final shot of the video tape playing on the television, framed so tightly that the screen is merely moving pixels, barely readable. The tape ends in static. The subjective shot of the camera walking into their bedroom, simultaneously presented with their reactions in extreme close up, positions them as intruders into the sanctity of their most private space, an eerie kind of "stalking by proxy" that would not be possible to present without the videotape's ability to offset time.

Another instance of Case B: successive events, simultaneous presentation is found in the independent film *Buffalo '66* (Vincent Gallo, 1998). See Critical Commons, "*Buffalo '66*: Successive Events, Simultaneous Presentation."[34] In the film, Billy Brown (Vincent Gallo), just released from prison for a crime he did not commit, kidnaps a girl and forces her to return to his mom and dad's house posing as his wife. With the Buffalo Bills football game droning on in the background, they have an extended scene at the dining table that shows how dysfunctional the family is. At one point, Billy's mother brings him chocolate donuts for a snack, and Billy does a slow burn while reminding his mom that he is allergic to chocolate and pointing out that his own mother is unaware of this. In some ways, the scene is a "recounted enactment" (discussed further below) where his telling of his childhood allergy leads to a flashback: we eventually see him as a child, eating chocolate donuts with a swollen face. But here, the unconventional methods used to render the simultaneous presentation of the successive events makes the reversal a "flaunted temporal reversal" that is extremely overt. The incoming shot of Billy as a child is rendered as a center wipe, entering the screen "from Billy's head" (Figure 4.10), until it *almost* fills the screen, while the outgoing shot is held underneath until it fades out at the same point. The incoming shot of the

Figure 4.10 Buffalo '66: *successive events, simultaneous presentation.* The difficulty of presenting successive
 events simultaneously is suggested by this weirdly rendered scene, where the transition *is* the scene.

Source: Copyright 1998 Lionsgate Films.

young Billy eating chocolate is ultimately held as a freeze frame, while the adult Billy continues
to berate his mother for not remembering her own son's allergy. The entire scene, which never
really leaves the "audio present" of the adult Billy berating his mom, takes :16 seconds, long
enough that what we would ordinarily call a transition, here is more accurately called a pointed
simultaneous presentation of successive narrative events. The difficulty of presenting successive
events simultaneously in motion picture is suggested by this weirdly rendered scene, where the
transition *is* in an important sense *the scene,* and the outgoing audio never really leaves the pre-
sent. No wonder that this arrangement of narrative events is rare.

Case C: Simultaneous Events, Successive Presentation

Case C – commonly called crosscutting or parallel action – represents one of the first narrational
strategies employed by early filmmakers, and is common. With two lines of action happening
simultaneously, crosscutting offers the editor an easy way to show the course of both actions by
spreading them out one after the other in the syuzhet: cut from Jones doing "x," to Smith doing
"y," and continue this until the actions are concluded.[35]

 We have looked before at classic crosscutting from *The Godfather* (see Chapter 2, p. 75), where
the baptism of Michael's nephew is cross cut with the executions of his Mafia rivals across town.
There, we classified that arrangement of space and time under Noël Burch's scheme, Case 11
Spatially Discontinuous Radical, Temporally Continuous. Rather than present narrative events in
the same frame, simultaneity is presented as the editor moves back and forth between more or less
distant locations, as time moves forward more or less linearly.

 I say "more or less" because this common notion of crosscutting glosses over some of the spatial-
temporal nuances that also arise when crosscutting. Crosscutting has been used from the early days

of cinema for the "last minute rescue," a cinematic figure of style attributed to D. W. Griffith. In this use, the victim under attack – e.g., the victim tied to the railroad track – is being rescued by a distant hero – e.g., the hero in the nearby town – who must hurry to the victim's aid, so the *initial* cutting is, in fact, Spatially Discontinuous Radical, Temporally Continuous. But ultimately, as the hero arrives at the scene of the rescue, the spatial relationship moves inevitably closer: the shots necessarily become Spatially Discontinuous Proximate, Temporally Continuous as the hero approaches, and eventually, Spatially Continuous, Temporally Continuous as the hero physically saves the victim by untying them from the track. Similarly, time in the "last minute rescue" is "more or less" linear: it does move inexorably forward, but traditionally editors extended or shortened either side of the "threat" side of the equation or the "rescue" side of the cutting equation to maximize the tension of the scene.

Bordwell makes note of this phenomenon discussing crosscutting in Christopher Nolan's *Inception* (2010):

> One thing that has long struck me about classical crosscutting is that in one line of action time is accelerated, while in another it slows down. The villains are inches away from breaking into the cabin/ the hero is miles away/ the villains are almost inside/ the hero is just arriving . . . I wonder if Nolan noticed this aspect of the crosscutting convention and built it into his plot, supplying motivation . . . by stipulating that different dream levels have different rates of change.[36]

Indeed, *Inception* is a science fiction thriller whose main character Dominick Cobb (Leonardo diCaprio) leads a team of "extractors" to create four levels of nested dreams to implant subconsciously in the mind of the son and heir of a giant energy conglomerate, Robert Fischer (Cillian Murphy), the idea being that the conglomerate should be dissolved. See Critical Commons, "*Inception:* Montage of Ariadne Awakening."[37] Here, Bordwell finds parallels with Griffith's *Intolerance* (1916), an early "nested narrative," that *Inception* mimics, providing a puzzle film structure that appeals to Nolan, a director of intricate, innovative narratives like *Memento* (2000). To help viewers stay oriented, Nolan visually differentiates each dream level – rainy L.A. streetscape, an understated hotel, a snowy mountain fortress and the mixed urban landscape of limbo – and gives each dream level its own clock speed, with time in the lower levels passing more slowly than "real time," an idea announced early in the film by showing a second hand on Cobb's watch accelerating before cutting from the dream level he's currently inhabiting to the real world "above." Nesting the stories within dream levels gives Nolan many opportunities for bravura cross cutting:

> What Nolan has done is created four distinct subplots, each with its own goal, obstacles, and deadline. Moreover, all the deadlines have to synchronize; this is the device of the kick, which ejects a team member from a dream layer. With so many levels, we need a cascade of kicks. . . . The last forty-five minutes of the film become an extended exercise in crosscutting. As each plotline is added to the mix, Nolan can flash among them, building eventually to four alternating strands – with additional crosscutting within each strand (in the hotel, Cobb at the bar/ Saito and Eames in the elevator/ Arthur and Ariadne in the lobby). Each level has its own clock, with duration stretched the farther down you go.[38]

In the climax of the film, the van holding the team of extractors in dream level one drives off a bridge – the intended "kick" to be synchronized with "kicks" at other levels – that will wake the dreamers at every level. In every subsequent shot in dream level one, the van's descent to the water is shown in extreme slow motion, and structurally, from the point it breaks through the bridge's guardrail until it hits the water, roughly 27 minutes of screen time elapses. The van's actions "above" are crosscut with actions in levels "below," beginning with a cut from breaking through the guardrail to an avalanche triggered in the snowy mountain level (Figures 4.11 and 4.12)

Like Coppola's baptism scene, where the anointing of the baby synchronizes with the killing of Michael's rivals across town, this first cut from the van suggests the power of distant actions,

a smaller scale impact at one level having a large scale impact at a lower level. And like the baptism scene, where the baptism in the church carries metaphorically into the other strands of action where a "baptism of blood" is inaugurating Michael into the Mafia, Nolan's cross cut here emphasizes the mystical, ineffable connections across the dream world "strands" because this cut is also a cut on an idea – van cascading over the bridge cut to the snow cascading down the mountain.

The audacious crosscutting between dream levels culminates as the van slowly hits the water, and the dreamers are extracted from each level. Nolan uses a series of loosely matched shots of Ariadne (Ellen Page) distributed across a montage of the dream worlds imploding, showing her waking in each level (Figures 4.13, 4.14, 4.15, 4.16).

Figure 4.11 Cross cutting in Inception: *outgoing shot.* Actions in the dream levels "above" are crosscut with actions in levels "below," like this cut from the van breaking through the guardrail to . . .

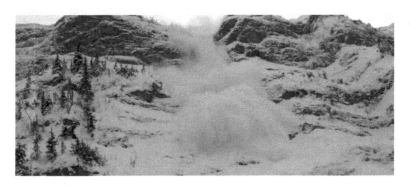

Figure 4.12 Cross cutting in Inception: *incoming shot.* . . .an avalanche triggered in the snowy mountain level.
Source: Copyright 2010 Warner Bros. Pictures.

Figure 4.13 Nested narrative montage: the "kick" cross cut across dream levels. A series of loosely matched shots of Ariadne (Ellen Page) mark the moments she awakens at the limbo level and . . .

Figure 4.14 at the snow level and . . .

Figure 4.15 at the hotel level and . . .

Figure 4.16 at the van level.

Source: Copyright 2010 Warner Bros. Pictures.

Bordwell concludes that the problem with these kinds of innovative narrative structures,

> is how to fill in the plotlines. Let me suggest a general principle, at least for storytelling aimed at a broad audience: *The more complex your macrostructure is, the simpler your microstructure should be.* . . [Nolan] recruits the conventions of science fiction, heist movies, Bond intrigues, and team-mission plots like *The Guns of Navarone* to make the scene-by-scene progression of the plot comprehensible. The iterated chases and fights keep us grounded too.[39]

Crosscutting between levels becomes the "macro structuring" technique that knits the four dream levels together.

Another hybrid method of crosscutting commonly used by editors mixes cases of A *and* C – simultaneous and successive presentation of narrative events – into a single sequence. How is this done? Typically mixing Case A and Case C simply means overlapping sound (simultaneous presentation) from two locations that are crosscut (successive presentation). See Critical Commons, "*Midnight Cowboy*: Opening Sound Bridges."[40] The opening of *Midnight Cowboy* (Schlesinger, 1969) offers just such a case as Joe Buck (Jon Voight) dresses to leave his job as dishwasher in a small Texas town for New York City. Joe sings a traditional cowboy ballad "Git Along Little Doggies" in the shower and dresses before the mirror, when a line of off screen sound from a female voice intrudes: "Where's that Joe Buck?" (Case A, j-cut. For an explanation of j-cuts and l-cuts, see Glossary.) The film then cross cuts to a diner where Joe is expected to show up for work: a fellow dishwasher in a waist shot, surrounded by stacks of dirty dishes, reiterates, "Where's that Joe Buck?" (Case C). As the film cross cuts back to a close up of Joe removing a new cowboy hat from a box, the off screen sound from another male voice continues the pattern: "Where's that Joe Buck?" (Case A, l-cut.) As he places the hat on his head, the female voice returns, "Where is that Joe Buck?" (Case A, j-cut), then cross cuts the woman in a medium close up, looking through the kitchen pass-through stacked with dirty dishes saying "Where is that Joe Buck? Look at this crap" (Case C). A quick cross cut back to Joe as he continues to dress seems to answer the question as he sneers rhetorically, "Yeah, where is that Joe Buck?" (Case C). The scene continues in this pattern, alternating off screen sound with cross cut shots. It concludes with the restaurant owner delivering an ultimatum straight into camera, "You are due here at 4 o'clock," cut to Joe (Case C), also looking straight into the camera, who seems to reply directly to him, "You know what you can do with them dishes. And if you ain't man enough to do it for yourself, I'd be happy to oblige" (Case C). Here, as the lines of dialogue delivered directly to camera are cut back and forth, the point is to create the false sensation that they are speaking to each other in person, i.e., the two shots are masquerading as "temporally continuous, spatially discontinuous proximate" to use Burch's nomenclature.

Case D: Successive Events, Successive Presentation

If narrative events are in no way simultaneous – neither simultaneous in the fabula or syuzhet – Bordwell says they represent Case D: Successive events, Successive presentation. Notice that "successive" in this instance means "following another without interruption," but not "following another without interruption *in some predetermined order.*" Bordwell spells this out clearly when he distinguishes the fabula, chronological by its very nature, from the syuzhet that can be chronological or not. While ordinarily presenting "fabula successivity" as "syuzhet successivity" (as opposed to simultaneity), the syuzhet routinely takes the liberty of reordering the presentation of events, notably through flashbacks.[41] We have examined how Burch's 3 x 5 matrix deals with these temporal manipulations at the *micro* level, that is, at the level of the cut. (See Chapter 2, p. 59). Flashforward, as we noted in Chapter 2, is relatively rare in classical cinema, as it is difficult to motivate realistically, because we expect the syuzhet to match the irreversible forward motion of time. Consequently, the "flashforward tends to be highly self conscious and ambiguously communicative. This is doubtless why classical narrative cinema has made no use of it and why the art cinema, with its emphasis on authorial intrusion, employs it so often."[42]

Regarding the flashback, Bordwell makes a further distinction that Burch does not. Because Bordwell's approach seeks to explain the *macro process of filmic narration* he wants us to recognize that a flashback can be either recounted or enacted: in other words, when a character communicates prior fabula events by speech or writing or video recording, etc., that is a *recounting*, but when prior fabula events are presented as if they were occurring in the moment, that is

enactment.[43] Such a distinction is needed, Bordwell argues, because films can show prior events or tell prior events, and it's common for film characters to discuss prior fabula events in dialogue.[44]

A particular hybrid form of the flashback in film that uses both methods is the *recounted enactment*, where a character begins telling an earlier narrative event, and the film cuts back to show that event.[45] *The Man Who Shot Liberty Valance* (Ford, 1962) contains a vivid example of the conventional Hollywood style of this form. Ransom "Ranse" Stoddard (James Stewart), a lawyer raised and educated in the East, comes to Shinbone in the Western territories, to set up a law office. He competes with the rancher Tom Doniphon (John Wayne) for the attention of Hallie (Vera Miles), and ultimately brings law and order to the town by shooting a local thug who terrorizes the town – Liberty Valance (Lee Marvin) – or so he thinks (Figure 4.17). See Critical Commons, "Flash Back: The Original Scene in *The Man Who Shot Liberty Valance* that Later Replays as a Recounted Enactment."[46] The first version of the shooting scene becomes the basis for comparison to the enactment that comes in a flashback later as Doniphon recounts the event, and Ford cuts to show it from his point of view.

At the convention to establish statehood, Stoddard is under consideration as the territory's delegate to Washington, but storms out after he decides he's unfit, given that his current fame is based on the fact that he killed a well known bad guy. See Critical Commons, "Flash Back: Recounted Enactment in *The Man Who Shot Liberty Valance*."[47] Doniphon takes Stoddard aside and tells him, "You talk too much. Think too much. Besides, you didn't kill Liberty Valance . . . Think back Pilgrim [Stoddard]. Valance came out of the saloon. You were walking toward him when he fired his first shot. Remember?" (Figure 4.18) The camera pushes in on these last two lines, and when a plume of smoke exhaled from Doniphon's cigarette fills the screen, the scene defocuses (a postproduction optical printer effect), while swirling strings fill the soundtrack and the film dips to black.

The film flashes back, cutting from black screen to the black image of Doniphan's back filling the camera frame. As he steps forward, the earlier action of Stoddard confronting Liberty Valance in the street is replaying, but shown now from Doniphon's point of view where he stands in a darkened alley to the side of the confrontation (Figure 4.19).

Doniphon's ranch hand Pompey (Woody Strode) tosses him a rifle as Valance taunts Stoddard and prepares to kill him. "This time, right between the eyes," says Valance, cocking his pistol. As Stoddard fires wildly with his pistol, Doniphon fires his rifle from the alley, killing Valance, who stumbles out into the street. The flashback formally "bookends" its opening as Doniphon walks into camera, causing the screen to return to black, while a fade in returns us to the two men talking.

John Ford presents the shooting of Liberty Valance twice in *The Man Who Shot Liberty Valance.* It's only when Doniphon takes Stoddard aside late in the film and tells him that he didn't kill Valance that the "true" presentation of killing unfolds – the second version – where Doniphon shoots him from the alley nearby.[48] As Bordwell points out, the Hollywood film can justify such replays when they bring to light new information, but without an authentic impetus in the story, the film's narration becomes unrestricted and self-conscious, repeating portions of the syuzhet at will.[49] It is a testament to the drive for narrative clarity in Hollywood films that the recounted enactment in *Liberty Valance* is marked by a push in, defocus, a string motif in the soundtrack, and a fade to black so that the viewer will clearly understand the flashback to follow. This convention of clearly marking flashbacks is such a common cinematic figure of style in classic Hollywood films that it is spoofed in *Wayne's World* (Penelope Spheeris, 1992) when Wayne and Garth make wavy motions with their hands, and sing a silly trilling song as the film offers two alternate endings to the film. See Critical Commons, "*Wayne's World*: Spoofing a Marked Temporal Reversal"[50] The first alternate ending is identified by Garth as "the Scooby Doo ending," a reference to the television cartoon franchise, because they unmask a character in that version, an action typical of the cartoon (Figure 4.20).

Figure 4.17 Shooting Liberty Valance: version 1. Ranse Stoddard (James Stewart) kills a local thug who
terrorizes the town – Liberty Valance (Lee Marvin) – or so he thinks. The first version of the
event is shown from Stoddard's point of view.

Source: Copyright 1962 Paramount Pictures.

Figure 4.18 Shooting Liberty Valance: version 2, recounted enactment. A hybrid form of flashback is the
recounted enactment, where a character begins telling an earlier narrative event . . .

Figure 4.19 Shooting Liberty Valance: new point of view. . . .and the film dissolves back in time to show that event. Here, the second version of the event is shown from Tom Doniphon's (John Wayne) point of view.

Source: Copyright 1962 Paramount Pictures.

Figure 4.20 Wayne's World: *flashback spoof.* The Hollywood convention of clearly marking flashbacks is spoofed when Wayne (Mike Myers) and Garth (Dana Carvey) make wavy motions with their hands to indicate a flashback.

Source: Copyright 1992 Paramount Pictures.

Narrative Functions of Manipulating Temporal Order

As we noted earlier, Bordwell's theorizing about narration in fiction films takes the macro approach. He argues that, as the viewer interacts with the film text unfolding on the screen, temporal order is one of the primary ways to cue important story building activities in the viewer. These temporal manipulations in the syuzhet have significant effects on the viewer's construction of the narrative because

1 Adherence to fabula order concentrates the viewer's thinking on upcoming events.
2 Adherence to fabula order favors the *primacy effect*, a demonstrated psychological tendency for items presented first in a series to be remembered better or to be more influential than those presented later in the series. Meir Steinberg borrowed this term to describe how early knowledge created by the story forms an initial "frame of reference to which subsequent information [is] subordinated as far as possible."[51]
3 Reordering fabula events is the most common method of creating gaps in the narrative. Gaps are untold portions of the fabula: they are important to the process of narration because they maintain viewer interest, either by leaving out unnecessary narrative events or by focusing the viewers' attention on what information is missing. Gaps in the story pointedly invite the viewer to frame expectations about upcoming story events.[52]

We will return to gaps below when we discuss temporal compression.

The Frequency of Narrative Events

Just as Bordwell lays out four possible cases for *order* of narrative events in fabula and syuzhet, he lays out a similar grid for all the possible cases of *frequency* of narrative events in fabula and syuzhet, using the "recounted/enactment" distinction we just looked at. He first notes that "The viewer presumes that fabula events are unique occurrences, but each one can be represented in the syuzhet any number of times. For convenience let us say that the syuzhet can represent fabula events once (1), more than once (1+), or not at all (0)."[53] Bordwell specifies further that a fabula event can be represented in two ways: by enacting it or by recounting is. Let's get the simplest case out of the way first: when a film neither enacts nor recounts a narrative event (the "0" case) it relies solely on the viewer to infer it as we saw above: a man and woman kiss goodnight by the woman's apartment door, cut to the man and woman the next morning lying in bed, and we infer they have had sex together. At a more mundane level, this is the ubiquitous case of elided events we noted in Chapter 2, where uninteresting events are not shown: a man talking on his cell phone says, "I'll see you at the airport," hangs up, and walks out his house. Cut to same man standing in an airline ticket line talking to his wife. If an event that has causal significance to the fabula occurred on the drive to the airport, it would ordinarily be recounted or enacted.

How does the syuzhet represent a fabula event once – the "1" case? One way is *by enacting it once*, a case exemplified by virtually all of pre-1908 cinema. Silent films enact every significant fabula event: nothing is left to infer. Kristin Thompson points out that "In the early films, there is virtually no difference between story events and the way they are presented in the plot. We seldom learn of any event we have not seen . . . In the primitive film, we seem often to have stumbled on characters we know little about, and we witness their actions out of context."[54] Likewise, representing a fabula event *once by recounting it once* is also common: a character explains their current behavior by telling of a prior event, thereby inscribing it to the syuzhet in a single instance.

How does the syuzhet represent a fabula event *more than once* – the "1+" case? This is infrequent in cinema, but we can think of examples where the multiple enactment of a fabula event is useful for thematic development and/or narrative development. In *October: Ten Days that Shook the World* (Eisenstein, 1928), Eisenstein presents the fall of the statue of Czar Alexander III twice, once in reverse, without any character recounting the event, a much more symbolic use of the shot, a striking visual figure of style.[55] (We will discuss *October*'s use of intellectual montage in Chapter 5.) Multiple enactments can even be the foundation of a story, as in the film *Groundhog Day* (Ramis, 1993) where meteorologist Phil Connors (Bill Murray) finds himself in a time loop, reliving the eponymous event in Punxsutawney, Pennsylvania.

Representing a fabula event *more than once by recounting* seems counterintuitive at first glance, but is actually common in classically narrated films, particularly in expository sequences. In the opening scene of *The Maltese Falcon* (Huston, 1941), for example, the private investigator Sam Spade (Humphrey Bogart) meets a prospective client Ruth Wonderly (Mary Astor) in his office, and she tells him that she is in San Francisco searching for her sister who she believes is with a man named Thursby. When Spade's partner Miles Archer (Jerome Cowan) enters the office later in the scene, Spade gets him up to speed by recounting Wonderly's tale of her search for her sister, a way for the syuzhet to concentrate and reinforce the narrative's opening complication. See Critical Commons, "*Maltese Falcon*: Opening scene."[56] Instances where a film enacts an event once, *and* recounts it once or more than once are also common: an action seen in a film is often the topic of discussion among the characters. In *La La Land* (Chazelle, 2016) Mia (Emma Stone), an aspiring actress, writes and performs a one woman show. The show is an on-going topic of discussion with her love interest Sebastian (Ryan Gosling), a jazz pianist, both before and after its production, a form of repetition central to the plot since it ultimately becomes the event that launches her successful career.

Another interesting case of recounting and enacting more than once is the murder of Parnell "Stacks" Edwards (Samuel L. Jackson) in Martin Scorsese's *Goodfellas* (1990). See "*Goodfellas*: Multiple Enactment, Single Recounting in the Murder of 'Stacks.'"[57] Stacks is part of the team that robs a Lufthansa shipment at John F. Kennedy International Airport, stealing $6 million, and his job is to get rid of the truck used in the heist. Instead he gets stoned, goes to his girlfriend's house and the police find the truck. Tommy DeVito (Joe Pesci) and Frankie Carbone (Frank Sivero) are sent to kill Stacks. They bang on his door, wake him and enter his apartment. Tommy sends Frankie to make coffee, and makes small talk with Stacks, circling behind him, as he pulls on his clothes. Standing outside the frame, Tommy raises an immense automatic pistol with a silencer attached into foreground and fires, scattering Stacks' brains across his bed in a moment of shocking violence. As the shooting continues, the film cuts to Frankie who comes into the bedroom doorway holding the coffee pot to see what has happened. They leave in a hurry, with Tommy first asking Frankie "Come on, make that coffee to go," and then chiding him, "It's a joke. A joke. Put the fucking pot down. We ain't going to take the coffee."

The film cuts to black as they close the door, and using staging that echoes Tom Doniphon's stepping into frame in *The Man Who Shot Liberty Valance* (see Figure 4.18, p. 120), Tommy steps away from the lens (a "tail-away" shot), moving into frame. As he turns and begins to fire more shots in slow motion, (Figure 4.21) Henry Hill (Ray Liotta), the film's narrator says in voice over, "Stacks was always crazy. Instead of getting rid of the truck like he was supposed to, he got stoned, went to his girlfriend's, and by the time he woke up, the cops had found the truck. It was all over the television. They even said they came up with prints off the wheel. It was just a matter of time before they got to Stacks." This last line falls over a high angle shot of Stacks' bloody corpse lying on the floor next to his blood-splattered bed.

Figure 4.21 Goodfellas: *multiple enactment, single recounting in the murder of "Stacks".* By avoiding the
conventional Hollywood "flashback markers" and using slow motion, the *frequency* of the nar-
rative event dominates in this immediate replay of Tommy (Joe Pesci) shooting Stacks (Samuel
L. Jackson), like a football play that is dissected by a sports announcer.

Source: Copyright 1990 Warner Bros.

Clearly, the cut back to the slow motion shot of Tommy firing his gun is a flashback. And in
Burch's terms could be described as Case 7 Spatially Discontinuous Proximate (cut from the
shot showing Stacks' apartment door to Tommy entering frame in Stacks' bedroom), Temporal
Reversal Measureable (cut from the moment they leave the apartment to an event that happened
seconds earlier). But the use of slow motion and a low camera angle, coupled with Henry Hill's
voice over and a 1960s do-wop love song added to the track, gives the viewer an immediate
replay of the shooting, almost like a football play that is dissected by a sports announcer. The
murder, abrupt and without warning, still "hangs in the air" as Tommy and Frankie leave the
apartment, joking about "coffee to go." The cognitive dissonance the murder creates in the
viewer – Stacks is part of the heist team and Stacks is murdered by the team – is brilliantly
resolved by the "slo-mo replay." Bypassing the conventional Hollywood "flashback mark-
ers," and not motivated by a character's subjective memory, *Goodfellas* immediately replays
the shooting, the slow motion rendering Tommy's actions "formalized" and menacing like an
avenging angel. Adding a somber voice over *14 seconds later into the flashback* via the narrator
Henry Hill, sets up the replay as more of an *enacted recounting* than a *recounted enactment*, and
the murder is shown the second time in a new context, rather than motivated by the traditional,
subjective, character memory.

The Duration of Narrative Events

Because pacing and rhythm are central to editing moving images, determining the duration of nar-
rative events is a critical function of the editor. The editor asks of every shot, whether literally or
intuitively, "What is the life of this shot?" i.e., how long can/should the film hold this shot? Ques-
tions of duration are critical to story comprehension, since under normal conditions, the viewer
has no control of how long the narration takes to unfold. The editor's choices regarding duration

can challenge fabula formation with rapid, concentrated story information, discourage it by proceeding so slowly that the viewer loses interest, or encourage it with narration that proceeds at a pace that is "just right:" the viewer is engaged but neither bored nor overly challenged. Bordwell identifies three parameters of duration:

1 the duration of the fabula or the overarching story
2 the duration of the syuzhet or plot shown in the film
3 the screen duration or "running time."

Using this guide, the durations for *Citizen Kane* (Welles, 1941) sort out like this,

1 fabula duration: from Kane as a boy of seven or eight playing in the snow in Colorado until a few days after his death when the reporters give up looking for the meaning of "Rosebud"
2 syuzhet duration: the stretches of time – some from his lifetime, some after his death – that are actually dramatized in the film
3 screen duration: 119 minutes.

Here, at the macro level, *Kane's* fabula duration > syuzhet duration > screen duration. For example, of the entire fabula, only a few minutes of Kane's childhood is shown, and none of his maturation into adulthood. His life in boarding schools in the U.S. and Europe, under the legal guardianship of Mr. Thatcher (George Coulouris), where he befriends Jedediah Leland (Joseph Cotten), is not shown. The viewer infers that young Kane was a bright but undisciplined student, unloved by Mr. Thatcher through his adolescence, and distant from his parents, who are not dramatized beyond the early scene in Colorado. This period in Kane's life is elided, save that Mr. Bernstein tells the reporter that he dropped out of Yale, Harvard and a school in Switzerland. This pattern of ellipsis is almost universal in narrative films, since the syuzhet selectively enacts the story, and not all fabula events are depicted.

In a fiction film, even when syuzhet/plot duration and screen duration are approximately equal, the fabula will typically be longer. The often cited example from classic Hollywood cinema is *High Noon*, (Fred Zinnemann, 1952), that tells the story of Marshal Will Kane (Gary Cooper) who must face down Frank Miller (Ian MacDonald), soon to arrive on the noon train and gunning for Kane. Here the plot duration and screen duration are roughly equal, 85 minutes, and a proliferation of clocks in the film's *mise-en-scène* (Figure 4.22) keeps us oriented to the approach of the eponymous title. But the fabula duration is presumed to be 10 years or so: "Instead of enacting phases of Marshal Kane's struggle with Frank Miller or moments of Kane's courtship, the syuzhet dramatizes only the climactic point of those relationships, in the span of a few hours of one day. All the rest of fabula duration is cued through recounting."[58] We know the fabula is longer, because the syuzhet points to events key to its narrative chain that lie *outside the stretches of time shown in the plot*: dialogue that reveals Marshal Kane is the person who sent Miller to jail, and that Kane previously promised his new wife Amy Fowler (Grace Kelly) he would retire and begin a new life as family man in a new town. Even when plot duration and screen time are roughly equivalent, fabula duration tends to exceed them.

Obviously, the fabula events that *are* depicted often have equivalent syuzhet and screen durations. The action of someone pouring a cup of coffee (its duration in the syuzhet and the fabula) is assumed to be equal to its screen duration. So at the *macro level, we have ellipsis* – fabula duration > syzhet duration > screen duration – and at the *micro level, we have equivalence* – a shot of pouring a cup of coffee represents its duration in all the realms

Figure 4.22 High Noon (*Zinnemann, 1952*): *clock motif reinforces equivalent syuzhet and screen durations*. Clocks are a significant motif in the film, as Marshal Will Kane (Gary Cooper) awaits the arrival of Frank Miller (Ian McDonald) on the noon train. The syuzhet duration and screen duration are both 85 minutes, but the fabula duration is longer: we learn that it was Kane who previously sent Frank Miller to jail.

Source: Copyright 1952 United Artists.

accurately. So where does the difference come into play? Viewers understand that editing within and between particular scenes is where the control of duration occurs: that the depiction of a sporting event will likely be elided to show just the highlights, that a huge explosion that destroys the evil space aliens will be expanded and savored in the syuzhet compared to its fabula duration, that a montage of a girl growing into a woman will show a lot of fabula time in a short amount of screen time, that chase scenes will be shortened, and concentrated. Moreover, as Bordwell points out, the proliferation in conventional narrative cinema of calendars of every kind, wristwatches, clocks, titles announcing a time change, dialogue that orients us to the time, character makeup to render an actor older or younger, cultural norms like church bells on Sunday, or a rooster crowing in the morning is testament to how carefully filmmakers want to articulate the relationship of fabula duration and syuzhet duration (as well as their order).[59]

Bordwell's possible relationships of fabula duration and syuzhet duration are summarized here, with typical instances noted.

Equivalence: FD = SYD = SCD

Examples of equivalence are more easily found in experimental and documentary work than in conventional narrative cinema, but perhaps the notion can be clarified by looking at films that contain *some equivalence* among fabula, syuzhet and screen duration, if technically not *all* of those factors. The often cited, seldom seen (and technically incorrect) example is *Sleep*

Table 4.2 Fabula duration versus syuzhet duration

Equivalence	Fabula duration equals syuzhet duration equals screen duration FD = SYD = SCD	Typically, a single shot document of an event
Reduction	**Fabula duration is reduced**	
	a. **Ellipsis:** fabula duration is greater than syuzhet duration, which is itself equal to screen duration. A discontinuity in the syuzhet marks an omitted portion of fabula duration **FD > SYD and SYD = SCD**	**Typically ellipsis.** Often occurs through crosscutting
	b. **Compression:** fabula duration equals syuzhet duration, both of which are greater than screen duration. There is no discontinuity in the syuzhet, but screen duration condenses fabula and syuzhet duration **FD = SYD and both FD and SYD > SCD**	**Typically fast motion.** Shortening screen duration without showing discontinuity, either by under cranking the camera or retiming the footage in post production
Expansion	**Fabula duration is expanded**	
	a. **Insertion:** fabula duration is less than syuzhet duration, which is itself equal to screen duration. A discontinuity in the syuzhet marks added material **FD < SYD and SYD = SCD**	**Typically repeated action.** Expanding the syuzhet by showing the same action or by including subjective sequences
	b. **Dilation:** fabula duration equals syuzhet duration, both of which are less than screen duration. There is no discontinuity in the syuzhet, but screen duration stretches out both fabula and syuzhet duration **FD = SYD and both SYD and FD < SCD**	**Typically slow motion.** Stretching out continuously depicted action, typically by **slow motion,** either by over cranking the camera or retiming the footage in postproduction

(Warhol, 1963) a roughly 5 hour film of John Giorno, Andy Warhol's lover at the time, sleeping. The artist intended *Sleep* to be an "anti-film," and the project was a success in that regard because of the nine people who attended the premiere, two left during the first hour.[60] Technically, *Sleep* does not fit the "equivalence category," since there were parts of the fabula (Giorno sleeping) that were omitted because the running time of raw 16mm film is limited: "The camera remains on him [Giorno] throughout the night, with the camera angle changing at the end of each reel."[61]

More recent examples of equivalence can be found in the documentary realm, like the "slow television movement" that emerged at the Norwegian Broadcasting Corporation since 2009, beginning with the live broadcast of a driver's eye view of the seven hour train ride between Bergen and Oslo, Norway (Figure 4.23). The piece made it to Netflix in 2016 as a seven hour episode entitled *Slow TV: Train Ride Bergen to Oslo* (Norsk Rikskringkasting, 2009), part of a series that included episodes on canal rides, national knitting night, salmon fishing and the chopping and burning of firewood.

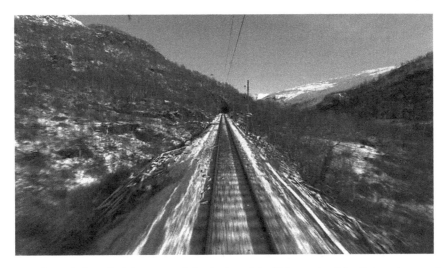

Figure 4.23 Slow TV: Train Ride Bergen to Oslo. As the original Norwegian title, *Bergensbanen minutt for minutt,* indicates fabula duration and syuzhet duration and screen duration are all "minute for minute" here – not one second is left out. FD = SYD = SCD.

Source: Copyright 2009 Norwegian Broadcasting Corporation.

A recent, albeit imperfect example of "single take" filmmaking is *Russian Ark* (Sokurov, 2002), a film where an anonymous narrator roams through Saint Petersburg's Winter Palace, happening upon people from assorted moments in three centuries of the city's history. Clearly the film is spatially continuous, but contains numerous temporal reversals as it moves from historical vignettes shown room-to-room. Moreover, though it was captured as a single shot, it technically contains temporal reductions and/or expansions (time warps) created in post-production: "the uncompressed HD 87-minute one-shot could be reworked in detail: besides many object removals, compositings, selective colour-corrections and digitally added focus changes, the whole film was continuously and dynamically reframed and for certain moments even timewarped."[62]

Reduction: Ellipsis FD > SYD and SYD = SCD

Having looked at ellipsis in Chapter 2, we can extend our understanding of it here by looking at a common narrative strategy that Bordwell identifies in the syuzhet: the creation of gaps. As we noted above, gaps are among the most significant cues for story constructing activities. If we compare the macro structures of two genres – the fairy tale and the detective story (e.g., Hitchcock's *Rear Window* [1954])[63] – we can quickly understand gaps on this macro scale. In the fairy tale the princess is born, and in the next scene she is a young lady. This temporal gap is fleeting: we quickly fill it in with the inference that nothing relevant to the story happened in the intervening period. In *Rear Window*, the pivotal gap "Why is Mrs. Thorwald missing?" is preserved across most of the film, only to be eventually closed.[64]

Using a model suggested by the work of Meir Sternberg, Bordwell further characterizes gaps in fiction films as *diffuse versus focused* (a gap can be filled with general assumptions or needs specific information for resolution) *flaunted versus suppressed* (a gap is called to our attention or

not) *temporary versus permanent* (a gap is filled soon, eventually, or not at all). Again, examples will help clarify some of the requirements for each classification.

At the *micro level,* we can look to particular edits for examples of temporal gaps in the syuzhet. They are usually easy to identify, particularly when their inclusion is flaunted to make an implicit meaning clear. In *The Last Temptation of Christ* (Martin Scorsese, 1988), an adaptation of Nikos Kazantzakis' 1955 novel, Scorsese creates a striking visual image of Jesus as the leader of a growing movement by using ellipsis in a sequence of spatially continuous shots, creating something like "symbolic jump cuts" (actually, jump "dissolves") that can be classified as syuzhet gaps that are diffuse, flaunted and permanent. See Critical Commons, "Jump Cuts (Dissolves) in *Last Temptation of Christ*."[65] After three fishermen/apostles see Jesus on the shore, they join him as he walks toward camera on a rocky plain. The film then dissolves to a shot staged about the same distance to camera where more followers are included in the frame. A second and third dissolve to a closer shot does the same thing, adding more followers. One final dissolve again advances the crowd closer to camera, filling the frame with his disciples. In this simple sequence of five shots, Scorsese communicates a meaning beyond the content of the single shots by flaunting the ellipsis: the followers of Jesus are quickly expanding, and the metaphor of the jump dissolve makes that idea visually explicit.

Reduction: Compression (Fast Motion) FD = SYD and both FD and SYD > SCD

If an editor does not create a discontinuity (an edit) in the syuzhet, then syuzhet duration and fabula duration is equivalent. If we then want to compress the syuzhet duration to fit shorter screen duration *without cutting*, we have to "speed up" the syuzhet, either through undercranking the camera – shooting at a lower frame rate than the playback rate – or by retiming the footage in post. Increasing a clip's playback speed to 200% reduces its screen duration by half. In either case we produce

Figure 4.24 Last Temptation of Christ *(Scorsese, 1998): flaunted temporal ellipsis.* In this sequence, Scorsese flaunts the temporal ellipsis to create a kind of symbolic "jump dissolve" to indicate that the followers of Jesus are quickly expanding.

Source: Copyright 1988 Universal Pictures.

"fast motion," though there will be slight visual differences depending on the method chosen. And fabula duration follows along: with no cutting, it's shortened the same amount as the syuzhet.

While a film may adopt either one of these time compression strategies across its entire screen duration – the whole film is in fast or accelerated motion – in most narrative films fast motion is typically employed in a single shot or within a sequence to create a particular aesthetic impact. As Zettl notes, while we can move very slowly, *accelerated motion* is contrary to our normal experience, and "has its own aesthetic feel. It shows the object not merely faster than normal but also more erratic, more jumpy. The comic energy of many cartoons and silent movies is based on accelerated motion . . . When shown in accelerated motion, objects sometimes seem to be self-propelled . . . For some reason, accelerated motion seems to trigger laughter more than awe."[66]

Common in early slapstick comedy and studio shorts like *The Three Stooges*, the use of fast motion is rarer in dramatic films. Stanley Kubrick uses fast motion to compress a scene in *A Clockwork Orange* (Stanley Kubrick, 1971) where Alex (Malcolm McDowell) invites two teenagers he meets in a record store home to have sex with him. See Critical Commons, "*Clockwork Orange*: Fast Motion (Syuzhet Compression)."[67] Shot in a single wide shot that is formally composed so that Ludwig Van Beethoven's image on the window shade is centered in the frame, the under cranked camera and slow shutter speed produce blurred images of the three rollicking in the nude as the "William Tell Overture (Abridged)," a fast paced, electronic version of Rossini's original, melds sound and picture into a frantic burst of audiovisual energy. Alex moves from woman to woman, rolling in his bed, and coaxing the women who dress and try to leave back to the action.

A more extended use of fast motion for dramatic effect is found in *Requiem for a Dream* (Aranofsky, 2000), where Sara (Ellen Burstyn) pops a pill, drinks coffee, cleans her house, then watches television. See Critical Commons, "*Requiem for a Dream* (Aronofsky, 2000) – Drug

Figure 4.25 A Clockwork Orange: fast motion. Alex (Malcolm McDowell) invites two women he meets in a record store home to have sex with him. Shot in a single wide shot, the under cranked camera and slow shutter speed produce blurred images of the three rollicking.

Timelapse."[68] After an :11 second opening montage that includes 24 fast motion shots, Aronofsky marks the accelerated sequence with a close shot of clock hands speeding around the dial before he dissolves to a long shot of Sara erratically jumping around her bedroom cleaning (Figure 4.26). The camera is tracking at normal speed (using slowed, incremental tracking moves) while the camera runs under cranked for fast motion, rendering the tracking speed normal and Sara's actions accelerated. As we follow Sara into her living room, she moves at break neck speed from vacuum cleaner to floor to hutch to wall painting to refrigerator in a cleaning frenzy.

The sequence cuts to her sitting, watching infomercials hosted by Tappy Tibbons, a fixed seated position that highlights her constant fidgeting, adjusting her glasses, and rearranging her blouse, fixing her hair. The infomercial is shown in fast motion, and the sound for the show is speeded up to a high pitched blur of voices as the images flash by. The show then shifts to slow motion before settling into normal speed. Sara rises to get a sleeping pill from her medicine cabinet, and returns to the show. Her world now shifts to "downer mode" in slow motion, her head slumping forward to sleep as Tibbons slows to a crawl on the screen, his voice low and distorted while the scene fades to black. Here, by using fast and slow motion combined with rapid cutting and speed shifts, Aronofsky captures a day in the life of Sara Goldfarb, struggling with her addiction and confined in her domestic routine.

Expansion: Insertion FD < SYD and SYD = SCD

If fabula duration is less than syuzhet duration, and syuzhet duration is equal to screen duration, then something has been inserted in the syuzhet to extend it. As noted above, in a "last minute rescue," it is not uncommon that one line of action is accelerated, while another is slowed down, the slower side containing more of its action shown than the other side to build suspense, often to an almost unbearable level: will the posse never arrive?

More overt is the tactic of repeating or overlapping action, replaying a portion of what has been shown to extend syuzhet and screen duration. Soviet directors, particularly Eisenstein, were known for this tactic, hoping to create a "motor imitative response" in the viewer (see a brief

Figure 4.26 Requiem for a Dream: *fast motion (reduction through compression of the syuzhet).* Director Daniel Aronofsky marks a fast motion sequence with a close shot of clock hands speeding around the dial before dissolving to a long shot of Sara erratically jumping around her bedroom cleaning.

Source: Copyright 2000 Artisan Entertainment.

discussion of overlapping action in Chapter 2, p. 54 and 60, and the next chapter for further discussion of Eisenstein.) See Critical Commons, "*His Girl Friday*: Temporal Expansion by Repetition/Insertion."[69] Bordwell provides a classic Hollywood example from *His Girl Friday* (Hawks, 1940) when Mollie Malloy (Helen Mack) the girlfriend of the escaped murderer Earl Williams (John Qualen) is driven from the room by the callous conversation of the newsroom reporters. Hildy Johnson (Rosalind Russell) leaves with Mollie, and the reporters know they have behaved badly. When she opens the door and returns to the room, Hawks cuts from the long shot of the group to a *plan-américain* of Hildy repeating the action, addressing them sarcastically as "Gentlemen of the press." *Plan-américain* is the default staging in Hollywood films of the classical period in which the actors are cut off just below the knees or at mid-thigh by the bottom frame line.[70] By overlapping the action, the pause in Hildy's reprimand is lengthened by repetition, and thus emphasized.[71]

Another well-known example of overlapping action comes from a groundbreaking film of the 1960s, *Bonnie and Clyde* (Penn, 1967). The historical drama concludes with the bloody, slow motion, rapidly cut depiction of the bank robbing couple's death in an ambush set up on a country road by lawmen pursuing them. See the clip "*Bonnie and Clyde:* Final Ambush Scene."[72] As the machine gun bullets rip into Bonnie (Faye Dunaway) and Clyde (Warren Beatty), the film extends the event by slow motion and by overlapping action, while cutting rapidly – the scene has 30 cuts in one minute. Penn said of the scene, "I wanted to get the spasm of death, and so I used four cameras, each one at a different speed, 24, 48, 72, and 96 [frames per second], I think, and different lenses, so that I could cut to get the shock and at the same time the ballet of death. . . I wanted two kinds of death: Clyde's to be rather like a ballet, and Bonnie's to have the physical shock."[73] David Cook calls this multi-frame rate montage style "ballistic balletics." It creates a powerful attraction for filmmakers and audiences:

> However socially responsible or irresponsible it maybe in context, the slow-motion depiction of death by high-powered weapons fire is aesthetically pleasing. As the avant-garde had understood for decades (and network television sportscasters had known since 1964), slow-motion photography offers one of cinema's greatest aesthetic pleasures. Combined with the thrill of pyrotechnic violence, it functions like an electrode implanted in the collective hippocampus. As proof, *Bonnie and Clyde* went on to become one of the most profitable films of 1967, earning by July 1968 nearly $28 million dollars in rentals worldwide on an investment of $2.5 million . . . Many returned to see it again and again, making *Bonnie and Clyde* one of the first films to do significant repeat business.[74]

In the famous closing sequence, connected by the overwhelming staccato of machine fire in the track, we first see Clyde standing, hit multiple times with bullets. Penn shows two different shots of Clyde hit by bullets in approximately this same standing position, intercut with the gunmen firing, and Bonnie's body beaten against the car seat in slow motion as the bullets strike her. Allen then cuts to three overlapping shots of Clyde's fall in different scopes – shots that are also in slow motion – to create an extended, :03 second "fall to the ground" that is visceral in its impact. The graphic violence of the film was unprecedented, and signaled a break with the traditional Hollywood approach that avoided realistic violence and often marked screen events like gunshots with simple moans. Post *Bonnie and Clyde*, screen violence acquired a different order of magnitude. Penn's film, and particularly the amount of blood shown, brought changes in the depiction of screen violence that continue to reverberate today: its slow motion/overlapping action techniques are now pervasive in action films. Equally important, the film combined explosive charges placed on the actor's body with artificial blood capsules to break "the last taboo against violent representation in American film."[75] The changes that the film ushered in are noted by Catherine Russell: "If *Bonnie and Clyde* was the 'first' film to represent death in anatomical detail, opening the 'bloodgates' of

American film, *The Wild Bunch* is the mythic initiator of a 'celebration' of violence'."[76] Peckinpah's film, coming a mere two years later, used many of the techniques that Penn did, but prolonged and extended the duration of his violent scene into an excessive spree that we will examine below.

Expansion: Dilation (Slow motion) FD = SYD and both SYD and FD < SCD

To reiterate, if an editor does not create a discontinuity (an edit) in the syuzhet, then syuzhet duration and fabula duration are equivalent. Now suppose we then want to fit a given syuzhet duration into a screen duration that is greater than it is *without cutting* in the syuhzet. Clearly, we would have to "slow down" the syuzhet, either by over cranking the camera – shooting at a higher frame rate than the playback rate – or by retiming the footage in post. Decreasing a clip's playback speed to 50% doubles its screen duration. In either case we produce slow motion, though there will be slight visual differences depending on the method chosen. Notice that fabula duration follows along: with no cutting, it's lengthened the same amount as the syuzhet.

And just like fast motion, a film may adopt either one of these time dilation strategies across its entire screen duration – the whole film is in slow motion – though in most narrative films slow motion is typically employed in a single shot or within a sequence to create a particular aesthetic impact. As Zettl notes, slow motion introduces a dream like feeling, a feeling like the direction of the object may change. He notes that, "An object in slow motion does not seem to simply move more slowly than usual; rather it seems to be moving through a denser medium than air, which appears to cushion the effect of gravity and makes the motion 'woolly and soft.'"[77]

The description of slow motion as "woolly and soft" comes from Rudolf Arnheim, and it suggests the particular aesthetic quality that Maya Deren was trying to capture when she said that slow motion has a *dual* quality to it:

> When a fast turning [head] is reduced, by slow motion, it still looks natural, and merely as if it were being performed more slowly; the hair, however, moving slowly in the lifted, horizontal shape possible only to rapid tempos, is unnatural in quality. The one creates a movement in one tempo, which has the qualities of a movement of another tempo, and it is the dynamics of the relationship between these qualities which creates a certain special effectiveness.[78]

Slow motion has been used regularly in cinema, particularly in sports films, and since the 1960s in broadcasting. In the early documentary art of Dziga Vertov, slow motion was used to dissect the image, to get the image captured closer to the truth before the camera. In *Man with a Movie Camera* (1929), Vertov shot the action of a number of sports in slow motion, to reveal the balletic quality of track and field athletes performing the high jump (Figure 4.27), the discus throw, the pole vault, hurdles, hammer throw. The sequence intercuts normal speed footage and slow motion, then continues with slow motion harness racing, high diving and soccer.

Vertov's experiment was followed by *Olympia* (Riefenstahl, 1938) a controversial film by Leni Riefenstahl that used slow motion in combination with other groundbreaking formal techniques to document the 1936 Berlin Olympic games. Widely admired for its aesthetic approach, the film was controversial given that Nazi Germany inevitably lent a political context to its creation. By 1961, ABC Sports used slow motion replay to show a highlight at half time in a broadcast of a college football game. Instant replay in slow motion grew quickly, becoming a regular feature in sports broadcasting by 1964, one that aestheticized action in close up and reduced the viewer's ability to see the overall pattern of the competition in a traditional long shot.[79]

Beyond documentary uses, early instances of slow motion usage in narrative films are somewhat rare, but Jean Vigo's *Zero for Conduct* (1936) was a very influential "featurette" using slow motion to end a monumental pillow fight, lending the anarchy of a boarding school rebellion a

Figure 4.27 Man with a Movie Camera: *sports in slow motion (expansion of the syuzhet without overlapping action).* Slow motion has been used often in sports films. In the early documentary art of Dziga Vertov, slow motion was used to dissect the movement before the camera.

Source: Copyright 2003 Kino International Corporation.

feeling of a triumphant dream. Jean Cocteau also uses slow motion for a similar effect in the French classic, *Beauty and the Beast* (1946), when Belle (Josette Day) comes to the Beast's castle for the first time. See "*Beauty and the Beast* (Cocteau): Slow Motion on Critical Commons."[80] Here, the use of slow motion coupled with the movement of Belle on a rolling platform provides a low-tech but profoundly enchanting quality to the sequence.

Using Slow Motion for Violence

At the other end of the spectrum, the use of slow motion in action cinema for scenes of violence and to suggest the moment of death, is pervasive, but the trend appears to have been started by Akira Kurosawa in the 1950s. The influential Japanese filmmaker, who directed 30 films in his 57-year career, brought aestheticized violence using slow motion to the attention of the world beginning in 1954 with *The Seven Samurai* (Kurosawa, 1954). The film won the Silver Lion at the Venice Film Festival, and was nominated for two Academy Awards. The scene that caught audiences' attention, and evolved in to a cinematic trope in action films, was Kurosawa's use of slow motion to suggest the death of a thief. See "*Seven Samurai:* Slow motion death sequence" on Critical Commons.[81]

The scene takes place in a small village where some peasants have travelled to recruit samurai to defend their village nearby, plagued for years by roving bands of brigands. They come upon a curious scene where a thief has taken a baby hostage in a barn. The peasants see Kambei (Takashi Shimura), an older rōnin, shave his head by a small stream and they become curious. Kambei asks for rice balls and a priest's robe. Apparently unarmed, Kambei approaches the barn where the child is being held hostage, and lifts the door open. The camera remains in a continuous shot from outside the barn as Kambei tries to reassure the thief he is only a priest with food for the boy.

The thief tells him to throw the food in, which Kambei does. Waiting a beat, he then rushes in. Kurosawa now begins to cut back and forth between the barn and the horrified crowd. The crowd surges forward with alarm, and the next shot of the empty barn door extends time, holding it for what seems like an interminable moment – in actuality :03 seconds – before the thief staggers to the threshold in slow motion.

As the child continues to cry off camera, time slows almost to a halt, as five shots come in quick succession, alternating between the crowd looking on in shock, and the thief staggering forward in slow motion, unbalanced on his feet and rising to his tiptoes to try to stop his forward motion. (Figure 4.28) Kurosawa cuts back to the crowd before we can determine if he has fallen, and when we return, a closer shot of the thief stunned, trance like, holds him in slow motion. What has happening to him? Will he fall? Again, we cut back to the crowd as the child's mother rushes forward to the barn. Kambei emerges, hands her the baby, and drops a bloody sword to the ground. The thief collapses in a heap and the scene resolves as the crowd moves forward to see the dead thief. Kambei will become the focus of admiration: two samurai want to follow him, and the travelling peasants see him as a hero they must recruit to defend their village.

The feeling of tension and release created here by the thief's slow motion stagger, alternating with the regular speed shots of the onlookers, is remarkable. The thief bursts out the door, then brakes, his forward motion suspending him on his tiptoes. This has taken :10 seconds – a long time in real time, but longer *feeling* in the dream-like time-space that the slow motion shots lend the entire sequence. From this point of suspension, the dissipation of his forward motion, Kurosawa delays his collapse for another :17 seconds, the solemn moment of death extended as long as possible, before adding a final shot of him face down in the dirt. This final shot is in real time, his bloodied shirt rippling in the wind confirming the complete stasis in his dead body.

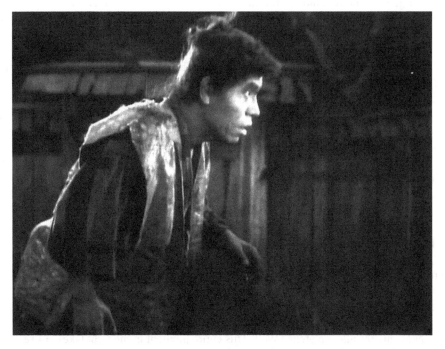

Figure 4.28 Seven Samurai: death in slow motion. The use of slow motion in action cinema for scenes of violent death is a trend that appears to start with Akira Kurosawa in this scene from *Seven Samurai* of a ronin who kills a thief who is holding a child hostage.

Source: Copyright 1954 Toho Co. Ltd.

Kurosawa's exploration of slow motion as an expressive technique became a flourishing trend by the late 1960s. As mentioned, *Bonnie and Clyde* used slow motion and overlapped action as part of Arthur Penn's strategy to further redefine screen violence. In the 1960s, the Motion Picture Production Code was crumbling. First adopted as the Hays Code in 1930, an attempt to clean up the image of the motion picture industry that had been tarnished by the scandals of excessive lifestyles of Hollywood stars in the 1920s, the Code had prohibited motion pictures from including content that would lower the moral standards of the audience and provided a list of specific items that could not be depicted, like drug use, contempt for law enforcement, miscegenation, etc. By the 1960s, filmmakers were interested in including more adult content in their work, and the pressure created by films like *Psycho* (Hitchcock, 1960) and *Some Like it Hot* (Wilder, 1959), released without Code office approval but successful at the box office, would eventually lead the industry to abandon the Code and adopt a new approach. Similarly, *Bonnie and Clyde* would be released unrated in August 1967, demonstrating that audiences were ready for more explicit depictions of violence in motion pictures. By October 1968, content would no longer be controlled by the industry, and the onus would shift to audiences to police themselves, following the adoption of a four level ratings system: G for general audiences, M for mature content, R for restricted (under 17 not admitted without an adult) and X for sexually explicit content.

Two years later, Sam Peckinpah's *The Wild Bunch* (1969) would expand the trend of using slow motion and exploding squibs to render violence simultaneously horrific and balletic. The film shows the "last ride" of Pike Bishop (William Holden), an aging outlaw who is struggling to keep his gang together long enough to pull off one last robbery. Led by one of the gang Angel (Jaime Sánchez) across the Rio Grande to his hometown in Mexico, the gang is drawn into the local struggles of the revolutionary Pancho Villa. At the end of the film, Angel is captured trying to smuggle guns to the revolutionaries, and is tortured by the corrupt and brutal general of the Federal Army, General Mapache (Emilio Fernández). The gang confronts Mapache in the town square as hundreds of his men look on, trying to force him to release Angel. The tension is palpable, as Mapache first appears to comply and then slits Angel's throat. Pike and his men quickly gun Mapache down, and their action freezes the assembled troops. The film cuts around the town square, from the outlaws sizing up their opponents to the frozen troops – 16 shots fill :20 seconds of screen time in rapid succession as the bandits survey the situation – until Pike's lieutenant Dutch Engstrom (Ernest Borgnine) finally laughs in a close up, suggesting both his recognition of the absurd futility of their situation, and perhaps his glee at the violence to come. The bandits exchange meaningful glances of admiration and farewell, and Pike rises to his full height, takes aim at the second in command, Colonel Mohr (Fernando Wagner), the German military adviser, and kills him.

Pandemonium erupts, and the cutting that carries the chaos mimics the editing style of *Bonnie and Clyde*: slow motion and fast cutting, but without the overlapping action of the earlier film. Peckinpah captured the majority of the shootout with up to six cameras, operating at various film rates, from 24 fps to 120 fps.[82] Peckinpah extends the gun battle over the next 4:00 minutes in roughly 243 shots, for an average shot length around 1.9 seconds.[83] If we examine a very short sequence of the scene, we can see some of the prominent editing strategies at work. See Critical Commons, "*The Wild Bunch*: Final Shootout (:14 Excerpt, Lyle on the Machine Gun)."[84] Midway through the shoot out, one of Pike's gang, Lyle Gorch (Warren Oates) gains control of the enemy's machine gun, and turns it first on some Mexican soldiers on a roof top, then on some soldiers attacking through an arched wall. This entire moment in the fight takes :14 seconds, and is shown in 19 shots (average shot length .73 seconds). There are two larger sections of the action: Lyle machine gunning the men on the roof and then turning the gun on those attacking through

the arch. Both sections are extended by slow motion, in that the target of Lyle's weapon is always shown in slow motion, while all the shots of Lyle firing the gun remain at regular speed. More striking is the temporal expansion: once a Mexican soldier is hit, and begins to fall off the roof, Peckinpah moves on to the action in the arch *before* the falling soldier ever gets to the ground. The sequence proceeds like this:

1 LS (slow) of two soldiers on the roofline raise their guns, cut to
2 MS Lyle firing machine gun, cut to
3 LS (continuous same as 1, slow) the roof structure is hit, cut to,
4 ECU Lyle firing (this shot crosses the 180° line), cut to
5 LS (closer, slow) one rooftop soldier is hit and blood spurts from his back, cut to
6 LS (slow) four soldiers rush in through the arches, cut to
7 MS Lyle (already turned) fires at the soldiers in the arch, cut to
8 LS (same as 6) the soldiers in the arch are hit, cut to
9 LS the rooftop soldier beings to fall off the roof, cut to
10 LS, (head on telephoto) six soldiers in an archway fire directly towards camera, cut to
11 LS (same as 9) the soldier continues falling towards a lower roof, cut to
12 MS, (same as 7) Lyle fires machine gun directly towards camera, cut to
13 LS, camera crash zooms to tight shot of soldiers in the arch crumbling to ground, cut to
14 LS (same as 9) the soldier rolls off the lower roof towards the ground (cut before that action is completed).

In opposition to the slow motion footage, the cutting here is short, and *once the soldier begins to fall* in shot 5, Peckinpah moves on to the soldiers rushing through the arch in a hail of gunfire (shots 6, 7, 8) *before he returns to show the soldier falling*, an action extended into two more shots (shots 11 and 14). By breaking the "falling shot" into three parts, a motif used in the film's first gunfight, Peckinpah gives an elastic quality of the scene's timing.

Peckinpah's style of cutting – mixing slow motion shots at different frame rates with normal footage, fast cuts, crash zooms and incomplete actions – grew from the lineage of *Seven Samurai* and *Bonnie and Clyde*. Like its predecessors, the extended bloodbath of *Wild Bunch* creates a fluid, elastic sense of time from very fast cutting, varied lens length and camera distances, and slow motion, further codifying an editing style that later become commonplace in the emerging genre of martial arts films and their Hong Kong descendants. See Critical Commons, "*The Matrix*: Slow Motion and 'Bullet Time.'"[85] Slow motion continues to evolve as a style element in science fiction films like *The Matrix* (Wachowski Brothers, 1999) where "bullet time," a profound alteration of time in which one element is slowed while the virtual, CGI "camera" moves through space in normal time, and in epic fantasy films like *300* (Snyder, 2006), where slow motion is used with green screen photography to mimic the aesthetic of the comic book on which it was based. See Critical Commons, "*300*: Slow Motion Violence."[86]

Slow motion – temporal expansion within a shot – has rightfully become the technique to aestheticize violence, particularly gun violence, because "once death is represented as violence to the body, a destruction of the skin that holds the body and soul together, the look of death becomes potentially repulsive. One of the conventions by which the gruesomeness of this form of death is 'contained' in narrative is slow-motion, also a key means by which violence can be construed as ballet. . . . [A]lthough slow motion is less real than 24 frames per second, when used to depict death, it attains a degree of realism, because the slowing down of the image speed portends, in a way, the death state itself."[87] Death in slow motion becomes a contradiction, an aestheticized ballet that attracts the eye, and repels our intellect.

Bordwell on Intensified Continuity

David Bordwell published *Narration in the fiction film* in 1985, but more recently he has published through an extensive personal blog http://www.davidbordwell.net/. Bordwell's blog offers PDFs of many of his earlier articles and books, including *Ozu and the poetics of cinema, Planet Hong Kong,* and *The way Hollywood tells it: story and style in modern movies.* His theorizing and criticism has continued energetically, ranging across a number of topics, including his identification in 2002 of an important change in Hollywood continuity editing, a new style he labeled *intensified continuity.* He describes intensified continuity's four key traits as:

1 more rapid editing
2 bipolar extremes of lens lengths
3 more close framings in dialogue scenes
4 a free-ranging camera.

While 2 and 4 are primarily production, not postproduction choices and represent areas of directorial, not editorial control, they nevertheless have significant ramifications for editors. The free ranging camera, Bordwell argues, has penetrated cinematic style so completely that we barely notice ordinary dialogue handled in a walking Steadicam shot, shots used for ordinary exposition craning from a high angle on the street to swoop and follow a character onto a doorstep, simple scenes at a dinner table covered with a circling camera, shot-reverse shot dialogue covered with constant "push-in" shots on both sides, and even "moving master" shots where the camera is dollying slowly forward or back, or tracking left or right. The free-ranging camera is so pervasive that "Today, everyone presumes that a long take, even a long shot, is unlikely to be a static one."[88] Such shots create an internal rhythm of their own, regardless of the profilmic material (i.e., the material before the camera) that the editor must recognize to use creatively. (Internal and external rhythm are discussed in Chapters 5, 7 and particularly in Chapter 8, p. 261.)

Moreover, Bordwell notes that, rather than sticking with the standard 50mm "normal" lens for 35mm film, and longer prime lenses like 75mm or 100mm for close ups, beginning in the 1970s, directors freely mixed focal lengths within a single film, a trend fostered by the invention of reflex view finders – mirrored shutters that allow the operator to look through the taking lens rather than having an auxiliary side-finder that approximates what the taking lens sees – and high quality, complex zoom lens designs made possible with the aid of computers. Shooting with longer focal lengths also made multicamera shooting easier, as the cameras could get close framings without being in each other's shot. As a byproduct, the narrow view of telephoto framings often creates situations where the foreground is completely obscured – say, when another character crosses the camera's field of view – allowing the editor to create an "in camera wipe" or "wipe by" cuts. Bordwell cites the prominent example in *Jaws* (Steven Spielberg, 1975) where Police Chief Brody (Roy Scheider) sits on the shore and nervously eyes the ocean, vigilant for signs of the great white shark. As people pass by in front of him, six in-camera wipes are used to make an axial cut to a closer or wider framing of Brody, or to cut to his point of view shot. The cuts are disguised by cutting between two people "mid-cross," the outgoing blur of person A is cut with the incoming blur of person B. The duration where the cross totally covers the frame ranges from 4–6 frames, roughly the duration that Dmytryk theorizes should be the "ordinary offset" that an incoming shot should be shifted to head, since those frames are routinely "not seen" on the incoming cut (see Chapter 3, p. 89). Also, the smoothness of the in-camera wipe seems to be confirmation of Walter Murch's theory that blink-like moments of "stimulus change" can be effective ways to structure the film text. In effect, the frames where the screen is filled act as a kind "crossing blink" for the audience as the incoming shot changes. See Critical Commons, "*Jaws*: In Camera Wipes or Wipe by Cuts."[89]

Another creative use of the in-camera wipe is found in *The Devil Wears Prada* (Frankel, 2006) where the foreground mask allows the editor to cover a jump cut where Andrea "Andy" Sachs (Anne Hathaway) is shown in a variety of clothing as she walks to her job as a personal assistant to Miranda Priestly (Meryl Streep), the tyrannical editor of a fashion magazine. See Critical Commons, "*Devil Wears Prada*: In Camera Wipes or Wipe by Cuts."[90] As she approaches a subway entrance, a black SUV crosses frame (Figure 4.29), covering a cut as Andy's outfit changes from a dark coat and knitted hat to a "mod" white coat, hat and purse (Figure 4.30). The transition works smoothly here because the framing is so close on both shots (or either side of the cut has been digitally reframed to closely match the other.) So smooth, in fact, that the transition may in fact be a soft edge digital wipe in the shape of the SUV's left rear edge following the SUV across the frame.

The intensified continuity's use of more rapid editing, and close framings in dialogue scenes represent two areas of more direct *editorial* control. Watching a 1930 Hollywood studio film usually makes us aware of their slower editing, overt statement of character goals, and sometimes plodding presentation of cause and effect. A significant change in the style of movies began in

Figure 4.29 The Devil Wears Prada: *in-camera wipe, the outgoing shot.* Long focal length lenses give editors the opportunity to create in-camera wipes, where something crossing the foreground covers the frame . . .

Figure 4.30 Devil Wears Prada: *in-camera wipe, the incoming shot.* . . and the incoming shot continues that motion, revealing a new scene.

the 1980s, and is frequently attributed to the influence of MTV, launched as a music video cable channel in 1981.

> The quick edits, special effects and rapidly unfolding storylines that were – and still are – the trademarks of music videos markedly influenced audience appetites. Heavy consumption of slick, style-over-substance music videos for example, rendered much film and TV as dull and dated in comparison . . . Many contemporary film-makers honed their craft making music videos (Spike Jonze, David Fincher, Michel Gondry, Mark Romanek, Anton Corbijn, Marc Webb, Jonathan Glazer) and today popular film and TV borrow much from the medium. [91]

Since the 1980s, average shot length (ASL), defined as the length of the film in seconds divided by the number of shots in it, has continued to decrease. Calculating ASL is one of the long time projects of Barry Salt, an Australian who has been a historian of film style, a ballet dancer, a professional lighting cameraman, a doctor of theoretical physics and a contributor to Cinemetrics, an online tool for counting shot lengths developed by Yuri Tsivian, a professor at Chicago University. This growing body of data about shot lengths allows historians of film style to specify how the pace of cutting in films has increased. In 1930s, classical Hollywood cinema the average shot length was between :08 and :11 seconds. By the 1980s, average shot lengths in the double-digit range virtually disappeared from feature films, with an average between :05 and :08 seconds. Certain films like *Top Gun* (Scott, 1986) and *Pink Floyd: The Wall* (Parker, 1982) were already testing that newer norm with ASLs from :03 – :04 seconds. Even in films that are more dialogue driven, not action driven, Bordwell notes the acceleration over the decades: the ASL of *Ordinary People* (Redford, 1980) is 6.1 seconds, of *Ghost* (Zucker, 1990) is 5.0 seconds, and *Almost Famous* (Crowe, 2000) is 3.9 seconds, a trend he attributes to more close ups cut at every line of dialogue, and the use of more reaction shots.[92]

Bordwell explicates the use of intensified continuity's in dialogue scenes with a close reading of Dorothy (Renée Zellweger) and Jerry (Tom Cruise) "meeting cute" in the airport from *Jerry McGuire* (Crowe, 1996). Having just gotten off a plane, Dorothy, an accountant in the same sports management firm as Jerry, runs into him as she is searching for her missing son near the baggage carousel. See Critical Commons, "*Jerry McGuire*: Intensified Continuity."[93]

The scene is staged "stand-and-deliver," a style of filmmaking where the actors enter a scene, hit their marks (standing or seated) and address each other. This staging usually is captured using the master shot technique where the camera films a master shot, then repeats the action to capture over the shoulder shots, singles and any cutaway material that might be useful. A contrasting style is known as "walk-and-talk," a kind of staging where two people (usually) walk towards camera (usually) delivering their dialogue as it tracks backward. This method allows longer takes of dialogue to be delivered in a space that is relevant to the story. Bordwell notes that *both* types of staging flourished in classical Hollywood films, along with a style in between called the *plan-américain*, in this instance, a framing where the bottom frame line falls from mid thigh to below the knee, often showing two people talking.

The camera does not move as freely in this scene as might be expected with intensified continuity; however, the opening shot of Dorothy dollies with her deeper into the space near the baggage carousel. Throughout, the long lens dominates, as there are only four long shots, and two of those re-frame to tighter shots. The longer shots that do orient us to Dorothy's initial conversation with Jerry are over the shoulder shots that shift to tight close ups as Jerry points Dorothy to her son Ray (Jonathan Lipnicki) riding on the baggage carousel. Dorothy chastises her son in tight close ups, and Jerry says good-bye to them, his luggage in tow. Drawn back to her as she compliments Jerry on his controversial mission statement, the scene moves from over the shoulder shots to tight

close ups almost exclusively, following the dialogue and occasionally showing Ray as he starts to swing playfully on their arms. Bordwell finds much here that is "intensified:"

> These framings are about as close as those seen earlier, but there are many more of them here, signaling the development of the romance. Most scenes in commercial movies (and television shows) are staged, shot, and cut as this conversation is. In stand-and-deliver passages like this, the visual interest springs not from complex staging but from techniques of editing and camerawork . . . [Intensified continuity] editing simply accelerates the pace of scenes presented in ordinary ways. Instead of three or four reverse shots we might get ten or twelve, with each line or facial reaction assigned a separate shot.[94]

With intensified continuity dominating the editing of contemporary films, many people feel that dialogue scenes have become reliant solely on facial expression rather than on gestures and body language between actors. The subtleties of acting honed in classic Hollywood films are lost in closer framings: the way an actor's stance addresses another actor, the use of eye-line and gaze, slight gestures that carry so much meaning. We will return to these issues in chapter 8 when we examine rhythm.

Conclusion

Bordwell's account of filmic narration has far reaching applications, and we have only scratched the surface of what he endeavors to explain with it. Armed with an account of how the viewer's perceptual capacities construct the story world, identify character motives, sift cause and effect, recognize gaps and so on, Bordwell has spent a large part of his professional life giving credible accounts of how meaning is made in a wide range of films, film styles and film genres. The impact of his co-authored book, *The classical Hollywood cinema: film style and mode of production to 1960*, has reverberated over the last decades, in part because, as Manohla Dargis notes

> This was history with a vengeance: detailed, rigorous, monumental. Though well received, the book had its detractors and continues to draw criticism for, among other things, its cut-off dates and insistence on the coherence of the Hollywood style. The book alone certainly didn't reintroduce history back into film studies, but its insistence on the historical conditions that control and shape "textual processes," along with the depth and breadth it brought to writing film history, has been profound.[95]

Perhaps more importantly, as he is quick to point out, his "middle-level" theorizing requires no overarching "Grand Theory" drawn from cultural studies, linguistics, postmodernism or psychoanalysis to frame its discussion. For Bordwell, this "middle-level" work remains the correct arena for fruitful research, a point made as only he can state it: "Sharply focused, in-depth inquiry remains our best bet for producing the sort of scholarly debate that will advance our knowledge of cinema. Grand theories will come and go, but research and scholarship will endure."[96]

Notes

1 David Bordwell, *Narration in the fiction film* (Madison, WI: University of Wisconsin Press, 1985), 74.
2 David Bordwell, "Historical Poetics of Cinema," in *The cinematic text: methods and approaches,* edited by R. Barton Palmer (New York: AMS Press, 1989), 370.
3 Ibid., 371.
4 David Bordwell, *Narration in the fiction film* (Madison, WI: University of Wisconsin Press, 1985), 39.

5 David Bordwell, Kristin Thompson and Jeff Smith, *Film art: an introduction*. (New York: The McGraw-Hill Companies, 2017), 73.
6 David Bordwell, "Three Dimensions of Film Narrative," *Poetics of cinema* (New York: Routledge, 2008), 14.
7 Ibid., 14.
8 The clip, "*Maltese Falcon*: Opening Scene," is on Critical Commons at http://www.criticalcommons.org/Members/m_friers/clips/maltese-falcon-opening-scene.
9 "Film Styles and Conventions Used by Filmmakers." Accessed January 14, 2017. http://www.cinemateca.org/film/film_styles.htm.
10 David Bordwell, "Three Dimensions of Film Narrative," *Poetics of cinema* (New York: Routledge, 2008), 13.
11 Bordwell describes *excess* as elements at work in the film that lie outside our awareness of a film's structures and conventions: "Is there anything in a narrative film that is not narrational? Any image or sound can contribute to narration, but we can also attend to an element for its sheer perceptual salience . . . Kristin Thompson has identified these elements as 'excess' . . . excess is precisely those elements that escape unifying impulses." David Bordwell, *Narration in the fiction film* (Madison, WI: University of Wiconsin Press, 1985), 53.
12 Ibid. 163.
13 David Bordwell, Kristin Thompson and Jeff Smith, *Film art: an introduction* (New York: The McGraw-Hill Companies, 2017), 73.
14 David Bordwell, *Poetics of cinema* (New York: Routledge, 2008), 98.
15 Edward Buscombe,"Film History and the Idea of a National Cinema," *Australian Journal of Screen Theory* 9(10) (1981): 141.
16 Ibid., 85.
17 David Bordwell, *Narration in the fiction film* (Madison, WI: University of Wisconsin Press, 1985), 157.
18 Ibid., 158.
19 Ibid., 157.
20 Ibid., 77.
21 André Bazin and Hugh Gray, *What is cinema? Volume I* (Berkeley: University of California Press, 1967), 60.
22 John Bailey, "Arthur C. Miller: Early Cinematography Pioneer and ASC President." ASC 2016. Accessed December 21, 2016. http://www.theasc.com/site/blog/johns-bailiwick/arthur-c-miller-early-cinematography-pioneer-asc-president/.
23 The clip, "Deep Focus Cinematography in *Citizen Kane* 2," is on Critical Commons at http://www.criticalcommons.org/Members/bnd/clips/deep-focus-cinematography-in-citizen-kane-2.
24 The clip, "Deep Space and Off-screen Sound in *How Green Was My Valley*," is on Critical Commons at http://www.criticalcommons.org/Members/m_friers/clips/how-green-was-my-valley/.
25 Mitry argues for three other fundamental structures underlying our experience of motion pictures: the dual nature of the photographic image as both psychological double and aesthetic representation of the world, the film frame as both a window on the world and a formalizing frame, and the illusion of movement created by the phi phenomenon. For a short overview of Mitry's synthetic theory on the fundamental structures that underlie the human experience of film, see Livingston, Paisley and Carl R. Plantinga (eds), *The Routledge companion to philosophy and film*, (London: 2009), 400.
26 Michael Betancourt, *Beyond spatial montage: windowing, or the cinematic displacement of time, motion and space* (New York, NY: Routledge, 2016) 3.
27 Ibid., 96.
28 Ibid., 97.
29 A longer, sustained use of the four panel construction is *Timecode*, a 2000 American experimental film written and directed by Mike Figgis.
30 The clip, "Split-screen in the Opening of *Requiem for a Dream*," is on Critical Commons at http://www.criticalcommons.org/Members/m_friers/clips/split-screen-in-the-opening-of-requiem-for-a-dream.
31 Ibid., 10.
32 Jeff Stark, "It's a punk movie," *Salon*. October 13, 2000. Accessed December 27, 2016. http://www.salon.com/2000/10/13/aronofsky/.
33 The clip, "*Lost Highway*: Second Video Replay" is on Critical Commons at http://www.criticalcommons.org/Members/m_friers/clips/lost-highway-2nd-video-replay/view.
34 The clip, "*Buffalo '66*: Successive Events, Simultaneous Presentation," is on Critical Commons at http://www.criticalcommons.org/Members/m_friers/clips/buffalo-66-successive-events-simultaneous.

35 David Bordwell, *Narration in the fiction film* (Madison, WI: University of Wisconsin Press, 1985), 77.

36 David Bordwell, "*Inception*; or, Dream a Little Dream within a Dream with Me." Accessed December 29, 2016. http://www.davidbordwell.net/blog/2010/08/06/inception-or-dream-a-little-dream-within-a-dream-with-me/.

37 The clip, "*Inception*: Montage of Ariadne awakening," is on Critical Commons at http://www.critical-commons.org/Members/m_friers/clips/inception-montage-of-ariadne-awakening/.

38 David Bordwell, "*Inception*; or, Dream a Little Dream within a Dream with Me," Accessed December 29, 2016. http://www.davidbordwell.net/blog/2010/08/06/inception-or-dream-a-little-dream-within-a-dream-with-me/.

39 Ibid.

40 The clip, "*Midnight Cowboy:* Opening Sound Bridges," is on Critical Commons at http://www.criticalcommons.org/Members/m_friers/clips/midnight-cowboy_opening_sound-bridges/.

41 David Bordwell, *Narration in the fiction film* (Madison, WI: University of Wisconsin Press, 1985), 77.

42 Ibid., 79.

43 Ibid., 78.

44 In Christopher Nolan's *The Prestige* (2006), a sonic flashback takes place at the end of the film, a recounting that is not enacted. See "Non-simultaneous Sound in *The Prestige*," on Critical Commons, http://www.criticalcommons.org/Members/pcote/clips/prestige-sonic-flashback-and-flashforward.mov.

45 Actually, the majority of the *Liberty Valance* is told in flashback, as Ranse Stoddard returns to Shinbone as an old man and is being interviewed by a reporter. So technically, this recounted enactment is a flashback within a larger flashback.

46 The clip, "Flash Back: The Original Scene in *The Man Who Shot Liberty Valance* that Later Replays as a Recounted Enactment," is on Critical Commons at http://www.criticalcommons.org/Members/m_friers/clips/flash-back-the-original-scene-in-the-man-who-shot.

47 The clip, "Flash Back: Recounted Enactment in *The Man Who Shot Liberty Valance*," is on Critical Commons at http://www.criticalcommons.org/Members/m_friers/clips/flash-back-recounted-enactment-in-the-man-who-shot.

48 This type of flashback, to an event *already seen* in the syuzhet is called an internal flashback, while a flashback to an event *not previously seen* in the syuzhet is called an external flashback.

49 David Bordwell, *Narration in the fiction film* (Madison, WI: University of Wisconsin Press, 1985), 80.

50 The clip, "*Wayne's World*: Spoofing a Marked Temporal Reversal," is on Critical Commons at http://www.criticalcommons.org/Members/m_friers/clips/waynes-world-spoofing-a-marked-temporal-reversal.

51 Meir Sternberg, *Expositional modes and temporal ordering in fiction* (Baltimore: Johns Hopkins University Press, 1978), 94.

52 David Bordwell, *Narration in the fiction film* (Madison, WI: University of Wisconsin Press, 1985), 55.

53 Ibid., 79.

54 Kristin Thompson, "The Formulation of the Classical Style, 1909–28," in *The classical Hollywood cinema: film style and mode of production to 1960* (New York, NY: Columbia University Press, 1985), 269.

55 David Bordwell, *The cinema of Eisenstein* (Cambridge, MA: Harvard University Press, 1993), 13.

56 The clip, "*Maltese Falcon*: Opening Scene," is on Critical Commons at http://www.criticalcommons.org/Members/m_friers/clips/maltese-falcon-opening-scene.

57 The clip, "*Goodfellas*: Multiple Enactment, Single Recounting in the Murder of 'Stacks'" is on Critical Commons at http://www.criticalcommons.org/Members/m_friers/clips/goodfellas-multiple-enactment-single-recounting-in.

58 David Bordwell, *Narration in the fiction film* (Madison, WI: University of Wisconsin Press, 1985), 80.

59 Ibid., 80.

60 Gary Comenas, "Sleep - Andy Warhol." Accessed January 3, 2017. http://www.warholstars.org/sleep.html.

61 Eugene Archer, "Festival Bringing Pop Artist's Films To Lincoln Center," *The New York Times* (September 12, 1964), Section: food fashions family furnishings. Accessed January 3, 2017. http://www.nytimes.com/ref/nytarchive.html.

62 "Russian Ark," Wikipedia. Accessed January 3, 2017. https://en.wikipedia.org/wiki/Russian_Ark.

63 Bordwell uses *Rear Window* as the basis for chapter 3 of *Narration in the fiction film* to compare and explain spectator activities: those of the photographer Jim Jefferies in the movie, and those of viewers watching narrative film.

64 David Bordwell, *Narration in the fiction film* (Madison, WI: University of Wisconsin Press, 1985), 55.

65 The clip, "Jump Cuts (Dissolves) in *Last Temptation of Christ*," is on Critical Commons at http://www.criticalcommons.org/Members/m_friers/clips/jump-cuts-dissolves-in-last-temptation-of-christ.

66 Herbert Zettl, *Sight sound motion: applied media aesthetics* (Boston, MA: Wadsworth, 2014), 282.

67 The clip, "*Clockwork Orange*: Fast motion (Syuzhet Compression)," is on Critical Commons at http://www.criticalcommons.org/Members/m_friers/clips/clockwork-orange-fast-motion-syuzhet-compression.

68 The clip, "*Requiem for a Dream* (Aronofsky, 2000) – Drug Timelapse," is on Critical Commons at http://www.criticalcommons.org/Members/dsbaldwin32/clips/requiem-for-a-dream-aronofsky-2000-2014-drug.

69 The clip, "His Girl Friday: Temporal Expansion by Repetition/Insertion," is on Critical Commons at http://www.criticalcommons.org/Members/m_friers/clips/his-girl-friday-temporal-expansion-by-repetition.

70 For more on staging styles, see David Bordwell, *Figures traced in light: on cinematic staging* (Berkeley: University of California Press, 2005), chapter 2.

71 David Bordwell, *Narration in the fiction film*. (Madison, WI: University of Wisconsin Press, 1985) 84.

72 The clip, "*Bonnie and Clyde*: Final Ambush Scene," is on Critical Commons at http://www.criticalcommons.org/Members/m_friers/clips/bonnie-and-clyde-final-ambush-scene.

73 Jean-Louis Comolli and André S. Labarthe, "Interview with Arthur Penn," in *Focus on Bonnie and Clyde*, edited by John G. Cawelti (Englewood Cliffs, N.J.: Prentice-Hall, 1973), 17.

74 David A. Cook, "Ballistic Balletics," in *Transfigurations: violence, death and masculinity in American cinema*, edited by Asbjørn Grønstad (Amsterdam: Amsterdam University Press, 2008), 142.

75 Ibid., 143.

76 Catherine Russell, *Narrative mortality: death, closure, and new wave cinemas* (Minneapolis: University of Minnesota Press, 1995), 183.

77 Herbert Zettl, *Sight sound motion: applied media aesthetics* (Boston, MA: Wadsworth, 2014), 280.

78 Maya Deren, "The Instrument of Discovery and Instrument of Invention/The Art of Film" from *An anagram of ideas on art, form and film* (Yonkers, NY: Alicat Book Shop Press, 1946), 48.

79 Ray Gamache, "A History of Sports Highlights: Replayed Plays from Edison to ESPN" (Jefferson NC, US: McFarland, 2010). http://public.eblib.com/choice/publicfullrecord.aspx?p=557080, Accessed January 7, 2017. ProQuest ebrary, 103.

80 The clip, "*Beauty and the Beast* (Cocteau): Slow Motion," is on Critical Commons at http://www.criticalcommons.org/Members/m_friers/clips/beauty-and-the-beast-cocteau-slow-motion.

81 The clip, "*Seven Samurai*: Slow motion death sequence," is on Critical Commons at http://www.criticalcommons.org/Members/m_friers/clips/seven-samurai-slow-motion-death-sequence.

82 Dan Eagan, "America's Film Legacy: The Authoritative Guide to the Landmark Movies in the National Film Registry," ProQuest Ebook Central and EBL catalog. 2010. Accessed January 9, 2017. http://public.eblib.com/choice/publicfullrecord.aspx?p=564235.

83 I am counting this four minutes from the close up of Dutch grinning that follows the shooting of Colonel Mohr until the firing stops with Pike still gripping the machine gun, before he and Dutch fall to the ground.

84 The clip, "*The Wild Bunch*: Final Shootout (:14 Excerpt, Lyle on the Machine Gun)," is on Critical Commons at http://www.criticalcommons.org/Members/m_friers/clips/the-wild-bunch-final-shootout-14-excerpt-lyle-on.

85 The clip, "*The Matrix*: Slow Motion and 'Bullet Time,'" is on Critical Commons at http://www.criticalcommons.org/Members/m_friers/clips/the-matirx-slow-motion-and-bullet-time.

86 The clip, "*300*: Slow Motion Violence," is on Critical Commons at http://www.criticalcommons.org/Members/m_friers/clips/300-slow-motion-violence.

87 Catherine Russell, *Narrative mortality: death, closure, and new wave cinemas* (Minneapolis: University of Minnesota Press, 1995), 186.

88 David Bordwell, "Intensified Continuity: Visual Style in Contemporary American Film," *Film Quarterly* 55(3) (Spring 2002): 21.

89 The clip, "*Jaws*: In Camera Wipes or Wipe by Cuts," is on Critical Commons at http://www.criticalcommons.org/Members/m_friers/clips/jaws-in-camera-wipes-or-wipe-by-cuts.

90 The clip, "*Devil Wears Prada*: In Camera Wipes or Wipe by Cuts," is on Critical Commons at http://www.criticalcommons.org/Members/m_friers/clips/devile-wears-prada-in-camera-wipes-or-wipe-by-cuts.

91 Lauren Rosewarne, "How the MTV Generation Turned Movies into Long Music Videos," *The Guardian*, January 6, 2014. Accessed January 11, 2017. https://www.theguardian.com/commentisfree/2014/jan/06/walter-mitty-music-video-movie-mtv-directors.

92 David Bordwell, "Intensified Continuity: Visual Style in Contemporary American Film," *Film Quarterly* 55(3) (Spring 2002): 17.

93 The clip, "*Jerry McGuire*: Intensified Continuity," is on Critical Commons at http://www.criticalcommons. org/Members/m_friers/clips/jerry-mcguire-jerry-and-dorothy-meet-cute.

94 David Bordwell, "Intensified Continuity: Visual Style in Contemporary American Film," *Film Quarterly* 55(3) (Spring 2002): 26.

95 Manhola Dargia, "You Can Judge a Book by Its Movie," *The New York Times*, April 25, 2010, AR8.

96 David Bordwell and Noël Carroll, *Post-theory: reconstructing film studies* (Madison: University of Wisconsin Press, 1996), 30.

5 Eisenstein and Montage

Sergei Mikhailovich Eisenstein (1898–1948) was the only son of a Jewish architect from Riga, and a mother who came from a well to do merchant family that was Russian Orthodox. The boy's early family life was troubled by the authoritarian rule of his father, and he moved with his mother to St. Petersburg in 1905. His father joined them there in 1910, and his mother moved to Paris shortly thereafter, leaving Sergei in the care of his father. Eisenstein tried to follow in his father's footsteps, studying civil engineering, but the 1917 Russian Revolution cut short his studies. He was drafted and sent to the front, and in 1918 he joined the Red Army while his father was allied with the White Guard, the anti-communist forces. An avid artist, Eisenstein drew continuously throughout his life, and his longstanding interest in the circus led him to a unit in the army that would stage plays and skits on the battlefront.

Mustered out of the army in 1920, he studied Japanese for a while before abandoning formal education for the Proletkult Central Workers Theatre. While working in this avant-garde theatre, Eisenstein studied under Vsevolod Meyerhold, a director of innovative, experimental drama, and an immensely influential figure in modern theatre. One of Eisenstein's early works was a production of the play *Gas Masks*, staged in the Moscow Gasworks using the working turbines and catwalks of the complex as the setting for the action. In 1924, he suggested to Proletkult that they make a seven-part film series of agitation-propaganda films to glorify the revolution, and he launched into direction of his first feature, *Strike* with very little film experience but with the help of Edward Tisse, a military newsreel cameraman who would become his lifelong collaborator and cinematographer. *Strike* examined the steps leading to the political awakening of a factory, using broadly drawn characters and masses of workers to enact a heroic uprising that ends with an extreme close up of a pair of eyes glaring at the audience coupled with the title, "Proletarians, remember!"

The next year, 1925, Eisenstein completed *Battleship Potemkin*, a remarkable, internationally recognized film, that was both celebrated and sharply contested in Germany, France, the United Kingdom and the Netherlands. The film brought unprecedented profits for the Soviet film industry, and its reach extended as far as Hollywood where the powerful producer David O. Selznick declared it "unquestionably one of the greatest motion pictures of all time" and encouraged MGM to hire the director.[1] Eisenstein was only 27 years old at the time, and *Potemkin* was a sensation, bringing the revolutionary fervor of his stage work to cinema, along with mass spectacle, intense screen violence never before seen, and a radically different style of editing. Along with the film, Eisenstein began to create a new theory of montage that explained how cinema could agitate the masses into political consciousness.

With only two films to his credit, Eisenstein was now world famous, at the center of Soviet filmmaking, and engaged in a community of young, emerging film artists, who worked in the state owned film industry bent on expanding the message of the Russian Revolution to mobilize mass action. In the vortex of revolutionary changes in social, political and artistic expression, Eisenstein would struggle his entire life to create imaginative works in a film, and to theorize

their construction, while negotiating the prevailing political winds of a state enterprise operating under Soviet dictatorship. Theorizing about practical methods for creating impactful films was central to Eisenstein's creative practice: he was as influential as a film theorist as he was a filmmaker. He was profoundly affected by *Constructivism*, a modern art movement that embraced abstraction, rejected the past, and sought to pare the work down to its essential elements. Constructivism advocated the creation of art that had the quality of *factura*, meaning the surface of the object should demonstrate how it had been made. In theatre, this meant that a creation for the stage should make its methods of production explicit. Constructivism was part of a larger trend in Soviet culture as a whole toward "*techné*-centered thought. *Techné* is Aristotle's term for the unity of theory and practice within skilled activity." [2] In his view, the craftsperson should seek to master not only techniques, but also the standardized knowledge underlying them. Likewise, Soviet filmmakers, in the spirit of the times, sought to fully explore and understand the creative means available to them. Given Eisenstein's international prominence, he was at the center of that enterprise, and both his creative film work and his dogged pursuit of the theoretical principles underlying them led to groundbreaking innovations in cinema.

At the same time, Eisenstein was largely a self-taught artist, a ravenous reader, and a prolific writer. His written work is wide open, overwrought and telegraphic, leaping from one topic to the next. His writing reflects a commitment to conflict and montage as much as his films do, and he tries to impress the reader with the connections he makes to other art forms and other cultures (i.e., music, kabuki theatre, haiku, etc.). Eisenstein is constantly remodeling old concepts and inventing new ones, "which are themselves transformed or 'outgrown.' Eisenstein himself rather aptly dubbed this aspect of his work a 'theoretical self-service cafeteria.'"[3] And while his theories explain film phenomena on the macro and the micro scale in intuitive and descriptive ways that perhaps only an accomplished film artist could, they often do not bear the weight of close scrutiny. His terminology is often vague or left undefined, and its use is undisciplined, so the reader is often left to ponder what exactly Eisenstein is referring to. In other instances, like Eisenstein's famous chart of "vertical montage" in *Alexander Nevsky* (see p. 191), scholars have dismissed his theories as "heavy artillery to shoot sparrows."[4] His work has resisted neat unification, and he has been called "an unsystematic autodidact, a modern Leonardo da Vinci, a materialist in the grips of mysticism and conversely a Mystic in the grip of materialism, A neo-formalist, a semiotician, compliant propagandist, and an artist driven by an unresolved Oedipal complex."[5] To understand the editing theory of Sergei Eisenstein, and the work that engenders it, we will first look to the theories of his Russian contemporaries for context, clarify a few meanings of the word "montage," examine Eisenstein's early theories on how montage works to "seize the spectator," and finally review the typology of montage that he proposed for understanding how editing functions in cinema.

Eisenstein's Contemporaries

Like Eisenstein, the most prominent filmmakers in the emerging Soviet cinema were very young: when *Potemkin* was released in 1925, three of the most significant were Dzia Vertov at 29, Lev Kuleshov, only 26 and Vsevolod Pudovkin who was 32. And while the left avant-garde was never a particularly unified movement,

> the new Soviet Cinema offered the welcome spectacle of an art of the machine age belatedly shaking off its early subservience to nineteenth-century popular entertainment values . . . Cinema as a new mode of vision, a new means of social representation, a new definition of popular art, embodying new relations of production and consumption – all these aspirations found confirmation in the films and declarations of Eisenstein, Pudovkin and Vertov.[6]

If we focus for a moment on three of Eisenstein's contemporaries – Vertov, Kuleshov and Pudovkin – we can better understand how Soviet cinema of the 1920s was a remarkable attempt to transform a popular art form, rapidly consolidating in Hollywood, into "a new mode of vision."

Dziga Vertov (1896–1954)

Born David Abelevich Kaufman into a Jewish family in Poland in 1896, he changed his name into the more Russian Denis Arkadievich, and ultimately into "Dziga Vertov," an avant-garde moniker that loosely translates from Ukranian as "spinning top" or "spinning gypsy." In spring 1918 Vertov joined the Moscow Cinema Committee, and worked as a cameraman on weekly newsreels designed to highlight the achievements of the Soviet government. By 1919, he met Elizaveta Svilova, who worked with the Moscow committee as an editor. Svilova was willing to edit his films to include the innovations he was seeking, and within a short time they were married. She edited every film he made from that point forward. The couple pursued a new newsreel series, *Cine-Pravda* (literally, *Cine-Truth*) with the help of Vertov's brother Mikhail Kaufman. Vertov quickly discovered the power of nonfiction motion picture propaganda to awaken the masses. This approach was consistent with the politics of the age in which Bolshevik journalism placed the newspaper at the center of motivating the masses. Lenin wrote: "A newspaper is not only a collective propagandist and a collective agitator, it is also a collective organizer."[7] Falling under many of the same influences as Eisenstein and Kuleshov, Vertov explored the formalist techniques consistent with the experimental milieu in which he came of age – slow motion, fast motion, double exposure, freeze frame, canted angles, superimposition, comparison by cutting, fastening the camera to cars and trains for tracking shots etc. – anything that would increase the impact of nonfiction motion pictures on Soviet audiences. While he condemned the study of aesthetics, he was writing provocative manifestoes about the power of the Kino-eye, the more perfect vision of the motion picture camera,

> more perfect than the human eye, for the exploration of the chaos of visual phenomena that fill space. The kino-eye lives and moves in time and space; it gathers and records impressions in a manner wholly different from that of the human eye . . . Until now, we have violated the movie camera and forced it to copy the work of our eye. And the better the copy, the better the shooting was thought to be. Starting today we are liberating the camera and making it work in the opposite direction – away from copying.[8]

Vertov aimed to capture "film truth" by organizing elements of reality into films that reveal a deeper truth unseen by the human eye. His greatest works combine un-staged footage ingeniously, with tremendous rhetorical force, distilling "the sensibilities of newspaper column and Futurist poem into nonfiction feature films of incredible power and sophistication."[9] Vertov's body of work had significant impact on the development of realism and nonfiction films during the 1920s, and his most famous feature film, *The Man with a Movie Camera* (1929) exhibits the creative genius of Svilova's editing, particularly in the accelerated editing sequence that ends the film. See Critical Commons, "Editing Rhythm in *The Man with a Movie Camera*."[10]

Vertov's work continued to influence the documentary into the 1960s. His goal of revealing the truth underlying brute reality with improvisational camerawork greatly influenced the emergence of *cinéma vérité*, led by the French anthropologist Jean Rouch, and the *direct cinema* movement of Albert and David Maysles, Richard Leacock and D. A. Pennebaker in the United States.

Lev Kuleshov (1899–1970)

In a career that spanned 50 years, Lev Kuleshov (1899–1970) was a groundbreaking director, film theorist, and professor at V.G.I.K. one of the oldest film schools in the world, established in

Moscow in 1919.[11] The feature films of Lev Kuleshov are rarely seen in the West, but many of Russia's most prominent directors trained under him, including Pudovkin, Eisenstein, Kalatozov and Parajanov. In his earliest writing about cinema he argued for a new, heroic style of filmmaking to replace the stultifying work coming from the budding Russian film industry. Kuleshov began to write and experiment with problems of acting and shot sequencing, and he sought to reduce film to its most basic material element, arriving at editing as the formal element specific to cinema. Though he directed 19 silent and sound feature films, many of which were nuanced psychological dramas, and wrote several significant books on filmmaking, he is known for his experiments in editing, particularly for what has become known as the "Kuleshov effect."

Working with only rudimentary resources – some of his editing experiments were shot in 1921 on 90 meters (roughly 3.5 minutes) of 35mm film[12] – Kuleshov began

> to consider whether, under the powerful influence of montage, the spectator perceives an intentionally created *Gestalt* in which the relationship of shot to shot overrides the finer aspects of any actor's performance. The famous "Kuleshov effect" with the Russian actor Mozhukin [also know as Ivan Mosjoukine] affirmed the speculation. Having found a long take in close up of Mozhukin's expressionlessly neutral face, Kuleshov intercut it with various shots, the exact content of which he himself forgot in later years – shots, according to Pudovkin, of a bowl of steaming soup, a woman in a coffin, and a child playing with a toy bear – and projected these to an audience which marveled at the sensitivity of the actor's range.[13]

Pudovkin went on to say that the audience "raved about the acting . . . the heavy pensiveness of his mood over the forgotten soup, . . . the deep sorrow with which he looked on the dead child, . . . the lust with which he observed the woman. But we knew that in all three cases the face was exactly the same."[14] Although the film does not survive intact, the impact of this experiment has been pervasive, suggesting that juxtaposition is a powerful creator of meaning. It has been studied and written about in countless texts, including a 1964 CBS television interview with Alfred Hitchcock. See Critical Commons, "A Talk with Hitchcock (1964) – Hitchcock Explains the Kuleshov Effect" and a reconstruction of the film *The Kuleshov Effect*.[15]

Beyond this experiment, Kuleshov is also remembered for experiments in "artificial landscapes" (now commonly called *creative geography*) in which a sequence containing shots of actors walking in disparate areas of Moscow ends with a two shot of them converging, an early demonstration that motion vectors in film (to use Herbert Zettl's terminology) are key to building and stabilizing the viewer's spatial orientation, (see Chapter 1, p. 24). Creative geography is further demonstrated in a Kuleshov sequence of actors walking up steps of a Moscow landmark, conjoined with a stock shot of the White House in Washington, D.C., creating a unique, unified screen space from distinct real spaces. In another instance, Kuleshov synthesized a film of a woman moving by cutting together shots of the feet, heads and hands of different women. Kuleshov went on to publish three significant books of film theory and practice, and, despite coming under attack in the Stalin era, was appointed in 1944 to Head of the All-Russian Institute of Cinematography (V.G.I.K.), received the nation's highest award, the Order of Lenin in 1967, and continued to lecture on filmmaking until very late in his life.

Vsevolod I. Pudovkin (1893–1953)

An engineering student in Moscow, Pudovkin served in the artillery during World War I. He was captured by the Germans, spent three years in prison, was released and returned to the city in 1918. He entered V.G.I.K. in 1920 and studied under Kuleshov, leaving in 1923 to join Kuleshov's Experimental Laboratory. One of his first successful features, *Mother* (1926) was drawn from the Maxim Gorky novel, and became a classic film of the Russian silent period.

Set in the Russian Revolution of 1905, a vast movement of peasant unrest, worker's strikes and mutinies in the armed forces, The Mother (Vera Baranovskaya) is caught between The Father (Aleksandr Chistyakov) and The Son (Nikolai Batalov) who are on opposite sides of a factory strike. After The Father is killed in the strike, The Mother's actions inadvertently send her son to prison. With her political consciousness transformed, she joins a march to free the strikers, who, learning of the approaching march, plan to escape. The Son is shot during the escape, and at the end of the film, The Mother is trampled to death by the Tsarist cavalry.

Pudovkin believed that a central problem for the film artist is to find a way to reveal emotions visually. He writes,

> The scenario-writer must bear always in mind the fact that every sentence that he writes will have to appear plastically upon the screen in some visible form. Consequently, it is not the words he writes that are important, but the externally expressed plastic images that he describes in these words.[16]

Plastic material is perhaps more commonly known as the *objective correlative*, a term coined in 1922 by T. S. Eliot who argues that "The only way of expressing emotion in the form of art is by finding an objective correlative; in other words, a set of objects, a situation, a chain of events which shall be the formula of that particular emotion."[17] Pudovkin argues that incorporating plastic material in film allows the actors to tone down their performances, to underplay what would be more broadly rendered on the stage because the director, through montage, is able to associate the actor's performance with powerful, expressive imagery that will help carry the scene.

After The Father is killed early in *Mother*, Pudovkin creates a long, somber evening scene of The Mother "sitting with the dead," as her husband lies in on a bier in their home. See Critical Commons, "*Mother* (Pudovkin, 1926) The Objective Correlative: Water Dripping."[18] The pace of the cutting is very slow and methodical, and the movements of the actors are subdued, and almost motionless. The sequence proceeds as follows:

1 A somber two shot in the family home of the mother, sitting in grief adjacent to the deceased father who is lying on a bier. The mother sits stoically. (:07 seconds)
2 Cut to a medium close up of a pan of water from a Russian "rukomoynik," a kind of functional, industrial wall-mounted sink. The water drips slowly into the basin, creating a slow, metronomic beat. (:07 seconds)
3 Cut to a medium close up of the mother, eyes distant, expressionless, staring straight into the camera. (:04 seconds)
4 Cut to the medium shot of the father motionless on his bier. (:04 seconds)
5 Cut to the medium close up (shot 2) of a slow drip into pan of water. (:07 seconds)
6 Cut to a long shot, the son opens the door and enters. (:05 seconds)
7 Cut to the somber two shot (shot 1) of mother by the bier. (:04 seconds)
8 Cut to long shot of the son at door (shot 6), he stares while the door continues to slowly swing open behind him. (:08 seconds)
9 Cut to the medium shot of the father (shot 4) motionless on his bier. (:03 seconds)
10 Cut to the medium close up (shot 3) of the mother expressionless, staring straight into the camera. (:03 seconds)
11 Cut to long shot of the son at door (shot 6), he stares and drops his hands to his side. (:05 seconds)
12 Cut to the medium close up (shot 3) of the mother expressionless, staring straight into the camera. (:03 seconds)
13 Cut to long shot of the son at door (shot 6), he crosses without taking his eyes off his parents, and sits slowly on the bed. (:07 seconds)

14 Cut to the medium close up (shot 2) of a slow drip into pan of water. (:07 seconds)
15 Cut to the medium close up (shot 3) of the mother expressionless, staring straight into the camera. (:03 seconds)
16 Cut to long shot of the son on the bed (shot 6) and he finally speaks. (:03 seconds)
17 Title card: "Who killed him?"

The Mother answers that one of his friends, a trouble making striker, killed his father, and Pudovkin returns for one more round of close ups, this time with tears in The Mother's eyes, followed by the water dripping, before closing on The Father dead on the bier.

The shot selection, acting, and cutting here are all very restrained. The shot selection consists of five shots that are virtually static, except for The Son who slowly sits on the bed. The establishing two shot of Mother and deceased Father is used to open the scene, and to re-establish when The Son enters. At the bier, there are close ups of the expressionless Mother (shown seven times) and the motionless Father (shown four times, including the closing shot). At the door there is a long shot of The Son entering, staring, then sitting, and asking who killed his father (shown six times). Also at the door is a close up of the water dripping from the rukomoynik into the basin (shown four times).

The cycling of these shots is tactful, and the cutting rhythm is tranquil and detached. At the core of the scene is the repeated stasis of mother and father, widow and corpse, intercut with the dripping water that continues to mark the slow, inevitable passage of time, like the grains of sand through an hourglass. Visually, the dripping water is a precise choice for the *objective correlative*, suggesting at once, the monotony of a ticking clock, the loss of vital essence, the relentless forward motion of time, and the mother's tears, which conclude the scene.[19] The fusion of these elements synthesizes a feeling of grief, "the Hour of Lead,"[20] to use a line from the famous Emily Dickenson poem.

Pudovkin returns to the use of plastic material throughout the film, creating *plastic synthesis* through montage:

> [In] *Mother*, I try to affect the spectators, not by the psychological performances of an actor, but by plastic synthesis through editing. The son sits in prison. Suddenly, passed in to him surreptitiously, he receives a note that next day he is to be set free. The problem was the expression, filmically, of his joy. The photographing of a face lighting up with joy would have been flat and void of effect. I show, therefore, the nervous play of his hands and a big close-up of the lower half of his face, the corners of the smile. The shots I cut in with other and varied material – shots of a brook, swollen with the rapid flow of spring, of the play of sunlight broken on the water, birds splashing in the village pond, and finally a laughing child. By the junction of these components our expression of "prisoner's joy" takes shape.[21]

See Critical Commons, "*Mother* (Pudovkin, 1926) The Objective Correlative: Spring."[22]

Pudovkin Versus Eisenstein

Beyond his use of plastic material, it is instructive to compare Pudovkin's concept of montage to Eisenstein's. Like Kuleshov, Pudovkin sees editing as linkage, shots joined like links in the chain, a construction assembled "Screw by screw, brick by brick."[23] Eisenstein counters that this notion of editing is only a diluted version of the real source of editing's power, conflict. In 1929, Eisenstein wrote a critique of Pudovkin's view,

> Before me lies a crumpled yellowing sheet of paper.
> On it there is a mysterious note:

"Series – P" and "Collision – E."

This is a material trace of the heated battle on the subject of montage between E (myself) and P (Pudovkin) six months ago.

We have already got into a habit: at regular intervals he comes to see me late at night and, behind closed doors, we wrangle over matters of principle.

So it is in this instance. A graduate of the Kuleshov school, he zealously defends the concept of montage as a *series* of fragments. In a chain. 'Bricks.' Bricks that *expound* an idea serially.

I opposed him with my view of montage as a *collision*, my view that the collision of two factors give rise to an idea.[24]

Eisenstein casts Pudovkin as a traditional director, whose use of montage remains grounded in Hollywood editing practices, particularly those gleaned from the films of D. W. Griffith, who was greatly admired by the Soviet filmmakers. Eisenstein sees Pudovkin's films as conventionally rendered stories. While not as precisely driven by the character-centered causality that gives Hollywood films a more tightly focused narrative, they do present ordinary people, swept along by the movement of the masses, transformed by the impact of the revolutionary events around them. Not surprisingly, Pudovkin argues for the "invisible observer" model of film editing; that is, the cuts in a film mimic the shifts in attention of an ideal observer who controls the flow of narrative information. So a close-up shot mimics our visual fixation on details, and by this shifting focus, the director controls the "psychological guidance" of the viewer.

By contrast, in *The Cinema of Eisenstein*, David Bordwell gives a thorough account of the *plotless cinema* advanced by the more radical film artist Eisenstein, a style that

1 rejects the notion of plot as a series of consequences developing from the actions of an individual
2 favors perceptual and emotional shock over stringent realism
3 depicts the "mass protagonist," not the individual, as the creator of historic change, and so . . .
4 unifies the film using acts and longer sequences that structure the stages of mass action
5 creates motifs of significant objects and graphic patterns to develop complex, unifying thematic associations
6 cultivates overlapping editing to create an agitated rhythm, and to replay key events
7 employs *typage*, Eisenstein's innovative portrayal of character through the external features of physiognomy, dress and behavior to indicate religion, region of origin, and class, particularly in the grotesque attributes of the bourgeois
8 paints the broad sweep of history using associative parallels. Where Pudovkin kept these parallels *within the diegesis* (e.g., the militants' march in *Mother* is compared with the ice thawing on a nearby river), Eisenstein moves beyond that to quasi-diegetic or *non-diegetic* parallels. (See intellectual montage below, p. 186.) Typically, non-diegetic material will be photographed against a black background in close up, providing "a kind of abstract commentary on the action, making the viewer aware of an intervening narration that can interrupt the action and point of thematic or pictorial associations."[25]

So while both Pudovkin and Eisenstein hope to propagandize the proletariat, Pudovkin is clearly more traditional in film style and form, providing the customary "psychological guidance" for the viewer through editing, while Eisenstein is more inventive, relentlessly bent upon pushing the artistic capabilities of the medium. Pudovkin's human scale stories are more conventional, while Eisenstein's strive for a vibrant new filmic art that can glorify the monumental heroics of the masses.

Likewise, Pudovkin's theoretical *writings* do not aim as high as Eisenstein's. Pudovkin wrote two practical handbooks for makers: *Film technique* (1929) and *Film acting* (1933). Since they are exclusively grounded in the practice of making films, his accounts of how editing works draw

heavily on what was known from the routines and practices of the day. Ordinary editing – what Pudovkin called "Structural Editing" – is the result of taking the shooting script and atomizing it: at the production stage, the filmmaker breaks the script down first into scenes, then into sequences, then into shots, and photographs that material. The resulting footage is assembled to reflect "the guidance of the attention of the spectator to different elements of the developing action in succession . . . [This] is, in general, characteristic of the film. It is the basic method."[26] (Note that *découpage* articulates the same concept. See p. 58.)

Beyond this basic method, Pudovkin described as early as 1926 a group of five elements of editing under the heading "Editing as an Instrument of Impression (Relational Editing)." He argues that these five are the primary "*special editing methods* having as their aim the impression of the spectator."[27] Again, the basic editing method is structural or constructive; relational editing is a subset of those methods that has special power to create impressions or associations in the viewer. Some of these five are more coherent and specific than others, but overall appear to be more committed to *crosscutting* than Eisenstein's conception of montage is to creating *metaphor* or *collision*. In other words, his typology remains within a coherent scenario of integrated characters, whose temporal and spatial relationships are clearly indicated. Pudovkin never seems to be willing to push very far beyond the coherent diegesis, even with these "special editing methods" which he differentiates as follows:

Contrast

In practice, this method seems to be nothing more than crosscutting between opposing images. Pudovkin writes,

> Suppose it be our task to tell of the miserable situation of a starving man; the story will impress the more vividly if associated with mention of the senseless gluttony of a well-to-do man. On just such a simple contrast relation is based the corresponding editing method. On the screen the impression of this contrast is yet increased, for it is possible not only to relate the starving sequence to the gluttony sequence, but also to relate separate scenes and even separate shots of scenes to one another, thus, as it were, forcing the spectator to compare the two actions all the time, one strengthening the other. The editing of contrast is one of the most effective, but also one of the commonest and most standardised of methods, and so care should be taken not to overdo it.[28]

The thrust here is to place opposites against each other in a sequence, but unlike the *idea-associative collision montage* or *intellectual montage* (see below p. 186) where the forward motion of an action on screen is stopped by radially colliding visuals, Pudovkin here is calling for a kind of pointed *crosscutting* – "to relate separate scenes and even separate shots of scenes to one another" – not the radical departure Eisenstein seeks.

Parallelism

Pudovkin uses the term *parallelism*, but it is not clear that his intended meaning for the word is the standard usage of film studies. The example he gives is a sequence in which

> a working man, one of the leaders of a strike, is condemned to death; the execution is fixed for 5 a.m. The sequence is edited thus: a factory-owner, employer of the condemned man, is leaving a restaurant drunk, he looks at his wrist-watch: 4 o'clock. The accused is shown – he is being made ready to be led out. Again the manufacturer, he rings a door-bell to ask the time: 4:30. The prison wagon drives along the street under heavy guard. The maid who opens the door – the wife of the condemned – is subjected to a sudden senseless assault. The

drunken factory-owner snores on a bed, his leg with trouser-end upturned, his hand hanging down with wristwatch visible, the hands of the watch crawl slowly to 5 o'clock. The workman is being hanged. In this instance two thematically unconnected incidents develop in parallel by means of the watch that tells of the approaching execution. The watch on the wrist of the callous brute, as it were connects him with the chief protagonist of the approaching tragic denouement, thus ever present in the consciousness of the spectator.[29]

Pudovkin's *parallelism* seems like a combination of motif (the clock/time motif), crosscutting (simultaneous actions) and contrast editing (worker vs. factory owner). Traditional usage, according to Kristen Thompson, defines crosscutting as "editing which moves between simultaneous events in widely separated locales. 'Parallel editing' differs in that the two events intercut are *not simultaneous*" and if the time relationship is unclear, the device could be either.[30]

Symbolism

What Pudovkin calls "symbolism" is more commonly called *idea associative comparison montage* or *visual metaphor*. (See below, p. 158.) Writing of Eisenstein's *Strike* (1925) Pudovkin says, "just as a butcher fells a bull with the swing of a pole-axe, so cruelly and in cold blood, were shot down the workers. This method is especially interesting because, by means of editing, it introduces an abstract concept into the consciousness of the spectator without use of a title."[31] The strikers are slaughtered cattle, and juxtaposition creates this "symbol" or visual metaphor.

Simultaneity

Known in American films since 1910, Pudovkin is referring to what is commonly known as *crosscutting*, when two simultaneous actions that are spatially distant are intercut. (See crosscutting, Chapter 2, p. 75.) Pudovkin writes that this ubiquitous device is aimed at suspense:

The whole aim of this method is to create in the spectator a maximum tension of excitement by the constant forcing of a question, such as, in this case: Will they be in time? –will they be in time? The method is a purely emotional one, and nowadays overdone almost to the point of boredom, but it cannot be denied that of all the methods of constructing the end hitherto devised it is the most effective.[32]

Leit-motif (reiteration of theme)

The German *leitmotiv* literally means "leading motif" or "guiding motif," and was first used to describe Wagner's association of short, distinctive musical phrases with a particular character, ideas, or situations in his operas. Here, Pudvokin simply means repetition for emphasis of theme, and gives this example: "In an anti-religious scenario that aimed at exposing the cruelty and hypocrisy of the Church in employ of the Tsarist regime, the same shot was several times repeated: a church-bell slowly ringing and, superimposed on it, the title: 'The sound of bells sends into the world a message of patience and love.' This piece appeared whenever the scenarist desired to emphasise the stupidity of patience, or the hypocrisy of the love thus preached."[33] Clearly, since Pudovkin is writing in the silent era, a leit-motif need not use sound or a superimposed title, though a musical accompaniment to a silent exhibition in a theatre may have used bells. Pudovkin is merely pointing to repetition as a way to reinforce meaning: the leit-motif could be audio or video.

Though Pudovkin's film work is of secondary importance to Eisenstein's, and indeed has been called "the work of a blackboard theoretician . . . [who] used images in an invariably dull

way – the photographed storyboard,"[34] he had a significant impact in the Soviet film industry. As a director of 27 films, as a screenwriter, actor, author of early books on film theory and as a film teacher at V.G.I.K., Pudovkin played a very important role in the development of Russian cinema. Eisenstein would always outshine Pudovkin, particularly in the West. Eisenstein's films were more innovative in their editing, more sensational in their violent clashes, more energizing in their nervous rhythm, and more heroic in scale than Pudovkin's work. We will survey Eisenstein's key contributions to Russian cinema after we first clarify a number of distinct meanings for the word "montage."

What is "Montage"?

Montage is a word that is frequently used to describe a range of filmic phenomena without ever specifying systematically all its uses. Montage in the broad sense describes a series of short shots that compress time, space, or narrative information, but it actually has several distinct meanings. Its association with Eisenstein is often condensed – too simply – into two words: "collision montage," whereby the juxtaposition of two shots that oppose each other on formal parameters or on the content of their images are cut against each other to create a new meaning not contained in the respective shots: shot A + shot B = new meaning C.

The association of collision montage with Eisenstein is not surprising. He consistently maintained that the mind functions dialectically, in the Hegelian sense, that the contradiction between opposing ideas (thesis versus antithesis) is resolved by a higher truth, synthesis. He argued that conflict was the basis of *all* art, and never failed to see montage in other cultures. For example, he saw montage as a guiding principle in the construction of "Japanese hieroglyphics in which two independent ideographic characters ('shots') are juxtaposed and *explode* into a concept. Thus:

Eye + Water = Crying
Door + Ear = Eavesdropping
Child + Mouth = Screaming
Mouth + Dog = Barking
Mouth = Bird = Singing[35]

He also found montage in Japanese haiku, where short sense perceptions are juxtaposed, and synthesized into a new meaning, as in this example:

A lonely crow
On a leafless bough
One autumn eve.

As Dudley Andrew notes, "The collision of attractions from line to line produces the unified psychological effect which is the hallmark of haiku and montage."[36] But there are at least six usages for the word "montage," of which collision montage is just one, and it is worth clarifying some of those usages before we proceed.

Six Usages of the Word "Montage"

1. Montage = Editing

In many contexts, "montage" simply means "editing." The French word "montage" means literally "a mounting," "an assembly," as in "mounting an engine," and the English screen credit "Editor" has the French equivalent "le monteur/la monteuse." This usage, editing as "mounting"

is relevant to Eisenstein's theory because he saw editing as the process whereby the simple assembly of shots, the "mounting" of the film shot by shot through editing, is a form of engineering, specifically "psycho engineering" whereby the assembled shots will create moments of raw stimulation, triggering basic emotions in the viewer that, over time, develop into larger themes.

2. Sequential Analytical Montage

Herbert Zettl defines this kind of montage as one that will "condense an event into key developmental elements and present these elements in their original cause-effect sequence."[37] While adhering to the ordinary forward progression of time, this type of montage routinely *implies* its central event or idea rather than show it explicitly. A car crash scene that intercuts the shots of two approaching cars without showing them hit, but includes the aftermath is one example given by Zettl for this type of montage. Eisenstein used this technique in *Strike* (1925). When Cossacks attack the workers in their living quarters, they drop a baby from a balcony. The horrifying montage ends with the baby lying on the ground, rather than showing the baby hit the ground. (Figure 5.1). See Critical Commons, "Kinds of Montage: Analytical Sequential Montage in *Strike*."[38]

3. The Hollywood Montage

This familiar *subset* of the **Sequential Analytical Montage,** where key elements of the narrative are compressed, often uses traditional markers of time passing like dissolves, but also tropes like

Figure 5.1 Sequential Analytical Montage in Strike. *When Cossacks attack the workers in their living quarters in* Strike, *they drop a baby from a balcony. The horrifying montage ends with the baby lying on the ground, rather than showing the baby hit the ground. Herbert Zettl identifies this as an analytical sequential montage in which the main event is implied.*

newspaper headlines. In *Heaven Can Wait* (Lubitsch, 1943) the aging socialite, Henry Van Cleve (Don Ameche), is lamenting growing older, and a humorous montage of birthdays passing, shown in cakes, candles, a telegram and an endless stream of birthday neckties summarizes the theme that getting older is not all that much fun. See Critical Commons, "Kinds of Montage: Hollywood Montage in *Heaven Can Wait*."[39]

Another classic example of the Hollywood montage comes from *Citizen Kane* (Welles, 1941) where Susan's disastrous opera career and her descent into an attempt at suicide is summarized with newspaper headlines and a flashing stage lamp that ultimately flickers out as the soundtrack winds down to a halt (Figure 5.2). Doug Travers at RKO created the montage. See Critical Commons, "Kinds of Montage: Hollywood Montage in *Citizen Kane*."[40]

4. Sectional Analytical Montage

Herbert Zettl uses this term for a montage that shows the various sections of an event and explores the complexity of a particular moment. Rather than showing cause and effect, a sectional analytic montage temporarily stops the progression of a screen event and explores an isolated point in time from various viewpoints.[41] We can imagine such a montage in a film that halts the progress of the narrative to bring out the *emotional* content of a scene. Imagine two lovers strolling a sidewalk. In one case, we could interrupt story progression to create a montage that illustrates "Manhattan, 5:00 pm, late autumn as winter approaches." In another case, with another shot of two lovers strolling on a sidewalk, we could interrupt story progression to create a montage that illustrates

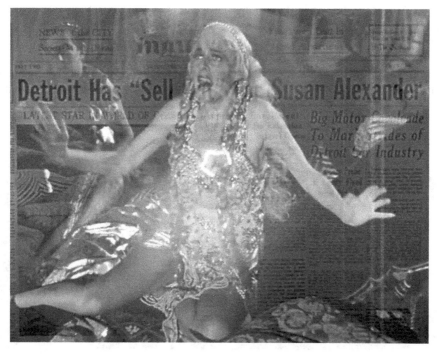

Figure 5.2 Hollywood montage in Citizen Kane. Susan Alexander's disastrous opera career and her descent into a suicide attempt is summarized with a series of newspaper headlines, shots of her performance and a flashing stage lamp.

Source: Copyright 1941 RKO Radio Pictures.

"Paris, 5:00 pm, early spring, as winter fades." We can imagine the kinds of images that would be expressive in each case, and how the cutting of these images would impact the emotional tone of the lover's interaction. (And it is worth noting that Zettl argues that a multiscreen presentation of this kind of imagery would be, by *definition*, a sectional analytical montage because the event details are presented simultaneously rather than sequentially.)

Another form of *sectional analytical montage* is one that portrays "subjective time" by temporarily arresting event progression to examine a specific moment. In Sam Peckipah's *The Wild Bunch* (1969), Pike Bishop (William Holden) and his men try to force General Mapache to release one of their gang, Angel (Jaime Sánchez), who is barely alive after being tortured. When the general cuts his throat, the men gun Mapache down almost by instinct, in front of hundreds of his men. At that point, "time stops," as they assess the hopelessness of their situation (Figure 5.3). Peckinpah stops the scene for roughly 30 seconds as the men react, looking at each other and the Mexican soldiers, taking in their situation and finally acknowledging their commitment and dedication to one another before the hopeless blood bath to come. See Critical Commons, "*The Wild Bunch*: Final Shootout," for a sectional analytical montage near the beginning.[42]

5. Idea-Associative Comparison

This type of montage uses successive shots that appose similar themes in different events, so that the thematically related events reinforce each other.[43] Here, by placing shots (or in Eisenstein's terminology "fragments") that are related thematically side by side, the viewer contemplates the similarity, and synthesizes a *tertium quid*, literally a "third thing," that is not contained in either shot. The classic example for this case is from Eisenstein's *October: Ten Days that Shook the World* (1928). Alexander Kerensky (Vladimir Popov), a member of the Socialist Revolutionary Party, is the Minster of Justice in the provisional government from the Winter Palace of Czar Nicholas II, who has been overthrown and executed with all his family. Kerensky is seeking democratic reforms but signs an order reinstating the death penalty for army deserters. In a segment that leads with the title card "A 'Royal' Democrat," Eisenstein places shots of Kerensky in his formal dress uniform with leather boots and gloves (Figure 5.4) against a shot ("fragment") of the mechanical peacock[44] unfurling his feathers (Figure 5.5), suggesting that he is vain and strutting like a peacock, and corrupted by the power he has ascended to.

Figure 5.3 *Sectional Analytical Montage in* The Wild Bunch. In Peckipah's *The Wild Bunch,* "time stops," as members of the gang – outgunned in a standoff with the Mexican army – assess the hopelessness of their situation. Peckinpah stops the scene for roughly 30 seconds as the men react.

Figure 5.4 October: *idea associative comparison, Kerensky vs. peacock.* Eisenstein intercuts shots of Alexander Kerensk, leader of the provisional government who occupies the former Czar Nicholas' palace, against a shot of a mechanical peacock unfurling his feathers, suggesting that he is vain and corrupted by power.

Source: Copyright 1926 Goskino.

Figure 5.5 October: *idea associative comparison, Kerensky vs. peacock.*

Source: Copyright 1926 Goskino.

See Critical Commons, "Kinds of Montage: Idea Associative Comparison, Kerensky vs. Peacock"[45]

Another famous comparison montage from Eisenstein is found in *Strike* (1925) that intercuts non-diegetic shots ("fragments") (i.e., images that are outside the story space of the film) of a bull being slaughtered with shots ("fragments") of soldiers killing striking factory workers. The visual metaphor – the strikers are cattle and the soldiers are butchers – is clear and effective, and continues the animal motif that runs throughout the film: each of the spies for the police shown earlier is tagged visually as Fox, Owl, Bulldog or Monkey. See Critical Commons, "Visual Metaphor in *Strike*."[46] Notice that because the footage of the bull is non-diegetic and viscerally violent it is tempting to classify this as a idea-associative *collision* montage rather than idea associative *comparison*, but the fact that we can describe its meaning as "the strikers are cattle led to the slaughter" points to the comparison rather than the collision of these two.

6. *Idea-Associative, Collision Montage*

In a collision montage, two opposing events express or reinforce a basic idea or feeling.[47] Here again, there is a *tertium quid*, a third something, generated from the placing the two events next to each other. But in this case the juxtaposition creates conflict, not comparison, and consequently tends to intensify the moment even more than a comparison montage. Given that it is an overtly rhetorical device, the collision montage has the potential to be impactful or alienating to an audience.

More than any other usage of the word "montage," it is this "collision" usage that we associate with Eisenstein. In part, this association grows from the fame Eisenstein achieved with the editing of the Odessa steps sequence from *Battleship Potemkin*, probably the most famous sequence in film history, and a masterful piece of editing the likes of which had not been seen when the film premiered in 1925. Certainly the notion of "collision" corresponds to "intellectual montage," a term from Eisenstein's typology of montage that we will deal with more fully below. For now, we can point to the closing of the steps sequence as an example of collision montage. See Critical Commons, "*Battleship Potemkin* (1925) Odessa Steps," to view the four closing shots.[48]

In the final four shots[49], Eisenstein synthesizes the idea of "horrific, violent repression." Starting from the final shot of the baby carriage beginning to flip over at the end of its journey down the steps (Figure 5.6), Eisenstein cuts to repeated actions of a Cossack slashing downward towards the camera, first in a medium close up (Figure 5.7), then in a tight close up (Figure 5.8) where he grimaces ferociously. Spatially, it is unclear where he is standing, and if he is slashing at the baby, since nothing in the sequence has shown their relative positions. The next shot – the school mistress with smashed pince-nez screaming with blood dripping down her face – only adds to horror and the spatial ambiguity: was she shot or was she slashed?

The explosive energy these four shots impart can be described in a number of ways, all of which demonstrate the difficulty in putting a highly kinetic image sequence into words, but also suggesting the range of formal parameters (attractions) embedded in the shot that potentially collide in the four shot sequence;

High angle shot (carriage tips), low angle shot (Cossack starts to strike), low angle shot (Cossack slashes once, and begins to slash again), head-on shot (woman with pince-nez is frozen in horror).

Objective medium shot (carriage tips), subjective shot (Cossack starts to strike towards *us*), subjective shot (Cossack slashes towards camera and begins to slash towards *us* again), objective medium shot (woman with pince-nez is frozen in horror).

Incomplete action (carriage tips), incomplete action (Cossack starts to slash), complete /incomplete action (Cossack slashes once, and begins to slash again), resolution (woman with pince-nez is frozen in horror).

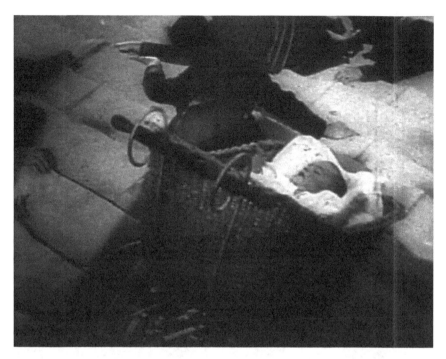

Figure 5.6 Idea-associative, collision montage. In the final four shots of the Odessa steps sequence in *Battleship Potemkin*, Eisenstein synthesizes the idea of "horrific, violent repression." Starting from the final shot of the baby carriage . . .

Source: Copyright 1925 Goskino.

Figure 5.7 . . .Eisenstein cuts to overlapping action of a Cossack slashing downward towards the camera, first in a medium close up . . .

Source: Copyright 1925 Goskino.

Figure 5.8 . . .then in a tight close up.

Source: Copyright 1925 Goskino.

Figure 5.9 Battleship Potemkin: the sequence ends with a tight close up of the woman in the pince-nez frozen in bloody horror.

Source: Copyright 1925 Goskino.

Forward energy down the stairs that does not resolve (carriage tips), forward energy down towards camera that does not resolve (Cossack starts to slash), forward energy down towards camera that resolves then does not resolve (Cossack slashes once, and begins to slash again), effect (woman with pince-nez is frozen in horror).

Regardless of how we try to account for the impact of the colliding attractions in each shot, their effect is palpable. They are clear evidence of Eisenstein's artistry, and the correctness of his theorizing: his intuition that collision montage can be a visceral stimulus towards the "psycho engineering" is obvious here.

One final question: What about audio? We have not accounted for the interaction of audio and video in the categories above, and audio is a powerful element to juxtapose within a montage sequence. Zettl says that often audio can work as a montage element in a way that is effective but less glaring than a visual element, since both kinds of analytical montage – sectional and sequential – and ideas-associative montage – collision and comparison – emerge when the sequence is juxtaposed with a specific track.[50] Zettl gives as an example of comparison idea-associative A/V montage a long shot of a sports car moving through tight turns juxtaposed with the sound of a jet engine of a fighter plane, which only hints at the potentials of audio in montage. Today, with advances in Dolby noise reduction and surround sound, the wide-ranging creative possibilities of audio as a crucial, combustive element in montage are unquestioned. But for Eisenstein, a famous filmmaker with *Potemkin* to his credit and his first sound film still 13 years ahead, the issue of how to integrate audio into his theory of montage is not a pressing one. More acute is the issue of how he will conceptualize montage, how he will catalog its formal potentials and account for its substantive impact on the viewer. His theorizing will progress in the silent period even though his filmmaking flounders politically, but ultimately he will return to the sound film as a creative and theoretical problem much later in his life.

Eisenstein's Early Theorizing: The Attraction and Seizing the Spectator

Eisenstein's early theorizing about montage grew out of his work in theatre, which began when he served in the Red Army. In 1918, as the civil war in Russia deepened, he began painting posters for *agit-prop* trains that were presented as simple plays with broadly drawn political characters representing good and evil. "Agitation-propaganda" trains were units of the army that spread the Bolshevik message across the vast expanse of Russia. Since much of the population was illiterate, the trains travelled to remote regions without electricity to propagandize the peasantry. Mustered out of the army in 1920, Eisenstein joined the Proletkult movement in Moscow, an experimental artistic group dedicated to advancing a new working class aesthetic in the arts.

In 1921, Eisenstein came under the tutelage of Vsevolod Meyerhold, the leading Russian director of avant-garde theatre, who became a primary influence in the development of the young man's aesthetics. "Eisenstein's belief in controlling the spectator through the performer's bodily virtuosity; his emphasis on pantomime; his interest in Asian theater, the circus and the grotesque; even his 1930s attempt to create a curriculum in which film directors would undergo stringent physical and cultural training – all were initiated by the association with Meyerhold."[51] The central tenet that Eisenstein drew from his mentor was grounded in an acting style Meyerhold pioneered, *biomechanics*, that replaced studied gesture and overwrought language with an emphasis on automatic reflexive motions that arise naturally in the actor. Under Meyerhold, Eisenstein came to believe that the stage director's goal is to be a "psycho engineer." Using biomechanics, the director strings together freestanding moments of peak action that reflexively deliver the desired shock to the audience's nervous system. By jolting the audience, the play will begin to turn their thinking toward the revolution. This belief in the power of art to motivate through reflex action drew not only on work of Meyerhold, but also on the contemporary experiments of Ivan Pavlov, the influential Russian psychologist who was demonstrating the power of classical conditioning by, among other things, training dogs in his lab to salivate to the ringing of a bell.

Beginning with the play *Enough Stupidity in Every Wise Man* that he co-produced with Sergei Tretyakov in 1923, Eisenstein sought to bring the spectator to revolutionary action. Eisenstein, rejecting the "dramatic illusion" of traditional theatre, transformed the original play into a revue, with remarkable, circus-like moments of acrobatics, tight rope walking, and feats of agility. He even created a short film to include in the production. He described his new method in a short article, "Montage of Attractions."

> Theatre's basic material derives from the audience: the molding of the audience in a desired direction . . . An attraction (in our diagnosis of theatre) is any aggressive aspect of the theatre, i.e. any element of it that subjects the audience to emotional or psychological influence . . . These shocks provide the only opportunity of perceiving the ideological aspect of what is being shown, the final ideological conclusion.[52]

For Eisenstein, the attraction is a way to dismantle the tradition of naturalism in theatre by focusing on the power of an independent moment of maximum performance, a "unit of impression," in Tom Gunning's words.[53] The attraction prompts a direct response: an audience member sits in the physical presence of an actor, and the actor's actions stimulate reactions in the primitive brain through a *motor-imitative response* in the audience. The motor-imitative response might arise as follows: the actor raises his fist on stage to strike another actor, and the audience experiences a primitive, reflexive mental response, an "inner recoiling" from that action.

For Eisenstein, biomechanical acting and the motor-imitative response it triggers in the audience opens up a new range of possibilities for stage and screen:

> Thanks to such a construction of stage movement, there is no more need for an actor's emotional experiencing of type, image, character, feeling, situation, since, as a result of expressive movement by the actor, the *emotion experiencing* is transferred where it belongs, specifically to the auditorium . . . It is precisely expressive movement, built on an organically correct foundation, that is solely capable of invoking this emotion in the spectator, who in turn reflexively repeats in weakened form the entire system of actors movements; as a result of the produced movements, the spectator's incipient muscular tensions are released in the desired emotion.[54]

Later, applied to film, this acting style will often reveal a flaw: the "realistic, ritualistically repeated and abstracted behavior on the part of the actors and participants who tend to become walking concepts . . . *typage* figures."[55]

Although there are two distinct periods in which Eisenstein theorizes about film's potential – his writings from the 1920s during the early silent period, and his revision of those ideas in the 1930s and 1940s – his notion of the "attraction" is carried into his filmmaking and into his theorizing with few modifications. In 1924, barely a year after his original statement on theatre, Eisenstein pens an article "The Montage of Film Attractions." Though he never defined the term concisely, in broad terms, the attraction for Eisenstein centered on both a visually expressive moment and the immediate shock effect on the viewer of seeing violent or frightful or surprising action represented (in film or theatre). Jacques Aumont points out that the ingredients that remain central to both are the attraction's autonomy, and its visual impact, and its rejection of the need to express theme through traditional character action within a scene:

> The *attraction in cinema* as well as elsewhere, thus supposes, first, a strong degree of autonomy (which will be expressed, in terms of montage, by the requirement of the high degree of heterogeneity) and, second, a visually striking existence (a requirement of effectiveness, as we shall see, but also a desire to be 'anti-literary' that was characteristic of the entire period) . . . Thus in cinema, the concept of attraction . . . will be what is opposed to any static 'reflection' of events.[56]

If the purpose of revolutionary art is to mold the spectator to the desired (political) end, then *any* striking aspect of theatre or film can serve as the attraction, as the "fist," that will deliver violent shocks to the audience and conquer their inflexible beliefs. The word choice here – "fist" – is calculated. Dziga Vertov's belief in the "Kino-eye," the power of the "film machine" to reveal the world in a way unique to that device, is transformed by Eisenstein who famously wrote, "I don't believe in the kino-eye, I believe in kino-fist."[57] And while Eisenstein's use of the attraction is political, notice that it is not excluded from entertainment cinema, where it has a long history. The attraction, common in early silent film spectacle, lives on, though tamed by narrative in entertainment cinema: "The Hollywood advertising policy of enumerating the features of a film, each emblazoned with the command 'See!' shows this primal power of the attraction running beneath the armature of narrative regulation . . . Clearly in some sense recent spectacle cinema has re-affirmed its roots in stimulus and carnival rides, in what might be called the Spielberg-Lucas-Coppola cinema of effects."[58]

Beyond the central role of the "attraction," "conflict" is the other key concept for Eisenstein in the 1920s, based on the prevailing philosophy of "dialectical materialism," developed in the writing of Marx and Engels. Dialectical materialism is "the Marxian interpretation of reality that views matter as the sole subject of change and all change as the product of a constant conflict between opposites arising from the internal contradictions inherent in all events, ideas, and movements."[59] Adopted as the official Soviet philosophy under Stalin, historical events are seen as resulting from the conflict of opposing ideologies, a series of contradictions that give rise to new social orders. Eisenstein, writing in 1929, argues that conflict permeates film art, starting with the lowest physiological basis for the perception of movement in the viewer, because persistence of vision is conflict:

In the realm of art this dialectical principle of the dynamic is embodied in

CONFLICT

as the essential basic principle of the existence of every work of art and every form . . . *in my view montage is not an idea composed of successive shots stuck together but an idea that DERIVES from the collision between two shots that are independent of one another* . . . We know that the phenomenon of movement in film resides in the fact that still pictures of a moved body blend into movement when they're shown in quick succession one after the other.[60]

In short, conflict drives the low-order, primitive brain function that allows the viewer to see movement in the projected image because persistence of vision collides sequential project frames on top of each other. Eisenstein goes on to distinguish his concept of montage from Pudovkin's using the same model, a way to distinguish his broad approach to storytelling from the traditional approach of Pudovkin. Pudovkin's sequential elements arrayed *next* to one another become Pudovkin's *shots as links in a chain.* Eisenstein's sequential elements arrayed on *top* of one another become Eisenstein's *shots as bundles of attractions in conflict.*

Conflict, then, becomes the overriding principle in Eisenstein's theory and later in "Film Attractions," he argues that Pudovkin's films use the "epic" principle of narration through a series of the hero's great achievements arrayed *next* to each other, versus Eisenstein's films that use the "dramatic" principle of narration through a *collision* of vivid contrasts. At this higher level of conflict, executive-level brain functions allow the viewer to synthesize new ideas from conflicting opposites. Thus, conflict is indispensable to a *range* of mental activities used to process film art: it is essential to both "bottom up" (sensation of movement) processes and "top down" (cognition) processes, essential to the viewer at both ends of the mental spectrum.

Given this plausible theoretical model, a central question for Eisenstein the filmmaker is more practical: "How can a conflict in the film form be used for a higher purpose, as the 'Kino-fist' to lead the viewer to the Marxist world view?" His first answer is "A Tentative Film Syntax," one of two taxonomies he constructed in 1929. "Tentative" is the operant word – this is mental

doodling, a piece of writing that reads like it was jotted down on a napkin, that might be just as accurately titled "Some Early Thoughts About How Montage Works on the Viewer." Nevertheless, "Syntax" is consistent with his early theorizing: it is hierarchical and it reflects the Pavlovian milieu of his silent film work. Stripped to its basic form, the hierarchy of possible shot arrangements follows a hypothesized hierarchy of *mental functions* in the viewer, namely perception, emotion, and cognition. Drawing from Eisenstein's "syntax," we can try to summarize his thinking about the impact of conflict/montage on a viewer's mental processes. (For clarity, Eisenstein's writing is in italics.)

A Tentative Film Syntax[61]

I. *Each moving piece of montage in its own right.* With this cryptic line, Eisenstein reiterates that, at the lowest level, the counterpoint between two frames of film, the finest grained conflict possible – frame against frame – is what creates movement in cinema.

II. *Artificially produced representation of movement.* Eisenstein says that the following examples show primitive-psychological cases – using only the optical superimposition of movement.

A. Logical . . . Montage: repetition of a machine-gun firing by cross-cutting the relevant details of the firing. At the level of the shot, we can mimic the creation of movement by intercutting short shots of relevant details. In *October: Ten Days that Shook the World*, Eisenstein intercuts shots of a machine gun (Figure 5.10) and shots of a machine gunner (Figure 5.11) in two frame shots that collide on a number of parameters including exposure or grey scale value and graphic mass.

The effect is a logical sensation of machine gun-like motion, recognized (or should we say *felt*) at the level of primitive-psychological perception. See Critical Commons, "*October*: Artificial Representation of Movement, Logical – Machine Gun."[62]

B. Alogical. . . This device used for symbolic pictorial expression [in] Potemkin. The marble lion leaps up surrounded by the thunder of Potemkin's guns firing in protest against the bloodbath Odessa steps. The effect was achieved because the length of the middle piece was correctly calculated. Super imposition on the first piece [Figure 5.12] produced the first jump. Time for the second position [Figure 5.13] to sink in. Superposition of the third position [Figure 5.14] on the second – the second jump. Finally the lion is standing. Struck by the effect of these three simple shots, Eisenstein wants to highlight both its psychological and intellectual forces. The lion rising is an overt, artificial representation of movement that works on a number of levels in the brain. From still shots of sculpture, it stimulates primitive brain functions to create motion. It also triggers psychological effects that Bordwell sees as multifaceted. "As literal filmic 'animation,' it snaps the spectator to attention. More specifically, the shots have an auditory effect. In whipping a snoozing lion into a roar, the editing synesthetically evokes the tumult of the barrage [seen in the previous shots]." [63] And clearly the lion sequence is also a metaphor: the revolution is waking even the sleeping stones. Or as Eisenstein puts it, "The jumping lions entered one's perception as a turn of speech — 'The stones roared.'"[64]

See Critical Commons, "*Battleship Potemkin*: Artificial Representation of Movement, Alogical."[65]

III. The case of emotional combinations not merely of the visible elements of the pieces but principally of the chains of psychological association. Associational montage . . . As a means of sharpening (heightening) a situation emotionally . . . EMOTIONAL DYNAMISATION. The shooting down of the workers is cut in such a way that the massacre is intercut with the slaughter of a cow. (Difference in material. But the slaughter is employed as an appropriate association.) This produces a powerful emotional intensification of the scene.

Figure 5.10 From The Dramaturgy of Film Form *(aka The Dialectical Approach to Film Form) (1929):*
Artificially produced representation of movement, logical. Just as the conflict between two
frames of film – frame against frame – creates movement in cinema, Eisenstein argues that the
conflict of short shots in montage can create artificial movement that arises *logically.* In *Octo-
ber: Ten Days that Shook the World*, Eisenstein intercuts shots of a machine gun . . .

Figure 5.11 . . .with shots of a machine gunner in two frame shots that collide on a number of parameters
including exposure or grey scale value and graphic mass.

Source: Copyright 1925 Goskino.

Figure 5.12 Artificially produced representation of movement, alogical: lion 1. Eisenstein claims the famous lion montage at the end of the Odessa steps sequence in *Battleship Potemkin* is a case of an artificially produced representation of movement, that is alogical. The first shot . . .

Figure 5.13 . . .is super imposed upon by the second shot in conflict. Eisenstein claims a key to the impact here is that the length of the middle piece was correctly calculated, giving it time to sink in . . .

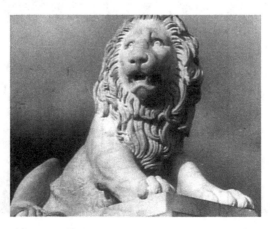

Figure 5.14 . . .before the third shot of the lion leaping up is super imposed upon the second. Here the editing synesthetically evokes the tumult of the ship's barrage . . . "The stones roared."

Though it works through "primitive-psychological perception" – all perception of motion does – associative montage also functions at a higher level of mental activity to sharpen what the viewer feels. Attractions juxtaposed through montage create "chains of psychological associations" that startle and rouse the spectator to strong *emotions*, a further step in seizing the political consciousness of the viewer. See Critical Commons, "Visual Metaphor in *Strike*".[46]

IV. The emancipation of closed action from its conditioning by time and space. The first attempts at this form made in the Ten Days film.

Example 1. (Ten Days)

A trench packed with soldiers [Figure 5.15] seems to be crushed by the weight of an enormous cannonball [sic: mechanized gun] descending on the whole thing [Figure 5.16]. Thesis brought to expression. In material terms, the effect is achieved through the apparently chance intercutting between an independently existing trench and a metal object with a similarly military character. In reality they have absolutely no spatial relationship with one another.

Reflecting on ways his silent films have worked to "seize the spectator," Eisenstein notes that the traditional, rigid adherence to "closed action" – the diegesis contained by time and space, the traditional story space created through analytical editing – is limiting. Here, with the spatial relationship between the two shots unspecified, the thesis of the juxtaposition is made explicit, using images that function more like language: the capitalist war machine oppresses the working class. Eisenstein argues further that unlike theatre, where a murder scene would be shown in continuous time and space (in the stage space before the audience) and affect the audience like an item of information, a single shot in film is not the reality of the theatre space, but a concrete image that has the potential to evoke associations. Given this power, cinema should become discursive, moving beyond the methods of theatre towards the methods of language, which can give rise to new ideas by factual description.[66]

Here, using *non-diegetic* material entering apparently by chance – the "cannonball" (a mechanized gun) that has not been located in the diegesis – Eisenstein can make a thesis statement, a *tertium quid*, using visually concrete images to express new ideas, just like language. The false eye-line match created by the soldier looking up (Figure 5.15) contributes to the third meaning by explicitly thwarting the viewer's expectation that the two are spatially connected. In the context of the film, where we have just seen early successes of the February Revolution and war weary Russian and German infantry exchanging food in friendly conversation, the mechanized gun descending (Figure 5.16) literally represents the "war machine" that continues to repress and crush the masses. The "war machine" in this instance is the provisional government, which the film has just shown honoring its commitment to the Allies rather than sue for peace. See "*October: Ten Days that Shook the World*, Cannon Lowers."[67]

"A Tentative Film Syntax" is based on a broad underlying model of montage that rests on a hierarchical view of the viewer's mind, a mind to be moved by embedded attractions from perception to emotion to cognition. Or as Eisenstein wrote, "From image to emotion, from emotion to thesis."[68] It builds on the notion that the very perception of motion in film dictates involuntary, "from the bottom up" processing (i.e., we can't will ourselves to see a film as individual frames). And since biomechanics drives the motor-imitative response (i.e., we reflexively repeat an actor's movement without conscious thought), "primitive-psychological perception" must be the foundation for the impact of montage. Eisenstein believes that when the director has transposed his theme into a set of attractions with a predetermined goal, the resulting pressures on the audience's psyche will "arouse us" and "infect us" with emotion.[69] At the highest level, the filmmaker can trigger cognition when he emancipates "closed action from its conditioning by time and space"; that is, when it uses quasi-diegetic or non-diegetic attractions within shots more like a language to communicate abstract ideas to the viewer.

Figure 5.15 *"The emancipation of closed action from it's conditioning by time and space".* Eisenstein argues that a montage using the *non-diegetic insert* (inserting a shot that is spatially unrelated) can release the associations of the concrete film images to create meaning more like the way language works. Here shots of soldiers in a trench who come under artillery fire . . .

Figure 5.16 . . .are intercut with shots of a mechanized gun descending which literally represents the "war machine" that continues to repress and crush the masses.

But what *precisely* happens to the spectator confronted with these overtly discontinuous shots? Why and how do quasi-diegetic and non-diegetic shots create more abstract meanings? In the second typology of montage that Eisenstein creates in 1929, "Methods of Montage," he offers "a richer taxonomy of formal options. Instead of postulating a conflict between equal forces within the shot, Eisenstein proposes that every cut juxtaposes two shots on the basis of some salient feature, *the dominant*."[70] For Eisenstein, this is a carefully chosen word. "The dominant" obviously relates to music – the dominant chord in a diatonic scale – but as Bordwell points out, the idea also reflects Eisenstein's continuing interest in physiology, to areas of the brain that "'dominate' a given behavior. More proximately, the term had also emerged in Russian formalist literary theory . . . the dominant as 'the preeminence of one group of elements and the resulting deformation of other elements.'"[71] The dominant is a factor in a sequence that is capable of working from the bottom up, and when it emerges, other attractions within the shot recede (and, as we shall see below, become "overtones"). Eisenstein writes,

> Orthodox montage is *montage on the dominant*. I.e., the combination of shots according to their dominating indications. Montage according to tempo. Montage according to the chief tendency within the frame. Montage according to the length (continuance) of the shots, and so on.[72]

Eisenstein argues that a canonical montage would be cut "according to the foreground" or the "dominating indications." That is, look at what two shots placed side by side are indicating to you as their most potent visual potentials – graphic, planar, volumetric, spatial, tempo or light values – in order to release emotion and meaning in the viewer. A reasonable suggestion, but should those "foreground properties" be edited in a way that places them in conflict or in harmony or somewhere in between? Should the cut juxtapose graphic contrasts that are large or minor? Should the sequence move from shots of slow tempo action into shots that are slightly more rapid or suddenly swift? Not surprisingly, given that the range of potential "foreground properties" is very large, Eisenstein points out it could be *any* of these: "This circumstance embraces all intensity levels of montage juxtaposition-all *impulses*: From a complete opposition of the dominants, i.e., a sharply contrasting construction, to a scarcely noticeable 'modulation' from shot to shot."[73] Moreover, as the dominant emerges from a sequence, it may fluctuate from shot to shot – a series of shots might relate to one another in terms of their brightness or value, but later shots in the sequence might relate to one another in terms of tempo – it is not "invariably stable." And he goes on to give this concrete example:

> If we have even a sequence of montage pieces:
> A gray old man,
> A gray old woman,
> A white horse,
> A snow-covered roof,
> we are still far from certain whether this sequence is working towards a dominating indication of "old age" or of "whiteness."
> Such a sequence of shots might proceed for some time before we finally discover that guiding-shot which immediately "christens" the whole sequence in one "direction" or another. That is why it is advisable to place this identifying shot as near as possible to the beginning of the sequence (in an "orthodox" construction). Sometimes it even becomes necessary to do this with a sub-title.[74]

Clearly, Eisenstein is seeing an edited sequence as a dynamic system, and the notion of a "guiding shot" placed at the beginning of the sequence that "christens" a sequence is a powerful one: in the irreversible flow of moving images, earlier images obviously shape the perception of later ones, but here Eisenstein, always the mystic, is arguing for a shot that "baptizes the sequence

to its community" or "christens the ship," both naming it and dedicating it to its purpose. If the christening shot can't be found, a title card (or later in the sound era, a line of dialogue, a sound effect or a musical element) may be necessary to identify the dominant.

Given that every shot is a plethora of potential attractions, when the dominant drives the editing of a sequence, the others must recede and become secondary. Rather than disregard these second-ary properties, Eisenstein wants to account for their impact, however modest, by introducing the notion of *overtone*. In sound, every musical instrument's middle A is 440hz, but the difference between the sound of a violin or cello comes from its timbre, or tone color, which is determined by the number and relative loudness of it overtones (harmonics). Rather than write off the poten-tial for secondary stimulants in a frame to create meaning, Eisenstein maintains that even these secondary "overtones" can play a vibrant part in the impact of a sequence.

Equipped with these two notions, Eisenstein offers a second typology, "Methods of Montage," to articulate the possibilities of montage. This time, the typology will not address effects on the viewer, but rather, montage techniques available *in the film itself* that follow the hierarchical Perception-Emotion-Cognition model. (Eisenstein's writings in italics):

Methods of Montage[75]

I. Metric Montage

The fundamental criterion for this construction is the absolute lengths of the pieces. The pieces are joined together according to their lengths, in a formula-scheme corresponding to a measure of music. Realization is in the repetition of these "measures."

With metric montage, the content of the shots is subordinated to the duration of the shots, thereby making duration the dominant. Notice that "metric montage" does not mean "all the shots are the same length," although the term is often used that way. Eisenstein recognizes that shortening the shots is an effective way for an editor to create tension within a metric montage. Hence, the term simply means the cutting rhythm dominates in the sequence over the shot con-tent, a difficult point we will return to shortly. *Accelerated montage* acknowledges a technique established in American films from at least Griffith's *Lonedale Operator* (1911) where the climax of a screen chase is punctuated with shorter and shorter shots. See Critical Commons, "*Lonedale Operator* (1911) – Ending."[76] Later, Eisenstein describes the power of metric montage as "rude motive force," and it is clear that metric montage functions from the "bottom up," at the lowest level of perception.

Metric montage has a direct, stimulus–response relationship with the audience that can bring the viewer's "pulse" in to perfect accord with the film. The grain-mowing contest in *The Old and the New* is a metric montage that accelerates, and Eisenstein laughed when he saw some in the audience begin to rock in rhythm to the cutting, much as they would to a brass band.[77] Another example of metric montage Eisenstein gives is from *October* when the Savage Division, a cavalry unit from the Caucasus region, is persuaded by Bolsheviks to put away their weapons and join them to prevent the return of General Kornilov to Petrograd. Kornilov is on his way to lead a coup d'état against the Petrograd soviet, which would leave the provisional government under Alexander Kerensky in power. Kornilov, a loyal tsarist who tolerated the provisional government, is not shown in the sequence but leaflets distrib-uted by the Bosheviks persuade the Savage Division not to join them. After the cavalrymen sheathe their knives, they celebrate by dancing the Lezginka, a folk dance commonly per-formed by peoples in the Caucasus region.

The cutting here is metric, but in typical Eisenstein fashion, it's not that simple: metric cutting, yes, but hardly metric alone. Besides accelerated editing, the sequence also exhibits moments of intellectual montage (see p. 186 below) by cutting in non-diegetic inserts of a wind-up sculpture, as well as shots that return to the motif of Kerensky in his "idle" boots,

lying on a couch surrounded by fluffy, brocade pillows. The wind-up sculpture is shot against a black background, like most of Eisenstein's non-diegetic inserts, and appears (to Western-ers) to be a caricature of a monk waving goodbye. However, the gesture in Japanese culture indicates "beckoning" as in the Maneki-neko, literally "beckoning cat," the common Japa-nese talisman, which is believed to bring good luck to the owner. The motif of Kerensky in boots, "pouting" on the couch is intended to be in stark contrast with the energy and dyna-mism of the Savage Division dancers.

To focus on metric cutting, we have to look at duration as the dominant. The cutting towards the end of the sequence is clearly accelerated, and the effect is rousing, with staccatto cuts from dancing feet (Figure 5.17) to spinning faces synthesizing into a dynamic whirlwind of dance (Figure 5.18). Nevertheless, it's difficult to imagine how to separate the *internal* visual rhythm – the movement of the actors – from the *cutting* rhythm here. In fact, if we examine these shots closely, many of the cuts show complete actions, like a dancer's full kick or a com-plete twirl from where the dancer is *spotting* towards camera (i.e., stopping the rotation of his head to prevent dizziness) until he returns to that position. This suggests that the editing does acknowledge the *shot contents* rather than *shot duration alone*, though the sheer speed of the accelerating montage at the end of the sequence clearly dominates. See Critical Commons, "*October*: Metric Montage."[78]

Counting from *after* the last shot of Kerensky with his boots on the couch, the shots come very quickly: these are short shots, and here, the cumulative impact of 26 staccato shots in roughly :14 seconds of screen time is the potential of metric montage that Eisenstein seeks (see Table 5.1). Clearly, the metric montage in this brief section begins in a rapid rhythm, and then accelerates by chopping it into a whirling, leaping frenzy. The dominant created through cutting makes it much more a mediated event than a realistic event. Or to use Herbert Zettl's terminology, Eisenstein is not objectively "looking at the Lezginka" here, but rather "creating a Lezginka event," a screen event that can only exist in the film medium, by bringing a predetermined concept of shot length to drive the sequence.

2. Rhythmic Montage

Here, in determining the lengths of the pieces, the content within the frame is a factor pos-sessing equal rights to consideration . . . Here its practical length derives from the specifics of the piece, and from its planned length according to the structure of the sequence.[79] Eisen-stein goes on to say that the tension in rhythmic montage can be increased by shortening the shots, and by violating the established rhythm of the montage by cutting in material that has a different, easily identifiable tempo. He sees these violations in shots of the soldiers' feet since their cadence is not synchronized with the established cutting rhythm and their march "comes in off-beat each time, and the shot itself is entirely different in its solution with each of these appearances."[80] This off-the-beat, accelerating cutting ultimately is transferred to the baby carriage: "The stepping descent passes into a rolling descent."[81]

Thus, in rhythmic montage, when you are thinking about where to cut, the "content within the frame" must be an *equal* consideration to the rhythm created by the cutting, that movement within the frame drives the montage.[82] On Eisenstein's mental hierarchy, rhythmic montage is of a higher order than perception, the "rude motive force" of metric montage. According to Eisenstein, this cat-egory could be called *primitive-emotive*, because even though "emotion is also a result of movement [in the montage], it is movement that is not merely a primitive external change [i.e., a simple "meter" created externally through cutting alone]."[83]

To briefly clarify here a topic we will expand on in Chapter 8, we can define two terms. The term *internal rhythm* refers to the rhythm that is created by whatever appears or occurs *within* the shot, principally movement of actors and objects within the frame – the tempo, direction, and pattern of this movement – along with *any of the formal elements available at the shooting stage*

Figure 5.17 Methods of Montage *(1929): metric montage.* Metric cutting, according to Eisenstein, treats duration as the dominant aesthetic parameter, and the constant cutting creates regular beats like measures of music, even if these beats are not recognizable to the audience. Tension is created through "mechanical acceleration by shortening the pieces," like the accelerating dance of the Savage Division in *October*. At the end of the dance, very short cuts hasten the move from dancing feet to . . .

Figure 5.18 . . .spinning faces, synthesizing into a dynamic whirlwind of dance. A metric montage can be rousing, bring "into unison the 'pulsing' of the film and the 'pulsing' of the audience."

Table 5.1 Number of shots by duration in *October* metric montage sequence

Duration in frames	Number of Shots
2 frames	2
3 frames	2
4 frames	4
5 frames	7
6 frames	2
7 frames	4
8 frames	1
10 frames	1
11 frames	1
12 frames	1
14 frames	1

to influence that movement, or create its own visual rhythm. A director can shape the rhythm of an actor's performance in a single take so that it starts slowly and builds in intensity, or so that it starts in an intense rhythm and subsides. This is the essence of directing, what D. W. Griffith calls "the soul of the movies . . . pace. It is a part of the pulse of life itself, and, in common to all human consciousness, its insistent beat has a curious power to seduce and sway the emotions, as the rhythmic tread of marching troops sways a suspended bridge."[84] Beyond performance, formal elements chosen and manipulated during the shooting stage can obviously affect the rhythm of whatever moves within the frame: to cite one example here, it is well known that a wide-angle lens accentuates (and a telephoto lens retards) motion towards and away from the camera.

External rhythm is cutting rhythm, the pattern established by the length of the shots that make up a scene. Lengthening or shortening the duration of the shots establishes a rhythmic measure that can complement or contrast the internal rhythm of a sequence. The kinds of transition (e.g., cut, fade, dissolve, wipe) used from shot to shot or from scene to scene also affect the nature of the cutting rhythm: if we take a sequence of shots and replace the straight cuts with leisurely dissolves, we would slow the *external* rhythm of the sequence. And though editors have no control of rhythm on the set, they absolutely control *external rhythm by deciding duration* of a shot, and to a lesser extent the internal rhythm *by selection from the material available.* (The editor can also modify *internal* rhythm by retiming the footage faster or slower in post, but this is rarely a first choice of how to manipulate internal rhythm unless it has been planned for in shooting.) Notice finally that internal rhythm and external rhythm are in constant flux, changing dynamically over a sequence, over a scene, and over the entire film. The editor modulates one of the primary stimuli for the viewer by controlling the dynamic, vibrantly changing rhythmic patterns that are displayed. We will return to these issues in the final chapter on rhythm.

Eisenstein notes that, even if you were creating a rhythmic montage with an eye towards *internal* rhythm as the dominant, you might still arrive at a sequence that exhibits "complete metric identity." Presumably this means that while cutting a sequence attending to the rhythm of its subject matter (dominant internal rhythm) you might arrive at a sequence in which the dominant that emerges is metric (dominant external rhythm). There are other shared potentials. As in metric montage, tension can be created in the viewer when cutting a rhythmic sequence by acceleration of the material. Always seeking conflict, Eisenstein suggests that when cutting a sequence in an accelerating rhythm, the "most affective violation [of the primary rhythm emerging is] . . . the introduction of material *more intense in an easily distinguished tempo.*" In other words, tension can be created through acceleration in a line of action "A," but the viewer's emotions can be roused beyond that by introducing another line of action "B" that is more intense and in an easily identifiable tempo. See Critical Commons, "*Battleship Potemkin*: Odessa Steps."[85]

Eisenstein points to the famous Odessa steps sequence from *Battleship Potemkin* as an example of rhythmic montage. In the film's third section, "The Odessa Staircase," the people of the city take to their small boats to bring food and drink to the rebellious sailors on board *Potemkin*. As the townspeople watch and cheer from the steps, the sailors welcome gifts of bread, eggs, chickens and even piglets. Their celebration is cut short, starting with the jarring title, "AND SUDDENLY," launching a briskly cut 157 shots in the next eight minutes (average shot length = 2.3 seconds) that is perhaps the most recognized scene in film history. Eisenstein cites the drum of the soldier's feet descending the stairs as violating metrical demands by being "unsynchronized with the beat of the cutting. . [and coming] in off-beat each time." Counting the three opening shots from the top of the stairs that show the soldiers from behind, there are 16 shots of the line of soldiers on the stairs (Throughout, I am using David Mayer's extensively cataloged shot list for *Battleship Potemkin*, where the shots of soldiers moving downward are cataloged as "subtheme F" in the sequence).

The volley of muskets firing in the Odessa steps sequence can be considered a "violation," a second line of action "B" used to accelerate the overall march of the soldiers down the stairs. Three shots of the line of soldiers are *taken from the side* and are simply framed, static shots of the muskets firing: shot 833 (the volley that hits the child) (Figure 5.19), shot 929 (the less orderly

Figure 5.19 From Methods of Montage *(1929): rhythmic montage.* A rhythmic montage is cut so the content within the frame (i.e., internal rhythm) is given equal consideration as the cutting rhythm (i.e., external rhythm) when deciding each shot's length. The editor can increase tension in a rhythmic montage by introducing other material "more intense in an easily distinguished tempo." Here, the static, orderly repeated forms of the soldier's guns, with bayonets afixed, firing a volley in shot 833 is a stark contrast with the bloody chaos of the scene. There are three static volley shots like this one in the Odessa step sequence.

Source: Copyright 1925 Goskino.

volley that sends a wave of citizens cascading down the steps), and shot 949 (the volley that hits the group of "pleaders," but spares the woman in the pince-nez). The orderly efficiency of the volley is a violation of the primary line of action, the mass of citizens cascading chaotically down the stairs. The repeated forms of the guns, motionless, with bayonets fixed, are sufficient to meet Eisenstein's criterion of "material more intense in an easily distinguished tempo." Moreover, their impact is enhanced because they are cut extremely tight (i.e., short duration), with no "breathing room" on either side of the firing of the volley.

In other shots, this characteristic appears again. The soldiers march relentlessly down the steps – "material more intense in an easily distinguished tempo" – but will the viewer experience these shots as "off-beat" or "unsynchronized"? Viewed in the rhythm of the adjacent shots, which starts with a huddled group of citizens (Figure 5.20) who are starting to turn against the soldiers, the next shot is a stark contrast, again using Mayer's shot description: "Shot 920: LS. The line of long, menacing shadows cast by the approaching off screen troops crawled slowly downward across the empty steps. Finally, the black-booted troops appear at the upper steps. They descend in slow, steady cadence, rifles grip and firing position." (Figure 5.21) Eisenstein then cuts from this highly graphic shot of the repeated shadows (moving left to right in the frame) to the mother carrying her son up the steps (moving right to left in the frame) and castigating the troops (Figure 5.22) Here, if not literally "off-the-beat," the cascade of 15 uniformed soldiers down the steps certainly is a "graphic violation" of the more chaotic, rounded close ups of the supplicants' faces, wracked with fear, and moving against the military "cascade" rolling down the steps.

But perhaps the best place to see the "off-the-beat" cutting of the soldiers marching comes in *adjacent* shots of the soldiers marching, where the outgoing shot and the incoming shot both show

Figure 5.20 From Methods of Montage *(1929): rhythmic montage.* To increase tension in a rhythmic montage, the editor introduces material "more intense in an easily distinguished tempo" – here, the rigid march of the soldiers' feet descending the Odessa steps. The cut from the rounded forms of the huddled citizens rising in shot 919 to . . .

Figure 5.21 . . .an "unsynchronized" shot 920 of the soldiers' menacing shadows descending the stairs that enters "off-the-beat" followed by . . .

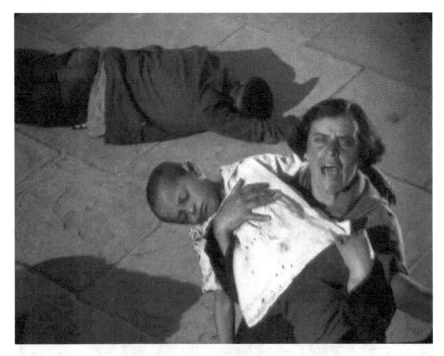

Figure 5.22 . . .the lone mother ascending the stairs castigating the soldiers in shot 921. Here, the repeated forms of shadows and soldiers marching relentlessly down the stairs fulfils the "violation" or conflict Eisenstein seeks to increase tension in a rhythmic montage.

soldiers marching. Three shots midway through the Odessa steps sequence provides an instance to examine adjacent cuts where the soldiers advance, fire a volley and hit the mother by the baby carriage.

Shots 958 (Figure 5.23), 959 (Figure 5.24) and 960 (Figure 5.25) are described by Mayer as:

> **Shot 958** CU. Five empty steps stretch across the screen. A line of black boots advances across the top step in unison and marches slowly, steadily downward. *(Cut to . . .)*
> **Shot 959** LS. *(From below)* Smoke erupts from a line of rifles silhouetted against the sky as they are fired. *(Cut to . . .)*
> **Shot 960** ECU. The young mother's head sways back. Her eyes closed as her mouth opens in mortal agony.

The "off-the-beat" cutting here arises from the fact that the outgoing shot 958 is profoundly dynamic in composition and in sustained movement from left to right – a descending march of soldiers in formation – while the next shot 959 abruptly transfers that dynamism to a static shot: a diagonal line of rigid bodies and static muskets erupts in a blast of gunfire. Not only is there unsynchronized conflict between a downward march that is abruptly arrested by the static shot of muskets, but Eisenstein emphasizes the "off–the-beat" quality of the cut by tightening shot 959 to its absolute essence: the volley is trimmed out to distill it into a :01 second shot of smoke bursting forth. The smoke that erupts from the muskets is propelled towards the right of the frame, and is answered by the cut to shot 960, a stable, centered close up of the mother in dark, rounded forms. The first two shots conflict in their movements, a descending march against a static volley, while the second two conflict on graphic parameters, parallel diagonals in a long shot against rounded ovals in close up. Taken together, the three shots contravene the principles of smooth continuity, and produce a halting, uneasy, a-rhythmic burst in the forward progress of the soldiers.

Similarly, in shots 970 and 971, we see the only cut where the *marching cadence* of the soldier's legs in one shot *continues* into the next shot. Those two shots of continuing action come after the mother who is shot grips her stomach and slumps to the ground, while her carriage hovers precariously on the edge of the steps:

> **Shot 970** CU. In a deadly cadence, the black boots from a long line of soldiers descends the five steps that stretch diagonally across the screen and move out of frame. *(Cut to . . .)*
> **Shot 971** CU *(From below)*. In the same cadence as the previous shot, white jackets of the soldiers move across the screen and out of the frame.

Notice that in a classically edited sequence, the positioning of the soldier's footsteps from the last frame of outgoing shot 970 (Figure 5.26) would be closely matched to the first frame of the incoming shot 971 (Figure 5.27) so that – whether they match exactly or not – the *illusion* is that the footsteps continue smoothly and seamlessly in the next shot. Here, no attempt is made to smooth that match, since the first few frames of the incoming shot 971 show the soldiers just beginning to move forward from a dead stop. This is the most clear cut "violation" of the drumming rhythm of the soldier's march, two shots that are "off-the-beat" in strict continuity editing terms, a deliberate rhythmic "stutter." Shots 970 and 971 are also the last time in the sequence the soldiers appear. Eisenstein correctly describes this moment as the transfer of the downward rhythm of the soldier's feet to the baby carriage rolling down the steps: rigid march transfers into uncontrolled rolling of the carriage, the "final pull of tension" that concludes the scene.

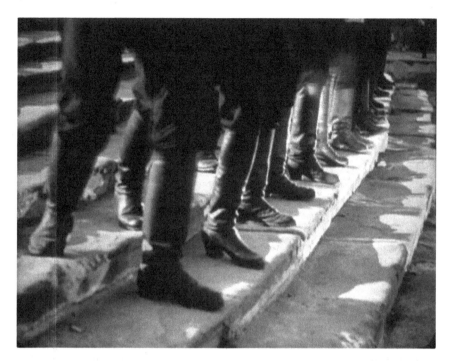

Figure 5.23 From Methods of Montage *(1929): rhythmic montage.* Eisenstein suggests "off-the-beat" cutting will increase tension in a rhythmic montage. The best place to see that comes in *adjacent* shots of the soldiers marching. Shot 958 is profoundly dynamic in composition and in sustained movement from left to right – a descending line of black boots – which conflicts with an arrhythmic cut to . . .

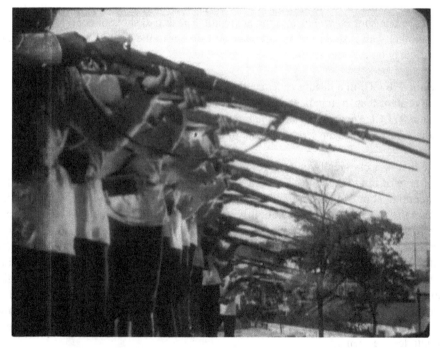

Figure 5.24 . . .shot 959 abruptly arresting that dynamism in a static shot, a diagonal line of rifles and rigid bodies firing a volley. The smoke erupting from the muskets is propelled towards the right of the frame, answered by a cut to . . .

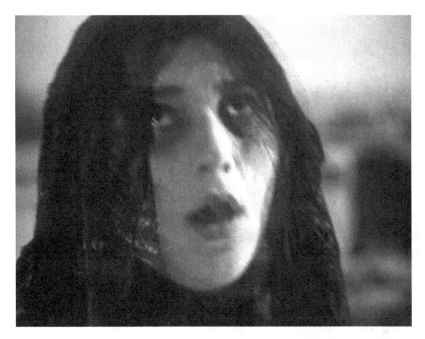

Figure 5.25 . . .shot 960, a stable, centered close up of the mother in dark, rounded forms standing near the carriage. Taken together, the three shots contravene the principles of smooth continuity, and produce a halting, uneasy, arrhythmic burst in the forward progress of the soldiers.

Source: Copyright 1925 Goskino.

Figure 5.26 *From* Methods of Montage *(1929): rhythmic montage.* To increase tension in a rhythmic montage, Eisenstein says the march of the soldiers should come in "off-the-beat," unsynchronized. In shots 970 and 971 we see the only cut in the Odessa steps sequence where the marching cadence of the soldier's legs in one shot continues into the next shot. The positioning of the soldier's footsteps from the last frame of outgoing shot 970 to . . .

Figure 5.27 . . .the first frame of the incoming shot 971 makes no attempt to preserve the illusion that the footsteps continue smoothly and seamlessly in the next shot, since the in the first few frames of 971, the soldiers are just beginning to move forward from a dead stop.

Source: Copyright 1925 Goskino.

3. Tonal Montage

"This term is employed for the first time." *It expresses a stage beyond rhythmic montage.*

In rhythmic montage it is movement within the frame that impels the montage movement from frame to frame. Such movements within the frame may be of objects in motion, or of the specta-tor's eye directed along the lines of some immobile object.

In tonal montage, movement is perceived in a wider sense. The concept of movement embraces all affects *of the montage piece. Here montage is based on the characteristic **emotional sound** of the piece-of its dominant. The general **tone** of the piece . . . An example: the "fog sequence" in* Potemkin *(preceding the mass mourning over the body of Vakulinchuk). Here the montage was based exclusively on the emotional "sound" of the pieces-on rhythmic vibrations that do not affect spatial alterations.*[86]

Eisenstein gives the fog sequence that precedes the mourning of Vakulinchuk as an exam-ple of tonal montage, but with again with caveats. First, he refuses to delimit it completely, saying "a secondary accessory rhythmic dominant is also operating." And second, given that metric montage is quantifiable in feet and frames, Eisenstein seeks not an "impressionistic" measure for tonal montage, but a scientific, quantitative method of measurement. He says that if we give a subjective designation "more gloomy" to a shot, we can use a light meter to read its density, and generate a mathematical coefficient for its ability to transmit light. The first caveat seems plausible, and Eisenstein argues for a secondary dominant that arises on the edge of our perception through the rippling water, the rocking of the ships, the sea gulls fluttering.[87] His later concern that tonal montage be quantifiable seems to equate "more gloomy" with "darker," which may not always be true. See Critical Commons, "*Battleship Potemkin*: Tonal Montage."[88]

The fog sequence combines 10 languid, homogenous wide shots of the bay at Odessa. David Mayer's account of the sequence follows:

> **Shot 640** LS. There is a hint of dawn. In the gray mist, a large sailing vessel rests quietly at anchor. Behind it, a large dockside crane slowly swings its load from ship to shore. *(Cut to . . .)*
>
> **Shot 641** LS. The sun looms behind the mist and burns a pale, flickering path of light across the harbor's waters. A tall sailing ship, deep in shadow, is anchored in the foreground. *(Cut to . . .)*
>
> **Shot 642** LS. The harbor is shrouded in the early morning fog. A pair of three-masted sailing ships, their details dissolved in grey, rest quietly as they await the dawn. *(Cut to . . .)*
>
> **Shot 643** LS. A low, round buoy looms in the fog. A darker shape against the enveloping mist. Seagulls huddle on its surface. *(Cut to . . .)*
>
> **Shot 644** LS. No wave breaks the oily calm of empty stretch of sea. Down its center a growing path of light is barely perceptible. *(Cut to . . .)*
>
> **Shot 645** LS. The gull-covered buoy is now seeing more clearly, its black hulk silhouetted against the increasing light. A gull soars off and flies away. *(Cut to . . .)*
>
> **Shot 646** LS. An empty sea stretches away, its horizon hidden in the mists. Soft light plays on its surface. *(Cut to . . .)*
>
> **Shot 647** LS. The bowsprit of a silhouetted sailing vessel at anchor juts diagonally across the scene. Far behind it, dockside cranes begin to appear in the dissolving early morning mists. *(Cut to . . .)*
>
> **Shot 648** LS. The camera moves slowly past steam ships at dockside. In the clearing skies soft clouds appear. *(Cut to . . .)*
>
> **Shot 649** LS. The huge prow of a steamship at anchor slides past the moving camera. Its starboard side is clearly defined. The mists have lifted. *(Cut to . . .)*[89]

The cutting rhythm here is very slow, with the shortest shot being roughly 2 seconds and the longest 13.5 seconds. Most of the shots are 5–7 seconds in length,[90] and the broad area of sea surface that fills much of the area of the shots is in the mid-grey range, with gently lapping waves. A soft fog permeates the scene, diffusing the deep background, while the camera itself often rocks slowly on a floating platform. This slight motion adds to the emotive tone of the scene, and Eisenstein identifies it as part of a "barely perceptible" range of movements that contribute to the "secondary rhythmic" quality of the sequence. Shots 643–646 are particularly evocative, and "checkerboard" back and forth between two shots – a shot of a buoy with sea gulls on top rocking in the water (Figure 5.28), and a shot of the placid water's "oily" surface swathed in light (Figure 5.29). The cuts move languidly back and forth – bouy/water/bouy/water – with the slowly fluttering gulls and the undulating water particularly effective in evoking the tranquil tone of the scene.

This kind of tonal montage is still higher on Eisenstein's mental hierarchy, and he designates the level *melodic emotive* where movement "passes over distinctly into an emotive vibration of a still higher order."[91] It is unclear exactly what this means, but Eisenstein maintains that conflict in the fog sequence creates a tonal dominant from the expressive pictorial qualities that pervade the shots, stimulating an emotive response like a melody would in the brain.

4. Overtonal Montage

In my opinion, overtonal montage . . .is organically the furthest development along the line of tonal montage. As I have indicated, it is distinguishable from tonal montage by the collective calculation of all the piece's appeals. This characteristic steps up the impression from a melodically emotional coloring to a directly physiological perception. This, too, represents a level related to the preceding levels. These four categories are methods of montage. They become montage

Figure 5.28 Methods of Montage *(1929): tonal montage.* Rhythmic montage takes into account movement within the frame, but with tonal montage, "movement is perceived in a wider sense . . . [it] embraces all affects of the montage piece . . . The general tone of the piece." In *Potemkin,* shots 643–646 are particularly evocative, cutting back and forth between two shots – a shot of a buoy with sea gulls on top rocking in the water cuts to . . .

Figure 5.29 . . .shot of the placid water's "oily" surface swathed in light. The cuts move languidly back and forth – bouy/water/bouy/water – with the slowly fluttering gulls and the undulating water evoking the tranquil tone of the scene.

constructions proper when they enter into relations of conflict with each other-as in the examples cited. Within a scheme of mutual relations, echoing and conflicting with one another, they move to a more and more strongly defined type of montage, each one organically growing from the other. Thus the transition from metrics to rhythmic came about in the conflict between the length of the shot and the movement within the frame. Tonal montage grows out of the conflict between the rhythmic and tonal principles of the piece. And finally – overtonal montage, from the conflict between the principal tone of the piece (its dominant) and the overtone.

Here again, Eisenstein's writing is obscure. Where metric montage creates a dominant of shot length, rhythmic montage creates a dominant of internal shot rhythms, and tonal montage a dominant of fundamental expressive shot features or "tones," overtonal montage "distinguishes itself by taking full account of all the stimulants in the shot."[92] Where tonal montage stimulates a "melodic emotive" response, overtonal montage stimulates a "directly physiological perception" that is nevertheless, "a level related to the preceding levels." How to understand this?

Eisenstein suggests, at this level, something else begins to activate the viewer with the direct motive force of a metric montage. What in an overtonal montage triggers this force? Like the overtones in a chime, an organ, a large drum, which seem to displace the fundamental tone, Eisenstein argues that sensed vibrations in the shot begin to displace the primary movement.[93] If we think of the sound of an organ, where stops have been engineered to mimic a clarinet, a flute, a piccolo, a tuba, to name just the horns it might emulate, clearly the overtones control in large part how the pipes "speak" to us – the overtones "displace" the dominant. By analogy, in overtonal montage, it is not the primary attraction that speaks, but the secondary attractions that emerge organically as the "collective calculation of all the piece's appeals." This explanation is only slightly more illuminating, but it is in keeping with the theorization of a film artist who is trying to untangle the rich knot of stimulants and associations that emerge through montage. Nevertheless, Eisenstein maintains that the montage of visual overtones is one of his most significant contributions to the future of cinema.[94]

Eisenstein cites *The Old and the New* (original title, *The General Line*) as an example of overtonal montage. Co-directed in 1929 with Grigori Aleksandrov (who played the lead in the stage version of *Enough Stupidity in Every Wise Man* from the early Proletkult days), the film focuses on a single heroine in the film, Marfa, rather than the mass as protagonist. Marfa becomes a revolutionary because the death of her father leaves her unable to farm the small piece of land left to her, and she turns to collective agriculture for help with her precarious circumstances. The film was sidelined to complete *October: Ten Days That Shook the World* for the tenth anniversary of the Revolution, and by the time Eisenstein returned to it, the political winds had changed. Reacting to a grain shortage in the winter of 1927–1928, Stalin was pushing for forced collectivization of farming, and this action drove changes in the film, including new scenes from Rostov-on-the-Don of a vast collective farming operation. Consequently, the film was re-edited and released under the new title, *The Old and the New*, which in the 1960s was restored under the original title, *The General Line* to an approximation of Eisenstein's original scenario.

Eisenstein says that *The Old and the New* was the first occasion that the montage of visual overtone was developed. And yet, the scene he cites to exemplify the technique is *not simply* "overtonal montage." Eisenstein finds it collides at various points with *all the previously specified forms of montage* – tonal and overtonal, metric and rhythmic. He finds examples of this complexity "in the various 'tangles' of the religious procession: those who fall on their knees beneath the ikons, the candles that melt, the gasps of ecstasy, etc."[95] See Critical Commons, "Kinds of Montage: Eisenstein's Overtonal Montage in *The Old and New* (aka *The General Line*)."[96] Over a decade later, writing about this sequence in a different context, Eisenstein specifies the "whole skein of separate motifs" seen in *The Old and the New* as:

1 *The motif of "heat,"* progressing, growing all the time, from sequence to sequence.
2 *The motif of successive close-ups*, increasing as purely graphic intensity (Figure 5.30).

Figure 5.30 Methods of Montage *(1929): overtonal montage.* Eisenstein says that overtonal montage "distinguishes itself by taking full account of all the stimulants in the shot . . . in overtonal montage, it is not the primary attraction that speaks, but the secondary attractions that emerge organically as the "collective calculation of all the piece's appeals." He cites the interwoven skein of motifs in the religious procession in *The Old and New* as an early example of overtonal montage at work.

Source: Copyright 1929 Sovkino.

3 *The motif of the mounting intoxication of religious fanaticism,* i.e. the *histrionic content* of the close-ups.
4 *The motif of female "voices"* – the faces of the peasant women singing and carrying icons.
5 *The motif of male "voices"* – the faces of the peasant men singing and carrying icons.
6 *The motive of a rising tempo* of movement by the people "diving" under the icons . . .
7 *The general theme of "grovelling,"* which unites both streams of people and the common progression of sequences "from the sky to the dust," i.e., from the crosses and the tops of the banner-staffs in the sky to the people prostrate in the dust and ashes.[97]

5. Intellectual Montage

Intellectual montage is montage not of generally physiological overtonal sounds, but of sounds and overtones of an intellectual sort: i.e., conflict-juxtaposition of accompanying intellectual affects.

The gradational quality is here determined by the fact that there is no difference in principle between the motion of a man rocking under the influence of elementary metric montage (see above) and the intellectual process within it, for the intellectual process is the same agitation, but in the dominion of the higher nerve-centers . . . Applying the experience of work along lower lines to categories of a higher order, this affords the possibility of carrying the attack into the very heart of things and phenomena. Thus, the fifth category is the intellectual overtone. Again, Eisenstein's writing is obscure here, and feels almost intentionally so. For example,

he is apparently shifting the discussion from visual attractions to "sounds and overtones of an intellectual sort," and by using the terms "intellectual montage" and "intellectual overtone" interchangeably.

Eisenstein likens intellectual montage to metric montage in that is stimulates the viewer's nerve centers, only here, in "higher nerve centers." Presumably Eisenstein is referring to areas of the brain known to handle higher order mental functions like language, including the cerebral cortex, Broca's area, and Wernicke's area all of which were known in the 1920s. Current research suggests, however, that language functions in the brain are no longer limited to those areas.[98] See Critical Commons, "Kinds of Montage: Intellectual Montage."[99]

More helpful for understanding intellectual montage is the concrete example he gives from the "Gods" sequence in *October: Ten Days the Shook the World*, the semi-factual film Eisenstein made to commemorate the tenth anniversary of the Bolshevik revolution. The sequence comes after Kerensky, mocked for his vanity by comparison to a peacock, has signed the order reinstating the death penalty for army deserters from the German front. After he signs the order, he ascends the steps, and assumes a stance that Eisenstein compares to a statue of Napoleon, asking with a title card whether Kerensky aspires to be emperor. As Kerensky pulls together a crystal cruet made in four sections and places a crown-shaped lid on top, Eisenstein cuts back and for to factory steam whistles, and titles that read "The Revolution in Danger!" and "Kornilov is Advancing!" General Kornilov's return to Petrograd to attempt a coup d'état against the Petrograd soviet would leave Kerensky free to ascend to "imperial power," so Eisenstein cuts to shots of the proletariat streaming from the factories to "Defend Petrograd!" as the title exhorts. The vitality of the proletariat in action is reinforced throughout the film by linking it with images of energy and power, a motif continued here by intercutting forceful images of steam whistles sounding the alarm.

At this moment, Eisenstein stops the emotional narrative of mass spectacle with a title card "In the name of God and Country," which he immediately breaks down further with a second title "In the name of God . . . " which is presumably what Eisenstein is referring to as the "Gods sequence." The next 29 shots include images of the ornate onion shaped domes of Russian orthodox churches (the first of several shapes that echo the crown Kerensky placed on the bottle), radiant statues of Jesus, Shiva, numerous statues of the Buddha, a Chinese lion (Figure 5.31) masks from Asian and African cultures, and other shamanistic figures. Many of the images appear against a black background that is typical of Eisenstein's non-diegetic inserts, but others are more spatially articulated. The sequence shows a close shot of a Hindu god and then cuts to a wider shot. Three shots of ceramic Buddha are shown in sequence, first lit with curls of smoke from incense rising into the frame, then a shot of his lower torso with his hands in resting meditation, and finally a full long shot with an oval of light on the background behind him. Many of the shots that move from close ups to wider shots are *axial cuts*. An axial cut is a cut from one scope of shot to another – either wider or tighter – where the axis extending from the center of the camera lens does not change. Axial cutting is a signature technique of Eisenstein and his cinematographer Edward Tissse, who frequently did not move his camera when changing shot scales, as opposed to following the traditional "30° rule," so named because a move of at least 30° off the axis of the previous shot is considered the minimum change of position to ensure smooth continuity cutting when shooting coverage.

Shots of church domes are also shown in canted angles, and adjacent cuts of an African mask show it facing screen right, then screen left, then in a wider shot head on to the camera. The arms of a wooden figure swing in motion from the elbows. In the "Gods" sequence, these "conflict-juxtapositions," and the manner in which they step outside the narrative of mass spectacle, clearly ask the viewer to construct abstract meanings. Eisenstein asserts that the *order* of the images moves from contemporary images of God to early images of God, forcing the viewer

Figure 5.31 Methods of Montage *(1929): intellectual montage.* Eisenstein says that intellectual montage is "conflict-juxtaposition of [a shot's] accompanying intellectual affects . . . Applying the experience of work along lower lines [of mental processes] to categories of a higher order, this affords the possibility of carrying the attack into the very heart of things and phenomena." He cites the "Gods" sequence in *October: Ten Days the Shook the World* as an example of intellectual montage. The film's narrative stops while 29 shots display images of the Russian orthodox churches, statues of Jesus, Shiva, Buddha, and masks from Asian and African cultures, and other shamanistic figures. Many of the images appear against a black background that is typical of Eisenstein's non-diegetic inserts.

Source: Copyright 1927 Sovkino.

to proceed backwards to the beginning of man's notion of God, and thus see man's "progress" intellectually.[100]

Notice that the "meaning making" cued by this sequence is perhaps not in the model of the simple dialectic that Eisenstein believes underlies everything, where contradictions give rise to new solutions, where thesis + antithesis = synthesis, since the opening title, "In the name of God . . . " is critical to understanding the sequence:

> We understand from the images following one another, from the non-diegetic nature of some of them and the fact that they do not all belong to the same spatial continuum, that there is a problem of meaning to be solved, a task for the decoder. But what guarantees that the conclusion made by a Leningrad spectator will not be "Aha, these are exotic objects from Peter the Great's *Kunstkammer* [the anthropological museum where Eisenstein photographed them], and Kerensky and his cohorts will soon be joining their a lot" – a not totally inappropriate deduction, instead of the intended general denunciation of religion to which the "In the Name of God" sequence aspires? From a purist point of view,

the intellectual montage in *October* sometimes puts the cart before the horse by using text frames to "assist" in the guiding process, thereby *presenting* the concept rather than *generating* it.[101]

Eisenstein does not address using *titles* with intellectual montage, a method aimed at creating abstract meanings of a high order, which of course, language can do easily. But he's certainly innovating with the intellectual montage method, an approach he believes cues concept formation *and* retains its physiological basis *and* offers complex levels of dialectic conflict. In fact, according to Bordwell, across *all these methods* of montage, Eisenstein aims not for a single sensory response but a cross-modal bodily response created by conflict on many levels:

> The overtone is potentially in opposition to the dominant, intellectual overtones clash with other sorts, and so on . . . Once more, Eisenstein construes the concept of dialectic so broadly as to make it vacuous or unchallengeable, and he posits an impossibly elaborate spectatorial activity. Still, if one drops commitment to the absolute notion of conflict and grants that there can be relative degrees of dynamic contrast between shots, *what remains is a useful heuristic tool for filmmaking and film analysis* . . . [that] moves us close to moment-by-moment fluctuations of cinematic texture"[102]

Eisenstein's Later Work: Making Films and Theorizing in the Age of Stalin

Eisenstein had two periods of productive filmmaking and theorizing in his life, separated by a period in which he left Russian in 1929, travelled to Europe, was courted in Hollywood by Charlie Chaplin and Paramount Pictures among others, and went to Mexico where he sunk a year of effort in 1931 into making a film that fell apart. *¡Que Viva Mexico!* was to be an episodic panorama of the history of Mexico, and Eisenstein shot well over 30 hours of film for the production with his collaborator/cameraman Edward Tisse. When Stalin called Eisenstein back to Moscow in January 1932, accusing him of deserting Russia, Sinclair Lewis, the acclaimed investigative journalist who was producing the film with a group of investors, initially told Eisenstein he would send the footage for him to edit in Moscow. Later, in order to recoup whatever money he could for the investors, Lewis took the footage and released a short feature *Thunder over Mexico* in 1934, and later sold whatever shots he could for stock footage.

The entire episode left Eisenstein despondent. He also found that much had changed in Russia since he left. Since the death of Lenin in 1924, Joseph Stalin had been relentlessly consolidating his power as General Secretary of the Communist Party by expanding the secret police, centralizing the economy, collectivizing agriculture through the use of forced labor camps, building a cult of personality that glorified himself, and by ruthlessly purging his opposition on a monumental scale. Estimates of the number of people sent to the gulag camps range from 14 million to 40 million, and "The official data presented by the Soviet authorities indicate that over 1 million people died in camps between 1934 and 1953. Independent analysts however estimate the number of victims was at least 10 times higher."[103]

Closer to Eisenstein, the communist party's influence in the cultural arena was driving a standardized style in the visual arts, fostering depictions of a typically robust and happy proletariat in a glorified struggle to achieve socialist progress. The increasing sway of this official style, *Socialist Realism*, was codified in the 1934 Communist Party Conference decree that art must be relevant to the proletariat, realistic in its depiction of everyday life, and support the goals of the state. The optimism of these monumental sculptures, murals, and

images of the idealized worker was so forced that the work was often derided by Western critics as "Girl meets tractor." In this politically charged atmosphere, Eisenstein's revolutionary films were denounced as too avant-garde, too formal. In January 1935, the All-Union Conference on Soviet Cinematography became a major humiliation for Eisenstein as other directors including Dovzhenko, Yutkevisch and Pudovkin ridiculed his focus on film theory, his formalist style, his ego and his lack of output – he had not released a film in roughly six years. Eisenstein ended the conference with speech in which he acknowledged his "failures," defended his theorizing, and promised to return to making films. His admission was answered by a triumphant ovation. But for those who continued to openly reject the official style, like Eisenstein's muse Vsevolod Meyerhold, there would be arrest and torture (1939) and death by a firing squad (1940).

In the years that followed, Eisenstein, like many in the Soviet Union, felt the terror of Stalin's reign. The filmmaker, who was gay,[104] was living in a society in which homosexual acts were punishable by death. He married filmmaker and writer Pera Atasheva in 1934 and remained married to her until his death in 1948, five years before Stalin's death ended his dictatorship. In 1935, he was tasked with directing *Bezhin Meadow*. The film celebrates a young boy who is killed by his father for condemning the father's counterrevolutionary actions. The film ran into script and budget problems as Eisenstein decided to change its thrust from the celebration of a young, contemporary socialist hero into a tragedy of patricide set against the industrialized transformation of agrarian culture. The film cost 2 million rubles, and took two years to make, partly because Eisenstein became ill with small pox and influenza. The Soviet Politburo, after reviewing a series of edits, refused to release the film. It was a dangerous moment, and Eisenstein publically recanted the work as a political error in an article titled "The Mistakes of *Bezhin Meadow*." Luckily, a written appeal from Eisenstein to Stalin asking the dictator to trust him to make another film as worthy as *Potemkin* was convincing, and the calamity was pinned on the Principal Directorate for the Cinema, Boris Shumyatsky, who three years later was convicted as a traitor and shot. Stalin also personally supervised the Politburo vote that allowed Eisenstein to make a new film, on the condition that the subject be approved in advance, and produced under close supervision. Disgraced and under financial pressure, Eisenstein was forced out of his teaching job at the national film school V.G.I.K. and looked for publishing or directing opportunities.

At this time, a strange convergence with the rise of Socialist Realism provided the backdrop for Eisenstein's struggle: the emergence of sound in cinema,

> . . . giving primacy to the exchange of words between characters [and thereby putting] focus on individual human attributes. These facts, demanded of the sound film throughout the world, fit perfectly with the demands of Socialist realism for a new conception of the hero . . . The combination was lethal. The sound film, developed throughout the world as dialogue film, becomes in the Soviet context the favored vehicle for the populism and pseudo-humanism of Stalinist ideology.[105]

Under pressure to find suitable films to make, Eisenstein made three sound films during the period – *Alexander Nevsky* (1938), *Ivan the Terrible Part I* (1944) and *Ivan the Terrible Part II* (1946). Since he was no longer teaching and making fewer films, he continued to write extensively during this period, reworking, but also advancing his film theory, moving from the reductive materialism of film as rhetoric, plotless cinema, typage, and montage as a stimulus set driving primitive-psychological responses, towards a more organic model of how montage, and indeed, how art itself works.

Eisenstein's Later Theorizing and Vertical Montage

By the late 1930s, Eisenstein sees montage as interweaving lines of various artistic potentials in the film's micro and macro structures into "artistic images." Montage, for Eisenstein, penetrates all levels of filmmaking, starting with motion that is created by projection of successive frames, through the montage process, and up to the juxtaposition of larger structures like sequences and scenes.[106]

To create the *artistic image* or *felt concept* (Russian: *obraz*) at any of these levels, Eisenstein says we need to accumulate the proper *depictions* (Russian: *izobrazhenie*). The example he gives is the process of *mentally* creating the "artistic image" of "5 o'clock" simply by seeing the *depiction* of clock hands pointing at 12 and 5. Triggered by that image, the viewer summons images of supper, leaving work, rushing home on the metro, shops closing, the quality of light at the end of the day.[107]

So the selection of depictions (*izobrazhenie*) that will dynamically, instantly cohere into felt concepts (*obraz*) as the film unfolds is the foundation of Eisenstein's organic model of montage. The progression of attractions that montage creates is woven into polyphonic lines of meaning that unite as a theme, and sound is now another element in that organic polyphony, beginning with his film *Alexander Nevsky*:

> [T]here is no difference in principle between purely visual montage and montage that embraces different areas of sensory perception, in particular the visual image and the auditory image, for the purpose of creating a single generalising audiovisual image . . . And the new form of montage, which remains inseparable from that picture in my memory, I shall call: *vertical montage.*[108]

Clearly, Eisenstein sees sound as broadening the possibilities of montage. This seems trivial today, but during the advent of sound, many prominent theorists, including Rudolf Arnheim, saw sound – dialogue particularly – as detrimental to the artistic potential of film. Incorporating sound in his theory, Eisenstein notes, began when he advocated the use of sound as a *contrapuntal* element in montage at the dawning of sound in the late 1920s. He points to a statement on the sound film that he signed with Alexandrov and Pudovkin, acknowledging the use of lip sync sound for entertainment in "talking pictures," but demanding – in capital letters – that "THE FIRST EXPERIMENTAL WORK WITH SOUND MUST BE DIRECTED ALONG THE LINES OF ITS DISTINCT NON-SYNCHRONIZATION WITH THE VISUAL IMAGE."[109] The difference is that his new theorizing will deemphasize conflict in image–sound relationships and look to synthesize correlations that exist in music and in image.

In his later writings, Eisenstein is more open to new, artistic uses of sound as long as they move beyond mere synchronized reproduction (i.e., the shot of a frog croaking synchronized with its croaking sound). These new uses are based in his formalist beliefs: film art does not use the combination of picture and sound as *reproduction*, but takes the expressive needs of the work as the starting point to build a connection between the two.[110] The central thrust of his thinking is that image and music will form a supposed *inner synchronicity* given their mutual reliance on "movement." What is "inner synchronicity"? Eisenstein's circular definition suggests it is whatever makes image and audio "compatible" when they aspire to an inexplicable, inner synchronicity wherein picture and sound merge completely.[111]

Mysterious perhaps, but potentially unmistakable, if the filmmaker can find moments of "inner synchronicity between picture and music that is as sharply perceptible to us as it

already is in our perception of examples of *outward synchronicity* (we have already learnt to be keenly aware of the slightest failure of synchronization between lip movements and the spoken word!)"[112] The connection between picture and sound that will allow inner synchronicity, Eisenstein says, is obviously *movement*, because all phenomena (clearly, all *filmic* phenomena) can be reduced to movement, movement that reveals to us the hidden layers of synchronicity and the emotional associations that images contain. According to Eisenstein, movement even reveals to the viewer how it creates these phenomena: *its very methodology.*[113] *Inner synchronicity* is thus part of Eisenstein's movement away from montage as a trigger of Pavlovian "stimulus-response," towards montage as entry into pre-logical, pre-verbal, sensuous interactions with art. Here, his thinking parallels the Associationists, psychologists of the period who saw the cognitive processes as following simple juxtaposition of imagistic precepts rather than some kind of mental syntax that mirrors language. And perhaps more importantly, Eisenstein's notion of inner synchronicity follows the famous theories of child psychologist Jean Piaget. Eisenstein was aware of the work of Piaget, though it is not clear how extensively.[114] Yet Eisenstein's organic model of how montage creates meaning parallels Piaget's thinking two in important ways:

> 1) Eisenstein talked explicitly about the ability of cinema to render the syntax of inner speech, the syntax of image clashes and overlaps which only later was translated and tamed into the logic of the uttered speech. [115]
> 2) In the 2–7-year-old stage, Piaget found the predominance of the felt symbol as an organizing operation. Such symbols are highly iconic in nature; that is, the symbol emulates as closely as possible the physical characteristics of that for which it stands. As an example of this, Piaget cited a child opening her mouth to facilitate learning how to open a box.[116]

In drawing on Piaget's work, Eisenstein is trying, like many art theorists, to recover supralogical thinking as a part of his aesthetic process: he sees the immediate experience of montage through inner synchronicity as a process that "by-passes public syntax and creates the strongest of poetic effects."[117] This approach also resonates with Eisenstein's long-standing interest in *synesthesia*, "a sensation produced in one modality when a stimulus is applied to another modality, as when the hearing of a certain sound induces the visualization of a certain color."[118] He hopes montage in his films will create organic combinations that trigger inner synchronicity and train the viewer's eyes to "hear" and their ears to "see."

To expand his vision for sound and image combinations, Eisenstein reverts to the musical analogy he first worked out in his 1929 typology. Thus, at the lowest level, the editor subordinates aural and visual elements to the same *rhythm* that emerges from the scene's content.[119] Metric montage *in the sound film* thereby has a vertical incarnation, where "stress accents" in the audio track *and in the picture track* – an expressive action, a change in the actor's demeanor, a lighting cue – synchronize with each other. Rhythmic vertical montage offers expressive effects of a higher order, created, according to Eisenstein's convoluted reasoning, by "purely rhythmic counterpoint through the formal play of non-coincident stress accents, lengths and frequency of repetitions, etc."[120] Here, Eisenstein is proposing that a very wide range of formal editing techniques can be used to create rhythmic counterpoint; visual or aural accents, shot length or repetition. Properly shaped, these elements can release an "audiovisual image" that is a vertical montage of the rhythmic variety.

These are dubious decrees. As Bordwell points out, the range of possible variables that can participate in contrapuntal vertical montage is large – plastic material in the shot, and accent in the shot, the cut, etc. – and since Eisenstein "assumes that the subtlest expressive

possibilities involve enjambement, or the non-coincidence of shot and musical measure . . . At the limit, he confesses, the subtlety of accent may yield more or less random, 'in-between' instances [of rhythmic vertical montage]."[121]

In his well-known analysis of *Alexander Nevsky* (1938), which he schematized in a famous chart, (Figure 5.32) Eisenstein argues for a new level of vertical montage, *melodic montage*, where the changing movement of the viewer's eyes along the graphic contours of the first twelve shots in a battle sequence synchronizes with the melodic contours of the score as it is unfolding in the audio track.

He begins by laying out his case for choosing the generic name *vertical montage*

> Everyone is familiar with the appearance of an orchestral score . . . Each part develops in a forward movement along the horizontal. No less important and decisive a factor, however, is the vertical: the musical interaction between the various elements of the orchestra in every given bar. Thus the advancing movement of the *vertical*, which permeates the entire orchestra and moves horizontally, creates the complex harmonic movement of the orchestra as a whole.[122]

This is Eisenstein's claim for melodic montage: that movement from left to right of a number of (vertically displayed) instrumental voices in an orchestral score mimics an edited picture track in which the "*simultaneous movement* of a number of motifs advances through a succession of sequences, each motif having its own rate of compositional progression, while being at the same time inseparable from the overall compositional progression as a whole."[123] To claim that one's eye movement across the succeeding compositional motifs in an edited shot sequence is synchronized to the visual layout of an orchestral score is audacious. The arguments against this claim are significant, since

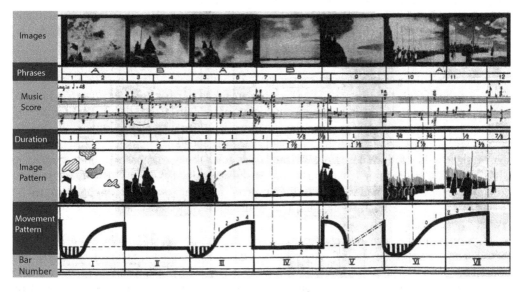

Figure 5.32 From Vertical Montage *(1940).* Eisenstein charts the relationship between the music and the image from "The Battle on the Ice" sequence from *Alexander Nevsky* (1938). Eisenstein claims that the shots in the opening of "The Battle on the Ice" sequence are structured around two motifs: an A arching motif, the rise of a scale and . . . a B linear, horizontal motif, a single note repeated in horizontal progression. (Illustration adapted from Eisenstein's original drawing.)

There is no guarantee that the viewer 'reads' the images in the way that Eisenstein's method intends. The musical score cannot correspond to the viewer's experience of the image. For example, there is no basis on which to assume the eye will follow the image from left to right, in the way that Eisenstein asserts in 'Vertical Montage'. Western musical notation is but one convention of recording musical tones through graphic means. Higher tones do not necessarily have anything to do with higher registers in the image, just as lower tones do not mean that we are getting closer to the bottom of the frame.[124]

Nevertheless, Kia Afra argues that Eisenstein's focus on "the correlation between the graphic aspects of musical notation and the pictorial aspects of the image [is only] a means of demonstrating the importance of *movement* as their common basis."[125] To synthesize an image-sound combination that moves beyond *inherent synchronicity* (i.e., ordinary synchronized sound) to *inner synchronicity*, "the filmmaker must be attuned to the fundamental thematic and structural dominant underlying a given work of art . . . Audiovisual combinations should therefore proceed from the trace of movement in a given musical or visual piece, where that work's line and shape can become the foundation for a corresponding visual or musical composition, respectively, to the final convergence of the two in vertical montage."[126] This process can work either way: the filmmaker can cut the image track first and let the movement of that picture sequence be the foundation for the composer's work or, alternatively, the filmmaker can cut the image track to the existing movement within the score. With *Nevsky*, his first sound film, Eisenstein was fortunate to work with Sergei Prokofiev, one of the most significant composers of the twentieth century. Working in the Soviet Union and abroad, Prokofiev created over 135 original works in a wide range of genres – symphonies, operas, ballets, and piano sonatas – including *Peter and the Wolf*, the ballet *Romeo and Juliet*, and the opera *Love of Three Oranges*. Yet for all his fame, Prokofiev was no more immune to the political pressures of Stalinism than other artists. At the height of Stalin's reign of terror, Prokofiev was working on an opera with Meyerhold when the playwright was arrested and shot. Shortly thereafter, Prokofiev was "asked" to compose a piece for Stalin's 60th birthday, and he promptly obliged.

See Critical Commons, "Alexander Nevsky 'Battle on the Ice' (first 12 shots looped 3x)."[127]

Eisenstein's collaboration with Prokofiev was educational, since they were both novices at creating a sound film: Eisenstein had worked with sound on the disastrous *Bezhin Meadow* and, although Prokofiev had written three previous scores for film, this would be his first time writing cues to fit specific scenes. But both had been courted in Hollywood and had toured the studios in the late 1930s, admiring the precision of the latest sync sound technology.[128] Consequently, in some instances they followed the pre-sync methods of the Disney cartoons they both admired, in which the sound was recorded first, and the image shot and edited to the track. In other instances, Prokofiev used a metronome that marked the tempo of rushes he screened or timings supplied by Eisenstein to guarantee precise synchronization of the track. Both were among the techniques that Prokofiev had seen in Hollywood.[129]

Much of what has been written about the collaboration between Prokofiev and Eisenstein focuses on the "Battle on the Ice" sequence, since Eisenstein himself made that sequence the centerpiece of his discussion of the vertical montage. There are complete analyses of the sequence using the famous graph Eisenstein produced, of which Afra's is among the most detailed. Here, in the interest of clarity, we will concentrate on the opening five shots of the sequence to gain a basic understanding of Eisenstein's method.

Eisenstein claims that the entire sequence is structured around two phrases: movement left to right across a curve rising in the film frame (A arc motif or arc phrase – See "Movement Pattern" in Bar Number I of Figure 5.32) and movement left to right across the bottom of the frame that

does not rise (B linear motif or linear phrase – See "Movement Pattern" in Bar Number II of Figure 5.32). In the opening four shots, Eisenstein's diagram indicates these movements alternate: that shot I (5.33) and shot III (5.35) follow the same "A arc motif" and shots II (5.34) and IV (5.36) follow the same "B linear motif." Let us examine the "A arc motif" shots first, with the assumption, of course, that we are reading these images left to right as is common in western printed matter.

In the opening shot, Eisenstein claims that *the fade in* guides the viewer's eyes across the frame as it emerges from black, first a shadowy group of soldiers with a flag, and then as the sky brightens, patches of clouds. Eisenstein claims this image mimics the *arching* of the diagram "Movement Pattern" in Bar Number I of Figure 5.32 due to "the curve of the shot's gradual brightening."[130] Eisenstein does not specifically address the "A arc motif" of shot III (Figure 5.35) in his essay, but graphically the composition of the shot clearly matches that motif because the graphic mass of the mountain with Nevsky on it anchors the left side of the frame, and the light toned curve of the cloud that arcs towards frame right. If we cut these two shots – shot I (Figure 5.33) and shot III (Figure 5.35) – together to compare the musical phrase with the image, the role of the music in creating a base from which the musical arc emerges is more apparent. See Critical Commons, "Alexander Nevsky 'Battle on the Ice' Arc Motif in Shot I and Shot III (looped 3x)"[131] As Kia Afra points out,

> Since arcing implies a gradual movement of divergence between two lines (i.e., the arc and the baseline from which any arc figure must be gauged), its tonal base, as the "musical" dominant, is defined by a gradual movement or change. The gradual movement inherent in the tonal (light/ darkness) and the linear aspects of shots I and III, respectively, acts as their shared compositional foundation, a structural relationship that is reinforced by the outline of movement in the parallel musical motifs. Accordingly, the music for shot I [Figure 5.33] involves a rising motif that Eisenstein has designated as the 'A' motif, where rising notes emerge out of a fifth in the bass (anchoring C minor in this case): this is a pattern that is depicted visually as an arc.[132]

Similarly, if we cut together the "B linear motif" – the "Movement Pattern" in Bar Number II of Figure 5.32 – that is seen in shots II and IV, the same linear phrasing of the music is apparent. See Critical Commons, "Alexander Nevsky "Battle on the Ice" Linear Motif in Shot II and Shot IV (looped 3x)."[133] In shot II (5.34), the "B linear motif," the linearity of the *image* – eye movement left to right finds the cloud, pictured on the same level as Nevsky, a balancing graphic weight – *is mirrored in the music* – the two highest and lowest voices hold the same pitch for the duration of the measure, while the middle voice plays evenly spaced eighth notes and eighth note rests, all on the same pitch. Since the rhythm of the five notes in the middle voice is regular and unchanging, time is divided evenly, reinforcing the linearity of the shots.

This five-note "D-motif" returns in shot IV (Figure 5.36), after there is movement *across the cut*: in shot III (Figure 5.35) the arc of the eyes from left to right in the image follows the music from fifth sustained in the bass violins to ascending tones to the upper right-hand corner of shot III (Figure 5.35). Eisenstein describes the shot change as a "chord preceded by a strongly accented semiquaver which in shot III corresponded to a sharp fall in the vertical plane at the transition from shot III to shot IV. In the shots, all movement took place vertically, and the abrupt break in the music was interpreted as a fall (from the *upper* right-hand corner of shot III to the *lower* left-hand corner of shot IV.)"[134] Eisenstein attributes this "fall' to elements of composition, but fails to note that Nevsky actually cues the cut in traditional fashion when he looks down over the edge of the cliff – even with all its graphic qualities, it is still a traditional cut on action, even though the action is shown in a wide shot. In the next shot, shot IV (Figure 5.36), the image is absolutely linear, a famous composition in motion picture history, where the horizon line with the mass German

Figure 5.33 Shot I from "The Battle on the Ice."
Source: Copyright 1938 Mosfilm.

Figure 5.34 Shot II from "The Battle on the Ice."
Source: Copyright 1938 Mosfilm.

Figure 5.35 Shot III from "The Battle on the Ice."
Source: Copyright 1938 Mosfilm.

Figure 5.36 Shot IV from "The Battle on the Ice."
Source: Copyright 1938 Mosfilm.

Figure 5.37 Shot V from "The Battle on the Ice."
Source: Copyright 1938 Mosfilm.

armies is placed at the bottom tenth of the frame with nine tenths of sky bearing down upon them, a pointed, non-traditional framing that forces linearity.

Notice that the last note of the five-note D-motif does play out here over shot IV (Figure 5.36), but takes us to the next shot, shot V (Figure 5.37), which Eisenstein maps on to the incoming shot as coinciding with the flag atop the cliff. The objections raised against Eisenstein's account of vertical montage are perhaps nowhere clearer than here, where the melodic contours of the *written score* can be matched to the graphic contours of shots, but perhaps do not match the *viewer's eye movements* that closely. Here, the fifth note more or less hits the cut,[135] but processing of the shot change makes the move to the flag in the next shot (more or less eight frames later) feel "off-the-beat" of that rhythm.

As usual, Eisenstein also sees larger structures at work in these first five shots:

> Similarly, the [visual] phase of *Alexander Nevsky standing on top of the cliff* runs through shots I, II, and III, after which begins the phase of *long shot of the troops at the foot of the cliff.* The depiction [i.e., image track] did not move into the latter phase by *transmission within one shot*, but by *transition through montage*. After shot III, the next – "troops" - phase entered the sequence through the long shot in IV, after which "Nevsky on the cliff" appeared again, also in a long shot, in V. This *substantive* transition from "Nevsky" to "troops" was marked by a *substantive* shift in the music: the change of key from C minor to C sharp minor.[136]

Eisenstein's search for macro structures that work beyond the level of the cut is in evidence here, coupled with his intention to find multivalent uses for the notion of "montage." Similarly, "vertical montage" will not be narrowly constrained to simple audio-visual juxtapositions in "The

Battle on the Ice." Eisenstein claims a range of graphic qualities carries the *gestures* of the arch (or arc) through the first twelve shots of the scene. He composes a list – annotated below – and argues

> Thus we see that a single type of [arch] gesture, which establishes synchronicity between the inner movements of music and pictures, is conveyed graphically by all of the following variants:
> tonal (shot I).
> [n.b., The fade in on shot I is like a *"tonal arc" to brightness.*]
> linear (shot III).
> [n.b., The graphic line formed by the clouds in shot III is an *arch shape.*]
> spatial (by the echeloned troops in VI and VII).
> [n.b., An echelon is a type of military formation so that the whole presents
> the appearance of steps, and the composition formed by the echeloned troops in shots VI and VII *creates an arc in depth*, along the z-axis deeper into the frame.]
> acting and volume (by the actors' behavior and shots IX and X; by the graphic use of volume in transitions from shots X to XI)
> [n.b., Eisenstein argues that the acting in shots IX and X is an *arc of mounting tension*, and growing nervous excitement; also that the cut from shots X to XI shows the a "fall" just like the cut from shots II to IV, but in *volumetric terms*, from a full face close up to a long shot of a group with their backs to the camera.][137]

Here, we begin to get a glimpse of the richness Eisenstein sees in a shot sequence, and it seems once again that Eisenstein's search for a fine grained understanding of montage will always be complicated, even though in some ways, the sound and picture combinations in *Nevsky* are not all that complex. Eisenstein's theory of vertical montage is, in many ways, just another product of his "vast theoretical imagination, a laboratory in which the director continued to work on his films long after their premieres, imagining audiovisual possibilities and models for their analysis. Eisenstein made a career of blurring boundaries, weaving together practical method and aesthetic philosophy, and abstracting practice to serve unrealized theoretical ambitions."[138] Numerous objections have been raised against the concept of vertical montage, centering on how the musical notation graphically replicates *only the shot composition, not the temporality* of the experience. So, for example, music is an art that absolutely controls the pace of the audience's aural experience, while the film director cannot exercise the same control over the viewer's eye movements:

> Music is an art that moves through time, an art that cannot be perceived instantaneously; whereas, in Eisenstein's graph, the pictures are perceived instantly. And while it is possible for the film director, through the composition of his shot, to control somewhat the direction of the viewer's eye movement across the frame, there is no way to control the rhythm or pace of that movement.[139]

Conclusion

Sergei Eisenstein was a film artist who created a groundbreaking body of film art that narrates in a unique manner: when you see an Eisenstein film, you recognize the single mindedness of its maker to grapple with the dense sensory, signifying potential of film. The films' technical daring reflects the courage of their maker to shake the viewer awake, to amplify any approach that might impart the message. Deeply connected with his art practice is his struggle to articulate a practical theory of making and editing the material as a socio-political revolution unfolded around him. Together, the films and the theory reflect an explosively creative mind that refused

to be constrained, and sought connections across cultures, across media, across art forms. David Thompson writes about seeing an Eisenstein show at London's Hayward Gallery in 1988,

> There were television monitors playing scenes from the films, to be sure, but there was so much else: the crowded life of Eisenstein, the range of things he read, saw, and was intrigued by; his psychology, emotional and jazzy with Freudian prospects; the astonishing graphic work that seem to spill out on paper like ink, or blood; the delight in dance, gesture, and theatrical moments. The movies were but a part of the whole, and not necessarily the most lively.[140]

Yet, as a towering film artist *and* film theorist, Eisenstein made unique developments in both fields, a monumental contribution succinctly summarized by Bordwell:

> Of all theorists of the silent era, Eisenstein most actively brings film study close to the techniques of literary and art-historical analysis. By fastening on fine points of cinematic texture and reflecting on what larger functions individual devices might serve, Eisenstein increases the options available to the director and at the same time forges a more sophisticated conception of film style than any other theorist had developed. In his hands film theory becomes not a quest for an essence of the medium but a reflection on concrete problems, a critical study of artistic achievements, a scanning of other arts for instructive parallels, and a scrutiny of "how a film is *made*" – in short, an empirical poetics of cinema.[141]

Notes

1 Richard Taylor, *The Battleship Potemkin: the film companion* (London: I.B. Tauris, 2000), 118.
2 David Bordwell, *The cinema of Eisenstein* (Cambridge, MA: Harvard University Press, 1993), 35.
3 Jacques Aumont, *Montage Eisenstein* (Bloomington: Indiana University Press, 1987), 27.
4 Hanns Eisler and Theodor Adorno, *Composing for the films* (New York: Continuum, 2007), 107.
5 James Goodwin, *Eisenstein, cinema, and history* (Urbana: University of Illinois Press, 1993), 9.
6 Richard Taylor and Ian Christie, *The film factory: Russian and Soviet cinema in documents* (Cambridge, MA: Harvard University Press, 1988), 4.
7 Vladimir Ilyich Lenin, Joe Fineberg, George Hanna and Victor Jerome, eds, *V.I. Lenin: collected works* (London: Lawrence & Wishart, 1961) volume 5, 22.
8 David Tomas, *Vertov, Snow, Farocki: machine vision and the posthuman* (New York: Bloomsbury Academic, 2013), 44.
9 Jeremy Hicks,. *KINO – the Russian Cinema: Dziga Vertov: Defining Documentary Film*, 1. (London, US: I. B. Tauris, 2007). http://public.eblib.com/choice/publicfullrecord.aspx?p=676793. Accessed February 13, 2017. ProQuest ebrary.
10 The clip, "Editing Rhythm in *The Man with a Movie Camera*," is on Critical Commons at http://www.criticalcommons.org/Members/ogaycken/clips/mwmcending.mp4.
11 The school was first known as Gerasimov Institute of Cinematography, named after S. A. Gerasimov, but later known as the All-Russian Institute of Cinematography.
12 Anna Olenina, "Lev Kuleshov's Retrospective in Bologna, 2008: An Interview with Ekaterina Khokhlova," ARTMargins. Accessed February 2, 2017. http://artmargins.com/index.php?option=com_content&view=article&id=90%3Alev-kuleshov&Itemid=133.
13 Lev V. Kuleshov and Ronald Levaco, *Kuleshov on film: writings of Lev Kuleshov* (Berkeley, CA: University of California Press, 1974), 8. Pudvokin gives his account of the Kuleshov experiments in Vsevolod Illarionovich Pudovkin, *Film technique, and film acting* (New York: Grove Press, 1976), 168.
14 Pudovkin, "Naturshchik Vmesto Aktera," in *Sobranie sochinenii*, vol. 1, Moscow: 1974, 182 cited in Amy Sargeant, *Vsevolod Pudovkin: classic films of the Soviet avant-garde* (London: I.B. Tauris, 2000), 7.
15 The clip, "A Talk with Hitchcock (1964) – Hitchcock explains the Kuleshov Effect," is on Critical Commons at http://www.criticalcommons.org/Members/kfortmueller/clips/a-talk-with-hitchcock-1964-hitchcock-explains-the. A reconstruction of the Kuleshov experiment, *The Kuleshov Effect*, is on Critical Commons at http://www.criticalcommons.org/Members/jkagan/clips/the-kuleshov-effect

16 Ibid., 54.

17 T. S. Elliot, *Selected Essays* (London: Faber and Faber, 1964), 83.

18 The clip, "*Mother* (Pudovkin, 1926) The Objective Correlative: Water Dripping," is on Critical Commons at http://www.criticalcommons.org/Members/m_friers/clips/mother-pudovkin-1926-the-objective-correlative.

19 Using Zettl's classifications, this montage has elements of sectional analytical montage – time stops – and comparison idea-associative montage – the mother's tears are echoed in the water dripping.

20 The full poem reads:
 After great pain, a formal feeling comes –
 The Nerves sit ceremonious, like Tombs –
 The stiff Heart questions "was it He, that bore,"
 And "Yesterday, or Centuries before"?
 The Feet, mechanical, go round –
 A Wooden way
 Of Ground, or Air, or Ought –
 Regardless grown,
 A Quartz contentment, like a stone –
 This is the Hour of Lead –
 Remembered, if outlived,
 As Freezing persons, recollect the Snow –
 First – Chill – then Stupor – then the letting go –

21 Vsevolod Illarionovich Pudovkin, *Film technique, and Film acting* (New York: Grove Press, 1976), 27.

22 The clip, "*Mother* (Pudovkin, 1926) The Objective Correlative: Spring," is on Critical Commons at http://www.criticalcommons.org/Members/m_friers/clips/mother-pudovkin-1926-the-objective-correlative-1

23 Sergei Eisenstein and Jay Leyda, "The Filmic Fourth Dimension," *Film form: essays in film theory.* (New York: Harcourt, Brace, 1949), 36.

24 S. M. Eisenstein and Richard Taylor, *Selected works, volume I, 1922–34* (Bloomington: BFI/Indiana University Press, 1988), 144.

25 David Bordwell, *The cinema of Eisenstein* (Cambridge, MA: Harvard University Press, 1993), 43–50.

26 Vsevolod Illarionovich Pudovkin, *Film technique, and Film acting* (New York: Grove Press, 1976), 71–73.

27 Ibid., 75, my emphasis.

28 Ibid., 75.

29 Vsevolod Illarionovich Pudovkin, *Film technique, and Film acting* (New York: Grove Press, 1976), 76–77.

30 David Bordwell, Janet Staiger and Kristin Thompson, *The classical Hollywood cinema: film style and mode of production to 1960* (New York: Columbia Univ. Press, 1985).

31 Vsevolod Illarionovich Pudovkin, *Film technique, and Film acting* (New York: Grove Press, 1976), 77.

32 Ibid., 77.

33 Ibid., 78.

34 David Thomson, *The new biographical dictionary of film* (New York: Alfred A. Knopf, 2014), 841.

35 S. M. Eisenstein and Richard Taylor, *Selected works, volume I, 1922–34* (Bloomington: BFI/Indiana University Press, 1988), 164.

36 Dudley Andrew, *The major film theories: an introduction* (London: Oxford University Press, 1976), 52.

37 Herbert Zettl, *Sight sound motion: applied media aesthetics* (Boston, MA: Wadsworth, 2017), 396.

38 The clip, "Kinds of Montage: Analytical Sequential Montage in *Strike*," is on Critical Commons at http://www.criticalcommons.org/Members/m_friers/clips/kinda-of-montage-analytical-montage-sequential

39 The clip, "Kinds of Montage: Hollywood Montage in *Heaven Can Wait*," is on Critical Commons at http://www.criticalcommons.org/Members/m_friers/clips/types-of-montage-hollywood-montage

40 The clip, "Kinds of Montage: Hollywood Montage in *Citizen Kane*," is on Critical Commons at http://www.criticalcommons.org/Members/m_friers/clips/kinds-of-montage-hollywood-montage

41 Herbert Zettl, *Sight sound motion: applied media aesthetics* (Boston, MA: Wadsworth, 2017), 398.

42 The clip, "*The Wild Bunch*: Final Shootout," contains a sectional analytical montage about :30 into the clip on Critical Commons at http://www.criticalcommons.org/Members/m_friers/clips/the-wild-bunch-final-shootout/.

43 Herbert Zettl, *Sight sound motion: applied media aesthetics* (Boston, MA: Wadsworth, 2017), 401.

44 Setting aside the "God and Country" sequence from *October* that clearly uses non-diegetic inserts, questions often arise about many of the metaphorical objects used in Eisenstein's films, like the peacock here, as to whether they are diegetic or non-diegetic. Presumably, the mechanical peacock is the type of elaborate toy the Czar would have owned, and is located in the Czar's palace, so it is "near" the diegesis, but framed and photographed in a way that "sets it off" from that space. Other quasi-diegetic images in Eisenstein's work that seem both in and out of the filmic space: the lions that rise up, the shot of the Egyptian sphinx in the raising of the bridge sequence in *October*, the sculpted lions that rise up as the Battleship Potemkin fires on Odessa.

45 The clip, "Kinds of Montage: Idea Associative Comparison, Kerensky vs. Peacock," is on Critical Commons at
http://www.criticalcommons.org/Members/m_friers/clips/kinds-of-montage-idea-associative-comparison

46 The clip, "Visual Metaphor in *Strike*," is on Critical Commons at
http://www.criticalcommons.org/Members/jbutler/clips/strikeviavlc_recaptured.mp4.

47 Herbert Zettl, *Sight sound motion: applied media aesthetics* (Boston, MA: Wadsworth, 2017), 402.

48 The clip, "*Battleship Potemkin* (1925) Odessa Steps," is on Critical Commons at http://www. criticalcommons.org/Members/brettservice/clips/battleship-potemkin_compress.mp4

49 Bordwell describes this scene in *The cinema of Eisenstein* (Cambridge, MA: Harvard University Press, 1993), 76, as having four shots of the Cossack slashing. In the version I examined, from Kino Video, there are only two shots of the Cossack.

50 Herbert Zettl, *Sight sound motion: applied media aesthetics* (Boston, MA: Wadsworth, 2017), 406.

51 David Bordwell, *The cinema of Eisenstein* (Cambridge, MA: Harvard University Press, 1993), 4.

52 S. M. Eistenstein and Richard Taylor, *Selected works volume I* (Bloomington: BFI/Indiana University Press, 1988), 34.

53 Tom Gunning, "The Cinema of Attraction: Early Film, its Spectator, and the Avant-garde," *Wide Angle*, Vol. 8, nos. 3 and 4 Fall, 1986, 66.

54 Sergei Eisenstein and Sergei Tretyakov, "Expressive Movement," translated by Alma H. Law, *Millennium Film Journal*, 3, (New York: Millennium Film Workshop, 1979) 36–37.

55 Hâkan Lövgren, "Eisenstein's *October*: On the Cinematic Allegorization of History," in Albert J. LaValley and Barry P. Scherr, *Eisenstein at 100: a reconsideration* (New Brunswick, NJ: Rutgers University Press, 2001).

56 Jacques Aumont, *Montage Eisenstein* (Bloomington: Indiana University Press, 1987), 43, my emphasis.

57 Quoted in Peter Wollen, *Signs and meaning in the cinema* (Bloomington: Indiana University Press, 1972), 41.

58 Tom Gunning, "The Cinema of Attraction: Early Film, its Spectator, and the Avant-garde," in Robert Stam and Toby Miller, *Film and theory: an anthology* (Malden, MA: Blackwell, 2000), 233.

59 American Heritage® Dictionary of the English Language, 5th edn. S. v. "dialectical materialism." Accessed January 30, 2017. http://www.thefreedictionary.com/dialectical+materialism

60 S. M. Eisenstein and Richard Taylor, *Selected works, volume I, 1922–34* (Bloomington: BFI/Indiana University Press, 1988), 161–164.

61 This material (direct quotes in italics) is taken from S. M. Eisenstein and Richard Taylor, *Selected works, volume I, 1922–34* (Bloomington: BFI/Indiana University Press, 1988), 172–180.

62 The clip, "*October*: Artificial Representation of Movement, Logical – Machine Gun," is on Critical Commons at
http://www.criticalcommons.org/Members/m_friers/clips/october-artificial-representation-of-movement.

63 David Bordwell, *The Cinema of Eisenstein* (Cambridge, MA: Harvard University Press, 1993), 78.

64 Sergei Eisenstein, *Nonindifferent nature*, translated by Herbert Marshall, (Cambridge: Cambridge University Press, 1994), 314.

65 The clip, "*Battleship Potemkin*: Artificial Representation of Movement, Alogical," is on Critical Commons at
http://www.criticalcommons.org/Members/m_friers/clips/battleship-potemkin-artificial-representation-of

66 S. M. Eisenstein and Richard Taylor, *Selected works, Volume I, 1922–34,* (Bloomington: BFI/Indiana University Press, 1988), 17.

67 The clip, "*October*: *Ten Days that Shook the World*, Cannon Lowers," is on Critical Commons at
http://www.criticalcommons.org/Members/m_friers/clips/october-ten-days-that-shook-the-world-cannonball

68 S. M. Eisenstein and Richard Taylor, *Selected works, volume I, 1922–34* (Bloomington: BFI/Indiana University Press, 1988), 199.

69 Ibid., 46.

70 David Bordwell, *The cinema of Eisenstein* (Cambridge, MA: Harvard University Press, 1993), 131, my emphasis.

71 Ibid., 131.

72 Sergei Eisenstein and Jay Leyda, "The Filmic Fourth Dimension," *Film form; essays in film theory* (New York: Harcourt, Brace, 1949), 64.

73 Ibid., 64.

74 Ibid., 65.

75 This material (direct quotes in italics) is taken from Sergei Eisenstein, and Jay Leyda, "Methods of Montage," *Film form; essays in film theory* (New York: Harcourt, Brace, 1949), 72–83.

76 The clip, "*Lonedale Operator* (1911) – Ending," is on Critical Commons at http://www.criticalcommons. org/Members/kfortmueller/clips/lonedale-operator-1911-ending.

77 Eisenstein, Sergei, and Jay Leyda, "Methods of Montage," *Film form; essays in film theory*. (New York: Harcourt, Brace, 1949)72.

78 The clip, "*October*: Metric Montage," is on Critical Commons at http://www.criticalcommons.org/Members/m_friers/clips/october-metric-montage/video_view.

79 Sergei Eisenstein and Jay Leyda, "Methods of Montage," in *Film form; essays in film theory* (New York: Harcourt, Brace, 1949), 73.

80 Ibid., 75. For clarity, I will hereafter use the term "off-the-beat" instead of Eisenstein's "off-beat," since the latter term can also mean "unconventional."

81 Ibid., 73.

82 Ibid., 75.

83 Ibid., 80.

84 D. W. Griffith, *Pace in the movies: a famous director reveals the secret of good pictures* (New York, NY: Liberty Library Corporation, 1975), 28.

85 The clip, "*Battleship Potemkin*: Odessa Steps," is on Critical Commons at http://www.criticalcommons.org/Members/m_friers/clips/battleship-potemkin-odessa-steps.

86 Sergei Eisenstein and Jay Leyda, *Film form; essays in film theory* (New York: Harcourt, Brace, 1949), 75.

87 Ibid., 76.

88 The clip, "*Battleship Potemkin*: Tonal Montage," is on Critical Commons at http://www.criticalcommons.org/Members/m_friers/clips/battleship-potemkin-tonal-montage/video_view

89 This and all the shot descriptions above are using the shot numbers from David Mayer and Sergei Mikhailovich Eisenstein. *Sergei M. Eisenstein's Potemkin: a shot-by-shot presentation*. New York, NY: Da Capo press, 1990, 133–135.

90 I am using the frame counts from Mayer's shot-by-shot description and his premise that the silent playback speed is 16 frames per second.

91 Sergei Eisenstein and Jay Leyda, *Film form; essays in film theory* (New York: Harcourt, Brace, 1949), 80.

92 This line is from S. M. Eisenstein and Richard Taylor, *Selected works, volume I, 1922–34* (Bloomington: BFI/Indiana University Press, 1988), 193, and is merely a different translation of the line above by Jay Leda that reads, "It is distinguishable from tonal montage by the collective calculation of all the piece's appeals."

93 Sergei Eisenstein and Jay Leyda, *Film form; essays in film theory* (New York: Harcourt, Brace, 1949), 81.

94 Ibid., 83.

95 Ibid., 81.

96 The clip, "Kinds of Montage: Eisenstein's Overtonal Montage in *Old and New* (aka *The General Line*)," is on Critical Commons at http://www.criticalcommons.org/Members/m_friers/clips/kinds-of-montage-eisensteins-overtonal-motage-in.

97 S. M. Eisenstein, Richard Taylor and Michael Glenny, *Selected works. Writings, volume II, towards a theory of montage* (London: BFI, 1998), 330.

98 "Localization (Brain Function)," *The Gale Encyclopedia of Psychology,* edited by Bonnie Strickland, 2nd edn, (Gale, 2001), 389. Gale Virtual Reference Library. Accessed August 28, 2017. go.galegroup. com/ps/i.do?p=GVRL&sw=w&u=gree35277&v=2.1&id=GALE%7CCX3406000391&it=r&asid=2e d9e22a56d5a5bab46505aa331b3137.

99 *The clip, "Kinds of Montage: Intellectual Montage," is on Critical Commons at* http://www. criticalcommons.org/Members/m_friers/clips/kinds-of-montage-intellectual-montage/view.

100 Sergei Eisenstein and Jay Leyda, "Methods of Montage," *Film form; essays in film theory* (New York: Harcourt, Brace, 1949), 82.

101 Hâkan Lövgren, "Eisenstein's October: On the Cinematic Allegorization of History," in Albert J. LaV- alley and Barry P. Scherr, *Eisenstein at 100: a reconsideration* (New Brunswick, NJ: Rutgers University Press, 2001), 84.

102 David Bordwell, *The cinema of Eisenstein* (Cambridge, MA: Harvard University Press, 1993), 133, my emphasis.

103 Robert A. Saunders and Vlad Strukov, *Historical dictionary of the Russian Federation* (Lanham, MD: The Scarecrow Press, 2010), 238.

104 Robert Aldrich and Garry Wotherspoon. 2002. *Who's who in gay and lesbian history: from antiquity to World War II*. London: Routledge, 2002) 170. In motion pictures, *Eisenstein in Guanajuato* (2015) by Peter Greenaway depicts Eisenstein's time in Guanajuato, Mexico somewhat salaciously as a period of passionate pursuit of his guide Palomino Cañedo (Luis Alberti).

105 S. M. Eisenstein, Richard Taylor and Michael Glenny. *Selected works. Writings, volume II, towards a theory of montage* (London: BFI, 1998), xiv.

106 Ibid., 109.

107 Ibid., 300.

108 Ibid., 329.

109 S. M. Eisenstein, V. I. Pudovkin, and G. V. Alexandrov, "A Statement," in Elisabeth Weis and John Belton, *Film sound: theory and practice* (New York: Columbia University Press, 1985), 84.

110 S. M. Eisenstein, Richard Taylor and Michael Glenny. *Selected works. Writings, volume II, towards a theory of montage* (London: BFI, 1998), 334.

111 Ibid., 334.

112 Ibid., 334, my emphasis.

113 Ibid., 334.

114 James Dudley Andrew, *The major film theories: an introduction* (London: Oxford University Press, 1976), 55.

115 Ibid., 56.

116 Ibid., 57.

117 Ibid., 57.

118 "Synesthesia," Dictionary.com. Accessed February 22, 2017. http://www.dictionary.com/browse/ synesthesia?s=t.

119 S. M. Eisenstein, Richard Taylor and Michael Glenny. *Selected works. Writings, volume II, towards a theory of montage* (London: BFI, 1998), 334.

120 Ibid., 335.

121 David Bordwell, *The cinema of Eisenstein* (Cambridge, MA: Harvard University Press, 1993), 186.

122 S. M. Eisenstein, Richard Taylor and Michael Glenny. *Selected works. Writings, volume II, towards a theory of montage* (London: BFI, 1998), 330.

123 Ibid., 330.

124 Kia Afra 2015, "'Vertical Montage' and Synaesthesia," *Music, Sound, and the Moving Image* 9(1) (2015): 38, doi:10.3828/msmi.2015.2

125 Ibid., 38.

126 Ibid., 38.

127 The clip, "Alexander Nevsky, 'Battle on the Ice' (first 12 shots looped 3x)" is on Critical Commons at http://www.criticalcommons.org/Members/m_friers/clips/alexander-nevsky-battle-on-the-ice- first-12-shots-1/

128 Kia Afra, "'Vertical Montage' and Synaesthesia," *Music, Sound, and the Moving Image* 9(1) (2015): 62, doi:10.3828/msmi.2015.2.

129 Kevin Bartig, *Composing for the red screen: Prokofiev and Soviet film* (New York: Oxford University Press), 70.

130 S. M. Eisenstein, Richard Taylor and Michael Glenny, *Selected works. Writings, volume II, towards a theory of montage* (London: BFI, 1998), 38.

131 The clip, "Alexander Nevsky 'Battle on the Ice' Arc Motif in Shot I and Shot III (looped 3x)" is on Critical Commons at http://www.criticalcommons.org/Members/m_friers/clips/alexander-nevsky- battle-on-the-ice-arc-motif-in-1.

132 Kia Afra, "'Vertical Montage' and Synaesthesia," Music, Sound, and the Moving Image 9(1) (2015): 45, doi:10.3828/msmi.2015.2

133 The clip, "Alexander Nevsky, 'Battle on the Ice' Linear Motif in Shot II and Shot IV (looped 3x)," is on Critical Commons at http://www.criticalcommons.org/Members/m_friers/clips/alexander-nevsky- battle-on-the-ice-linear-motif-in.

134 S. M. Eisenstein, Richard Taylor and Michael Glenny. *Selected works. Writings, volume II, towards a theory of montage* (London: BFI, 1998), 384.
135 In the Criterion Collection print, the note hits on the cut, and is followed by a second note.
136 S. M. Eisenstein, Richard Taylor and Michael Glenny. *Selected works. Writings, volume II, towards a theory of montage* (London: BFI, 1998), 385.
137 Ibid., 394.
138 Kevin Bartig, *Composing for the red screen: Prokofiev and Soviet film* (New York: Oxford University Press, 2013), 60.
139 Roy A. Prendergast, "The Aesthetics of Film Music." Accessed July 24, 2017. http://classic-web. archive.org/web/19970516041845/http:/citd.scar.utoronto.ca/VPAB93/course/readings/prenderg. html.
140 David Thomson, *The new biographical dictionary of film* (New York: Alfred A. Knopf, 2014), 329–330.
141 David Bordwell, *The cinema of Eisenstein* (Cambridge, MA: Harvard University Press, 1993), 138.

6 Realism and André Bazin

André Bazin, French film critic, co-founder of *Cahiers du cinéma* in 1951, and "the sound film's master-thinker and the first to register the effervescence of the cinematic modernism that began to come to prominence during his professional life," wrote roughly 2,600 articles in the 15 years (1943–1958) he wrote exclusively about cinema. That only 52 of these articles – 26 in English translation – form the basis of what most people know of his ideas has not diminished his stature in the field of film theory, even as scholars have recently tried to expand our understanding of what forms the basis of his theorizing.[1]

With only a small portion of his writing widely available, Bazin is nevertheless considered one of the most important figures in the history of film theory, second only in the early period to, perhaps, Eisenstein. One reason for this is the emergence of what David Bordwell has called "The Basic Story." Most early histories of film style tell a similar story, that film became an art form only by casting off its inherent ability to *record* an event, and embracing its ability to *create* an event using the resources that are uniquely available to it. Recounted with each new advance in motion picture style – the artificial arrangement of scenes by Georges Méliès, the presentation of simultaneously occurring events by Edwin S. Porter, the perfection of film syntax through flashback and fades by D. W. Griffith, etc. – the history of these stylistic achievements is seen as a step-by-step movement away from the camera capacity to record and towards the emergence of cinema as a unique, creative art form.[2]

Simultaneously, what Bordwell calls the "Standard Version" of film's stylistic history was also emerging. In this account, not only was film style moving away from merely recording, this evolution was exposing the innate artistic potentials of the medium.[3] Initially, the argument for film as an independent art form, uncovering its intrinsic capacities to create, centered around the potentials of the image – framing, the projection of solids on to a plane surface, the reduction of depth in film, lighting, the monochrome quality of the image, etc. – the fundamental ways in which the medium *differed from reality*. Film theorist Rudolf Arnheim led this approach. Subsequent theorists (led by Sergei Eisenstein) focused on the potentials of montage – the ability of film to create meaning and affect through juxtaposition of images – as the grounds for demonstrating that film was a new form of art unique from all of the other traditional arts. Given that these intellectuals were bent on promoting cinema as a new art form, the plastics of the image and/or the resources of montage were soon seen to be the *essential* aesthetic elements unique and specific to cinema. And yet,

> From today's standpoint, such definitions and defenses of the seventh art look decidedly forced. In particular, the idea of medium–specificity has not aged well. It seems unlikely that any medium harbors the sort of aesthetic essence that silent film aficionados ascribed to cinema. There're too many counterexamples – indisputably good or historically significant films that do not manifest the theorist's candidate for the essence of cinema."[4]

Nevertheless, the formalist theorists – loosely grouped around advocates of the plastics of the image or the resources of montage – would hold sway throughout the silent period, until a dialectical program arose, finding new value in cinema's faithful representation of the world, and sensing a decline in the use of "montage," in the sense of abstract, conceptual montage pioneered by the Russians. For even though Russian filmmaking was realistic in its use of non-actors and locations, its use of montage was the height of formal manipulation, since it produced new meanings from simple juxtaposition. This new group of theorists emerged in France and centered around *Cahiers*. They were led by André Bazin, advocating that "cinema's artistic possibilities lay exactly in that domain which the silent-cinema adherents despised: representational fidelity."[5] Of course, this new approach, *la nouvelle critique*, did not reject editing completely. They recognized that in the sound era, traditional *découpage* had earned its place – unambitious but with time-tested, predictable results:

> After 10 years of talking pictures, [Hollywood's] technicians brought to perfection the most economical and transparent technique possible. The film was made of a series of sequences in *plan américain* [knees up framing], with some camera movement and a constant play of shot and reverse-shot . . . The movements of the camera were utilized in very precise framings: tracking shot to give the impression of depth, the pan shot to give a sense of breadth.[6]

Having examined the formalist theories of montage advanced by Sergei Eisenstein, we now consider how theories of realism address editing, in particular how André Bazin thought and wrote about editing as a creative technique in cinema. Writing at a time when cinema was not universally recognized as an art form, these two theorists were at the center of the historical debate whether the realist style or the formalist style of filmmaking is closest to the intrinsic aesthetic capacity of the medium, and fulfills its highest purpose. Here it is useful to simply examine Bazin's ideas on editing without addressing those larger questions, recognizing that the search for essential characteristics of the film medium is a fruitless search given its diversity of forms. Bazin's insights about how *découpage* shapes meaning in film, and particularly how the choice *not to cut* – i.e., the use of long takes in film – returns the camera to its primary function as a device that records space in the world automatically are original and inventive. "He was without question the most important and intelligent voice to have pleaded for the film theory and a film tradition based on a belief in the naked power of the mechanically recorded image rather than on the learned power of artistic control over such images."[7]

Early Life, Philosophical Influences and Ciné Clubs

Bazin's work as a film theorist was shaped by his early study and struggle as a person deeply engaged in a search for the meaning of his life. Bazin was the son of a bank clerk and lived in La Rochelle, on the Atlantic coast of France in a simple home beside a stream. He loved books, animals and nature, and from his earliest years he collected rocks, bones, feathers, small plants, lizards and turtles. "Reptiles fascinated him most of all because, despite a lifetime of study, he could never quite imagine how they experienced the world. He would watch them for hours and even imitate them, trying to feel what they felt, see what they saw. This genius for sympathetic imagination was the secret of his critical power; for a man prepared to invade the consciousness of an iguana, the consciousness of Buñuel is not an impossible problem."[8]

After he graduated from high school, he took an entrance test to attend a teachers' college – the Ecole Normale Supérieure de Saint-Cloud – that was ranked as one of the best in the public system, and he spent three years there on a scholarship, hoping to begin a career in education within a system steeped in *positivism*, a philosophy that rejected anything other than assertions subjected

to logical or mathematical proof. France has traditionally maintained one of the most highly centralized, rigid and hierarchical education systems in the world. Bazin felt immediately alienated by the rigid educational goals of Saint-Cloud and fell under the influence of Henri Bergson, the famous French philosopher of the early twentieth century:

> Against the dominant positivism [Bergson] invoked higher science, one that would encompass the *experience* of nature, not merely the *facts* of nature. He thereby gathered to him certain factions of the scientific community, the greater portion of the artistic community, and a strain of theologians, all of whom were looking for a philosophical vocabulary capable of describing man in an animated and evolving universe.[9]

Bergson argued that there are three methods of experiencing the world: raw perception, rational thought and intuition. Perception provides us the most basic sense data about the world. Reasoning allows us to organize those perceptions into coherent patterns. Intuition is more transcendent, allowing human beings to return to the experience of the thing itself. When we pick out a single bird song from a cacophony of birds singing in a meadow, we don't analyze the individual notes and construct the singular song through rational thought, we simply catch the bird's melody by intuition, a form of thinking beyond logic that allows us to grasp meanings from a world in constant flux. Bergson would provide a basis for Bazin's film theory because Bazin shared his respect for the unity of universe in flux, and thus, from the outset, saw the shot and analytical editing as less revealing than the greatest films for which "there remains henceforth only the question of framing the fleeting crystallization of the reality of whose environing presence one is ceaselessly aware."[10]

Bazin served for a while in the French army, but with the Nazi takeover of France in May–June, 1940, Bazin sank into a deep despair, and he spoke openly about the failure of French institutions like the clergy and the press who made accommodations towards Nazi rulers. He returned to St. Cloud to take his examinations to enter a teaching career, but found that he could barely tolerate the hypocrisy he found there under the occupation. "He saw French education as a wasteful and debilitating institution that rewarded blind adherence to red tape and 'tradition.'"[11] Since St. Cloud turned out school administrators, Bazin saw this intransigence throughout the institution. Bazin passed his written exam, but failed his oral exam because, in his nervousness, his tendency to stutter rendered him almost unable to speak. Bazin also suspected his blunt criticism of St. Cloud did not help, and though the examiners were split and encouraged him to try again, in the next few years, Bazin would question deeply the French educational system, while turning his course towards the informal companionship he found in organizations of public intellectuals, in writing for highbrow journals and daily newspapers, and seeking his own definition of the value of his life.

During the war, following the "youth fad" in Germany, groups of young people were organized in Vichy France under the *Jeunes du Maréchal*, a kind of right wing, anti-communist, nationalist youth group. At the Sorbonne, an opposition movement arose to organize groups of youths with credible left wing credentials into four "houses" – one for arts, letters, law and science – to maintain cultural activity in the face of the occupation. Bazin was among the first recruited and made the Maison des Lettres his refuge for the next few years. With no official coursework, he lived in a dormitory at the university with the sole purpose of organizing cultural events and study groups in theatre, urban architecture, the modern novel, and popular entertainments like the circus. A fellow student posted a notice for help starting a cinema study group, and Bazin's path forward in film was launched.

It would be a daunting journey. As Dudley Andrew points out, the contempt for motion pictures at the Sorbonne extended into the culture at large:

> It is difficult for us in our age to feel the depth of contempt in which cinema was generally held in the period. There had been a flowering of ciné-clubs in the late twenties and early

thirties in France, but by the time of the invasion there were literally no ciné-clubs or any serious journals devoted to the art. Once the sound film came into use, most intellectuals placed the cinema beside the circus as a popular art not warranting reflection. The cult of star and the dominance of Hollywood in the thirties solidify this view.[12]

Bazin's efforts were further hampered by the technology itself. It is difficult in the age of the internet to recall how hard it was to find film prints and a projector to screen films. With traditional cinemas under the censorship of the Nazis, Bazin would travel around Paris to camera shops looking for interesting 8mm prints – the amateur format – that he would show to groups of 25 or 30, and lead a discussion with whoever would stay afterwards. Alain Resnais became a supporter, and a useful one, since he had already made a few experimental films, had a 9.5mm projector and prints of interesting films by Buster Keaton, Fritz Lang and others that Bazin had not seen. After the screenings at venues around Paris, Bazin would dominate the discussions, taking each new film as a point of departure for an inquiry in to shot selection, lighting, staging, etc. This was a passionate, life changing endeavor for the young man, barely 25 years old, who had transformed himself in to a bohemian film critic: "Bazin had entered the Maison des Lettres with an interest in cinema scarcely greater than his interest in anything else: animals, literature, philosophy; but the end of 1943, film has become a passion which never left him."[13] That same year, he wrote his first published works, telling his readers of his desire to teach them everything about cinema, to become a kind of school for the spectator, to demystify how films are made, to explicate their aesthetics, to uncover their economics, psychology, and sociology.[14] As he read and studied more about philosophy and film, he continued to forge new outlets for his writing in journals and the popular press, which had largely ignored serious criticism of motion pictures. It was a fortuitous moment, because the postwar world would be different, with a different concept of what motion pictures could be, and Bazin's work would help identify and legitimize the foundations of this emerging art.

Theorizing Film

By 1945, Bazin had written one of his seminal works, "The Ontology of the Photographic Image." Bazin's first principle is that there is in man the desire to reproduce the world in a perfect, life like manner, to literally "embalm time," to conquer death by a complete representation of the world, of the subject, that would be timeless. This desire, which he compares to man's desire to fly, is integral to all of human culture. For example, Egyptian mummies "by providing a defense against the passage of time [satisfied] a basic psychological need in man, for death is but the victory of time."[15] Similarly, man's efforts at faithful reproduction in painting – perspective painting in the Renaissance that created the illusion of depth, and the Baroque era's pursuit of the representation of motion – are seen by Bazin as ill conceived attempts to combine spiritual expression with a complete imitation of the external world. According to Bazin, "Perspective was the original sin of Western painting,"[16] because it is pseudo realism, a painterly deception. Continuing the metaphor, Bazin saw photography and cinematography as "redeemers" because their essence is the realism that man constantly seeks; these new media have freed painting from its preoccupation with reproduction, satisfying the need of the mass audience for "realism" and allowing modernist painters to move on to other issues.

Whereas realism in painting is always suspect because the hand of the artist intercedes between the object and its reproduction, photography produced a radically new *psychology of the image.* Photographs have a credibility lacking in other methods of making pictures:

We are forced to accept as real the existence of the object reproduced, actually *re*-presented, set before us, that is to say, in time and space . . . For the first time, between the originating

object and its reproduction there intervenes only the instrumentality of a nonliving agent. For the first time, the image of the world is formed automatically, without the creative intervention of man . . . All the arts are based on the presence of man, only photography derives an advantage from his absence. Photography affects us like a phenomenon in nature, like a flower or a snowflake."[17]

In order to reinforce this idea of "transference of reality" from the object to the photograph, Bazin constructs metaphors in his writings that try to get at this puzzling connection, comparing the photograph/object to fingerprint/finger, in that both share a common being that permits their existence.[18] Elsewhere he compares photography to a mold, in that it takes an impression in light from the object photographed.[19] The photograph has an almost mystical connection to the object it captures, like the veil of Veronica[20] or the shroud of Turin.[21] Like each of these examples, there is a direct linkage between photograph and object that confers on the image an immediate realism. The photograph frees the object from its spatial and temporal bounds because of this ontological linkage: "No matter how fuzzy, distorted, or discolored, no matter how lacking in documentary value the image may be, it shares, by virtue of the very process of its becoming, the being of the model of which it is the reproduction; it *is* the model."[22]

These metaphors also hint at the *giveness* of photography's objectivity, a factor that may account for the human fascination with photographs, in combination with the overwhelming level of visual detail they capture. But since photography can only capture a single moment, for Bazin it is feeble when compared to cinema, which can take a mold of an object *and* an imprint of its duration.[23] In short, "the cinema is objectivity in time."[24]

For Bazin, the camera's automatic recording of reality makes its objectivity axiomatic. As Eric Rohmer wrote in tribute to Bazin immediately after his passing, "Each essay and indeed the whole work itself fits perfectly into the pattern of the mathematical demonstration. Without any doubt, the whole body of Bazin's work it's based on one central idea, affirmation of the objectivity of the cinema in the same way as all geometry is centered on the properties of the straight line."[25] In practical terms, Bazin *was* consistent, but his method of theorizing was never as broad and as systematic as mathematics, because his ideas grew from the articles on contemporary cinema he wrote about ceaselessly for in the popular/intellectual press. Though he wrote a short book on Orson Welles, a collection of short essays on Chaplin, and was working on a book about Jean Renoir when he died of leukemia at age 40, his work was mostly in essay form where he would watch a film, try to experience it objectively without preconceived notions, and then write about the fundamental issues that the film suggested to him. As Andrew puts it, "Bazin begins with the most particular facts available, the film before his eyes, through a process of logical and imaginative reflection, he arrives at a general theory."[26] This approach is consistent with the contemporary movement in French thinking driven by the magazine *Esprit*, and the writer Emmanuel Mounier known as *personalism*, that locates the human person as the ontological and epistemological starting point of philosophical reflection. Bazin's immersion in the thinking of Mounier – as well as the existentialist writings of Sartre, Marcel and Merleau-Ponty – ties together his objectivity axiom and his theorizing. Bazin sees ambiguity as an essential attribute of reality, not a limitation of our ability to perceive what is real. He sees in external reality a "mysterious otherness:"

Mournier taught that this otherness, while inexhaustible, can be known in part by the properly trained person. Such training produces a self-effacing listener, whose senses, mind, and soul are focused on the physical world, waiting for it to make itself known little by little . . . [For] existentialists reality is not a situation *available to experience* but an "emerging something" which *the mind essentially participates in* and which can only be said to exist only *in experience*.[27]

Fundamentally, Bazin's theory rests first on the idea that no occurrence in the world has an *a priori* meaning – the world in flux is simply that, nothing more, and a flower blooming is not a sign that there is a supernatural being watching over the universe. Secondly, it rests on the notion that "The cinema's ontological vocation is the reproduction of reality by respecting this essential characteristic [i.e., the ambiguity of reality] as much as possible. The cinema, therefore, must produce, or strive to produce, representations endowed with as much ambiguity as exist in reality itself."[28]

This notion of "experiencing ambiguity in reality" is central to two films Bazin champions for their realist style:: "The two most significant events in this evolution [towards realism] in the history of the cinema since 1940 are Orson Welles's *Citizen Kane* (1941) and *Paisà* [Rossellini, 1946]."[29] Welles was the actor/director/radio producer and *enfant terrible* who came to Hollywood from New York's *Mercury Theatre*. Welles had gained immense notoriety with the live broadcast on October 29, 1938 of the H. G. Wells classic *War of the Worlds*, which caused widespread panic when many listeners were convinced that Martians were invading the U.S.

Rossellini was one of the early giants in the *Italian neorealism*[30] movement, a body of work that emerged in postwar Italy that rejected the well-made studio film for "found stories" of common people that would provide thematic credibility with audiences experiencing the deep-rooted social problems laid bare by the devastation of World War II. Shot in the streets for visual authenticity, often with non actors, neorealist films routinely examined the simple struggle to survive with scenes of the poor and the lower classes going about the mundane activities of their daily lives. Rossellini grew up in a cinema – his father opened the first movie theater in Rome – and he worked early in his career as a sound engineer. Why did these directors hold such a special place for Bazin?

Dudley Andrews suggests that they were, in many ways, simply kindred spirits. In Bazin's view, reality is the result of an active perceiver and his encounter with a field of phenomena. Cinema, as an apparatus that engages the world, is an instrument with a parallel function, and Bazin's theorizing is, in large part, simply preparing us for what cinema can reveal to us about the world. In spite of their differences in style, Bazin found purpose and pleasure in trying to account for the incredible emotion he felt seeing *Paisan* (Rossellini, 1940) and *Citizen Kane* (Welles, 1941).

> Welles and Rossellini share an attitude toward filmmaking that makes it more of an exploration than a creation . . . These films marked out for [Bazin] the spectrum of his interests, for *Paisa* examined a political reality which was even then struggling to come into existence while *Citizen Kane* explored more abstractly man's position in time and space . . . both attempt, in different ways, to record and preserve the complexity of our encounters with the world.[31]

In "From *Citizen Kane* to *Farrebique*," Bazin compares the film styles of both Welles and Rossellini with the yardstick of continuity editing (*découpage classique* or the Institutional Mode of Representation), where shot changes duplicate the changes in attention of the observer so seamlessly that the viewer rarely notices that the event has been fragmented. While Bazin does not deny that traditional *découpage* has earned its place in cinema, he argues that what makes the technique possible is the inherent realism of the film image:

> Under the cover of the congenital realism of the cinematographic image, a complete system of abstraction has been fraudulently introduced. One believes limits have been set by breaking up the events according to a sort of anatomy natural to the action: in fact, one has subordinated wholeness of reality to the "sense" of the action. One has transformed nature into a series of "signs."[32]

In other words, as the director's sense of the action at the shooting stage dictates what camera placements and framings are selected, reality is made to serve a prior logic, rendering the shots as simple signs, bearers of meaning other than what they mean in themselves.

Bazin on Rossellini and *Paisan*

Bazin moves directly to contrast this kind of traditional découpage with the work of Rossellini in *Paisà* (aka *Paisan* Rossellini, 1946). No longer are shots signs, because Rossellini camerawork – though selective – respects the "ambiguity in reality," so prized by Bazin: "The unit of cinematic narrative in *Paisà* is not the 'shot,' an abstract view of a reality which is being analyzed, but the 'fact.' A fragment of concrete reality in itself multiple and full of ambiguity, whose meaning emerges only after the fact, thanks to other imposed facts between which the mind establishes certain relationships."[33] Three key concepts are expressed here. First, Bazin acknowledges that, even in the realist style, the director *selects* reality by use of the camera. Second, Bazin recognizes that the director will *arrange* (impose) these selections with others. Finally, if the director respects the factual integrity of the shot by capturing a fragment of reality that is multiple and ambiguous, then the viewer's mind will establish *certain relationships* – in other places Bazin calls these *correspondences* after the poet Baudelaire[34] – so that a kind of meaning will emerge *a posteriori* from the scene. In this way, Bazin attempts to distinguish the realist approach to filmic construction – a recording – from traditional *découpage* – a telling.

Bazin argues that the neorealist approach in *Paisà* is unique, first, in its episodic structure, which links six stories that occur as Italy is being liberated by the Allies. The film opens with the invasion of Sicily, but after that, there is no indication of the temporal relationships between the short stories which cover an American soldier and a local girl who are killed in a castle by the sea, a street kid from Naples who sells the clothes of a drunk African American soldier, etc. See Critical Commons, "Ellipsis in Paisan: 'Like Stone to Stone Crossing a River' – André Bazin."[35] Bazin sketches in broad strokes a poignant sequence from the final installment,

> 1) A small group of Italian partisans and Allied soldiers have been given a supply of food by family of fisher folks living in an isolated farmhouse in the heart of the marshlands of the Po delta. Having been handed a basket of eels, they take off. Some while later, a German patrol discovers this, and executes the inhabitants of the farm. 2) An American officer and a partisan are wandering at twilight in the marshes. There's a burst of gunfire in the distance. From a highly elliptical conversation we gather that the Germans have shot the fisherman. 3) The dead bodies of the men and women lie stretched out in front of the little farmhouse. In the twilight, the half-naked baby cries endlessly.[36]

Bazin acknowledges that Rossellini has left enormous ellipses in these events. (And in fact, in describing the scene, Bazin omits a scene where soldiers light flares to attract an Allied plane that is trying to rescue a OSS officer, which is a central premise for the story.) Bazin reminds us that it is common for directors to use ellipses, and in traditional découpage, these omissions will ordinarily allow the easy, seamless movement from cause to effect. But Bazin claims Rossellini's ellipses are different, creating a film whose events drive the story not like a sprocket and bicycle chain, but in a fashion much looser: "The mind has to leap from one event to the other as one leaps from stone to stone in crossing a river. It may happen that one's foot hesitates between two rocks, or that one misses one's footing and slips. The mind does likewise [with this film]."[37]

Here is another of Bazin's enduring metaphors, the idea that the realist film asks more of the viewer. Just as one must find one's own path in crossing a river stone by stone, so the realist film asks the viewer to make their own connections between the "stones," the narrative events that are

Figure 6.1 Paisan *(Rossellini, 1946)*. André Bazin argues that Rossellini's editing in *Paisan* creates "an intelligible succession of events," but asks more of the viewer. Just as one must find one's own path in crossing a river stone by stone, the realist film asks the viewer to make their own connection between the "stones," the narrative events that are present in the film. Here, the crying baby standing with the dead bodies of his parents is a "fact" that forces us to make narrative connections.

Source: Copyright 1946 Arthur Mayer & Joseph Burstyn.

present in the film. By honoring the ambiguity inherent in the events, the realist filmmaker challenges the viewer to link the narrative events in a process that may move forward in fits and starts, that may cause one to hesitate, to occasionally "slip." This metaphor is so integral to Bazin's thinking that it is worth considering an expanded version he wrote later. Classical art (and classical film) is a form of "bridge" constructed with "bricks" – basic units of meaning pre-formed to fit together into a structure. By contrast, neorealist films are made with facts, "rocks scattered in a ford" whose meaning is not pre-determined. These rocks are not affected by the mind that connects them to lead across a river, and yet,

> If the service which they have rendered is the same as that of the bridge, it is because *I have brought my share of ingenuity to bear on their chance arrangement; I have added the motion which, though it alters neither their nature nor their appearance, gives them a provisional meaning and utility*. In the same way, the neorealist film has a meaning, but it is *a posteriori*, to the extent that it permits our awareness to move from one fact to another, from one fragment of reality to the next, whereas in the classical artistic composition the meaning is established a priori: the house is already there in the brick.[38]

So the conventional filmmaker uses "bricks," shots shaped for a predetermined usage or meaning, and strings them together one after another, and *découpage* constructs the house, the narrative

of the film, much like Pudovkin's "links in a chain" seen in Chapter 5. Likewise, stones mesh together seamlessly to form a bridge. What matters in both cases is that they fit together to build the structure. But the realist filmmaker uses shots that are unaltered in nature and appearance and "scattered in a ford" like mere rocks found in a river crossing. These rocks are objective facts that will never be affected or altered, simply used to create a provisional meaning assembled by the viewer.

Returning to *Paisà,* Bazin finds authenticity in the fact that in shot 2, distant gunfire is the basis for the partisans' deduction that the farmers are dead: it is a sound they would know well. Bazin finds particular significance in the final shots of the baby (Figure 6.1), because the baby exhibits "presence," and the camera does not analyze that fact in a predetermined way. How the farmer died will never be known, but the baby remains a real presence, a fact that seems to exist independent of how the viewer uses the baby to imaginatively construct the story.[39] The baby is a haunting presence that lingers, no doubt. But for contemporary audiences, the realism in *Paisan* is a mixed bag. The performers are almost exclusively non-actors and the amateur acting is overt and flat in places. Despite its remarkable feeling for real places and the cultural milieu, overt underscoring tries to smooth its disjointed structure in places, and truncated resolutions of the episodes often feel forced. Bazin himself concedes, "Unfortunately the demon of melodrama that Italian film makers seem incapable of exorcising takes over every so often, thus imposing a dramatic necessity on strictly foreseeable events."[40]

Yet, we can understand Bazin's admiration for its unique, personal approach to the work and for the potent mirror it held up to the problems of postwar Europe. He also respected Rossellini greatly, because this film marked a seminal convergence in Bazin's career that would affect him deeply:

> [A] sense of the harmony between art and life, between France and Italy, between philosophy and politics overwhelmed Bazin one evening late in 1946 in Paris, when he arranged for the French premier of *Paisà.* Rossellini drove up from Rome with the film and . . . The crowded audience of workers, intellectuals, former resistance fighters and prisoners of war saw what was for Bazin perhaps the most important and revolutionary film ever made.[41]

Bazin spoke afterward, and though he was initially overcome with emotion, he rallied the audience as he explained his reaction to the film, creating one of those electric moments that shapes in some small way the course of film history. He continued to speak about the film for days afterwards, and wrote a wonderful essay about the film a month later. Rossellini was forever grateful that Bazin had situated the film so that it would be widely appreciated in France. And Bazin was not alone in recognizing the film. Bosley Crowther of *The New York Times* praised the film as extraordinary, "the antithesis of the classic story film . . . a milestone in the expressiveness of the screen . . . a film to be seen – and seen again."[42]

While it remains difficult for us today to appreciate the contemporary response that *Paisan* generated, the special critical approach of André Bazin, who took every film on its own terms and appreciated each for its own values, is clearly at work here. In a wider context, perhaps we find here the budding concepts of *le caméra-stylo* and *la politique des auteurs* that would emerge in a few years and form a central concern of *Cahiers du Cinéma* when the magazine launched in 1951. *Le caméra-stylo* means literally "camera-pen," the concept advanced by film critic and director Alexander Astruc in 1948 that film directors should use their cameras like writers use their pens, as an instrument of individual expression. Astruc saw cinema moving away from its roots as spectacle and literary adaptation. Now the film artist can "express his thoughts, however abstract they maybe, or translate his obsessions exactly as he does in the contemporary essay or novel. This is why I would like to call this new age of cinema the age of the '*caméra-stylo.*'"[43] Central to this

position was Astruc's belief that there is no longer any need to maintain the traditional division of labor where the director merely stages a scene from the script. Rather, directing – in the hands of certain directors – becomes an authentic act of writing.

Six years later, François Truffaut would write his contentious article, "A Certain Tendency of the French Cinéma," which would fix the term *la politique des auteurs* (literally "a policy of authors," translated in English as the *autuer theory*) which argues that certain directors deserve to be called the author of their films, because their vision drives the artistic control of the film. So rather than viewing filmmaking as an art form created by a collection of artists, the *Cahiers* critics – not only Truffaut, but Godard, Rivette and Chabrol – began to advocate for pivotal directors, known and unknown, as auteurs, which in the simplest application of the critical-theoretical term, describes a filmmaker whose body of work exhibits personal vision and stylistic consistency. In this context – a culture of film criticism advocating for a revitalization of the cinema with a provocative doctrine championing the work of auteurs, particularly American auteurs – Bazin continued to argue against putting the filmmaker above the work, against putting the individual director above his more "botanical" view that saw these "auteurs as distinctive flowers produced by complex organism and nourished by a very special soil, the ideology of American society."[44] More interested in classifying films in genres, we can still see in Bazin's elevation of Rossellini (as well as Welles and Renoir) the roots of auteurism, an admiration not simply for the realistic style of the work, but also for the consistency and the integrity that often required the artist to break out of the system which constrained their work. For contemporary audiences, *Paisan* seems an odd film to place on par with *Citizen Kane*, because the plodding dialogue and the overly lush music tends to undercut the drama inherent in the locations of the partisan struggle. But given the revolutionary aesthetic Rossellini discovers to create *Paisan*, the realism so deeply rooted in contemporary postwar Italy, Bazin's early recognition of its international significance is justified.

Bazin on De Sica and *Bicycle Thieves*

Vittorio De Sica (1901–1974) was born into poverty in Sora, Italy and became a stage actor in the early 1920s. With his wife Giuditta Rissone, De Sica founded a theatre company a decade later and performed mostly comedic fare with significant directors like Luchino Visconti.

His meeting with Cesare Zavattini, one of the most prolific Italian screenwriters who penned over 80 screenplays in his lifetime, marked the beginning of a very productive collaboration. Together they created *Shoeshine* (1946) and *Bicycle Thieves* (1948) both of which won Academy awards. When *Bicycle Thieves* was released, Bazin was already speculating whether neorealism had a future, but he found in this film all of the compelling elements of the movement: a motion picture filmed entirely in the streets, with no studio shots, using players with no previous acting experience, and a plot that was partly improvisational. De Sica spent many months auditioning and casting the film in order to find players with "natural nobility, that purity of countenance and bearing that the common people have."[45] He found two remarkable novice performers: the factory worker Lamberto Maggiorani, who plays the father struggling to feed his family Antonio Ricci, and Enzo Staiola, a seven-year-old who plays his son Bruno.

Bicycle Thieves does not have the constructed plot of a traditional motion picture, but rather grows from a truly " . . . insignificant, even a banal incident: a workman spends a whole day looking in vain in the streets of Rome for the bicycle someone has stolen from him." [46]

The man has as new job hanging movie flyers and without his bike, he will lose his job. Late in the day, after hours of fruitless wandering, he tries to steal a bicycle. Caught by the police but released, he feels shame at having stooped to the level of the thief. Unlike the classic Hollywood film, where the psychologically well-defined protagonist is center stage, here the focus in on the

socioeconomic obstacles that confront the father, hurdles foregrounded by placing him in a very difficult economic situation. Bazin argues that *Bicycle Thieves* does not cheat reality, but treats each narrative in the event in a way that respects its natural occurrence:

> In the middle of the chase the little boy suddenly needs to piss. So he does. The downpour forces the father and son to shelter in a carriageway, so like them we have to forgo the chase and wait till the storm is over. The events are not necessarily signs of something, of a truth of which we are to be convinced; they all carry their own weight, their complete uniqueness, that ambiguity which characterizes any fact.[47]

De Sica's style is neutral, without pointed close ups to tell the audience what to think about next. He retains the "phenomenological integrity" of his scenes by clear camera placement, by reframing rather than cutting, and by using tracking shots extensively, in a range of framings. See Critical Commons, "*Bicycle Thieves*: Neorealism and Camera Movement, the Tilt."[48] Early in the film, the workman goes to the pawnshop with his wife to retrieve his bike so that he can take his new job as a poster hanger. The wife pawns the bed linens that were part of her dowry in order to pay to get the bike out of hock. As she negotiates with the pawnbroker through a window in a translucent glass divider, the husband inserts himself into the window to ask for more money. His naturalistic appearance into the conversation creates a "shot change" from a single shot to a "two-shot" that respects the space of the scene, emphasizing their shared interest, the barrier between them and the stereotypical world of the pawnbroker, playing on the tribulations of the working poor. The man shows them a touch of mercy, granting them an extra 500 lira.

As the husband waits to redeem his bicycle, he sees the clerk take the bed linens to the back of the store. At first, it appears that the clerk will place them with other linens that occupy a couple of rows of shelves. But the clerk begins to climb to the shelving and the wide shot tilts up to follow him, revealing that there are actually six *immense* shelves holding hundreds of pawned linens, the slow tilt up revealing in this small corner of Rome, the immensity of the economic misery facing the Italian working class (Figure 6.2).

By shooting in gritty streets that are not the scenes we typically associate with Rome, De Sica creates a natural, flow of life quality to the search for the bicycle: the locations are ordinary Rome, not extraordinary Rome. Throughout the film, the workman's son Bruno stays close by his father's heels, helping him look through the markets where they think the bicycle might have been "chopped" and sold for parts. Bazin finds this pairing to be pivotal in the film. The boy adds a personal, ethical dimension to the story, which otherwise would have been only a sociological study. The boy provides accompaniment or counterpoint to his father's purposeful gate, and De Sica "wanted to play off the striding gate of the man against the short trotting steps of the child, the harmony of this discord being for him of capital importance for the understanding of the film as a whole."[49]

The position of Bruno as they walk is telling, an emotional barometer of the state of their feelings towards each other. At one point, they are caught in a downpour and Bruno sticks close as they search helter-skelter through the chaos of a market place that is folding up, as vendors and buyers seek shelter. The rain drenches them. Father and son look to each other for some kind of guidance as the camera tilts between them: should they continue or surrender to the rain? Ultimately they give up and take cover, Bruno falling on the curb as they race for cover. As Bruno wipes the grime off of himself furiously, his father is oblivious, asking, "What happened?" Bruno gestures to the curb and answers indignantly, with that certain Italian flair, "I fell!" The father hands him his handkerchief to wipe with and touches the boy's head tenderly. Seven Austrian clerics then rush in for cover from the rain, surrounding the father, prattling in German and pinning Bruno against the wall (Figure 6.03). Bruno is in no mood to be respectful, and he quickly shoves the clergyman out of his space.

Figure 6.2 Bicycle Thieves *(De Sica, 1948): camera movement instead of cutting.* In *Bicycle Thieves*, De
 Sica uses camera movement to reframe action rather than cut, often to make a point. At the pawn
 shop, a wide shot tilts up to follow the clerk climbing a ladder, revealing that there are actually
 hundreds of pawned linens, the slow tilt revealing the immensity of the economic misery facing
 the Italian working class.

Source: Copyright 1948 Ente Nazionale Industrie Cinematografiche.

As the rain shower ends, the scene ends and the clerics go on about their business. Bazin
writes that these "events are not necessarily signs of something, of a truth of which we are to
be convinced; they all carry their own weight, their complete uniqueness, that ambiguity which
characterizes any fact. So if you do not have the eyes to see, you're free to attribute what happens
to bad luck or chance."[50] Bazin, on the other hand, sees correspondences, a kind of meaning that
grows *a posteriori* from the downpour scene, because it is "another stone in the river," part and
parcel of a society that is unhelpful in the face of the man's personal tragedy, the uncaring world
that he has met at every turn. "On that score, the most successful scene is that in the storm under
the porch when a flock of Austrian seminarians crowd around the worker and his son. We have no
valid reason to blame them for chattering so much and still less for talking German. But it would
be difficult to create a more objectively anti-clerical scene."[51]

Later in the film, the pair follow an old man into a church that ministers to street people,
because they think he can give them information about the stolen bike. The old man gives them
the slip, and they rush out of the back of the church frantic to find him. See Critical Commons,
"*Bicycle Thieves*: Bruno's Spatial Relation to his Father after he is Hit."[52] Bruno remains close, as
the camera tracks with them, but his hopes are fading. Bruno blames his father for letting the old
man escape, and his father slaps him in the face in frustration and anger. There is a long moment
of sorrowful contemplation, played out in alternating medium close ups, as they both let that
transgression sink in, and then De Sica cuts wide as Bruno moves away from his father crying,
with the camera tracking their separation. Bruno latches onto a tree, half defiant, half afraid, and
says his father will have to go on alone. As Bruno relents and they begin to move on, the argument

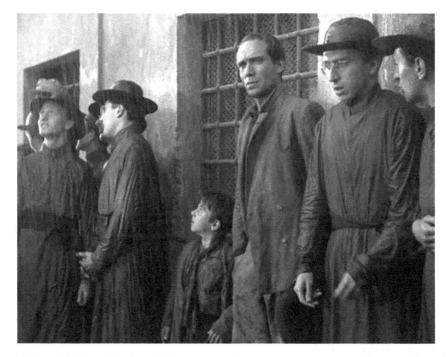

Figure 6.3 Bicycle Thieves *(De Sica, 1948): correspondences.* Bazin sees correspondences, a kind of mean-
ing that grows a posteriori from the downpour scene when a flock of Austrian seminarians sur-
round the worker and his son. "We have no valid reason to blame them for chattering so much
and still less for talking German. But it would be difficult to create a more objectively anti-
clerical scene."

Source: Copyright 1948 Ente Nazionale Industrie Cinematografiche.

continues in single tracking shots with Bruno threatening the ultimate consequence: "I'm going
to tell Mama what happened when we get home." The sequence ends with father and son physi-
cally separated as the camera tracks with them (Figure 6.4), a telling moment according to Bazin,
"Whether the child is ahead, behind, alongside – or when, sulking after having had his ears boxed,
he is dawdling behind in the gesture of revenge – what he is doing is never without meaning. On
the contrary it is the phenomenology of the script."[53] The sequence ends as the father tells Bruno
to go wait on a nearby bridge.

The father continues searching up and down along the river. He hears someone cry for help
back towards the bridge where he left Bruno. A commotion ensues, people running towards the
river, shouting that a boy is drowning in the river. Panicked, the father races back to the bridge –
he thinks his boy has fallen in – and waits pensively as people in a boat pull two swimmers from
the river. He breathes a sigh of relief that the person they drag to shore is not his son, then turns
to see the tiny Bruno standing at the top of an immense stairway (Figure 6.5). The low camera
placement and wide scope make the boy seem somehow more fragile, more precious in the eyes
of the worried father, and he races up the steps to be reunited with his son.

As they walk off – united again as a family – the father tells the boy to put his jacket back
on before he catches a chill. In these two street scenes that flow effortlessly forward as the day
of searching progresses, De Sica has moved the viewer through the pair's frustration, the trans-
gression of the slap, the shame and recrimination that bubbles up in its wake, the raw panic of
the father who fears for his child's life, and their ultimate reunion. De Sica's *découpage*, while

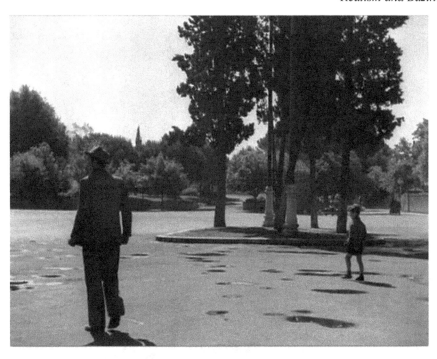

Figure 6.4 Bicycle Thieves *(De Sica, 1948): tracking shot and relative position.* De Sica used the tracking shot showing the relative position of Bruno searching with his father as an emotional barometer of the state of their feelings towards each other.

Source: Copyright 1948 Ente Nazionale Industrie Cinematografiche.

conventional in some respects, is always fluid and respectful of the spatial arrangement of these moments between the pair, careful to render the boy's position an emotional and moral indicator naturally embedded in the story, like river stones for those who can discover the connections. For Bazin, the boy's actions are simple, but the ethical correspondences he embodies are part of the particulars presented:

> In fact, the boy's part is confined to trotting along beside his father. But he is the intimate witness of the tragedy, its private chorus. It is supremely clever to have virtually eliminated the role of the wife in order to give flesh and blood to the private character of the tragedy in the person of the child.[54]

This role of witness culminates at the end of the film, when the workman's desperation to find his bicycle intensifies. His emotional barometer is, again, the boy, and the father's despair registers as indifference to his son's safety. See Critical Commons, "*Bicycle Thieves*: Bruno's Spatial Relation to his Father as the Film Ends."[55] As the father crosses a yet another street downcast, the boy tags far behind, dodging one car, before another one skids to avoid hitting him. They round a corner to see a soccer stadium and the boy sits down on the curb, exhausted from the search. For roughly the next three minutes, the boy anchors the corner where the father will sway back and forth in a kind of soul searching dance, struggling to decide whether or not he will steal a bike in order to feed his family. De Sica's staging here is brilliant, and alternates between chest high wide shots of the workman pacing back and forth between the stadium and the unlocked bike standing near a doorway behind him, and point of view long shots of both ends of that line of action: at one end, a lone policeman strolling among a sea of bicycles parked for the soccer match and at

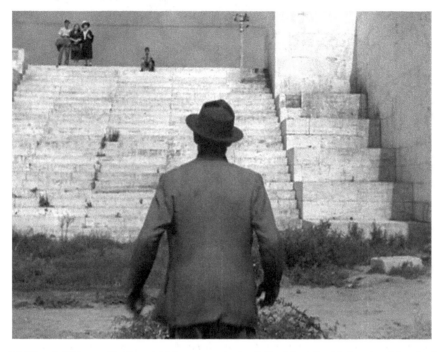

Figure 6.5 Bicycle Thieves *(De Sica, 1948): staging in depth.* Panicked that his boy has fallen in the river, the father turns and De Sica uses the wide scope and low placement of the camera to make the boy seem somehow more fragile in the eyes of the worried father.

Source: Copyright 1948 Ente Nazionale Industrie Cinematografiche.

the other, a lone bicycle sitting unattended leaning against a doorway. For a moment, the father hesitates and returns to sit with Bruno on the curb. His anguish is magnified as the camera pushes in, literally moving through a team of bicycle racers that flash by in front of him.

When he rises and looks towards the stadium, the camera slowly pans across a river of people leaving the stadium. He paces again away from the stadium and as the camera tracks around the corner with him, the sidewalk clears revealing the lone bicycle still standing by the doorway (Figure 6.6).

He paces back towards the stadium, and a sea of soccer fans remove their bicycles from a rack and begin to set off for home. The workman takes off his hat, and returns once more to the lone bicycle, this time gripping the hair on the back of his head, distraught, but knowing what he has to do. He gives Bruno some money, sends him off to catch the streetcar, and tells him where to wait for him. Bruno hesitates and the father drives him away, the camera tracking around the corner again to reveal the lone bike. The father circles the lone bicycle tentatively, then pounces on it, only to be immediately spotted by the owner who shouts, "Thief! Stop him! Thief!" alerting passersby in the street who give chase.

The chase is short lived. The workman races around the corner on the stolen bike, followed closely by a band of men giving chase. The chase continues around the block, returning to the same corner where he started from, and De Sica cuts to Bruno, who missed the streetcar, looking on intensely, and as the camera tracks closely around him, it reveals the moment of realization that his father is a thief. A scuffle ensues as the father is caught, and a policeman summoned. The camera alternates between close shots of the fearful Bruno, waist high in a sea of angry men, tugging at this father's coat and shouting "Papa!" and shots of the irate crowd above him pelting

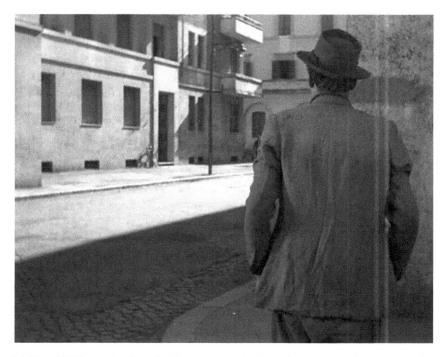

Figure 6.6 Bicycle Thieves *(De Sica, 1948): staging in depth.* As the father agonizes about stealing a bike, De Sica's staging alternates between wide shots of the workman pacing back and forth in a kind of soul searching dance.

Source: Copyright 1948 Ente Nazionale Industrie Cinematografiche.

with slaps to the back of his head and to his face. The business of the angry crowd continues: as a street car pushes to pass, they drag the workman to the sidewalk, and Bruno is left to pick up his father's hat, dust it off and walk behind him. De Sica gives us the boy's face in a medium tracking shot that registers the boy's slow, sorrowful walk. The boy is now a tearful accomplice, walking and dusting the hat, a trace of his father's former dignity (Figure 6.7).

The angry crowd continues to constrain the father, but the bike's owner, seeing the boy walking up to look on, ultimately decides not to press charges. As the men push the humiliated workman off on his way, warning him not to return, De Sica returns to his faithful tracking shot to end the film. Ten tracking shots follow to end the film, showing the faces of the boy and his father, overcome by events, and walking in the crowds surrounding them, and culminating in a moment where the father bursts into tears. Bruno takes his hand, one of their closest moments in the entire film, and they simply walk, together in their own thoughts (Figure 6.8). The final wide shot is static, traditional and summative: the pair walks away from the camera surrounded by a sea of strangers moving the same direction, facing an uncertain future, down a street that stretches deep into the city.

Here, Bazin's summary of the film's closing theme is typically concise and insightful. The father's humiliation in the street has been witnessed by his son, and their relationship is changed forever.

> Up to that moment the man has been like a god to his son; their relations come under the heading of admiration. By his action the father has now compromised them. The tears they shed as they walk side by side, arms swinging, signify their despair over a paradise lost. But

Figure 6.7 Bicycle Thieves *(De Sica, 1948): medium tracking shot.* De Sica places Bruno's face in a
medium tracking shot that reveals the boy walking and dusting off his father's hat, a tearful
accomplice to his shameful theft.

Source: Copyright 1948 Ente Nazionale Industrie Cinematografiche.

the son returns to a father who has fallen from grace. He will love him henceforth as a human
being, shame and all. The hand that slips into his is neither a symbol of forgiveness nor of a
childish act of consolation. It is rather the most solemn gesture that could ever market rela-
tions between a father and his son: one that makes them equals.[56]

Bazin on Welles and *Citizen Kane*

As the auteur theory took center cage at *Cahiers du Cinèma*, Bazin was sympathetic but remained
skeptical of the romantic notion that a film springs from the single mind of the director, and leery
of all the attention given to American filmmakers. Orson Welles was different in Bazin's eyes,
however, because he was new to Hollywood, very young, edgy and creating truly innovative
work. Many of his innovations grew out of his experience in radio, which gave Welles a lot of
practice grappling with a particular problem: fitting stories into a rigid running time, a fundamen-
tal problem also faced by the filmmaker. With *Kane*, Francois Truffaut notes, Welles placed

> . . . three pints of liquid in a two-pint bottle . . . In many films, the expositional scenes are too
> long, the "privileged" scenes too short, which winds up equalizing everything and leads to
> rhythmic monotony . . . Welles benefited from his experience as a radio storyteller, for he must
> have had to learn to differentiate sharply between expositional scenes (reduced to flashes of
> four to eight seconds) and genuine emotional scenes of three to four minutes . . . Thanks to this
> quasi-musical conception of dialogue, *Citizen Kane* "breathes" differently from most films.[57]

Figure 6.8 Bicycle Thieves *(De Sica, 1948): medium tracking shot.* De Sica returns to his faithful tracking
 shot to end the film, culminating in a moment where the father bursts into tears. Bruno takes his
 hand. Bazin writes, "The son returns to a father who has fallen from grace. He will love him
 henceforth as a human being, shame and all."

Source: Copyright 1948 Ente Nazionale Industrie Cinematografiche.

Welles' radio experience provided him a clear understanding of pace and momentum, a trait
Bazin would recognize and celebrate.

When *Citizen Kane* opened in Paris in July 1946 after a five-year delay because American films
were banned during the Nazi occupation, Bazin was only 28 years old and had only been a film
critic for two years. But the film forged a soulful connection between the two young men, because
Bazin started his first book four years later in 1950 devoted to the work of Welles. Bazin acknowl-
edges *Kane* as a story with a challenging structure and multiple points of view. And while these
are not new innovations for the medium, it is the comprehensive application of these techniques
throughout the story that Bazin finds original. The film's most important technical innovation is,
of course, deep focus – the use of a wide angle lens at an aperture that allows the area from the
immediate foreground to the deepest background in the framing to remain in focus. Gregg Toland,
the cameraman for *Kane*, had recently won an Academy award for cinematography on *Wuthering
Heights* (Wyler, 1939), and had worked with the Mitchell camera company on their new, self-
blimped (noise dampening) BNC camera.

Toland came in early on the production, and, in addition to deep focus, the film broke
ground in a number of other ways including " . . . long takes; the avoidance of conventional
intercutting through such devices as multiplane compositions and camera movement; light-
ing that produces a high-contrast tonality; UFA-style expressionism in certain scenes; low
angle camera setups made possible by muslin ceilings on the sets; and an array of striking
visual devices, such as composite dissolves, extreme depth of field effects, and shooting
directly into the lights."[58]

Toland credits coated lenses, faster film stocks (exposure index of 100 daylight) and arc lighting on floor stands for the look of the film, allowing him to shoot with a 24mm lens that when stopped down to f/11 or f/16 was essentially a "universal focus" lens. Deep focus was used throughout to simplify the coverage and capture "*découpage* in depth." One such shot that Toland found remarkable was a close up of Mr. Bernstein (Everett H. Sloane)

> . . .reading the inscription on a loving-cup [Figure 6.09]. Ordinarily, such a scene would be shown by intercutting the close-up of the man reading the inscription with an insert of the inscription itself, thereafter cutting back again to the close-up. As we shot it, the whole thing was compressed into a single composition. The man's head filled one side of the frame; the loving-cup, the other. In this instance, the head was less than 16 *inches* from the camera while the cup was necessarily at arm's length – a distance of several feet . . . Also, beyond this foreground were a group of men from 12 to 18 feet focal distance. These men are equally sharp.[59]

Toland said his collaboration on the film was aimed at fulfilling Welles' instinctive grasp of the power of the camera to convey drama without words, for systematically breaking new ground using *mise-en-scène* and camerawork to tell a story without cutting.

> *Citizen Kane* is by no means a conventional, run-of-the-mill movie. Its key-note is realism. As we worked together over the script and the final, pre-production planning, both Welles

Figure 6.9 Citizen Kane *(Welles, 1941): deep focus.* André Bazin greatly admired the work of Orson Welles, particularly the deep focus cinematography of Gregg Toland in *Citizen Kane* (1941). Toland singles out this shot as one of the deepest focus shots he created, with the focus carrying from Mr. Bernstein's face (frame left) about 16" from the camera, to the loving cup at "arm's length," to the men in the deep background 12 to 18 feet away.

Source: Copyright 1941 RKO Radio Pictures.

and I felt . . . the picture should be brought to the screen in such a way that the audience would feel it was looking at reality, rather than merely at a movie.

Closely interrelated with this concept were two perplexing cinetechnical problems. In the first place, the settings for this production were designed to play a definite role in the picture – one as vital as any player's characterization. They were more than mere backgrounds: they helped trace the rise and fall of the central character.

Secondly – but by no means of secondary importance – was Welles' concept of the visual flow the picture. He instinctively grasped a point which many other far more experienced directors and producers never comprehend: that the scenes and sequences should float together so smoothly that the audience would not be conscious of the mechanics of picture-making . . .

Therefore from the moment the production began to take shape in script form, everything was planned with reference to what the camera could bring to the eyes of the audience. Direct cuts, we felt were something that should be avoided whenever possible. Instead, we try to plan the action so that the camera could pan or dolly from one angle to another whenever this type of treatment was desirable. In other scenes, we preplanned our angles and compositions so that action which ordinarily would be shown in direct cuts be shown in a single, longer scene – often one in which important action might take place simultaneously in widely-separated points in extreme foreground and background.[60]

For Bazin, *Kane* marked an intelligent step forward in film realism, and he felt the impact of these techniques on the viewer was revolutionary. Rejecting analytical editing for camerawork that presents the entire dramatic field with equal clarity, the viewer is "forced to discern, as in a sort of parallelepiped of reality with the screen as its cross-section, the dramatic spectrum proper to the scene."[61] Bazin is returning here to the notion of the screen as a "window," a cross-section that reveals a space beyond. Bazin calls this space "parallelepiped" – a prism shaped from six parallelograms – to capture the feeling of the three-dimensional space represented in the image that "extends beyond" the cross-section/widow/screen as a kind of three-dimensional "spatial box" captured by the lens, of which the cross-section/widow/screen is one "face."

For Bazin, Susan Alexander's (Dorothy Comingore) suicide attempt in *Citizen Kane* is a key scene that illustrates the congenital realism between the film image and the object reproduced, as well as the ability of a single shot to incorporate the principles of analytical editing. See Critical Commons, "*Citizen Kane*: Susan's suicide as découpage in depth."[62] Bazin focuses not only on the staging in depth of the shot (Figure 6.10), but also the sound usage:

The screen opens on Susan's bedroom seen from behind the night table. In close-up, wedged against the camera, is an enormous glass, taking up almost a quarter of the image, along with a little spoon and an open medicine bottle. The glass almost entirely conceals Susan's bed, enclosed in a shadowy zone from which only a faint sound of labored breathing escapes, like that of a drugged sleeper. The bedroom is empty; far away in the background of this private desert is the door, rendered even more distant by the lens' false perspectives, and, *behind* the door a knocking. Without having seen anything but a glass and heard two noises, on two different sound planes, we have immediately grasped the situation: Susan has locked herself in her room to try to kill herself; Kane is trying to get in. The scene's dramatic structure is basically founded on the distinction between the two sound planes: Susan's breathing, and from behind the door her husband's knocking. A tension is established between these two poles, which are kept a distance from each other by the deep focus. Now the knocks become louder; Kane is trying to force the door with his shoulder; he succeeds. We see him appear, tiny, framed in the doorway, and then rush towards us. This spark has been ignited between the two dramatic poles of the image. The scene is over.[63]

Figure 6.10 Citizen Kane *(Welles, 1941): in camera double exposure.* Bazin praised this deep focus scene
from *Kane* where Susan attempts suicide, but the shot is not made with traditional "deep focus"
techniques but actually made as a special effects shot created in camera. We can see that this
scene is "faked" because the focus is split – foreground and background in sharp focus, but the
middleground in soft focus, which is not possible with a single take where the depth of field
would be continuous from near to far.

The shot is impactful, as the audience actively struggles at first to decode the image, then begins
to synthesize the meaning between the "two dramatic poles" as it unfolds. Bazin argues that the
real revolution in this type of sequence shot is that is asks the viewer to actively participate in
creating the meaning of the scene, to distinguish "the implicit relations, which the découpage no
longer displays on the screen like the pieces of a dismantled engine."[64]

However, in this scene, it turns out that Bazin's faith in the ontological relationship of the
image to reality is somewhat misguided, because the shot is not made with traditional "deep
focus" but actually made as a special effects shot created in camera.

The process is not complicated, but is risky in the sense that the final effect cannot be pre-
viewed (since it is shot with a film camera) and if the effect is not properly aligned in the camera,
it will have to be reshot. First, the camera is locked in place so that it is immobilized and the
starting footage mark noted. Then the foreground composition – water glass and pills – is photo-
graphed first, with the focus set close, the foreground lit and background in total darkness. Then,
with the lens capped, the film is run backwards to the starting position, and the lighting reversed:
the foreground is left in total darkness and the background lit. With the focus reset to the deep
background, the scene is re-photographed with Susan breathing deeply and Kane breaking down
the door. What tells the audience that this scene is "faked" is that the focus is split – foreground
and background in sharp focus, but the *middleground* is in soft focus, which is not possible with
a single take where the depth of field would be continuous from near to far.[65]

For the time period, Bazin's mistake is understandable since the film image was infrequently
manipulated to this degree, and when it was, the effect was often visible, even without the tech-
nology for repeatedly viewing and studying a shot or a sequence. Though special effects imagery

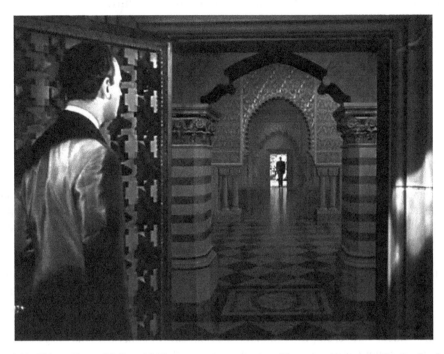

Figure 6.11 Citizen Kane *(Welles, 1941): miniature projection. Kane* was innovative for its day because of its extensive use of the optical printer developed by Linwood Dunn. This "deep focus" shot was created optically: the foreground is a prop door, the middle ground is a matte painting with Kane's reflection on the floor, and the image of Kane a miniature projection printed into that composition.

Source: Copyright 1941 RKO Radio Pictures.

had existed since the early days of photography, and the digital tools for photo realistic image manipulation that simulates reality were decades in the future, most of the contemporary image compositing techniques like matte painting and miniature projection that Bazin might have encountered did not efface the means of their production very well. In short, trick shots in Bazin's day were fairly obvious. But *Kane* was innovative for its day because of its extensive use the optical printer developed by Linwood Dunn at RKO, a device he eventually patented and sold in Hollywood under the Acme-Dunn brand of optical printers. In the hands of Dunn, the printer allowed very precise image compositing, with the caveat that more complicated shots required duplicating the footage in steps that built up grain and contrast, depending on the number of duplications required. Toland was resistant to new technology, which explains why he created the suicide shot in camera. Other "deep focus" shots were created optically: Raymond (Paul Stewart) looking at Kane in the distance moments after Susan Alexander has left him for good at Xanadu. Here the foreground is a prop door with Raymond looking through, the middle ground is a matte painting with Kane's reflection rendered on the floor, and the image of Kane a miniature printed into that composition (Figure 6.11). This shot was created because Welles and Toland liked the feeling of depth that an earlier shot of Bernstein standing in a distant doorway had created, but there was no set built for the Xanadu shot; Dunn's optical printer work solved the problem.[66]

It is a solution that Bazin might have praised, had he known about it, because in another instance he did praise the creation of spaces specifically for the camera. For *The Grand Illusion* (1937), French director Jean Renoir had moveable, partial sets built on location in the courtyard of a real barracks, rather than move into the studio, so that he could stage scenes with actors "inside" while the camera captured soldiers training through the set's "window" in the background. Bazin writes,

"It is through such techniques that Renoir attempts to portray realistically the relations between men and the world in which they find themselves."[67]

A few observations about the suicide scene may clarify how it qualifies or does not quality as a counterexample to the realism of a deep focus shot. First, if we consider camera tricks or optical printing as a kind of "pseudorealism" on par with perspective in painting, we can try to unpack how Bazin would think about this shot, had he known how it was created. Bazin's criticism of perspective as a form of pseudorealism in image creation *is a question of balance*: he chides those works of art that aim for the mere pseudorealism of faithful reproduction over the symbolic expression of a spiritual reality.[68] Thus, to the extent that the suicide image aims at symbolic (or thematic) expression, its pseudorealism can be accepted: in so far as the image serves to express the depths of Susan's despair at her domination by Kane, and the ego needs of Kane himself, its constructed nature can still be valued. This is consistent with what we know about Bazin's theorizing, since he was more practical than pure, and saw deep focus as an important, not exclusive, aesthetic value that could interact with other value cinematic resources like lighting, editing and sound. For example, he accepted the more flamboyant moments in the film – Hollywood montage (Susan's career montage) and flaunted temporal ellipsis (the breakfast scene) – because in his view, deep focus gives these moments a point of reference: "It is only an increased realism of the image that can support the abstraction of montage."[69] If the film is grounded in realism, then other methods are allowed.

Second, Bazin's concern that perspective is pseudorealism addresses painting and drawing, where the technique is visible. Perspective in painting is a deceit that fools the eye, a construct that "will never have the irrational power of the photograph to bear away our faith . . . The fact that a human hand intervened [in a painting] cast a shadow of doubt over the image."[70] Presumably, all of these shortcomings of pseudo realistic perspective are erased if the viewer is *unaware* that a human hand intervened. One need only look at contemporary hyperrealism in painting and drawing, techniques that make the images indistinguishable from photographs, to understand that there is no "shadow of doubt" cast over these images: one is either fooled into thinking they are photographic images and accepts them as indexically linked to the reality they portray, or one is in on the ruse and marvels at how the artist has mimicked the aesthetic of the photograph. Similarly, Susan's suicide is either regarded as indexically linked to the event or marveled at as a cinematic trick that mimics deep focus. This argument is underscored by Michael Betancourt in *Beyond Spatial Montage*, when he writes

> Contra Bazin, it is not a presumed ontological relationship preserved by the long take but rather *the appearance of such* that is the significant element allowing the long take to seemingly present "reality" on screen beyond spatial montage . . . The aesthetic demand that Bazin makes is . . . one grounded in the *belief* that what appears on screen should be indexically linked to what would be visible if it were not cinema but actuality that was on view. It is not a denial of the constructed nature of cinema but *a demand that cinema not appear to be constructed.*[71]

In short, Bazin does not prohibit us from drawing on our experience with deep focus shots to engage the illusion created by Toland in the suicide shot. Given that it will never be as self evident as shot-reverse shot, and that it balances the pseudo-realism of the in camera composite shot with the thematic, symbolic needs of the scene, its semblance of deep focus is sufficient to transfer "reality" to it, and thus it is valued under Bazin's theory. And besides, it was good enough to fool Bazin's own eyes.

Bazin on Welles and *The Magnificent Ambersons*

Welles' next film after *Kane* was *The Magnificent Ambersons* (Welles, 1942) a film based on the Pulitzer-prize winning novel by Booth Tarkington that Welles had previous adapted to radio.

Bazin argues that, even though Gregg Toland's "rugged frankness" was replaced by cinematographer Stanley Cortez's "sophisticated elegance" on *Ambersons*, the foundational principles of both films – deep focus that holds the actors within the *mise-en-scène*, coupled with long takes that allow the dramatic flow of a scene to be an undivided unit – are maintained.[72] A critical scene Bazin cites that demonstrates this foundational principle is a kitchen conversation between George (Tim Holt) and his aunt Fanny (Agnes Morehead).

The intricacies of the family ties in *Ambersons* are many, but in this scene, the privileged son George has just returned from a trip to Europe with his recently widowed mother, Isabel (Dolores Costello). George is trying to prevent his mother's childhood flame, Eugene Morgan (Joseph Cotten), who has moved back to town after a 20-year absence, from proposing to her. Isabel's spinster sister Fanny has secretly been in love with Eugene for decades, so she has been feeling anxious, hoping that the rekindled romance between her sister Isabel and Eugene will fail. See Critical Commons, "*Magnificent Ambersons*: Kitchen Scene as Découpage In Depth."[73] In the scene, George comes on a stormy night into the kitchen, where his Aunt Fanny has made him strawberry shortcake. George is aware that Fanny has feelings for Eugene, but Fanny tries to feign indifference while she tries to find out if Eugene accompanied them to Europe. The pretext drags out for a while until she finds out that he did not go to Europe, but did travel back from the East coast with them on the train. If that were not bad enough, Uncle Jack (Ray Collins), who has just wandered in on the discussion, begins to taunt her that Eugene is "dressing up more lately" and she should " . . . be a little encouraging when a prized bachelor begins to tell you by his haberdashery what he wants you to think about him." George continues to devour shortcake, and joins in the teasing, saying he would not be surprised if Eugene would soon be asking him for Fanny's hand in marriage. Fanny finally bursts into tears and runs from the room, as they plead that they were "only teasing."

Bazin points out that the strawberry shortcake is the "pretext action," while finding out about Eugene, Fanny's obsession is the "real action" underlying the scene. He compares Welles's approach – filming the entire scene in a single four and a half minute long take, using deep focus – to the traditional Hollywood continuity approach.

> Treated in the classic matter, this scene would have been cut into a number of separate shots, in order to enable us to distinguish clearly between the real and the apparent action. The few words that reveal Fanny's feelings would have been underlined by a close-up, which would also have allowed us to appreciate Agnes Morehead's performance at that precise moment. In short, the dramatic continuity would have been the exact opposite of the weighty objectivity Welles imposes in order to bring us with maximum effect to Fannie's final breakdown . . . The slightest camera movement, or a close-up to cue us in on the scene's evolution, would have broken this heavy spell which forces us to participate intimately in the action . . . It is obvious that this shot was the only one that allows the action to be set in such relief. If one wished to play each moment on the unity of the scene's significance, and construct the action not on a logical analysis of the relations between the characters and their surroundings, but on the physical perception of these relations as dramatic forces, *to make us present at their evolution right up to the moment when the entire scene explodes beneath this accumulated pressure*, it was essential for the borders of the screen to be able to reveal the scene's totality.[74]

After Fanny's outburst, the scene continues for another full minute, with the reverberations of the outburst still echoing in the darkened kitchen. The men feel some remorse, but try to shift the blame for their cruelty back on her. George sees the situation in monetary terms: "It's getting so you can't joke with her about anything anymore. It all began when we found out that father's estate was all washed up and he didn't leave anything. I thought she'd feel better when we turned over the insurance to her." Uncle Fred's remorse rings equally false, patriarchal, and desolate as he delivers his final lines with his eyes wistfully in the middle distance: "I think maybe we've

been teasing her about the wrong things. Fanny hasn't got much in her life. You know George, being an aunt isn't the great career it sometimes seems to be. I really don't know much of anything Fanny has got. Except her feeling about Eugene." The melancholy end of this scene is punctuated with a fade.

In Bazin's view, the approach here by Welles – découpage in depth – is *more engaging* for the viewer than traditional montage, and *more laden with meaning* because it provides us with *less guidance* about the scene's significance while preserving the *excess ontological realism* of a concrete space of the action.

> Obliged to exercise his liberty and his intelligence, the spectator perceives the ontological ambivalence of reality directly, in the very structure of its appearances . . . And during the whole scene, objects, outrageously irrelevant to the action yet monstrously present (cakes, food, kitchenware, a coffee-pot), solicit our attention without a single camera movement conspiring to diminish their presence . . . Contrary to what one might believe at first, "*découpage* in depth" is more charged with meaning than analytical *découpage*. It is no less abstract than the other, but the additional abstraction which it integrates into the narrative comes precisely from a surplus of realism. A realism that is in a certain sense ontological, restoring to the object and the décor their existential density the weight of their presence; a dramatic realism which refuses to separate the actor from the décor, the foreground and the background; a psychological realism which brings the spectator back to the real conditions of perception, perception which is never completely determined a priori."[75]

For Bazin, the *découpage in depth* of Welles returns us in some ways to the staging of early cinema, but his committed exploration of the technique marks a significant evolution in the language of cinema. Welles is probing the potentials of realism with techniques that let the action *and the mise-en-scène*, the realistic combination of both, become the meaning of the film. Welles' achievement isn't *mettre en scène,* merely a particular way of placing the camera, sets and actors. The realist style, in Welles' hands, "replaces the very nature of the story in question. With this technique, the cinema strays a little further from the theater, becomes less the spectacle than a narrative."[76] And among the French directors, Bazin sees one other person working ceaselessly towards the same goal of realism: Jean Renoir.

Bazin on Renoir

It would be difficult to leave our discussion of André Bazin without touching on the work of Jean Renoir, who Bazin regarded as the greatest French filmmaker. Bazin was writing a book on Renoir when he died of leukemia at age 40 in 1958. François Truffaut, who helped complete the book, famously said of his effort, "*Jean Renoir* is the best book on the cinema, written by the *best* critic, about the *best* director." Jean Renoir (1894–1979) was born in the Montmartre district of Paris, the son of Aline Charigot and Pierre-Auguste Renoir, the renowned impressionist painter. Renoir served in World War I as a cavalryman, and after being shot in the leg, as a reconnaissance pilot. He enjoyed great success in Europe in the 1930s, directing two films that are widely regarded as among the best films ever made: *La Grande Illusion* (1937), the first foreign language film to be nominated for the Academy Award for Best Picture, and *The Rules of the Game* (1939), a commercial failure that was difficult to find for years when the original negative was destroyed in an Allied bombing raid during World War II. Reconstructed under Renoir's direction in the 1950s, the nearly complete version of the film was reappraised by critics as a modern classic. When he came to Hollywood in the 1940s, Renoir struggled to find projects he could believe in, but his film *The Southerner* (1945) earned him an Academy award nomination for directing, and is regarded as probably his best American film.

Bazin, always the moderate, does not deny that plastic values in cinema – composition, lighting, contrast level, brightness, value, hue, graphic elements, lens usage, whether or not the image itself exhibits grain, etc. – can be manipulated in a film. He merely asks that those manipulations respect the essential realism of what the camera photographs. He felt that among the many films with subtle, restrained style that had been overlooked, the films of Jean Renoir are the most powerful exemplars. Much like De Sica, Renoir's neutral style is difficult to capture in words, since his editing is subtle, and his staging in depth is neutral, a forerunner to the more conspicuous deep focus of Welles. Moreover, Bazin's writing about Renoir tends to focus on the nuances of the acting, the elegance of the scenarios, and the intricacies of French culture that are explored rather than on the specifics of the sequence shots used. Here, we will focus on *A Day in the Country* (Renoir, 1936), a useful film to look at because it is a simple, touching featurette of 40 minutes. The film suffered significant production problems as a few scenes were left unfinished due to weather issues, and the film was cut and released by the film's producer a decade later. Bazin regards the film as perfectly finished, and a look at a few scenes will give a glimpse of the kinds of *découpage* and staging in depth Renoir employs that he so admired. See Critical Commons, "*A Day in the Country*: Window Scene as Staging In Depth."[77]

One of the most striking deep focus scenes occurs early in the film when the Dufour party – the father is a hardware dealer from Paris accompanied by his wife, mother-in-law, daughter and his store clerk and future son-in-law – arrive at a country inn by a river and ask the proprietor to prepare them a picnic. Two young sports on vacation, Henri (Georges D'Arnoux) and Rodolphe (Jacques B. Brunius), see the family arrive. As they eat lunch in the inn, they discuss what they should do for the day. Much of this dialogue at the table is cut slowly, but the energy of the scene rises when, hearing the group frolicking outside, Rodolphe flings open the shutters to "Check out the dairymaids" (Figure 6.12). The shot is accompanied by a romantic musical cue and a camera focus pull from foreground to background, an almost imperceptible shift carried by the movement of Rodolphe as he thrusts his head out the window to see the mother, Madame Dufour (Jane Marken) and Dufour's daughter Henriette (Sylvia Bataille) cavorting on the swings.

Bazin sees the scene's movement in the opposite direction: "The opening of the shutters ushers in both joy and desire. Renoir's lens allows this to happen naturally without disturbing the space or time."[78] The film then cuts outside to a (mismatched) wide shot, as the Dufours continue to swing and discuss what they want to have for lunch with the owner of the inn, Monsieur Poulain (Jean Renoir). This long shot holds :33 seconds, making the cut the next even more dynamic by contrast: for the incoming shot, Renoir mounts the camera with the swing so that it arcs back and forth holding the energetic Henriette in the center of its motion.

Renoir returns to this shot of Henriette on the swing as her beauty and exuberance become the focus not only of the two sports, but also a band of priests who walk by and a group of young boys who peer over the fence. Henriette's innocence and energy on the swing are a sharp contrast to the overt longing of all the males present. What is noteworthy about the scene is how Renoir refuses the manipulation of analytical editing, and remains true to the realistic decor of the inn. This approach integrates the natural setting of the interior and exterior action by using the window shutter as both spatial and emotional transition, a kind of "spatial fulcrum" that contains the men at one end and frees the women at the other. At the end of the sequence, the shots alternate between material that is shot towards the swing and material shot towards the inn. The "swing end" of the axis is more dynamic, with the closer rocking shots that move with Henriette and the long shots that show her exuberance. On the reverse end, long shots of Rodolphe leering out of the window are lower energy but maintain a sense of depth as the waitress brings wine to the table inside. As Henriette finally sits down on the swing, the camera goes low, giving the audience a glimpse of what Rodolphe hopes to see – her undergarments. The scene turns more serious as Rodolphe retires back to his kitchen seat, and the two men begin to talk about the nature of human love. In the end, they decide that they will try to try to lure the mother and daughter into visiting an island in the river so that they can engage in some "hanky-panky."

Figure 6.12 A Day in the Country *(Jean Renoir, 1936): creative staging in depth.* Bazin admired the work
of Jean Renoir for his creative staging in deep focus scenes like this one, where two men open a
window to watch a young girl swinging outside. Bazin sees the scene's movement in the oppo-
site direction: "The opening of the shutters ushers in both joy and desire. Renoir's lens allows
this to happen naturally without disturbing the space or time."

Source: Copyright 1950 Joseph Burstyn Inc.

The sequence of the couple's skiffs on the river is beautifully realized, and Bazin notes that
across his body of work, Renoir has a fondness for scenes with water, while acknowledging all
the difficulties shooting around water presents for the director: camera placement, sound record-
ing, the ability to push in or pull back from the action. While Hollywood directors might content
themselves with shooting a few establishing shots on location and using rear screen projection for
dialogue scenes on the water,

> This technique would be unthinkable for Renoir, for it necessarily dissociates the actors from
> their surroundings and implies that their acting and their dialogue are more important than
> the reflection of the water on their faces, the wind in their hair, for the movement of a distant
> branch. All of Renoir's boating scenes are shot entirely on location, even if he has to sacrifice
> the shooting script to do so, and their quality is a direct result of this technique. A thousand
> examples that illustrate this marvelous sensitivity to the physical, tactile reality of an object
> and its milieu; Renoir's films are made from the surfaces of the objects photographed, and his
> direction is frequently but a caress, a loving glance at those surfaces.[79]

As the boat glides along, Renoir shows the beauty of the riverbank in leisurely long shots
"tracking" from the boat: banks covered in waving grasses and banks covered in trees whose
branches create small eddies in the river. In some shots, it appears that the boat is anchored close
to shore and the swift movement of the river itself, coupled with Georges D'Arnoux's (Henri's)
deft manipulation of the oars to "fake rowing," carry the idea that he is rowing, a manipulation
Bazin would likely approve of since it stays true to the actual space.

Henri suggests they go ashore, and in a beautifully held moment, Henriette hesitates, knowing what he has in mind. Bazin singles out the next scene of her seduction on the island as an exceptional example of Renoir's découpage and directing of actors. The scene opens with a series of wide shots that follow the couple deeper into the woods as they follow a nightingale, a rich symbol in Western culture with a wide range of associations including melancholy, creativity, nature's purity, and in the hands of the poets, as a bird for lovers (John Milton, "Sonnet to the Nightingale," 1632) and uniting with nature (John Keats, "Ode to a Nightingale," 1819). As they walk, Henri holds her closer and she resists. Their walk opens to a small shady glade in the woods that Henri calls "his private office," where they sit and watch the bird. Henri again pulls her closer, but she removes his arm and considers him, looking him squarely in the eyes. Here, the film cuts away to Rodolphe and the mother, who are on another part of the island. Their wild cavorting in the fields will provide vivid contrast to the more secretive, tender encounter between Henri and Henriette.

Renoir's directing here is deft and the shot sequence respects the space of the actors. As the nightingale sings, Henriette wipe a tear from her face, a continuation of the bittersweet feelings she has for the beauty of the natural setting of the countryside. Bazin writes, "One of the most beautiful sequences in all of cinema is the moment in *A Day In The Country* when Sylvia Bataille is about to accept the advances of Georges Darnoux. The scene opens in the light, comic vein which one would logically expect to turn bawdy. We are ready to laugh, when suddenly the laugh catches in our throat. With Sylvia Bataille's incredible glance, the world begins to spin and love bursts fourth like a long-stifled cry. No sooner is the smile wiped from our faces than tears appear in our eyes. I can think of no other director, except perhaps Chaplin, who is capable of evoking such a wrenching bit of truth from a face, from an expression."[80] The shot he refers to is the only extreme close up in the film (Figure 6.13). Though we have seen other close shots in the film, like the beautiful staging of Madame Dufours' playful flirting with her husband, Renoir's directorial restraint holds this moment for the closest shot in the film, and as Bazin notes, it is not wasted, as she address the camera with a "wrenching bit of truth": it is a multivalent image that marks the moment of her conflicting emotions.

By celebrating the films of Renoir as a director who capitalizes on the shot in depth and neutral style, Bazin would lift his reputation as a filmmaker from obscurity to worldwide fame. Renoir, who was never seen as a leading French filmmaker, was dogged by his image as wealthy dilettante, one who had avoided the Nazi occupation by leaving the country. In the early 1950s, with the attention from Bazin and other *Cahiers* critics, Renoir retrospectives began to proliferate in museums and ciné clubs, leading to a restoration of *Rules of the Game* in 1959 dedicated to Bazin that played around the world, a film still considered among the best ever made.

Conclusion

As André Bazin took up film criticism in the 1940s, he faced a radically changing world undergoing immense destruction, social upheaval, the near extermination of European Jewry, the division of Europe by the Iron Curtain, the end of European dominance in world affairs, and the emergence of the nuclear age. And yet Bazin's baptism into film theory came at a propitious moment, when the sound films of the 1930s were giving way to a modern style of film that was bubbling up in different areas of the world. Looking back over the evolution of film style, Bazin saw what other historians saw. In the silent period he saw the Basic Story, key artists whose work advanced the medium by separating its resources from mere photographic replication, using analytical editing, and national schools of cinema like the Russians, who explored the use of abstractive techniques of cinema through montage. But Bazin also saw a second tendency that he thought had been overlooked, namely, directors like Robert Flaherty, Eric Von Stroheim and F. W. Murnau, who valued the camera's ability to reproduce reality and who used the revelatory power of film to record continuous space and time, making a body of work that was equally powerful. The advent

Figure 6.13 A Day in the Country *(Jean Renoir, 1936): a rare close up.* Renoir reserves a rare close up
to show Henriette's reaction after having sex on a secluded island in middle of a river. Bazin
writes, "I can think of no other director, except perhaps Chaplin, who is capable of evoking
such a wrenching bit of truth from a face, from an expression."

Source: Copyright 1950 Joseph Burstyn Inc.

of sound cinema in the late 1920s brought an end to these innovations in cinematic style, replac-
ing it with the "moderate realism" of *découpage classique* that emerged in Hollywood studio pic-
tures in the 1930s and quickly became a world-wide cinematic "language" for representing time
and space. This "moderate realism" still retained elements of abstraction – it routinely elided and
expanded time, and retained many of the elements of nineteenth century literature and painting
– and so did not completely fulfill the realist film style Bazin sought, one that would encompass
the fullest experience of the world. Classical cutting that so dominated the sound era marked an
advance, but came at the cost of suppressing other equally cinematic techniques.[81] Encountering
an expanding range of film styles from Welles and Wyler in Hollywood, as well as contemporary
film movements emerging in Italy and France, Bazin was energized. He championed their use
of staging in depth as a seismic shift, arguing that " . . . depth of field is not just a stock in trade
of the cameraman like the use of a series of filters or of such-and-such a style of lighting, it is a
capital gain in the field of direction – a dialectical step forward in the history of film language."[82]
Staging in depth, he argued, was not a reversion to the static shot of primitive cinema, but a step
forward, marking " . . . a decisive stage in the evolution of film language, which after having
passed through the montage of the silent period and the *découpage* of the talkies, is now tending
to revert to the static shot but *by a dialectical progress which incorporates all the discoveries
of découpage* into the realism of the sequence shot."[83] Bazin remained a moderate with an open
mind advocating this middle path. And so he celebrates in one of his favorite scenes – the suicide
scene in *Kane* – not simply a sequence shot, but one that assimilates the analytical techniques that
came before, essentially a single shot that incorporates the cuts that other lesser directors might
have made. Among the *Cahiers* critics who became fanatical advocates of this or that auteur,
this kind of paradoxical observation seems less dogmatic and more poetic, more emotionally

connected to the phenomenon, more "Bergsonian," more open to grasping meaning by first and foremost simply experiencing the world in front of him. Dudley Andrew, who spent a lifetime reading and explicating Bazin's writings, argues that cinema shaped Bazin's way of thinking and summarizes his unique contribution to film theory this way:

> Bazin is indeed cinema's poet laureate, or better, it's griot. Full of praise poems and aphorisms, his essays emblazon cinema's history and its possibilities in lapidary language that remains unmatched in both precision and luminescence . . . he regards his own essays the way he feels a critic should treat films, elaborating their lofty narrative and thematic problems, yet attending sympathetically to the contingencies and impurities that made them fitting expressions in their historical moment. As a medium, cinema begs exactly such double vision: the nature of photography ties cinema's huge ambitions to historical and material circumstances.[84]

Notes

1 J. Dudley Andrew writing in Hervé Joubert-Laurencin and James Dudley Andrew, *Opening Bazin: postwar film theory and its afterlife* (New York: Oxford University Press, 2011), ix.
2 David Bordwell, *On the history of film style* (Harvard: Harvard University Press, 1999), 12.
3 Ibid., 31.
4 Ibid., 31.
5 Ibid., 51.
6 Alexandre Astruc quoted in David Bordwell, *On the history of film style* (Harvard: Harvard University Press, 1999), 55.
7 J. Dudley Andrew, *The major film theories: an introduction* (London: Oxford University Press, 1976), 134.
8 J. Dudley Andrew, *André Bazin* (New York: Oxford University Press, 1978), 13.
9 Ibid., 19.
10 André Bazin, "Theater and Cinema – Part 1," *What is cinema?: Volume I* (Berkeley, CA: University of California Press, 1967), 91.
11 J. Dudley Andrew, *André Bazin* (New York: Oxford University Press, 1978), 43.
12 Ibid., 53.
13 Ibid., 57.
14 Ibid., 63.
15 André Bazin, "The Ontology of the Photographic Image," *What is cinema?: Volume I* (Berkeley, CA: University of California Press, 1967), 9.
16 Ibid., 12.
17 Ibid., 13–14.
18 Ibid., 15.
19 Ibid., 12.
20 André Bazin, "Cinema and Exploration," *What is cinema?: Volume I* (Berkeley, CA: University of California Press, 1967), 163.
21 André Bazin, "The Ontology of the Photographic Image," *What is cinema?: volume I* (Berkeley, CA: University of California Press, 1967), 14.
22 Ibid., 14.
23 Ibid., 97.
24 Ibid., 14.
25 Eric Rohmer, "La Somme d'André Bazin," *Cahiers du Cinema* 16(91) (January, 1959): 37
26 J. Dudley Andrew, *The major film theories: an introduction* (London: Oxford University Press, 1976), 136.
27 J. Dudley Andrew, *André Bazin* (New York: Oxford University Press, 1978), 106.
28 Jacques Aumont, Alain Bergala and Michel Marie, *Aesthetics of film* (Austin: University of Texas Press, 1992), 54.
29 André Bazin, "From *Citizen Kane* to *Farrebique*," in *What is cinema?: volume II* (Berkeley, CA: University of California Press, 1971), 27.
30 Bazin rejected the broad use of the term *neorealism* since the meaning of those films was open and only available *a posteriori*. He writes "Neorealism as such does not exist. There are only neorealist directors." See André Bazin, "In Defense of Rossellini," *What is cinema?: volume II* (Berkeley, CA: University of California Press, 1971), 99.

31 J. Dudley Andrew, *André Bazin* (New York: Oxford University Press, 1978), 117.

32 André Bazin, quoted in J. Dudley Andrew, *The major film theories: an introduction* (London: Oxford University Press, 1976), 161. The passage is from the original French edition of *Orson Welles* (Paris: les Editions du Cerf, 1971) but is omitted in *Orson Welles: a critical view*, trans. Jonathan Rosenbaum (New York, NY: Harper & Row, 1978).

33 André Bazin, *What is cinema?: volume II* (Berkeley, CA: University of California Press, 1971), 37.

34 See J. Dudley Andrew, *The major film theories: an introduction* (London: Oxford University Press, 1976), 154–155.

35 The clip, "Ellipsis in *Paisan*: 'Like stone to stone crossing a river' – Bazan," is on Critical Commons at http://www.criticalcommons.org/Members/m_friers/clips/ellipsis-in-paisan-like-stone-to-stone-crossing-a.

36 André Bazin, "An Aesthetic of Reality," *What is cinema?: volume II* (Berkeley, CA: University of California Press, 1971), 34–35.

37 Ibid., 35.

38 Ibid., 99, my emphasis.

39 Ibid., 35.

40 Ibid., 31.

41 J. Dudley Andrew, *André Bazin* (New York: Oxford University Press, 1978), 119.

42 "*Paisan*," Wikipedia, March 9, 2017. Accessed March 15, 2017. https://en.wikipedia.org/wiki/Paisan.

43 Alexandre Astruc, "The Birth of a New Avant-Garde: La Caméra-stylo," in *The New Wave* edited by Peter Graham(Garden City, NJ: Doubleday, 1968), 17.

44 J. Dudley Andrew, *André Bazin* (New York: Oxford University Press, 1978), 224.

45 André Bazin and Bert Cardullo, *André Bazin and Italian neorealism* (London: Continuum, 2011), 69.

46 Ibid., 64.

47 Ibid., 65.

48 The clip "*Bicycle Thieves*: Neorealism and Camera Movement, the Tilt," is on Critical Commons at http://www.criticalcommons.org/Members/m_friers/clips/bicycle-theives-tilt-to-reveal-economic-hardship.

49 André Bazin and Bert Cardullo, *André Bazin and Italian neorealism* (London: Continuum, 2011), 67–68.

50 Ibid., 65.

51 Ibid., 66.

52 The clip, "The clip "*Bicycle Thieves*: Bruno's Spatial Relation to his Father after he is Hit," is on Critical Commons at http://www.criticalcommons.org/Members/m_friers/clips/bicycle-theives-brunos-spatial-relation-to-his-1

53 André Bazin and Bert Cardullo, *André Bazin and Italian neorealism* (London: Continuum, 2011), 68.

54 Ibid., 66.

55 The clip, "*Bicycle Thieves*: Bruno's Spatial Relation to his Father as the Film Ends," is on Critical Commons at http://www.criticalcommons.org/Members/m_friers/clips/bicycle-theives-brunos-spatial-relation-to-his-2.

56 André Bazin and Bert Cardullo, *André Bazin and Italian neorealism* (London: Continuum, 2011), 67–68.

57 François Truffaut, in André Bazin, *Orson Welles: a critical view*, translated by Jonathan Rosenbaum (New York, NY: Harper & Row, 1978), 7.

58 Robert L. Carringer, *The making of Citizen Kane* (Berkeley: University of California Press, 1997), 72.

59 Gregg Toland, "Realism for *Citizen Kane*," *American Cinematographer* February 1941: 80.

60 Ibid., 54.

61 André Bazin, "An Aesthetic of Reality," *What is cinema?: volume II* (Berkeley, CA: University of California Press, 1971), 40.

62 The clip, "*Citizen Kane*: Susan's Suicide as Découpage in Depth," is on Critical Commons at http://www.criticalcommons.org/Members/m_friers/clips/citizen-kane-susans-suicide-as-decoupage-in-depth/view.

63 André Bazin, *Orson Welles: a critical view*, translated by Jonathan Rosenbaum. (New York, NY: Harper & Row, 1978), 77–78.

64 Ibid., 80.

65 For more information about the technical production of this and other scenes in the film, see Robert L. Carringer, *The making of Citizen Kane* (Berkeley: University of California Press, 1997).

66 Ibid., 92.

67 André Bazin, *Jean Renoir*, edited with an introduction by François Truffaut, translated from the French by W. W. Halsey, and William H. Simon (New York: Simon and Schuster, 1973), 64.

68 André Bazin, *What is cinema? Volume I,* essays selected and translated by Hugh Gray (Berkeley: University of California Press, 1967), 11.

69 Ibid., 49.

70 Ibid., 12 and 14.

71 Michael Betancourt, *Beyond spatial montage: windowing, or the cinematic displacement of time, motion, and space* (New York: Routledge, 2016), 39–40.

72 André Bazin, *Orson Welles: a critical view*, translated by Jonathan Rosenbaum (New York, NY: Harper & Row, 1978), 68.

73 The clip, "*Magnificent Ambersons:* Kitchen Scene as Découpage In Depth," is on Critical Commons at http://www.criticalcommons.org/Members/m_friers/clips/magnificent-ambersons-kitchen-scene-as-a-sequence/view.

74 André Bazin, *Orson Welles: a critical view*, translated by Jonathan Rosenbaum (New York, NY: Harper & Row, 1978), 72–73, my emphasis.

75 Ibid., 80.

76 Ibid., 81.

77 The clip, "*A Day in the Country*: Window Scene as Staging In Depth," is on Critical Commons at http://www.criticalcommons.org/Members/m_friers/clips/staging-in-depth-a-day-in-the-country-window-scene/view.

78 J. Dudley Andrew, *The major film theories: an introduction* (London: Oxford Univ. Pr., 1976), 153.

79 André Bazin, *Jean Renoir*, edited with an introduction by François Truffaut, translated from the French by W. W. Halsey and William H. Simon (New York: Simon and Schuster, 1973), 86.

80 Ibid., 78.

81 André Bazin, "The Evolution of Film Language," *What is cinema?: Volume I*, essays selected and translated by Hugh Gray (Berkeley: University of California Press, 1967), 35.

82 Ibid., 35.

83 André Bazin, *Orson Welles: a critical view*, translated by Jonathan Rosenbaum (New York, NY: Harper & Row, 1978), 82, my emphasis.

84 J. Dudley Andrew, "Foreword to the 2004 Edition," in *What is cinema?* André Bazin et al. (Berkeley: University of California Press, 2005), ix and xi.

7 Dream and Ritual

Andrei Tarkovsky and Maya Deren

Andrei Tarkovsky and Maya Deren are two filmmakers from different eras who made significant contributions to the art of filmmaking, and who also wrote theoretical works about their film practice. Taking their own film work as a starting point, Tarkovsky and Deren theorize that one of the filmmaker's primary functions is the control of time within the shot. Since every shot necessarily has a sense of time inherent within it, these filmmakers embrace the temporal command of the shot (and thus ultimately of the film) – what Tarkovsky called "time pressure" and what Deren described as "composition in time" – as a primary element of artistic control. In other words, these two filmmakers see the control of the *internal rhythm* of a film, the rhythm created *within a shot* by the movement of actors or objects or the camera itself as a significant area of creative control, rather than *external rhythm*, the rhythm created by editing and length of the shots. Since both artists are interested in the connection between film and inner mental states, perhaps it is no coincidence that their work foregrounds rhythm as a primary resource for building oneiric structures in film. The stream of spaces and the range of movement tempos constructed in the imaginary realm of dreams can be mimicked through careful control of movement within a shot. We will examine a key film from each artist, and locate that work within their theorizing to better understand the aesthetic choices needed to create a representation of "inner" reality, that is, a screen construction that is oneiric (literally, "relating to dreams") and anti-realistic.

While both artists concentrate on internal rhythm, their overall approach to creating oneiric films is different. Tarkovsky tries to simply show life to the viewer by removing all expressive, poetic formalization from the image, since the film image observes the fact of life over time, organized in a pattern dictated by life itself and by its time laws.[1] At first, this appears to be a contradiction: with his dedication to capturing concrete "facts" and their natural temporal flow, how can Tarkovsky create the inner reality of dreams? Thorsten Botz-Bornstein argues that, "Dreams are not produced by a process that attempts to stylize the reality of waking life into a reality of dreams but what really 'makes' the dream is the fact that reality and non-reality seem indistinguishable."[2] One of the primary characteristics of dreaming is that it is "experience unchained," a flow of mental activity freed from any constraint as the controlling power of our will is released, and the mind is isolated from the outer world. In a dream state, the unity of our conscious life, its regularity and coherence is upended. Without the ability to reflect logically, elements in our dreams that are based in reality, and elements that are not based in reality, are equivalent. Our experience of each, no matter how strange or how ordinary, is the same. Film art in Tarkovsky's view can only duplicate the dream through the raw power of the bare cinematic image. "Dream is the artistic phenomenon within which (as Tarkovsky says about Bresson) all expressiveness of the image has been eliminated and where only 'life itself' remains expressive."[3] For Tarkovsky, "life itself" will find expression in the film image as *time pressure* or internal rhythm.

By contrast, Maya Deren's approach to film is poetic. In 1953, at a symposium on poetry and film, she described this mode as "a 'vertical' investigation of a situation, in that it probes the

ramifications of the moment, and is concerned with its qualities and its depth, so that you have poetry concerned, in a sense, not with what is occurring but with what it feels like, for what it means."[4] While traditional drama is based on character centered causality, presenting well defined individuals struggling to attain specific goals, there are moments even in Shakespeare's work – *Hamlet*, for example – of these vertical, poetic moments. Later in the same symposium, Deren points out that Hamlet's soliloquy "To be or not to be," stops the forward progression of the drama to explore his feelings on whether he would be better off dead. Deren's vertical, poetic approach to filmmaking grew out of her graduate level study of poetry, and ultimately

> Deren's early interest in the use of ritual and myth in poetry became a guiding force in her creative work. The French symbolist school and T. S. Eliot were particular key influences. The symbolist effort to *spiritualize* language and Elliot's *mystical method*, which transformed the architecture of modern poetry, influenced both the nature and form of her films . . . Because they embodied the element of a *depersonalized* individual within the dramatic whole, Deren later came to call the form of her films *ritualistic*. She vigorously endeavored to develop a new syntax or vocabulary of filmic images.[5]

In practical terms, this approach meant that choreographed movements before the camera are carefully controlled for pace and often repeated, character movement and the syntax of continuity editing are used to break free of the natural laws of movement we find in our waking life, and – perhaps most important – the reliance on filmmaking "tricks" in the style of the French film pioneer Georges Méliès try "to convince us that an alternative universe is 'true.' "Hence, for Deren, Méliès's beloved camera "tricks" are not mere technological stunts but sacred devices for linking the "real" to the "unreal."[6] In short, Maya Deren's creation of oneiric films is more overt than Andrei Tarkovsky's, employing a more explicit use of formal, poetic devices to unlock inner reality. To paraphrase Thorsten Botz-Bornstein, in Deren's films, we see dreams *in the film*; in Tarkovsky's films, we cannot see dreams in the film because *the film itself is a dream*.[7] A look at the life and work of these two artists will reveal how creative editing and the control of internal rhythm is the central arena for the exercise of their artistic vision.

Andrei Tarkovsky

Andrei Arsenyevich Tarkovsky was born in 1932 in the village of Zavrazhye in Ivanovo Oblast, about 300 miles northwest of Moscow. His mother, Maria Ivanova Vishnyakova, graduated from the Maxim Gorky Literature Institute and worked as a proof-reader for a publisher. His father, Arseny Alexandrovich Tarkovsky, was a famous Ukrainian poet who left the marriage in 1937, when Andrei was five, an event that affected him deeply. During World War II, the family evacuated Moscow to live in the country with his maternal grandmother while his father went to fight in the army (and later returned as an amputee.) These childhood memories, and even a reconstruction of his grandmother's country house in Yuryevets, reappear in his 1975 film *Mirror*, which we will examine below.

Tarkovsky studied at the Academy of Sciences, but dropped out to pursue a year-long research expedition to prospect for minerals near the river Kureikye in the remote snow forest north of Mongolia. He decided to study film, applied to V.G.I.K. the state-run Russian film school, and was accepted. Tarkovsky met Andrei Konchalovsky, an emerging screenwriter-director, with whom he would collaborate in his early career. At film school, the two collaborated on the short film *The Steamroller and the Violin* (1960), which earned Tarkovsky a degree and won the New York Student Film Festival in 1961. The next year, Tarkovsky picked up his first film project, *Ivan's Childhood* (1962), a production that was dropped by another director, and the film went on to win the Golden Lion at the Venice Film Festival in 1962.

In the postwar Stalin era, Soviet film production increased and a new generation of Soviet directors emerged, including Sergei Parajanov and Nikita Mikhalkov. Funded by the state, this new work tended to draw heavily on Russian culture, in part because that tended to be safe material, and in part because these directors, freed from the concern of box office receipts, sought artistic rather than commercial success. In the 1960s, young Russian directors pursued poetic/artistic films and pushed the limits of state censorship. Tarkovsky's second feature, *Andrei Rublev*, was shot in 1965 but quickly ran afoul of the state censors, since it dealt with the topic of artistic freedom under a repressive regime in fifteenth-century Russia. After many re-edits, a version of the film was shown in Venice in 1969, and a censored version was finally released in the Soviet Union in 1971. Tarkovsky's struggles within the Soviet system were typical, but not as severe as those faced by other directors: Paranjanov's *Shadows of Our Forgotten Ancestors* (1965), a story of star crossed lovers set in the rich, colorful Ukrainian culture of the Hutsuls, won him critical acclaim and an immediate hostile assault from the Soviet film industry whose tradition of socialist realism he had violated. Paranjanov was *persona non grata* in the Soviet film industry from 1965 until 1973, when he was sent to the Gulag for four years on charges of rape, homosexuality and bribery. In this atmosphere of fear and repression, Tarkovsky made *Mirror* in 1974, a dream-like reminiscence of his childhood. Soviet authorities regarded the film as highbrow art, due to its continuous, nonlinear structure. They sunk the film by limiting its distribution, so Tarkovsky began to pursue co-productions outside the Soviet Union. By 1982, he had completed a feature in Italy *Nostalgia*, with R.A.I., the Italian national television broadcaster, as the sole underwriter after Mosfilm pulled out of the project. He never returned to the U.S.S.R., and died of lung cancer in 1985 after completing *The Sacrifice*, a Swedish production that won him a grand jury prize at Cannes.

Tarkovsky and Time Pressure

The centerpiece of Tarkovsky's written theory is known in English as *Sculpting in Time*, (literal translation from Russian: *Imprinted Time*) a term the director uses to describe his filmmaking style. In broad terms, Tarkovsky sees filmmaking as a unique art form, and denies, just as many film theorists do, that cinema's aesthetic is a composite of other forms like the novel, or painting. Coming from the Soviet tradition, he nevertheless takes a position contrary to Eisenstein (and others) that montage is the primary formative element in cinema. Tarkovsky states directly that there is only one element that is the indispensible aesthetic characteristic of cinema:

> The dominant, all-powerful factor of the film image is rhythm, expressing the course of time within the frame . . . One cannot conceive of a cinematic work with no sense of time passing through the shot, but one can easily imagine a film with no actors, music, décor or even editing . . . And I am convinced it is [internal] rhythm, not editing, as people tend to think, that is the main formative element of cinema.[8]

If this sounds remarkably close to the kind of cinema valorized by André Bazin, it is because, as we shall see, they both can be usefully seen in light of the philosophy of Henri Bergson. Bergson, as we mentioned in Chapter 6, sees time not as a succession of discrete events, but as a constant, unified state of heterogeneous flux that is often experienced by the individual as sped up or slowed down in contrast to conceptual time or time as delineated by a clock.

Not surprisingly, Tarkovsky rejects the idea of collision montage – two shots juxtaposed produce a new, third idea – as contrary to the inherent nature of cinema. And while every art form is "edited" in the sense that materials are selected, assembled and modified, the mere interplay of ideas driven by such "editing" is an unworthy goal for any film that aspires to

be art. The traditional plotting of a narrative film Tarkovsky dismisses as nothing more than a "fussily correct way of linking events [that] usually involves arbitrarily forcing them into sequence in obedience to some abstract notion of order. And even when this is not so, even when the plot is governed by the characters, one finds that the links which hold it together rest on a facile interpretation of life's complexities."[9] He also decries the clichés and crutches used since the silent period by directors who are unwilling to confront their material honestly. If two actions in a film are simultaneous, Tarkovsky says it is an immutable fact that they must be presented sequentially. Tarkovsky notes that some uses of parallel editing in the early period were driven by the lack of sound: he points to a scene from *Earth* (Dovzhenko, 1930) where the hero is shot, and as he collapses, the film cuts to a nearby field showing startled horses rearing their heads, before cutting back to the dead man. In the silent period, the cut to the horses was needed, because it carried the notion of a gunshot ringing out. With the advent of sound, such a shot is no longer needed, but gratuitous intercutting remains the norm in modern cinema:

> You have someone falling into the water, and then in the next shot, as it were, "Masha looks on." There is usually no need for this at all, such shots seem to be a hangover from the poetics of the silent movie. The convention dictated by necessity has turned into a preconception, a cliché.[10]

For Tarkovsky, cutting away from the primary action, here, the fall into the river, is a gratuitous relic, a custom that has crept into films where the director is unable to concentrate his vision sufficiently to see the facts before him. In contrast, in Tarkovsky's method, the authentic film image juxtaposes

> a person with an environment that is boundless, collating him with a countless number of people passing by close to him and far away, relating a person to the whole world: that is the meaning of cinema . . . The cinema image, then, is basically observation of life's facts within time, organised according to the pattern of life itself, and observing its time laws. Observations are selective: we leave on the film only what is justified as integral to the image.[11]

As a director, Tarkovsky focuses on how that "time within the frame" is constructed: "The cinema image comes into being during the shooting, and exists *within* the frame. During shooting, therefore, I concentrate on the course of time in the frame, in order to reproduce it and record it. Editing brings together the shots which are already filled with time, and organizes the unified living structure inherent in the film; and the time that pulses through the blood vessels of the film, making it alive, is of varying rhythmic pressure."[12] Again, it is this "time pressure" or internal rhythm created by the director that is the pivotal factor controlling the rhythm of the film, not cutting rhythm. One of the primary methods Tarkovsky uses for revealing time pressure in a shot is by including nature in his *mise-en-scène*. Tarkovsky relies on life processes and natural phenomena, the texture of their fluctuation, to drive or bolster the internal rhythm of his work, no matter how constructed the setting.

> Even though the fires, downpours and gust of wind are staged, re-shot or recreated there still remains the spontaneous element of "nature's time" within the filmic time. Each of the natural events and elements – water, wind, fire, snow – have their own sustained rhythm. Tarkovsky uses these natural rhythms to express his own, that of his characters and the temporal shape of the film.[13]

Armed with this method – the control of time pressure within the shot – as the *sine qua non* of cinema, Tarkovsky proceeds to build a definition of editing around that:

> Editing is ultimately no more than the ideal variant of the assembly of the shots, necessarily contained within the material that has been put onto the roll of film. Editing a picture correctly, competently, means allowing the separate scenes and shots to come together spontaneously, for in a sense they edit themselves; they join up according to their own intrinsic pattern . . . Time, imprinted in the frame, dictates that particular editing principle; and the pieces that "won't edit" – that can't be properly joined – are those which record a radically different kind of time. One cannot, for instance, put actual time together with conceptual time, any more than one can join water pipes of different diameter. The consistency of the time that runs through the shot, its intensity or "sloppiness," could be called time-pressure: then editing can be seen as the assembly of the pieces on the basis of the time-pressure within them.[14]

For Tarkovsky, intercutting *actual time* – time as we experience it subjectively in one continuously unraveling present that produces an accumulating past, what Bergson calls *duration* (French: *durée*) – to *conceptual time* – clock time, artificially segmented time, time divided arbitrarily in to minutes, hours, days is impossible. For Tarkovsky, these two approaches can never be joined in a film. The central task for the filmmaker is maintaining consistent time pressure across shots, because time pressure is the natural, determining factor for their assembly.

Within his notion of "time pressure" resonates a deeper, philosophical understanding of the power of cinema. Tarkovsky argues that starting from the Lumière film *Arrival of a Train at La Ciotat* (1895) cinema gave man the technology to print and reprint time, to take an impression of time and the power to repeat that time over and over on a screen. Cinema gave man "a matrix [a mold] for *actual time . . . Time, printed in its factual forms and manifestations*: such is the supreme idea of cinema as an art."[15] Here Tarkovsky, like André Bazin, sees cinema's ability to capture and "mummify" time as part of a fundamental human need to master and know the world, (see Chapter 6, p. 209). Tarkovsky argues that time imprinted in film is the essential reason that people frequent the cinema, not for stories, for stars or for entertainment. Normally, what a person goes to the movies for "is *time*; for time lost or spent or not yet had. He goes there for a living experience; for cinema like no other art, widens, enhances and concentrates a person's experience – and not only enhances it but makes it longer, significantly longer."[16] For the modern audience, immersed in a mass culture of consumerism that is spiritually crippling, that creates barriers to engaging the deep questions about the meaning of our existence, artistic films will strive to concentrate the continuous time of human consciousness, thereby bring the audience closer to the truth.

Obsessed with this *actual time*, the time of human consciousness that cannot be paused, Tarkovsky offers us some cryptic glimpses of his understanding of that concept: "Time is necessary to man, so that, made flesh, he may be able to realize himself as a personality . . . Time is a state: the flame in which there lives the salamander of the human soul."[17] This rich metaphor associates salamanders with fire, because in Russian folklore salamanders were thought to be impervious to fire. In fact, salamanders are all poisonous to humans if ingested since they secrete toxins through their skins. They were nevertheless used to make "salamander brandy," a drink supposed to have hallucinogenic or aphrodisiac properties that is created by immersing live salamanders in fermented fruit juice. Here, Tarkovsky conjures the almost mystical nature of actual time.

A key part of that mystery is human memory, accumulating as time moves forward. Tarkovsky writes, "Time and memory merge into each other: they are like the two sides of a medal. It is obvious enough that without Time, memory cannot exist either. But memory is something so complex that no list of all its attributes could define the totality of the impressions through which it affects us. Memory is a spiritual concept!"[18] Like Bergson, Tarkovsky is suggesting that the

subjective experience of time is participation in a constant flux that moves indivisibly between present and past. Clearly, the long take is one way cinema can represent the unfolding present with fidelity,

> but a complete cinematic interpretation of Bergson's *duration* would also include editing that links past/present, memory/perception, fantasy/reality, and dream-time/real-time. In short, inner and outer reality. Indivisibility can also be represented by a cutting and narrative style that does not call attention to these shifts in time and realms of reality (as they are not codified in consciousness) . . . Tarkovsky's films require several viewings before one can make easy separations between the inner (mind) and outer (social/physical reality) world. This is what characterizes Tarkovsky's narrative structure as durational.[19]

For Tarkovsky, then, the first aesthetic choice is the use of cutting that minimizes or masks temporal ellipses and avoids juxtaposition, a choice that moves his films closer to the uninterrupted living flux of actual time.

The moving camera is Tarkovsky's second aesthetic choice for exploring duration, because, as many theorists have noted, the moving camera "temporalizes space:" that is, represented space loses its static homogeneity as the camera travels through it, much like a Cubist painting that tries to represent space from a number of different perspectives.[20] A moving camera and the seamless editing of moving shots is Tarkovsky's method to transport the viewer freely through a range of times, in the same way that we experience dreams, moving forward and unstoppable. Or as Donato Totaro puts it, "Our true inner self, our emotions, thoughts, and memories do not lie next to each other like shirts on a clothesline but flow into one another."[21] A few examples will indicate how these choices work in Tarkovsky's *Mirror.* See Critical Commons, "The *Mirror*: Time Pressure and Découpage in Oneiric Cinema. Fire, Leaves, Shower."[22]

The nonlinear narrative of *Mirror* (1975) captures the remembrances of a dying poet, Alexei, or Alyosha (Ignat Daniltsev). The character is loosely based on Tarkovsky's father Arseny, and some of his poetry is included as voice over in the film. The film reveals key personal and historical moments from three time periods: the narrator's childhood in the countryside before World War II, the war period and after the war in the 1960s or 1970s. The film includes biographical details of Tarkovsky's life, such as the fact that his mother was a proofreader in a printing shop and that they were evacuated from Moscow to the surrounding countryside during the war. Part of Tarkovsky's intentional blurring of these time periods is casting the same actress, Margarita Terekhova, as Alexei's mother *and* wife.

An early scene in *Mirror* takes place before the war where Maria (Terekhova) has given breakfast to two children (Alexei's siblings?), and she stares off camera, contemplating something, gently crying while a love poem is read in voice over. A commotion erupts outside of the dacha, with people shouting and a dog barking. Maria walks to see what is the confusion is, then calmly returns to tell the two children, "It's a fire. Don't shout." The children rise and exit to see what is happening. After they exit, the camera pulls back slowly and a bottle falls off the table; auto kinetic objects are a running motif in the film. The camera pans left to reveal a mirror in which the two children can be seen standing at the screen door, out of focus, but with a blaze beyond them outside. As the camera racks the fire into focus, a young Alexei walks into frame, and the camera follows him outside to the porch. The camera continues to glide right, revealing a huge fire engulfing a barn. Rainwater pours off the porch roof in the foreground as a man in a hat and woman in a headscarf, their backs to the camera, look on impassively as the immense fire rages. The inference in the moment is that the woman is Maria – she just exited from this space – and this inference seems to be confirmed when Alexei, wearing the same shearling coat he had on inside the dacha, walks from the porch into the frame. The timing of his movement off the porch relative to where she stands seems to be about the right "temporal separation" of the two figures.

But the next cut shows Maria nearby – she doesn't have a headscarf on, and she never did – standing relaxed with her arms crossed, looking frame right, the sound of the fire (or is it dripping water?) continuing outside the frame. She casually walks forward, and the camera follows, tracking her to a well where she stops to splash her face from the bucket, and then sits down on a wall surrounding the well. Spatially, this shot is difficult to integrate with earlier shots, since the earlier inference – even if it was in the moment, almost subliminal – was that Maria was standing *closer* to the fire in the previous shot. As Maria now sits calmly at the well, the camera is carefully framed so that no fire is shown: Tarkovsky is withholding the excitement of the fire from the audience. A man in boots and a hat calmly walks into frame and the camera slowly tilts up to reveal that the barn (the same barn?) is still burning intensely. But something is off: the spatial arrangement of the fences and the barn are different from the previous shot, adding to the scene's spatial ambiguity.

As the man begins to run closer to the barn, the film cuts to the young Alexei sleeping in his bed. The typical inference from this juxtaposition is that the fire shown before is an "unmarked" dream sequence. But as the boy wakes and sits up in bed, Tarkovsky cuts to a black and white shot of beautiful underbrush, which, blown by a rising wind, ripples in slow motion as the camera tracks away, a typical strategy he uses to display "time pressure." Shots of fields mysteriously blown by the wind are a running motif in the film and here break any narrative arc with pure movement. The next cut comes quickly, returning to Alexei in essentially the same position again sleeping, but this time in black and white. He wakes and sits up again, just as he did before, although it seems to be morning in the bedroom now. Alexei rises and tiptoes to the next room, and as he peers in through the door, an object (a cloth, a towel?) flies across the top of the doorway. The film cuts instantly to Alexei's father, as he pours water in slow motion over a woman's hair. The woman slowly rises, her face hidden by wet hair. She stands dripping, and the film cuts to a shot framed so closely to the outgoing shot that the woman "pops out" of frame as water cascades from the ceiling in slow motion. The camera holds the long shot as soaked plaster slowly breaks and falls to the floor. A cut to medium shot of the woman shows her walking and tousling her wet hair in slow motion. She lowers her arm, revealing it is Maria, as the camera pans from her to her reflection in to a mirror with water cascading down one edge. The pan continues to the left, where a well disguised cut in black carries the pan to another shot that comes to rest on an exterior doorway where Maria inexplicably enters from outside. As Maria steps forward towards a mirror, her reflection appears as an older woman (played by Tarkovsky's mother Maria Vishnyakova) with a landscape seen through an arched window – or perhaps a landscape painting of the same –superimposed over it. The old woman/Maria walks forward and wipes haze from the mirror, and the scene cuts to a recurring shot of a hand that is at first glance appears to be on fire, but then is seen to be cupping a burning stick. (Tarkovsky next cuts to a room and a phone rings, a scene we will take up again shortly.)

Excluding the "hand-on-fire" shot (:03 seconds long) at the end, which is a recurring, interstitial, symbolic shot in the film, the average shot length of this sequence is :37 seconds. The shortest shot is of the plaster falling at :13 seconds, and the longest apparent shot is of Alexei walking outside to see the fire at :59 seconds (though there appears to be a very well disguised cut in this shot, it is unlikely to be seen on first viewing.) Two other shots are close to a minute long: the shot where Maria walks to a well and sits (:53 seconds) and the shot where Maria washes her hair (:52 seconds).

Throughout the scene, the interplay of these long takes with the flexible, "rubbery" time pressure within them seems slightly off-kilter. The relaxed stroll that Maria takes to sit down at the well and watch the barn burning, the slow motion hair washing and plaster falling (Figure 7.1), the slow, deliberate movement of the old woman towards her reflection at the end of the episode all feel emotionally slowed down, like movement retarded in space that is "thick" and restrictive. Vlada Petric sees this unease as part of a tradition in the Russian arts to highlight the subjective experience of the work:

The phenomenological signification of Tarkovsky's oneiric vision rests on an interaction between the representational and the surreal: the viewer feels that something is "wrong"

Figure 7.1 Mirror (Tarkovsky, 1975): slow motion. In *Mirror*, Alexei rises from his bed to discover his
mother washing her hair – shot in slow motion. The shot is almost a minute long, and the inter-
play of the long take with the "rubbery" time pressure within is part of a strategy by Tarkovsky
to render the scene slightly off kilter.

Source: Copyright 1975 Mosfilm.

with the way things appear on the screen, but is incapable of detecting sufficient "proof" to
discredit presented events on the basis of every day logic. As a result, the shot is "estranged"
poetically in the best tradition of the famous Russian Formalist poets and Constructivist art-
ists, who insisted that viewers always be aware of experiencing a work of art as a subjective
transposition of reality.[23]

This tension between *Mirror's* representational and estranged elements is a way to ensure that
a scene's meaning is not predetermined for the viewer. In the shower scene, this ambiguity is
reinforced at the end of the scene when Alexei's mother is "transformed" from a young woman
into an old woman by a cut on action as she moves towards a mirror. As she "wipes steam" from
the mirror, nothing changes – her image remains in a sort of soft, "cobweb" reflection that will not
"clarify." Her hand appears solid and in crisp focus while her image is indistinct and enshrouded
(Figure 7.2).

This extended moment is followed by a cut on idea, from her hand motion to the "flaming
hand" shot that recurs throughout the film (Figure 7.3), a punctuation at the end of the dream that
suggests a symbolism that Tarkovsky himself would deny. Tarkovsky says, "I had the greatest dif-
ficulty in explaining to people that there is no hidden, coded meaning in the film, nothing beyond
the desire to tell the truth. Often my assurances provoked incredulity and even disappointment.
Some people evidently wanted more: they needed arcane symbols, secret meanings."[24] Thematic
ambiguity is central to Tarkovsky's work, and is nowhere more apparent than *Mirror.* The viewer,
forced to deal with narrative uncertainty and cutting that seems vaguely symbolic, finds in *Mirror*

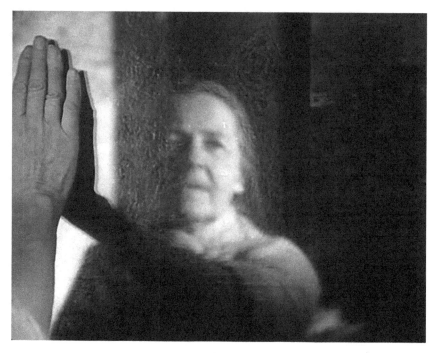

Figure 7.2 Mirror *(Tarkovsky, 1975)*: cut on idea from hand . . .

Figure 7.3 Mirror. . . .*to a recurring interstitial shot of a hand* .a cut on idea to the "flaming hand" shot that
recurs throughout the film, a suggestion of symbolism that Tarkovsky consistently denies in his
work.

the same kind of slippery, disorganized meaning that we encounter with dreams after waking reflection.

As if to confirm this commitment to ambiguity, in the scene that follows the "flaming hand" shot, the phone rings. Alexei answers, though the film shows only camera movement through his apartment. He has a phone call (entirely off camera) with his mother. He tells his mother he just had a dream about her and asks two questions: when did his father leave them, and when did the barn catch on fire? She answers each time, "1935." Alexei, having dreamed about the barn burning, wakes to associate that event with his father leaving. Somehow, in Alexei's dream and in his memory, there is a kind of "subjective transposition" of these two events. Tarkovsky will only reveal that Alexei has made the transposition, without any hint as to its meaning.

In a second oneiric scene set during wartime, Alexei and his mother Maria return to a dacha that her stepfather previously owned to speak to the woman there about a private matter. See Critical Commons, "*Mirror*: Time Pressure and Découpage in Oneiric Cinema. Earrings, Cockerel, Bed."[25] Maria drops a small coin purse on the floor that she has brought with her, and a ring and a pair of blue stone earrings rolls on to the floor. Maria and the woman move to an adjacent room, and the boy has to wait in the living room while they speak privately. He stares at himself in a mirror. A close up of embers in the fire tilts up to a mirror propped in the fire whose hazy reflection shows a young boy. A hand closes a door very, very slowly, and the natural inference is that it is the woman closing the bedroom door so that she and Maria can converse in private. But when the door is finally pulled into its latch, the camera seems to have tracked left to reveal a young Maria nursing the infant Alexei by a fire. Here, Tarkovsky repeats a striking shot seen earlier of a hand that appears to be aflame – in actuality, the hand is simply in front of a flaming stick.

Alexei turns to see a kerosene lamp sputtering out, and close shots follow of his mother and the woman speaking (their lips move but there is no sound but dripping water). The woman tries on the blue earrings. Her headband, the earrings and the Rembrandt style lighting of the scene, strongly suggest the Vermeer painting "Girl with a Pearl Earring." The lighting is very selective, so the spaces are very dark and indeterminate. The woman with the blue earrings circles Maria, and their conversation ends as she steps forward into the darkness, a hidden cut in black resolves to an incoming pan shot and rack focus back to the boy deep in thought. His mother and the woman emerge from the adjacent room, relight the lantern, and then go to see the woman's angelic young baby, who sleeps on a drapery-covered bed. The baby awakens.

Maria moves to the kitchen with the woman with the blue earrings, and the subtext of the dialogue reveals that Maria has come a long way, trying to pawn the earrings. The woman asks Maria to slaughter a cockerel for dinner, since she is pregnant and even milking the cow makes her queasy. She brings the bird in, places it on a wooden chopping block, and hands Maria a sharp ax. Tarkovsky cuts to a close up of the woman, who waits for Maria to strike the bird. There is a squawk off camera and feathers float onto the woman. A cut back to Maria in close up shows her face, eyes down, lit from below eyelevel and shot from below eyelevel, in a classic, threatening horror film composition. She casts a sly glance off camera towards the woman, and the viewer slowly realizes that she is photographed in slow motion. Maria turns to address the camera (and the audience), with an enigmatic, disturbing look on her face. She holds that position for a full eight seconds (Figure 7.4). If the slow motion and underlighting are not enough to "estrange" this shot for the viewer, the hold and the cut that follows certainly do.

As the mother addresses the camera – and the viewer – for what seems like an eternity, the film cuts to a matched black and white shot of Alexei's father, also addressing the camera (Figure 7.5).

Figure 7.4 Mirror *(Tarkovsky, 1975): shifting modes of address, from looking at the audience to ...* In *Mirror,* an extended shot of the mother in slow motion addressing the camera at first feels like she is looking at the the audience, but as the film cuts to ...

Figure 7.5 ...looking at the father in some other place and time. ... a matched reverse shot of the father in black and white, Tarkovsky is recreating the shifting, disorganized time and space of dreams.

Given that the camera placement is carefully matched – he is shot from slightly above eye-level and centered – the film strongly suggests she is staring at him, and that he is spatially proximate. Ultimately, the matched cut to black and white marks a sudden shift – she is not looking "at us," the viewers, but "at him" in the future or the past, or "at him" in a dream. Here again, Tarkovsky is playing with the kind of disorganized time and space that we encounter with dreams, to the same end: he is thwarting any attempt to impose a narrative logic on his more pointed cuts. The scene ends as the father holds, and then turns in slow motion, stroking the hand of a reclining woman, telling her not to fret. The camera tracks right revealing that Maria is the reclining person he is touching, and when the camera pulls back, that she is floating above the bed, speaking to him as if in a dream, "Don't be so surprised I love you." A white dove flits momentarily across the upper right corner of the screen, and the scene ends.

Mirror's mise-en-scène moves effortlessly between the present and the past, shifting freely from remembered past to living present, from imagined world to real world. Long takes, the assembly of those takes, and the precise control of time pressure within his films allows Tarkovsky to emulate the subjective, organic flux of actual time. And in the process, the flux created by Tarkovsky in *Mirror* reconstructs "the lives of people whom I love dearly and knew well. I wanted to tell the story of the pain suffered by one man because he feels he cannot repay his family for all they have given him. He feels he hasn't loved them enough, and this idea torments him and will not let him be."[26]

Tarkovsky has an almost fanatical faith in the power of cinema to give people the living flux of time because cinema is not stars, nor entertainment, nor stories. Only by remaining true to actual time, undivided time, time lived subjectively, can the filmmaker give the audience a concentrated experience of life. And so it follows that the essence of a director's work boils down to the English title chosen for his book, *Sculpting in time*.

Just as a sculptor takes a lump of marble, and, inwardly conscious of the features of his finished piece, removes everything that is not part of it – so the film-maker, from a "lump of time" made up of an enormous, solid cluster of living facts, discards what ever he does not need, leaving only what is to be an element of the finished film, what will prove to be integral to the cinematic image.[27]

Maya Deren

Maya Deren was born Eleanora Derenkowsky in 1917 in Kiev, Russia and emigrated to the United States in 1922 with her father, Solomon Derenkowsky, a psychologist, and her mother Marie Fiedler to escape the anti-Semitic pogroms of the period. Her father shortened the family name to Deren when they arrived in Syracuse, New York, and he quickly learned English and took medical classes at Syracuse University. He passed his American medical exams within two years of coming to America, and became the staff psychiatrist at the State Institute for the Feeble-Minded in Syracuse. A prolific writer from an early age, Eleanora moved with her mother to Geneva, Switzerland to study at the League of Nations International School from 1930 to 1933, and entered Syracuse University at age 16. She married the socialist organizer Gregory Bardacke at age 18, moved to New York City and divorced him three years later. Deren earned a degree in literature from New York University, and later a master's degree from Smith College at age 21. Her thesis was entitled *The influence of the French Symbolist School on Anglo-American poetry* (1939).

After moving to Greenwich Village, Maya worked as a freelance photographer and then as a manager and publicist for the choreographer Katherine Dunham. Dunham was studying Caribbean dance and culture, and had recently completed her own master's thesis in anthropology on the Haitian dance using 16mm film to capture dances and some of the ceremonies for her research. The work with Dunham kindled Deren's life long interest in Haitian rituals

and the Haitian religion Voudoun, a uniquely Caribbean synthesis of West African cosmology and polytheism with European Catholicism. Beginning in the late 1940s, Deren travelled four times to Haiti to document Mardi Gras, drumming, dance and Voudoun ceremonies, from which she produced numerous articles for magazines, a record album entitled "Voices of Haiti" and a book, *Divine horsemen: the living Gods of Haiti*. At the end of a tour with the Dunham troupe, Deren stopped in Los Angeles for several months, and met Alexandr Hackenschmied (later Hammid), a still photographer and accomplished motion picture cameraman from Czechoslovakia who became her second husband a few months later in 1942. Hammid would collaborate with Deren on perhaps her most famous film, *Meshes of the Afternoon* (1943), during which time Deren also adopted the pet name Hammid used for her – "Maya." He would go on to make numerous documentary films including *To Be Alive* for the 1964 New York World's Fair, a film that won him an Academy award for Best Documentary Short. The couple were married from 1942 to 1947, and their collaboration fed Deren's interest in filmmaking, trained her in camera and editing techniques, and guided her emerging vocation as an independent filmmaker.

From 1943 to 1948, in an extraordinary burst of inspiration, Deren made five films that are among the most significant experimental films made in the United States. Her body of work is characterized by creative use of the camera to enliven space through the power of movement, and the transformation of time and space through imaginative editing. Deren used the cut on action to continue motion across discontinuous spaces, as well as jump cutting, slow motion, multiple exposure and super imposition to transform the viewer's ingrained notions of time (*duration*) into films of dream-like, stream of consciousness. Her films also became the basis for her independent distribution business, Maya Deren Films. She rented her films to museums, schools and film societies around the world, covering all of the tasks associated with the enterprise: Deren handled the shipping and billing, wrote the brochure copy, printed the promotional stills and even the program notes to accompany the films, such as this one written in the third person from 1950:

> As a finished product, Maya Deren's films – with their haunting poetic images, their unorthodox filmic concept and techniques – are in themselves quite extraordinary. But even more extraordinary, perhaps, is the fact that Maya Deren is all things to her films – writer, producer, director, actress, light man, editor, and distributor. Moreover, since such non-commercial films, like any other art form, do not provide substantial remuneration, she has extended her versatility even further and has gained a considerable reputation as a still photographer, lecturer and writer, not only on films but on a variety of subjects including cats, ethnic dance, etc. Lately she has become known particularly as an authority on Haitian dance, music and mythology.[28]

As Renata Jackson points out, the claim of being a one-woman show is an exaggeration, since all of her films excluding her last one, *Meditation on Violence* (1948) were made with the contributions of Hammid and Hella Hyman, and her distribution business was often manned by friends when she was travelling.[29] But the singularity of vision and the determination to make films in the absence of "substantial remuneration," was part and parcel of her bohemian lifestyle and self-made career as an independent film artist.

Like Eisenstein, Maya Deren was a filmmaker *and* a film theorist. She wrote extensively for journals and popular magazines, and produced a book length treatise, *An anagram of ideas on art, form and film* published in 1946 that has been generally overlooked as a serious work of film theory. The book validates the foundations of Deren's creative work, and explores the full range of her ideas including "classical form, the essential properties of film in movement and temporality

that lead Deren to explore the intersections of film and dance, her opposition to documentary film, 'vertical' versus 'horizontal' structure, the idea of art as ritual, and the moral imperative underlying artistic production."[30] Deren's theorizing was a clarion call for a new kind of cinema, and ran parallel to Eisenstein's

> in their insistence on the grounding of this cinema in a solid basis of theory, in their reference to other disciplines and forms of artistic practice. Of major importance as well was their grounding in theatrical (and choreographic) movement and gesture, their adventurous forays into other cultures, their interest in ritual, and the manner in which their production is crowned by ambitious and uncompleted ethnographic projects – Eisenstein's in Mexico, Deren's in Haiti.[31]

Later in her life, Deren was critical of Hollywood's economic, artistic and political dominance of the cinema, and particularly of the narrow mode of production that limited the creative exploration of forms other than narrative. Deren once told an interviewer, "I make my pictures for what Hollywood spends on lipstick,"[32] a statement that summarizes how marginalized she felt as an experimental filmmaker during her lifetime. To expand film's potential and oppose the dominance of Hollywood, Deren urged emerging film artists to abandon narrative, and to embrace dream, ritual, myth and magic: "Instead of trying to invent a plot that moves, use the movement of wind, or water, children, people, elevators, balls, etc. as a poem might celebrate these. And use your freedom to experiment with visual ideas; your mistakes will not get you fired."[33] Maya Deren died suddenly at age 44 in 1961 from a brain hemorrhage. A look at her first and perhaps most powerful film, *Meshes of the Afternoon*, will illustrate her exploration of space and time to create oneiric, ritual structures in film.

Maya Deren and *Meshes of the Afternoon*

The first collaboration of Maya Deren and Czech cinematographer Alexandr Hammid, *Meshes of the Afternoon*, is one of the most widely seen and historically significant experimental films of the twentieth century, a film that was influential in the emergence of American avant-garde film in the 1960s. While *Meshes* clearly deals with a dream or trance state, and its overall form is circular and oneiric, Deren was unequivocal in disavowing its connection to the larger surrealist movement, with its emphasis on signification through chance juxtaposition. For years, she rejected as excessive the numerous Freudian, psycho-sexual interpretations of *Meshes*, and for a time, stopped showing the film because she thought it was being analyzed in these terms well beyond her intent. In 1959, 16 years after it was created, she added an "impersonal" score to the film, written by her third husband Teiji Ito. Deren was hoping to

> reinforce the depersonalized character of *Meshes* and save it from "the rapacious analysis" under which it had suffered since 1943 . . . But while the presence of Oriental instruments does provide an interesting contrast to the film's west coast milieu . . . Teiji Ito's score cannot "off-set" the intersection between the represented actions or objects in our understanding of them through a Freudian paradigm: the vaginal connotation of the flower and the woman's placement of it on her lap; the phallic connotations of the knife and the key; the visual connections made between the lover and the figure in black; figure in black as a symbol of death; the association between sex and death.[34]

While these Freudian overtones are hard to deny, Deren's intent to thwart any narrative arc driven by character is clear. The female figure is shown initially only as a shadow, and at points

where traditional cutting would show her face – notably, a shot of her feet crossing the threshold of the house and coming to a stop would ordinarily be followed by a close up of that person – there is none.

The female figure's face is not shown (excluding an extreme close up of her eye) until over four minutes of the film have elapsed. Subjective, P.O.V. camera movements "looking throughout the house" are not "answered" with reverse shots of the person whose P.O.V. is represented. Further, the introduction of a second figure that is masked continues Deren's intentional "disembodiment" of character. For all its Freudian symbols, *Meshes* tends to neutralize any tendency from the audience to identify with character, so the circular, repeated, choreographed route of the female figure dominates: the ritual of this journey is, in the end, about all the "character development" viewers are left with.

Meshes opens with a mannequin's hand descending from the top of the frame to deposit a flower on a sidewalk that climbs up a hill. The film shows the shadow of a female figure picking up the flower, turning to her left into an opening in a stucco wall, climbing some steps and struggling to get a key to open the door. The establishment of this opening space – the rising sidewalk, the steps that lead off of it and the door close by – is clear, and classically constructed cinematically. It will recur four more times in the film, three as the female figure turns from the sidewalk to enter the door, and once at the end when the male figure does the same. The female figure enters the house. Subjective camera movement carries her to the kitchen table, where a knife resting half way through a loaf of bread falls auto kinetically to the table. The camera then moves on to a telephone lying off the hook on the stairs, and up the stairs to an empty bedroom where a phonograph plays. There is a moment of spatial disorientation when, without re-establishing the female figure's position, her hand abruptly enters the frame to stop a phonograph record. A whip pan moves away from the phonograph, and a hidden cut within the pan takes the subjective camera downstairs. See Critical Commons, "*Meshes of the Afternoon*: Female Figure Dreams."[35]

The female figure falls asleep on a stuffed chair by the window. For all of *Meshes'* creative, experimental construction, Deren reverts to another classical cinematic figure of style here by using traditional, repeated markers for the dream sequence, altered with simple effects. The beginning of the dream is marked by four cuts: an extreme close up of her eye (cut to) the sidewalk seen out the window as a veil or thin gauze descends over the lens (cut back to) the extreme close up of her eye as a veil or thin gauze descends over the lens (cut back to) the sidewalk seen out the window, as the camera pulls back into a tunnel-like pipe and a hooded figure enters the frame (Figure 7.6). Here, the low-tech effects created in front of the lens became a prototype that many experimental filmmakers would follow, an effective "hands-on" gesture that transforms the dominant editing forms of Hollywood cinema for personal expression.

The next scene returns to the sidewalk as the figure in black turns to reveal a "mirror face," and then continues up the hill. The film crosscuts back and forth between the female figure's shadow running up the hill in real time, and the figure in black ascending the hill in slow motion, with two cleverly disguised cuts within whip pans creating a seamless transition between the two camera frame rates. A panning shot of the female figure's feet again reveals the earlier geography of the steps that open in the stucco wall, and the female figure climbs the steps and re-enters the house. A kind of ritual is emerging: the female figure can pursue the figure in black up the hill only so far before turning away to return to the house. By masking the figure, Deren attempts to "depersonalize" one of the central characters, and move *Meshes* away from a film of strictly personal expression, an idea she associates with the romantic notion of the artist, struggling to express his own personal preoccupations. Deren mistrusts this romantic ideal, writing in *Anagram*,

> Accustomed as we are to the idea of a work of art as an "expression" of the artist, it is perhaps difficult to imagine what other possible function it could perform. But once the question is

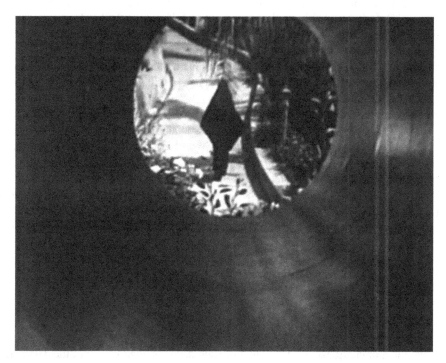

Figure 7.6 Meshes of the Afternoon *(Deren, 1943).* In *Meshes of the Afternoon,* Maya Deren signals the
beginning of a dream state by a low-tech effect created in front of the lens: the camera dollies
back inside a metal pipe.

Source: DVD copyright 2002 Mystic Fire Video.

posed, the deep recesses of our cultural memory release the procession of indistinct figures
wearing the masks of Africa, or the Orient, the hoods of the chorus, or the innocence of the
child virgin . . . the face is always concealed, or veiled by stylization – moving in formal pat-
terns of ritual and destiny. And we recognize that an artist might, conceivably, create beyond
and outside all the personal compulsions of individual distress . . . it becomes important to
discover how and why man renounced the mask and started to move towards the feverish
narcissism which today crowds the book-stores, the galleries, and the stage.[36]

While Deren wrote very little about ritual in her theory, she sees the use of masked figures and
un-individuated, almost Jungian archetypes as part of her strategy to broaden the reading of her
films beyond the narrow Freudian interpretations that so often greeted her work.

Moreover, the creative camera work and deft editing of this scene exemplifies Deren's poetics
of cinema, as expressed in *Anagram*, that creative filmmaking involves both the camera – as a tool
of discovery – and editing – a tool of invention. Filmmaking is an

instrument composed of two separate but interdependent parts, which flank the artist on
either side. Between him and reality stands the camera . . . with its variable lenses, speeds,
emulsions, etc. On the other side is the strip of film which must be subjected to the mecha-
nisms and processes of editing (a relating of all the separate images), before a motion picture
comes into existence. The camera provides the elements of the form, and, although it does

not always do so, can either discover them or create them, or discover and create them simultaneously. Upon the mechanics and processes of "editing" falls the burden of relating all of these elements into a dynamic whole.[37]

In this scene, the use of the sidewalk and steps as a circular, ritual landscape, the subjective camera moves and the extreme close up of the eye rely on the camera's ability to discover. The use of gauze over the lens, the tunnel shot and the use of slow motion rely on the camera's ability to create. The tight structuring of an editing "figure of style" to cue the viewer to the dream state, the invisible cuts within footage to shots of different frame rates and the repeated action of turning away from the ascending sidewalk to the stairs rely on editing's ability to invent a dynamic structure from the elements the camera provides. See Critical Commons, "*Meshes of the Afternoon*: Female Figure Tumbles."[38]

As the female figure returns up the steps to the door, the camera shows her face for the first time. She again sees the knife, and ascends to the bedroom through a veil to find the phone off the hook lying on the bed. Pulling back the bed covers reveals the knife again, a moment punctuated by an extreme close up of her distorted reflection moving across the blade. The force of that moment seems to propel the female figure backwards across the veil she entered through. A series of seven spatially disorienting jump cuts in the stairwell follow, cuts that capture her dream-like "tumble down the rabbit hole" until she emerges through an archway. In a subjective shot from that position, she scans the room, returning to the chair by the window, where she sees herself sleeping once again. The circular structure, the ritual procession/return of the female figure to the chair is another part of a strategy of "depersonalization" of the central figures in Deren's films. "The ritualized form treats the human being not as the source of the dramatic action, but as a somewhat depersonalized element in a dramatic whole. The intent of such depersonalization is not the destruction of the individual; on the contrary, it enlarges him beyond the personal dimension and frees him from the specializations and confines of personality."[39] A remarkable cut on action takes the female figure "flying" forward from the high arch to a moving shot of her hand "landing" at the phonograph, returning her to the ground level of the house, ending a sequence with a travelling camera that creatively mimics the dream-like feeling of tumbling and floating through space.

The next section of *Meshes* uses low-tech, creative filmmaking techniques that echo, in many ways, the early work of the French stage illusionist turned "trick-film" maker, Georges Méliès (1861–1938). These effects center on doubling the female figure within the same frame, the use of the stop-motion substitution effect, and the eye-line match or referential cut to create the impression that the female figure is looking at herself. In this "third round" of the journey through the house, the female figure will witness herself in multiple, dream-like paths that bring her into a face-to-face confrontation with herself. The sequence opens with the female figure rising from the phonograph, and as she stands up, she turns into a profile shot, a startling moment that reveals the female figure doubled in the frame, a duplication that suggests her active, "dreaming spirit" is rising from her body, still sleeping in the chair. An in-camera split screen creates the effect, which was a trick known from still photography and adopted in the earliest days of cinematography by filmmakers like Méliès. The image is created by locking down the camera, making note of the starting frame, masking one side of the frame while exposing the other, rewinding to the start and reversing the mask to expose the portion of the frame that was masked off in the first pass.

In the next four shots, the female figure standing at the window is intercut with point of view shots from the window: the female figure touches the window and looks down (cut to), a subjective shot from the window, the hooded figure carries a flower and moves up the sidewalk and she runs after him (cut to), the female figure is still touching the window, her eye-line following the action below (cut to), the hooded figure moves up the sidewalk and she hurries to follow him, coming once again to the steps where she turns away, back towards the house. In a tight close up, the female figure pulls a key from her mouth, a surreal, "sleight of hand" that is simultaneously a "visible utterance" of entry and passage. The film cuts to the female figure entering the door, and the third round of her journey up the stairs – this time rocked by earthquake-like movements of

the stairs – takes her again to the bedroom, where the hooded figure lays the flower on the pillow. See Critical Commons, *"Meshes of the Afternoon*: Female Figure 'Pops' In/Out and Multiplies."[40] As she looks on, the hooded figure pops out of the frame using a Méliès-style stop-motion effect, setting off a series of 11 stop-motion-like jump cuts that "animate" the female figure down the stairs and back up again. In the next series of shots, which presumably are upstairs, the female figure eyes the knife in close up, and when she looks off out of frame, the camera tilts up to reveal that she is once again by the chair at the window, looking at herself asleep. Deren, writing about her early work, notes that this kind of uncanny movement creates the feeling of a dream state. "[T]he central character of these films moved in a universe which was not governed by the material, geographical laws of *here* and *there* as distant places mutually accessible only by considerable travel. Rather, he moved in a world of imagination in which, as in our day or night-dreams, a person is first one place and then another without traveling between."[41]

As the female figure returns again to the window, the fourth round of pursuing the hooded figure up the sidewalk ends as it has before: with another turn to the steps, another key pulled from her mouth, which is immediately transformed by stop-motion substitution into a knife. This time, as the female figure enters the house, she carries a knife, only to find two more versions of herself seated at the table (Figure 7.7), where the bread was seen earlier. Lucy Fischer notes that this "multiplication" of the filmmaker is also an early trick film technique used by Méliès who once played seven different people in the same shot in *The One-Man Band* (1900). Fischer continues, "That Deren's films and writings would be informed by a sense of magic should come as no surprise to us. Born Eleanora, she changed her name to Maya, in honor of the Hindu goddess of sorcery. Beyond that, Deren's poetry and theoretical musings on art and cinema were laden with references to prestidigitation."[42]

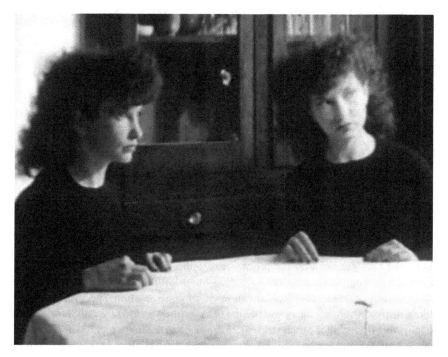

Figure 7.7 Meshes of the Afternoon *(Deren, 1943).* Deren uses an early trick film technique to multiply the female figure within the frame for a game of "drawing straws." In this way, *Meshes* is closer to the screen magic of the pioneer filmmaker Georges Méliès, trying to persuade us that the dream/ritual before our eyes is real.

Source: DVD copyright 2002 Mystic Fire Video.

Filmic prestidigitation is precisely what follows. With three versions of the female figure around the table, a game of "drawing straws" commences. Placing the knife on the table, it is instantly transformed into a key by stop-motion substitution. The key is picked up from the table, shown to the other players, only to be "popped" back into place on the table by stop-motion substitution. The spatial relations here are quite explicit, with traditional matched eye-lines in the two-shot and in the single of the female figure who entered the house, indicating it is now the latter's turn to play. Reaching for the key, she turns her hand over to reveal that her palm is black, and a quick stop motion substitution transforms the key back into a knife. The two female figures react in shock, a whip pan disguising the cut between their two positions.

The female figure rises, holding the knife, now with her eyes obscured by silver orbs. A matched cut on the action of her standing uses creative geography to take her outside, and five matched profile shots of her feet walking show her advancing ominously towards the sleeping figure on the chair by the window. The cuts make the foreground action read as temporally continuous, but spatially, each shot is different. In a 1955 letter to James Card of the George Eastman House, Deren wrote about this remarkable sequence,

> There is a very, very short sequence in that film [*Meshes*] – right after the three images of the girl sit around the table and draw the key until it comes up knife –when the girl with the knife rises from the table to go towards the self which is sleeping in the chair. As a girl with a knife rises there is a close-up of her foot as she begins striding. The first step is in sand (with suggestion of sea behind), the second stride (cut in) is in grass, the third is on pavement, and the fourth is on the rug, and then the camera cuts up to her head with the hand with the knife descending towards the sleeping girl. What I meant when I planned that four [sic] stride sequence was that you have to come a long way – from the very beginning of time – to kill yourself, like the first life emerging from the primeval waters. Those four strides, in my intention, span all time . . . That one short sequence always rang a bell, a buzzer in my head . . . And so [I] came to the world where the identity of movement spans and transcends all time and space . . . here is continuity, as it were, holding its own in a volatile universe . . . that movement, or energy is more important, or powerful than space or matter – that, in fact, it creates matter – seemed to me to be marvelous, like an illumination that I wanted to just stop and celebrate.[43]

Here, the creative geography of matched action, the deliberate, trance-like walk across the flux of discontinuous space lends an allegorizing quality to the female figure's journey of aggression. The spatial/temporal transformations continue as the female figure appears to be lowering the phallic knife into the sleeping woman's mouth, which jolts her awake, her eyes wide in an extreme close up, as a shadow passes over her face. A close up of a man withdrawing from her follows, from her point of view, as if he had just kissed her.

From this point forward, the man replaces the hooded figure, leading the female figure upstairs to the bedroom, putting the phone back on the hook, placing the flower on the bed. The female figure lies on the bed, her head on the pillow next to the flower, and the man caresses her and moves towards her. The flower magically "pops" into a knife. An extreme close up shows her eye glancing towards it and as they hold the moment of confrontation, she strikes and his image shatters like a mirror, revealing the ocean behind. The journey up the sidewalk now resumes for a final time, only this time with the man striding up the steps to the door, picking up the flower, turning the key to find the female figure in the chair slashed and bloodied, surrounded by the broken shards of a mirror. This is the circular ritual brought to its final conclusion.

After *Meshes*, Deren maintained "the function of film, like that of other art forms, was to *create experience* – in this case, a semi-psychological reality."[44] But as Renata Jackson points out, Deren's theorizing about her later work shifted: she began to see the proper goal for cinematic art as the manipulation of space/time through purely filmic means, rather than methods that look

to literature or drama. By the time she wrote her theoretical treatise *Anagram*, her special focus on spatial/temporal manipulation had not diminished, but was supplemented with an additional admonition: the overall form of art films should be ritualistic.

> In other words, although the film artist must take advantage of the medium's special ability to creatively manipulate movement, these space-time manipulations must not be used to make a film form solely for the purpose of self-expression; rather, like the shaman or artist in "primitive society," the film artist must engage in a more selfless goal of creating depersonalized art objects whose design and function, like that of ritual forms, is to assist others in comprehending their contemporary social conditions.[45]

While such prescriptive generalities ignore the overlapping possibilities of other forms, and while Deren herself never wrote extensively about the implications of ritual in film, the circular structure and trance like movements in *Meshes* render the female figure as a sort of "spiritual automaton," moving in a measured, ritualistic way towards the destruction of the self. And Deren's deep interest in continuity editing "holding its own in a volatile universe" would eventually bring her in the early 1950s "to call all her films 'choreographies for camera,' 'chamber films,' or 'cine-poems,' while emphasizing the medium's ability to manipulate the temporal dimension above all else."[46] Deren writes that the cinema's specific power comes from being

> a time-form . . . more closely related to music and dance than it is to any of the spatial forms, [e.g., architecture] the plastic forms [e.g, sculpture, but here also, painting or photography that represents of solid objects with three-dimensional effects]. Now it's been thought that because you see it on a two dimensional surface which is approximately the size and shape of the canvas . . . that it is somehow in the area of the plastic arts. This is not true, because it is not the way anything is at a given moment that is important in film, it is what it is doing, how it is becoming; in other words, it is the composition over time, rather than within space, which is important.[47]

Deren is arguing here that film is essentially a time art, experienced like music or dance each time as a recreation, *as it becomes*, rather than a series of dimensional, pictorial compositions within a frame.

Conclusion

The nontraditional narratives of Andrei Tarkovsky and the experimental work of Maya Deren use internal rhythm and editing in different ways to open up the "inner sphere" of human life. Compared simply as examples of *cutting*, *Mirror* and *Meshes of the Afternoon* are more alike than they seem at first glance. Tarkovsky and Deren share at least two common cutting techniques: cuts that disguise the shot change by cutting within a camera move that is matched on the outgoing and incoming shot and cuts that "pop" objects and people out of frame. But Tarkovsky would likely object to some of Deren's overt uses of the stop-motion substitution technique, including the locked down camera sequence that "animates" her up and down the stairs. He would also oppose some of the unconcealed editing techniques where Deren aims for a predetermined effect, like the stride sequence in *Meshes* that match cuts the female figure wearing reflective glasses stepping into five different spaces to visualize the internal journey towards suicide. As Tarkovsky once wrote, "Never try to convey your idea to the audience – it is a thankless and senseless task. Show them life, and they'll find within themselves the means to assess and appreciate it."[48]

Compared simply as examples of *internal rhythm*, both Tarkovsky and Deren carefully control character movement and use slow motion as a way to mimic the fluctuating rhythms of *duration*, or time as we experience it. Both use camera movement to follow action in lieu of cutting,

repeated movement motifs and the dream like effect created by slow motion cinematography. With its low tech, poetic approach, multiple imagery and ties to dance and ritual, *Meshes* is closer to the screen magic of Georges Méliès, trying to persuade us that the dream/ritual before our eyes is real, while Tarkovsky's *Mirror* works to continually blur the distinction between reality and non-reality through a restrained editing style that avoids analytical cutting.

Notice that many of the issues we examine in this chapter lead us to the next chapter, since they fall under the broad concept of *pacing* which Karen Pearlman defines as "a felt experience of movement created by the rates and amounts of movement in a single shot and by the rates and amounts of movement across the series of edited shots . . . Pacing is the manipulation of pace for the purpose of shaping the spectators' sensations of fast and slow. The word "pacing," like the word "timing," is used to refer to three distinct operations: the rate of cutting, the rate of concentration of movement or change in shots and sequences, and the rate of movement or events over the course of the whole film."[49] For Tarkovsky, the singular focus he gives to "the rate of concentration of movement" within a shot becomes the point of convergence in an editing process where shots join up naturally according to the intrinsic movement patterns they contain.

For Deren, the focus on pace is less central because it is only part of a choreography before the camera that will be augmented with low tech special effects, with screen magic using the stop-motion substitution effect, and with continuity editing that energizes and destabilizes space to generate extraordinary movement. Cinematic pace, for these two filmmakers, is one way to unlock the inner reality of human life. But as we will see in the next chapter, it is also a primary area for emotional and narrative control in the editing of more traditional narratives.

Notes

1　Andrey Tarkovsky and Kitty Hunter-Blair, *Sculpting in time: reflections on the cinema* (Austin: University of Texas Press, 1986), 68.
2　Thorsten Botz-Bornstein, *Films and dreams: Tarkovsky, Bergman, Sokurov, Kubrick, and Wong Karwai* (Lanham, MD: Lexington Books, Rowman & Littlefield, 2008), xi.
3　Ibid., 15.
4　Maya Deren, "Poetry and Film: A Symposium," in *Film Culture Reader*, edited by P. Adams Sitney (New York: Praeger, 1970), 171.
5　Moira Sullivan, "Maya Deren's Ethnographic Representation of Ritual and Myth in Haiti," in Bill Nichols and Maya Deren, *Maya Deren and the American avant-garde* (Berkeley, CA: University of California Press, 2001), 208.
6　Lucy Fischer, "The Eye for Magic: Maya and Méliès," in Bill Nichols and Maya Deren, *Maya Deren and the American avant-garde* (Berkeley, CA: University of California Press, 2001), 202.
7　Thorsten Botz-Bornstein, *Films and dreams: Tarkovsky, Bergman, Sokurov, Kubrick, and Wong Kar-Wai* (Lanham MD: Lexington Books, 2008), 23.
8　Ibid., 113 and 119.
9　Ibid., 20.
10　Ibid., 70.
11　Ibid., 66 and 68.
12　Ibid., 114.
13　Donato Totaro, "Time and the Film Aesthetics of Andrei Tarkovsky," *Canadian Journal of Film Studies* 2(2) (1992): 23.
14　Andrey Tarkovsky and Kitty Hunter-Blair, *Sculpting in time: reflections on the cinema* (Austin: University of Texas Press, 1986), 116–117.
15　Ibid., 63.
16　Ibid., 63.
17　Ibid., 57.
18　Ibid., 57.
19　Donato Totaro, "Time and the Film Aesthetics of Andrei Tarkovsky," *Canadian Journal of Film Studies* 2(2) (1992): 26, my emphasis.
20　Ibid., 22.

21　Ibid., 25.

22　The clip, "The *Mirror*: Time Pressure and Découpage In Oneiric Cinema. Fire, Leaves, Shower" is on Critical Commons at http://www.criticalcommons.org/Members/m_friers/clips/the-mirror-time-pressure-and-decoupage-in-oneric.

23　Vlada Petric, "Tarkovsky's Dream Imagery," *Film Quarterly* 43(2) (1989): 32, doi:10.2307/1212806.

24　Andrey Tarkovsky and Kitty Hunter-Blair, *Sculpting in time: reflections on the cinema* (Austin: University of Texas Press, 1986), 133.

25　The clip, "*Mirror*: Time pressure and Découpage in Oneiric Cinema. Earrings, Cockerel, Bed." is on Critical Commons at http://www.criticalcommons.org/Members/m_friers/clips/mirror-time-pressure-and-decoupage-in-oneric.

26　Andrey Tarkovsky and Kitty Hunter-Blair, *Sculpting in time: reflections on the cinema* (Austin: University of Texas Press, 1986),133.

27　Ibid., 63. The Russian title of Tarkovsky's book, "Запечатлённое время", is literally translated as "imprinted" or "depicted" time.

28　Maya Deren in Renata Jackson, *The modernist poetics and experimental film practice of Maya Deren* (Lewiston, NY: E. Mellen Press, 2002), 36.

29　Ibid., 37.

30　Richard Allen in ibid., 36.

31　Annette Michelson, "Poetics and Savage Thought: About *Anagram*," in Bill Nichols and Maya Deren, *Maya Deren and the American avant-garde* (Berkeley, CA: University of California Press, 2001), 27.

32　Maya Deren, quoted in Douglas Gilbert, "Pioneer in New Film Art Makes Camera Part of Her Pictures," *New York World Telegram*, April 17, 1946.

33　Maya Deren, "Amateur Versus Professional", *Film Culture* 39 (1965): 45–46.

34　Renata Jackson, *The modernist poetics and experimental film practice of Maya Deren* (Lewiston, NY: E. Mellen Press, 2002), 202.

35　The clip, "*Meshes of the Afternoon*: Female Figure Dreams," is on Critical Commons at http://www.criticalcommons.org/Members/m_friers/clips/meshes-of-the-afternoon-female-figure-dreams/.

36　Maya Deren, *An anagram of ideas on art, form and film*, reprinted as end matter in *Maya Deren and the American avant-garde*, Bill Nichols and Maya Deren (Berkeley,CA: University of California Press, 2001), 18.

37　Ibid., 46.

38　The clip, "*Meshes of the Afternoon*: Female Figure Tumbles" is on Critical Commons at http://www.criticalcommons.org/Members/m_friers/clips/meshes-of-the-afternoon-female-figure-tumbles/.

39　Ibid., 20.

40　The clip, "*Meshes of the Afternoon*: Female Figure 'Pops' In/Out and Multiplies," is on Critical Commons at http://www.criticalcommons.org/Members/m_friers/clips/meshes-of-the-afternoon-female-figure-pops-in-out.

41　Sarah Keller, *Maya Deren: incomplete control* (New York: Columbia University Press, 2015), 107.

42　Lucy Fischer, "The Eye for Magic: Maya and Méliès," in Bill Nichols and Maya Deren, *Maya Deren and the American avant-garde*, (Berkeley, CA: University of California Press, 2001), 186.

43　"Untitled," Maya Deren to James Card, April 19, 1955, in *Essential Deren: collected writings on film,* edited by Bruce R. McPherson (Kingston, NY: Docutext, 2005), 191. Note that Deren is not accurately describing the sequence: there are two shots near the ocean at the beginning rather than one, for a total of five matched shots.

44　Maya Deren, *An anagram of ideas on art, form and film,* reprinted as end matter in *Maya Deren and the American avant-garde*, Bill Nichols and Maya Deren (Berkeley, CA: University of California Press, 2001), 5, my emphasis.

45　Maya Deren in Renata Jackson, "The Modernist Poetics of Maya Deren," in Bill Nichols and Maya Deren, *Maya Deren and the American avant-garde* (Berkeley, CA: University of California Press, 2001), 49.

46　Ibid., 51.

47　Ibid., 51.

48　Andrey Tarkovsky and Kitty Hunter-Blair, *Sculpting in time: reflections on the cinema* (Austin: University of Texas Press, 1986),158.

49　Karen Pearlman, *Cutting rhythms: shaping the film edit* (New York: Focal, 2015), 47.

8 Rhythmic and Graphic Editing

An introductory text on film aesthetics argues that creative editing "offers the filmmaker four basic areas of choice and control:

1 graphic relations between shot A and shot B
2 rhythmic relations between shot A and shot B
3 spatial relations between shot A and shot B
4 temporal relations between shot A and shot B."[1]

These four areas are universally available in the editing process, regardless of the genre. An experimental film might be constructed graphically, so that the edits are chosen solely on whether there is, say for example, the form of a circle present in each outgoing and incoming frame. Or that same film might be structured overall as a temporal reversal, so that the edits are chosen based solely on whether the incoming shot occurred before the outgoing shot. At the same time, these areas of control rarely exist "in a vacuum" as distinct categories: as editors, we might consider how a cut alters the spatial relationship of two shots, but that does not mean that other relationships – say, the graphic or purely pictorial parameters of the two cease to exist. Often, the editor merely is choosing which of these four to privilege at the cut or in the sequence. As we have seen, this phenomenon is what Eisenstein refers to as the emergence of the "dominant" in a sequence, and in classical Hollywood, the dominant was clarity in spatial and temporal relations between shots. As we saw in Chapter 3, that demand for clarity diminished in the 1960s: Walter Murch's "Six Rules for the Ideal Cut" place those at the very bottom of his considerations for a cut after Emotion, Story, Rhythm and Eye-trace (or Eye-guiding) (See Chapter 3, p. 87.) Nevertheless, spatial and temporal concerns remain paramount in most editing decisions, a simple acknowledgement of the central aesthetic foundations of the medium. The noted art theorist Erwin Panofsky once described the unique potential of motion pictures as the *'dynamization of space'* and the *'spatialization of time'*.[2] In other words, inherent in the film medium is the ability to dynamically transport the viewer anywhere by a cut to another location, *and* the ability to depict the space before the camera over time (i.e., every shot necessarily reveals a sense of time inherent within it.)

Because continuity editing is the dominant style of editing in narrative filmmaking, we tend to forget that it is a creative *choice*. We have seen the influence of continuity editing throughout this book in establishing what is known as the "zero point of cinematic style," the "default mode" of editing. Continuity editing in the fiction film is a precise approach to *mise-en-scène* and cinematography that takes a series of discontinuous shots, and cloaks their discontinuity in a system of cutting that renders them "continuous." Michael Betancourt acknowledges the long-standing maxim that editing simply mirrors the process of sequential photography that creates motion pictures in the first place:

> The interruption of continuous motion that the edit inherently *is* results in a dramatic shift in space and perspective on the screen. Each image appears as an entire replacement of

what was onscreen previously. The relationship between individual shots emerges within the minds of the audience: every shot is singular, the degree of its disruption simply being *an exaggeration of the underlying sequential nature of images* in a motion picture. Where normally only small differences appear, resulting in motion, with sufficiently large differences the changes become a change of shots.[3]

The "transparency" of classical film editing organizes shots into a larger structure that keeps the spatial/temporal/causal relationships clear throughout the course of a film. The general "invisibility" of continuity editing is supported by research finding that viewers have difficulty recalling the particulars of a film's editing, and instead recall events in the film as one continuous progression.[4] In many ways, this centrality of continuity editing has shaped our examination of all the theories examined here: it is the foundation, the normative "field" against which other "figures," other approaches stand in relief.

The rules governing this style of editing are well codified, but more difficult to master than one might think: one need only watch amateur films to see the myriad ways in which the continuity system can be poorly executed. The system's main rules are well known: the 180° rule for shooting coverage, the 30° rule for moving the camera between takes and cutting on action to facilitate smooth transitions from shot to shot. Continuity editing is frequently "analytical" meaning it smoothly cycles from establishing shots – providing the audience with the locale, time of day, relative position of the characters – through a series of closer shots that use continuing graphic, index or motion vectors to keep the audience spatially oriented. Continuity editing often returns to the establishing shot to "reestablish" the larger space as a character crosses or exits, uses cutaways to cover mismatches in action, and relies on transitions like dissolves and fades to signal temporal relations between shots and scenes, etc. But it is important to notice that while spatial and temporal concerns often prevail in continuity editing, rhythmic and graphic concerns remain, albeit as considerations that are generally less dominant. For example, regardless of the spatial and temporal relations between shot A and shot B, they will not cut seamlessly if the internal rhythm (what Tarkovsky calls "time pressure") is mismatched in the two shots. Or if the basic graphic parameters of the two shots are mismatched – one of the shots is severely underexposed or mismatched in color balance – the cut cannot be seamless. (This, at the most basic level, is one meaning of the term "graphic match," though the term "color correction" is more commonly used to describe how mismatched shots are "smoothed" against each other.) So when editing that makes temporal and spatial coherence the accepted goal is the "zero point" of style, it is not surprising that editing styles that move beyond that stand out as exceptional for their creativity and their expressivity. They also tend to be fertile ground for analysis, since they often expose assumptions about how the continuity editing system works at large. With that in mind, we will shift focus in this chapter from spatial and temporal questions to understanding the rhythmic and graphic possibilities of editing, primarily as these potentials are used in narrative filmmaking.

Rhythmic Relations in Editing

Pacing was identified early on in the history of motion pictures as an element that distinguishes a good silent picture from a bad one. D.W. Griffith once wrote,

> [Pace] is a part of the pulse of life itself, and, being common to all human consciousness, its insistent beat has the curious power to seduce and sway the emotions, as the rhythmic tread of marching troops sways a suspended bridge. When the pace of a picture weds the pace of an audience, the results are astonishing.[5]

We identified three aspects of pace in the last chapter: "the rate of cutting, the rate of concentration of movement or change in shots and sequences, and the rate of movement or events over the course of the whole film."[6] In this chapter, we will focus on the first two, rather than the latter – analyzing the pace of entire feature films – and our purpose will be to understand some of the basic aspects of filmic rhythm and graphic relations in narrative films. Two caveats are worth noting here. The film theorist Jacques Aumont notes that the ear, not the eye, is our most accurate sense organ for determining rhythm. Unlike the perception of musical rhythm to which the ear is very precisely tuned, the eye is not adept at perceiving duration, so Aumont argues that rhythm in film is a combination of temporal *and* plastic rhythm, which are quite distinct.[7] Plastic rhythm is characteristic of visual arts where repeated objects or shapes recur in a regular arrangement. We will examine some film scenes that foreground plastic rhythm below. And while the limitations of the visual system in determining duration may be significant, Karen Pearlman argues that we have intuitive access to rhythm:

> I propose an editor learns where and when to cut to make a rhythm from two sources: one is the rhythms of the world that are experienced by an editor, and the other is the rhythms of the body that experiences them . . . The universe is rhythmic at a physical, material level. Seasons, tides, days, months, years and the movement of the stars are all examples of universal rhythms, and our survival depends on us oscillating with these rhythms and functioning as part of the rhythmic environment. Waking/sleeping, eating/digesting, working/resting and inhaling/exhaling are just some of living beings' ways of following the rhythms of the world.[8]

Pearlman goes on to say that editors use their innate "kinesthetic empathy" or "corporeal imagination" to *read* the rhythm in rushes, and their own bodies to *write* filmic rhythm, in the same way that a musician's body participates in the transmission of musical rhythm, "the rhythm of the material passes through the rhythms of the editor on the way to being formed."[9] "Reading" the rhythm of a shot we are intuitively deciphering *internal rhythm*; "writing" the rhythm of the edit by cutting, we are creating the external rhythm of a sequence, a scene, an entire film.

Early on, the French critic Léon Moussinac distinguished between diegetic elements that control rhythm and those created by the timing of the cuts, and the concept was expanded upon by the theorist Jean Mitry who first coined the terms internal rhythm and external rhythm.[10] Mitry was a French film theorist and filmmaker who co-founded France's first film society in 1925. A significant figure in the development of French cinema, Mitry directed and edited cutting edge films like *Le Rideau Cramoisi* (Astruc, 1953) and his own *Pacific 231* in 1949. Mitry was highly influential as a film historian and film theorist, publishing his seminal *The aesthetics and psychology of cinema*, an extensive two-volume work in 1963 that systematically examined forms and structures that had been previously identified and debated by other theorists. Dudley Andrew points out that of all the classical film theorists only Eisenstein exceeds Mitry "in time and energy spent in editing rooms."[11] As a film practitioner, theorist, and historian, Mitry became a member of the inaugural faculty of L'Institut des hautes études cinématographiques, the national French film school when it opened in 1945 and later taught film studies at the University of Montreal.

Mitry endorses the notion that *rhythm*, or "perceived periodicity," is tied to the two psychophysiological cadences of life – our heart-beat and our breathing – that establish:

- the concept of musical measure – the normal resting human heartbeat is 80 beats per minute
- the concept of "fast versus slow rhythm" – one faster or slower than normal resting heartbeat
- the rhythmic concepts of "tension, release, and rest" – the rhythmic pattern of breathing.[12]

Mitry says that only music can create *pure rhythm*, a system of strong and weak melodic or harmonic beats, while rhythm in literature, employing words, is less pure but attainable. For

example, poetry creates a pattern of stresses on words within lines and measures of verse based on a preexisting pattern imposed by the form, as in this famous poem by Henry Wadsworth Longfellow:

> Tell me not, in mournful numbers,
> Life is but an empty dream!
> For the soul is dead that slumbers,
> And things are not what they seem.

Film rhythm, however, is more like *rhythmic prose.* Mitry argues film rhythm is linear, "It is the rhythm of narrative, whose continuous flow never repeats itself . . . it is the free and 'continuous' rhythm of *rhythmic prose*, never imposing a metric system on its cyclical forms but rather allowing its own requirements to dictate its terms of reference."[13] In contrast to the poetry above, consider the rhythm of prose in this line from the opening of Salman Rushdie's *The Satanic Verses*, in which the character Gibreel is thrown from an exploding plane,

> Gibreel, the tuneless soloist, had been cavorting in moonlight as he sang his impromptu gazal, swimming in air, butterfly-stroke, bunching himself into a ball, spreadeagling himself against the almost-infinity of the almost-dawn, adopting heraldic postures, rampant, couchant, pitting levity against gravity.[14]

In this instance, there is not an external, abstract form determining how the rhythm of the passage unfolds, but rather an unfolding rhythm continuously moving through the text. Given that film automatically captures time unfolding in a certain space, the existence of film rhythm seems indisputable: Mitry notes that there are film genres that "quite consciously involve the use of a specific rhythm. Clearly, a psychological film does not have the same rhythm as, say, an epic; it would be foolish to think otherwise."[15] Moreover, narrative filmic rhythm is "not produced, as in music, by rhythmic *form* but by events being followed through in the sequence. It is time experienced by characters objectively presented to us, not a sequence of time formulated and conditioned by pure rhythm."[16] The shots themselves, Theo Van Leeuwen notes, provide potential cutting points: "[F]ilm editors [do not] impose their rhythm on images, the images and sounds impose their rhythms on the editors, restrict them as to where and how the film can be cut."[17]

Mitry points out that editors of narrative film are generally trying to determine the "life of the shot," to use a familiar term. He says their aim is to create shot durations

> proportional to the interest and signification of the content. It is this interest and it alone which can and must determine the shot-relationships, calculated in terms of the impression of duration which they produce and not by virtue of the metric length . . . [I]t is only a posteriori, i.e., at the editing-stage with the image on the editing-bench, that we can judge it at all accurately . . . In other words, film rhythm is never an abstract structure controlled by formal laws or principles applicable to all kinds of film but, on the contrary, a structure rigorously determined by the content.[18]

With Mitry in mind, we will use the term *internal rhythm* to mean "the rate of concentration of movement or change in a shot," a term that encompasses character movement as well as any aspect of *mise-en-scène* that contributes to the perception of that change. Under that expansive term, we can also apply Herbert Zettl's nomenclature describing timing and principal motions on the screen for greater precision. Describing event motion relative to the camera, Zettl uses the term *primary motion* that "always occurs in front of the camera, such as the movement of performers,

cars, or a cat escaping a dog."[19] Zettl defines *secondary motion* as "camera motion, such as the pan, tilt, pedestal, boom, dolly, truck, and arc. Secondary motion includes the zoom, although only the lens elements, rather than the camera itself, move; aesthetically, we nevertheless perceive the zoom as camera induced motion."[20] Zettl argues that a director's first concern should be with primary motion and camera placement that is best placed to capture that natural flow. Zettl points out that camera movement is independent from whatever action is happening in front of the camera and therefore, if used incorrectly, can bring attention to itself, rather than reinforce the intended effect of a sequence. "Nevertheless, secondary motion fulfills several important functions: to follow action, to reveal action, to reveal landscape, to relate events, and to induce action."[21]

We will use Herbert Zettl's term *tertiary motion* as the equivalent to *external rhythm*. External rhythm is sequence motion or dynamism, "the movement and the rhythm induced by shot changes by using a cut, dissolve, fade, wipe, or any other transition device to switch from one shot to shot."[22] Zettl acknowledges that external rhythm of a sequence is primarily determined by the simple rate of cutting within a sequence, how slowly or quickly the cuts follow one another. But what he wants us to recognize is that, at the most abstract level, the change from one vector field to another vector field as the shot changes has its own visual energy, an energy that can be different depending on whether the change is a cut, a dissolve, a wipe or a fade. Given this fact, "Transition devices *and* the length of shots determine the basic beat and contribute to the rhythm of the sequences and the overall pace of the show."[23] We will examine this idea further below.

Music: Internal or External Rhythm?

Finally, there is often some debate about how to classify sound elements under this scheme. Should music used to drive the cutting rhythm of a scene be classified as internal or an external element of rhythm? A simple resolution is to let the answer hinge on whether the sound element is *diegetic or non-diegetic*: that is, whether the sound source emanates (or appears to emanate) from the story space or whether it is "outside the story space." For example, if a piano is being played in a scene, and it is part of establishing the rhythm of a scene, it is an element of internal rhythm, while a musical theme is added to a scene in postproduction is an element of external rhythm.

And here we should pause to note the obvious: the range of aesthetic factors driving the rhythm of a single shot change – much less of a sequence – is *vast*. For the editor – and for our analysis here – it is often difficult to isolate what the determining factor for a rhythmic cut is, as that factor is part of a complex of aesthetic factors in each shot. Or as Van Leeuwen describes the process from the editor's perspective, "As there may be (and usually is) more than one profilmic rhythm, editors are faced with the problem of synchronizing the various profilmic rhythms – at least insofar as these have not been recorded simultaneously [i.e., if the shots are captured sequentially rather than with multiple cameras] and synchronously [i.e., if, for example, the dialog is looped], or been postsynchronized, as music often is. To do so, the editor chooses one of the profilmic rhythms, as an *initiating rhythm* and subordinates to this rhythm the other profilmic rhythms."[24] In short, when we analyze film rhythm here, we will simplify. But thinking through the myriad aesthetic forces that are at work within "filmic rhythm" will help you as an editor: you should emerge with some sense of the range of factors involved and with some tools to evaluate how rhythm is brought to bear in editing.

External Rhythm: Cutting Rhythm and the Decrease in Average Shot Length

We have already seen the leisurely external rhythm that results when a filmmaker relies on the long take championed by André Bazin in Chapter 6, and when Andrei Tarkovsky makes the "time pressure" of a shot the pivotal factor controlling overall rhythm in Chapter 7. On the other end of the "cutting spectrum," we have seen how the new Hollywood style

identified by Bordwell as *intensified continuity* results in faster cutting in Chapter 4. The average shot length for a Hollywood feature film was between :08 and :11 seconds in the 1930s, and five decades later, that number had dropped to between :05 and :08 seconds in the 1980s. Looking at a film like *Almost Famous* (Crowe, 2000) with an average shot length of just 3.9 seconds, David Bordwell argues that faster dialogue scenes must be responsible for the shorter shot length and that "Today's editors tend to cut at every line, sometimes in the middle of a line, and they insert more reaction shots than we would find in movies from the classic studio years."[25]

That may account for the accelerated cutting of the romantic comedy genre, but some of the acceleration in average shot lengths can also be attributed to covering the sheer progression of physical movement that unfolds in action movies. These films use extremely short shot durations to increase audience impact, while trying to maintain a level of narrative clarity, or clarity of action. When covering action, Dziga Vertov's concept of documentary editing may be the most apt: "To edit: to wrest, through the camera, whatever is most typical, most useful from life; to organize the film pieces wrested from life into a meaningful rhythmic visual order, a meaningful visual phrase, an essence of 'I see.'"[26]

In cutting an action scene, the question for the editor often is what will give the audience that essence of "I see"? In this regard, Karen Pearlman talks about three kinds of "movement" that unfold across any scene. First, there is *physical movement* in a scene – the editor focuses on actor movement, its arc, its acceleration, its velocity, its flux, etc. – by which the viewer experiences "kinesthetic empathy" (what Eisenstein termed the "motor imitative response"). Secondly, there is *emotional movement* in a scene where an editor might focus less on physical movement than on emphasizing the "dance of emotions" across a scene. (Pearlman admits that is a subtle difference, since emotion will often emerge from a movement pattern.) Finally, there is the *movement of events* across a scene, which includes things like the revelation of new information (significant or insignificant), the change of a direction in the pursuit of a goal, the reversal of a character's objective, etc.[27]

To thrill audiences with the sheer kinesis that escapist films offer, action scenes staging a race, a fight, a rescue, a chase, etc., often focus on the first factor: physical movement. The editor works to enhance internal rhythm of the action covered in the source footage through fast paced, non-stop cutting. The dystopian action-thriller-chase *Mad Max: Fury Road* (Miller, 2015), a film that brought the director's wife Margaret Sixel the Oscar for Best Editing in 2016, provides a wealth of examples of editing for physical action. Miller wanted the film to be comprehensible without dialogue, saying

> Hitchcock had one of my favorite sayings about cinema: he said, "I want to make movies where they don't have to read the subtitles in Japan." And these chase films are like that. You want to be able to have clear syntax and for people to be able to read the film as if it were a silent movie."[28]

Fury Road was extensively storyboarded to facilitate the roughly 2,700 cuts in the film. The cutting rhythm of the film is very fast. The Cinemetrics website tallied the first half hour of the film at 665 shots at an average shot length of 2.6, and a mean shot length of 1.7 seconds.[29] John Searle, ASC, the cinematographer for the film, said that Miller, knowing the cutting would be fast, was adamant that the center of interest for every shot be placed in the center of the screen, so that

> your eye won't have to shift on an anamorphic frame, won't have to shift to find the next subject when you've got 1.8 seconds of time to do that . . . All we would hear all the time was George saying "Put the cross hairs on her [Charlize Theron's] nose" . . . The camera had to be in the center. He was very disciplined that way. Everything had to be in the center.[30]

Halfway through the film, Imperator Furiosa (Charlize Theron) negotiates with a biker gang, offering gasoline for safe passage through a canyon. See Critical Commons, "External Rhythm: Mad Max Fury Road, Quick Cuts."[31] The bikers believe her to be alone, but one of the women in Furiosa's party, hiding in the gasoline tanker, begins to moan because she is in labor. Sensing that the standoff is about to go downhill, Furiosa leaps in to action to escape the canyon. This scene continues for sometime, but for the sake of brevity, we will look at the first :30 seconds of this sequence. It contains 27 shots, and the longest shot – at 54 frames or 2.25 seconds – is a wide shot of a single motorcyclist charging down the hill to attack the tanker. The shortest shots are both seven frames in length – a duration of roughly 1/3 of a second. One of these shots shows the motorcyclist sliding from frame left under the tanker and the other shows Furiosa looking down at her feet dangling through a hole in the tanker floor, after that same motorcyclist has grabbed her legs (though he's not visible in this shot.) The average shot length here is thus 26 frames, or slightly over one second.

The first shot of action shows Furiosa diving over the trailer hitch, and the next shot continues that action as she rolls onto the ground on the other side of the trailer. The match is smooth, carried in part by the attack in the soundtrack of machine gun fire, which begins in the outgoing shot but syncs to her roll into the incoming shot with three bullet hits that kick up small clouds of dust. Centering in both shots is clear as she dives (outgoing) and particularly as the dust clouds erupt kinetically (incoming) precisely on the spot that she hits as she rolls. As she stops and turns to scramble aboard the tanker, which begins to roll out of the canyon, the action of the truck begins to dominate the primary motion vector: this is the first of a series of three shots moving left to right, that will be followed by a z-axis neutral close up of Max Rockatansky (Tom Hardy) driving the truck away. A high angle long shot from the other side of the canyon reverses the screen direction. From this point forward, with the tanker at the bottom of the canyon, and gunfire and motorcycles harassing "The War Rig" tanker from both sides, screen direction will shift quickly (yet appropriately) with an occasional neutral shot to soften the shifts. At durations of roughly :01 second, these reversals hardly "read" as screen direction reversals. And even at that extreme pace, the continuity cutting of the physical action is well matched and flows naturally throughout.

Once the motorcyclist has grabbed her legs, seen from under the truck, six neutral, z-axis shots follow, either from inside or from under the long tanker. The cutting here is quick and covers Furiosa's struggle to kick free of the biker (Figure 8.1). The shot transitions from interior to exterior are very clean, because the primary motion vector is z-axis, and the action centered. The shots show Furiosa's shock at being grabbed and then three kicks that break her free: one from inside the tanker, the next from the front undercarriage and the last from the rear undercarriage that show the motorcyclist sliding into the camera. This last moment of the biker rolling into the camera cuts seamlessly with the final shot – 22 frames long – that shows the fate of the motorcyclist, crushed under the armored wheels of the tanker. This explosive montage of struggle and death is the essence of action cutting: a clear string of six "cause-and-effect" shots in seven seconds that end "punctuated" with an easily readable moment of finality. While the pace of the cutting rhythm is blazing, Miller's focus never leaves continuity of action.

And yet, fast cutting need not converge on the continuity of physical action. The climatic fight scene between Sugar Ray Robinson (Johnny Barnes) and Jake LaMotta (Robert DeNiro) in *Raging Bull* (Scorsese, 1980) uses quick cutting to synthesize the brutality of boxing with little regard for continuity. The scene was meticulously shot and edited using the collision montage techniques pioneered by Eisenstein. Longtime collaborator Thelma Schoonmaker won the Oscar for Best Editing on the film, a task that took six months rather than the seven weeks that was scheduled. Schoonmaker credits the preproduction of director Scorsese for her award: "I felt that *my* award was *his* because I know that I won it for the fight sequences, and the fight sequences are as brilliant as they are because of the way Marty thought them out.

Figure 8.1 Rapid cutting for physical movement in Mad Max: Fury Road *(Miller, 2015)*. This dystopian chase film has an average shot length of 2.1 seconds. In order to make the rapid editing in the film comprehensible, Miller insisted that the primary action be consistently centered in the frame, as in this shot of Furiosa (Charlize Theron).

Source: Copyright 2015 Warner Bros. Pictures.

I helped him put it together, but it was not my editing skills that made the film look so good."[32] Todd Berliner argues that the film, shot by cinematographer Michael Chapman, was "grueling to plan, shoot, and edit, partly because it violates the logic of Hollywood's filming and editing conventions which offer filmmakers a ready-made, time-tested blueprint for keeping spatial relations coherent, for comfortably orienting spectators, and for maintaining a consistent flow of narrative information . . . *Raging Bull* offers an aesthetically exciting alternative to Hollywood's narrative efficiency and visual coherence."[33] Berliner points to Scorsese's application of Eisenstein's collision montage in some of the violent boxing scenes to underscore not just the *physical movement* of the scene, but Jake LaMotta's *subjective experience* of that brutality. Continuity takes a back seat to the emotional/intellectual effect created by editing for visual/kinetic conflict. Scorsese creates the experience of Jake's whipping through collision editing, beyond what would be possible with conventional continuity that covers the scene's physical movement.

As LaMotta's life is crumbling around him, he takes on Robinson on February 14, 1951, in a legendary battle that was later known as "The St. Valentine's Day Massacre." The scene opens in the final, savage 13th round, and after a minute, the two challengers face each other exhausted, with LaMotta on the ropes taunting Sugar Ray to continue. Internal and external rhythms slow as the scene cuts to Robinson, centered in the arena lights, breathing heavily. Scorsese uses a *dolly zoom* – a dolly back as the camera zooms in – coupled with a fade to near silence in the soundtrack to temporarily arrest the progression of "clock time," to move the emotional tone of the moment into the uninterrupted flux of slowed, subjective time, a shift marked by a shot nearly :12 seconds in duration. The caesura continues in the reverse shot: a slow motion, push in of almost :09 seconds with LaMotta still on the ropes, standing almost dazed, as smoke swirls behind him. He appears almost Christ-like, seeming to accept the punishment that must come.

In the next shot – :02 seconds, 13 frames long – internal and external rhythm begin to accelerate. The soundtrack goes from eerie silence to a deafening roar, as Robinson, and the "sound space" around him advances to thrash LaMotta. Robinson moves forward to strike as the camera zooms in on his taut face, centering his predatory eyes, while his fists remain oddly quiet by his side. A punishing upper cut is shown in the next close up – technically, mismatched continuity

– but a satisfying "energy release" that fulfills Sugar Ray's forward, aggressive surge in the outgoing shot. From this point forward, Berliner notes, creating the subjective experience of LaMotta through collision montage dominates over continuity concerns, as mismatched action, jump cuts and nine violations of the 180° rule are obviated by the speed and intensity of colliding shots:

> Scorsese packs into twenty-six seconds of screen time a sequence of thirty-five discordant shots that break fundamental rules of continuity editing in order to convey a subjective impression of La Motta's [sic] brutal experience in the ring. As Robinson pummels La Motta, who is too tired even to defend himself, shots of the challenger's punches combine in a barrage of inconsistent images . . . As the sequence progresses from shot to shot, the camera angles and framing do not follow customary editing patterns. Indeed, the combination of shots seems almost random.[34]

There are seldom slight changes in angle on the physical action; rather, the shots change dramatically from one side of LaMotta to the other side (Figure 8.2), from high to low angle placements, moving erratically to close ups of disparate material. See Critical Commons, "External Rhythm: *Raging Bull*, Quick Cuts, Collision Montage."[35] Berliner focuses on seven shots in the sequence to demonstrate just how far Scorsese goes to make the fight montage collide:

> Shot one: Low-angle extreme close-up of the front of Robinson's face. [22 frames]
> Shot two: High-angle shot of La Motta's head and his left arm on the ropes. [25 frames]
> Shot three: Close-up tracking down from La Motta's trunks to his bloody legs. [25 frames]
> Shot four: Close-up of La Motta's face being punched. [18 frames]
> Shot five: Extreme low-angle shot of Robinson's face. [9 frames]
> Shot six: Extreme close-up of the left [sic] side of La Motta's face, slightly low-angle, as a glove hits his head. [23 frames]
> Shot seven: Bird's-eye shot of Robinson's head and face. [27 frames][36]

Figure 8.2 Rapid cutting for the collision montage in Raging Bull *(Scorsese, 1980).* Collision montage – editing for visual/kinetic conflict – is used by Scorsese not primarily to show the physical movement in this scene, but Jake LaMotta's (Robert DeNiro) subjective experience of that brutality.

Source: Copyright 1980 United Artists.

All of the conflict emerging from the juxtaposition of these close ups is augmented by irregular bursts of "flashbulbs from the press cameramen", bright illumination that sometimes blows the exposure of the entire frame to a white flash. The flashing increases the internal rhythm of the scene through the irregular pulse it creates, while the cutting rhythm is very fast – the longest shot is 27 frames and the shortest is 9 frames, with an average shot length of just 21 frames. Berliner concludes that, unlike Eisenstein's use of collision montage,[37] which builds visual metaphors through the non-diegetic insert (i.e., Kerensky + peacock = Kerensky is vain), *Raging Bull* remains in the extant space of the boxing ring, using agitated editing to convey LaMotta's inner experience of violence. This places the scene more in the company of non-traditional representations of the subjective experience of violence like the shower scene from *Psycho* (Alfred Hitchcock, 1960) than Eisenstein's efforts to "seize the spectator" with an edit that signifies a larger meaning.

Factors that Control Internal Rhythm

As we said earlier, internal rhythm is controlled by elements within the shot, mainly the movement of objects and people (primary motion). While any aspect of the *mise-en-scène* – not merely sets, props, costumes, but also camera or lens movement (secondary motion) and other elements like focal length, camera placement, and lighting – can make significant contributions to internal rhythm, we will begin by looking at primary motion, the movements of objects and people, movements that can be further classified by their tempo direction and pattern of the movement on the screen.[38] To understand how primary motion controls internal rhythm, we can begin by looking at a scene from *Citizen Kane* that has very little cutting: the scene where Kane demolishes Susan's bedroom after she leaves Xanadu. This scene demonstrates the importance of tempo. See Critical

Figure 8.3 Internal rhythm: character movement in Citizen Kane *(Welles, 1941).* With little cutting, this two-minute scene shows the ability of Orson Welles to control its internal rhythm through character movement by regulating his anger in a meaningful trajectory.

Source: Copyright 1941 RKO Radio Pictures.

Commons, "*Citizen Kane*: Internal Rhythm, Movement of People and Objects and Composition (Repeated Forms)."[39]

Internal Rhythm: Tempo of the Action

Kane stands in the doorway of the Susan's bedroom and, and as she leaves, he is clearly over-come with emotion, and turns back into the bedroom. The room is quiet. Kane walks stiffly to the bed and fumbles to place some of the clothes Susan has left behind into a suitcase. His anger is evident as he grapples with the latch. He turns abruptly and throws the suitcase (Figure 8.3). His blood begins to boil. The camera remains low and wide to show his full figure as he throws another suitcase and pulls the bedspread to the floor. The camera cuts closer as he proceeds to destroy the room in earnest, the sound level rising as he rips a bed canopy from the wall, and moves deeper into the room to smash a lamp with the sweep of one arm. From this point, Kane's movements become more erratic, and the level and tempo of the soundtrack increase, growing denser and more chaotic. Welles holds his upper body in check, creating a contrast between the awkward, stiff movements of the elder Kane, and the expanding destruction around him. As Kane staggers through the wreckage of the room, tossing over a dresser and a chair, a match cut to a low angle shot brings the action close, and Kane looms in the foreground. He wrenches a small shelf of bric-a-brac from the wall and tosses it aside as his focus turns elsewhere. The pace is rising as he attacks another shelf, and the soundtrack is fierce with the clatter of books hitting the ground. He finds a bottle in his hand, and pauses to glance at it. He hurls it against the far wall, the singular crash marking a momentary pause. Kane lurches for a mirror and rips it from the wall. Fatigued, he stumbles against an overturned chair and circles back towards the camera, gasping for breath.

Now the pace is slowing, and the soundtrack returning to normal levels, as Kane comes close to the camera. He sends a final group of perfume bottles crashing to the ground, and pulls up short in a tight framing that shows only his hands and the bottom of his suit jacket. There is a moment of pause and dead silence. The camera tilts slightly as Kane carefully picks up a glass globe and moves towards the door, brushing an overturned nightstand out of his way. His outburst concluded, there is a welcome caesura: Kane pauses and looks down at the globe, and the film cuts to a close up of the snow filled globe seen at the beginning of the film and later on Susan's dresser in the "love nest." "Rosebud," he whispers, and the camera tilts up to reveal the broken Kane staring into the middle distance, his eyes glistening with tears. To recap, the internal rhythm to this point has chaotic forward propulsion that steadily builds across most of the scene, broken only by moments of Kane staggering to the next section of the room he is intent on destroying. Once his anger is spent, however, the rapid deceleration in his pace is punctuated by only a few destructive bursts that tail off in to silence and this single word of dialogue.

From the point that Kane turns to destroy the room, the action plays out in four wide shots that run :46 seconds, :19 seconds; :07 seconds and :45 seconds. As an example of pacing controlled by character action, this two-minute scene shows the remarkable ability of Orson Welles to regulate the "time pressure" of his anger in a meaningful trajectory. The scene concludes as a slow dirge that brings Kane out of the bedroom into the halls of Xanadu. His household staff stand by silently, their inertia marking their emotional distance from him. Kane presses forward down the hall, condemned to loneliness, the figure of a "dead man walking." As he passes an arched hall of mirrors, the stiff, "mechanical trance" of his broken walk is the primary motion controlling internal rhythm. But repeated in an infinity of mirrors, the multiplication of this action adds its own *plastic rhythm* to conclude the scene. We will address other examples of plastic or compositional rhythm later in this chapter (see p. 290 below).

Internal Rhythm: Pattern of Movement and Lens Usage

Another key parameter for the control of internal rhythm is the pattern of movement within the frame. As we noted in Chapter 1, Arnheim described the motion picture as something between two-dimensional and three-dimensional, a medium which has "simultaneously the effect of an actual happening and of a picture."[40] When we look at "pattern of movement" as a part of a scene's internal rhythm, we try to focus on how action and composition produce the "pictureness" or two-dimensional composition in a frame. Again, this is "plastic rhythm" resulting "from the organization of the frame's surface content or its division in terms of lighting intensities, colors, or any other compositional factors. Such plasticity in the image follows from classic issues dealt with by such theorists of twentieth-century painting as Paul Klee and Wassily Kandinsky."[41] Like any complex phenomenon, "pattern of movement" in a film is hard to describe in words, not only because words like "flowing" or "balanced" or "staggered" or "chaotic" are broad terms, but also because in every shot, other factors interact to facilitate the pattern, notably lens usage, camera placement, lighting and color. Concrete examples here will illustrate how a pattern of movement influences internal rhythm, and the comparison of two scenes of men marching from the work of Stanley Kubrick will be our starting point.

See Critical Commons, "Internal Rhythm: Barry Lyndon, Pattern of Movement, Marching Comparison."[42]

In *Barry Lyndon* (Kubrick, 1975), one of the early scenes of the film shows a British army company led by John Quin (Leonard Rossiter) parading for the people of Bradytown in Ireland, as they prepare for war against French invaders. The scene opens with a classically composed wide shot of the company standing to attention in a field with no real sense of the surrounding space: in this instance, the men are arranged as a long, flat, red "graphic area" that fills the lower third of the frame. They face head on to the camera as two flags flap in the breeze, the composition flattened by the use of a long lens. As Captain Quin orders the company to forward march, the fife and drum corps begins to play "The British Grenadiers." The lines of men are straight and their bayonetted muskets are all properly aligned, and their marching is precisely coordinated. They all start off in unison on their left foot, standard procedure that is initiated after the preparatory command "Company . . . " and the command of execution, "Forward march!"

A slow zoom out – :20 seconds of a :47 second long shot – accompanies their march forward revealing the assembled townspeople in the foreground, and fields in the middle ground and a mountain in the distance. The soldiers are now considerably smaller in the frame as the camera zooms out, but they continue as a single unit, marching towards the camera in tight formation. With aerial perspective from the haze in the valley flattening the composition, the scene ends as a stable, balanced, symmetrical arrangement, the internal rhythm of the marching slowed since the formation occupies a smaller portion of the frame. In this shot, the zoom is useful as a device to literally "open the scene" and reveal the townspeople present. Zoom outs are a common aesthetic device in *Barry Lyndon*: 36 appear in the film, including six of the first eleven scenes in the film that each begin with a long zoom out.[43] In addition, this is the first of a number of marching scenes that will appear in the film. The stable primary motion created by the march itself, augmented by the slow zoom out, and the balanced composition that ends the shot, gives a feeling of quaint patriotism, particularly in comparison to some of the later marching scenes where the soldiers calmly advance into withering, deadly fire from the enemy. Overall, the opening rhythm here is lively and stable.

Later in the scene, the company marches right to left across the screen in perfect formation, with the camera trailing behind them in a slight pan to the right. The closer placement and horizontal movement in the frame is more dynamic, but controlled and even, still following the cadence of the original shot. Two closer shots introduce Quin, and show Barry (Ryan O'Neal) looking on enviously with his cousin Nora (Gay Hamilton). The scene closes as it opened, with

a return to the opening wide shot as the soldiers raise their muskets and fire a salute, startling the crowd and their horses. The regularity and bright energy of this marching scene will stand in contrast to ones that come later.

Thinking that he has killed Captain Quin in a duel, Barry escapes to join the army. He fights in battle, and ultimately deserts the British army by stealing a courier's uniform and horse. Barry is exposed as a fraud and forced to join the Prussian army. Later in the film, a four-shot sequence shows the dissipation of the Prussian army at the end of the Seven Years' War, and links that decline to the moral fall of the protagonist. The internal rhythm established in this scene is more rambling and loose, and the lens usage here plays a more important role in flattening the movements of the army into a visual pattern covering the screen (Figure 8.4).

The sequence uses foot soldiers that are staged marching carelessly towards the camera in three telephoto shots and one wide-angle shot. In the first shot, Barry is centered in an uncoordinated platoon of soldiers who loosely march towards the camera. The action is staged with Barry centered in the bottom third of the frame, the platoon walking roughly in time with the march of a fife and drum corps that accompanies the scene. The soldiers move down a slightly sloped field, and the telephoto lens used flattens the perspective of the shot so that the army is spread across the frame, with a few rows in the back in slightly soft focus. The lines are ragged and irregular. The soldiers do not coordinate the alternate hand forward as they step. Their muskets are held at a variety of angles, particularly Barry's which is sloping towards his right shoulder, making it one of the more visibly "out of formation."

The fife and drum song continues, and in a second wide shot, the musicians lead the platoon as it snakes down a hillside. Here, their movement is no longer directly along the z-axis towards the camera, but rather, off axis, so that the platoon is seen almost like a river of men flowing down the hill, with a camera placed "on the river bank". Given that the shot is wide, the platoon's

Figure 8.4 Internal rhythm: pattern of movement and lens usage in Barry Lyndon *(1975).* A shot's "pattern of movement" can control internal rhythm by arranging the two-dimensional composition in a frame. The pattern established in this scene is rambling and loose. The telephoto lens usage here plays an important role in flattening the movements of the army into a visual pattern covering the screen.

movements are no longer "spread" across the screen. Consequently, the effect is as if they are moving in a formation that is tighter than the previous shot.

The third shot returns to a long lens with the action directly towards the camera, but this time the framing is wider than the first shot. The wider scope reveals roughly 10 rows of soldiers marching, their lines extending deep towards the horizon. Here, two flapping flags and an officer who leads on his horse breaks the offhand formation of the lines while overlapping rows of soldiers fill the spaces in between. With the flattened perspective of the lens, the mass of men fills the frame and seems to oscillate forward at a pace that loosely follows the drum corps. The scene closes with a telephoto shot that singles out Barry using selective focus, as the ragged procession continues to shamble towards the camera. Here again, the telephoto lens slows the primary motion of the shot since its inherent aesthetic retards z-axis motion towards (or away from) the camera. The disorder of this scene visually encapsulates how the war has worn down and commandeered the lives of the impoverished Prussian soldiers, particularly in comparison to the polished, but untested, vigor of Quin's regiment seen earlier. Pattern of movement and internal rhythm make the comparison clear.

Another exceptional example of the telephoto lens effect on internal rhythm is found in an airport scene in *Tinker Tailor Soldier Spy* (Alfredson, 2011). See Critical Commons, "Internal Rhythm: *Tinker Tailor Soldier Spy*, Telephoto Lens Slows Motion Towards the Camera."[44] A retired British intelligence officer George Smiley (Gary Oldman) is trying to get Toby Esterhase (David Dencik) to reveal the location of a safe house where Soviet spies are meeting with a British agent. Smiley threatens to send Esterhase back to Hungary, where he would be treated as a traitor. At the airport, Esterhase and Smiley are talking on the tarmac, when suddenly in the distance a plane drops into the frame and lands on the runway behind them. The plane represents an immediate threat to Esterhase, and as the plane taxies forward, he tries to explain his way out of being sent back.

The approach of the plane is acutely slowed and the space of the runway "flattened" so much so that it almost appears as if they are standing in front of a digital projection of a plane. Esterhase is unnerved by the plane's approach, whose arrested movement seems ominous and dream-like (Figure 8.5). This visual "spell" is broken at the end of the shot as the plane finally pulls close enough to come into focus, turns slightly and brakes while killing its engines. Smiley's dialogue punctuates that moment in rhythm by finishing Esterhase's thought: "Operation Witchcraft. Yes, I know," and the shot ends with a cut to the next shot. Esterhase pleads for his freedom, but ultimately gives up the address of the safe house. The scene was reportedly shot with an extremely long, 2000mm lens.

One final example will illustrate how patterns of movement and lens usage can work together to control internal rhythm. In *Aguirre: Wrath of God* (Herzog, 1972), the Spanish soldier Lope de Aguirre (Klaus Kinski) leads a group of conquistadors down the Amazon River in a mad search for the legendary city of gold, El Dorado. After enduring months of treacherous slogging through the jungle with European armor, guns and canons wholly unfit for the jungle, the decimated party builds a raft to float down the Amazon. By the end of the film, all of the party except Aguirre has died from starvation, disease or from the arrows that constantly strike them from unseen natives on the banks. See Critical Commons, "Internal Rhythm: Aguirre, Character Movement, Wide Angle Lens."[45]

The sequence opens as Aguirre cradles his daughter, killed by an arrow. He surveys what is left of the raft, now overrun by monkeys. In a voice over peppered throughout the scene, Aguirre's metal illness and megalomania is fully revealed. His raft is slowly sinking, but he is thinking grandiose thoughts that he narrates intermittently across the entire scene:

> When we reach the sea, we'll build a bigger ship, and sail north in it to take Trinidad from the Spanish crown. Then we'll sail on and take Mexico away from Cortés. What great treachery

Figure 8.5 Internal rhythm: telephoto lens in Tinker Tailor Soldier Spy *(Alfredson, 2011).* In this shot, the internal rhythm of the primary motion – the plane approaching down the runway – is slowed by an extremely long telephoto lens.

Source: Copyright 2011 Focus Features.

that will be! Then we shall control all of New Spain and will produce history as others produce plays. I, the Wrath of God, will marry my own daughter, and with her I'll found the purest dynasty the earth has ever seen.

Throughout, the wide angle lens is used for practical reasons – it is easier to maintain focus and framing when hand-holding a camera – as well as aesthetic ones – its great depth of field and distorted perspective allow Herzog to push in unnervingly close to Kinski, whose unstable stance and piercing gaze carry the authentic look of insanity (Figure 8.6).

A number of shots in this sequence are particularly telling of Aguirre's lunacy. As he stands defiant in the center of the raft, a handheld, wide angle shot pushes so close to his face that the *proxemics* of the shot become intimate, uncomfortably close, and time seems to slow as the shot holds for :15 seconds. Proxemics in film refers to the effects of spatial relations between camera and subject on the kinetic and emotional impact of a scene.

As the camera sways slightly with the rocking of the raft, Kinski stands upright and intractable, the intensity of his madness written in his eyes. (Apropos Murch's blink theory, notice that Kinski does not blink in this shot.) Here, character movement is absolutely minimal, so the camera's instability and wide lens' power to slightly distort his face and maintain close focus amplify what little primary motion is present to an acute level: there is an energy present in Aguirre that projects into the space. Interviewed once about *The Great Ecstasy of Woodcarver Steiner* (Herzog, 1974) Herzog commented on his use of the handheld camera versus the tripod:

> I want the camera to breathe and be physically present . . . A tripod always corresponds to an inhuman position, it's fixed . . . So the camera should always be steady *as if it were on a tripod*, and yet the cameraman actually moves closer to the subject . . . It's another kind of internal involvement, another form of access.[46]

A second shot that exemplifies internal rhythm well is a: 53-second wide shot in which Aguirre walks in his armor, helmet, sword and leather boots across the sinking raft. The footing is clearly treacherous, but Aguirre's gait has the air of a mad man, staggering in an angular walk and kneeling to come face to face with a group of monkeys cowering on the corner of the raft. In stark contrast to his grandiose scheme to conquer New Spain, he is literally "lording it over the monkeys."

Figure 8.6 Internal rhythm: wide angle lens in Aguirre: Wrath of God *(Herzog, 1972).* With character movement minimal in this shot, the wide lens' power to slightly distort Aguirre's (Klaus Kinski) face, coupled with the camera's instability, amplify what little primary motion is present to an acute level: the intensity of the conquistador's madness is palpable.

Source: Copyright 1972 Werner Herzog Filmproduktion.

The pattern of chaos created as the monkeys scurry across the raft, leaping in fear from log to log and scrambling over one of the dead crewmembers suggests that maybe even they understand that Aguirre is unhinged. At the end of this shot there is a jump cut to Aguirre staggering forward to catch his balance against a canon.

That cut is part of a strategy of hard cutting across the scene so that the external rhythm reinforces the edgy internal rhythm that is unfolding across the raft. Shot in cinéma vérité style, the coverage lends itself to elliptical cutting, and jump cuts propel Aguirre forward in the scene, while cuts to the monkeys roving across the raft serve as the "objective correlative:" they are forcible images of his deterioration. If we consider only the progression of Aguirre's placement in scene, the elliptical cutting moves him from cradling his daughter to a close up in the center of the raft looking over his right shoulder, to a circling close shot looking over his left shoulder, to the long shot just described where he staggers along the edge of the raft, to the canon, to the final tracking shot over his shoulder where he corners a group of monkeys. Spatially, Aguirre ranges erratically across the raft, via a weaving camera that follows him and via the jump cuts that render his movements even more volatile.

In the last shot particularly, the wide-angle lens brings the viewer into Aguirre's madness by dynamically spatializing his walk. As he moves past a flag, the camera crosses very close on the other side, sweeping it across the foreground and energizing it with distorted perspective. As he moves under a wooden tent pole, the camera ducks under with him, as if the viewer is prowling behind. At the close of this careening shot, the camera pushes in for a climatic moment: Aguirre grips a small monkey who writhes and screams in fear. He declares aloud, "I am the Wrath of

God. Who else is with me?" Then, in an inspired moment where Kinski truly inhabits his character, he casually tosses the monkey into the river. Herzog says of the film's ending, "it isn't so much a happy ending as an exact one, a suitable ending – there is no deeper meaning in it. As for the monkeys on the raft at the end of *Aguirre,* that was the only way to end the film, the only way to get an appropriate ending."[47]

Internal Rhythm: Camera Placement

Beyond character movement and lens usage, the placement and movement of the camera itself can contribute to the internal rhythm of a shot. Again, the range of potential choices here is vast, but a few examples can illustrate the underlying rhythmic principles an editor must be aware of in constructing a scene. Camera placements that are at the eye level of the actor are considered normative, and elevations above or below this placement frequently connote power or lack of it. As Herbert Zettl notes,

> Physical elevation has strong psychological implications. It immediately distinguishes between inferior and superior, leader and follower, and those who have power and authority and those who do not. Phrases like *the order came from above, moving up in the world, looking up to and down on . . .* all are manifestations of [this] strong association.[48]

Moreover, traditional screen aesthetic holds that camera elevation has an effect on internal rhythm: a high angle shot tends to slow or diminish internal rhythm, while a low angle shot tends to accentuate internal rhythm. See Critical Commons, "Internal Rhythm: *Citizen Kane*, Low Angle Increases Internal Rhythm."[49]

Low angle camera placements are used throughout *Citizen Kane* (Welles, 1941), and the film was notable for showing the ceilings of its set – made from stretched muslin – a rarity for a Hollywood studio production of its era. In the film, the political boss Jim Gettys (Ray Collins) uses Kane's affair with Susan Alexander (Dorothy Comingore) to destroy Kane's chance to be elected governor and end corruption in the state. In the morning following Kane's loss, Jedediah Leland (Joseph Cotten) comes to the campaign headquarters drunk and angry that Kane has failed his family, his friends and electorate of the state. Character movement in the scene is minimal, and the pacing of the dialogue is even, save for those moments when Leland presses Kane to let him go to work on the newspaper *Chicago*, the first crack in their solid friendship. Neither actor is heroic in this scene, so the choice of the low angle, wide shot to "elevate" them, to "look up to them" is not a thematic concern.

What does emerge from the low camera placement is a kind of smoldering anger, a tension that builds as they circle each other. Leland dresses Kane down for his failure to really love anyone, but Kane is unwilling to acknowledge and accept his failures. The low placement helps carry the threat implied in their body language and dialogue that this encounter might spill over into hostility and even violence. The scene begins to pivot when Jedediah's criticism of Kane becomes more pointed (Figure 8.7). He finally says, "You don't care about anything except you." Now Kane retreats toward a nearby table, and the low placement reveals a reminder of his failure – a "Kane for Governor" banner on a ceiling beam – and renders his crossing of the room dynamic and charged with emotion in a way that an eye level placement could not. The staging, the use of ceilings and the low placement playing against the traditional "elevation" of the character energize Kane's movements so that they read more like "caged animal" than "hero."

Jedediah continues his attack, and the shot changes to another low angle wide shot as he walks forward, marching into Kane's personal space to ask for a transfer to Chicago. Now both men loom in the foreground as they struggle over the issue, and as it becomes clear that Jedediah will resign if he's not granted a transfer, Kane relents and says he can go. But as Kane pours himself a

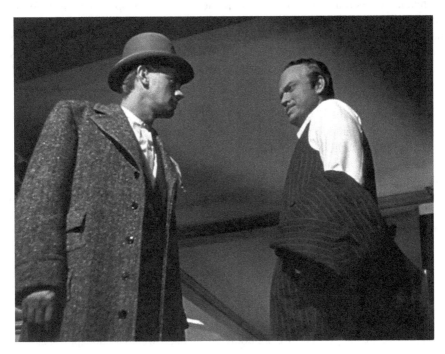

Figure 8.7 Internal rhythm: low angle placement in Citizen Kane *(Welles, 1941).* With character movement
 minimal, the low placement in this scene helps to energize the internal rhythm of the dialogue
 and movements of Kane (Orson Welles) and Jedediah Leland (Joseph Cotten) as they stare each
 other down.

Source: Copyright 1941 RKO Radio Pictures.

drink, he tries one more time to convince Jed to stay, only to be interrupted, "Will Saturday after
next be alright [for me to leave]?" The low placement continues to energize the internal rhythm of
their dialogue and their movements as the stare each other down, the hostility and disappointment
between them palpable. Kane closes the scene with a toast: "To love on my terms, that's the only
terms anybody ever knows – his own." Throughout, the visual dynamism of the low placement
has enlivened the emotionally charged exchange between the two old friends.

An altogether different use of camera placement crowns the ending of the 1960s classic film,
Blowup (Antonioni, 1966). Here, the central character Thomas (David Hemmings), a swinging
London fashion photographer, returns to a park where he believes he has photographed a murder.
Antonioni's film expresses deep reservations about a "mod" world in which the photographer is
so distracted by the surfaces of the world he inhabits that he lacks the moral gumption to actually
deal with what he believes to be the death of another human being. At the same time, Antonioni
asks the audience to address questions about whether what the photographer sees may or may not
be true. Those two ideas dovetail effortlessly in the closing sequence of the film. See Critical Com-
mons, "Internal Rhythm: *Blowup,* High Angle Camera Placement Decreases Internal Rhythm."[50]

The photographer wakes up at sunrise in a house where he partied all night long, and returns
to the park alone, having failed to convince anyone of what he thinks he has seen. He finds noth-
ing to prove there was a murder, and is leaving the park when a troupe of anarchic mimes arrive
in the park and begin to "play tennis" in pantomime. The photographer looks on as the "match"
progresses, and is slowly drawn into the "game," as one of the mimes appears to hit the tennis
ball over the fence and out of the court. The camera tracks the illusory "ball" as it rolls to a stop,

and the female tennis mime gestures for the photographer for help retrieving it. As the troupe looks on silently, he trots over to retrieve the "ball." Setting his camera on the grass, he "hefts" the imaginary ball and runs towards camera, "heaving" it back onto the court. Here, the camera holds him in a medium close-up for :36 seconds, while the sounds of a tennis ball being volleyed back and forth are slowly sneaked underneath the shot. In a remarkable moment, the photographer's eyes begin to follow the "ball" until he pauses, and seems to be thinking back over what has transpired.

The film then cuts to an extremely high angle wide shot (Figure 8.8), a framing that not only trivializes the main character and all he represents, but that also reduces his movements to a slow crawl as he walks idly back to pick up his camera. He then walks to the center of the frame and pauses, swinging his camera slightly by his side. With this placement, the film's momentum gradually winds down. The high angle shot brings down the curtain on his moment of contemplation and serves as a visual marker that slows his actions. An instant later, Antonioni dissolves to the same framing without the photographer, essentially erasing him from the film in a moment of overt directorial control, and triggering the appearance of the end credits. Roger Ebert summarizes the ending of the film this way:

> What remains is a hypnotic conjuring act, in which a character is awakened briefly from a deep sleep of bored alienation and then drifts away again. This is the arc of the film. Not "Swinging London." Not existential mystery. Not the parallels between what Hemmings does with his photos and what Antonioni does with Hemmings. But simply the observations that we are happy when we are doing what we do well, and unhappy seeking pleasure elsewhere.[51]

A similar effect where the high angle shot slows the primary motion of many actors can be seen throughout the climactic battle scene in *Spartacus* (Kubrick, 1960), a Roman epic that Kubrick was brought on to direct after Anthony Mann was fired early in the production. The film was shot in an ultra-widescreen Super 70 Technirama format, a horizontal 35mm format

Figure 8.8 Internal rhythm: high angle placement in Blowup *(Antonioni, 1966).* In the last moments of the film, Antonioni cuts to an extremely high angle wide shot of the main character Thomas (David Hemmings), a vapid fashion photographer of the mod scene in London. The framing reduces his movements to a slow crawl as the film's momentum winds down.

for blow up to 70mm that is similar to VistaVision. The wide, high definition image was used to capture large panoramic scenes, including one battle scene with 8,000 Spanish soldiers playing the Roman army. In the scene, the opposing forces occupy opposite sides of a valley. Spartacus (Kirk Douglas) and his rag tag army of rebellious gladiators face a much larger force of disciplined Roman legions lead by Crassus (Laurence Olivier). Spartacus' army holds the high ground while the legions organize their formations in the valley, preparing for the assault. See Critical Commons, "Internal Rhythm: *Spartacus,* High Angle Camera Placement Decreases Internal Rhythm."[52]

Shots of the legions marching into position are captured in extreme wide shots from a high angle position, while the long shots showing the concerned reactions of the rows of soldiers in each army are much closer, and often below eye level. The sheer magnitude of the Roman legions is impressive, and once they move to mid-valley and pause, the camera's point of view remains with the gladiators as the legions approach. Pre-battle maneuvering was a common Roman legion tactic as commanders prepared for an impending clash. The tempo of the legion's choreographed formations moving into position – shot from an aloof angle that scales their forward march into sweeping formations – is slowed by the high camera placement, allowing the patterns to play out in very long, leisurely takes. As the tension of the impending battle builds, a line of Roman soldiers moves into a forward line, while the legions in the rear close ranks into a tighter formation. A high angle side shot brings the two armies to a face off from opposite sides of the frame, while the sound of thousands of shields being raised in unison creates a thunderous noise. As the legions begin their charge, Spartacus, in a series of closer shots, orders flaming logs rolled down the hills to halt the Roman attack (Figure 8.9).

But Kubrick stays with the high angle wide shot as the battle begins to turn, the blazing logs breaking the Roman ranks as the gladiators' counterattack commences. For the opening of this battle, the high angle wide shot is a choice that reveals the scale and pattern of the maneuvering legions, a choice that will be fully evident in the 70mm widescreen distribution for which it is intended. Moreover, the high angle shot slows the pace of the ponderous pre-battle, providing contrast to the aggressive, close combat to follow. Kubrick will move the camera closer and lower as the battle plays out, but even here will often stay above the fray so that the sheer scale of the production is written across the big screen.

Figure 8.9 Internal rhythm: high angle placement in Spartacus *(Kubrick, 1960). In* Spartacus, *the tempo of the Roman legion's formations moving into position is slowed by the high camera placement, allowing the patterns to play out in very long takes, even in a series of closer shots where flaming logs are rolled down the hills to halt the Roman attack.*

Source: Copyright 1960 Universal International.

Internal Rhythm: Scope of the Shot

Classic screen theory holds that the scope of the shot can affect the perceived duration of a shot. Jean Mitry acknowledges that hard-and-fast rules about the relationship between the scope of a shot and perceived duration are suspect because of the large possible number of variables involved. Nonetheless, he claims that, in general, "the more dynamic the content and the wider the framing, the shorter the shot appears; the more static the content and narrower the framing, the longer the shot appears."[53] If we first consider "movement energy" in the frame, it seems obvious that – given two shots of the same scale – shot A of a moving scene or high dynamism action will appear shorter than shot B of a static scene or low dynamism action. Further, if any given action C is framed as a wide shot, if feels *shorter* (duration) than if C is framed in close up, since the viewer often has the need to visually scan the frame in a long shot. As the viewer interacts with information distributed across the frame, the time it takes to completely survey and absorb the image can feel abbreviated by the cut. Conversely, if action C is framed closer, it can feel *longer* since the viewer has "nowhere else to look." Or to put it another way, closer shots concentrate and enhance dynamism or internal rhythm, and so they generally need less screen time than wide shots.

Zettl expands this idea further by noting that a close up usually carries the same impact *as if we are close* to an actual subject. In other words, the close up replicates the same proxemics as actually being close. Zettl says, "Long shots and close-ups differ not only in how big objects appear on screen (graphic mass relative to the screen borders) but also on how close they seem to us, the viewers. Close-ups seem physically and psychologically closer to us than long shots."[54]

We can see this principle at work in shots at the opposite end of the shot scale from those we looked at in *Spartacus*. The "Life Lessons" segment of the short film anthology *New York Stories* (Martin Scorcese, Francis Ford Coppola, Woody Allen, 1989) provides a compelling example. Here, the extreme close up adds energy and increases internal rhythm by narrowing and concentrating the field of view. In the film, the painter Lionel Dobie (Nick Nolte) struggles to complete a number of large works for a show that is opening soon, while struggling to keep his young assistant Paulette (Rosanna Arquette), with whom he shares a loft, in an exploitive relationship. As Lionel struggles for inspiration, he is sexually distracted by the presence of Paulette, who has decided to leave him. See Critical Commons, "Internal Rhythm: 'Life Lessons,' Close up and Color Usage."[55]

Lionel finally quits procrastinating and gets down to painting. He puts in a cassette of the 1960s blues classic "Politician" by Cream. Director Martin Scorsese opens the scene energetically with a series of tracking shots, but the camera quickly moves in close, as Lionel sees a nude photograph on an art magazine strewn on the floor and seems to take that as a momentary inspiration. What follows is a :30 second sequence of eleven extreme close ups of oil paint squeezed from a tube or swirled onto the canvas, intercut with two extreme close ups of Lionel engrossed in the creative process as he contemplates his next brush stroke. The shot length is short, with an average shot length of 2.5 seconds, so the external cutting rhythm contributes to the burst of creative energy that is expressed in the sequence. But the pinpoint framing of the extreme close-up contributes equally to the aesthetic energy of the scene by heightening the internal rhythm of brush strokes pushing paint into visceral shapes (Figure 8.10).

The paint colors are vibrant, and the kinetic process as Lionel works the material on the canvas is magnified by the narrow field of view, which is only slightly larger than the painter's hand (Figure 8.10). The framing brings a haptic intensity to the moist textures and fluid physicality of the oil paint as it squirts onto the palette and swirls in broad curves across the canvas, one layer smothering another. The framing also ensures that the motion vectors of Lionel's aggressive brush across the canvas are essentially mapped "stroke for stroke" across the film screen, an intensification of the brush's primary motion that communicates the essential qualities of Lionel's active technique.

Figure 8.10 Internal rhythm: the close up in "Life Lessons" (Scorsese, 1989). The close framing in this sequence ensures that the motion vectors of Lionel Dobie's (Nick Nolte) hand, aggressively painting his canvas, are essentially mapped "stroke for stroke" across the film screen, an intensification of the brush's primary motion.

Source: Copyright 1989 Buena Vista Pictures.

Internal Rhythm: Camera Movement

Conventional aesthetics assumes that a moving camera increases internal rhythm more than a static camera. This dynamic "boost" is partly because the move overcomes the limitations of the camera's fixed aspect ratio – a tilt can show the height of a towering tree, a pan can show the sweep of a river – and partly because the gradual *revelation* of the profilmic material over time is more dynamic than a fixed shot. Here again, the work of Stanley Kubrick provides many examples of moving camera, particularly the reverse dolly shot that he used extensively. In *Paths of Glory* (Stanley Kubrick, 1957) Colonel Dax (Kirk Douglas) is leading a regiment engaged in vicious trench warfare in France, while his superior, the ambitious General Mireau (George Macready) tries to engineer a battlefield victory no matter what the cost. Mireau leaves his palatial office and comes to the trenches to fire up the troops for their impending charge "over the top" into "no man's land." This is the viewer's first introduction to the realm of trench warfare, and most of the scene is captured in a single :90 second reverse dolly shot that will match its movements to those of the General. The tempo of both character and camera movement here is deliberate and unhurried, with pauses to converse with the troops. See Critical Commons, "Internal Rhythm: *Paths of Glory*, Reverse Dolly."[56]

Mireau, living in the comfort of a rear echelon, has been largely removed from the reality of the trenches. The scene opens with a wounded man carried away from the camera as Mireau approaches with his aide-de-camp. The general strides confidently and offers breezy salutes to the enlisted men, his crisp uniform and cape at oddly out of place in a dirty trench that is lined with irregular wooden bulwarks. He stops three times to make awkward chat with his foot soldiers,

playing up to each with the line, "Ready to kill more Germans, soldier?" The tracking shot pauses for each interlude as the general dispenses platitudes freely. But when he stops to tell a soldier that a rifle "is a soldier's best friend, you be good to it and it will be good to you," an exploding shell in the background ironically undercuts the small talk (Figure 8.11).

The general continues his inspection, the camera leading his confident stride through the long trench, and revealing the impressive scale of the battle preparations. He comes to group of soldiers in a fire bay and the steady rhythm of his review comes to an abrupt end, as the camera track pauses for the final time. His question, "Ready to kill more Germans, soldier?" is met with an awkward, extended silence from a soldier who is unresponsive. As the general tries to learn what the problem is, Kubrick turns to traditional coverage for the dialogue scene that follows, and medium close ups of the soldier show his empty stare as he talks vacantly about his wife back home. Appeals from his buddies that he is suffering from "shell shock" (the World War I name for "posttraumatic stress disorder") are dismissed. "I beg your pardon, Sergeant, there is no such thing as shell shock," the general counters. The soldier quickly breaks down in fear that he will never see his wife again. The general promptly slaps him and orders him dismissed from the regiment, "I won't have my brave men contaminated by him." The scene ends with a tracking shot that follows the general away from the men as his aide-de-camp ironically congratulates Mireau on his decisive action: "You know general, I'm convinced that these tours of yours have an incalculable effect on the morale of these men."

Throughout this scene, there is ebb and flow between movement and conversation, a rise and fall that the reverse dolly is uniquely adept at capturing, simply by taking its cue from the pattern

Figure 8.11 Internal rhythm: reverse dolly in Paths of Glory *(Kubrick, 1957).* The tempo of both character and camera movement in this long take is deliberate and unhurried, with pauses as General Mireau (George Macready) stops to converse with the troops. The ebb and flow between movement and conversation is adeptly captured by the reverse dolly which simply takes its cue from the pattern of Mireau's movements.

of Mireau's movements. The unfolding architecture, the scale of the space and the feel of the trench can best be communicated by actually *moving through it*, not cutting the space into a series of shots. And for the viewer, the rhythm of that "discovery" is controlled completely by the pace and pattern of Mireau's movements, underscored in the track by a single, crisp military snare drum that evenly punctuates his stroll, and resolves in a drum roll as he pauses. As we noted above, because that sound is *non-diegetic* – external to the story space – it is ordinarily classified as part of the *external rhythm* of the scene. We will examine other external rhythm devices below.

Wes Anderson is another filmmaker who uses a range of camera movements throughout his films, in conjunction with very formal compositions and traditional editing structures. In *Moonrise Kingdom* (Wes Anderson, 2012), he captures the routines of the Khaki Scouts at summer camp with orderly camera moves, impeccably staged military spaces, and exquisitely framed compositions. In the film, Sam (Jared Gilman) resigns from the Khaki Scouts, and runs away with Suzy (Kara Hayward). They are nerdy, innocent adolescents, and they retreat to a secluded island cove that they name Moonrise Kingdom. Eventually, they decide to see if Cousin Ben (Jason Schwartzman) who works at Fort Lebanon, a Khaki scout camp nearby, will marry them. See Critical Commons, "Internal Rhythm: *Moonrise Kingdom*, Layered Composition in a Tracking Shot."[57]

Cousin Ben meets the fugitive Sam, and first advises him on his best chance to escape. Their clipped, military dialogue plays out in a remarkable tracking shot in which multiple planes of the shot are chock full of motion: in the foreground, a picket fence rattles across the frame while Cousin Ben and the younger scouts walk in time with the camera; while in the middle ground, lines of troops hike the opposite direction against symmetrical rows of canvas tents and an obstacle course of old tires, while in the distance, scouts run in single file against a row of flag poles and a climbing ropes obstacle that more scouts clamber over. The regular cadence of the snare drum is a complimentary postproduction element of external rhythm that syncs closely to the primary motions in the foreground – the group following Cousin Ben and the regular ratatatat of fence pickets sliding across the frame (Figure 8.12). The sheer number of visual rhythms at work in the shot reflects Anderson's meticulous control of *mise-en-scène*. The visual variation in the shot emerges from the steady march of Cousin Ben's group, holding a fixed position relative to the camera, in contrast with a range of other visual rhythms: the "chatter" of fence pickets crossing the bottom of the frame, the triangular tents crossing at various speeds due to parallax, the unruly flow of loose troop formations, the single lines of boys crossing a rigid row of flags in opposite directions.

Sam agrees to leave, but when he says he wants to bring his "wife Suzy," the film cuts to a static shot and the visual rhythm screeches to a halt as Cousin Ben turns in a cartoon-like "take," trying to understand what he has just heard. Suzy steps into the arrested frame and notes dryly, "But we're not married yet." No longer moving the camera to enliven the background, Anderson resorts to a model rocket launch and a Khaki scout on a zip line in the back ground to punctuate the foreground dialogue. The scene ends with a complete change of axis of movement: in the next shot, Ben enters vertically by sliding down a pole and walking towards the camera. His unorthodox entrance underscores the tongue in cheek warning he delivers as the scene ends, ordering the young couple to "go over by that trampoline and talk it through" before they take such a momentous step.

Thus far we have looked at smooth, stabilized camera movements: the Kubrick reverse track and Anderson's formal tracking shot. As we noted above in our discussion of *Aguirre*, some directors like Herzog regard shots from a tripod as inherently "inhuman," since the camera's viewpoint is fixed and "stabilized" and human perception is not. For Herzog, the handheld camera is more in tune with human perception. Silent features used the handheld shot sparingly, due in part to the difficulty with holding *and* cranking the camera simultaneously. Likewise, shooting handheld for sound pictures on a Hollywood set was prohibited by the noise created by smaller,

Figure 8.12 Internal rhythm: tracking shot in Moonrise Kingdom *(Anderson, 2012).* The sheer num-
ber of visual rhythms at work in this shot reflects Wes Anderson's meticulous control of
mise-en-scène. The steady march of Cousin Ben (Jason Schwartzman) and his entourage
holding a fixed position relative to the camera, contrasts with a range of other visual rhythms
in the background.

Source: Copyright 2012 Focus Features.

handheld units. Only newsreels came to use the handheld camera extensively, where the need for
speed and immediacy in framing action was paramount. It was not until the early 1960s that the
development of a system by Leacock-Pennebaker that paired light weight, self-blimped cameras
with small double system sound recorders – all running on battery power – that "direct cinema"
documentaries like *Primary* (Richard Leacock and Albert Maysles cinematography, edited by
D. A. Pennebaker, 1960) were possible. Around the same time, French New Wave films quickly
made the handheld camera a distinguishing technique in their films in the narrative domain.

Conventional aesthetics holds that the handheld camera increases internal rhythm. If we
divide possible camera movement into two large classes – movements possible with a hand-
held camera versus movements possible on a tripod mount, the most common stable mount,
we can see the scope of conceivable camera movements is very large indeed, since the hand-
held camera can emulate the two primary tripod movements, pan and tilt. In addition, vir-
tually any "stable" camera *movement* such as a traditional dolly shot, tracking shot, crane
shot, or even a Steadicam shot that is done on a stable but *mobile* mount can be improvised
using a handheld camera (with a different aesthetic result obviously). In addition, there are
a wide range of handheld camera movements that can emulate almost any human movement
but remain largely unnamed. So, given the range of possible movements with the handheld
camera, we will simplify here by looking at a single sequence of the technique from *Saving
Private Ryan* (Steven Spielberg, 1998) in order to clarify how the technique impacts primary
motion.

Throughout *Saving Private Ryan*, cinematographer Janusz Kaminski employs the handheld
camera to tell the story of the search for the last surviving brother of four service men following
the D-Day landing in Normandy, France. *Ryan* won five Academy awards, including Best Direc-
tion, Best Editing for Michael Kahn, and Best Cinematography for Kaminski's creative work that
helped redefine the depiction of combat violence. In addition to the handheld camera, Kaminski
employed short exposure times from a 90° or 45° shutter angle to sharpen the internal dynamism
of the combat shots. Shutter angles less than 180° or "full shutter" take short duration samples

that are spaced farther apart temporarily, so they add an edgy, "staccato" look to the footage. A look at seven handheld shots in the landing vehicle as the squad led by Captain John H. Miller (Tom Hanks) lands on Omaha beach will demonstrate the contribution of the technique to internal rhythm. See Critical Commons, "Internal Rhythm: *Saving Private Ryan,* Handheld Camera Increases Internal Rhythm."[58]

The beach scene opens with almost two minutes of shots that show the rugged transport of landing craft towards the beach. Miller's squad rides the stormy swells towards the beachhead, his men alternately praying and vomiting as they prepare for the landing ramp to open. Throughout the landing scene, the sky is cloudy, the lighting diffuse, with a somber color palette of desaturated blues, greens and greys. There is a gritty feeling to the scene, and Kaminski says,

> You don't always have to provide beautiful lighting. I often think ugly lighting and ugly composition tells the story better than the perfect light . . . For the most part we really didn't light much on the invasion. The lighting was more about how the negative was being exposed, the lenses and the use of ENR.[59]

ENR is a proprietary film development process used by Technicolor that produces rich blacks, muted colors, and a higher contrast image by leaving silver halide in the image, much like the better known bleach bypass process.

From the point that the ramp opens, the unanticipated strength of the German defensive positions is made tangible and visceral. In shot 1, the camera is placed low and close to the ramp, whose slow descent reveals two soldiers in a waist shot as the German bullets begin to fly. The shot is :01 second, 6 frames long, and roughly half way through the shot, there is a convergence of simultaneous phenomena into a single moment that punctuates the ferocity of the first two deaths shown: the ramp reveals the pair, the flight of bullets is heard whistling through the air, and both soldiers are hit simultaneously and fall backwards. Within such a short shot, this is a moment of cognitive dissonance: we expect the soldiers to charge forward but the impact hurls them back. That impact – the reversal of their primary motion – is reinforced by the handheld camera which careens upwards as the soldiers arms flail backwards, the camera rise clearing the edge of the landing craft enough to create a lens flare that sweeps across the screen. Shot 1 ends before we are sure what we have actually seen, but shot 2 repeats the same idea to reinforce the horror. The medium close up frames three soldiers in a line, on the other side of the landing craft, where the sharp focus falls only on the lead soldier. Shot 2 is only 23 frames long, and the primary motions are minimal, but the bullet hole in the lead soldier's helmet reads easily, as does the splatter of blood captured mid-air by the short shutter. The camera shake here is more subtle – more like raw vibration from the force of bullets striking hard – but part of the energized chaos that is erupting. We get the sense of lead ripping through the air, and making the bodies of the soldiers almost dance.

Shot 3 reverses direction, shooting from the back of the boat. The handheld placement is centered and slightly above head height, as if from a soldier's point of view. The camera feels squeezed into the cramped space, "rubbing shoulders" with the other eleven men and contained by the walls of the craft. Explosions lift the surf into the air, creating a vertical primary motion, while the boat and camera tilt right, buffeted by blasts. Since shot 3 holds :04 seconds of screen time, we feel the handheld rhythm of the boat rocking, as a burst of fire tears though men, flinging blood and debris towards the camera, splattering the lens. These lens blemishes, something rarely seen in a Hollywood film, lend a raw, documentary feel to the shot, and are part of a strategy by Kaminski to include "imperfections" in the cinematography:

> We were kind of aiming towards imperfection, little so called 'flaws' that might be considered mistakes. Such as handheld shots in scenes that would normally be shot on the dolly. It was simply more real to have certain imperfections in the camera movement. Or soft [out of focus] images. All those elements will add to the emotional side of the movie.[60]

Shot 4 is nearly as long as 3, a waist shot from the front of the boat that shows helmets flying and men crumpling under the withering fire. Now the camera flails to the right and downwards, towards the bottom of the boat, roughly mimicking the spray of falling bodies, violence almost too searing to take in. The next shot, shot 5, brings a change in perspective: the camera shows the beach from a German pillbox, with a machine gun and cartridge belt in soft focus but clearly silhouetted against the beachhead. The handheld camera tracks to the right side of the gun, revealing the rapid fire of tracers lighting up the muzzle; the camera holds for a beat, then continues to the right, revealing a second machine gun raking the beach below with fire (Figure 8.13).

Here, the short shutter and longer lens create a shaking action in the camera that mimics the machine gun fire: it is brisk, explosive and barely under control of the operator. At :06 seconds, 11 frames, this is the longest shot in the sequence. What the camera movement lacks in elegance and clarity, the silhouette lighting adds naturally: the shape of the machine guns devouring belts of ammo and spitting fire is distinct and instantly identifiable (Figure 8.13).

The next shot, shot 6, covers a line of dialogue that avoids many of the conventions of classic Hollywood war pictures. Captain Miller shouts, "Over the side!" pushing his men to dive overboard rather than be mowed down in the boat. Here, the realism in *Saving Private Ryan* extends to the audio track, since he is practically cut off by the chaotic sounds of war. Where canonic war films ensure that "If an actor has a line to deliver, the audience can always hear it, even if whispered in a raspy voice by dying man as furious combat rages is all around,"[61] *Ryan* lets the chaos of war compete with the dialogue track. Shot 6 is barely longer than the line, a mere 46 frames long. Miller's line covers 32 frames of that time, while the remaining 14 frames show Miller pulling a soldier across the frame. The handheld camera here is intimate and low, the lens still splattered in blood, and in such tight quarters that the soldier who is pulled across the frame almost touches the lens. The contrast to the previous shot is stark: :06 seconds versus :02 seconds, the interior of the dark pillbox versus the bleak light of open boat, the rattle of the machine gun versus a single barked line of dialogue. The final shot, shot 7, returns to the back of the boat, with the camera framed tighter. Now more soldiers are hit and the primary motion is downward as

Figure 8.13 Internal rhythm: handheld camera in Saving Private Ryan *(Spielberg, 1998).* Shot from a German pillbox, a machine gun is silhouetted against the beachhead. The handheld camera, short shutter and longer lens create a shaking action in the camera that mimics the machine gun fire: it is brisk, explosive and barely under control of the operator.

they fall out of frame, leaving the kinetic energy deeper in the frame as the pillbox fire continues, and a large explosion lifts the black surf high into the air. Again, the short shutter and long lens enhance the camera's instability as it rocks in the boat first left to right, then up and down, as if barely able to maintain its balance. The sequence ends with a shot from the side of the boat of the men diving overboard, the handheld camera following into the water before fading to black. The sequence that follows shows the soldiers underwater to a slow-motion world of quiet drowning and death – a stark shift in internal rhythm as the soldiers drift downward – before they return to the surface and struggle towards the beach. Spielberg takes a horrific moment from the first wave of the D-Day landing, and using a handheld camera and tight editing, intensifies the soldiers' chaotic ordeal.

Internal Rhythm: Color

Classic screen theory holds that color can energize and amplify the emotional impact of scene. Zettl says, "High-energy colors are more active than low-energy colors. For example, the high-energy red of a sports car seems to fit our concept of power and speed, and a red ball promises more fun than a white one."[62] The main parameters of color energy in a shot are hue (warm vs. cold colors), brightness (luminous vs. dim), saturation (intensity or degree of difference from white), and contrast ratio (the range of the brightest area to the darkest area). Zettl argues that the highest aesthetic energy in a shot is associated with a warm hue, of high brightness, that is deeply saturated, within a composition that has a large contrast ratio. We will look at three scenes to demonstrate the contribution of color to internal rhythm of a scene.

A simple use of color tinting – washing an entire frame with of a scene with a single color – is found in the "Life Lessons" segment of the short film anthology *New York Stories* (Martin Scorsese, Francis Ford Coppola, Woody Allen, 1989) that we touched on earlier. At the end of the sequence where Lionel (Nick Nolte) furiously paints, he comes upstairs to Paulette's (Rosanna Arquette) bedroom, ostensibly looking for his sable brush. See Critical Commons, "Internal Rhythm: 'Life Lessons,' Blue Tint vs. B&W."[63]. As she lies in bed, Scorsese uses an iris matte around a medium shot of her foot to mark it as a subjective shot from Lionel's point of view. She catches him looking at her foot, and he defends himself: "This is crazy, I just had this impulse – I wanted to kiss your foot." Paulette reacts violently with a jerk of her foot, pulling the bed cover closer to her. This action is covered in a quick cut from the iris shot of her foot – the iris widening instantly – to a long shot of her in bed, as she rebukes him, "You're nuts!" Lionel unleashes a litany of complaints – he's working too hard, the opening of his gallery show is in three weeks, his agent is harassing him like a mocking bird – and then feebly tries to excuse his sexual impulse: "I just wanted to kiss your foot. I'm sorry. It's nothing personal." When he offers her an olive branch, adding, "You want me to get you anything?" the film cuts to a series of blue tinted, erotic images of Paulette and Lionel, engaged in sexually laden touching, suggesting that he's imaging the kinds of things he would like to give her in that moment.

The cut to seven blue shaded images is cued by a return to a signature song used earlier in the film "Whiter Shade of Pale," by Procol Harum who sing "That her face at first just ghostly, turned a whiter shade of pale." Initially, the blue tint seems to be over a black and white image, a kind of literal visualization of the song. But later, Paulette's fingers and lips reveal a faint hint of red in the image, so the base image is not monochromatic. The character movement here is minimal, smooth, and slow, with a specific action captured in each shot: Paulette turns to look slowly to look over her left shoulder, she strokes her hands across her knees, she lifts her hair and turns to the camera, Lionel lifts her hand and kisses it. A few of these shots are accented by camera moves like slow zoom in/tilt up combinations or by simple follow focus moves.

If we remove the blue tint entirely from the scene, and compare it to the original, the contribution of the blue is clear: the black and white version is formalized, bur it lacks the emotional pull

of the blue version. The blue values add a calm, "tranquillizing" effect that slows the stylized primary motion, an effect heightened because the *entire frame* is cooler. As Zettl says, "Color effects seem to show up best in a positively predisposed context, that is, in a field in which most other elements display similar tendencies."[64] Frame tinting and the use of the iris harken back to the traditions of the silent era. By contrast, the structure of Scorsese's daydream sequence is nontraditional, since the fantasy is *launched* from Lionel's point of view (i.e., his "look" in the outgoing shot begins the daydream) but *returns* from the reverie with Paulette turning towards the camera, a refreshing twist in the edit that suggests perhaps she has been sharing the same thoughts.

The impact of color on internal rhythm can also be clearly seen in *Barry Lyndon* (Stanley Kubrick, 1975). Kubrick uses a specially designed Zeiss 50mm Planar f/0.70 lens to photograph scenes of Barry (Ryan O'Neal) working with the Chevalier du Balibari (Patrick Magee) to cheat European royalty at cards using only the light from candles. See Critical Commons, "Internal Rhythm: Candle Light in *Barry Lyndon*."[65] To film in this low light level, there were technical modifications made to the camera and lens mount, and Kubrick used special candles with three wicks for maximum brightness.[66] Ed DiGiulio, the President of Cinema Products Corporation, who worked on the project as a technician, asked Kubrick the obvious question, "Why were we going to all this trouble when the scene could be easily photographed with the high-quality super-speed lenses available today (such as those manufactured by Canon and Zeiss) with the addition of some fill light? He replied that he was not doing this just as a gimmick, but because he wanted to preserve the natural patina and feeling of these old castles at night as they actually were."[67]

Primary movement in the scene is carefully controlled, in part because of the nature of the scene, and in part because the depth of field was so shallow that it would have been difficult to pull focus accurately if the characters' movement ranged very far. The primary motions in the scene are dictated by the gambling, which begins energetically in the long shots, as Lord Ludd (Steven Berkoff) initially wins a hand. As Ludd begins to lose, and the competition intensifies,

Figure 8.14 Internal rhythm: candle light in Barry Lyndon *(Kubrick, 1975).* In this gaming scene, the desaturation of the colors, particularly the flesh tones muted by white facial powder, and the low overall brightness level of the scene tend to dampen the dynamism of the scene considerably. By contrast, the flickering movement of the candlelight contributes to an otherwise restrained internal rhythm.

Source: Copyright 1975 Warner Bros.

Kubrick stays with a tighter shot of Ludd flanked by two ladies, and the same two-shot of the Chevalier and Barry across the table. The primary movements are very small – the kiss of a hand, the roll of a card, the raking of the pot – and these diminutive motions are set against the continuous fluttering of the candelabra that are spread across the table.

The low key, candle-lit table is ceremonial and romantic almost by definition, and the ritual of the gaming table is infused with the soft, flickering presence of multiple candles (Figure 8.14). These candles have their own "hypnotic" effect on the internal rhythm of the scene. The German psychiatrist Paul Näcke (1851–1913), writing about pyromania, argued that the attraction of fire for humans is threefold: *phototropic*, the simple attractive power of bright light, *thermotropic*, the magnetic power of warmth, and *the attractiveness of its movement*. Of this last factor, he writes,

> These movements of fire are monotonous, almost rhythmic and through them, it would appear, from continual staring at fire, there are gradually formed slight circulatory disturbances in the brain which produce the same pleasant and semi-intoxicating effect as the influence of alcohol, dancing, swinging, etc. This is further assisted by the brightness, colour and outburst of the flame.[68]

If we set aside the phototropic and thermotropic associations of the candles here, considered here only the *movement* of the candlelight, they do make a significant contribution to an otherwise restrained internal rhythm. Under Zettl's scheme, the fact that the scene is warm and that the contrast range is wide would suggest that the color would *energize* the internal rhythm of the scene. However, the *desaturation* of the colors, particularly the flesh tones muted by white facial powder, and the low overall brightness level of the scene tend to dampen or *lower* the dynamism of the scene considerably. In addition, the color palette of the scene – a combination of *mise-en-scène* and candlelight – creates a narrow, monochromatic design that quiets the scene. The "low energy" lighting underscores the polite etiquette of gaming that unfolds as Lord Ludd first must borrow money from the Chevalier, and then must sign an I.O.U. in front of his friends. It also reinforces the restrained emotions, the self-conscious politeness and elegant posturing that befits both the members of the aristocracy and the scoundrels at table who aspire to that rank.

A contrasting use of bright color is found in the bizarre comedy film *Beetlejuice* (Tim Burton, 1988). The film opens on Barbara (Geena Davis) and Adam Maitland (Alec Baldwin) who, in the process of redecorating their country home, take a quick jaunt into town to pick up supplies from the hardware store. See Critical Commons, "Internal Rhythm: Saturated Colors in *Beetlejuice*."[69] On the return trip, Barbara swerves to avoid a dog, the car plunges through the wall of a covered bridge, and they teeter on the edge of the bridge, before plunging into the river below. Throughout, the scene is shot with the popular contemporary look of Kodak 35mm daylight balanced negative film: a fine-grained, deeply saturated film stock with great sharpness and accurate color reproduction. Clearly, the scene is more kinetic than the gaming scene above, and beyond the contribution of character movement to internal rhythm, the high key daylight look in *Beetlejuice* produces colors that border on cartoonish, adding a distinct aesthetic energy to the scene. Overall, the scene is bright, with a wide contrast range, and the colors are deeply saturated. The super saturated color scheme is particularly prominent in the wide shot where the Volvo protrudes from the fire engine red covered bridge. Large and centered in the frame, the bridge clearly dominates in the composition, with the other colors taking secondary role. The bright, clear northern sky of New England creates an eye-popping field that contrasts with the old white farmhouse, the deep green pastures surround it, and the "corn-on-the–cob" yellow Volvo they drive. The color choices adapt the "triadic" approach, with three colors evenly spaced around the color wheel: here, red, blue and yellow modified by the green landscape that bridges blue and yellow. The color energy here is opposite to the muted colors and low key lighting of *Barry Lyndon*, the saturated colors and high key lighting brightened by a color palette that is bold and vibrant.

Internal Rhythm: Repeated Forms

As we noted above, *plastic rhythm* is produced by arrangement of shapes, colors, textures or other visual elements across the two-dimensional space of an image. When composing visual images, repetition is one of the most basic design principles used to create plastic rhythm. In motion pictures, the repetition of forms to create plastic rhythm is augmented by the element of time: the viewer can see the repetition of forms change over time via character motion, reframing, camera movement, etc. Repetition of forms is often used in many motion pictures to create the internal rhythm for a shot or scene that naturally attracts the eye through compelling compositions, as the Hollywood choreography of Busby Berkley from the 1930s clearly demonstrates. Outside Hollywood, Sergei Eisenstein was a film artist who had an abiding interest in repeated forms as a way to enliven the primary motion of a shot. From the soldiers descending the stairs in the "Odessa Steps" sequence of *Battleship Potemkin* to the German invaders from the "Battle on the Ice" sequence of *Alexander Nevsky*, Eisenstein returns to this device again and again as a way to invigorate patterns of movement within the frame. See Critical Commons, "Internal Rhythm: *Alexander Nevsky*, Repeated Forms."[70]

In *Alexander Nevsky* (Sergei Eisenstein, 1938), there is a moment when the Teutonic knights' attack on the Russian forces falters, and the invaders use rams' horns to signal a retreat. As the Germans are forced to regroup, Eisenstein uses reverse motion from a high angle camera placement to "reassemble" their forces into an impenetrable "wall of shields" formation with soldiers standing shoulder to shoulder, their shields adjoining. From that point forward, every shot of the formation uses repeated forms of helmets, shields and pikes to give more life to the impermeable German ranks (Figure 8.15). The cutting proceeds inductively, widening from a two-shot of helmeted soldiers to a longer shot of six in a line, with each soldier cloaked in a faceless helmet that suggests the demeanor and beak of a bird of prey. Behind them another row of faceless soldiers stand ready with pikes.

The next shot begins a series of three, widening shots of the same action. In succeeding shots, each wider than the first, two rows of soldiers in the "wall of shields" formation lower their pikes, festooned in flags and a streamers. If we imagine for a moment a *singular* primary motion – a precisely descending, angular pike set against the soft, swirling form of flags – and then multiply that across a *platoon* of soldiers, we begin to understand effect, the activating force that the *plural form* – shield after shield, helmet after helmet, pike after pike – adds to the shot. It is the plural form that truly activates the plastic rhythm of the shot. And it is through montage – the repetition of that plastic rhythm *in a series of three widening shots* – that Eisenstein creates the meaning of sequence: the Teutonic knights are unstoppable. Or as the Russian soldier says in the very next shot, "Now a sword is powerless against them!" Repetition – intra-shot and inter-shot – is the visual activation of that idea.

A different use of repeated forms is found in a single, unfolding shot in *Blowup*. The disdain that the photographer Thomas (David Hemmings) has for women, particularly for the fashion models he works with, comes to light early in the film. As the photographer enters his studio to contemplate how he will execute the fashion shoot he faces, he looks up and sees the models he will work with that day in an upstairs room, obscured by a plastic window. In a sly comment on their spatial arrangement, he tells his assistant Reg (Reg Wilkins) to "get the birds down," the first indication of his distaste for them. See Critical Commons, "Internal Rhythm: *Blowup*, Repeated Forms, Plastic Rhythm."[71] As he enters the white box studio where they will shoot, there are a number of tinted glass panels standing in the space, arranged as a kind of "maze," that will be used for props. These panels break the space into a number of overlapping "planes of density": the more panels the camera looks through, the darker the space. Overlapping planes is a primary visual cue for human *depth* perception. But here, in the four-minute scene that follows, Antonioni will use the panels more as a playful element to ultimately *flatten* the composition in the scene to the point where the women's bodies read almost like cut out "paper dolls."

Figure 8.15 Internal rhythm: repeated forms in Alexander Nevsky *(Eisenstein, 1938).* Eisenstein uses plural forms and repeated motions to activate the plastic rhythm of this sequence. Faceless German soldiers, whose helmets suggests the demeanor of birds of prey, are multiplied to energize the impermeable German ranks.

Source: Copyright 1938 Mosfilm.

Figure 8.16 Internal rhythm: repeated forms in Blowup *(Antonioni, 1966).* Antonioni organizes the repeated form of the tinted glass panels in this scene of a fashion shoot. He carefully places the models so they are "cut" in half lengthwise by the panels' edge, generating a controlled, plastic composition where the women's bodies read almost like cut out "paper dolls."

Source: Copyright 1966 Metro-Goldwyn-Mayer.

The opening shot has Thomas placed so that he is visible through an open slot between the "density planes." He removes his shoes and walks through the maze of intersecting planes which render rectangular sections of his body into picture-like, graphic units of varying density, until he finally arrives at the same opening space where we can see half of his body unobstructed. The fashion shoot continues, and as Antonioni moves the camera through different set ups, the models, who are all dressed in weird, "mod" outfits, are either flattened or reflected by the dark glass. Thomas clearly loathes the process and the models. He barks orders, "No chewing gum! Get rid of it!" He treats the models as peons, and in the ultimate demonstration of unprofessionalism, he steps onto the set and places a model's leg it where he wants it. A high angle pan shot shows the configuration of models in various stages of striking poses, and the muted palette of their outfits only adds to the mélange of rectangles and reflections flattened and spread across the white surface of the cove studio. Wide shots give some sense of the larger composition the photographer is trying to achieve: the models' angular postures and monochromatic clothing are framed and reframed by the overlapping, angular grid of varying density glass.

The scene culminates in a tracking shot that reveals the models almost as colorful "bird specimens" laid out on glass slides for a microscope (Figure 8.16). Here, Antonioni organizes the repeated form of the tinted glass panels, and he carefully places the models so they are "cut" in half lengthwise by the panels' edges, generating a controlled, inventive, plastic composition that is stunning and linked to the theme of the film. As Peter Brunette has pointed out, *Blowup* is about male artistic perception since virtually all of Antonioni's films

> can be interpreted as questioning, ambivalently, perhaps, the phallic, penetrating power of his own camera. His decision in this film to move to a male protagonist who is a photographer seems, among other things, to have been made to more directly foreground this problematic. Hemmings is an obnoxious human being, a predatory male who says he is sick of all the "birds" and "bitches" he comes into contact with. The models he lives off are grotesquely anorexic beings, horribly made up, who have been turned into near monsters. The screaming artificiality of their clothes, hairdos, and poses . . . strip them of any residual humanity. These women have been completely made into objects for the dominating male gaze.[72]

Here Antonioni fragments the scene visually to underline photography's ability to "flatten" and objectify its subjects, and in a larger sense, the power of plastic rhythm to energize a scene.

External Rhythm: Modification by Transitions

As we noted above, Herbert Zettl's concept of tertiary motion (external rhythm or "sequence motion") includes the length of shots *and* the rhythm induced by transition devices. Cuts are instantaneous and "invisible" changes that do not occupy screen time, and we looked at the simple acceleration of external rhythm by rapid cutting above in films like *Mad Mad: Fury Road* and *Raging Bull*. Other things being equal, the cutting rhythm of sequence, chiefly determined by how slowly or quickly cuts follow one another, can be modified by adding transition devices that have their own *screen duration*, such as dissolves, fades, wipes and irises. The general rule is clear: the longer the transition, the slower the external rhythm of a given sequence. And in contrast to the use of the cut as part of the "invisible" system of continuity editing, transitions like the wipe are overt and "style conscious." They have their own screen duration and method of construction, which gives them their own unique screen presence. When a filmmaker uses a transition device like the wipe, the indexical relation of the camera to the profilmic material is tossed aside. "In such cases, the camera detaches itself from the object and projects its own technique onto the screen. Such efforts are the most specific subjective lyrical manifestations and the director, in

identifying himself with them, can place a subtle personal emphasis on certain features in the film."[73] In short, the cut is "concealed" because it is instantaneous; every other transition is, by contrast, "unconcealed" and hence, a potential factor in sequence motion.

Christian Metz, in his seminal article, " 'Trucage'[74] and the Film," details the ways in which the image track is more than shots, since it normally includes text like credits, title cards, "The End," etc. as well as

> various optical effects obtained by the appropriate manipulations, the sum of which constitutes *visual*, but not *photographic* material. A "wipe" or a "fade" are visible things, but they are not images or representations of a given object. A "blurred focus" or "accelerated motion" are not photographs in themselves, but modifications of photographs. The "visible material of transitions," to quote Etienne Souriau, is always extradiegetic. Whereas the images of films have objects for referents, the optical effects have, in some fashion, the images themselves, or at least those to which they are contiguous in the succession, as referents.[75]

Unlike the cut, where discrete spatial/temporal fragments or "shots" are presented linearly, with one shot completely replacing the shot before, visible shot transitions represent a divergence from the normal photographic image. A wipe or a dissolve is *suprasegmental*, literally "above, on top of" the segment, or more specifically "they refer to an image with which it is simultaneous,"[76] as Metz puts it. We will look at how the use of the "extradiegetic" transitions alters the external rhythm of a sequence next.

But before moving forward, it is worth mentioning the contribution of Christian Metz to film theory. Metz admired Jean Mitry's work as "a powerful and at times glorious final to the first epoch of film theory,"[77] but he argued that it was time to develop precise theories of film that focus on specific topics. Metz proposed that Mitry's encyclopedic work could become the road map for more narrow theorizing that tests the topics outlined in Mitry's work. This scientific attitude towards film theory drove Metz to write extensively on small-scale questions that would reveal the practicalities of cinema, rather than its overarching nature. Metz followed in the tradition of Ferdinand de De Saussure (1857–1913) who first proposed semiology as the study of meaning making, the study of processes by which signs and conceptual objects create meaningful communication. Applying the concepts of semiology to film, Metz tried to uncover how film uses cinematic *signs* – conceptual objects that consists of signifier (the name of sign) and signified (the mental concept it triggers, the idea created) – to codify meaning. In essence, Metz used the methods of linguistics to explore the ways in which films "speak," the ways in which cinema is like (and not like) a verbal language. In the 'trucage' article we will examine here, Metz explores how fades, dissolves and wipes, etc. function as *taxemes*, a minimum feature of grammar.[78] Later in his life, Metz came to the conclusion that his methods focused solely on the cinematic text with little consideration of the audience, so he began to integrate concepts from psychoanalysis into his work, to show how films are similar to dreams or hallucinations. Metz took his own life in 1993 at the age of 61.

External Rhythm: Dissolves

Because the magic lantern slide show was an influential screen practice that used dissolves as a transition device and guided the development of early motion pictures, the dissolve emerged very early as nearly an identical mechanism in the new medium of film. A dissolve is basically a "mix transition" where the gradual fading out of one shot and the simultaneous fading in of another produce a momentary overlap between the two images. Barry Salt has chronicled how the French film pioneer Georges Méliès used dissolves exclusively, "As soon as he began regularly making

multi-shot films in 1899, he started putting a dissolve between every shot in his films, regardless of the temporal relation between the adjoining shots. And he continued to do this to the end of his filmmaking career."[79] Salt points out that while later exhibitors frequently cut these dissolves out of Méliès prints to make them more consistent as editing conventions standardized, many prints retain traces of the dissolves that were not completely removed. The *single* dissolve remained a staple convention in the Hollywood feature, typically used (along the fade and the wipe) to indicate "ellipsis between shots, usually the end of one scene in the beginning of the next. The Hollywood rule was that a dissolve indicates a brief time lapse and a fade indicates a much longer one."[80] Dmytryk adds that while "fades are now rarely used, except at the start and finish of the film . . . [and] if the story breaks down into markedly disassociated episodes, fades can still be useful, giving the viewer a brief pause to catch his breath and gather his senses for the incoming section.[81] For example, in the film *Effie Briest* (Rainer Werner Fassbinder, 1974) this strategy of segmentation is fully mined, as tightly confined vignettes are further separated by harsh fades to white.

A recent study by Cutting, Brunick and Delong analyzed 150 films to study the use of dissolves from 1935 to 2005. The quantitative study looked at transitions of all types including cuts, dissolves, fade ins, fade outs, wipes, and other transitions such as iris outs and ins, frame flips, opening doors, morphs. The study found that of the 170,000 transitions examined,

> Almost 97% of these are cuts [but there were] 5400 non-cuts across all films. Of these, 69% are dissolves, 22% fades, 5% wipes, and 4% others.

> [There are] two ways in which dissolves have been used – singly and typically separating scenes, and in clusters creating what has been called the Hollywood or classical montage. Single dissolves are typically surrounded by shots much longer than the median shot length of a given film, thus giving the viewer anticipatory information about a scene change with longer shot lengths and, once that change has occurred, guiding the viewing into the subsequent scene with incrementally shorter shots. As the use of dissolves in film declined (1970–1990), the Hollywood montage essentially disappeared while the use of a few isolated dissolves remained.

> [Dissolves] were used a great deal during the studio era (as much as 8% of all transitions), but shortly thereafter they underwent a striking decline (1970–1990), only to recover a bit more recently (1995–2005) to about 1%.[82]

Sideways (Payne, 2008) is a good example of this slight uptick in the use of the dissolve, because it is a notable stylistic motif throughout. The film tells the adventures of Miles Raymond (Paul Giamatti), a struggling writer and Jack Cole (Thomas Haden Church), an aging actor, who take a bachelor's road trip to Santa Barbara wine country before Jack's impending wedding. In this film, *cluster dissolves* are used throughout, part of a trend "at least partly attributable to digital (nonlinear) editing, [for] the Hollywood montage to re-establish itself as an important storytelling device."[83] Undoubtedly, digital editing makes it much faster and cheaper to experiment with how images "mix" against each other than was possible when editing film, which required the film lab to create the effect in an optical printer.

Sideways' use of serial dissolves conforms with a few of the uses that are identified by Cutting et al. to depict: "(a) travel; (b) large and small scale temporal transition; (c) the early setup of a film; (d) altered mental states; and (e) celebrations of various kinds."[84] The authors argue that (a) and (b) are more likely to be found in earlier classical works, but that the remaining three are found in more often in contemporary work since "setups, altered states, and celebrations present collages of images that, by running together across a series of dissolves, create mood and atmosphere in a way that cannot be achieved through simple juxtaposition of shots through cuts."[85] In

Sideways, there are sequences of dissolving California landscapes where the duo's car is shown travelling through rolling vineyards. These interludes are used to characterize the area as idyllic and romantic, as well as a space for voice over dialogue to advance the narrative.

In an early scene at a restaurant, Miles and Jack take two available women – Maya Randal (Virginia Madsen) and Stephanie (Sandra Oh) – on a double date. Jack is hoping for one last fling before he gets married but claims the dinner is to celebrate the publication of Miles' new book (which, in fact, he has yet to receive a contract for). See Critical Commons, "External Rhythm: *Sideways*, Cluster or Serial Dissolves."[86] In this two minute sequence, Payne uses over 25 relatively long dissolves (interspersed with a few cuts) to create a "soft focus," romantic "wash" of one image over the next. Here the dissolves lend a slow, dreamy visual pattern to the warm table conversation, which centers on expensive wines, each of which is given its close up during the montage. Many of these dissolves blend close shots of the reflective surfaces of wine glasses or wine bottles with close ups of the four diners in warm, rose colored lighting. The initial effect is leisurely, tender and amorous, which sets up a shift later in the sequence for Miles, the insecure writer, to start obsessing about his ex-wife's recent marriage. As Miles begins to get tipsy, glances and slight gestures indicate that his dinner companions are worried about him. An incessant telephone ringing sneaks in under the dreamy jazz instrumental, and the sequence abandons the slow dissolves for short, flash-forward cuts to Miles dialing a payphone. The shift in tertiary rhythm is blunt, as the quick cuts move the sequence from romantic to anxious. Miles cannot live in the moment and connect with the woman he is with; instead, he has to leave the table to call his ex-wife and confront her about her new husband.

Later in the film, two scenes using dissolves provide a contrasting thematic use of external rhythm. See Critical Commons, "External Rhythm: *Sideways*, Two Dissolves."[87] The first scene is set in an emergency room waiting area, a place where time seems to naturally slow to a crawl. Jack has been beaten up by Stephanie for not disclosing that he is getting married, and as Miles waits for his friend, he calls Maya to clear up an argument they have had. It is an emotional low point in the film for Miles, as he admits to Maya in a voice mail that his book will not be published, and that "I am not much of a writer, I am not much of anything." Here a "held dissolve" lasts :20 seconds, as a close shot of Miles on the phone is mixed with a wider shot of the same action – then held as a superimposition – before dissolving through to the wide shot (Figure 8.17). The external rhythm here literally slows to a crawl, to emphasize Miles' moment of listless despair. Much like a sectional analytical montage, Payne temporarily arrests the progression of events with the "held dissolve" to carefully point out the significance of this moment. But rather than cutting to a *series of successive shots* to crystallize the moment, here the editor chooses the simultaneous presentation of the *same* event in shots of different scope, an unusual, but effective choice. The sequence ends with a long dissolve that returns Miles to the hospital waiting room, back to the place where time is still suspended, and Jack emerges in the distance with new stitches.

A second voice mail – this time left by Maya for Miles – sets up the film's ending. Miles returns to his apartment from another day of teaching to find a message from Maya. She is conciliatory telling him sweetly that she loved his book manuscript. As the camera pushes slowly in, Miles sits down to take it all in. Maya says, "Who cares if it's not getting published? There are so many beautiful and painful things about it." As the wide shot slowly dissolves in closer – a reversal of the earlier pay phone sequence – she asks a pointed question about whether or not the father in the novel committed suicide, a reference to the fact Miles considered suicide. As Miles contemplates this, his close up begins a long dissolve to windshield wipers and a subjective shot of a car rolling down the highway. Here, the transition is a :04 second dissolve, so the external rhythm of the transition is slow, but not suspended as in the "held dissolve." Yet the *internal rhythm* of the incoming shot is much more active, given the subjective forward motion from the car and the

Figure 8.17 External rhythm: held dissolve in Sideways *(Payne, 2008).* In an emergency room waiting
 area, Alexander Payne uses a "held dissolve" that lasts :20 seconds to mix a close shot of Miles
 Raymond (Paul Giamatti) with a wider shot of the same action. Much like a sectional analyti-
 cal montage, Payne temporarily arrests the progression of events to show the significance of
 this moment. It is an emotional low point for Miles, as he admits to failure: his book will not
 be published.

Source: Copyright 2004 Fox Searchlight Pictures.

wiper blades visually marking an *andante* or "walking tempo" – of roughly 75 beats per minute.
The slow transition creates a moment of curious dissonance: where is the film going? As the tran-
sition resolves into a rain-washed highway, Maya (still in "voice mail") shifts the talk to onset of
winter, offers to meet him if he gets up to wine country again, and tells him not to give up writing.
The film closes with three poignant shots: Miles climbs the stairs to Maya's apartment in a long
shot, his hand knocks on her door in close up, and after a beat, the film cuts to black, the final
dramatic thread neatly tied off.

Finally, as Cutting et al. note, the dissolve is often used to show altered mental states. In *Grand
Prix* (Frankenheimer, 1966) the mental fog of Scott Stoddard (Brian Bedford), brought on by his
use of painkillers, is shown in a series of long dissolves that depict the driver in his cockpit with
other racecars swirling around his car. As the sequence progresses, repeated shots of racecars in
a variety of scales following a variety of motion vectors creates a swirling plastic rhythm that
visualizes the driver's mental agitation. Rather than the warm romance of a wine dinner in *Side-
ways*, the dissolve here creates visual chaos, the sensation that "bees are buzzing" in the head of
the Scott Stoddard as he struggles to keep his car under control on the racecourse. The sequence
ends with a contrasting series of hard, graphic matches of racecars to bring the viewer back to
the reality of the dangers of the racecourse. See Critical Commons, "Graphic Edits: *Grand Prix*,
Super and Cut on Form."[88]

External Rhythm: Fades

Like the dissolve, the fade has a long history tied to magic lantern shows and emerged early in
motion picture history. Early cameramen would create fades manually, in-camera, by stopping
down the iris while they continued to hand-crank the film at a more or less continuous speed.
The fade is a "mix transition" using black as one source: it produces the gradual appearance of

an image from black or disappearance of an image to black. Not surprisingly, the fade-in marks beginnings, and the fade-out marks endings, like the raising and lowering of the curtain in theatre. In that way, a fade is more an indicator of duration, rather than a true transition from one shot (or spatio-temporal fragment) to another shot (spatio-temporal fragment). In that way, it is a unique and useful tool for narrative clarity where the filmmaker wants to clearly delineate one sequence from the next. As Christian Metz argues, the fade out is like a title card in the silent film because in both cases, the image track offers no *photographic* image. With title cards, the image track offers only written text, and in the fade out, even less:

> In the fade-out, [the image track] offers us nothing: the black rectangle is viewed far less as [a black rectangle] than as a brief instant of filmic void. Such a diminution creates its own strength. This singular void on the screen, in a filmic universe normally so full and so dense, by its very singularity leads us to assume a strong separation between before and after. The fade-out is perhaps the only true "punctuation" mark which the cinema possesses to date.[89]

An abiding interest in the dramatic use of the fade is found in work of the Polish filmmaker Krzysztof Kieślowski. His early documentary, *I Was a Soldier* (1970) ended each of seven interviews with blind soldiers from World War II with a fade to white, but concluded the film with a fade to black to emphasize their disability. Other films like *The Double Life of Veronique* (Kieślowski, 1990), *Three Colours: White* (Kieślowski, 1994) also employ the fade as a way to segment or suspend the film's forward motion. In *Three Colours:Blue* (Kieślowski, 1993), the first part of a trilogy inspired by the ideals of the French revolution, the fade is used as a sustained motif to help portray "a protagonist typical of art cinema: alienated, sensitive, with psychological problems and observed during an existential crisis. Like other great art cinema *auteurs*, Kieślowski is preoccupied with the exploration of the protagonist mind."[90] In the film, Julie (Juliette Binoche) recovers physically and mentally from a car wreck in which her husband, a composer, and her daughter were killed. She isolates herself in grief, and tries to cope with memories of her husband. The surprising discovery that her husband was having an affair, brings acceptance and an upward turn in her recovery.

As Julie negotiates her new life, Kieślowski fashions an inspired use of the fade to visualize how her husband's death is moving her towards spiritual transformation. At four points in the film, Kieślowski stops the scene to replay audio of a dramatic, unfinished concerto that her husband was composing when he died. The last occurrence of this interruption – when Julie learns from her friend Oliver (Benoît Régent) about her husband's mistress – is worth examining in detail. See Critical Commons, "External Rhythm: *Three Colors: Blue*, Fade out/in Suspends the Narrative."[91]

In a mundane conversation with Oliver, Julie learns that her deceased husband had been having an affair for several years with a woman who lives near Montparnasse. When Oliver asks her what she wants to do about it, her husband's concerto (once again) unexpectedly resounds in track as Julie opens her eyes, as if the attack of the music startles her awake. "The music of her husband suddenly returns in the moments when it is least expected. The recurring motif is not accidental. It is the word 'love' transformed into a few musical strains."[92] Two seconds later, the picture begins a slow fade out, and Kieślowski arrests any forward movement of the dialogue, with a hold in black for :11 seconds, roughly the duration needed for the motif to be played again by a single oboe. The music and blackout suspend us in the moment, and hold us there for what feels like a very long span of empty, black screen. At the same time, Oliver's question hangs in the air, suspended as spiritual confusion rushes over her: "What does she want to do?" As the music trails off, the shot fades back in, resuming just where it left off. Her repressed grief is past, but it is transformative: Julie turns decisively to answer directly, "Meet her." The scene holds a couple of beats, then cuts to Julie running up some stairs, now energized as she begins to

move beyond uncertainty. Here, the external, tertiary rhythm – including the non-diegetic music – overrides the limited primary motion of their ordinary conversation completely, and we feel the power of Julie's loss to suspend their interaction, and ultimately to alter her negative, downward trajectory of grief and isolation. The fade here "conveys the living from the outside world into the world of the dead. The effect is stunning in its spiritual uncertainty, especially given that these fade outs disrupt mundane scenes . . . [These everyday scenes] become significant only as these fragments of reality which lead to the reconsideration of such issues as memory, death, love and compassion."[93] By the end of the film, these powerful, suspended moments lead Julie to a new perspective based on love.

Wayne's World spoofs the conventional use of the fade out to finalize the ending of film when Wayne and Garth, sitting in their basement studio, reappear near the completion of the final credit roll. See Critical Commons, "External Rhythm: *Wayne's World*, Spoof the Fade Out."[94] They leaf through magazines as if in a waiting room, and Garth says, "I don't think anyone is going to tell us when to leave." Wayne replies, "Yeah, good call Garth. I guess we're going to just sit here until they fade to black." When the film finally fades out, Wayne says, "I told ya." This comedic use of the fade is part of a tradition that uses fades, irises, etc. in classic Hollywood comedy. We will turn next to this comedic tradition in the Laurel and Hardy film, *Thicker Than Water* (James W. Horne, 1935) as a technique to "break the fourth wall".

External Rhythm: Wipe

The wipe is a transition where the incoming shot moves across the screen to replace the outgoing shot, an overtly graphic transition that acknowledges the film image's two-dimensional representation of space. The transition appears early in film history, at least as early as the pioneering comedic trick film, "Mary Jane's Mishap" (George Albert Smith, 1903). In classical Hollywood films, wipes replace the more mundane dissolve with a graphic, visually imaginative way for an editor to transition between two different times and places. Or if the aim of a scene is to present action in a traditional split screen – left half, shot A, right half, shot B – the wipe can transition the film into and out of the split screen, regardless of how long we want to remain in the split screen between those two points. In that way it becomes a "held wipe," like the "held dissolve" discussed above. Given its overtness, the wipe is a technique used less frequently than the dissolve or fade: as we noted above, for transitions that are not cuts only 5% are wipes.

Like the spoof of the fade from *Wayne's World*, *Thicker Than Water* (Horne, 1935) a Laurel and Hardy comedy uses the wipe as a technique to "break the fourth wall" by bringing attention to the filmic conventions that ordinarily require the audience to suspend their disbelief. See Critical Commons, "External Rhythm: *Thicker Than Water*, Humorous Wipe Sequence."[95] At three points in the story, Laurel and Hardy interact with the borders of the film frame in *Thicker Than Water*, literally "dragging" the wipe border and incoming shot across the frame in order to change the scene or bring on the closing credits. This is *graphication* in Zettl's terminology, where "the three-dimensional lens generated screen image is deliberately rendered in a two-dimensional graphic, picture like format."[96] In contemporary television, graphication appears as superimposed titles, or "picture in picture" as two interviewees are shown adjacent to each other in what Zettl calls "second order space." In this instance, the graphication of the incoming shot is made more apparent because the incoming shot appears almost like a large photograph being dragged across the profilmic space. Clearly, a cut would be a faster transition and a dissolve a more traditional one, but here the timing of the wipe is driven by the primary motion of the scene: in the two scenes where Oliver Hardy drags the wipe through the scene (Figure 8.18), the pace is leisurely and the joke dawns over the duration of his walk while Stan Laurel's is more frantic as he rushes Hardy to the hospital. Here, breaking this fourth wall is a funny, technical, visual gag, and it is part of a longstanding Hollywood strategy, particularly in animation and special effects films, to keep cinema a "perpetual novelty."

Notice too that wipes are often used in intertextual films where the source material is a graphic form like the comic book or illustrated fairytale. Used this way, the wipe mimics design elements that are extradigetic in the source material – the page turn of a fairy tale book, the page composition of a comic book that uses a split panel or overlapping images. A typical use of a wipe in an intertextual film is found in the Columbia Pictures serial *Superman* (Carr, 1948). In "Man of Steel," episode four, Lois Lane (Noel Darleen Neill) is captured and taken blindfolded to the headquarters of Spider Lady, "mysterious queen of the underworld." See Critical Commons, "*Superman* Wipe."[97] Lois is a reporter who knows too much, Spider Lady has her henchmen place her, still blindfolded, next to the magnetic/electric cobweb. As Lois begins to fry in the web, the film wipes in the manner of a "clock hand ticking" to the next shot of Clark Kent (Kirk Alyn) and cub reporter Jimmy Olsen (Tommy Bond) driving in a car unaware of the danger that Lois is in. This round wipe is more apparent because its circular movement maps the graphic shape of the Spider Lady's web, a dynamic representation of time passing that energizes the transition much more than a straight cut would. Harry Benshoff argues that the wipe, like the dissolve, signifies a change of time and place, but that

> the wipe is a more action oriented device (and is thus used heavily in action adventure movies like *Star Wars* [1977]). A wipe might best be considered an iconic sign in that it uses graphic qualities to create meaning: in this case "exciting movement" as the scene changes, as opposed to the "lazy tranquility" signified by an extended dissolve between scenes.[98]

The wipe, despite its value as a transition for graphication or intertexuality, remains relatively rare: in the Cutting et al. study, the dissolve was used almost 14 times as often as the wipe. And yet, some

Figure 8.18 External rhythm: humorous wipe in Thicker Than Water *(Horne, 1935).* At three points in this film, Laurel and Hardy interact with the borders of the film frame, literally "dragging" the wipe border and incoming shot across the frame in order to change the scene. This is *graphication* where the screen image is deliberately rendered as a two-dimensional graphic. Here, the technique is used to "break the fourth wall," part of a longstanding Hollywood strategy to keep cinema a "perpetual novelty."

Source: Copyright 1935 Metro-Goldwyn-Mayer.

directors have come to relish the wipe. Akira Kurosawa, the famous Japanese filmmaker, routinely used the wipe throughout his career, even as it was becoming an anachronistic transition. Beginning with his first script for *Bravo, Isshin Tasuke!* – directed in 1945 by Kiyoshi Saeki – Kurosawa indicated a sequence of comic stances linked by wipes to introduce a character in the film. *Sanshiro Sugata* (Kurosawa, 1943), his directorial debut uses "Rapid but unemphatic wipes, in both horizontal and vertical directions, [which] either link actions within the scene or relate successive events."[99] In later films like the highly acclaimed *Rashomon* (Kurosawa, 1950) – a film that brought international awareness to Japanese cinema as the unexpected winner of the 1951 Venice Film Festival – the director "freely uses the wipe cut, a visual device common in many traditions of silent film but generally suppressed within the classical sound cinema and its codes of realism."[100] An examination of Kurosawa's uses of the wipe in *Rashomon* will reveal its impact on tertiary rhythm.

Rashomon is a mobile narrative that tells the story of a rape and murder in the woods from four points of view: a woodcutter, a bandit, a samurai's wife and the ghost of the samurai who has been murdered. To complement the film's sweeping, kinetic camera style, there are five standard wipes in *Rashomon*: four created by a vertical border moving from screen left to screen right and one moving in the other direction. See Critical Commons, "External Rhythm: *Rashomon*, The Wipe."[101] Two of these wipes are used as transitions for shots of a character running, and they clearly increase external rhythm. Early in the film when the woodcutter (Takashi Shimura) finds the dead body, he flees in horror. Kurosawa cuts to three rapid pan shots taken with a long lens, framing each tighter as the woodcutter runs through the underbrush. The three pan shots are all roughly :03 seconds long. The series ends with a wipe that continues the motion vector (left to right) of the woodcutter's scramble through the brush, before resolving into a fixed medium shot of the woodcutter testifying as he kneels to face his inquisitor in a prison yard (Figure 8.19).

Figure 8.19 External rhythm: the wipe in Rashomon *(Kurosawa, 1950).* As the woodcutter (Takashi Shimura) runs through the underbrush in fear, Kurosawa wipes to a fixed medium shot of him testifying about what happened as he kneels to face his inquisitor. In this instance, the wipe edge follows behind the runner leading to the incoming shot, matching his primary motion in direction and speed.

Source: Copyright 1950 Daiei Film.

In Noël Burch's scheme, this is a "Temporal Ellipsis, Spatially Discontinuous Radical" change that, if made with a cut, would be unexceptional. But in this instance, the wipe edge *follows behind the runner* leading to the incoming shot, matching the primary motion in direction and speed. Similarly, when the bandit (Toshiro Mifune) later lures the samurai (Masayuki Mori) into the woods and ties him up, Kurosawa uses the left to right wipe to *overtake the runner* as the bandit pulls up from his run to turn and laugh at the samurai he is leaving behind. In both instances, since the primary motion is a rapid, energetic run of the character from left to right as the camera pans to keep them framed, the wipe as a transition becomes a kind of "force magnifier" – like a lever is a force magnifier – to increase the tertiary motion beyond what a simple cut could achieve. Accenting a running character with a wipe is part of the kinetic style Kurosawa brings to forest settings in *Rashomon*, drawing on a wide range of camera positions and camera movements, extreme fluctuations in shot scales, and impressionistic elements like shots of sunlight slashing through the tree branches.

The remaining three wipes in *Rashomon* are simple transitions from static shot to static shot, although one of the shots tilts down to the samurai's wife (Machiko Kyō) after the wipe is complete. Unlike the running shots that seem to naturally suggest the use of the left to right wipe, the use of the wipe in these static shots seems a less intuitive transition, more an anachronistic device. Kurosawa acknowledged his connection to silent films when he said, "I like silent pictures and I always have. They are often so much more beautiful than sound pictures are. Perhaps they had to be. At any rate, I wanted to restore some of this beauty [in *Rashomon*]."[102] Donald Richie goes further, suggesting "The [wipe] is relatively uncommon in modern cinema and yet is so consistently used by Kurosawa that it seems to have a definite meaning for him. Perhaps it is its finality that appeals, this single stroke canceling all that went before, questioning it, at the same time bringing in the new."[103] Richie's reading of the wipe's significance is a better fit with the testimony in the prison yard: as one witness concludes, the "page is turned," ceding a "clean slate" to the next witness.

A mere two years later in *Ikiru* (Kurosawa, 1952), Kurosawa again deploys the wipe in a humorous sequence where a group of women hoping to drain a cesspool in their neighborhood are given the runaround by bureaucrat, after bureaucrat, after bureaucrat. Here, a series of 16 wipes function as a humorous "accented narrative connective to designate *ongoing* events."[104] Kurosawa is more ruthless with the shot length in the opening of the sequence, and the ability of the wipe to augment the tertiary motion in the sequence is initially more apparent. Later, as the dialogue dominates, the wipes seem to be used more as a matter of humorous consistency within the sequence, which ends as the complaint rises up the bureaucratic ladder to the Ward Representative, the Deputy Mayor, and then back down to newly established Department of Public Affairs. See Critical Commons, "External Rhythm: *Ikiru*, Humorous Wipe Sequence."[105]

As we have seen, wipes are often used as graphic transitions that draw on visual elements from within the outgoing shot to transition to the next shot in ways that *map the incoming shot onto the outgoing shot.* In the Laurel and Hardy movie above, that transition can be somewhat broadly executed – the incoming shot is dragged across the screen. In more contemporary films, that "mapping" can become very precise, adding creative complexity to the spatio-temporal relationship from outgoing to incoming shot. *Highlander* (Mulcahy, 1986) brought the MTV aesthetic of the 1980s to the "sword and sorcery" genre, and launched a franchise that produced five sequels and a television series. The film tells the story of a climactic battle between timeless warriors, and knits present day action and battles in the sixteenth-century Scottish highlands by following the character Connor MacLeod (Christopher Lambert). MacLeod, one of a group of immortal swordsmen, is living now as an antiques dealer in New York City under the alias Russell Nash. After a sword battle in a parking garage, Nash returns to his apartment. He looks at a book by Brenda Wyatt (Roxanne Hart), one of the detectives investigating the attack in the garage. He thinks back to the Scottish highlands, many centuries earlier, when his mentor Juan Sánchez Villa-Lobos Ramírez (Sean Connery) first taught him to fight with a sword. See Critical Commons, "External Rhythm:

Highlander, Spatially Integrated Wipe."[106] The camera moves past Nash, sharpening one of his blades, as he recalls one of Ramírez's adages: "Sometimes, MacLeod, the sharpest blade is not enough." As the camera tightens and tilts upward to an aquarium located behind him, a rippling edge of water maps the incoming shot onto the aquarium in an "spatially integrated wipe." As a result, the camera appears to rise from present day apartment/aquarium space into an ancient Scottish loch (Figure 8.20), where we find Ramírez training MacLeod to balance by standing in a boat. It's a flashy transition, and the rhythm of the wave line passing across the screen enlivens the moment with its own energy, capitalizing on the matched camera moves in each shot in a way that the "lazy tranquility" of a simple dissolve could not. The overt quality of the wipe is nowhere more apparent than here, because the wave line – the line of the wipe itself – coupled with contrasting colors – the warm, yellow "underwater" of the aquarium and the cold blue surface of the loch – creates a moment of cognitive dissonance with its spatial ambiguity. In the outgoing space, the viewer is "outside" the aquarium looking in, and when the incoming space "resolves," we are on the surface of a loch, but for the duration that the wipe crosses the screen, we are simultaneously in *both spaces*: outside the aquarium *and* rising up from underwater at the loch.

External Rhythm: The Iris

Around 1913, the "iris-in," a new kind of transition first appeared in motion pictures. The "iris-in" masks the outgoing shot off into a circle (typically, though diamonds, triangles and rectangles are possible) that decreases in size until the entire frame is black. If the incoming shot reverses the process to bring the incoming image from black to full screen, the transition is called "iris-in/iris-out." Between 1914 and 1919, D. W. Griffith used the technique extensively, and given his stature as a director at the time, is credited with popularizing the technique throughout the industry. Barry Salt notes that, throughout this period, Griffith's cameraman, Billy Bitzer, continued to use a Pathé camera, which did not have a shutter capable of in-camera fades, and so the in-camera,

Figure 8.20 External rhythm: spatially integrated wipe in Highlander *(Mulcahy, 1986).* As the camera tightens and tilts upward to an aquarium located behind Connor MacLeod (Christopher Lambert), a rippling edge of water maps the incoming shot onto the aquarium in a "spatially integrated wipe." As a result, the camera appears to rise from present day apartment/aquarium space into an ancient Scottish loch in an energetic way that the "lazy tranquility" of a simple dissolve could not.

iris-in/iris-out remained a common method for their transitions between scenes.[107] The iris transition typically moved to or from the center of the frame, but came to be used as a way to focus the viewer's attention on an area of the screen at the beginning or end of the effect, by positioning the iris mechanism so that the circle would move to or from the point of interest before the camera. So, for example, the iris might close in on the principal actor's face, and hold there for a beat before closing the rest of the way to black. By modifying the composition in a single shot, the "isolation effect" of this type of iris-in is similar to a zoom in, except without the magnification of the image.

The Artist (Hazanavicius, 2011) is a French film that mimics the style of silent films with a range of aesthetic choices including the use of title cards, vignettes, black and white cinematography, wipes and iris transitions. The film tells the story of an aging silent film star, George Valentin (Jean Dujardin) who struggles to make the transition to the new era of talkies, while watching the rise of a new, young female lead Peppy Miller (Bérénice Bejo). The film was nominated for 10 Academy awards and won five, including Best Picture, Best Director and Best Actor for Dujardin. Hazanavicius uses the iris eight times as a stylistic device to create a range of effects in the film. See Critical Commons, "External Rhythm: *The Artist*, Iris Transition and Circular Motif."[108]

After a title card announces "1923," the opening iris-out not only launches the narrative, it also functions as a match on form, match on position to George Valentin's mouth, screaming in melodramatic agony as he is strapped in a chair and tortured by arcing, electrical current striking his head. Here, the device serves as an early stylistic flourish, a poetic embellishment to launch the silent film aesthetic that will permeate the film.

Later, as Valentin leaves his dressing room on the studio lot with his dog, the camera tilts down to a photograph of the screen idols that Valentin has autographed with "Woof!" and a dog print (Figure 8.21). The iris-in that closes the scene slows the external rhythm as the scene draws to close: the closing black circle imparts its leisurely duration as the shot deliberately resolves into black. It also lends a timeless, romantic quality to this vintage 1920s icon of stardom. The incoming shot continues that notion by fading in on "the sky," which a pan reveals to be a piece of painted scenery on the studio lot, a further suggestion that the Hollywood "dream factory" is more about surface than substance.

Valentin refuses to admit that the silent era is ending, and risks his entire fortune on one last silent picture that he will direct and star in. When the picture is complete, he chooses October 25 for the film's premier, only to discover that Peppy Miller's new talking picture will debut the same day. Here, a soft-edged circular vignette is held as the camera tilts up to the date on the poster, emphasizing Valentin's feeling of dread when he discovers the same release date on Peppy's film poster. The circular form mimics a kind of "tunnel vision" that represents Valentin's acute visual focus on their impending box office showdown. A similar soft-edge vignette is used as Peppy, who has come to the hospital to nurse the despondent Valentin back to health, looks back nostalgically on a reel of film from an early dance number they performed together. A circular wipe ends the iris/circular motif in the film, as Peppy heads off to work shooting a new picture at the studio, while Valentin recuperates in bed, trapped in the monotonous luxury of her Hollywood mansion.

Like the fade, Metz argues that the iris-in has a dual nature:

> If we consider that part of the image which remains visible to the end, it is an exponential process, the exponent here being the black halo which closes on that which we continue to see. But if we consider that invading black, in itself soliciting attention, the iris reveals itself to be related to the fade-out – which in fact it replaced – in the history of the cinema, [in] most of its functions. And it is, to a certain point, the iris as such which occupies the corresponding segment of the film.

In other words, the iris-in is a "circle becoming smaller," a transition that introduces a "black halo," while at the same time creating a moment of black in the image track that is a non-

Figure 8.21 External rhythm: the iris in The Artist *(Hazanavicius, 2011).* As George Valentin (Jean Dujardin) leaves his dressing room on the studio lot with his dog, the camera tilts down to a photograph of the two screen idols. The iris-in that closes the scene slows the external rhythm as it slowly, deliberately resolves into black. Here, the device serves a poetic embellishment that references silent film aesthetics.

Source: Copyright 2011 Warner Bros.

photographic marker distinguishing one scene from another. The iris-in *The Artist* does all this and more. It serves as a "black halo" that slows external rhythm as the film transitions between scenes. Like the fade, it marks a non-photographic break between scenes. And stylistically, it openly "quotes" from silent films as part of a larger strategy to ingrain a distinctive period feeling within the piece.

Graphic Relations in Editing

As noted earlier, one of the most basic aspects of continuity cutting is that shots made in color have to match in overall exposure level and color balance, otherwise they cannot intercut seamlessly. Anyone who has struggled to edit the footage of beginning cinematographers learns how frequently this foundational principle is ignored. Or to think of it another way, one of the primary responsibilities of the cinematographer is maintaining *consistency within a scene*: shots that will be cut together have to be in a range of brightness and color values so that they can – with the help of color correction at the end of the editing process – be seamlessly cut together. So, for example, when the cinematographer brings large scale lighting to an outdoor setting – 24k HMI fixtures with tremendous daylight balanced output – one goal is to ensure that there is consistency in brightness and color balance available to create footage that has consistent "daylight," as the sun's direction and intensity changes over the course of a day's shooting. As Bordwell and Thompson put it, "The director will usually strive to keep the main point

of interest roughly constant across the cut, to maintain the overall lighting level, and to avoid strong color clashes from shot to shot."[109] Graphic concerns, as we noted above, will always remain in a continuity editing system where spatial and temporal concerns tend to dominate our notion of the "match cut."

Beyond the concern for technical consistency, Bordwell and Thompson point out that the formal elements of any shot offer an immense range of possibilities to emphasize the graphic relations between shots:

> If you put any two shots together, you'll create some interaction between the *purely pictorial* qualities of those two shots. The four aspects of mise-en-scène (lighting, setting, costume, and the movement of the figures) and most cinematographic qualities (photography, framing, and camera mobility) all furnish graphic elements. Every shot provides possibilities for purely graphic editing, and every shot-change creates some sort of graphic relationship between two shots.[110]

Further, they note that the primary possibilities for editors to take advantage of are "graphic matches" and "graphic clashes." See Critical Commons, "Graphic Edit: *The Birds*, Graphic Contrast."[111] In their very useful analysis of the scene from *The Birds* (Hitchcock, 1963) where Melanie Daniels (Tippi Hedren) sees a gas pump explode, Bordwell and Thompson give complete explication of how the graphic clashes are created from shot-to-shot by contrasting Melanie's static index vector with the dynamic motion vector of the flames spreading across the gasoline flowing down the street.[112] We will focus more on graphic matches[113] here, since they activate some of the most memorable and justifiably famous cuts in the history of film.

First, we should note that the word "match" is used in many different ways in reference to editing, but the concept of "graphic match" carries two notions: "cut-on-form" and "cut-on-position." A cut-on-form matches the shape or shapes prominent in the outgoing shot with those of the incoming shot. Notice that, at some level, *all* match cuts are cuts-on-form, since when we cut from a wide shot of someone pointing a gun to closer shot of that action, the form of the gun repeats in both shots. However, the term "cut-on-form' is usually used in reference to cuts that stand out as exceptional for a higher degree of equivalence (and frequently, metaphoric expressivity) than the garden variety "match cut." Often, these exceptional graphic matches also "cut-on-position." To cut-on-position means to map the location of a point of visual interest in the outgoing shot (i.e., that point's x,y coordinates if we consider the screen in Cartesian terms) to that same location on the incoming shot. To describe the effect of a cut-on-position on the viewer, we commonly use the term "eye-trace" or "eye-guiding," since the edit leads the viewer to look in a particular place across a cut or other transition.

The ingenious film pioneer Buster Keaton used the graphic match to great effect in his film comedy *Sherlock Jr.* (Keaton, 1924). See Critical Commons, "Graphic Edits: *Sherlock Jr.*, Cut on Form and Position."[114] In the film, Keaton falls asleep at his job as a projectionist and dreams he "enters" a film playing in the auditorium below. Once he is "inside" the filmic space projected on the screen, he moves through a number of scenes that change suddenly, creating gags where he nearly falls off a cliff, dives in to a snow bank, etc. Through careful cinematography and staging, Keaton is photographed so that he is in the same position on the last frame of the outgoing shot and the first frame of the incoming shot; thus, while his foreground action is closely matched, a new camera set up ensures that the background scenery changes completely. In essence, the footage was staged and shot to allow *seamless cutting of the foreground only*: a "cut-on-form" – that is, *Keaton's body*, performing the same action at the same image scale in the footage – and "cut-on-position" – that is, *Keaton arranged in exactly the same place in the frame* – for each different scene. As the shot changes, the viewer reads Keaton's foreground action as *continuous* – matched action so cleverly done that it is "invisible" – while the background is *discontinuous*, changing

instantaneously as if by magic. It is as if time and space in the foreground is unhooked from the changing background. In *The figure in film,* N. Roy Clifton identifies this edit as the cinematic equivalent of *anadiplosis,* a rhetorical figure in which the last word of a line is carried over in the next line, as in these lines from *Richard III*: "My conscience hath a thousand several tongues, And every tongue brings in a several tale, And every tale condemns me for a villain." Clifton calls this cinematic figure of style the *carry over dissolve* (though in Keaton's film, it is a cut).[115] In *Sherlock Jr.,* Keaton painstakingly creates an inventive sequence of pratfalls that "plays with" the film medium itself by constructing what must be one of the purest examples of graphic editing in film.

A more modern, less rigorous use of graphic editing is found in "Love for Sale," a Talking Heads music video embedded in their cult feature film, *True Stories* (Byrne, 1986). The song does not do much to advance the film's loose narrative; rather, it is a contained segment within the film to simply parody the camera and editing styles of television advertising. In the film, Miss Rollings (Swoosie Kurtz), a character who never leaves her bed, flips the channel to find the Talking Heads video "Love for Sale" playing, and is immediately captivated by the band. The song, which pokes fun at how television advertising mixes ideas of romance, desire, arousal and commerce, is summed up by the verse "Push my button . . . The toast pops up, Love and money, Gettin' all mixed up."[116]

The video intercuts actual television ads with footage of the band that mimics the staging and cinematic style of the ads. Specifically, the video stages the band members in shots that foreground the use of abstract motion vectors, slow motion photography, high key lighting and the reflective glitz of food styling in television spots. The video is rich with graphic matches. For example, founding member and bass player Tina Weymouth, dressed entirely in bright red, is staged and photographed to graphically match two shots of an airliner moving right to left across the screen. The three-shot sequence shows a Pan Am jumbo jet entering frame right, which cut, on-form and (precisely) on-position to a full body shot of Weymouth standing erect but rotated 90° to match the plane's movement, followed by a cut that is less precisely on-form and on-position to another airliner, a Purolator Courier plane with red lettering following the same motion vector. Later, an extreme close up of a lipstick, centered in frame and rotating as it extends from its case is followed by a shot of the red-clad Weymouth, centered in frame and rotating the same direction, a graphic match again carried by similarities in form, position and action.

Stylized, slow-motion food photography is parodied also in a sequence that uses two existing ad shots of cookies being slowly broken in half to feature their soft interiors. The existing shots are extreme close ups featuring fingers gripping and breaking the cookies apart. These shots are matched with animated hands holding the band members – lip syncing the song – as they are separated, with their animated movement matching the existing shots less on form than on-position and motion vector. More shots of round cookies dipped in milk and broken apart follow, and the video concludes with a slow-motion sequence where the band members mimic the languid descent of peanuts into a vat of milk chocolate. Throughout, the absurdity of the band's antics mocks the way in which television ads use stylized cinematic techniques to create a surface of fabricated desire, without any real attempt to create significant, metaphorical linkages across the graphic edit. At under four minutes, it is a quirky, upbeat, visual exposé of the genre, laying bare the methods by which television ads try to arouse and satiate the viewer. Made for the feature, the video was later recut and distributed on MTV without intercutting to Rollings lying in bed.

A more subtle use of graphic matching is found in Kurosawa's adaptation of *King Lear,* the Shakespearean tragedy: *Ran* (Kurosawa, 1985). The film opens with a boar hunting expedition in ancient Japan, and Kurosawa establishes the Lear character – Hidetora Ichimonji (Tatsuya Nakadai) – as an aging warlord who has unified a large territory and fathered three sons. A critical part of the *mise-en-scène* is the triadic color scheme of the sons' hitatare. Their vibrant red, blue and yellow hitatares are evenly spaced apart on the color wheel, conveying their distinctive

personalities, while the father's hitatare of white – the mixture of all colors – suggests the idea that he is the unifying source of the spectrum he has fathered. Throughout these opening scenes, the aging Ichimonji, with his white hair and robe, will be associated with pointed cuts to images of clouds. See Critical Commons, "Graphic Edits: *Ran*, Cut on Form and Position."[117]

After killing a boar, the Lord and his guests enjoy a picnic, and Ichimonji drifts off to sleep in front of his three sons and his hunting guests, leaving them to withdraw so that he can nap. Ichimonji sleeps seated, slumped towards the left of the frame in a stable, centered triangular composition.

Figure 8.22 Graphic edit: cut on form and position in Ran *(Kurosawa, 1985) Outgoing shot.* A subtle use of graphic matching is found in *Ran*, where an aging Hidetora Ichimonji (Tatsuya Nakadai) with his white hair and robe . . .

Source: Copyright 1985 Toho Co., Ltd.

Figure 8.23 Ran, *incoming shot* . . . will be associated with pointed cuts to images of clouds.

Source: Copyright 1985 Toho Co., Ltd.

Kurosawa holds the shot for roughly :04 seconds (Figure 8.22), and then cuts to a shot of a towering white cumulus cloud for roughly the same duration (Figure 8.23). The incoming shot is a cut-on-form, since the cloud is roughly triangular, and arcs slightly to the left, mimicking the Lord's slump. It is also a cut-on-position, since both are roughly centered and stably placed at the bottom of the frame. But within a *mise-en-scène* that has carefully articulated the color relationships between father and son, the connection of the two shots by use of the color white is what makes the graphic connection "read." Kurosawa's initial visual metaphor resonates: the sleeping king is both a towering eminence and an ominous sign of a potential storm brewing. Once established, this king/cloud metaphor works in subsequent iterations, even though those are not as "matched" as this combination is graphically.

A short time later, Ichimonji springs from his nap to find the hunting party. He recounts a disturbing dream he has had of walking in a desolate land, unable to find another soul. His three sons are concerned by his unusual behavior, and worry that he is either mad or becoming senile. Ichimonji orders the entire hunting party to assemble for an announcement he has to make. Kurosawa cuts again to the towering cumulus cloud, centered and roughly triangular, this time rising rapidly in the frame through time lapse, making a further graphic connection to the white clad Lord. Perhaps a storm is indeed brewing.

Ichimonji announces to the assembled hunters that he will cede his throne to his eldest son, and the fault lines among his sons and vassals erupt immediately. He becomes so enraged that he banishes his son and one of his advisers from his kingdom, and the scene ends as he turns his back on the group. With everyone facing away from the camera, Kurosawa again holds the shot – this time for :10 seconds – before cutting to a darker, rounded cloud centered at the bottom of the frame with rays of light emanating from it. Here, the centered, stable *position* of the cloud matches the centered stance of Ichimonji, while its *form* echoes the shape of the group, their backs flattened into a graphic mass by the telephoto lens. The triple iteration of King/cloud is graphic matching at its best: a visual metaphor that is evocative of the emotional arc of the scene.

Later in the film, Kurosawa creates another striking graphic match as Ichimonji searches the castle of his son Jíro (Jinpachi Nezu) for Lady Sué, (Yoshiko Miyazaki) a devout Buddhist and the most spiritual figure in the film. When the king opens the door to her residence, Kurosawa axially cuts into a close shot of a golden image of the Buddha hanging on her wall, and then to Sué nearby, standing on the castle wall chanting to the Buddha. The graphic match here is very strong, carried by the form, position and strong color match of the two images. Lady Sué is steadfast in her faith, even after Lord Ichimonji tells her, "Buddha is gone from this miserable world."

While Kurosawa's use of the graphic match often centers on color scheme, in more traditional Hollywood films, the graphic match is often more overt. In *All that Jazz* (Fosse, 1979) a series of cuts connects action, form and position to create a short burst of energy within an extended audition sequence that appears early in the film. Joe Gideon (Roy Scheider), a Broadway producer, is under stress about a new show he is trying to open, and after his morning hit of eye drops and speed, he goes to an audition to whittle down a massive group of aspiring singer/dancers that show up in order to cast the show. This rhythmic scene, cut to jazz guitarist George Benson's version of *On Broadway*, opens with high angle long shots showing long rows of dancers crammed onto a stage that will gradually empty as the scene progresses over the next 4:30. The shot selection in the scene is extensive and highly kinetic, and the editing of the scene modulates between dynamic dance movements and quieter moments where Gideon dismisses dancers who do not make the cut. See Critical Commons, "Graphic Edits: *All that Jazz*, Cut on Form, Position and Motion."[118]

The scene begins to build as the cast is pared down to the most talented dancers who go through the dance routine with increasing precision. Groups of dancers leap through the frame in unified formations, followed by single dancers somersaulting high in the air or leaping into a mid-air split.

Figure 8.24 Graphic edit: cut-on-form, position and action in All that Jazz *(Fosse, 1979) Outgoing shot.*
In this scene, 11 cuts of dancers auditioning are matched action, cut-on-form, cut-on-position.
The effect is as if the dancers are fused into a single "spinning top," a precise but anonymous
"dancing machine" that electrifies the space before the camera.

Source: Copyright 1979 20th Century Fox.

Figure 8.25 All that Jazz, incoming shot.

Source: Copyright 1979 20th Century Fox.

Fosse then launches into a quick cut sequence that fuses 11 rapid cuts of dancers executing jazz
pirouettes, spotting directly towards the camera so that their eyes are fixed forward. The cuts are
very short: the longest shot is 15 frames, where a dancer pirouettes through two revolutions, and
the shortest shot is only eight frames, with an average shot length of just eleven frames. All the
cuts maintain the spin of the body from shot to shot. If we imagine looking down at the camera
set up from above, as if the dancer is at the center of a clock face, and the camera is at 6 o'clock,
most of the cut points fall there – six in total – where the "spot" towards the camera is ending
and the dancer's head is beginning to turn (Figures 8.24 and 8.25). Three other cuts are made
when the dancer is turned away from the camera at 12 o'clock, and two are made with the dancer

spinning at the 3 o'clock position. The camera is not locked down, which suggests that perhaps this edit was not planned at the shooting stage, but only emerged in the edit. At any rate, because all the cuts are matched action, cut-on-form, cut-on-position, the effect is as if the dancers are fused into a single "spinning top," a precise but anonymous "dancing machine" that electrifies the space before the camera. A similar effect is created in *Seven Samurai* (Kurosawa, 1954) when Kikuchiyo (Toshiro Mifune), feeling insulted by the villagers who hide in their homes when the samurai arrive, sounds the alarm that the village is under attack, creating a panic. The other six samurai rush to protect the center of the village, and Kurosawa cuts together six, tightly framed telephoto pan shots of the samurai running from left to right atop a ridge. The shots are all under :01 second, with the longest 22 frames and the shortest 12 frames for an average shot length of 15 frames. The samurai lean into their runs, and the shots are highly kinetic, since the pan is swift and the grass rushing by in the foreground of each shot creates a soft focus blur. The rapid primary motion and short length of the six shots, rather than precise cuts-on-position, fuses the shots together much like the sequence from *All that Jazz*, suggesting both their bravery and their emergence into a unified fighting force. See Critical Commons, "Graphic Edits: *Seven Samurai*, Cut on Form and Position."[119]

Overtly metaphorical uses of the graphic match have become some of the most famous edits in film history, well known exemplars of imaginative cutting to create meaning. Like Eisenstein's juxtaposition of shots of Alexander Kerensky with shots of a mechanical peacock that mock his vanity (see Chapter 5, p. 158), these graphic edits carry clear metaphorical meaning through juxtaposition. But what is different in these metaphorical, *graphic* edits is that the interaction of the two shots juxtaposed centers around their pictorial qualities. For example, the famous shower sequence from *Psycho* (Hitchcock, 1960) ends with a push in on the water rushing down the drain that dissolves to an extreme close up of the eye of Marion Crane (Janet Leigh), a woman running from a crime she committed by stealing money from her boss. See Critical Commons, "Graphic Edits: *Psycho*, Dissolve-on-form, Dissolve-on-position."[120] Here, the dissolve suggests time is passing, the shower is still running, but more importantly that death has suspended time. The circular form of the drain is carefully centered over Marion's eye so that the form and position matches are nearly perfect, and the darkest part of the drain shot lines up closely to Marion's iris. In fact, to match the size of her eye more closely to the drain shot, a single frame of film was enlarged in the optical printer to create a closer match. In addition, this freeze frame is rotated in the printer so that the incoming shot is not a "kinetically dead" freeze, but has a bit of motion to it. The vortex in the drain rotates in one direction and her eye the opposite, as the optical move begins to "zoom out." Beyond the metaphor of Marion's life force draining from her, other writers claim larger issues at work. The dissolve to her eye signifies death, "an emblem of final hopelessness and corruption . . . Marion's blood swirling into the black void of the tub drain ends the descent into darkness that began when she decided to make off with [another's] cash."[121]

Perhaps the most famous graphic cut of all is found in *2001: A Space Odyssey* (Kubrick, 1968). The first 20 minutes of the film opens, without dialogue, on the African veldt millions of years ago, as a tribe of primitive ape/men interacts with a strange black monolith and discovers how to use bone tools. During a confrontation at a watering hole, the dominant ape/man, identified as "Moonwatcher" (Daniel Richter) in the credits, kills an ape/man from another tribe with a long femur bone. See Critical Commons, "Graphic Edits: *2001*, Cut on Form and Position."[122] Kubrick cuts to a slow motion shot of Moonwatcher as he tosses his weapon high in the air. As the bone leaves the frame, Kubrick follows with two short, slow-motion close ups: one in which the bone continues its rise in the air, exiting the top of the frame, and a second shot in which the camera tilts up, following the bone (now spinning in the opposite direction) to the apex of its flight, and back again as it begins to fall back to earth. The famous cut that follows is to a futuristic space ship, "falling" though space in almost the same trajectory. At one level, this graphic cut is jarring pictorially, as the value of the background changes from light to dark, from the outgoing shot of

the bone against blue sky to the incoming shot of the ship against the black, star-strewn void of space. Likewise, both the cut-on-action and the cut-on-position are imprecise matches: the bone rotates in the outgoing shot, the spaceship does not in the incoming shot, and the position of the two intersects only at the left tip of each (Figure 8.26).

Kubrick scholar Michel Ciment writes that "The bone cast into the air by the ape (now become a man) is transformed at the other extreme of civilization, by one of those abrupt ellipses characteristic of the director, into a spacecraft on its way to the moon."[123]. By the end of the film, Kubrick has continued this technological progression across millennia, culminating in the HAL 9000, a computer with a desire to serve humans, and ultimately to dominate them. This progression – launched by a remarkable edit – shows "the series of equations by which Kubrick makes ape equal to man, and man to machine, the better to undermine the complacency of his audience."[124]

Conclusion

Continuity editing is the "default mode" of editing, a system of cutting that renders the time and space taken from disparate shots as "continuous." While spatial and temporal clarity tend to dominate in continuity editing, the change in rhythmic and graphic parameters form shot to shot will always remain potential areas for creative expression. Filmmakers who exploit filmic rhythm by shaping internal and external rhythm, who take advantage of the capacity of the latent graphic relations between shots, can move beyond spatial/temporal representation to transform their "aesthetic canvas" into a full expression of their underlying theme. This is a broad goal, but Karen Pearlman has specifically addressed the application of rhythm in editing in very practical terms:

> Shaping event rhythm relies, in the first instance, on knowledge of the audience the film is addressing and their likely physical rhythms, rates of assimilation of information, and expectations of change. The editor uses this knowledge, and her own feeling for sustaining the tension of dramatic questions, to organize the plot events into a rhythmically coherent and compelling structure. To shape event rhythm effectively, the editor has to continually refresh and retrain her awareness of her own kinesthetic responses to the movement of the events in a film.[125]

Figure 8.26 Graphic edit: cut-on-form and postion in 2001: A Space Odyssey *(Kubrick, 1968).* A well known graphic edit in this film cuts from a bone tossed in the air by apes to a spaceship millions of years later. Here for illustration, the last frame of the outgoing shot is superimposed with the first frame of the incoming shot. This graphic cut is slightly jarring, as the value of the background changes from light to dark, and the cut-on-action and the cut-on-position are imprecise matches.

Source: Copyright 1968 Metro-Goldwyn-Mayer.

The graphic potentials of editing are perhaps more elusive for the editor to uncover, unless they have been carefully crafted during production. But they are some of the most memorable, effective edits available because of their opportunity to challenge the viewer to visually connect two shots in ways that would have been missed had they not been juxtaposed.

Notes

1 David Bordwell, Kristin Thompson and Jeff Smith, *Film art an introduction* (New York, NY: McGraw-Hill, 2017), 219.
2 Erwin Panofsky, Irving Lavin and William S. Heckscher, *Three essays on style* (Cambridge: The MIT Press, 1997), 96.
3 Michael Betancourt, *Beyond spatial montage: windowing, or the cinematic displacement of time, motion, and space* (New York: Routledge, 2016), 74.
4 Paul Messaris, *Visual "literacy": image, mind, and reality* (Boulder: Westview Press, 1994), 44.
5 D. W. Griffith, "Pace in the Movies: A famous director reveals the secret of good pictures," *Liberty,* April 18, 1925, 28.
6 Karen Pearlman, *Cutting rhythms: shaping the film edit* (New York: Focal, 2015), 47.
7 Jacques Aumont and Richard Tr. Neupert, *Aesthetics of film* (Austin: University of Texas Press, 1994), 51.
8 Karen Pearlman, *Cutting rhythms: shaping the film edit* (New York: Focal, 2015), 7.
9 Ibid., 15.
10 Danijela Kulezic-Wilson, "The Musicality of Film Rhythm," in *National cinema and beyond*, Kevin Rockett (Dublin: Four Courts Press, 2004), 121.
11 J. Dudley Andrew, *The major film theories: an introduction* (London: Oxford University Press, 1976), 186.
12 Matila Ghyka, cited in Jean Mitry, *Semiotics and the analysis of film* (London: Athlone, 2000), 212.
13 Jean Mitry, *Semiotics and the analysis of film* (London: Athlone, 2000), 223, my emphasis.
14 This example of rhythmic prose from *The Satanic Verses* is suggested in Ben Smith, "On Rhythmic Prose," *Mosaic Art & Literary Journal*, October 22, 2015. Accessed May 30, 2017. https://mosaiczine.com/2015/10/22/on-rhythmic-prose/.
15 Ibid., 222.
16 Jean Mitry, *Semiotics and the analysis of film* (London: Athlone, 2000), 221.
17 Theo Van Leeuwen, "Rhythmic Structure of the Film Text," in Teun A. van Dijk, editor, Discourse and communication: new approaches to the analysis of mass media discourse and communication (Berlin: W. de Gruyter, 1985), 217.
18 Ibid., 223.
19 Herbert Zettl, *Sight, sound, motion: applied media aesthetics* (Boston, MA: Wadsworth, 2016), 294.
20 Ibid., 294.
21 Ibid., 295.
22 Ibid., 294.
23 Ibid., 299.
24 Theo Van Leeuwen, "Rhythmic Structure of the Film Text," in Teun A. van Dijk, editor, Discourse and communication: new approaches to the analysis of mass media discourse and communication (Berlin: W. de Gruyter, 1985), 216.
25 David Bordwell, *The way Hollywood tells it: story and style in modern movies* (Berkeley: University of California Press, 2010), 124.
26 Annette Michelson and Kevin O'Brien, *Kino-eye: the writings of Dziga Vertov* (Berkeley: University of California Press), 88.
27 Karen Pearlman, *Cutting rhythms: shaping the film edit* (New York: Focal, 2015), 84–85.
28 Josh Rottenberg, " 'Mad Max: Fury Road': George Miller on Car Crashes, Tom Hardy's Animal Magnetism," *Los Angeles Times*, July 30, 2014. Accessed June 24, 2017. http://herocomplex.latimes.com/movies/mad-max-fury-road-george-miller-on-car-crashes-tom-hardys-animal-magnetism/#/0.
29 "Mad Max: Fury Road (2015, USA, Australia) Directed by: George Miller, Measured with FACT," *Cinemetrics*, Movie. Accessed June 24, 2017. http://www.cinemetrics.lv/movie.php?movie_ID=18994.
30 Searle's comments are at Vashikoo, "*Mad Max:* Center Framed," *Vimeo*. June 24, 2017. Accessed June 24, 2017. https://vimeo.com/129314425.
31 The clip, "External Rhythm: *Mad Max Fury Road*, Quick Cuts," is on Critical Commons at http://www.criticalcommons.org/Members/m_friers/clips/external-rhythm-mad-max-fury-road-quick-cuts.

32 Mary Pat Kelly, *Martin Scorsese: a journey* (New York: Thunders Mouth, 2004), 150.
33 Todd Berliner, "Visual Absurdity in *Raging Bull*," in *Martin Scorsese's Raging Bull*, Kevin J. Hayes 2005, 43. http://hdl.handle.net/2027/heb.07612.
34 Ibid., 47.
35 The clip, "External Rhythm: *Raging Bull*, Quick Cuts, Collision Montage," is on Critical Commons at http://www.criticalcommons.org/Members/m_friers/clips/external-rhythm-raging-bull-quick-cuts-collision.
36 Todd Berliner, "Visual absurdity in *Raging Bull*," in *Martin Scorsese's Raging Bull*, Kevin J. Hayes, 2005, 48. http://hdl.handle.net/2027/heb.07612.
37 Here, Berliner uses the term "collision montage" for what we more narrowly termed the "idea associative comparison" montage following Herbert Zettl's nomenclature.
38 Traditionally, film theorists have claimed that that there is an asymmetry in the film screen – i.e., that the right hand side of the screen holds the viewer's attention more – and that the *direction* of movement on screen can increase internal rhythm – i.e., that character or object movement from left-to-right across the screen appears "faster," "easier" or increased in tempo, while movement right-to-left is "slower," "more difficult" or decreased in tempo. This longstanding claim appears to ignore the pattern of the eye movements of many filmgoers in many cultures that read right to left – Arabic, Hebrew, Japanese, Persian, for example – and empirical studies are inconclusive. In *Alexander Nevsky* (Eisenstein, 1938) the attacking German soldiers are staged with strong, repeated diagonal compositions that use rows of descending pikes to create a powerful left-to-right vector field. If we flop that image to orient the composition right-to-left, you can judge the relative aesthetic energy created with screen direction. See Critical Commons, "Internal Rhythm: *Alexander Nevsky*, Direction of Movement Compared" at http://www.criticalcommons.org/Members/m_friers/clips/internal-rhythm-alexander-nevsky-direction-of-1.
39 The clip, "*Citizen Kane*: Internal Rhythm, Movement of People and Objects and Composition (Repeated Forms)," is on Critical Commons at http://www.criticalcommons.org/Members/m_friers/clips/citizen-kane-internal-rhythm-movement-of-people/.
40 Rudolf Arnheim, *Film as art* (Berkeley: University of California Press, 2009), 12.
41 Jacques Aumont and Richard Tr. Neupert, *Aesthetics of film* (Austin: University of Texas Press, 1994), 51. Klee was an accomplished musician who compared the rhythms of Bach's musical contrapuntal compositions to the visual rhythm in drawings.
42 The clip, "Internal Rhythm: *Barry Lyndon*, Pattern of Movement, Marching Comparison," is on Critical Commons at http://www.criticalcommons.org/Members/m_friers/clips/internal-rhythm-barry-lyndon-pattern-of-movment/.
43 Jim Emerson, "Kubrick and the Cosmic Zoom | Scanners | Roger Ebert," *RogerEbert.com*, August 8, 2006. Accessed May 16, 2017. http://www.rogerebert.com/scanners/kubrick-and-the-cosmic-zoom.
44 The clip, "Internal Rhythm: *Tinker Tailor Soldier Spy*, Telephoto Lens Slows Motion Towards the Camera," is on Critical Commons at http://www.criticalcommons.org/Members/m_friers/clips/internal-rhythm-telephoto-lens-slows-motion/view.
45 The clip, "Internal Rhythm: *Aguirre,* Character Movement, Wide Angle Lens," is on Critical Commons at http://www.criticalcommons.org/Members/m_friers/clips/internal-rhythm-aguirre-character-movement-wide/.
46 Werner Herzog and Eric Ames, *Werner Herzog: interviews* (Jackson: University Press of Mississippi, 2015), 120, my emphasis.
47 Ibid., 70.
48 Herbert Zettl, *Sight, sound, motion: applied media aesthetics* (Boston, MA: Wadsworth, 2016), 230.
49 The clip, "Internal Rhythm: *Citizen Kane*, Low Angle Increases Internal Rhythm," is on Critical Commons at http://www.criticalcommons.org/Members/m_friers/clips/internal-rhythm-citizen-kane-low-angle-increases.
50 The clip, "Internal Rhythm: *Blowup,* High Angle Camera Placement Decreases Internal Rhythm," is on Critical Commons at http://www.criticalcommons.org/Members/m_friers/clips/internal-rhythm-high-angle-camera-movment.
51 Roger Ebert, *The great movies* (New York: Broadway Books, 2005), 78.
52 The clip, "Internal Rhythm: *Spartacus*, High Angle Camera Placement Decreases Internal Rhythm," is on Critical Commons at http://www.criticalcommons.org/Members/m_friers/clips/internal-rhythm-spartacus-high-angle-camera.
53 Jean Mitry, *Semiotics and the analysis of film* (London: Athlone, 2000), 22.
54 Herbert Zettl, *Sight, sound, motion: applied media aesthetics* (Boston, MA: Wadsworth, 2016), 229, my emphasis.

55 The clip, "Internal Rhythm: 'Life Lessons,' Close up and Color Usage," is on Critical Commons at http://www.criticalcommons.org/Members/m_friers/clips/internal-rhythm-life-lessons-close-up-and-color.

56 The clip "Internal Rhythm: *Paths of Glory*, Reverse Dolly," is on Critical Commons at http://www.criticalcommons.org/Members/m_friers/clips/internal-rhythm-reverse-camera-track-in-paths-of.

57 The clip, "Internal Rhythm: *Moonrise Kingdom*, Layered Composition in a Tracking Shot," is on Critical Commons at http://www.criticalcommons.org/Members/m_friers/clips/internal-rhythm-moonrise-kingdom-tracking-shot.

58 The clip, "Internal Rhythm: *Saving Private Ryan*, Handheld Camera Increases Internal Rhythm," is on Critical Commons at http://www.criticalcommons.org/Members/m_friers/clips/internal-rhythm-saving-private-ryan-handheld-1/.

59 Janusz Kamiński and Evan Luzi, "Janusz Kamiński Case Study," *The Black and Blue*, January 21, 2014, 22 and 24. Accessed May 26, 2017. http://www.theblackandblue.com/2014/01/21/cinematography-case-study/.

60 Ibid., 4.

61 Peter Maslowski, "Reel War vs. Real War," *Military History Quarterly* (Summer, 1998): 71.

62 Ibid., 69.

63 The clip "Internal Rhythm: 'Life Lessons,' Blue Tint vs. B&W," is on Critical Commons at http://www.criticalcommons.org/Members/m_friers/clips/internal-rhythm-life-lessons-blue-tint-vs-b-w/.

64 Peter Maslowski, "Reel War vs. Real War," *Military History Quarterly* (Summer, 1998): 67.

65 The clip, "Internal Rhythm: Candle light in *Barry Lyndon*," is on Critical Commons at http://www.criticalcommons.org/Members/m_friers/clips/internal-rhythm-candle-light-in-barry-lyndon.

66 Dave Mullen, A.S.C. says, "Kubrick used special 3-wick candles to increase the light output and shot at f/0.7 on 100 ASA film stock pushed to 200 ASA. F/0.7 is 2-stops faster than the common f/1.4 fast lenses available, such as the Zeiss Master Primes." See *Barry Lyndon* Candle lit scenes [Archive] – *REDUSER.net*. Accessed May 24, 2017. http://www.reduser.net/forum/archive/index.php/t-65115.html.

67 Ed DiGiulio, "Two Special Lenses for 'Barry Lyndon'." Accessed May 24, 2017. http://www.visual-memory.co.uk/sk/ac/len/page1.htm.

68 Paul Adolph Näcke, "Feuremanie," in *Hans Gross Archiv fürKriminal-Anthropologie and Kriminalistik*, vol. 26 (1906) cited in Sergei Eisenstein and Jay Leyda, *Eisenstein on Disney* (London: Methuen, 1988), 24.

69 The clip, "Internal Rhythm: Saturated Colors in *Beetlejuice*," is on Critical Commons at http://www.criticalcommons.org/Members/m_friers/clips/internal-rhythm-saturated-colors-in-beetlejuice.

70 The clip, "Internal Rhythm: *Alexander Nevsky*, Repeated Forms," is on Critical Commons at http://www.criticalcommons.org/Members/m_friers/clips/internal-rhythm-alexander-nevsky-repeated-forms.

71 The clip, "Internal Rhythm: *Blowup*, Repeated Forms, Plastic Rhythm," is on Critical Commons at http://www.criticalcommons.org/Members/m_friers/clips/internal-rhythm-composition-repeated-forms-in-blow.

72 Peter Brunette, *The films of Michelangelo Antonioni* (Cambridge, MA: Cambridge University Press), 111 and 113.

73 Béla Balázs, *Theory of the film: (character and growth of a new art)* (New York: Roy Publishers, 1953), 143.

74 As Francoise Meltzer notes in his translation of this article, that since the term trucage literally means "trick photography" in the singular and "special effects" in the plurual, it is best to retain the French term rather than translate it, since Metz uses it much more broadly to include effects like accelerated motion and blurred focus that are usually created in production as well as fades, wipes, etc. that are created in postproduction.

75 Christian Metz and Françoise Meltzer, " 'Trucage' and the Film," *Critical Inquiry* 3(4) (1977): 657, doi:10.1086/447911.

76 Ibid., 660.

77 J. Dudley Andrew, *The major film theories: an introduction* (London: Oxford University Press, 1976), 212.

78 The Merriam-Webster dictionary defines taxeme as "a minimum grammatical feature of selection (as the occurrence of the noun *actor* before *-ess* in *actress*), of order (as the fact that *actr-* precedes *-ess* in *actress*), of stress (as the occurrence of one main stress on the first syllable in *actress*), of pitch (as the interrogative final pitch when *Actress?* is an entire utterance constituting a question), or of phonetic modification (as the change of *actor* to *actr-* before *-ess*)."

79 Barry Salt, "Dissolved Away," *The Velvet Light Trap* 64(1) (2009), doi:10.1353/vlt.0.0046.

80 David Bordwell, Kristin Thompson and Jeff Smith. *Film art an introduction* (New York, NY: McGraw-Hill, 2017), 251.

81 Edward Dmytryk, *On film editing: an introduction to the art of film construction* (Boston: Focal Press, 1984), 84.

82 James E. Cutting, Kaitlin L. Brunick and Jordan E. Delong, "The Changing Poetics of the Dissolve in Hollywood Film," *Empirical Studies of the Arts* 29(2) (2011): 154–165, doi:10.2190/em.29.2.b.

83 Ibid., 166.

84 Ibid., 166.

85 Ibid., 166.

86 The clip, "External Rhythm: *Sideways*, Cluster or Serial Dissolves," is on Critical Commons at http://www.criticalcommons.org/Members/m_friers/clips/external-rhythm-sideways-cluster-or-serial.

87 The clip, "External Rhythm: *Sideways*, Two Dissolves," is on Critical Commons at http://www.criticalcommons.org/Members/m_friers/clips/external-rhythm-sideways-two-dissolves.

88 The clip, "Graphic Edits: *Grand Prix*, Super and Cut on Form, " is on Critical Commons at http://www.criticalcommons.org/Members/m_friers/clips/graphic-edits-grand-prix-super-and-cut-on-form.

89 Christian Metz and Françoise Meltzer, "'Trucage' and the Film," *Critical Inquiry* 3(4) (1977): 661, doi:10.1086/447911.

90 Marek Haltof, *The cinema of Krzysztof Kieślowski: variations on destiny and chance* (London: Wallflower, 2004), 131.

91 The clip, "External Rhythm: *Three Colors: Blue*, Fade out/in Suspends the Narrative," is on Critical Commons at http://www.criticalcommons.org/Members/m_friers/clips/external-rhythm-three-colors-blue-fade-out-in.

92 Janina Falkowska, "*The Double Life of Veronica* and *Three Colours*: an escape from politics?" in *Lucid dreams: the films of Krzysztof Kieślowski*, edited by Paul Coates (Trowbridge: Flicks Books, 1999), 145.

93 Ibid., 143.

94 The clip, "External Rhythm: *Wayne's World*, Spoof the Fade Out," is on Critical Commons at http://www.criticalcommons.org/Members/m_friers/clips/external-rhythm-waynes-world-spoof-the-fade-out.

95 The clip, "External Rhythm: *Thicker Than Water*, Humorous Wipe Sequence," is on Critical Commons at http://www.criticalcommons.org/Members/m_friers/clips/external-rhythm-thicker-than-water-humorous-wipe.

96 Herbert Zettl, *Sight, sound, motion: applied media aesthetics* (Boston, MA: Wadsworth, 2016), 204.

97 The clip, "*Superman* Wipe," is on Critical Commons at http://www.criticalcommons.org/Members/ogaycken/clips/superman-wipe-critical-commons-1.mp4.

98 Harry M. Benshoff, *Film and television analysis: an introduction to methods, theories, and approaches* (London: Routledge, 2016), page number unknown.

99 James Goodwin and Carlos Giménez Soria, *Akira Kurosawa and intertextual cinema* (Baltimore: The Johns Hopkins University, 2010), 146.

100 Ibid., 143.

101 The clip, "External Rhythm: *Rashomon,* The Wipe," is on Critical Commons at http://www.criticalcommons.org/Members/m_friers/clips/external-rhythm-rashomon-the-wipe.

102 Donald Richie and Joan Mellen, *The films of Akira Kurosawa* (Berkeley, CA: University of California Press, 2006), 79.

103 Ibid., 15.

104 James Goodwin and Carlos Giménez Soria, *Akira Kurosawa and intertextual cinema* (Baltimore: The Johns Hopkins University, 2010), 146.

105 The clip, "External Rhythm: *Ikiru*, Humorous Wipe Sequence," is on Critical Commons at http://www.criticalcommons.org/Members/m_friers/clips/external-rhythm-ikiru-humorous-wipe-sequence.

106 The clip, "External Rhythm: *Highlander*, Spatially Integrated Wipe," is on Critical Commons at http://www.criticalcommons.org/Members/m_friers/clips/external-rhythm-highlander-integrated-wipe.

107 Barry Salt, *Film style and technology: history and analysis* (London: Starword, 2009), 129.

108 The clip, "External Rhythm: *The Artist*, Iris Transition and Circular Motif," is on Critical Commons at http://www.criticalcommons.org/Members/m_friers/clips/external-rhythm-the-artist-iris-transition-and.

109 David Bordwell, Kristin Thompson and Jeff Smith, *Film art an introduction* (New York, NY: Mc Graw-Hill, 2017), 221.

110 Ibid., 220.

111 The clip, "Graphic Edit: *The Birds*, Graphic Contrast," is on Critical Commons at http://www.criticalcommons.org/Members/m_friers/clips/graphic-edit-the-birds-graphic-contrast.

112 David Bordwell, Kristin Thompson and Jeff Smith, *Film art an introduction* (New York, NY: McGraw-Hill, 2017), 222–223.

113 Kristin Thompson claims to have coined the term: "Most people don't realize this, but David [Bordwell] and I invented the term 'graphic match.' As we recall, this happened in 1975. David was teaching a course that involved screening Yasujiro Ozu's second color film, *Ohayu* (1959), a wonderful comedy about television, farting, and small talk. We had never seen the film before and were watching a 16mm print of it.
 When the two shots below passed before our eyes, we both gasped and lunged for the projector. We ran the film back and watched the cut again. There was no doubt that Ozu had deliberately placed a bright red sweater in the upper left quadrant of the frame in one shot and a bright red lamp in the same basic position in the next shot. We didn't know what to call this technique, so we dubbed it a 'graphic match.'" See "Graphic Content Ahead," *Observations on film art.* Accessed July 19, 2017. http://www.davidbordwell.net/blog/2011/05/25/graphic-content-ahead/.

114 The clip, "Graphic Edits: *Sherlock Jr.*, Cut on Form and Position," is on Critical Commons at http://www.criticalcommons.org/Members/m_friers/clips/graphic-edits-sherlock-jr-cut-on-form-and-position.

115 For a discussion of use of the carry over dissolve in animation, see Michael Frierson, "The Carry Over Dissolve in UPA Animation," *Animation Journal,* 10 (2002): 50–66.

116 David Byrne, "Love For Sale," Warner Bros./Sire, 1986.

117 The clip, "Graphic Edits: *Ran*, Cut on Form and Position," is on Critical Commons at http://www.criticalcommons.org/Members/m_friers/clips/graphic-edits-ran-cut-on-form-and-position.

118 The clip, "Graphic Edits: *All that Jazz*, Cut on Form, Position and Motion," is on Critical Commons at http://www.criticalcommons.org/Members/m_friers/clips/graphic-edits-all-that-jazz-cut-on-form-and.

119 The clip, "Graphic Edits: *Seven Samurai*, Cut on Form and Position," is on Critical Commons at http://www.criticalcommons.org/Members/m_friers/clips/graphic-edits-seven-samurai-cut-on-form-and.

120 The clip, "Graphic Edits: *Psycho*, Dissolve-on-form, Dissolve-on-position," is on Critical Commons at http://www.criticalcommons.org/Members/m_friers/clips/graphic-edits-psycho-dissovle-on-form-dissolve-on.

121 Lesley Brill, *The Hitchcock romance: love and irony in Hitchcock's films* (Princeton: Princeton University Press, 1992), 224–225.

122 The clip, "Graphic Edits: *2001*, Cut on Form and Position," is on Critical Commons at http://www.criticalcommons.org/Members/m_friers/clips/graphic-edits-2001-cut-on-form-and-position.

123 Michel Ciment, *Kubrick* (New York: Holt, Rinehart, and Winston, 1983), 128.

124 Ibid., 134.

125 Karen Pearlman, *Cutting rhythms: shaping the film edit* (New York: Focal, 2015), 250.

Glossary

30° rule Moving the camera at least 30° off the axis of the previous shot is considered the minimum change of position to ensure smooth cutting when shooting traditional continuity coverage.

Actual time Time experienced subjectively in one continuously unraveling present that produces an accumulating past; what philosopher Henri Bergson calls *duration* (French: *durée*).

Analytical editing A dominant style of editing where the scenic space is first shown in an establishing shot to show the relative positions of significant elements, and subsequently broken down into closer shots or "analyzed," ensuring that the viewer is spatially oriented. Often, if a character changes position or crosses the space, a wide shot is used to reestablish relative positions. Same as **deductive visual approach** below.

Applied media aesthetics The branch of aesthetics that deals with sense perceptions and how to influence them through the fundamental image elements of light and color, space, time/motion, and sound, with a focus on video, film and other electronic audiovisual media. Herbert Zettl, *Sight, sound, motion* (SSM).

Attraction Any striking aspect of theatre or film that can serve to stimulate the audience. In broad terms, the attraction for Eisenstein centered on both the visually expressive moment, and the immediate mental impact on the viewer seeing the violent, frightful or surprising action represented.

Axial cut A cut from one scope of shot to another – either wider or tighter – where the axis extending from the center of the camera lens does not change significantly.

Axis of action An imaginary line that connects the primary visual elements in a scene, typically two characters facing each other. The axis is used to position the camera on one side of the line so that screen direction continuity is maintained within a scene.

Caméra-stylo Literally "camera-pen," the concept advanced by film critic and director Alexander Astruc in 1948 that film directors should use their cameras like writers use their pens, as an instrument of individual expression.

Complexity editing The building of an intensified screen event from carefully selected event essences. Complexity editing is used to create certain kinds of montage sequences (SSM).

Conceptual time Clock time, time divided arbitrarily into minutes, hours, days, etc.

Constructivism A modern art movement that emerged in Russia in 1913 that embraced abstraction, rejected the past, and sought to pare the work down to its essential elements. Constructivism advocated the creation of art that served social purposes and had the quality of *factura*, meaning the surface of the object should demonstrate how it had been made.

Converging vector Vectors that point or move towards each other (SSM).

Creating an event Building a unique event on screen that depends entirely upon the medium (SSM). (See **Looking at an event** and **Looking into an event**.)

Creative geography A form of narrative editing in which the shots taken in different locations suggest a spatial unity within a scene.

Crosscutting (parallel editing) Editing that alternates shots of two or more lines of action occurring in different places, usually simultaneously.

Découpage has three meanings: 1) the final form of a script, incorporating whatever technical information the director feels it is necessary to set down on paper to enable a production crew to understand his intention and find the technical means with which to fill it; 2) the more or less precise breakdown of a narrative action into separate shots or sequences *before filming* ... called a "shooting script" in English; and 3) the underlying structure of the finished film. Nöel Burch, *Theory of film practice* (TFP).

Deductive visual approach Moving from an overview into event detail. (SSM). This approach relies on wider shots before moving to closer shots.

Dialectical materialism The Marxian interpretation of reality that views matter as the sole subject of change and all change as the product of a constant conflict between opposites arising from the internal contradictions inherent in all events, ideas and movements.

Diegesis A term for all that exists within the world of a film or play – characters, dialogue, sounds, music. Diegetic sound is sound that appears to be coming from the filmic space, as opposed to say, background or incidental music that is added to a scene in postproduction. Frank Beaver, *Dictionary of film terms* (DFT).

Dissolve A mix transition where the gradual fading out of one shot and the simultaneous fading in of another produce a momentary overlap between the two images. The dissolve usually represents a temporal ellipsis between the two shots.

Dominant The supremacy of one group of formal elements in an artistic composition, and particularly in film, the ascendancy of one group of elements in a sequence.

Editing The entire process of putting a film together into its final form, which includes the selection and shaping of shots; the arrangements of shots, scenes and sequences; the mixing of all soundtracks; and integrating of the final soundtrack with the images. Editing controls the order of shots, the frequency of shots, and the duration of shots. Ira Konigsberg, *The complete film dictionary* (CFD).

Elliptical editing An editing style that leaves out action without including covering shots or shot transitions. Such editing results in jump cuts from action to action or place to place (CFD).

External rhythm The rhythm created by editing and the length of the shots. Zettl calls this "tertiary motion."

Eye-line The vector created by the direction in which a character is looking.

Fabula The story's state of affairs and events, including all the explicitly presented events (i.e., plot) *plus* all the events we infer from the plot. A rough equivalent to "fabula" is "story." David Bordwell, *Narration in the fiction film* (NFF).

Fade A mix transition using black as one source: it produces the gradual appearance of an image from black or disappearance of an image to black. The fade-in usually marks beginnings, and the fade-out marks endings, like the raising and lowering of the curtain in theatre.

Film narration The process by which the film prompts the viewer to construct the ongoing fabula on the basis of syuzhet organization and stylistic patterning. In a fiction film, narration is the process whereby the film's plot and style interact in the course of cueing and channeling the spectator's construction of the story. (NFF)

Film style The manner or group of conventions by which a motion-picture idea is expressed so that it effectively reveals the idea as well as the filmmaker's attitude toward the idea (DFT).

Formalist film theory A theory of film study that is focused on the formal elements of a film – lighting, sound and set design, use of color, shot composition, editing, etc. – and how those elements reveal theme, or other interpretations.

Graphication A three-dimensional lens generated screen image that is deliberately rendered in a two-dimensional graphic, picture-like format (SSM).

Graphic vector A vector created by lines or by stationary elements arranged in such a way to suggest a line. Although graphic vectors are ambivalent to precise direction, they do indicate a directional tendency, such as horizontal, vertical, curved, uphill or downtown (SSM).

Head-on, tail-away A cut wherein a character (or object) moves close towards the camera lens and a cut is then made to the character (or another character) who moves away from the camera to reveal what is "behind the camera" (or to reveal a new scene). The head-on, tail-away movement relies on neutral z-axis action to create a smooth cut (DFT).

Index vector A vector created by someone looking for something pointing unquestionably in a specific direction (SSM).

Inductive visual approach Moving from one event detail to another to create the overall event in the viewer's mind (SSM). This approach uses closer shot and moves to wider shots.

Institutional mode of representation (IMR) A standardized system of filmic narration aimed at maintaining comprehensible illusion of continuous time and space relationships using smooth cuts between shots of differing scope and placement (TFP).

Intellectual montage The highest order of montage in Eisenstein's typology, this form of collision montage juxtaposes two shots to give rise to a third idea.

Internal rhythm The rhythm created *within a shot* by the movement of actors or objects or the camera itself. This term encompasses primary motion – everything that moves in front of the camera – and secondary motion – the motion of the camera and the motion simulated by camera zooms.

Invisible observer model of editing A concept of film editing claiming that cutting mimics the shifts in attention of an ideal observer who controls the flow of narrative information, and provides the psychological guidance of the viewer.

Iris-in Masking the outgoing shot off into a circle typically, (though diamonds, triangles and rectangles are possible) that decreases in size until the entire frame is black. If the incoming shot reverses the process to bring the incoming image from black to full screen, the transition is called iris-in/iris-out.

Italian neorealism A body of filmmaking from postwar Italy that rejected the well-made studio film for found stories of common people, shot in the streets for visual authenticity, often with non-actors.

Izobrazhenie Images/depictions are accumulated to create *obraz*, the overarching form or "artistic image" (See **Obraz.**)

J-cut A cut in which the sound for the incoming shot precedes the picture; an edit that "prelaps" the audio of the incoming shot into the outgoing scene. (See **L-cut.**)

Jump cut A shot in which some of the frames have been excised, typically creating an undisguised, measurable temporal ellipsis that shows time has been elided. In other cases, the jump cut simply rearranges temporal events.

Kuleshov effect The meaning and/or emotional impact derived from juxtaposing individual shots to create a context existing only in the editing itself and not inherent in any of the single pieces of film (CDF).

L-cut A cut in which the sound of the outgoing shot continues after the picture ends; an edit that "postlaps" the audio of the outgoing shot into the incoming shot. (See **J-cut.**)

Looking at an event Presenting an event on screen in order to clarify the viewer's understanding of what is occurring; reporting the main elements of the event as it unfolds (SSM). (See **Looking into an event** and **Creating an event.**)

Looking into an event Presenting an event on screen in order to scrutinize it as closely as possible, to look behind its obvious outer appearance to probe into its structure and essence (SSM). (See **Looking at an event** and **Creating an event.**)

Match cut In the broadest sense, the term that refers to a cut where there is duplication in the profilmic material of the outgoing shot A and the incoming shot B. A **match on action** is a

more narrow term that means the incoming shot B continues an action begun in the outgoing shot A. A **graphic match** (as opposed to a graphic contrast) occurs when the shapes, colors and/or overall movement of two shots match in composition.

Metric montage A term used by Sergei Eisenstein to describe an edited sequence wherein all shots are essentially the same length (duration). (See **Rhythmic**, **Tonal**, **Overtonal** and **Intellectual Montage**.)

Mise-en-scène A term that generally refers to the elements within a scene, that is, the physical setting that surrounds a dramatic action. In film criticism, *mise-en-scène* has sometimes been used to describe an approach to cinematic arts placing greater emphasis on pictorial values within a shot than on juxtaposition of two shots (montage) (DFT). In film, the term also includes lens usage, camera placement, and composition within the frame.

Montage has at least six meanings: 1) Montage = editing; 2) Sequential analytical montage: to condense an event into key developmental elements and present these elements in their original cause–effect sequence; 3) The Hollywood montage: a *subset* of the analytical sequential montage, where key elements of the narrative are compressed, often using traditional markers of time passing like dissolves; 4) Sectional analytical montage: temporarily arrests the progression of an event and examines an isolated moment from several viewpoints; 5) Idea-associative Comparison Montage: this type of montage "consists of succeeding shots that juxtapose two events that are thematically related in order to express or reinforce the theme or basic idea; 6) Idea-associative Collision Montage: the juxtaposition of two opposite events to express or reinforce a basic idea or feeling.

Motion vector A vector created by an object actually moving in any specific direction or an object that is perceived as moving on the screen. A photograph or drawing of an object in motion is an index vector but not a motion vector (SSM).

Motor-imitative response A primitive, reflexive mental response triggered in a subject simply by seeing a stimulus. When an audience sees an actor executing a movement, the audience reflexively repeats that action in a weakened form releasing emotion. David Bordwell, *The cinema of Eisenstein* (CE).

Non-diegetic insert A shot or a series of shots that shows things outside the space of the unfolding narrative. While the non-diegetic image insert is relatively rare, by comparison, non-diegetic sound is common: sound that has been created separately and added to the on-screen source sounds, like a musical score is ubiquitous.

Objective correlative To express human emotions, the artist must create a visible counterpart an object, a chain of events – that evoke that feeling in the viewer. (Also called "plastic material" by Pudovkin.)

Obraz Russian word for the overarching form, the "artistic image" or "felt concept" created by the accumulation of formal elements, or proper images/depictions (See **Izobrazhenie**.)

Overtonal montage A term used by Sergei Eisenstein to describe montage in which the primary attractions/primary movements no longer speak to the viewer, but rather secondary attractions/sensed vibrations that emerge begin to displace the primary movement. Like the sound of an organ, where stops have been engineered to mimic a clarinet, a flute, a piccolo, or a tuba, clearly the overtones control in large part how the pipes speak – the overtones displace the dominant tone. (See **Metric**, **Tonal**, **Rhythmic** and **Intellectual Montage**.)

Pacing The combination of internal and external rhythm, the felt experience of movement created by the rates and amounts of movement in a single shot and by the rates and amounts of movement across the series of edited shots.

Plan-américain A medium wide shot framed on the human figure from the knees up, which usually contains more than one character engaged in dialogue, arranged so that all are visible to the camera.

Plastic rhythm A pattern characteristic of visual arts where repeated objects or shapes recur in a regular arrangement.

Plotless cinema A style developed by Eisenstein that rejects the notion of plot as a series of consequences developing from the actions of an individual. The style favors perceptual and emotional shock over stringent realism, depicts the "mass protagonist" as the creator of historic change, uses motifs of significant objects and graphic patterns to develop thematic associations, and employs typage (CE).

Politique des auteurs Literally "a policy of authors," translated in English by film critic Andrew Sarris as the "auteur theory." The on-going argument that certain directors deserve to be called the author of their films, because their vision drives the artistic control of the film.

Primacy effect In a narrative, the tendency for early knowledge to form a frame of reference to which subsequent information is subordinated as far as possible.

Primitive mode of representation (PMR) An early style of filmic narration that uses the tableaux, action staged frontally along the x-axis that plays out in a single shot, using acting styles that rely on the grand gestures of bourgeois theatre, often with accompaniment by presenters or lecturers to explain the story unfolding on the screen to the audience.

Profilmic material Literally, the material "before the camera," in front of the camera.

Proxemics In film, the effects of spatial relations between camera and subject on the kinetic and emotional impact of a scene.

Referential cut A figure of film style in which character looks towards a space outside the space of the frame, the shot holds for a few frames, and then cuts to what the character is looking at.

Rhythmic montage A term used by Sergei Eisenstein to describe editing that combines shots and determines the length (duration) based on their content; determining the external rhythm of a sequence not simply by shot length, but by taking into account the internal rhythm of each shot. (See **Metric**, **Tonal**, **Overtonal** and **Intellectual Montage**.)

Schema A pattern of thought or behavior that organizes categories of information and the relationships among them.

Screen space The space as contained within the borders of the screen, or the cumulative screen space of a shot sequence or of multiple screens (SSM).

Shot/reverse shot Two or more shots edited together that alternate characters, typically in a conversation. In *continuity editing*, characters in one framing might typically look left; in the other framing, right. Over-the-shoulder framings are common in shot/reverse shot editing.

Socialist Realism An official style of art codified in the 1934 Communist Party Conference decree that art must be relevant to the proletariat, realistic in its depiction of everyday life, and support the goals of the state.

Syuzhet The arrangement of explicitly presented events in the narrative text. A rough equivalent to "syuzhet" is "plot."

Tonal montage A term used by Sergei Eisenstein to describe montage where "movement" is perceived in a wider sense, as all affects of the montage piece; a montage is based on the general emotional tone of the piece. (See **Metric**, **Rhythmic**, **Overtonal** and **Intellectual Montage**.)

Techné The principles and systematic knowledge employed in making something. Aristotle's term for the unity of theory and practice within a skilled activity (CE).

Two pop A 1 kHz tone that is one frame long and placed 2 seconds before the start of a program as part of the Academy leader system to ensure synchronization between sound and picture in film or video.

Typage Portraying character through the external features of physiognomy, dress and behavior to indicate religion, region of origin and class. Casting for "type."

Vector In media aesthetics, a perceivable force with a direction and in magnitude. Also any aesthetic that leads us into a specific space/time – or even emotional – direction (SSM).

Vector field A combination of vectors operating within a single picture field (frame), from picture field to picture field (frame to frame), from picture sequence to picture sequence, from screen to screen (multiple screens), or from screen to off screen events (SSM).

Vertical montage Eisenstein's term for applying the principles of montage to the interaction of the visual image and sound. Vertical montage moves beyond reproduction — sync-sound — to create theme from polyphonic lines of meaning that emerge from techniques such as contrapuntal sound.

Windowing Editing by visual organization of materials within the frame, often multiple images simultaneously on screen. Zettl calls this "second-order space."

Wipe A transition where the incoming shot moves across the screen to replace the outgoing shot, an overtly graphic transition that acknowledges the film image's two-dimensional representation of space.

Index

Note: when the text is within a table or figure, the number span is in **bold.**